AMERICAN WOMEN PHOTOGRAPHERS

AMERICAN WOMEN PHOTOGRAPHERS

A Selected and Annotated Bibliography

MARTHA KREISEL

Art Reference Collection, Number 18

Greenwood Press
Westport, Connecticut · London

Library of Congress Cataloging-in-Publication Data

Kreisel, Martha, 1948–
 American women photographers : a selected and annotated
bibliography / Martha Kreisel.
 p. cm.—(Art reference collection, ISSN 0193–6867 ; no. 18)
 Includes bibliographical references and index.
 ISBN 0–313–30478–5 (alk. paper)
 1. Women photographers—United States—Bibliography.
2. Photography—United States—History—Bibliography. I. Title.
II. Series.
Z7134.K74 1999
[TR139]
016.77′082′0973—dc21 98–48654

British Library Cataloguing in Publication Data is available.

Library of Congress Catalog Card Number: 98–48654
ISBN: 0–313–30478–5
ISSN: 0193–6867

First published in 1999

Greenwood Press, 88 Post Road West, Westport, CT 06881
An imprint of Greenwood Publishing Group, Inc.

Printed in the United States of America

CONTENTS

INTRODUCTION

Women have been involved in the professional, amateur, and artistic progress of photography for a over a century. In the early years they served as photographic assistants in their husbands' studios. Upon a husband's death, the wife often assumed control of the business as a way of supporting herself. Since equipment was heavy and awkward to transport, many of the women stayed in the studio. They would often specialize in portraiture of women and children, allowable subjects for women to pursue.

By the 1880s as innovations by George Eastman and Kodak made the camera easier to handle, photography became accessible to everyone. The marketing strategy for the Kodak *Brownie* reached a new audience of women, giving them a lightweight, inexpensive camera on which to record their children and their surroundings. This respectable and genteel hobby allowed women to photograph scenes around the home, providing us with documentation of domestic life in the late 1890s. At around the same time, women such as Gertrude Käsebier and Adelaide Hanscom Leeson, members of the Photo-secessionist Movement, sought the promotion of photography as a true art form. In both ways, women have made significant contributions to photographic history.

The early advances and interest in photography also opened up areas for professionals photographers: Frances Benjamin Johnston photographed numerous historic homes in North Carolina and made her classic studies of the education of African-American children at the Hampton Institute; Gertrude Käsebier was known for her portraiture; Myra Albert Wiggins professionally photographed life in the Northwest, and Jesse Tarbox Beals was considered one of the first women news photographers for taking photographs of the 1904 World's Fair.

Women like Alice Austen chronicled 19th-century life on Staten Island, New York, and Evelyn Cameron turned her camera to life in late 19th-century Montana. For an extensive treatment of photographers of the 19th-century consult C. Jane Gover's *The Positive Image: Women Photographers in Turn of the Century America* (see entry 1022).

Immediately following the First World War, much was being written on the value and accessibility of photography as a profession for women. Throughout the 1930s there was tremendous economic and social upheaval in American life. The farm families of the Dust Bowl found themselves without a home, without an income, and on the road West to a new life. The lives of migrant workers and tenant farmers, the working poor, and the city dwellers became the subject of documentary photographers. Margaret Bourke-White, Eudora Welty, Marion Post Wolcott, and Dorothea Lange traveled the country to tell their stories. Publications such as *Life* magazine gave photographers an important vehicle to show America the new industrial and construction revolution and chronicle the life of people in far-flung corners of the world and the United States.

American women covered the war in Europe as photojournalists. Their images are some of the most haunting. They documented the children of the war, the concentration camps, and the lives of soldiers and civilians. Chapelle Dickey, Margaret Bourke-White, Mabel Thérèse Bonney, Toni Frissell, and Lee Miller were there to record history.

Throughout the decades many sought to document the pulse of New York City. Helen Levitt saw the life of the City in the chalk drawings on the street. Berenice Abbott sought to capture the architecture of New York City before the skyscrapers changed the skyline forever, and Ruth Orkin captured the changing tempo of the City from her apartment window.

Some of the images teach, some show us beauty, and some make us uncomfortable. The work of Diane Arbus can be unsettling, as can the nude images of Sally Mann's children. We can contemplate the powerful portraits of Native Americans by Laura Gilpin, Marcia Keegan, and Toba Pato Tucker, or we can consider the images by Native American photographers Carm Little Turtle and Hulleah J. Tsinhnahjinnie. We can travel to China with Eve Arnold or Inge Morath, see the brothels of India with Mary Ellen Mark, or view the carved landscapes of Peru in the aerial photography of Marilyn Bridges.

Images of the poor and the rich, the famous and the infamous, are all recorded in a woman's camera with a woman's eye. Feminist agendas, government assignments, agendas of compassion or curiosity, documentation of events for history, or search for beauty--American women photographers have covered it all. For a recent overview of women photographers, consult Naomi Rosenblum's *A History of Women Photographers* (see entry 1058).

This bibliography serves two purposes. The first is to have, in one volume, a substantial body of work on and by American women photographers. The second is to provide a listing of these artists. Some are pioneers in the history of photography, but many are not well known. Many were major influences in documentary photography, experimental photography, or feminist photography. For some artists, this work provides only their name and an image for future study, but they all deserve recognition. My hope is that this work will contribute to further research.

American Women Photographers is really only a beginning, or perhaps,

more correctly, a continuation. I have not attempted to duplicate all of the bibliographic citations that can be found in books and articles, but have indicated those works that contain bibliographies. For exhaustive study of one particular photographer, those bibliographies should be consulted. Monographs, journal articles, doctoral dissertations are included; master's theses, and short notices of exhibitions are not. Brief annotations are provided for monographs and exhibition catalogs that were accessible, but not for journal articles, very short exhibition catalogs, and works not readily available through interlibrary loan.

Peter E. Palmquist has done extensive work compiling bibliographies of women photographers, with an emphasis on early writings (see entries 1042-1050). I have not tried to duplicate his work. I am sure that some names and sources were inadvertently missed, but hopefully others have been included that will pique interest in the work of particular photographers. No attempt has been made to judge the quality of images or the body of work of the photographers. That is for the critics and the public. What is important is to recognize the continuing contribution women photographers have made to the medium of photography and the record of humankind.

ABBREVIATIONS
AND NOTATIONS

c. Approximate date

fig. Figure number

oclc Descriptions taken from OCLC database

p. Page number

pl. Plate number

[] Within the [] are descriptions which were provided by the compiler for those photographs that did not have titles assigned to them by the photographers. These are not *Untitled* photographs.

Actual titles designated by the photographer appear in *Italics* in upper and lower case. Descriptive titles provided by the photographer appear in lower case *italics*.

"See also" references are provided as cross-references from the individual photographers to the collected works in which their names may also appear.

BIBLIOGRAPHY OF AMERICAN WOMEN PHOTOGRAPHERS

Abbe, Kathryn, 1919-
 See also #1058, 1062, 1069, 1070

Abbott, Berenice, 1898-1991
 See also #1000, 1008, 1009, 1026, 1028, 1037, 1053, 1054, 1058, 1061,
 1063

1. Abbott, Berenice. *Berenice Abbott*. With an essay by Julia Van Haaften.
 New York: Aperture Foundation, 1988. 93 p. Bibliography: p. 91-92.
 Includes a brief chronology, list of selected collections and a biographical
 essay.
Fifth Avenue Houses, Numbers 4, 6, 8, 1936, Front cover; *Parabolic Mirror,
Cambridge*, Massachusetts, 1959-1961, Frontispiece; *Jean Cocteau, Paris*, 1927,
p. 9, 13; *Janet Flanner, Paris*, 1927, p. 11; *Nora Joyce, Paris*, 1927, p. 15; *Eugène
Atget, Paris*, 1927, p. 17; *Red River logging project, California*, August, 1943, p.
19; *Triboro Bridge, East 12th Street Approach*, 1937, p. 21; *A. J. Corcoran water
tanks, New Jersey*, 1930, p. 23; *Hester Street*, c. 1929, p. 25; *Repair Shop,
Christopher Street*, c. 1949, p. 27; *Pine and Henry Streets*, 1936, p. 29; *Cheese
Shop on West 8th Street*, c. 1949, p. 31; *Trinidad dancer at the Calypso,
Macdougal Street*, c. 1949, p. 33; *Broadway to the Battery, from the roof of the
Irving Trust Company Building*, 1938, p. 35; *Designer's window, Bleecker Street*,
1947, p. 37; *Union Square, Manhattan*, 1946, p. 39; *Trinity Church, New York*,
1934, p. 41; *Statue along Tidal Basin, Washington, D.C.*, 1954, p. 43; *Exchange
Place from Broadway*, c. 1934, p. 45; *Manhattan Bridge*, 1936, p. 47; *Flatiron
Building, Broadway and Fifth Avenue*, c. 1934, p. 49; *Tempo of the City, Fifth
Avenue and 44th Street*, 1938, p. 51; *Fifth Avenue Coach Company*, 1932, p. 53;
View, Lower Manhattan, 1956, p. 55; *Nightview, New York*, 1932, p. 57; *Van de
Graff generator, MIT, Cambridge, Massachusetts*, 1938, p. 59; *Interference
pattern, New York*, 1959-1961, p. 61; *Multipurpose of bouncing golf ball*, New
York, 1959-1961, p. 63; *Focusing water waves, MIT, Cambridge, Massachussetts*,
1958-1961, p. 65; *Patterns of the magnetic field*, 1958-1961, p. 67; *Penicillin mold*,
1958-1961, p. 69; *Light rays through a prism*, Cambridge, Massachusetts, 1959-
1961, p. 71; *Amusement park, Daytona Beach, Florida*, 1954, p. 73; *Prospect
Harbor, Maine*, c. 1966, p. 75; *Melbourne Hotel, Melbourne, Florida*, 1954, p. 77;
Houses, Newark, New Jersey, 1933; p. 79; *Bonaire Motel, Miami Beach*, 1954, p.
81; *Boardwalk, Daytona Beach, Florida*, June 23, 1954, p. 83; *Edward Hopper,
Greenwich Village, New York*, 1947, p. 85; *Milliken's general store on Sunday
morning, Bridgewater, Maine*, August 22, 1954, p. 87; *House Belfast, Maine along
Route 1*, 1954, p. 94.

2. Abbott, Berenice. *Berenice Abbott: A View of the 20th Century*. Sherman
 Oaks, CA: Ishtar Films, 1992. Videocassette, 57 min. Producers,
 directors, editors, Kay Weaver, Martha Wheelock. Includes interviews
 with Abbott.

3. Abbott, Berenice. *Berenice Abbott: Documentary Photographs of the 1930s: An exhibition.* Organized by the New Gallery of Contemporary Art. Cleveland: The Gallery, 1980. 64 p.

4. Abbott, Berenice. *Berenice Abbott, Photographer: A Modern Vision: A selection of photographs and essays.* New York: New York Public Library, 1989. 95 p.

5. Abbott, Berenice. *Berenice Abbott Photographs.* Foreword by Muriel Rukeyser and introduction David Vestal. Washington, D.C.: Smithsonian Institution, 1990. 176 p. Chiefly illustrations.

6. Abbott, Berenice. *Berenice Abbott, the 20's and the 30's: A traveling exhibition.* Washington, D.C.: Smithsonian Institution Press, 1982. 22p.

7. Abbott, Berenice. *Changing New York.* Text by Elizabeth McCausland. New York: E. P. Dutton, 1939. Reprinted as *New York in the Thirties*, New York: Dover, 1973. 97 p. See Yochelson, Bonnie. *Berenice Abbott at Work.*

8. Abbott, Berenice. "Eugène Atget," *U.S. Camera* 1, 12 (Autumn 1940): 20-23+ and (Winter 1940): 68-71.

9. Abbott, Berenice. *A Guide to Better Photography.* New York: Crown Publishers, 1941. 182 p. Bibliography: p. 175-177.
 An illustrated textbook to "master the photographic process step by step," enhanced with photographs from some of the finest photographers, including Abbott.
Night View, frontispiece; *Time Out for Beer,* pl. 7; *Heymann's Butcher Shop,* pl. 8; *Statue of Liberty,* pl. 10; *Stock Exchange: I,* pl. 13; *Stock Exchange: II,* pl. 14; *Hands of Jean Cocteau,* pl. 17a; *Buddy,* pl. 17b; *Electronics,* pl. 19b; *Joe Gould,* pl. 21; *John Watts,* pl. 22; *Manhattan Skyline,* pl. 26; *City Landscape,* pl. 29; Eye of Audrey McMahon, pl. 30; *Battery Chickens,* pl. 32; *José Clemente Orozco, New York,* 1936, pl. 33; *Agrobiology,* pl. 37; *Barn near Pulaski, Tenn.,* 1935, pl. 38; *Eugène Atget, Paris,* 1927, pl. 43; *Puck,* pl. 44a; *Exchange Place,* pl. 44b; *Rockefeller Center,* 1932, pl. 49; *James Joyce, Paris,* 1928, pl. 54; *Portrait of an Artist,* pl. 57; *Portrait of a Writer,* pl. 58; *Trinity Church,* pl. 63; *Art Class,* pl. 64.

10. Abbott, Berenice. "It Has to Walk Alone," *American Society of Magazine Photographers* (November 1951): 6-14.

11. Abbott, Berenice. "Lisette Model," *Camera (Switzerland)* 56, 12 (December 1977): 4+.

12. Abbott, Berenice. "Mr. Manufacturer--My Ideas on Camera Design,"

Popular Photography 4, 5 (May 1939): 13+.

13. Abbott, Berenice. *New Guide to Better Photography*. Rev. ed. New York: Crown Publishers, 1953. Revised edition of *Guide to Better Photography*. 180 p.

14. Abbott, Berenice. *New York in the Thirties*. New York: Dover Publication, 1973. Reprint of *Changing New York*, 1939.

15. Abbott, Berenice. *Photographs*. Foreword by Muriel Rukeyser and Introduction by David Vestal. Horizon Press, 1970. 175 p. Includes Chronology, list of exhibitions and Bibliography: p. 171, 173, 175. Chiefly illustrations.
Introduction is a short biographical essay.

Jean Cocteau, p. 18-21; *Margaret Anderson*, p. 22; *James Joyce*, p. 23-26; *Nora, Wife of James Joyce*, p. 27; *Lucia, Daughter of James Joyce*, p. 28; *Jane Heap*, p. 29; *Sylvia Beach*, p. 30; *Adrienne Monnier*, p. 31; *Robert McAlmon*, p. 32; *George Antheil*, p. 33; *Marcel Duchamp*, p. 34; *Max Ernst*, p. 34; *Peggy Guggenheim*, p. 35; *Princess Eugène Murat*, p. 37; *Princess Marthe Bibesco*, p. 38; *Foujita*, p. 39; *Elliot Paul*, p. 40; *Paul Morand*, p. 41; *Sophie Victor*, p. 42; *Andrè Gide*, p. 43; *Renè Crevel*, p. 44; *Solita Solano*, p. 45; *Pierre de Massot*, p. 46; *Janet Flanner*, p. 47; *Frank Dobson*, p. 48; *Cedric Morris*, p. 48; *Leo Stein*, p. 49; *Claude McKay*, p. 49; *Mrs. Raymond Massey*, p. 50; *Buddy Gilmore*, p. 51; *Jules Romains*, p. 52; *Marie Laurencin*, p. 53; *François Mauriac*, p. 54; *Edna St. Vincent Millay*, p. 55; *Mme. Theodore van Rysselberghe*, p. 56; *Philippe Soupault*, p. 57; *André Siegfried*, p. 57; *Paul Cross*, p. 58; *Djuna Barnes*, p. 59; *Eugène Atget*, p. 60; *Floating Oyster Houses*, p. 62; *Peddler*, p. 62; *Hester Street*, p. 63; *Under the El*, p. 63; *Statue of Liberty*, p. 64; *Broadway to the Bowery*, p. 65; *The Abraham De Peyster Statue, Bowling Green*, p. 66; *The "Watuppa" off Manhattan Island*, p. 67; *Trinity Church*, p. 68, 69; *Three Views of Trinity Church*, p. 70; *The John Watts Statue in Trinity Churchyard*, p. 71; *West Street*, p. 72; *Washington Street*, p. 73; *Barclay Street Hoboken Ferry, I* , p. 74; *Lower Manhattan, View Toward Brooklyn*, p. 75; *Birdseye View, Wall Street*, p. 76; *Federal Reserve Building*, p. 77; *View Toward the Brooklyn Bridge*, p. 78; *Erie Station*, p. 79; *Warehouse, Lower Manhattan*, p. 80, 81; *Department of Docks*, p. 82; *Barclay Street Station*, p. 83; *Financial District*, p. 84, 85; *Puck Building*, p. 86; *At Beaver and William Streets*, p. 87; *Blossom Restaurant, The Bowery*, p. 88, 89; *Grand Street*, p. 90; *East Side Portrait*, p. 91; *Cherry Street*, p. 93; *Lower East Side*, p. 94; *Chicken Market*, p. 95; *West Side, Highway and Piers*, p. 96, 97; *Railroad Yard*, p. 98; *At 125th Street*, p. 99; *Pennsylvania Station*, p. 100; *El at Battery*, p. 101; *Butcher Shop*, p. 102; *Shoeshine Parlor*, p. 103; *Christopher Street Shop*, p. 104; *El at Columbus Avenue and Broadway*, p. 105; *A & P*, p. 106; *Courtyard of Model Early Tenement, East 70's*, p. 107; *At the Whitney Museum, 8th Street*, p. 108; *John Sloan*, p. 109; *Fifth Avenue at 8th Street*, p. 110; *Edward Hopper*, p. 111; *Hardware Store*, p. 112, 113; *Hubbie Ledbetter (Leadbelly)*, p. 114; *Dancer, Macdougal Street, Greenwich*

Village, p. 115; *Newsstand*, p. 116, 117; *Centre Street*, p. 118; *Flatiron Building*, p. 119; *West Side Looking North From Upper 30's*, p. 120; *Exchange Place*, p. 121; *Fifth Avenue at 44th Street*, p. 122; *42nd Street at Fifth Avenue*, p. 123; *Daily News Building*, p. 124; *Times Square*, p. 125; *Rockefeller Center*, p. 126, 127, 128, 129; *Mirror Reflections*, p. 133; *Magnetic Field*, p. 135, 136, 137; *Two Water Patterns*, p. 139, 142; *Water Pattern*, p. 140, 141; *Soap Bubbles*, p. 143; *Beams of Light Through Glass*, p. 145; *Penicillin Mold*, p. 147; *Time Exposure*, p. 148; *Strobe Photograph*, p. 149; *Spinning Wench*, p. 150, 151; *Pendulum*, p, 152; *Transformation of Energy*, p. 153; *Multiple Flash Photograph*, p. 154; *Collision of Two Balls*, p. 155; *Swinging Ball*, p. 156; *Elliptical Orbit*, p. 157; *Path of a Moving Ball*, p. 158.

16. Abbott, Berenice. *Photographs [c. 1935-1938]* Museum of the City of New York. Department of Paintings, Prints and Photographs.

17. Abbott, Berenice. *The Portrait of Maine*. Text by Chenoweth Hall; New York: Macmillan, 1968. 175 p.
 Photographs give visual representation to the accompanying text on the people and places in the state of Maine.
The west fork of Grand Lake Road, p. 8; *A beaver dam*, p. 11; *Rocks as big as houses*, p. 13; *Moosehead Lake*, p. 14; *Burnt Mountain in Baxter State Park*, p. 16; *Drowned trees call Driki*, p. 17, 18; *Barrows Falls, Piscataquis River*, p. 20; *Lane Brook in Pittston Academy Township*, p. 21; *Part of the complex tapestry ...of forest*, p. 22; *Air view of the harbor of the fishing village of Corea*, p. 24; *When the tide goes out the gulls clean the shores*, p. 27; *The home of a fisherman conforms to the landscape*, p. 28; *North Haven Island*, p. 29; *A man of the sea at Spruce Head*, p. 29; *Grove of White Pine*, p. 32; *Felling a spruce with a chain saw*, p. 35; *Woods road through a lumber camp*, p. 36; *Inside a lumber camp*, p. 38; *Young lumberman*, p. 39; *Pulpwood, destined for the paper mills*, p. 40; *The trailer tractor can carry up to eight cords of wood*, p. 41; *A lumber camp in winter*, p. 42; *As many as sixty horses are maintained in a modern lumber camp*, p. 43; *Cord length logs are shoved into the stream*, p. 44; *Spring sluicing*, p. 45; *Logs en route to the paper mill*, p. 46; *Loggers' implements*, p. 47; *The river driver...wears a life jacket*, p. 47; *Log Boom*, p. 48; *The Driver Boss watching out for log jams*, p. 49; *The Dining Room at the Great Northern Paper Company camp*, p. 50; *Four to six men live in each oil heated house*, p. 51; *"Cookie" serves up better food than the best hotels*, p. 51; *End of the season--a few logs caught up on the ledges*, p. 53; *A catch of herring*, p. 54; *"Strip fish." Slack salted fish*, p. 56; *A fish weir on the horizon*, p. 57; *Note the rope set into the granite stone*, p. 58; *A sardine carrier*, p. 59; *Herring nets on the wharf*, p. 60; *Surrounding a school of fish with a purse seine*, p. 61; *Drawing in a purse seine*, p. 62-63; *Suction line from the seiner draws the herring out of the net*, p. 65; *Lobster fisherman rowing out*, p. 66; *Lobster boat at the wharf*, p. 68; *Lobster traps and marker buoys*, p. 69; *Lobster boat and wharves*, p. 70; *A fleet of lobster boats*, p. 71; *A young lobsterman*, p. 72; *Lobster traps are kept neatly piled*, p. 73; *The makings of lobster traps*, p. 74; *A lobster fisherman*,

p. 75; *Lobster trap breaking water,* p. 75; *A lobster fisherman tosses out a "short lobster,"* p. 77; *All short lobsters are immediately thrown back into the sea,* p. 79; *The day's work over, the lobsterman moors his boat,* p. 81; *The Captain's Cabin on the Mary A,* p. 84; *The Mary A takes supplies and passengers,* p. 85; *Rain leaves deep puddles in the gravel road,* p. 86; *Even in November...wild flowers bloom,* p. 87; *[Grassy fields]* p. 89; *[Lobster traps]* p. 91; *Inside a lobster shack,* p. 92; *Lobster fisherman,* p. 93; *Fisherman outside his house,* p. 94; *A whimsical birdhouse on Matinicus,* p. 95; *Potatoes are properly dug,* p. 96; *Aroostook County potato farmers,* p. 98; *A shortage of workers is a problem,* p. 99; *Picking potatoes,* p. 101-104; *The mechanical harvester,* p. 105; *Harvesting potatoes,* p. 106-108; *[Wooden barrels]* p. 110; *[Harvesting blueberries]* p. 112; *Hikers at Horse Mountain,* p. 116.

18. Abbott, Berenice. *The View Camera Made Simple.* Chicago: Ziff-Davis Pub., 1948. 124 p.

19. Atget, Eugène. *The World of Atget.* Edited with an introduction by Berenice Abbott. New York: Horizon Press, 1964. 109 leaves of plates.

20. *Berenice Abbott: American Photographer.* By Hank O'Neal. Introduction by John Canaday. Commentary by Berenice Abbott. New York: McGraw-Hill Book Company, 1982. 255p. Contains Notes on the Photographs, List of Exhibitions and Bibliography: p. 255.
Nightview, p. 2; *Bust of Edgar Allan Poe,* p. 9; *View of Amsterdam,* p. 10; *Eugène Atget,* p. 11; *André Calmettes,* p. 12; *Chick Webb's Orchestra, Savoy Ballroom, 1929,* p. 14; *Manhattan Bridge,* p. 15; *Doorway, 204 West 13th Street, 1937,* p.17; *Red River Logging Company Project,* p. 21; *W. Eugene Smith with Unipod,* p. 24; *Houses, Stonington,* p. 30; *Janet Flanner,* p. 35; *René Crevel,* p.36; *Isamu Noguchi,* p. 37; *George Antheil,* p. 37; *Sophie Victor,* p. 38; *Princess Eugène Murat, 1930,* p. 39; *Caridad de Laberdeque,* p. 40; *Peggy Guggenheim and Pegeen,* p. 41; *James Joyce, 1928,* p. 42, 44; *James Joyce, 1926,* p. 43; *Nora Joyce,* p. 45; *Coco Chanel,* p. 46; *Djuna Barnes,* p. 46, 47; *Jane Heap,* p. 48; *Margaret Anderson,* p. 49; *Jean Cocteau,* p. 50, 51; *Sylvia Beach,* p. 52; *Mme. Guerin with Bulldog,* p. 53; *André Gide,* p. 54; *François Mauriac,* p. 55; *Jules Romains,* p. 55; *Mme. Theodore van Rysselberghe,* p. 56; *Bronja Perlmutter,* p. 57; *Solita Solano,* p. 57; *Robert McAlmon,* p. 58; *Lelia Walker,* p. 59; *Foujita,* p. 60; *Pierre de Massot,* p. 61; *Dorothy Whitney,* p. 62; *Marie Laurencin,* p. 63; *Eugène Atget,* p. 64, 65; *Renée Praha,* p. 66; *Edna St. Vincent Millay,* p. 67; *Alexander Berkman,* p. 68; *Serge Soudekian,* p. 69; *Elliot Paul,* p. 70; *Helen Tamaris,* p. 71; *Fratellini Brothers,* p. 72; *Buddy Filmore,* p. 73; From <u>New York City Project, 1929- 1939</u>; *Washington in Union Square,* p. 75; *Rag Merchant,* p.76; *Storefront,* p. 77; *Friedman and Silver,* p. 77; *El at Columbus Avenue and Broadway,* p. 78; *Madison Square Park,* p. 79; *Elevated Railway,* p. 79; *Beach Scene,* p. 80; *George Washington Bridge under Construction,* p. 81, 86; *Selling Out Men's Clothing,* p. 82; *Burlesk Theater,* p. 82; *Man on Brooklyn Bridge,* p. 83; *Lincoln in Union*

Square, p. 83; *Construction Workers*, p. 84; *Building New York*, p. 85; *Foundations of Rockefeller Center*, p. 87; *Girders and Derricks (Rockefeller Center)*, p. 88; *Rockefeller Center*, p. 89; *Under the El at the Battery, 1932*, p. 90; *Dead Person, early 1930s*, p. 91; *Saints for Sale*, p. 92; *Fifth Avenue Coach Company*, p. 93; *City Arabesque, from the Roof of 60 Wall Tower*, p. 94; *John Watts Statue, from Trinity Church Looking toward One Wall Street*, p. 95; *Poultry Shop, East 7th Street*, p. 96; *El, Second & Third Avenue Lines, Bowery and Division Streets*, p. 97; *Ropestore: Peerless Equipment Company, 109 South Street*, p. 98; *Brooklyn Bridge, Water and Dock Streets, Brooklyn*, p. 99; *William Goldberg Store, 771 Broadway*, p. 100; *General View Looking Southwest to Manhattan from Manhattan Bridge*, p. 101; *Pennsylvania Station Interior*, p. 102, 103, 104, 105; *Gunsmith and Police Department, 6 Centre Market Place and 240 Centre Street*, p. 106; *Murray Hill Hotel, 112 Park Avenue*, p. 107; *Fifth Avenue House, Nos. 4, 6, 8*, p. 108; *Oldest Frame House in Manhattan, Weehawken Street*, p. 109; *Jacob Heymann Butcher Shop, 345 Sixth Avenue*, p. 110; *Henry Street, Looking West from Market Street*, p. 111; *Trinity Churchyard*, p. 112; *Trinity Church and Wall Street Towers*, p. 113; *Under Riverside Drive Viaduct at 125th Street*, p. 114; *Brooklyn Bridge with Pier 21, Pennsylvania Railroad, East River*, p. 115; *Department of Docks and Police Station, Pier A, North River*, p. 116; *"Theoline," Pier 11, East River*, p. 117; *Squibb Building with Sherry Netherland in background*, p. 118; *El, Second and Third Avenue Lines, 250 Pearl Street*, p. 119; *Hoboken Railroad Yards, Looking Towards Manhattan*, p. 120-121; *Hester Street, Between Orchard and Allen Streets*, p. 122; *Herald Square*, p. 123; *57-61 Talman Street, Brooklyn*, p. 124; *Talman Street, Between Jay and Bridge Streets, Brooklyn*, p. 125; *Hardware Store, 316-318 Bowery*, p. 126; *Stuyvesant Curiosity Pawn Shop, 48 Third Avenue*, p. 127; *General View from Penthouse at 56 Seventh Avenue*, p.128; *Fortieth Street, Between Sixth and Seventh Avenues from Salmon Tower*, p. 129; *View of Exchange Place from Broadway*, p. 130; *Willow Place, Nos. 43-49, Brooklyn*, p. 131; *Columbus Circle*, p. 132, 133; *Daily News Building*, p. 134; *Father Duffy, Times Square*, p.135; *Yuban Warehouse, Brooklyn*, p. 137-138; *Consolidated Edison Power House, 666 First Avenue*, p. 138; *Stone and William Streets*, p. 139; *El Station Interior, Sixth and Ninth Avenue Line*, p. 140; *Automat, 977 Eighth Avenue*, p. 141; *Lamport Export Company*, p.142; *DePeyster Square, Bowling Green Looking North to Broadway*, p.143; *Snuff Shop, 113 Division Street*, p. 144; *Roast Corn Man, Orchard and Hester Streets*, p. 145; *Church of God, 25 West 132nd Street*, p. 146; *Walkway, Manhattan Bridge*, p. 147; *Hoboken Ferry Terminal, Barclay Street*, p. 148; *Broadway to the Battery, from Roof of Irving Trust Company Building, One Wall Street*, p. 149; *Pine and Henry Streets*, p. 150; *Queensboro Bridge from Pier at 41st Road, Queens*, p. 151; *Waterfront from Pier 19, East River*, p. 152-153; *104 Willow Street, Brooklyn*, p. 154; *Construction, Old and New, from Washington Street*, p. 155; *Manhattan from Pier 11, South Street and Jones Lane*, p. 156; *Old Post Office with Trolley Car, Broadway and Park Row*, p. 157; *Broadway and Rector Street from Above*, p. 158; *Old-Law Tenements, Forsythe and East Houston Streets*, p. 159; *Lyric Theatre, 100 Third Avenue*, p. 160; *Tri-Boro Barber School, 264 Bowery*, p. 161; *Canyon, Broadway and*

Exchange Place, p. 162; *Flatiron Building, Broadway and Fifth Avenue*, p. 163; *Cherry Street*, p.164; *115 Jay Street, Brooklyn*, p. 165; *Newsstand, 32nd Street and Third Avenue*, p. 166; *Blossom Restaurant, 103 Bowery*, p. 167; *154 Fourth Avenue, Brooklyn*, p. 168; *Manhattan Bridge, Looking Up*, p. 169; *Sunday Afternoon, Colliersville, Tennessee*, p. 171; *Main Street, Chillicothe, Ohio*, p. 172; *Square, Pulaski, Tennessee*, p. 172; *Farm, Pulaski, Tennessee*, p. 173; *West Virginia Family*, p. 174; *Miner's Wife, Greenview, West Virginia*, p. 175; *Tennessee Portrait*, p. 176; *Weaver's Store, near Marshall, Illinois*, p. 176; *Dirt Farmer, Hertzel, West Virginia*, p. 177; *Miner's Family, Greenview, West Virginia*, p. 177; *Abandoned Fox Farm, near Calfax, Ohio*, p. 178; *Norris Dam, Tennessee*, p. 179; *East Side Portrait*, p. 180; *John Sloan*, p. 181; *Max Ernst*, p. 182; *José Clemente Orozco*, p. 183; *Isamu Noguchi*, p. 184; *Lewis Hine*, p. 185; *Philip Evergood*, p. 186; *Louis Eilshemius*, p.187; *Eva La Gallienne*, p. 188; *Leadbelly (Hubie Ledbetter)*, p. 189; *Frank Lloyd Wright*, p. 190; *Edward Hopper*, p. 191; *Designer's Window, Bleecker Street*, p. 192; *Repair Shop, Christopher Street*, p. 193; *McSorley's Ale House, 15 East 7th Street*, p. 194; *Hacker's Art Books*, p. 195; *Mill Pawtucket, Rhode Island*, p. 196; *American Shops, New Jersey*, p. 197; *Sunoco Station, Trenton, New Jersey*, p. 198; *Pile of Junked Cars, West Palm Beach, Florida*, p. 199; *Red River Logging Project, California*, p. 200-201; *Fruit Market, South Dixie Highway, Miami, Florida*, p. 202; *Row of House, Georgia*, p. 203; *Bus Tourist Court, near St. Augustine, Florida*, p. 203; *Superhot, Daytona Beach, Florida*, p. 204; *Woman on Steps, Baltimore, Maryland*, p. 205; *Old Man on Porch*, p. 206; *King Baitman, Florida*, p. 207; *Postcards, 819 Main Street, Daytona, Florida*, p. 208; *Signs Along U.S. Route 1*, p. 209; *1411 9th Street, Augusta, Georgia*, p. 210; *Baptist Church, Augusta, Georgia*, p. 211; *Boardwalk from Beach, Daytona Beach, Florida*, p. 212; *Beach from Boardwalk, Daytona Beach, Florida*, p. 213; *Parabolic Mirror*, p. 215; *Cycloid*, p. 216-217; *Spinning Wrench*, p. 216-217; *Time Exposure of a Bouncing Ball*, p. 218; *Strobe Photograph of a Bouncing Ball*, p. 219; *Transformation of Energy*, p. 220; *Collision of a Moving Sphere and a Stationary Sphere*, p. 221; *Multiple Exposure of Bouncing Golf Ball*, p. 221; *Multiple Exposure of a Swinging Ball in an Elliptical Orbit--1 & 2*, p. 222; *The Pendulum*, p. 223; *Magnetism and Electricity--1 & 2*, p. 224; *Magnetism with Key*, p. 225; *Wave Forms: Interference Pattern*, p. 226; *Expanding Circular Waves*, p. 227; *Parabolic Reflection*, p. 227; *Periodic Straight Waves*, p. 228; *Reflected Water Waves*, p. 229; *Focusing Water Waves*, p. 229; *Water Waves Change Direction*, p. 229; *Water Waves Produce Shadows*, p. 229; *Light Rays*, p. 230; *Bubbles*, p. 231; *Multiple Exposure Showing the Path of a Steel Ball Ejected Vertically from a Moving Object*, p. 232-233; *House, Belfast, along Route 1*, p. 235; *Rutted Road*, p. 236; *Old man, Spruce Head, near Port Clyde*, p. 237; *Lobster Traps and Workmen, Stonington*, p. 238; *[Church and woodpile]*, p. 239; *Mitten Knitting Contest, Sander's Store, Greenville*, p. 240; *Pony Endurance Contest*, p. 241; *Millikin's General Store on Sunday Morning, Bridgewater*, p. 242; *Group of Potato Farmers, Aroostook County*, p. 243; *Horse-drawn Sledge*, p. 244; *Dog in Bushes by Road, Matinisus Island*, p. 245; *Child Gathering Potatoes, Aroostook County*, p. 246; *Canoe Tobogganing at Moosehead Lake, Greenville*, p. 247;

Swamp, p. 248-249.

21. Berman, Avis. "The Unflinching Eye of Berenice Abbott," *Artnews* 80, 1 (January 1981): 86-93.

22. Berman, Avis. "The Pulse of Reality--Berenice Abbott," *Architectural Digest* 42, 4 (1985): 74, 78, 82.

23. Coleman, A. D. "Berenice Abbott," *Artnews* 89, 2 (1990): 156-157.

24. Lanier, Henry Wysham. *Greenwich Village, Today & Yesterday.* New York: 1949. 161 p.

25. Lloyd, Valerie. "Berenice Abbott," *Creative Camera* (London) 154 (April 1977): 112-121.

26. McQuaid, James. *Interview with Berenice Abbott: conducted at Miss Abbott's home in Maine during July 1975 by James McQuaid and David Tait.* 1978. 2 v.
 "Transcription of tape recorded interviews conducted for the Oral History Project of the International Museum of Photography at the George Eastman House." oclc

27. Marks, Robert. "Chronicler of Our Times: In the Hands of Berenice Abbott the Camera is an Instrument of Social Documentation," *Coronet Magazine* (December 1938): 157-169.

28. Martinez, R. E. "Berenice Abbott--New York 1932-1938," *Camera (Switzerland)* 43, 4 (April 1964): 3-11.

29. Mileaf, Janine. *Constructing Modernism, Berenice Abbott and Henry-Russell Hitchcock: A re-creation of the 1934 exhibition, the urban vernacular of the thirties, forties and fifties, American cities before the Civil War: Davison Art Center, Weleyan University.* With an essay by Carla Yanni. Middletown, CT: The Center, 64 p. Includes bibliographical references.

30. Newman, Julia. "Berenice Abbott: Pioneer, Past and Present," *U.S. Camera,* 23 (February, 1960): 36-41.

31. Osterman, Gladys. "Berenice Abbott Speaks," *Women Artists News* 7, 4 (February 1982): 200-201.

32. *Peggy Guggenheim and Her Friends.* Milano, 1994. 191 p. Includes bibliographical references.

33. Raeburn, John. "'Culture Morphology' and Cultural History in Berenice Abbott's Changing New York," *Prospects (Great Britain)* 9 (1984): 255-291.

34. Reilly, Rosa. "Berenice Abbott Records Changing New York," *Popular Photography* 3, 3 (September 1938): 8-10.

35. Sundell, Michael G. "Berenice Abbott's Work in the 1930s," *Prospects (Great Britain)* 5 (1980): 269-292.

36. Valens, Eugene G. *The Attractive Universe: Gravity and the Shape of Space*. Photographs by Berenice Abbott. Cleveland: The World Publishing Co., 1969. 187 p.
 Photographs by Abbott which illustrate scientific principles.

37. Valens, Eugene. G. *Magnet*. Photographs by Berenice Abbott. Cleveland: The World Publishing Co., 1964. 155 p.
 Photographs illustrate many of the traits and properties of magnets and magnetic fields.

38. Valens, Eugene G. *Motion*. Photographs by Berenice Abbott. Cleveland: The World Publishing Co., 1965. 80 p.

39. "A Woman Photographs the Face of a Changing City," *Life* (January 3, 1938): 40-45.

40. Woodward, Richard B. "Berenice Abbott's Many Lives," *Art News* 91, 2 (February 1992): 29.

41. Yochelson, Bonnie. *Berenice Abbott at Work: the Making of Changing New York*. New York: New Press, 1997. 399 p.
 This is a comprehensive examination of the extensive photographic study that Abbott produced for the Federal Art Project and sponsored by the Museum of the City of New York from 1935 to 1939. The 307 plates are accompanied by numerous variant images and period street maps. There is a descriptive catalog of the sites, commentary on the districts, and an introductory essay which describes the process by which these images came into being, and publication of the guidebook *Changing New York* with captions written by Elizabeth McCausland.
 Sylvia Beach, c. 1926, fig. 1; *Building New York*, 1929, fig. 2; *Lincoln Square*, 1929, fig. 3; *Hester Street*, 1929, fig. 4; *Cherry Street*, 1930, fig. 5; *New York (photomontage)*, 932, fig. 6; *Central Park*, 1930-33, fig. 9; *Flatiron Building*, 1930-1933, fig. 10; *West Houston and Mercer Streets,* October 25, 1935, fig. 12; *Union Square*, March 20, 1936, fig. 11; *"Changing New York" installation photograph*, 1937, fig. 13; *South Street and James Slip*, 1954, fig. 15; **Wall Street:** *DePeyster*

Statue, Bowling Green, pl. 1; *Custom House Statues and New York Produce Exchange*, pl. 2; *Department of Docks Building, Pier A*, pl. 3; *Battery, Foot of West Street*, pl. 4; *Firehouse, Battery*, pl. 5; *Immigration Building, Ellis Island*, pl. 6; *Our Lady of the Rosary, 7 State Street*, pl. 7; *Shelter on the Waterfront, Coenties Slip, Pier 5, East River*, pl. 8; *Manhattan I, from Pier 11, East River*, pl. 9; <u>*Theoline*</u>, *Pier 1, East River*, pl. 10; *Downtown Skyport, Foot of Wall Street*, pl. 11; *Tugboats, Pier 11, East River*, pl. 12; *"El," Second and Third Avenue Lines, Hanover Square and Pearl Street*, pl. 13, 14; *Hanover Square*, pl. 15; *Stone and William Streets*, pl. 16, 17; *Canyon: Broadway and Exchange Place*, pl. 18; *Broad Street, Looking toward Wall Street*, pl. 19; *Cedar Street from Wall Street*, pl. 20; *Pine Street, U.S. Treasury in Foreground. Between Nassau and Broadway*, pl. 21; *Irving Trust Company Building, One Wall Street*, pl. 22; *John Watts Statue from Trinity Courtyard*, pl. 23; *Broadway to the Battery*, pl. 24; *Wall Street District*, pl. 25, 26; *Wall Street Showing East River*, pl. 27; *Waterfront from Roof of Irving Trust Co. Building*, pl. 28; *Financial District Rooftops I*, pl. 29; *Financial District Rooftops III*, pl. 30; *Financial District Rooftops II*, pl. 31; *City Arabesque*, pl. 32; *St Paul's Chapel*, pl. 33; *Old Post Office, Broadway and Park Row*, pl. 34; *Old Post Office and Trolley*, pl. 35; *Woolworth Building, 233 Broadway*, pl. 36; *City Hall Park, "Newspaper Row,"* pl. 37; *Broadway and Thomas Street*, pl. 38; *Facade: 317 Broadway*, pl. 39; *"El," Second and Third Avenue Lines, 250 Pearl Street*, pl. 40; *Cliff and Ferry Street*, pl. 41; *South and DePeyster Streets*, pl. 42; *Fulton Street Dock, Manhattan Skyline*, pl. 43; *Fish Market, South Street*, pl. 44; *South Street, nos. 151-166*, pl. 45; *Waterfront from Pier 19, East River*, pl. 46; *Brooklyn Bridge with Pier 21, Pennsylvania Railroad*, pl. 47; **Lower East Side:** *Waterfront, South Street*, pl. 1; *South Street and James Slip*, pl. 2; *Rope Store, Peerless Equipment Co.*, pl. 3, 4; *Oak and New Chambers Streets*, pl. 5; *"El," Second and Third Avenue Lines*, pl. 6; *Snuff Shop, 113 Division Street*, pl. 7; *Henry Street*, pl. 8; *Pike and Henry Streets*, pl. 9; *Chicken Market, 55 Hester Street*, pl. 10; *Allen Street, nos. 55-57*, pl. 11; *Hester Street, Between Allen and Orchard Streets*, pl. 12; *Roast Corn Man, Orchard and Hester Streets*, pl. 13; *Stanton Street, nos. 328-334*, pl. 14; *Corlears Street, nos. 3-5*, pl. 15; *East River, Foot of East 9th Street*, pl. 16; *Oliver Street, nos. 131/2-29*, pl. 17; *Oliver Street, nos. 25-29*, pl. 18; *East Broadway, no. 294*, pl. 19; *East Broadway, no. 113*, pl. 20; *Manhattan Bridge, Looking Up*, pl. 21; *Manhattan Bridge*, pl. 22; *General View Looking Southwest to Manhattan from Manhattan Bridge*, pl. 23; *Oyster Houses, South Street and Pike Slip*, pl. 24; *Grand Street, nos. 605-609*, pl. 25; *Grand Street, nos. 511-513*, pl. 26; *Old Low Tenements, 35-47 ½ East First Street*, pl. 27; *Advertisments, East Houston Street and Second Avenue*, pl. 28; *Gunsmith and Police Department Headquarters*, pl. 30; *Gunsmith, 6 Centre Market Place*, pl. 29; *Mulberry and Prince Streets*, pl. 31, 32; *Blossom Restaurant, 103 Bowery*, pl. 33; *Tri-boro Barber School, 264 Bowery*, pl. 34; *Hardware Store, 316-318 Bowery*, pl. 35; *Tredwell House, 29 East 4th Street*, pl. 36; *Lyric Theatre, 100 Third Avenue*, pl. 37; *St. Mark's Church: Skywriting Spiral, East 10th Street and Second Avenue*, pl. 38; *St. Mark's Church*, pl. 39; *St. Mark's Church, Cloister*, pl. 40; *St. Mark's Church, Statue in Courtyard*, pl. 41; *Avenue D and East 10th Street*, pl. 42; **Lower West**

Side: *Construction Old and New, 38 Greenwich Street*, pl. 1; *Downtown Manhattan, West Street*, pl. 2; *Lebanon Restaurant, 88 Washington Street*, pl. 3; *Vista, Thomas Street*, pl. 4; *Radio Row, Cortlandt Street*, pl. 5; *New York Telephone Building, 140 West Street*, pl. 6; *West Street between Warren and Murray Streets*, pl. 7; *West Street, Row I, nos. 178-183*, pl. 8; *West Street, Row II, nos. 217-221*, pl. 9; *Hot Dog Stand, West and Moore Streets*, pl. 10; *Dey Street, between West and Washington Streets*, pl. 11; *Vista from West Street*, pl. 12; *West Street, Row III, nos. 115-118*, pl. 13; *West Street, Row IV, nos. 126-130*, pl. 14; *Pier 13, Foot of Cortlandt Street*, pl. 15; *Pier 14, Foot of Fulton Street*, pl. 16; *Pier 18, Foot of Murray Street*, pl. 17; *Ferry, Central Railroad of New Jersey*, pl. 18, 19; *Ferry, Central Railroad of New Jersey, Foot of Liberty Street*, pl. 20; *Ferry Erie Railroad, Foot of Chambers Street*, pl. 21, 22; *Trucks, West and Debrosses Streets*, pl. 23; *West Washington Market, West Street and Loew Avenue*, pl. 24; *Gansevoort Street, no. 53*, pl. 25; **Greenwich Village :** *Broome Street, nos. 512-514*, pl. 1; *Broadway near Broome Street*, pl. 2; *Lamport Export Company, 507-511, Broadway*, pl. 3; *Spring and Varick Streets*, pl. 4; *Pioneer Restaurant, 60 West 3rd Street*, pl. 5; *Mori Restaurant, 144 Bleecker Street*, pl. 6; *Minetta Street, nos. 2, 4, 6*, pl. 7; *Provincetown Playhouse, 133 MacDougal Street*, pl. 8; *Cheese Store, 276 Bleecker Street*, pl. 9; *Bread Store, 259 Bleecker Street*, pl. 10; *Grove Street, no. 45*, pl. 11; *St. Luke's Chapel, 483 Hudson Street*, pl. 12; *St. Luke's Church and Old Houses*, pl. 13; *Milkwagon and Old Houses: 8-10 Grove Street*, pl. 14; *Christopher and Bleecker Streets*, pl. 15; *"El" Station, Ninth Avenue Line., Greenwich and Christopher Streets*, pl. 16; *Frame House: Bedford and Grove Streets*, pl. 17; *Commerce Street, nos. 39-41*, pl. 18; *Pingpank Barber Shop, 413 Bleecker Street*, pl. 19; *Charles Lane*, pl. 20; *Wrought Iron Ornament: 112-114 West 11th Street*, pl. 21; *Three-Decker Houses: West 11th Street between Sixth and Seventh Avenues*, pl. 22; *Rhinelander Row I, Seventh Avenue Between West 12th and 13th Streets*, pl. 23; *Rhinelander Row II*, pl. 24; *Rhinelander Row III*, pl. 25; *Doorway: 204 West 13th Street*, pl. 26; *Doorway: 16-18 Charles Street*, pl. 27; *Gay Street, nos. 14-16*, pl. 28; *Jefferson Market Court, Southwest Corner, Sixth Avenue and West 10th Street*, pl. 29; *Jefferson Market Court and 447-461 Sixth Avenue*, pl. 30; *Patchin Place*, pl. 31; *Patchin Place with Jefferson Market Court in Background*, pl. 32; *Milligan Place, 453 Sixth Avenue*, pl. 33; *Studios: 51 West 10th Street*, pl. 34; *Salmagundi Club, 47 Fifth Avenue*, pl. 35; *14 West 12th Street*, pl. 36; *Brevoort Hotel with Mark Twain House, Fifth Avenue between East 8th and 9th Streets*, pl. 37; *Lafayette Hotel, University Place and East 9th Street*, pl. 38; *Wanamaker's, Fourth Avenue and East 9th Street*, pl. 39; *William Goldberg, 771 Broadway at East 9th Street*, pl. 40; *William Goldberg*, pl. 41; *Fifth Avenue, nos. 4, 6, 8*, pl. 42; *Fifth Avenue, no. 8 (Marble House)*, pl. 43; *MacDougal Alley*, pl. 44; *Washington Square North, nos. 21-25*, pl. 45; *Washington Square, Looking North*, pl. 46; *Fifth Avenue Bus, Washington Square*, pl. 47; *Washington Square with Statue of Garibaldi*, pl. 48; **Middle West Side:** *General View from Penthouse, 56th Street*, pl. 1; *Civic Repertory Theater, 105 West 14th Avenue*, pl. 2; *Rothman's Pawn Shop, 149 East Avenue*, pl. 3; *West 18th Street, nos. 461-463*, pl. 4; *Grand Opera House, West 23rd Street and Eighth Avenue*, pl. 5; *Grand Opera House*, pl.

6; *Ferries, Foot of West 23rd Street*, pl. 7; *Starrett-Lehigh Building I, 601 West 26th Street*, pl. 8; *Starrett-Lehigh Building II*, pl. 9; *Chelsea Hotel, 222 West 23rd Street*, pl. 10; *"El" Sixth Avenue Line: 28th Street Station*, pl. 11; *Fifth Avenue Theatre: 28th Street Facade*, pl. 12; *Fifth Avenue Theatre: Staircase*, pl. 13; *Fifth Avenue Theatre: Chandelier, Rotunda, and Second Balcony*, pl. 14; *Fifth Avenue Theatre: Orchestra, Boxes, First and Second Balconies*, pl. 15; *Fifth Avenue Theatre: Detail of Proscenium Arch*, pl. 16; *Fifth Avenue Theatre: Grand Chandelier and Proscenium*, pl. 17; *Fifth Avenue Theatre: Drinking Fountain Behind Scenes*, pl. 18; *Fifth Avenue Theatre: Entrance from 1185 Broadway*, pl. 19; *Fifth Avenue Theatre: Section of Orchestra and First Balcony*, pl. 20; *Greyhound Bus Terminal, 244-248 West 34th Street*, pl. 21; *Herald Square, West 34th Street and Broadway*, pl. 22; *Herald Square*, pl. 23; *Seventh Avenue Looking North from 35th Street*, pl. 24; *Seventh Avenue Looking South from 35th Street*, pl. 25; *Fortieth Street between Sixth and Seventh Avenues*, pl. 26; *Fortieth Street betweeen Fifth and Sixth Avenues*, pl. 27; *McGraw-Hill Building, 330 West 42nd Street*, pl. 28; *Father Duffy, Times Square*, pl. 29; *Whelan's Drug Store, Eighth Avenue and West 44th Street*, pl. 30; *Manhattan Skyline II: from Weehawken, New Jersey*, pl. 31; *West Side Express Highway and Piers 95-98, from 619 West 54th Street*, pl. 32; *Facade: Alwyn Court, 174-182 West 58th Street*, pl. 33; *Automat, 977 Eighth Avenue*, pl. 34; *Columbus Circle*, pl. 35;

Middle East Side: *Union Avenue, Fourth Avenue between East 15th and 16th Streets*, pl. 1; *Union Square, East 14th Street between Fourth Avenue and Broadway*, pl. 2; *Union Square West, nos. 31-41*, pl. 3; *Luchow's Restaurant, 110 East 14th Street*, pl. 4; *Irving Place Theatre, 118-120 East 15th Street*, pl. 5; *Oldest Apartment House in New York City, 142 East 18th Street*, pl. 6; *Gramercy Park West, nos. 3-4*, pl. 7; *A & P, Great Atlantic and Pacific Tea Company, 246 Third Avenue*, pl. 8; *Twentieth Street between Second and First Avenue*, pl. 9; *Henry Maurer, 420-422 East 23rd Street*, pl. 10; *Flatiron Building, Madison Square*, pl. 11; *Madison Square*, pl. 12; *Newsstand, East 32nd Street and Third Avenue*, pl. 13; *J.P. Morgan House, 231 Madison Avenue*, pl. 14; *Murrary Hill Hotel, 112 Park Avenue*, pl. 15; *Murray Hill Hotel: Spiral*, pl. 16; *Madison Avenue and 39th Street, Looking North*, pl. 17; *Park Avenue and 39th Street*, pl. 18; *Daily News Building, 220 East 42nd Street*, pl. 19; *Contrasting 331 East 39th Street with Chrysler Building and Daily News Building*, pl. 20; *Consolidated Edison Power House, First Avenue between East 38th and 39th Streets*, pl. 21; *Vanderbilt Avenue*, pl. 22; *Tempo of the City II, Fifth Avenue and 42nd Street*, pl. 23; *Tempo of the City I, Fifth Avenue and 44th Street*, pl. 24; *Rockefeller Center with Collegiate Church of St. Nicholas, Fifth Avenue and West 48th Street*, pl. 25; *Rockefeller Center Parking Space, 40 West 49th Streets*, pl. 26; *Rockefeller Center from 444 Madison Avenue*, pl. 27; *General View Looking Northeast from 444 Madison Avenue*, pl. 28; *St. Bartholomew's Church, Waldorf Astoria Hotel, and General Electric Building, Park Avenue and 51st Street*, pl. 29; *Forty-eighth Street*, pl. 30; *Glass-Brick and Brownstone Fronts, 209-211 East 48th Street*, pl. 31; *Sumner Healey Antique Shop, 942 Third Avenue*, pl. 32; *Sumner Healey Antique Shop*, pl. 33; *Billie's Bar, First Avenue and East 56th Street*, pl. 34; *Sutton Place, Anne Morgan's Town House*, pl.

35; *General View Looking South from 32 East 57th Street*, pl. 36; *Squibb Building with Sherry Netherland in Background, 745 Fifth Avenue*, pl. 37; *Central Park Plaza*, pl. 38; **North of 59th Street:** *Gas Tank and Queensboro Bridge, East 62nd Street and York Avenue*, pl. 1; *Third Avenue Car Barns, Third Avenue and East 65th Street*, pl. 2; *Court of the First Model Tenements in New York City, 361-365 East 71st Street*, pl. 3; *Duke Town House, 4 East 78th Street*, pl. 4; *Brownstone Front and Skyscraper, 51 East 78th Street*, pl. 5; *"El" Station, Sixth and Ninth Avenue Lines, Downtown Side, 72nd Street and Columbus Avenue*, pl. 6; *Cathedral Parkway, no. 542*, pl. 7; *Gus Hill's Minstrels, 1890-1898 Park Avenue*, pl. 8; *Firehouse: Park Avenue and East 135th Street*, pl. 9; *Firehouse*, pl. 10; *Triborough Bridge: East 125th Street Approach*, pl. 11; *Triborough Bridge: Steel Girders*, pl.. 12; *Triborough Bridge: Cables*, pl. 13; *Flam and Flam, 165 East 121st Street*, pl. 14; *Church of God, 25 East 132nd Street*, pl. 15; *Harlem Street, Eighth Avenue and West 140th Street*, pl. 16; *Harlem Street II, 422-424 Lenox Avenue*, pl. 17; *Under Riverside Drive Viaduct, West 125th Street and Twelfth Avenue*, pl. 18; *USS Illinois and Launch: Armory for Naval Reserves, West 135th Street Pier*, pl. 19; *USS Illinois and Wharf: Armory for Naval Reserves, West 135th Street Pier*, pl. 20; *Burns Bros. Coal Elevator and USS Illinois Armory for Naval Reserves, West 135th Street Pier*, pl. 21; *Tusitala, North River and 156th Street*, pl. 22; *Wheelock House, 661 West 158th Street*, pl. 23; *Wheelock House*, pl. 24, 25; *Riverside Drive, no. 857*, pl. 26; *Columbia Presbyterian Medical Center, Broadway and 168th Street*, pl. 27; *George Washington Bridge I, Riverside Drive*, pl. 28; *George Washington Bridge*, pl. 29; **Outer Boroughs: Bronx:** *Ewen Avenue, no. 2565, Spuyten Duyvil*, pl. 1; *Country Store Interior, 2553 Sage Place, Spuyten Duyvil*, pl. 2; *Palisade Avenue, no. 2505, Spuyten Duyvil*, pl. 3; *Firehouse, Spuyten Duyvil*, pl. 4; *Gasoline Station, Tremont Avenue and Dock Street*, pl. 5; **Queens:** *Queensboro Bridge I, from Manhattan*, pl. 6; *Queensboro Bridge II, from Long Island City*, pl. 7; *Hell Gate Bridge I, from Astoria*, pl. 8; *Stevens House, Vernon Boulevard and 30th Road, Astoria*, pl. 9; *27th Avenue, no. 805, Astoria*, pl. 10; *27th Avenue, no. 1422*, pl. 11; *Jamaica Town Hall, Parsons Boulevard and Jamaica Avenue*, pl. 12; **Staten Island:** *Garibaldi Memorial, Tompkins and Chestnut Avenues*, pl. 13; *Hope Avenue, no. 139*, pl. 14; *St. Mark Place, nos. 340-348*, pl. 15, 16; **Brooklyn:** *Children's Aid Society Summer Home, Bath Beach*, pl. 17, 18; *Cropsey Avenue, no. 1736, Bath Beach*, pl. 19; *Belvedere Restaurant, Bay 16th Street and Cropsey Avenue, Bath Beach*, pl. 20; *Fort Lowry Hotel, 8868 17th Avenue Bath Beach*, pl. 21; *Cropsey Avenue, no. 2442, Bath Beach*, pl. 22; *Billboards and Signs, Flatbush Avenue between State Street and Ashland Place*, pl. 23; *Fourth Avenue, no. 154*, pl. 24; *Graham and Metropolitan Avenues*, pl. 25; *Powers and Olive Streets*, pl. 26; *Williamsburg Bridge, South 6th and Berry Streets*, pl. 27; *Talman Street, nos. 57-61*, pl. 28; *Talman Street between Jay and Bridge Streets*, pl. 29; *Jay Street, no. 115;* pl. 30; *Traveling Tin Shop*, pl. 31; *Warehouse, Water and Dock Streets*, pl. 32; *Brooklyn Bridge, Water and New Dock Streets*, pl. 33; *Columbia Heights, no. 222*, pl. 34; *Willow and Poplar Streets*, pl. 35; *Brooklyn Facade: 65-71 Columbia Heights*, pl. 36; *Willow Street, no. 70*, pl. 37; *Willow Street, no. 131-137*, pl. 38;

Willow Street, no. 113, pl. 39; *Willow Street, no. 104*, pl. 40; *Willow Place, nos. 43-49*, pl. 41; *Joralemon Street, no. 135*, pl. 42; *Watuppa, from Brooklyn Waterfront*, pl. 43.

42. Zwingle, Erla. "A Life of Her Own," *American Photographer* 16 (April 1986): 54-67.

Adams, Clover
See also #1009
Agins, Michelle
See also #1040
Aguilar, Laura
See also #1055
Albuquerque, Lita
See also #1041
Alda, Arlene
See also #1069, 1070
Ali, Salimah
See also #1040
Allen, Frances S., 1854-1941
See also #1022, 1058
Allen, Judy
See also #1071
Allen, Mariette Pathy
See also #1072
Allen, Mary E., 1858-1941
See also #1022, 1058
Allen, Mary North
See also #1072
Allen, Winifred Hall
See also #1040
Allport, Catherine Gardner
See also #1006
Andrews, Alice see **Wells, Alice**
Andrews, Mary Ellen
See also #1070
Antman, Fran
See also #1070
Appleton, Jeannette M., Active 1880s to 1905
See also #1058

Arbus, Diane, 1923-1971
See also #1000, 1008, 1026, 1028, 1056, 1058, 1061, 1063

43. Alexander, M. Darsie. "Diane Arbus: A Theatre of Ambiguity," *History*

of Photography 19 (Summer 1995): 120-123.

44. Andre, Linda. "Bosworth on Arbus: The Story Behind the Story," *Popular Photography* 91, 12 (December 1984): 72-73+.

45. Arbus, Diane. *Untitled*. Edited by Doon Arbus and Yolanda Cuomo. New York: Aperture, 1995. Afterword by Doon Arbus. Unpaged. Chiefly illustrations.
 These photographs were part of a series of photographs which were never given titles by Arbus. They were taken at residences for the mentally retarded between 1969 and 1971. The Afterword is a short critical essay on Arbus' work and the social territory into which she ventured.

[Wearing clown suit and mask] frontispiece; *[Woman standing in field]; [Two women in stripped shorts]; [Woman trying to do headstand]; [Woman in wet bathing suit]; [Children, inside, by wagon]; [Old women in coats and hats]; [Two women sitting on lawn]; [Young woman with wet lips]; [Woman wearing witch's mask, in wheelchair]; [Women on lawn]; [Sitting with small piece of cloth]; [On swings and slide]; [Older woman holding doll]; [Two people in coats over costumes]; [Four people in costumes and paperbag masks]; [Person in white mask and white sheet]; [Woman wearing hat and holding cup]; [Old women wearing masks and wool coats]; [Woman in face paint, holding pumpkin]; [Boy eating food]; [Young woman in mask and coat] [Boy and girl in costumes]; [Women in bathing suits]; [In paper costumes, holding paper wands] [Wrapped in blankets as costume]; [Girls and women in Spring hats];[Standing in costumes]; [Holding shoe box]; [Male little person]; [Woman laying on grass near swings]; [Wearing mask]; [Women in masks and costumes]; [Woman sitting on picnic table bench]; [Two women holding hands]; [Woman in polka dot blouse]; [Older women in costumes].*

46. Arbus, Doon and Israel, Marvin, ed. *Diane Arbus: Magazine Work*. With texts by Diane Arbus; essay by Thomas W. Southall. New York: Aperture, 1984. 176 p. Bibliography of known magazine photographs published by Diane Arbus from 1960-1971, p.172-175.

The Greatest Showman On Earth, and He's the First to Admit It, p. 6; *Hesekiah Trambles, "The Jungle Creep," Performs Five Times a Day At Hubert's Museum, 42nd & Broadway, Times Square*, p. 8; *Mrs. Dagmar Patino, Photographed At the Grand Opera Ball Benefiting Boystown of Italy, Sheraton East Hotel*, p. 9; *Andrew Ratoucheff, Actor, 54, in His Manhattan Rooming House Following a Late-Show Performance Of His Specialty: Imitations of Marilyn Monroe and of Maurice Chevalier Singing "Valentina,"* p. 10; *Flora Knapp Dickinson, Honorary Regent of the Washington Heights Chapter of the Daughters of the American Revolution*, p. 11; *Walter L. Gregory, Also Known As The Mad Man From Massachusetts*, Photographed in the City Room of *the Bowery News*, p. 12; *Person Unknown, City Morgue, Bellevue Hospital*, p. 13; *Jack Dracula, the Marked Man*, p. 14; *William Mack, The Sage of the Wilderness*, p. 15; *His Serene Highness, Prince Robert de*

Rohan Courtenay, p. 18; *Max Maxwell Landar, Uncle Sam*, p. 19; *Mrs. Cora Pratt, the Counterfeit Lady*, p. 21; *Polly Bushong*, p. 22; *Frederick Keiseler*, 1962, p. 24; *Christopher Isherwood*, 1962, p. 25; *James T. Farrell: Another Time, Another Place*, 1962, p. 26; *Europe's Uncommon Market* (Marcello Mastroianni), 1963, p. 27; *Bill Blass Designs For Little Ones*, 1962, p. 28; *Petal Pink For Little Parties, White-Over-Pale For Parties*, 1962, p. 29; *William Golding*, 1963, p. 30; *The Kennedys Didn't Reply* (Author Norman Mailer In His Brooklyn Home), 1963, p. 31; *The Auguries of Innocence*, 1963, p. 32-35; *The Soothsayers: Doris Fulton, Dr. George Dareos, Leslie Elliot, Madame Sandra*, 1964, p. 37; *Madame Grès: a Unique Talent* (Alix Grès, one of France's most distinguished fashion designers), 1964, p. 38; *Lillian and Dorothy Gish, Eleventh-Generation Americans and Renowned Film Stars*, p. 41; *Poets W. H. Auden and Marianne Moore, Friends For Twenty Years, Shortly Before She Introduced His Reading At the Guggenheim Museum in New York City*, p. 42; *Erik Bruhn and Rudolf Nureyev In New York For the Presentation Of An Evening of Their Ballet Pieces*, p. 43; *Lee Oswald's Letters To His Mother* (Mrs. Marguerite Oswald, mother of the alleged assassin of President John F. Kennedy) 1964 p. 44; *Mildred Dunnock* (American character actress), 1964, p. 45; *Blaze Starr In Nightown* (A queen of burlesque), 1964, p. 46-47; *The Bishop's Charisma*, 1964, p. 49, 51, 53; *Ruth St. Denis* (Pioneer of American dance), 1964, p. 54; *Nevertheless, God Probably Loves Mrs. Murray. Yeah, But It's One Nation Under <u>Nothing</u>, Says She, With Honesty, Honest, Honest For All. Madalyn Murray Wears No Girdle* (Madalyn Murray, the atheist who fought against prayer in public schools), 1964, p. 55; *This Ho-Ho-Ho Business* (Student Santas attending the twenty-eighth annual Santa Claus School in Albion, New York) 1964, p. 56, 57; *Mae West: Once Upon Our Time*, 1965, p. 59, 60; *Mr. and Mrs. Howard Oxenburg*, p. 62; *Mr. and Mrs. Armand Orsini*, p. 62; *Mr. and Mrs. Herbert Von Karajan*, p. 62; *Robert Shaw and Mary Ure*, p. 62; *John Gruen and Jane Wilson*, p. 62; *Dame Edith Evans*, 1965, p. 64; *Marcel Duchamp* (Expatriate French Dadaist and his wife Alexina Sattler), 1965, p. 65; *Writer Susan Sontag With Her Son, David*, 1965, p. 66; *Jayne Mansfield Climber-Ottaviano, Actress, With Her Daughter, Jayne Marie*, 1965, p. 66; *Sociologist Jane Jacobs With Her Son, Ned*, 1965, p. 67; *Notes on the Nudist Camp*, 1965, p. 68; *Fashion Independents: Mrs. T. Charlton Henry*, 1965, p. 70-73; *James Brown Is Out Of Sight* (The King of Soul, Backstage At the Apollo Theater in Harlem), 1966, p. 74, 75; *The Girl Of the Year, 1938* (Brenda Diana Duff Frazier, 28 years after she appeared on the cover of *Life* magazine as the most famous debutante of the year), 1966, p. 76; *Gerard Malanga* (Poet and member of Andy Warhol's Factory), 1966, p. 78; *Lucas Samaras*, 1966, p. 82; *Agnes Martin*, 1966, p. 83; *Richard Lindner*, 1966, p. 84; *James Rosenquist*, 1966, p. 85; *Frank Stella*, 1966, p. 85; *Marvin Israel*, 1966, p. 85; *Roy Lichenstein*, 1966, p. 85; *Just Plain H.L. Hunt*, (H.L.Hunt, Texas oil baron), 1967, p. 87; *Thomas Hoving Talks About the Metropolitan Museum* (Thomas Hoving, former Commissioner of Parks after he became Director of the Metropolitan Museum of Art), 1967, p. 88; *The Transsexual Operation* (In 1958, at the age of fifty-two, this man became a woman legally and physically) p. 89; *Betty Blanc Glasbury*, 1968, p. 90; *God Is Back, He Says So Himself* (Mel

Lyman, folk singer), 1968, p. 91; *The New Life* (Anderson Hayes Cooper, son of Gloria Vanderbilt and Wyatt Cooper), 1968, p. 92; *A Race For Pre-Toddlers in Suburban New Jersey, Featuring a Saliva Contestant*, 1968, p. 94-95; *Campers at Camp Lakecrest for Overweight Girls in Dutchess County, New York*, 1968, p. 96-99; *Let Us Now Praise Dr. Gatch* (Dr. Donald E. Gatch, crusading country doctor who fought hunger and parasite disease in a poor community of South Carolina's affluent Beaufort County), 1968, p. 100-105; *Two American Families*, 1968, p. 106-107; *Tiptoe To Happiness with Mr. Tiny Tim*, 1968, p. 108; *Eugene McCarthy*, 1968, p. 110; *On a Photograph of Mrs. Martin Luther King at the Funeral*, 1968, p. 111.

47. Arbus, Doon and Marvin Israel, eds. *Diane Arbus: An Aperture Monograph*. Millerton, NY: Aperture, 1972. Unpaged. Chiefly illustrations. Included text was "edited from tape recordings of a series of classes Diane Arbus gave in 1971 as well as from some interviews and some of her writings."

Russian midget friends in a living room on 100th Street, N.Y.C., 1963; *A young man in curlers at home on West 20th Street, N.Y.C.*, 1966; *The Junior Interstate Ballroom Dance Campions, Yonkers, N.Y.*, 1962; *Girl with a cigar in Washington Square Park, N.Y.C.*, 1965; *Retired man and his wife at home in nudist camp one morning, N.J.*, 1963; *Loser at a Diaper Derby, N.J.*, 1967; *A family on their lawn on Sunday in Westchester, N.Y.*, 1968; *A castle in Disneyland, Cal.*, 1962; *A young Brooklyn family going for a Sunday outing, N.Y.C*, 1966; *Puerto Rican woman with a beauty mark, N.Y.C.*, 1965; *A family one evening in a nudist camp*, 1965; *Boy with a straw hat waiting to march in a pro-war parade, N.Y.C.*, 1967; *Girl in a coat lying on her bed, N.Y.C.*, 1968; *Elderly couple on a park bench, N.Y.C.*, 1969; *A flower girl at a wedding, Conn.*, 1964; *A Jewish giant at home with his parents in the Bronx, N.Y.*, 1970; *Lady at a masked ball with two roses on her dress, N.Y.C.*, 1967; *Identical twins, Roselle, N.J.*, 1967; *Four people at a gallery opening, N.Y.C.*, 1968; *Two men dancing at a drag ball, N.Y.C.*, 1970; *A husband and wife in the woods at a nudist camp, N.J.*, 1963; *A lobby in a building, N.Y.C.*, 1966; *A child crying, N.J.*, 1967; *A young man and his girlfriend with hot dogs in the park, N.Y.C.*, 1971; *Transvestite at her birthday party, N.Y.C.*, 1969; *Lady in a rooming house parlor, Albion, N.Y.*, 1963; *Woman with a locket in Washington Square, N.Y.C.*, 1965; *Burlesque comedienne in her dressing room, Atlantic City, N.J.*, 1963; *A Jewish couple dancing, N.Y.C.*, 1963; *Triplets in their bedroom, N.J.*, 1963; *Masked man at a ball, N.Y.C.*, 1967; *Nudist lady with swan sunglasses, Pa.*, 1965; *A woman with pearl necklace and earrings, N.Y.C.*, 1967; *Man at parade on Fifth Avenue, N.Y.C.*, 1969; *A young man and his pregnant wife in Washington Square, N.Y.C.*, 1965; *Hermaphrodite and a dog in a carnival trailer, Md.*, 1970; *Woman on a park bench on a sunny day, N.Y.C.*, 1969; *Topless dancer in her dressing room, San Francisco, Cal.*, 1968; *Patriotic young man with a flag, N.Y.C.*, 1967; *Masked woman in a wheelchair, Pa.* 1970; *Teenage couple on Hudson Street, N.Y.C.*, 1963; *Girl sitting on her bed with her shirt off, N.Y.C.*, 1968; *The King and Queen of a Senior Citizens Dance, N.Y.C.*, 1970; *Blonde girl with shiny*

lipstick, N.Y.C., 1967; *Muscle man contestant, N.Y.C.,* 1968; *A woman in a bird mask, N.Y.C.,* 1967; *Young couple on a bench in Washington Square Park, N.Y.C.,* 1965; *Child with a toy hand grenade in Central Park, N.Y.C.,* 1962; *Two girls in matching bathing suits, Coney Island, N.Y.,* 1967; *Girl in her circus costume, Md,* 1970; *Mother holding her child, N.J.,* 1967; *Seated man in a bra and stockings, N.Y.C.,* 1967; *A Puerto Rican housewife, N.Y.C.,* 1963; *Two boys smoking in Central Park, N.Y.C.,* 1963; *Woman with a veil on Fifth Avenue, N.Y.C.,* 1968; *A naked man being a woman, N.Y.C.,* 1968; *Man dancing with a large woman, N.Y.C.,* 1967; *Lady bartender at home with a souvenir dog, New Orleans,* 1964; *Transvestite at a drag ball, N.Y.C.,* 1970; *A woman with her baby monkey, N.J.,* 1971; *Woman with a fur collar on the street, N.Y.C.,* 1968; *Man and a boy on a bench in Central Park, N.Y.C.,* 1962; *Woman in her negligee, N.Y.C.,* 1966; *A widow in her bedroom, N.Y.C.*

48. Armstrong, Carol M. "Biology, Destiny, Photography: Difference According to Diane Arbus," *October (Cambridge, MA)* 66 (Fall 1993): 29-54.

49. Bedient, Calvin. "The Hostile Camera: Diane Arbus," *Art in America* 73 (January 1985): 11+.

50. Bosworth, Patricia. *Diane Arbus, a Biography.* New York: Alfred A. Knopf, 1984. 366 p.
 This work is a biography based on many interviews with members of Arbus' family, but not including her daughters or husband Allan. There were also interviews conducted with other individuals including her photography teacher, Lisette Model, and several photographs of members of her family.

51. Brill, Lesley. "The Photography of Diane Arbus," *Journal of American Culture* 5, 1 (1982): 69-76.

52. Budick, Ariella. "Diane Arbus: Gender and Politics," *History of Photography* 19 (Summer 1995): 123-126.

53. Czach, Marie. "Diane Arbus, Sylvia Plath and Anne Sexton: Astringent Poetry and Tragic Celebrity," *History of Photography* 19 (Summer 1995): 100-106.

54. "Diane Arbus," *History of Photography,* 19 (Summer 1995): ii-134.

55. "Diane Arbus," *Infinity* 19, 9 (September 1970): 16-17.

56. Edwards, Owen. "Exhibitions: The Magnetic Eye," *American Photographer* 5, 5 (November 1980): 17-18.

57. *Going Where I've Never Been: The Photography of Diane Arbus*. New York: Camera Three Productions, 1989. Video recording, 30 minutes. Producer and Director, John Mitchell. Narrator: Doon Arbus and others. Explores her work and ideas through her own words and the reflections of her daughter and close friends.

58. Gross, Jozef. "Diane Arbus: Life and Death," *British Journal of Photography* 132 (March 22, 1985): 321-4.

59. Hill, E. and Bloom, S. "Diane Arbus," *Artforum* 26, 10 (1988): 145.

60. Hulick, Diane Emery. *Diane Arbus and Her Imagery*. Dissertation, Princeton University, 1984. Includes bibliographical references, 2 volumes.

61. Hulick, Diana Emery. "Diane Arbus Expressive Methods," *History of Photography* 19 (Summer 1995): 107-116.

62. Hulick, Diana Emery. "Diane Arbus Women and Transvestites: Separate Selves," *History of Photography* 16 (Spring 1992): 34-39.

63. Israel, Marvin. "Diane Arbus," *Infinity* 21, 9 (November 1972): 4-15.

64. Jeffrey, Ian. "Diane Arbus and the Past: When She Was Good," *History of Photography* 19 (Summer 1995): 95-99.

65. Kavaler, Susan Adler. "Diane Arbus and the Demon Lover," *The American Journal of Psychoanalysis* 48, 4 (1988): 366-370.

66. Lemann, Nicholas. "Whatever Happened to the Family of Man," *Washington Monthly* 16, 9 (1984): 12-18.

67. Linhoff, Aimee J. "Diane Arbus: A Bibliography," *History of Photography* 19 (Summer 1995): 130-134.

68. Lobron, Barbara. "MOMA in Labor," *Camera 35* 17, 3 (April 1973): 38-39+.

69. Lord, Catherine. "What Becomes a Legend Most: The Short, Sad Career of Diane Arbus," *Exposure* 23, 3 (Fall 1985): 5-14.

70. McPherson, Heather. "Diane Arbus' Grotesque Human Comedy," *History of Photography* 19 (Summer 1995): 117-120.

71. Muchnic, S. "Body, Sole, and a Good Cigar," *Artnews* 93, 8 (October

1994): 27-28.

72. Smith, C. Zoe. "Audience Reception of Diane Arbus' Photographs," *Journal of American Culture* 8, 1 (1985): 13-19.

73. Sontag, Susan. "Freak Show," *New York Review of Books* (November 15, 1973): 13-19.

74. Stevens, Robert B. "The Diane Arbus Bibliography," *Exposure* 15, 3 (September 1977): 10-19.

75. Tucker, Anne Wilkes. "Arbus Through the Looking Glass," *Afterimage* 12 (March 1985): 9-11.

76. Warburton, Nigel. "Diane Arbus and Erving Goffman: The Presentation of Self," *History of Photography* 16 (Winter 1992): 401-404.

77. Woodward, Harry Loomis. *In Bold and Fearless Connection: A Study of the Fiction of Flannery O'Connor and the Photography of Diane Arbus.* Dissertation. University of Minnesota, 1978. 221 p. Bibliography: 210-221.

78. Zuliani, Diane. "Diane Arbus and Franz Kafka: Canine Investigations," *History of Photography* 19 (Summer 1995): 127-129.

Armstrong, Carol
See also #1071

Armer, Laura Adams, 1874-?

79. Dicker, Laverne Mau. "Laura Adams Armer: California Photographer," *California Historical Quarterly* 56, 2 (Summer 1977): 128-139.

Arnold, Eve. 1913-
See also #1008, 1026, 1058

80. Arnold, Eve. *Eve Arnold: In Retrospect.* London: Sinclair-Stevenson, 1995. Originally published: New York: Alfred A. Knopf, 1995. 289 p. Illustrations.
The text, which runs throughout the book, was written by Arnold, as an archive to examine the "failures as well as the successes" of her career. The autobiographical work contains personal anecdotes on her life and the conditions under which many of her photographs were taken.
Hubert's Museum, 42nd Street, New York City, 1950, p. viii; *Charlotte Stribling, a.k.a. Fabulous, fashion show, Harlem,* 1952, p. 3; *Self-portrait in a distorting*

mirror, 42nd Street, New York, 1950, p. 8; *The Davis family church supper, Mount Sinai, New York*, 1952, p. 18; *Childbirth, Port Jefferson, New York*, 1952, p. 21; *Sailor and his family, Newport News,Virginia*, 1954, p. 22; *Roy Cohn and Joseph McCarthy, House Committee on Un-American Activities,Washington,D.C.*, 1954, p. 24; *Dwight D. Eisenhower and Robert Taft after Republican nomination, Chicago*, 1952, p. 26; *Marlene Dietrich, recording session, New York*, 1952, p. 29; *Republican Convention, Chicago*, 1952, p. 31; *Queen Elizabeth, first royal tour, Jamaica*, 1954, p. 32; *Fisherman and family, Bahía Honda, Cuba*, 1954, p. 35; *Miltown experiment, insane asylum, Haiti*, 1954, p. 39; *James Cagney and his wife, Willy, hoofing in their barn, Massachusetts*, 1955, p. 43; *Clark Gable on location for* The Misfits, *Nevada*, 1960, p. 44; *Joan Crawford on soundstage, Hollywood*, 1959, p. 48; *Joan Crawford undergoing a beauty treatment, New York*, 1959, p. 51; *Joan Crawford, dress fitting, Hollywood*, 1959, p. 54; *Marilyn Monroe, airport ladies' room, Chicago*, 1955, p. 57; *Marilyn Monroe in the bulrushes, Mount Sinai, Long Island*, 1954, p. 58; *Marilyn Monroe with Arthur Miller, on location for* The Misfits, *Nevada*, 1960, p. 61; *Malcolm X collecting money for the Black Muslims, Washington,D.C.*, 1960, p. 64; *George Lincoln Rockwell head of the American Nazi Party, at Black Muslim Party, at Black Muslim meeting, Washington, D.C.*, 1960, p. 66; *Music student sounding her A, London*, 1963, p. 70; *One of four girls who share an apartment, London*, 1963, p. 73; *Orson Welles, deathbed rehearsal for* A Man for All Seasons,*England*, 1966, p. 79; *Richard Burton and Elizabeth Taylor during the filming of* Becket, *Shepperton, England*, 1963, p. 80; *Andy Warhol lifting weights, Silver Factory, New York*, 1964, p. 82; *Alec Douglas-Home, Prime Minister of England, and his wife, Lady Douglas-Home, The Hersil, Scotland*, 1964, p. 84; *Father Gregory Wilkins, Kelham, Nottinghamshire, England*, 1963, p. 88; *Republican Convention fund-raising,San Francisco*, 1964, p. 91; *John Huston as Noah in* The Bible, *Rome*, 1965, p. 93; *Lesbian wedding celebration, London,*1965, p. 94; *The oldest men in the world, the Caucasus, USSR*, 1965, p. 97; *Psychiatric hospital, Moscow*, 1966, p. 100; *Divorce, Moscow*, 1966, p. 104; *Hydrotherapy for political prisoners, psychiatric hospital, Moscow*, 1966, p. 108; *Nuns, the Vatican*, 1965, p. 110; *Nuns ironing cardinal's vestments, the Vatican*, 1965, p. 114; *Beekeeper, Krasnadar, USSR*, 1966, p. 117; *Returned Vietnam warriors, Fort Bragg, North Carolina*, 1968, p. 118; *Anjelica Huston at sixteen, Ireland,*1968, p. 121; *Black society debut, Waldorf-Astoria Hotel, New York*, 1964, p. 124; *Black is beautiful, New York*, 1968, p. 126; *Pretty Polly advertisement, London*, 1969, p. 131; *Three widows on their way to their mutual husband's grave, Kabul, Afghanistan*, 1969, p. 134; *Buzkashi game, Kabul Afghanistan*, 1969, p. 138; *A Sheikha in her harem, Arab Emirates*, 1970, p. 141; *Hint Bint Maktoum with her brother in her harem, Dubai*, 1971, p.146; *Prince Maktoum, younger son of the ruler of Dubai, Dubai*, 1971, p. 149; *Welder, Swan Hunter shipyard, Newcastle, England*, 1972, p. 152; *Student, Royal Veterinary College, London*, 1972, p. 155; *Child suffereing from Kwashiorkor, Nqutu, Zululand*, 1973, p. 161; *[Pregnant women]* p. 162; *Miner, medical examination, Val Reef Mines, South Africa*, 1973, p. 164; *André Malraux, Paris*, 1974, p. 169; *Sweeper,Castle Medina-Celi, Madrid*, 1977, p. 170; *Margaret Thatcher with Churchill statues, London*, 1977, p. 178;

Vanessa Redgrave dressing for the role of Anne Boleyn in A Man for All Seasons,England, 1966, p. 182; *Indira Gandhi, speaking engagement, Uttar Pradesh, India*, 1978, p. 185; *Audience for an Indira Gandhi rally, Uttar Pradesh, India*, 1978, p. 186; *Retired worker, Gwelin, Chica*, 1979, p. 190; *Family in alpine forest, Sinkiang, China*, 1979, p. 195; *Bottler in a beer factory,Tsingtao, China*, 1979, p. 196; *Nursery in a cotton mill, Beijing*, 1979, p. 200; *Art class, Chungking, China*, 1979, p. 203; *Folk song group, Inner Mongolia*, 1979, p. 205; *Horse training for the militia, Inner Mongolia*, 1979, p. 208; *Buddhist monks studying sutras, Inner Mongolia*, 1979, p. 210; *Television, Shanghai*, 1979, p. 212; *Donabah Barney baking bread for peyote ceremony, New Mexico*, 1982, p. 218; *Male stripper, Sneaky Pete's, New Jersey*, 1982, p. 225; *Shelter for homeless men, Chester, New York*, 1981, p. 227; *Neighbors, Craig, Nebraska*, 1981, p. 230; *Member of Sisters of Perpetual Indulgence,San Francisco*, 1981, p. 233; *On the flight path, Daly City, California*, 1981, p. 237; *HRH Oba Oseiijeman Adefunmi, Beaufort, South Carolina*, 1982, p.238; *Chess Pavilion, Chicago*, 1981, p. 243; *Prisoners, Sugarland, Texas*, 1982, p. 248; *Motion Picture Home for the Aged, Los Angeles*, 1982, p. 251; *A Mexican prostitute who plays a whore in Under the Volcano, Mexico*, 1983, p. 252; *Rock breaking in the clay pits, Delhi, India*, 1984, p. 254; *Isabella Rossellini, Finland*, 1985, p. 257; *Mikhail Baryshnikov in rehearsal, New York*, 1987, p. 259; *Dancer Lisa Reinhart, New York*, 1987, p. 260; *American tourists, amateur theatricals, Rostov on Don, Russia*, 1988, p. 263; *A scribe and his client, Afghanistan*, 1969, p. 269; *Sculptor Marcia Panama, London*, 1975, p. 270; *Prime Minister John Major of Britain with Prime Minister Giuliano Amato of Italy, press conference, Rome*, 1992, p. 276; *My grandson Michael Arnold, age sixteen, London*, 1994, p. 285.

81. Arnold, Eve. *Flashback! The 50's*. New York: Alfred A. Knopf, 1978. 150 p.

The essays by Arnold which accompany the photographs indicate that these images were her attempt to get a sense of America in the 1950's. Arnold photographed not only those people who made headlines in the fifties, but also those in small towns and big cities, who made up the essence of America.

1952 Republican Presidential Convention, p. 7; *Mamie Eisenhower*, p. 8; *Dwight D. Eisenhower*, p. 9; *[Taft supporter]* p. 10; *Robert Taft*, p. 11; *Richard Nixon*, p. 12; *Joseph McCarthy*, p. 13; *[Ike Supporters]* p. 14; *Wayne Morse*, p. 15; *[At the Bar]* p. 17; *[Men in Suits Watching Television]* p. 18; *Adlai Stevenson*, p. 19; *[Father Meeting Family at Door]* p. 21; *[Sailor and Family in Living Room]* p. 24; *Senator McCarthy at Senate Hearing Press Conference*, p. 28; *Roy Cohn, Joe McCarthy, and G. David Schine*, p. 29; *Cohn and McCarthy*, p. 30; *Brookhaven*, p. 32-33; From the "Davis Family:"*Election Day*, p. 34, 35; *[Portrait of a Woman]*, p. 38; *[Portrait of a Man]*, p. 39; *[Six Member Jury]*, p. 40-41; *[Farmer in Plowed Field]*, p. 42; *[Grave Digger]*, p. 43; *[The Groom]*, p. 44; *[Bride and Groom Kissing]*, p. 45; *Last Day of School*, p. 46; *The Prom*, p. 47; *[Kids in a Station Wagon Window]* p. 48-49; *Library*, p. 50; *[Men and Children by a White Picket*

Fence] p. 51; *Church,* p. 52; *Pageant,* p. 53; *[Supper by the Cemetery]* p. 54-55; *Long Island Migrant Labor Camp,* p. 57; *[Men Lifting Sacks of Potatoes]* from the Labor Camp, p. 58; *[Women at Washtub]* from the Labor Camp, p. 59; *[Young Woman by Jukebox]* from the Labor Camp, p. 60; *[Black Debutante Ball at the Waldorf Astoria]* p. 62-65; *Mrs. Luci Halm Cullinan, Houston Museum of Fine Arts,* p. 66; *René d'Harnoncourt,* p. 67; *[People in a Gallery]* p. 68-69; *Mr. and Mrs. Edward Steichen,* p. 70; *Mary Rockefeller* p. 71; *[Shadowy Figure at Times Square Show]* p. 73; *[Peek-a-boo Vending Machines]* p. 74; *[Dance Hall Photographs]* p. 75; *Flea Circus,* p. 76; *Peep Show,* p. 77; *Marilyn Monroe and Arthur Miller,* p. 79; *Fleur Cowles and Margaret Truman,* p. 80; *Silvana Mangano, Johnny Mathis, and Dave Brubeck,* p. 81; *Jayne Mansfield and Mr. Universe,* p. 82; *David Oistrkh,* p. 83; *Christopher Isherwood and W. H. Auden,* p. 84; *Josephine Baker,* p. 85; *Laurence Olivier and Marilyn Monroe,* p. 86-87, 88-89; *Joan Crawford,* p. 90, 91; *James Cagney,* p. 93; *Mary Martin,* p. 94; *Lynn Fontanne and Alfred Lunt,* p. 95; *William Carlos Williams,* p. 96; *Andy Warhol,* p. 97; *Margaret Sullivan,* p. 98; *Paul Newman at the Actors Studio,* p. 99; *Clark Gable,* p. 100-101; *Alistair Cooke,* p. 102; *Rocky Marciano,* p. 103; *Gwen Verdon* p. 104; *I.I. Rabi,* p. 105; *Oral Roberts,* p. 106; Selections from *Fortune* assignment "Saving Souls is Big Business," p. 107-111; *CORE Training for Sit-ins,* p. 112; *Singing "We Shall Overcome" at Virginia State College with Guy Carawan,* p. 114-115; *[Holding Placards - My $$ is Green What Color is Yours]* p. 116; *[White Woman and Black Woman at Table]* p. 117; *Malcolm X,* p. 119, 129; *Black Muslim Graduation,* p. 121; *Black Muslim Honor Guard,* p. 122; *Black Muslim Army, Fruit of Islam,* p. 124-125; *Elijah Muhammad and Malcolm X,* p. 126; *Elijah Muhammad's Daughter and Wife,* p. 127; *George Lincoln Rockwell Flanked by Members of American Nazi party at Black Muslim Meeting,* p. 131, 132; *Miss America Pageant,* p. 134-137; *Owner of the 711 Bar,* p. 139; *Female Bartender,* p. 140; *Head of the Woman's Christian Temperance Union,* p. 141; *[Bartenders Union Picket]* p. 142; *Mrs. Richard Nixon,* p. 144; *Mrs. Hubert Humphrey,* p. 145; *Mrs. Lyndon Johnson,* p. 146; *Mrs. John F. Kennedy and Caroline,* p. 147.

82. Arnold, Eve. "I Covered a Sports Spectacular," *Camera 35* 17, 1 (January/February 1973): 36-38.

83. Arnold, Eve. *In America.* New York: Alfred A. Knopf, 1983. 207 p. Chiefly illustrations. Introduction and accompanying explanatory essays by Eve Arnold.

Bucksport, Maine, Independence Day, p. 9; *Ossabaw Island, Georgia, Mother and Daughter,* p. 10; *New Orleans, Mother and Sons,* p. 11; *New York City, Spanish Harlem,* p. 12; *Savannah, Georgia, Hearing Test, Junior League Volunteer,* p. 13; *Chinle, Arizona, Little League Baseball Team,* p. 14; *South Carolina, "African Village,"* p. 15; *Mayking, Kentucky, Head Start Class,* p. 16; *Whitesburg, Kentucky, Family Dinner Blessing,* p. 17; *Fort Defiance, Arizona, Kindergarten Graduation Rehearsal,* p. 18; *Immokalee, Florida, Haitian Migran and Daughter,* p. 19; *Houston, Patient with Cancer Coloring Book,* p. 20; *Craig, Nebraska,*

Community Picnic, p. 21;*Boonville, California, Apple fair, 4-H Club*, p. 22; *Tekamah, Nebraska, Omaha Indian*, p. 23; *Massachusetts, Farm*, p. 27; *Albuquerque, New Mexico, Mission*, p. 28; *Milwaukee, Industrial Landscape*, p. 29; *Chicago, Flea Market*, p. 30; *Sparks, Kansas, Building a Fertilizer Plant*, p. 31; *New York City, Dawn*, p. 32; *Seattle, Picks Place Market*, p. 37; *Washington, D.C., High School Band and Girl Scout Troop*, p. 38; *Natchez, Mississippi, Pilgrims*, p. 39; *Provo, Utah, Brigham Young University*, p. 40; *New York City, Subway*, p. 41; *New York City, James Taylor Concert*, p. 42; *Lynchburg, Virginia, Liberty Baptist Choir*, p. 43; *New York City, Feast of San Gennaro*, p. 44; *Palm Beach, Florida, Polo Player*, p. 45; *Asbury Park, New Jersey, Amusement Arcade*, p. 46; *Lynchburg, Virginia, Born-Again Christian*, p. 47; *San Antonio, Texas, Plasma Center*, p. 48; *Bronx, New York, Guardian Angels*, p. 49; *Newport, Rhode Island, Coaching Event*, p. 50; *Chester, New York, Homeless Youth*, p. 51; *Pasadena, California, Klansman*, p. 52; *Salt Lake City, Mormon Missionaries*, p, 53; *Charleston, South Carolina, The Citadel*, p. 54; *New York City, Anti-Nuclear Demonstration*, p. 55; *Fort Bend City, Texas, State Prison*, p. 56; *New York City, Andy Warhol Opening*, p. 57, *Baton Rouge, Louisiana, Chemical Dependency Unit*, p. 58; *New York City, Labor Day Parade*, p. 59; *Port Angeles, Washington, Marriage*, p. 60; *Santa Monica, California, Shopping Mall*, p. 67; *De Kalb, Illinois, North Illinois University*, p. 68; *Charlottesville, Virginia, Waiting for a Parade*, p. 69; *New Mexico, Sandia Mountains*, p. 70; *Chicago, Chess Pavilion*, p. 71; *Port Levaca, Texas*, p. 72; *New York City, Seventh Avenue Receptionist*, p. 77; *Seattle, Draftsman*, p. 78; *Los Angeles, Shakira Caine*, p. 79; *Orland, Maine, Spinners*, p. 80; *Union, New Jersey, Stripper at Sneaky Pete's*, p. 81; *Everett, Washington, Laser Operations*, p. 82; *Nora, Virginia, Mine Superintendent and Supervisor*, p. 83; *New York City, Construction Worker*, p. 84; *Saint Matthews, South Carolina, Housewife*, p. 85; *Chicago, Marathon*, p. 86; *Orlando, Florida, Disney World*, p. 87; *Detroit, Satan's Sidekicks, Bikeriders*, p. 88; *Jemez Springs, New Mexico, Hot Springs*, p. 89; *Bel Air, California, Angelica Huston*, p. 90; *San Francisco, Member of the Order of Sisters of Perpetual Indulgence*, p. 91; *Coral Gables Florida, George Segal Sculpture*, p. 92; *Asbury Park, New Jersey, Boardwalk*, p. 93; *New York City, Model at Perry Ellis*, p. 94; *Alexander Valley, California, Grape Picker*, p. 95; *Simi Vineyard, California, Vintner*, p. 96; *Los Angeles, Pregnancy Exercise Class*, p. 97; *San Francisco, Friends*, p. 98; *Gretna, Louisiana, Gun Class*, p. 99; *Rio Rancho, New Mexico, Navajo Carpenter*, p. 100; *Clinchfield, Virginia, Miner*, p. 101;*Coralles, New Mexico, St. Ysidro Mass*, p. 102; *Brooklyn, New York, Lubavitcher Chasid*, p. 103; *Charlottesville, Virginia, Dogwood Festival*, p.104; *New Orleans, Mardi Gras*, p.105; *San Francisco, Policewoman*, p. 106; *Leighton, Pennsylvania, Mud Wrestlers*, p. 107; *Venice, California, Sunday*, p. 108; *Everett, Washington, Aircraft Painter*, p. 109; *Los Angeles, U.C.L.A. Art Class*, p. 110; *Sugarland, Texas, Prisoners*, p. 111; *Saint Matthews, South Carolina, Political Candidate*, p. 112; *Chicago, A Lake View*, p. 117; *White Cloud, Kansas, Main Street*, p. 118; *Elizabeth, New Jersey, Oil Refinery*, p. 119; *Frankfort, Maine, Boat Races*, p. 120; *Cape Canaveral, Florida, Spaceship Model*, p. 121; *Colorado, Ghost Town*, p. 122; *Des Moines, Iowa, Corn Growers' Association*, p. 123; *New*

Orleans, Jackson Square, p. 124; *Coon Rapids, Iowa, Cattle Artificial Inseminator*, p. 127; *Coon Rapids, Iowa, Blacksmith*, p. 128; *New York City, 100th Anniversary Celebration of Organized Labor*, p. 129; *Chicago, Architect and State Senator*, p. 130; *Channelview, Texas, Imperial Wizard, Ku Klux Klan*, p. 131; *Natchez, Mississippi, Fourth Street Church of Christ*, p.132; *Cane River, North Carolina, Baptism*, p. 133; *Chicago, Psychiatrist and Educator*, p. 134; *Houston, Philanthropic Fund Raiser*, p. 135; *Hawley, Massachusetts, Dedication of a Stupa*, p. 136; *Beaufort, South Carolina, HRH Oba Oseiijeman Adefunmi I*, p. 137; *Natchez, Mississippi, Courtroom*, p. 138; *Natchez, Mississippi, Mayor*, p. 139; *Marin County, California, Rabbi on Yom Kippur*, p. 140; *Chester, New York, Home for Homeless Men*, p. 141; *Craig, Nebraska, Neighbors*, p. 142; *Washington, D.C., Outside the White House*, p. 143; *Seattle, Laotian Woman, Literacy Class*, p. 144; *San Francisco, Head of the Hookers' Union*, p. 145; *Immokalee, Florida, Haitian Migrant*, p. 146; *Port Angeles, Washington, Minister*, p. 147; *Stanford University, California, Dr. Paul Berg, Nobel Laureate in Genetics*, p. 148; *Washington, D.C., The Reverend Jerry Falwell*, p. 149; *Gilbert, Pennsylvania, Dog Show, the West End Fair*, p. 150; *Fort Defiance, Arizona, Memorial Day*, p. 151; *New Orleans, Cajun Chef*, p. 152; *Coon Rapids, Iowa,Cattle Breeder*, p. 153; *Chicago, Tunnel "Stiff,"* p. 154; *Bernalillo County, New Mexico, Sheriff*, p. 155; *Salt Lake City, Tabernacle Choir*, p. 156; *Chicago, Curator of Twentieth-Century Art*, p. 157; *Chicago, Fund-raising Party*, p. 158; *Eastgate, Texas,Rodeo*, p. 159; *Cleveland, Wisconsin, Farmer*, p. 160; *Chicago, Going to Work*, p. 167; *Louisiana, Bayou*, p. 168; *East Los Angeles, Barrio*, p. 169; *Everett, Washington, The Boeing Company*, p. 170; *Eureka, California, Early Morning Mist*, p. 171; *Sabbathday Lake, Maine, Shaker Deaconess*, p. 175; *Young's Island, Georgia, Fireman's Wife*, p. 176; *New York City, Patternmaker*, p. 177; *Salt Lake City, Dr.Willem J. Kolff with Model of Artificial Heart*, p. 178; *Seattle, Owner of King Broadcasting Company*, p. 179; *Narrow Creek Canyon, New Mexico, Bread Baking*, p. 180; *Brooklyn, New York, Hasidim*, p. 181; *Pender, Nebraska, Auction*, p. 182; *Moline, Illinois, Company President*, p. 183; *East Bronx, New York, Salvation, Army Thanksgiving*, p. 184; *Micaville, North Carolina, Sick Man at Revival Meeting*, p. 185; *Orland, Maine, Manager of the H.O.M.E.Crafts Cooperative*, p. 186; *Northern California, Morris Graves*, p. 187; *Los Angeles, Centerarian*, p. 188; *Natchez, Mississippi, Bingo at the Senior Citizens' Multi-purpose Center*, p. 189; *Appalachia, Tennessee, Balladeer and Coalman*, p. 190; *Window Rock, Arizona, Navajo Matriarch*, p. 191; *Century City, Florida, Tricycle Club*, p. 192; *Natchez, Mississippi, County Nursing Home*, p. 193; *Los Angeles, Motion Picture and Television Home and Hospital*, p. 194; *Lafayette, Louisiana, Prairie*, p. 201; *Columbia, South Carolina, Construction*, p. 202; *Placedo, Texas, The HK Ranch*, p. 203; *Los Angeles, Freeway*, p. 204; *Salt Lake City, The Capitol*, p. 205; *Chicago, The Cubs versus Atlanta*, p. 206; *Daly City, California, On the Flight Path*, p. 207.

84. Arnold, Eve. *In China*. New York: Alfred A. Knopf, 1980. 202 p. Chiefly illustrations.
 Accompanying essays include an introduction, "Landscape," "People,"

"Work," and "Living."

Inner Mongolian Steppes/Cowboy, p. 17; *Tsingtao/Holiday Beach*, p. 18; *Peking/Winter*, p. 19; *Inner Mongolia/Cowboy Dwellings*, p. 20; *Chungking/Life on the Yangtze*, p. 21; *Wanhsien/Traffic Control*, p. 22; *Victory Oilfields/Riggers*, p. 23; *Kunming/Peasant Houses*, p. 24; *Kweilin/Cormorant Fishing*, p. 25; *Shanghai/River Traffic*, p. 26; *Hsishuang Panna/Buddhist Temple Used As a Granary*, p. 27; *Wanhsien/Industrial Countryside*, p. 28; *Szechwan/Spring Planting*, p. 29; *Yangtze/Industrial Complex*, p. 30; *Hsishuang Panna/Weeding*, p. 31; *Shanghai/Seen From a Television Tower*, p. 32; *Tibet/Mountains In Summer*, p. 33; *Hsishuang Panna/Day's End*, p. 34; *Turgan-Sinkiang/Lost City On the Silk Road*, p. 35; *Soochow/Traffic On the Grand Canal, p. 36; Sinkiang/Family In an Alpine Forest*, p. 37; *Hsishuang Panna/Planting Rice Shoots*, p. 38; *Lhasa, Tibet/Potala Palace*, p. 39; *Retired Worker*, p. 43; *Peasant Farmer*, p. 44; *Tribal Woman*, p. 45; *Sinkiang Cowboy and Son*, p. 46; *Friends*, p. 47; *105-Year-Old Woman in an Old-Age Home*, p. 48; *91-Year-Old Man In an Old-Age Home*, p. 49; *Hui Women*, p. 50; *Caretaker At the Potala Palace*, p. 51; *Dancer*, p. 52; *Tractor Factory Worker*, p. 53; *Mullah*, p. 54; *Retired Peasants*, p. 55; *Scientists At Home*, p. 56; *Cowboy In Inner Mongolia*, p. 57; *Tibetan Pilgrim*, p. 58; *Tribal Woman In Hsishuang Panna*, p. 59; *Mother and Child*, p. 60; *Military Doctor*, p. 61; *Student*, p. 62; *Shanghai Millionaire and His Wife*, p. 63; *Athlete*, p. 64; *Soldiers*, p. 65; *Tibetan Women On a Sunday Stroll*, p. 66; *Tibetan Lamas At Prayer*, p. 67; *Deputy To the People's Congress From Hsishuang Panna*, p. 68; *Vice Chairman Liao At Home*, p. 69; *Welder, Locomotive Plant*, p. 73; *Inspector, Cotton Mill*, p. 74; *Machine Operator, Tractor Plant*, p. 75; *Lunch Break, Locomotive Plant*, p. 76; *Bottler, Beer Factory*, p. 77; *Steelworker*, p. 78; *Oil Worker*, p. 79; *Dawn Milking/Inner Mongolia*, p. 80; *Roundup/Inner Mongolia*, p. 81; *Rice Shoot; Planting/Hsishuang Panna, p. 82; Rice Gleaning/Hsishuang Panna*, p. 83; *Clearing Ssnow from Winter "Greenhouses,"* p. 84; *Leveling the Land*, p. 85; *Bringing Rice To the State Granary/Grand Canal*, p. 86; *Fishing On the Grand Canal*, p. 87; *Making Steamed Bread*, p. 88; *Making Noodles*, p. 89; *Cook In Peking Duck Restaurant*, p. 90, 91; *Mayor of Wanhsien and His Deputies*, p. 92; *Mayor Inspecting Embroidery Factory*, p. 93; *Skilled Embroiderers*, p. 94; *Rug Weaving/*Tibet, p. 95; *Rubber Tapping*, p. 96; *Accountant*, p. 97; *Shoemaking*, p. 98; *Roadbuilding/*Tibet, p. 99; *Logging/*Sinkiang, p. 100; *Clearing Stony Soil*, p. 101; *Weighing the Newborn, Western-Style Hospital/*Tibet, p. 102; *Technician Applying Moxibustion*, p. 103; *Preparing Herbal Medicine For Impotency*, p. 104; *Pharmacist Filling Prescription*, p. 105; *Barefoot Doctor Dispensing Pills and Water on the Burmese Border*, p. 106; *Barefoot Doctor In Tibet*, p. 107; *Barefoot Doctor in Shanghai Commune*, p. 108; *Traditional Doctor*, p. 109; *Herb Seller, Free Market*, p. 110, 111; *Astronomer*, p. 112; *Teaching Poetry*, p. 113; *Officials Of the Potala Palace*, p. 114; *Disc Jockey in the Commune*, p. 115; *Muralist*, p. 116; *Huan Yung Yu, Famous Painter, In His Studio*, p. 117; *Chen Chong, Film Actress--First Take*, p. 118; *Camera Crew Film Studio*, p. 119; *Song-and-Dance Troupe, p. 120; Traditional Orchestra*, p. 121; *Glassblower*, p. 122; *Typesetter At the* People's Daily*/Peking*, p. 123; *Western-Trained Doctors Studying Tibetan*

Medical Texts, p. 124; *Fireman,* p. 125; *Scientist and Family at Home in the Victory Oilfields,* p. 135; *Army Officer and Family on Holiday in Wuhan,* p. 136; *Scientist's Children,* p. 137; *Tibetan Family outside Their Home,* p. 138; *Cowboy and His Children/Inner Mongolia,* p. 139; *Mother and Sons/Chungking,* p. 140; *Modern Apartment House/Kweilin,* p. 141; *Building Permanent Dwellings for Cowboys/Tibet,* p. 142; *Peasant Houses/Hsishuang Panna,* p. 143; *Caretakers' Housing/Potala Palace,* p. 144; *Accountant's House/Peking,* p. 145; *Room for Newlyweds/Peking Commune,* p. 146; *Yurt Interior, Heavenly Lake/Sinkiang,* p. 147; *Dormitory For Women Oil Workers,* p. 148; *Peasant Cadre Preparing Lunch,* p. 149; *Hospital Nursery/Lhasa, Tibet,* p. 150; *Cotton Mill Nursery/Peking,* p. 151; *Playground Of the Great Leap Forward Commune/Lhasa, Tibet,* p. 152; *School Play/Chungking,* p. 153; *Permanent Wave,* p. 154; *Extracurricular Training, Children's Palace*/Shanghai, p. 155; *Children's Hygiene Campaign*/Shanghai, p. 156; *Athletic Field*/Wanshsien, p. 157; *Workers Reading <u>People's Daily</u> During Morning Coffee Break,* p. 158; *Art Class*/Chungking, p. 159; *Mother Bringing Newborn From Maternity Hospital*/Sian, p. 160; *Peasant Girl Waiting For Husband*/Hsishuang Panna, p. 161; *Democratic Posters*/Chungking, p. 162; *Billboard Advertising Heart Medication*/Shanghai, p. 163; *Demonstration Against Unemployment*/Shanghai, p. 164; *Retirement Celebration,* p. 165; *Merchandise For Export*/Shanghai, p. 166; *General Store*/Inner Mongolia, p. 167; *Peasant Coming Home From Market*/Kweilin, p. 168; *Supermarket*/Peking, p. 169; *Wedding Photographs,* p. 170; *Funeral Wreath,* p. 171; *Hospital Waiting Room/Lhasa, Tibet,* p. 172; *Sand Therapy/Sinkiang,* p. 173; *Old Man and His Wife/Sinkiang,* p. 174; *Old-Age Home/Peking,* p. 175; *Priest Of the Church Of the Immaculate Conception/Peking,* p. 176; *Buddhist Monk, Could Mountain Monastery/Soochow,* p. 177; *Catholic Worshipers/Peking,* p. 178; *Three Tibetan Nuns/Steps of Potala Palace,* p. 179; *Lamas At Prayer/Drepung Monastery, Tibet,* p. 180; *Muslims At Prayer/Urumchi, Sinkiang,* p. 181; *Beadle In Buddhist Temple/Kunming,* p. 182; *Buddhists Monks Studying Sutras/Cold Mountain Monastery, Soochow,* p. 183; *Art Gallery/Wuhan,* p. 184; *Buddhist Temple Used As a Gallery/Wuhan,* p. 185; *Acrobats/Wuhan,* p. 186; *Circus/Chungking,* p. 187; *Recreation/Wuhan,* p. 188; *Boat Racers/Tsingtao,* p. 189; *Vacationers/Tsingtao,* p. 190; *Entertainment For Cowboys/Grasslands of Tibet,* p. 191; *Member Of the Militia/Inner Mongolia,* p. 192; *Horse Training For the Militia/Inner Mongolia,* p. 193; *Wrestlers/Inner Mongolia,* p. 194; *Wrestling/Inner Mongolia,* p. 195; *Song At Dusk/Inner Mongolia,* p. 196; *Militia Of Golden River White Horse Company Singing a Folk Song,* p. 197; *Peking Sunday,* p. 198; *Chungking Sunday, p. 199; Fashion Show Of Pierre Cardin Clothes/Great Wall,* p. 200; *Television,* p. 201.

85. Arnold, Eve. *The Unretouched Woman.* New York: Knopf, 1976. 111 p. "This is a book about how it feels to be a woman, seen through the eyes and the camera of one woman--images unretouched, for the most part unposed, and unembellished." (p. 7) The photographs are accompanied by several short explanatory essays by Arnold, on how she came to take the pictures and the social significance of the lives these women were

living.

[Woman touching infant's fingers], p. 5; *Girl, Kabul, Afghanistan*, p. 9; *Member of Royal Toxophilite Society (archers). London, England*, p. 10; *Congregation of Self-Realization Fellowship at meditation. Los Angeles, California*, p. 11; *Kyung-Wha Chung, Korean violinist before her debut in London*, p. 12; *Lillian Briggs, trombonist, Brooklyn, New York*, p. 13; *Queen Elizabeth II at a bicycle plant in the Midlands, England*, p. 14; *Cicely Tyson, actress, Harlem, U.S.A.*, p. 15; *Nursing mother, London*, p. 16; *Baking hoecakes . New Buffalo Commune, New Mexico*, p. 17; *Nun ironing Cardinal's vestments. Vatican, Rome*, p. 18; *Nomad woman in Hindu Kush, Afgahanistan*, p. 20; *Lady Spencer Churchill (Mrs. Winston Churchill) under bulldog painting by Bambois*, p. 21; *Egyptian woman. Valley of the Kings, Upper Egypt*, p. 22; *Black lady at a garden party at Count Basie's in St. Albans, New York City*, p. 23; *Classmate of Barry Goldwater's . Phoenix, Arizona*, p. 24; *Lady with Baskin scultpure. Museum of Modern Art, New York*, p. 28; *Birth. Port Jefferson, Long Island, New York*, p. 30; *Steven Wood and his mother. Port Jefferson, Long Island*, p. 31; *D.A.R. meeting, Sorosis Club, Patchogue, Long Island*, p. 32; *Allegiance to the flag, Mount Sinai, Long Island*, p. 33; *Descendant of early settlers*, p. 34; *Migratory potato pickers. Cutchogue Labor Camp, Brookhaven*, p. 35, 37; *Literacy class. Petersburg, Virginia, 1958*, p. 36; *Pickets. Petersburg, Virginia, 1958*, p. 35; *Mrs. Barry Goldwater. Republican National Convention, San Francisco, 1964*, p. 36; *Mamie Eisenhower, looking at herself in a distorting mirror at an amusement park in Denver, Colorado, 1952*, p. 37; *Delegate to Republican National Convention collecting money for the election campaign. San Francisco, 1964*, p. 38; *Protesting Khrushchev's visit, New York, 1958*, p. 39; *Behind the scenes. Fashion show, Abyssinian Baptist Church, Harlem*, p. 42; *Fashion show. Model awaiting her cue*, p. 43; *Ladies' room, the old Metropolitan Opera Housein New York*, p. 44; *Mrs. George Washington Cavanaugh, a descendant of George Washington, at the opera, New York*, p. 45; *Mrs. Elsie Truesdell plays with children of the nursery school on the grounds of the old-age home where she lives, Stony Brook, New York*, p. 46; *Miss Kate Davis, postmistress, paring apples for church-supper pies. Miller Place, Long Island*, p. 47; *Italian immigrant women beside their husband and father--a veteran of World War I--in Hoboken, New Jersey*, p. 48; *The wake. Hoboken*, p. 50; *Mama Colaurde prepares pasta. Hoboken*, p. 51; *Dorothy Maynard at the Community Center in Harlem*, p. 52; *James Cagney and his wife singing risqué Yiddish ditties*, p. 53; *Marlene Dietrich recording the songs she sang to the soldeirs during the Second World War*, p. 54, 55; *Gordon Parks photographing Bendetta Barzini for <u>Vogue</u> magazine, New York*, p. 56; *Pregnant Zulu women at Charles Johnson Memorial Hospital in Nqutu, Kwa Zulu, South Africa, 1973*, p. 58; *Waiting to be weighed, 1973*, p. 60; *Nurse checks baby, 1973*, p. 61; *Mrs. Maphumulo and her son Nthokozisi in an isolation ward at the Charles Johnson Memorial Hospital, 1973*, p. 62; *Nthokozisi (his name means "Bring Us Happiness") 1973*, p. 63; *An eight-year-old boy, the victim of kwashiorkor, a disease caused by hunger and malnutrition, 1973*, p. 64; *Two kwashiorkor victims in an isolation ward, 1973*, p. 65; *Joan Crawford, 1959*, p. 66-73; *Veiled woman and child. Muscat, Oman*, c.

1970, p. 74; *Three veiled wives inside the walls of their harem, Dubai,* c. 1970, p. 75; *A woman in a market. Kandahar, Afghanistan,* c. 1970 p. 76; *Two women shopping. Kabul, Afghanistan,* c. 1970, p. 77; *A man and one of his four wives, Jalabad, Afghanistan,* c. 1970, p. 78; *Three wives of one man on their way to the cemetery to see their husband's grave,* c. 1970, p. 79; *A nomad wedding in the Hindu Kush,* c. 1970, p. 80, 81; *A veiled woman. Mazar-i-Sharif, Afghanistan,* c. 1970, p. 82; *A veiled woman. Dubai,* c. 1970, p. 83; *Nomad tribeswomen find thier face veils hamper their movements,* c. 1970, p. 84; *A woman outside her hut in a purdah compound. Muscat, Oman,* c. 1970, p. 85; *A woman signing a bank slip with her thumb print in the purdah section of a modern bank in Dubai,* c. 1970, p. 86; *A teacher in a literacy class for adults in Abu Dhabi,* c. 1970, p. 87; *Marilyn Monroe,* 1955, p. 88-95; *Marilyn Monroe,* 1960, p. 97, 99; *A London secretary in an apartment she shares with three other girls,* p. 103; *Saturday night bath. South Ormsby, Lincolnshire,* p. 104; *Mrs. Toni Liffers, a midwife, teaching natural childbirth a Charing Cross Hospital, London,* p. 106; *Louise Russell with her two children,* p. 107; *Sunday serevices (Church of England). South Ormsby, Lincolnshire,* p. 108; *Salvation Army,* p. 109; *Widow Dora Grubb at the Royal Academy, London,* p. 110; *Mrs. Grubb with her bookkeeper,* p. 111; *Waiting to see the Queen, who is on a tour of the Northwest to look at a scheme called Operation Spring Clean. Manchester,* p. 112; *Elizabeth Taylor with two of her children,* p. 114; *An old-age home in the Cotswold,* p. 115; *Fencing mistress at girls' public school. Wycombe Abbey, High Wycombe, Buckinghshire,* p. 116; *Whipping as part of a lesbian wedding ceremony. Clapham Common, London,* p. 118, 119; *Mathematics teacher Mrs. Veronica Briggs at Wycombe Abbey,* p. 120; *Cello practice,* p. 121; *Contralto Delia Woolford at her audition. Morley College, London,* p. 122; *W.R.A.C. -- Women's Royal Army Corps,* p. 124; *Reducing salon. Forrest Mere, Hampshire,* p. 125; *Members of the Royal Toxophilite Society founded in 1781,* p. 126; *Prue and Mabel Mitchell, spinster sisters, in their garden in Chagford, Devon,* p. 128; *Mrs. Butler,* p. 129; *Mary Flaherty and her father-in-law in her cottage in Inishmaan, Aran Islands,* p. 130; *Woman's Royal Army Corps training,* p. 132; *Salvation Army. Manchester,* p. 133; *Vanessa Redgrave ... dressing for her part as Anne Boleyn in the film A Man for All Seasons,* p. 134; *Lacrosse players at Wycombe Abbey,* p. 135; *Beginning of final vows before the altar after a five-year novitiate. Ladywell Convent, Godalming, Surrey,* p. 136; *Dressed as brides for their espousal to Christ,* p. 138; *The "clothing ceremony,"* p. 139; *A wedding cake for the Brides of Christ,* p. 140; *The novice's hair is cut short so she will be more comfortable in her coif,* p. 141; *The community meets for study and meditation,* p. 142; *Final vows after five years,* p. 144; *Sweeping up at the castle of the Medina-Celi, Madrid,* p. 147; *Weighing in at the Pilatos olive factory in Madrid,* p. 148; *A Spanish Gypsy and her son,* p. 149; *Contessa Casilda Ussia Figueros at a boar hunt in the Sierra Morena, Andalusia,* p. 150; *The nun has come to bless the hunt at dawn and collect alms from the hunters and beaters alike,* p. 151; *Cuban family in Bahia Honda, a key in the Gulf of Mexico,* p. 152; *Bar girl in a Cuban brothel,* p. 154; *Two women (one black, one white) and their children wait to use the toilets,* p. 156; *Friends come to gossip while the laundry*

is done for the whites on the mainland, p. 157; *The voodoo ceremony is a baptism of fire*, p. 158; *Inmate in an insane asylum, Haiti*, p. 159; *Bahía Honda, Cuba*, p. 160; *Juana Chambrot. Bahía Honda, Cuba*, p. 162; *Two children in a Puerto Rican ghetto*, p. 163; *A new baby swaddled in the traditional Russian fashion, called* kosinka, p. 167; *A nursery school in a village in the Kuban, where working mothers leave their children*, p. 168; *Children in a nursery school in Kuban*, p. 170; *A high school in a village in the Kuban*, p. 171; *A circus training school in Moscow*, p. 172; *Physical checkup at a high school in Krasnodar*, p. 173; *Ilya Ilych Tolstoy, eldest surviving grandson of Count Leo Tolstoy*, p. 174; *Tanya Vladimirovna Gladnicha takes dictation from her boss in the main office of the Ministry of Agriculture, Moscow*, p. 176; *Vyacheslav Zaitsev "the Russian Dior," rehearsing his models in the House of Fashion in Moscow*, p. 178; *Betrothal in the Caucasus*, p. 179; *A newly married couple before the Eternal Flame at the Tomb of the Unknown Soldier in Kiev*, p. 180; *Divorce in Moscow*, p. 182; *Sylvana, a patient in a mental hosptial in Moscow, with Professor M. Vartanian*, p. 184; *Chess supervised by a prison warden in the library of a juvenile delinquency colony outside Moscow*, p. 186; *Waiting for a streetcar in Moscow*, p. 188; *A pilgrim at the entrance to the monastery at Zagorsk*, p. 189; *Pilgrims pray at the monastery at Zagorsk*, p. 190; *After service at a church in Moscow*, p. 192; *Cleaning up Lenin's statue for the fiftieth anniversary of theRevolution, in a village in Kuban*, p. 193; *Mother and child in a Muslim area of the U.S.S.R.*, p. 194; *Matrons and lovers on the Black Sea at Sochi*, p. 195; *The changing of the guard at the Tomb of the Unknown Soldier in Kiev*, p. 196; *Sitting guard over the Matisse section of the Hermitage, Leningrad*, p. 198.

86. Baro, Gene. "China Faces: Photographs by Eve Arnold," *Camera Arts* 1, 1 (January/February 1981): 88-97.

87. Fraser, John. *Private View: Behind the Scenes with Baryshnikov's American Ballet Theatre*. Photographs by Eve Arnold. New York: Bantam, 1988. 259 p.
 A collaboration of text and photographs to produce a behind-the-scenes document on one of America's most important dance companies and its artistic director.
Mikhail Baryshnikov; Charles France; Susan Jaffe; Leslie Brown; Olga Evreinoff; Martine van Hamel; Lucette Katerndahl and John Renvall; Susan Jaffe, Leslie Browne, Alessandra Ferri; Ballet studets waiting for rehearsal; Baryshnikov and Kathleen Moore rehearsing; Charles Dillingham; Cheryl Yeager John Taras, Amanda McKerrow; Florence Pettan, introductory photographs; *Mikhail Baryshnikov*, p. 1, 10, 46, 47, 52, 53, 71, 73, 75, 210, 245; *A dancer waiting to rehearse*, p. 12; *Class with canine friend*, p. 18; *Dana Stackpole and Rocker Verastique*, p. 19; *Isabela Padovani*, p. 20; *Carla Stallings*, p. 21; *Bonnie Moore and Melissa Allen*, p. 22; *Shawn Black and John Gardner*, p. 23; *Mikhail Baryshnikov and Tim-the-dog at class in Washington, D. C.*, p. 38; *Sir Kenneth MacMillan*, p. 60; *Susan Jones working with Kathleen Moore*, p. 66; *Bonnie Moore*

and Jurgen Schneider, p. 67; *Johan Renvall at ABT's home, 890 Broadway*, p. 68; *Martha Johnson*, p. 69; *Audition aspirants*, p. 70; *Artistic staff members: Mikhail Baryshnikov, Charles France, Susan Jones, David Richardson, Florence Patten*, p. 72; *Ashley Tuttle, one of those chosen for the company*, p. 74; *Lora Smith*, p. 76; *Georgina Parkinson, Wendy Walker, John Taras, Mikhail Baryshnikov, Charles France*, p. 77; *Georgiana Parkinson*, p. 78; *The artistic staff discussing the audition*, p. 79; *Peter Marshall*, p. 87; *Baryshnikov and Peter Marshall*, p. 88; *Susan Jaffe being massaged by Raymond Serrano*, p. 89; *Susan Jaffe*, p. 90, 120, 196, 217; *Patrick Bissell*, p. 91, 175; *Pointe shoes*, p. 102, 206; *Lauren Perry*, p. 112; *Deanne Albert, Cynthia Balfour, Cynthia Anderson, Cheryl Yeager, Alessandra Ferri*, p. 121; *Christine Dunham*, p. 122; *Susan Jaffe and Leslie Browne*, p. 123, 131; *Martine van Hamel with Clark Tippet's dog*, p. 124; *Amanda McKerrow*, p. 125; *Lynn Stanford playing for class*, p. 126; *Susan Jaffe, Leslie Browne, Baryshnikov, Kathleen Moore*, p. 127; *Baryshnikov and Susan Jaffe*, p. 128; *Bonnie Moore and Baryshnikov*, p. 129; *Leslie Browne and Baryshnikov*, p. 130; *Charles France*, p. 142; *France with Cheryl Yeager's pointe shoes*, p. 152; *France, Julio Bocca, Alessandra Ferri*, p. 153; *Baryshnikov and France looking at designs for Baryshnikov's Bodywear*, p. 154; *France and Baryshnikov reviewing a script*, p. 155; *Victor Barbee and Baryshnikov*, p. 164; *Julio Bocca*, p. 174; *Baryshnikov working with Julio Bocca on* Don Quixote, p. 176; *Mark Morris, Tina Fehlandt, Wendy Walker*, p. 177; *Robert Wallace, Baryshnikov, Mark Morris*, p. 178; *Mark Morris*, p. 179; *Isabella Padovani, Jeremy Collins, Roger van Fleteren*, p. 180; *Terry Orr and Wendy Walker*, p. 181; *Agnes deMille at a rehearsal of her new ballet,* The Informer, p. 182; *Martha Johnson and Agnes de Mille*, p. 183; *Clark Tippet*, p. 191; *Agnes de Mille, Baryshnikov, Jerome Robbins, and Paul Taylor*, p. 192; *Robert Wallace, John Gardner, Kevin McKenzie, and Clark Tippet in a workshop performance*, p. 193; *Baryshnikov and Helga de Mesnil*, p. 200; *Baryshnikov working the press*, p. 201; *Charles France and Susan Jaffe*, p. 202; *Julie Kent and friend*, p. 203; *Christine Dunham, Baryshnikov, Leslie Browne*, p. 211; *Leopold Allen with Baryshnikov in the makeup mirror*, p. 212; *Christopher Davis*, p. 213; *Julie Kent*, p. 214; *Leslie Browne*, p. 215; *Lisa Rinehart*, p. 216; *Christine Dunham and Amy Groos*, p. 218; *Kathleen Moore and Lisa Rinehart*, p. 219; *Barbara Matera at work on a costume for the upcoming production of* Gaîté Parisienne, p. 220; *Cherly Yeager*, p. 221, 222; *Christine Dunham sewing pointe shoes*, p. 223; *Baryshnikov with his daughter, Aleksandra*, p. 228; *Baryshnikov receiving an Indian ceremonial headdress*, p. 238; *Baryshnikov at an event in his honor*, p. 239; *Lisa Rinehart and Baryshnikov*, p. 240; *John Fraser, Olga Evreinoff, Lisa Rinehart, and Baryshnikov at his country home*, p. 241; *Baryshnikov with Tim-the-dog*, p. 242, 246; *Johan Renvall*, p. 254.

88. Harris, Mark Edward. "All About Eve," *Camera & Darkroom Photography* 16, 7 (July 1994): 24-31. Interview.

89. Williams, Val. "Eve Arnold - Val Williams on the Problems of Photographing Celebrities," *New Statesman Society* (May 17, 1996): 32+

Aschenbach, June
 See also #1006

Astman, Barbara
 See also #1007, 1070

Auerbach, Ellen 1906-
 See also #1007, 1058

90. Auerbach, Ellen. "Get 'Em Young," *Minicam Photograph* 5, 5 (January 1942): 70-73.

Augeri, Lynne
 See also #1011

Austen, Alice, 1866-1952
 See also #1022, 1058, 1061, 1062

91. Austen, Alice. *Papers and Photographs*. Staten Island Historical Society. Staten Island, NY.

92. *Holiday* editors. "Alice Austen's America," *Holiday* 12 (September 1952): 69-71.

93. Humphreys, Hugh and Benedict, Regina. "The Friends of Alice Austen: with a Portfolio of Historic Photographs," *Infinity* (July 1967): 4-31.

94. "The Newly Discovered World of Alice Austen," *Life*, 21 (September 29, 1951): 137-144.

95. Novotny, Ann. *Alice's World: The Life and Photography of an American Original: Alice Austen, 1866-1952*. Preface by Oliver Jensen. Old Greenwich, CT: The Chatham Press, 1976. 222 p.
 This lengthy biography not only traces the life of Austen, but also describes the world that surrounded her. Novotny writes of the personal growth and triumphs, the setbacks in Austen's later years, and the place Austen's images have in the history of American photography. The photographs, mirrors into a lost time in American history, are enhanced by descriptive comments, putting them in their proper settings, with Austen's technical comments about time, and lenses, etc.
'Clear Comfort' in the 1880s, p. 14; *Dr. Peter Townsend Austen* p. 20; *Eighteen-year-old Alice, holding the pneumatic cable to release her camera's shutter* p.20; *Oswald Müller* p. 21; *Mamma & Cat, 1887*, p. 21; *E.A.A., Full Length With Fan, 1892*, p. 22; *Auntie's Roof. Sofa and Tea Table, 1911*, p. 24; *The Lawn* p. 25; *Collection of Victorian bathroom humor* p. 25; *John Haggerty Austen, Alice's*

Grandfather p. 28; *The photographer's grandmother, Elizabeth Alice Townsend Austen, and her friend,* p. 28; *Copy of Grandpa Austen Portrait,* 1894, p. 33; *Cousin Emily, Cousin Emmie & 'Beauty',* 1888, p. 33; *Shared bedroom* p. 36; *Our Parlor,* 1897, p. 40; *Corner of bedroom,* p. 41; *Our Old Knocker,* 1890, p. 41; *Grandpa on Ladder,* 1891, p. 42; *'Clear Comfort' in Winter* p. 43; *'Clear Comfort' in Spring* p. 43; *Group in Bathing Costumes,* 1885, p. 47; *Bowling Club,* 1895, p. 48; *Group on Tennis Ground,* 1886, p. 49; *Group Apparatus,* 1893, p. 49; *Alice strums the banjo* p. 50; *Julia Martin, Julia Bredt and Self Dressed Up As Men,* 1891, p. 51; *Lewis Austen and Self, in Middle Room, Dressed For Charity Ball,* 1894, p. 52; *Myself in Spanish Costume,* 1886, p. 53; *Group Near Hammock,* 1888, p. 54; *The Darned Club,* 1891, p. 54; *Group on Petria, Trude, C. Barton and H. Wright,* 1888, p. 55; *Violet Ward and Gymnast Daisy Elliott,* p. 56; *The Ward's tennis court,* p. 56; *Miss Hoyt, Horses and Phaeton,* 1889, p. 57; *Wagonnette, V & C Ward and Miss Miller,* 1890, p. 58; *Party On Steps of Wagonnette,* 1891, p. 58; *Group in Parlor at V. Ward's,* 1889, p. 59; *Five-masted [sic] Schooner & Children On Beach,* 1890, p. 62; *A Cartful,* 1889, p. 63; *Roger Emmons and his Shetland pony,* p. 63; *Pears Soap,* 1889, p. 64; *Gertrude Tate,* p. 65; *View of Their Place From Lou Alexander's Piazza,* 1891, p. 66; *Rhine Castle on Grymes Hill,* p. 69; *New York Avenue--Election Banners and Catholic Church,* 1888, p. 69; *O'Connor's Blacksmith shop,* 1896, p. 70; *John Silva's shad-fishing station,* p. 70; *Wreck Off Mike Lyman's Caribbean Dock,* 1897, p. 71; *Midland Beach,* p. 76; *South Beach bathing party,* 1886, p. 77; *Bathers on South Beach watch a catamaran,* p. 77; *The Staten Island Cricket and Tennis Club,* c. 1885, p. 78; *The Finals, Boys in Foreground, Staten Island Ladies Club,* 1892, p. 80; *Tennis Grounds at Fort, Officers Playing,* 1888, p. 80; *S. I. L.C. Tournament,* 1892, p. 81; *Lunch Party Without Dog,* 1892, p. 82; *Group of Officers, Trude and Self at Fort,* 1888, p. 83; *Staten Island Bicycle Club Tea,* 1895, p. 82; *Paddle wheeler comes alongside cargo ship,* p. 84; *Crew members taken off the 'Cyrene,'* p. 85; *Quarantine. Disinfecting Boat. Dr. Doty & Alvah On Deck,* 1896, p. 85; *Quarantine. "Fred" At Work,* 1901, p. 86; *The steam disinfecting chambers,* p. 87; *Smiling immigrants, released from isolation,* p. 88; *Immigrants waiting for isolation to end,* p. 89; *South Ferry. Emigrants Seated Near Tree,* 1896, p. 90; *Part of Our Ferry Boat Deck,* 1890, p. 94; *Fifth Avenue Stage Auto,* p. 96; *A hansom cab and driver,* 1896, p. 96; *One of New York's first automotive taxi cabs,* p. 97; *Newsgirl,* p. 99; *Newsboy and newsgirl,* p. 98; *Hester Street. Egg Stand Group,* 1895, p. 99; *Three Bootblacks, South Side of New York Post Office,* 1896, p. 100; *Shoe Blacks and Stand, 4th Avenue,* 1894, p. 100; *Old man trying to make a living as an organ grinder,* p. 101; *On a street of Russian- and Polish-Jewish shops, a knife grinder,* p. 101; *Policeman & Street Sweeper, 6th Ave. & 46th St.,* 1896, p. 102; *Rag Pickers,* 1896, p. 103; *A Naval parade,* 1899, p. 104; *Swan Boat and Lake Bank, Central Park,* 1891, p. 105; *Self Starting For Chicago. Punch Also,* 1893, p. 106; *A flat tire,* 1910, p. 113; *Surrey with trunks,* p. 114; *A Packard touring car delivers guests,* p. 114; *Mr. Munroe & Nellie In Boat On Assabet River,* 1892, p. 115; *Public Buildings, Pennsylvania Depot & Omnibus,* 1893, p. 116; *An open trolley, Boston,* 1892, p. 117; *Gertrude Tate on horseback in Alps,* p. 118;

Canal Trip, Our Party in Stern of Wabun, 1892, p. 120; *Naval Cadets in Boats, Oars Up,* 1894, p. 121; *Mrs. Strong's House from Gate,* 1890, p. 122; *A week-long house party,* p. 124; *Mauch Chunk. Group at Big Split Rock,* 1893, p. 125; *Procession of Students & Alumni in Yard, Harvard, on Its Way to Lunch,* 1892, p. 126; *Annapolis. Darkies Opening Oysters,* 1894, p. 127; *Mrs. Harrison's Funeral at White House. Carriages In Circle,* 1892, p. 128; *The Minute Man statue, Concord, Massachusetts,* p. 129; *View Down Beacon St. from Top of Hotel Bellevue,* 1892, p. 130; *World's Columbian Exposition in Chicago,* p. 132; *Electric illuminations at the Pan-American Exposition in Buffalo,* 1901, p. 133; *Basque dancers and musicians,* 1909, p. 134; *Old windmill in Dordrecht,* c. 1909, p. 135; *One of Alice's cameras,* p. 136; *Alice's bedroom,* p. 140; *A European collapsible camera, tied to tree,* p. 140; *Getting water from a pump,* p. 141; *Our Place. View with Jimmy Jumping Box,* 1897, p. 142; *Cousin Emmie's Pony Trotting. Fishkill,* 1890, p. 142; *Violet Ward on her bicycle,* p. 143; *Car race on track in auto speed trials,* c. 1903, p. 144; *The Cocroft Children in the Trees,* 1886, p. 149; *Miss Sanford & Mrs. Snively,* 1890, p. 150; *Trude & I Masked, Short Skirts,* 1891, p. 151; *Nellie, Miss Butler & Children Laughing,* 1892, p. 152; *Trude's bedroom,* 1889, p. 153; *Two Little Darkies,* 1892, p. 154; *The Cornell boys and a new automobile*, p. 155; *Old Man & Wheelbarrow, St. Mary's Avenue,* 1890, p. 156; *Children on the road,* 1890, p. 157; *From Violet Ward's book on cycling for ladies,* p. 161; *Wisteria Taken from Window Upstairs,* 1914, p. 164; *The Lusitania,* p. 168; *Vaderland [sic] on right,* 1914, p. 169; *Leviathan, Old Faderland [sic], camouflaged,* 1918, p. 169; *Alice and Gertrude motored in their own Franklin,* 1910, p. 172; *Richmond County Country Club,* 1916, p. 173.

Baade, Lee
 See also #1071
Bachman, S. A.
 See also #1055
Bai, Debbie
 See also #1057
Baker, Maude Davis
 See also #1038

Baldwin, Maud, 1878-1926

96. Drew, Harry J. *Maud Baldwin: Photographer.* Klamath County Museum. Research Paper Number 10. Klamath Falls, OR: The Museum, 1980. 141 p. Chiefly illustrations.

Barney, Tina.
 See also #1008, 1017, 1063

97. Adams, Brooks. "The High Windows: Dorothea Rockburne's Skyscrapers (photographs by Tina Barney)," *Artforum* 31 (May 1993): 78-82.

98. Adams, Brooks. "Tina Barney," *Art in America* 76, 7 (1988): 139-140.

99. Ash, J. "Tina Barney," *Artforum* 32, 3 (November 1993):108.

100. Bolt, Thomas. "Tina Barney," *Arts Magazine* 59, (1985): 25.

101. Decter, J. "Tina Barney and Tina Howe," *Arts Magazine* 66, 2 (1991): 97.

102. Grundberg, Andy. "Tina Barney," *Art in America* 73 (October 1985): 158-159.

103. Hagen, Charles. "Tina Barney," *Artforum* 24 (September 1985): 125-126.

104. Lieberman, R. "Tina Barney," *Artforum* 30, 3 (1991): 136.

105. Loke, M. "Tina Barney," *Artnews* 92, 9 (November 1993): 160.

106. Rimanelli, David. "People Like Us," *Artforum* 31, 2 (October 1992): 70-73.

107. Rubinstein, Meyer Raphael. "Life-Styles of the Protestant Bourgeoisie, The Photographs of Tina Barney," *Arts Magazine* 62, 8 (1988): 50-52.

108. Squiers, Carol. "Tina Barney: An Insider Look at the Good Life," *American Photographer* 21, 6 (December 1988): 42-47.

Barron, Susan, 1947-

109. "Susan Barron," *Camera (*Switzerland) 52, 3 (March 1973): 26-33.

Bartlett, Mrs. (Mary) Gray, active from about 1888
 See also #1022, 1058

110. Humphrey, Marmaduke. "Triumphs in Amateur Photography--V, Mrs. Gray Bartlett," *Godey's Magazine* 136 (April, 1898): 368-378.

Barton, Nancy
 See also #1055

Bassman, Lillian
 See also #1007

111. Fishman, Walter Ian. "A Woman's Camera in a Woman's World," *Popular Photography* 28, 3 (April 1951): 37-41+.

112. Harrison, Martin. "Capturing the Intimate Gesture," *Graphis* 51 (July/August 1995): 30-39.

Baubion-Mackler, Jeannie
 See also #1070

Bauer, Peggy
 See also #1039
Baylis, Diane
 See also #1010

Beals, Jessie Tarbox, 1870-1942
 See also #1061, 1063

113. Alland, Alexander, Sr. *Jessie Tarbox Beals: First Woman News Photographer*. New York: Camera/Graphic Press, Ltd., 1978. 92 p. and portfolio of 95 plates
 The accompanying text includes a biographical essay which incorporates passages from Beals' diary, portraits of Beals at various stages of her life, press notices, advertisements and other memorabilia.
The Tamed Owl, p. 22; *Alfred Beals*, p. 23; *Evening View of the Hudson River*, p. 27; *On the Way to Florida*, p. 29; *Jessie at Work in Buffalo*, p. 32; *Jim Lopp, Octogenarian*, p. 34; *Michael Davis, Blind*, p. 34; *Sam Henderson, "Stone Blind," and His Little Boy*, p. 35; *Charles E. George, Blind Improvisator*, p. 35; *Scene in Court Room While Mrs. Hull, Burdick's Mother-in-Law, Was Giving Her Testimony, New York American Journal, March 15, 1903*, p. 37; *Ellis Island, 1903*, p. 38; *Sir Thomas Lipton, the Indefatigable*, p. 40; *Sir Thomas Lipton the Guest of His Canadian Fellow Britishers at the Queen's Royal Hotel, Niagara-on-the-Lake, Ontario*, p. 41; *Jessie's Photomontage Of the St. Louis World's Fair Photographs*, p. 42; *Pumpkin and Jessie*, p. 46; *Jessie At Work*, p. 47; *Alice Roosevelt, 1904*, p. 48; *Jessie in the Balloon*, p. 49; *David R. Francis with Mryon T. Herrick, Governor of Ohio*, p. 51; *Jessie Photographing William Jennings Bryan*, p. 54; *Jessie at Work in the Stanley Studio*, p. 57; *Jessie with Her Messenger Boys, 1906*, p. 59; *Off to Work*, p. 60; *Postal Card, Sheridan Square, New York*, p. 63; *Restaurant in Greenwich Village, New York*, p. 64; *Off Sheridan Square*, p. 66; *"You Don't Have to Have a Drawing Table To Be An Artist."* p. 67; *"Ever Meet Jessie Tarbox Beals?" The St. Louis Republic, Sunday, February 20, 1910*, p. 68; *Jessie in Her Early 40s*, p. 70; *Nanette, a Few Months Old*, p. 72; *Nanette, 15 Months Old*, p. 73; *Alfred and Jessie in the Darkroom*, p. 74; *The Village Art Gallery*, p. 75; *Tea Room and Village Art Gallery*, p. 76; *Dorothy Usner Baxter's Greenwich Village Rendezvous*, p. 77; *[Group of portraits by Jessie, New York Tribune, July 4, 1920]* p. 78; *[New York Tribune feature, July 4, 1920]* p. 81; *Dogwood in Bloom*, p. 85; *"...Swinging Down the Lane," Santa Barbara, 1929*, p. 88; *California Courtyard*, p. 89; *Jessie 62 Years Old*, p. 90; *Jessie in Her Mid-60s*, p. 91; *Jacksonville, Florida, 1901*, pl. 1; *Jacksonville, Florida, 1901*, pl. 2; *News*

Boys, Buffalo, New York, 1902, pl. 3; *Group of Politicians, Buffalo, New York,* 1903, pl. 4; *Patagonian Woman, Louisiana Purchase Exposition, St. Louis,* 1904, pl. 5; *Igorote Boys, St. Louis,* 1904, pl. 6; *American Indians, St. Louis,* 1904, pl. 7; *Filipinos, St. Louis,* 1904, pl. 8; *Navaho Indians, St. Louis,* 1904, pl. 9; *Moro Boys, St. Louis,* 1904, pl. 10; *Ainus of Japan, St. Louis,* 1904, pl. 11; *Philippine Negritos, St. Louis,* 1904, pl. 12; *View of Fair Grounds From a Balloon, St. Louis,* 1904, pl. 13; *View From a Twenty Foot Ladder, Auto Parade, St. Louis,* 1904, pl. 14; *Daniel Chester French,* 1905, pl. 15; *Childe Hassam,* 1905, pl. 16; *Norman Bel Geddes,* 1905, pl. 17; *Jonas Lie,* 1905, pl. 18; *Fifth Avenue At Madison Square Park, N.Y.C.,* 1905, pl. 19, 20, 21; *Fifth Avenue From 25th Street, N.Y.C.,* 1906, pl. 22; *Old Brevoort, Fifth Avenue, N.Y.C.,* 1906, pl. 23; *In Madison Square Park,* 1906, pl. 24; *Patachin Place, Greenwich Village, N.Y.C.,* 1916, pl. 25; *The Library of Columbia University, N.Y.C.,* 1916, pl. 26; *Mark Twain,* 1906, pl. 27; *William H. Taft,* 1913, pl. 28; *Irving Wiles,* pl. 29; *Vincente Blasco Ibanez,* pl. 30; *César Thomson,* pl. 31; *Bill Raull As Abe Lincoln,* pl. 32; *Sadakichi Hartmann,* 1919, pl. 33; *Paul Troubetzkoy,* 1912, pl. 34; *John Burroughs,* 1908, pl. 35; *Jessie Tarbox Beals With John Burroughs,* 1908, pl. 36; *Children of the New York City Slums,* 1910, pl. 37, 38; *Room In a Tenement Flat, N.Y.C.,* 1910, pl. 39; *Family Making Artificial Flowers, New York City Slums,* 1910, pl. 40; *Cigar Store Statuary,* 1910, pl. 41, 42; *Charles Lewis Tiffany,* pl. 43; *Rose O'Neill, Originator of the Kewpie Doll, With Her Sister,* pl. 44; *"Clam Chowder," Buffalo,* 1903, pl. 45; *[Cat]* c. 1908, pl. 46, 47; *William Jennings Bryan,* 1904, pl. 48; *Calvin Coolidge,* 1924, pl. 49; *William Howard Taft,* 1913, pl. 50; *Herbert Hoover,* 1928, pl. 51; *Presidential Inauguration Of William Howard Taft,* 1909, pl. 52, 53; *Chicago,* 1935, pl. 54; *Key West, Florida,* 1940, pl. 55; *Santa Barbara Mission,* 1929, pl. 56; *Interior, Chicago,* 1936, pl. 57, 59; *[Exterior of house]* c. 1936, pl. 58; *Men's Powder Room, Chicago,* 1936, pl. 60; *Profile,* 1924, pl. 61; *Secretary of the Treasury, William H. Woodin,* 1933, pl. 62; *Lawn Party,* pl. 63; *Studio Party,* pl. 64; *Buffalo,* pl. 65; *Grove Park, Boston,* pl. 66; *Chicago,* pl. 67, 72; *Little House O'Dreams,* pl. 68; *Country Walk,* pl. 69; *New England,* pl. 70; *Boston,* pl. 71; *Peaceful Afternoon,* pl. 73; *Retreat,* pl. 74; *Rendezvous,* pl. 75; *Moonlight in the Garden,* pl. 76; *Nan and I Went Driving,* pl. 77; *Lazy Days,* pl. 78; *New England Cobbler,* pl. 79; *Old Uncle Billy,* pl. 80; *Country Girl,* 1907, pl. 81; *Fishin',* pl. 82; *Monterey Cypress, Carmel-By-The-Sea, California,* 1930, pl. 83; *San Diego California Pines,* 1930, pl. 84; *Nanette In the Hospital, July 1917,* pl. 85; *Printemps,* pl. 86; *On the Maine Coast,* 1907, pl. 87; *Boston Common,* pl. 88; *The Old "Hant" House,* 1914, pl. 89; *Country Kids,* 1927, pl. 90; *California,* 1929, pl. 91; *Hollywood, California,* 1930, pl. 92; *Magnolia Garden, Charleston, S. Carolina,* pl. 93; *Woodland Garden, California,* 1930, pl. 94; *[Garden]* c. 1938, pl. 95.

114. Alland, Alexander. "Cameras & Corsets: Jessie Tarbox Beals, the First Lady Photojournalist," *Modern Photography* 26, 9 (September 1962): 68-69+.

115. Alland, Alexander, Sr. "Jessie Tarbox Beals: Pioneering Woman Press

Photographer," *American Photographer* 1, 3 (August 1978): 52-59.

116. Beals, Jessie Tarbox. *Photographs, 1896-1941.* Schlesinger Library. Radcliffe College.

117. Moenster, Kathleen. "Jessie Beals: Official Photographer of the 1904 World's Fair," *Gateway Heritage* 3, 2 (1982): 22-29.

Beckman, Judith A.
 See also #1071

Ben-Yusuf, Zaida, active c. 1895-
 See also #1009, 1058

118. Hartmann, Sadakichi. "A Purist," *The Photographic Times* 31 (October 1899): 449-455.

119. Murray, William. "Miss Zaida Ben-Yusuf's Exhibition," *Camera Notes* 2 (April, 1899): 171.

Benedict-Jones, Linda
 See also #1006, 1008
Berg, Gretchen
 See also #1072
Berg, Niki
 See also #1071
Berger, Eileen
 See also #1006, 1070, 1072
Bergstedt, Marie
 See also #1071

Bernhard, Ruth, 1905-
 See also #1007, 1054, 1058, 1061

120. "American Aces: Ruth Bernhard," *U.S. Camera* 1, 4 (June 1939): 52-55.

121. Bernhard, Ruth. "Beachcomber's Art," *Popular Photography* 15, 5 (November 1944): 49-50+.

122. Bernhard, Ruth. *The Big Heart.* Text by Melvin Van. New York: Fearon Publishers, 1957.
 Photographic documentation to accompany an essay on the life of a San Francisco cable car gripman.

123. Bernhard, Ruth. "Portfolio: Ten Reproductions," *Aperture* 7 (1959): 109-121.

124. Bernhard, Ruth. *Ruth Bernhard*. Milpitas, CA: R. L.Burrill Associates, 1988. Video recording, 56 minutes. Cinematography, Robert Burrill.

125. Bernhard, Ruth. "She Sells Sea Shells," *Popular Photography* 11, 1 (July 1942): 34-35+.

126. Lufkin, Liz. "Ruth Bernhard: After Half a Century of Exuberant Devotion to Her Craft, an Extraordinary Octogenarian Finally Gets Her Due," *American Photographer* 20, 4 (April 1988): 60-66.

127. *Ruth Bernhard*. [Cincinnati, OH]: Lightborne Communications, 1983. Video recording, 30 minutes. Interview by Margaretta Mitchell.

128. Weinberg, Herman. "Out of This World," *Minicam Photography* 8, 6 (March 1945): 43-49+.

Bernard, Cindy
 See also #1071
Bernstein, Andrea J.
 See also #1072
Bernstein, Nita
 See also #1072

Beveridge, Edyth Carter, 1862-1927

129. Moore, Stacy Gibbons. "The Photographer as Documentary Artist: The Work of Edyth Carter Beveridge," *Virginia Cavalcade* 41, 1 (1991): 34-47.

Bing, Ilse, 1899-
 See also #1007, 1058, 1063, 1074

130. Stagg, Mildred. "Ilse Bing: 35mm Specialist," *U.S. Camera* 12, 8 (August 1949): 50-51.

Bloomfield, Lisa
 See also #1071

Blondeau, Barbara, 1938-1974
 See also #1058

131. *Barbara Blondeau, 1938-1974*, edited by David Lebe, Joan S. Redmond

and Ron Walker. Rochester, NY: Visual Studies Workshop, 1976. 30 p.

132. Hagan, Charles. "Barbara Blondeau," *Afterimage* 3, 9 (March 1976): 10-13.

Blue, Patt
See also #1070
Blum, Arlene
See also #1039
Boffin, Tessa
See also #1062
Boice, Judith
See also #1039
Bomar, Johnnie Mae
See also #1040
Bondy, Friedl
See also #1006

Bonney, Mabel Thérèse , 1894-1978
See also #1058

133. Blanch, Lesley. "History in the Taking: Therese Bonney...War Photographer," *Vogue*, 1 July 1943, 52-53+

134. Bonney, Mabel Thérèse. *Europe's Children, 1939 to 1943*. New York: Duell, Sloan & Pearce, 1943. 62 p.Chiefly illustrations.
A photographic record of the plight of children in Europe during the years of World War II.

135. Bonney, Mabel Thérèse. *French Cooking for English Kitchens.* London: Allen & Unwin, 1929. 269 p.

136. Bonney, Mabel Thérèse, "Fruits of War," *Collier's Magazine*, 22 August 1942, 44-45+.

137. Bonney, Mabel Thérèse. "How France Eats," *Collier's Magazine*, 23 May 1942, 16-18.

138. Bonney, Mabel Thérèse. "How France Lives," *Collier's Magazine,* 25 June 1942, 54-55.

139. Bonney, Mabel Thérèse. "I Cover Two Wars," *Popular Photography* 8, 3 (March 1941): 22-23+.

140. Bonney, Mabel Thérèse. "Men in Bondage: The Story of Two Million

Frenchmen," *New York Times,* 17 August 1944, VII, 14.

141. Bonney, Mabel Thérèse. "Our Only Hope," *Collier's Magazine,* 6 December 1941, 22-24+.

142. Bonney, Mabel Thérèse. *Remember When--a pictorial chronicle of the turn of the century and the days known Edwardian....* New York: Coward McCann, 1933. 127 p.

143. Bonney, Mabel Thérèse. "Roses From France," *Collier's Magazine,* 27 June 1942, 20-21.

144. Bonney, Mabel Thérèse. *Thérèse Bonney Papers.* The Bancroft Library, University of California, Berkeley.

145. Bonney, Mabel Thérèse. *The Vatican, text and photographs.* Introduction by the Reverend John La Farge. Boston: Houghton Mifflin, 1939. 131 p.

146. Bonney, Mabel Thérèse. *War Comes to the People.* London: Pendock Press, 1944. 103 p.
 Includes a portrait of Bonney, and photographs which record the "texture of life" as the war in Europe erupted.
On a Sunday near Brussels, p. 8; *Grown-ups talk neutrality*, p. 9; *In France soldiers work in the fields*, p. 10; *Children watch while men dig trenches*, p. 11; *War seems so far away*, p. 12; *Communications cut*, p. 14; *[Evacuation]*, p. 15; *[Leaving the family dog]*, p. 16; *They gather before the churches*, p. 17; *Huddle before the stations*, p. 18; *So few find room on trains*, p. 19; *Most of them have walk*, p. 20; *Hordes of refugees on the road*, p. 21; *They abandon prams and wheelbarrows*, p. 22; *[Taking his clock]*, p. 23; *[Taking his dogs]*, p. 24; *[Taking her doll]*, p. 25; *In their Sunday best for travel*, p. 26; *Through three wars, 1870-1914-1940*, p. 27; *Tiny tots*, p. 28; *The very old*, p. 29; *[Sleeping on the sidewalk]*, p. 30; *[Bewildered woman]*, p. 31; *They take refuge in barns*, p. 32; *Sleep under farm carts*, p. 33; *[Sleeping near a tree]*, p. 34; *[Personal messages on wall]*, p. 35; *[Old woman and children on steps]*, p. 36; *[Nun helping child]*, p. 37; *There is so little one can do*, p. 38; *As the bombs fall*, p. 39; *Danger everywhere*, p. 40; *Only once in a while someone breaks down*, p. 41; *And the old give the example*, p. 42; *[Tired child]*, p. 43; *[Carrying a sleeping child]*, p. 44; *[Interior of bombed home]*, p. 46-53; *And even the dead may not rest in peace*, p. 54; *[Looking over maps]*, p. 56; *Sailors and soldiers from France*, p. 57; *Ferry pilots from the U.S.A.*, p. 58; *[Soldiers reading the newspaper]*, p. 59; *[Memorial plaque]*, p. 60; *[Old couple holding a cat]*, p. 61; *Children have gas-mask drill*, p. 62; *School in shelters*, p. 63; *Blitzed out*, p. 64; *They sleep in the Underground*, p. 65; *The young learn incredible things*, p. 66; *[Old woman on an assembly line]*, p. 67; *Men and women work side by side building aircraft*, p. 68; *[Men and women at Bomber Command]*, p. 69; *Boys do men's work*, p. 70; *Miners return to the pits*, p. 71;

[Home guard searching sky], p. 72; *[Wardens in shelter]*, p. 73; *[Blacksmith]*, p. 74; *In the shadow of the flag of the conquerer*, p. 76; *Millions are prisoners in their own land*, p. 77; *[Stern family around table]*, p. 78; *Three generations*, p. 79; *[Old woman looking out window]*, p. 80; *[Mother and child]*, p. 81; *Children mourn their fathers*, p. 82; *[Children in line for food]*, p. 83; *All is rationed*, p. 84; *Shelves are empty*, p. 85; *No more bread*, p. 86; *Shoeless thousands trek mile for food*, p. 87; *Milliions starve*, p. 88; *The coming generation is in peril*, p. 89; *In concentration campsmen dream of tomorrow*, p. 90; *Children look anxiously out into the future*, p. 91; *[Old woman with hand on cheek]*, p. 92; *The young face all with courage*, p. 93; *[Girl with milk pails]*, p. 94; *[Old woman milking a cow]*, p. 95; *[Man with torn socks]*, p. 96; *[Two men]*, p. 97; *A voice from across the channel*, p. 98; *[Young boy at bakery]*, p. 99; *[Old man and woman]*, p. 100-101.

147. Bonney, Therese. *French Cooking for American Kitchens*. New York: R. M. McBride, 1929. 295 p.

148. Bonney, Therese. *A Shopping Guide to Paris*. New York: R. M. McBride & Co., 1929. 281 p.

149. Downes, , Bruce. "Europe's Children--Therese Bonney Photographs Nazi Victims, and Makes a Dramatic Book of Photographs," *Popular Photography* 13, 6 (December 1943): 38-50.

150. "Hostages of War," *New York Times Magazine*, 29 September 1943, 20-21.

Bordnick, Barbara

151. "Portfolio: Barbara Bordnick," *American Photographer* 1, 2 (September 1978): 56-65.

152. Williams, R. "The Invisible Technology: Barbara Bordnick," *Graphis* 51, 298 (July-August 1995): 84-89.

153. Bordnick, Barbara. "Breezy," *Lear's* 3, 2 (April 1990): 98-105.

154. Bordnick, Barbara. "New York Nights," *Lear's* 3 (March 1990): 112-121.

Bostrom, Paula
See also #1057

Boughton, Alice, 1866-1943
See also #1000, 1022, 1058

155. Boughton, Alice. "Photography, a Medium of Expression," *Camera Work*

26 (April 1909): 33-36.

156. Wilcox, Beatrice C. "Alice Boughton--Photographer," *Wilson's Photographic Magazine* 51, 4 (April 1914): 151-169.

Bourke-White, Margaret, 1904-1971
 See also #1000, 1008, 1009, 1026, 1028, 1037, 1058, 1061, 1063

157. "American Aces: Margaret Bourke-White," *U. S. Camera* 1, 9 (May 1940): 43-48.

158. Arlen, Michael J. "Green Days and Photojournalism, and the Old Man in the Room," *Atlantic*, August 1972, 59.

159. "Aviators of 38 Nations Do Their Jumping in U.S. Parachutes," *Life,* 22 March 1937, 17-18+.

160. Blanch, Lesley. "History in the Taking: Margaret Bourke-White...War Photographer," *Vogue*, 1 July 1943, 50-51+.

161. Bourke-White, Margaret. *"Dear Fatherland, Rest Quietly": A Report on the Collapse of Hitler's "Thousand Years."* New York: Simon and Schuster, 1946. 175 p.
 From the Foreword: "This book is a description of Germany as I saw it in defeat and collapse. Perhaps because I am primarily a photographer, I have tried to give a candid picture rather than to suggest solutions to the problems I found there."
Section I:
A Mighty Fortress is Our God, Pastor Goebbels and His Wife; Dr. Heinrich Tully; Herr H. W. Lumme; A "Foreign Director" of a chemical concern who arranged for foreign slave labor; Prelate Dr. Jacob Herr, dean of the Catholic Priests in Frankfurt; Herr Ernst Tengelmann, the biggest coal baron in the Ruhr; A little Nazi who looked the part; Herr Walter Rohland...Czar of the German steel industry; A middle-shot Nazi--also frightened; Bernard Scholz, doctor who refused to stop treating Jews; Communist Detleff, union leader in Hamburg; Four middle-of-the-road anti-Nazis; Professor Koch; Niemöller's sister; Ingeborg Walther, was an upper-class Nazi German soldier; Patton; Eisenhower at a press conference in Berlin; A German butcher and his wife.
Section II:
This boy is dying in the Buchenwald murder factory; All that remained of a man trapped in the Leipzig slave camp when the Nazis set it afire; Some men lived through Buchenwald and retained human characteristics; Skillful Germans designed and installed Buchenwald's ghastly crematory furnaces; Each furnace could turn three bodies to ashes every fifteen minutes; Raw material; The German's cried: "We didn't know!" ; Fräulein, you who cannot bear to look;

*Prisoners who escaped at Leipzig return to find friends; He, too found his friend;
Buchenwald interior: trembling with death; Gangrenous and starved; Hausfraus
at Leipzig-Mochau;*
Section III:
*Bombs could not distinguish good people from bad; Housewives getting water near
Cologne; A district leader of the Hitler Maidens in jail; "I am not responsible! It
was others!" ; Four of the forty prostitutes the Nazis left behind in Frankfurt jail;
The Kaiser's fourth son, Prince August Wilhelm; Suicide of the Leipzig city
treasurer; There were many prison pens like this one near Munich; Two
generations of grief at the grave of a suicide; The wreath is to honor German
soldiers of World War I; German civilians looting a train; Healthy German girls
and with soldiers;*
Plündern verboten;
Section IV:
*Give me five years and you will not recognize Germany again ; Cologne in ruins;
The Hohenzollern Bridge in Cologne; Bombed freight yards at Nüremberg; Not
enough was left of Hamburg to make an impressive ruin; Industrial cadaver at
Leuna; A road through the wilderness at Hamburg; At Ludwigshaven the ruin
spread as far as the eye could reach; Bremen was a desert;*
*Nüremberg; Würzburg; Detail of any German city; Shopping center of Cologne;
The Cologne Cathedral; Celebrating Mass for GIS in Cologne Cathedral ; A Nazi
banker appraises the collateral in Cologne;*
Section V:
*[German child looking through bars]; Mr. and Mrs Hugo Stinnes and their two
children; [A little boy in Buchenwald]; [The children of Prince Christophe of
Hesse]; A groups of boys at Buchenwald; [Two little boys poisoned by their
mother]; There were little Czech girls too;*
*[Mother with children on wagon]; There was milk in the country only; The Lamb
will lead;*
*Someone must teach; First Communion at Höchst; [Young German girl]; [Young
German boy]; [German boys carrying briefcases on shovels];*
Section VI:
*Alfried Krupp; Two Essen steel workers; Herr Krupp; Field Marshall Montgomery,
has tea with four generals; Dancers from the Düsseldorf opera...in the Krupp
ballroom; Villa Hügel, the Krupp homestead; Street scene in Essen; The Ruhr
industrial plants; Steel plants; The Ruhr River; [Cleaning up the steel works];
[Fragments of apartments in Essen]; Field Marshal Montgomery;*
Section VII:
*Marshal Shukov wore his medals for the Victory Parade in Berlin; The
Brandenburg Gate, shorn of its glory; Brother and sister in Berlin; Berlin's
Anhalter Bahnhof; The open road is no good for a man with a crutch; Father and
son going to the country to hunt for food; A baby cart can carry a good load, needs
no gasoline; [People crowded on top of train]; The old man could not find a place;
German Red Cross girl giving money to a soldier; A concentration camp uniform
brought a man special privileges; The locomotive was the last chance to find a*

place on the train; They didn't know where they were going....

162. Bourke-White, Margaret. "Dust Changes America," *The Nation*, 22 (May 1935): 597.

163. Bourke-White, Margaret. *Eyes on Russia*. New York: Simon and Schuster, 1931. 135 p.
Bourke-White states in the "Author's Note" that this book records in words and photographs her experiences in the Soviet Union in 1930, photographing the new industry being built under their "Five Year Plan."
The World's Largest Dam, frontispiece; *The Russian Land*, p. 34; *A Workers' Club in Moscow*, p. 39; *A Soviet Official*, p. 44; After p. 52: *Watching Ore Threads for Breaks*; *Tending the Automatic Mule*; *Calender Rolls*; *Photographed with a Broken Ground Glass*; *The Women Who Wept for Joy*, p. 56; *A Soviet Artist, Semionova*, p. 67; *The Towers of St. Basil's*, p. 70; After p. 88: *The Bridge*; *A Generator Shell*; *The Dam*; *Assembling a Turbine*; *The Dam in Contruction*; *Crane and Crossbeams*; *Locomotive Cranes*; *A Girl Conductor on a Russian Train*, p. 89; After p. 97:*272,000 Acres*; *An American Disc-Harrow*; *A Storehouse*; *State Farm No. 2*; After p. 100:*A Peasant*; *In the Storehouse*; *At the Winches*; *In the Quarry*; *Loadin Crushed Rock*; *The Kiln Tender*; *Cement Blocks*, p. 104; *Cement Workers*, p. 105; *An Iron Puddler*; *Shaking Down Slag*; *Steel Worker*; *Pouring the Heat*; After p. 120: *A New Tractor*; *A Russian Worker*; *From the Baltic Fleet to the Tractor Plant*; *On the Assembly Line*; *A Foreman*, p. 125.

164. Bourke-White, Margaret. "Famous Lady's Indomitable Fight," *Life*, 22 June 1959, 102-109.

165. Bourke-White, Margaret. *Halfway to Freedom: In the Words and Pictures of Margaret Bourke-White*. Bombay: Asia Publishing House, 1950. 192 p.
This work was begun as a photographic assignment for *Life* magazine. Bourke-White states that she considered herself "fortunate to have witnessed and been able to document the historic early days of these two nations: India and Pakistan." (p. 15)
After page 32:
The Great Migration, formally known at 'Exchange of Populations'; Millions of refugees took to the roads; The strong survive: A Sikh family making their way to India; Seeking sanctuary and shelter in Sher Shah's mosque; The remains of a refugee encampment trapped by flood; Cholera hospital; The old and the weak fall by the way; At the graveside; A busy Calcutta corner; The chawls, where millions of Indians live; Hindu Temple in Srirangam; Kutb Minar, as Islamic monument in Delhi outside the boundaries of Pakistan; At the spinning wheel, Gandhi; Keeping abreast of the latest political developments, Gandhi; The aging mahatma walking with his grand-daughter Sita and his grand-niece Abbaha;
After page 96

Women may not pray with men, but are permitted to stand in the rear; Jinnah--facing east; Jinnah--facing west; Said Haron addressing a Young Muslim League meeting; Muslim scholar; The Shahi Mosque in Lahore is the biggest in India; The feminine impedimenta of Muslim orthodoxy do not apply to these wives of Muslim League leaders; Mir George Alimurad Khan Talpur, the boy ruler of Khaipur; Untouchable boy treading hides in a lime vat; Tannery union meeting of untouchables; Whole families work as a unit in the tannery pits; Many untouchables turn to Christianity; Untouchable women fall on their hands and knees before the village headman; The wages of untouchables are wrapped in a leaf and dropped from a safe distance into their hands; Untouchable's wedding; The Indian peasant;
After page 128:
At the well; Peasant boy; the daily bath is a religious injunction; This boy, in South India, walked twelve miles with this bundle of grass; Too weak to stand, this old man exists on a diet of green leaves; A Lifetime of work on the land, spent in grim poverty; Considerably younger than he looks; Not an ounce of grain remains; Gazing into the face of famine; The moneylender; The moneylender's house; H.H. The Prince of Berar; H.H. The Maharajah of Bikaner; Sita Ram, Shivite Brahmin priest; The Maharajah of Mysore; Princely India;
After page 160:
This Sikh is refreshing his body and soul in the scared waters; The Sikhs have a deserved reputation for military prowess; Shiekh Mohammed Abdullah, Prime Minister of Kashmir; Jawaharlal Nehru, Prime Minister of India; Vallabhbhai Patel, Deputy Prime Minister; Maulana Abul Kalam Azad, Minister of Education; Chakravarti Rajagopalachari, first Indian Governor-General of India; Raj Kumari Amrit Kaur, Minister of Health; Sarojini Naidu, Governor of the United Provinces; Ghanshyamdas Birla; Jayaprakash Narayan, head of the Socialist Party; Gandhi was on his way to a prayer meeting when the assassin's bullet struck him; At the gates of Birla House, the procession starts for the funeral pyre; The Mourners; The funeral pyre.

166. Bourke-White, Margaret. "How I Photographed Stalin and Hopkins Inside the Kremlin," *Life*, 8 September 1941, 26-29.

167. Bourke-White, Margaret. "Life's Bourke-White Goes Bombing: First Women to Accompany U.S. Air Force on Combat Mission Photographs Attack on Tunis," *Life*, 1 March 1943, 17-23.

168. Bourke-White, Margaret. "Moscow Fights Off Nazi Bombers and Prepares for a Long War," *Life*, 1 September 1941, 15-21.

169. Bourke-White, Margaret. *Papers, 1928-1964.* George Arents Research Library for Special Collections at Syracuse University, Manuscript Collections. Bird Library.

170. Bourke-White, Margaret. "A Photographer in Moscow," *Harper's Magazine,* March 1942, 414-420.

171. Bourke-White, Margaret, "Photographing This World," *The Nation,* February 1936, 217.

172. Bourke-White, Margaret. *Portrait of Myself.* New York: Simon and Schuster, 1963. 383 p.
 Autobiography of Bourke-White, with many of the photographs taken throughout her career, as well as portraits of her taken by others.

A preacher and his parishioners, Cleveland Public Square, 1928, p. 37; The Flats were a happy hunting ground for pattern pictures of industry such as this arched railway trestle framing the distant Terminal Tower, p. 39; Dynamos, Niagara Falls Power Company, p. 41; The Towering smokestacks of the Otis Steel Company, Cleveland, Ohio, p. 54, 55; Pouring the heat. Open hearth mill, Ford Motor Company, Detroit, p. 56; 200-ton ladle, Otis Steel Company, p. 57; Electric welder, Lincoln Electric Company, Cleveland, Ohio, p. 61; Plow blades lined up for their bath of red paint, p. 67; Logs on their way to the paper mills cluster like lily pads, p. 73; A coal rig rises like a dinosaur on the shore of Lake Superior, p. 74; George Washington Bridge, p. 75; Iron puddler at Red October Rolling Mill, Stalingrad, U.S.S.R., 1930, p. 91; Dnieper Dam construction, first Five-Year-Plan, 1930, p. 98; A blast furnace under construction in the Ural Mountains as part of the first Five-Year-Plan, 1931, p. 99; Stalin's great -aunt, 1932, p. 101; Ekaterina Dzhugashvili, mother of Josef Stalin, p. 103; Drought erosion, South Dakota, 1934, p. 108; Sharecropper couple, p. 127; A boy in his newspaper-insulated home, Louisiana, p. 129; The Captain stands guard over a Georgia Chain gang, p. 131; Tenant farmer's wife, p. 135; Fort Peck Dam, Montana, 1936, p. 140; The Bar X, New Deal, Montana, p. 143; A steel "liner" designed to carry a fourth of the Missouri River in a vast irrigation project, p. 144-145; Lord Tweedsmuir, Governor-General of Canada, during his tour through the unpopulated valleys of the world's top, p. 155; During this spectacular night bombing in July 1941, the Germans dropped eleven huge parachute flares over the Kremlin, lighting up the whole central section of Moscow, p. 180; Josef Stalin, photographed in the Kremlin, August 1, 1941, p. 185; Skinny and I bought our Russian fur hats in Arhangel for the homeward trip by convey through the Arctic, p. 187; Accredited as a war correspondent assigned to the Air Force, p. 198; The christening of the "Flying Flitgun," p. 201; En route to the North African campaign. Lifeboat crowded with survivors, p. 214; Brigadier General Atkinson, p. 221; I was flattered when this picture in my high-altitude flying suit became popular as a pin-up, p. 215; Hotly contested Cassino Valley, p. 240; Artillery barrage: supporting fire for an infantry action south of Bologna, Italy, 1944, p. 245; At an observation post overlooking Cassino Valley, 1943, p. 249; The living dead of Buchenwald, April 1945, p. 268; Mahatma Gandhi with his charka, or spinning wheel, symbol of India's struggle for independence, April 1946, p. 276; At the ashram, I practiced spinning with Sita, Gandhiji's granddaughter, p. 279; Mohammed Ali Jimah, founder of

Pakistan, which became a nation separate from India on August 15, 1947, p. 282; *The Great Migration*, p. 288; *With Alexander Schneider, noted violinist and magnificent cook*, p. 305; *The modern city of Johannesburg sits deep amid hills of refuse from the gold mines*, p. 311; *Gold miners working two miles straight down in the mines under Johannesburg*, p. 317; *Recruits for the gold mines, who have not been taught to read and write, sign their work contracts with their thumbprints*, p. 319; *In a Korean village a wife, mother and grandmother lament the death of their boy in guerrilla warfare*, p. 333; *Chief Han at a primitive mountain fortress ringed by bamboo barricades*, p. 339; *These hats, worn by youthful Volunteer Police, were not for play but for camouflage in the deadly game of guerrilla warfare*, p. 341; *Chief Han celebrates his successes over Red guerrillas at a victory party in a Buddhist temple*, p. 345; *Ex-guerrilla Nin Churl-Jin is welcomed home by his wife and family and the baby he had never seen*, p. 353; *Churl-Jin and his mother are reunited*, p. 357.

173. Bourke-White, Margaret. "Portraiture Is Going Informal," *Popular Photography* 5, 6 (December 1939): 22-23+

174. Bourke-White, Margaret. *Shooting the Russian War.* New York: Simon & Schuster, 1942. 298 p.
 An autobiographical account of Bourke-White's journalistic trip to the Soviet Union to bring the "first photographs, taken by a non-Russian, out of the Soviet Union." (p. 5) Along with the text, which helps to put the photographs in context to the events, are Bourke-White's personal remembrances of the people she met and photographed, and the experience of living through the bombing and the air raids.
Football Crowd at Dynamo Stadium, p. 36; *Kowboy Koktail*, p. 40; *Chairman D. V. Nerivny, Head of the Soviet Collective Farm "105,"* p. 43; *Rest Home for Locomotive Workers at Sochi on the Black Sea*, p. 48; *Collective Farmers Hear War News*, p. 52; *"Sanitary Training," Soviet Equivalent of First Aid*, p. 61; *Classroom Demonstration on the Construction and Use of Fire Extinguishers, Given in the School for Instructors*, p. 63; *Solomon A. Lozovsky, the Assistant People's Commissar for Foreign Affairs*, p. 68; *A Press Conference at Narkomindel, Soviet Foreign Office*, p. 70; *German Army Documents Captured by the Red Army*, p. 73; *Camouflaging Moscow*, p. 76; *Subway Shelter*, p. 80; *Spazzo House*, p. 82; *Dining Room on Moving Day*, p. 84; *The Beginning of an Air Raid*, p. 87; *From the Roof of Spazzo*, p. 88; *Embassy Table and Floor after Bombing*, p. 91; *Window of Spazzo Foyer after Bombing*, p. 93; *Editorial Conference at <u>Pravda</u>*, p. 96; *Department of Letters at <u>Pravda</u>*, p. 98; *Pavel F. Yudin, Head of State Publishing House--Ogiz*, p. 101; *Ambassador Steinhardt*, p. 102; *Street Bookstalls on Kuznetsky Most*, p. 106; *German Prisoner of War*, p. 108; *Nazi Infantrymen*, p. 110; *Germans in Moscow*, p. 112; *Air-Raid Warden at Entrance to Bomb Shelter*, p. 114; *Apartment-House Shelter Situated in Krasnopresnensky, a Manufacturing District at the West End of Moscow*, p. 116; *Antiaircraft Barrage*, p. 120; *Bombing of the Kremlin*, p. 122; *<u>Propusk</u>*, p. 130; *Kissing the Icon*, p. 136; *Patriarch Sergei,*

p. 139; *Bishops before the High Altar of Bogoyavlensky Cathedral, Moscow*, p. 140; *Tea with Archbishops*, p.142; *Old Orthodox Worshipers*, p. 144; *Worshipers in New Orthodox Church*, p. 146; *Metropolitan Alexander Vvedensky at Home*, p. 148; *Metropolitan Vvedensky Giving the Benediction*, p. 151; *Bishop of the New Orthodox Church*, p. 152; *Minister Mikhail Akimovich Orlov*, p. 155; *Baptist Church, Moscow*, p. 156; *Order of Lenin*, p. 158; *Order of the Red Banner of Labor*, p. 159; *Badge of Honor*, p. 159; *The Stairway of a Typical Crèche*, p. 162; *Ukrainian Farm Women*, p. 165; *Harvest on "Spark of the Revolution" Farm*, p. 166; *Poster Factory Run by Moscow Artists*, p. 170; *Poster Artist with Stencil*, p. 172; *Poster in Window of Dietetics Shop on Gorky Street*, p. 175; *Orlova, the Movie Queen of Russia, and Her Husband, Alexandrov, Leading Cinema Director*, p. 176; *Alexandrov and Orlova Entertaining Friends at Their <u>Dacha</u>*, p. 178; *Fire-Fighting Poster in the Park of Culture and Rest*, p. 181; *Ptashkinaa and Her Fire-Fighting Brigade*, p. 182; *General F. N. Mason MacFarlane, Head of the British Military Mission*, p. 185; *Belfry of Ivan the Great During an Air Raid*, p. 187; *Kremlin by Moonlight*, p. 188; *Path of a Parachute Flare*, p. 190; *Agricultural Exhibit, Moscow*, p. 194; *Victor V. Talalikhin, Twenty-three Years Old--Soviet Air Hero*, p. 196; *Talalikhin and the Mayor of Moscow at the Park of Culture and Rest*, p. 199; *Parachute Jump in the Park of Culture and Rest*, p. 200; *Harry Hopkins and Sir Stafford Cripps and Joe*, p. 206; *Mr. Hopkins and the American Ambassador on a Shopping Tour*, p. 209; *Harry Hopkins' Press Conferene at Spazzo House*, p. 210; *Hopkins and Stalin*, p. 214; *The People's Commissar of Defense*, p. 216; *Plowing through the Mud*, p. 224; *Supper for Correspondents in Vyazma, the Night before the Bombing*, p. 226; *Rescue Squad*, p.228; *Death Comes to Vyazma*, p. 230; *No. 9 Trubetsov Street*, p. 230; *Captured German Bomber Crew*, p. 232; *Wrecked Nazi Raider*, p. 240; *Russian Guarding German Plane*, p. 2242; *Members of an Infantry Platoon*, p. 246; *Artillerymen Shafran and Zolkin*, p. 249; *Guarding the Ruins of Dorogobuzh*, p. 252; *Pilots in Mess Tent at Airport*, p. 256; *Where the Germans Dug In*, p. 260; *Land Mines*, p. 262; *Great Battlefield of Yelnya*, p. 264; *Ghost Town*, p.266; *The Cathedral of Yelnya*, p. 268; *German Decorations*, p. 274; *Convoy Formation*, p. 276; *Action Station*, p. 280; *First Sight of Land*, p. 282.

175. Bourke-White, Margaret. *They Called It "Purple Heart Valley": A Combat Chronicle of the War in Italy*. New York: Simon & Schuster, 1944. 182 p.
 Photographs originated from a *Life* magazine assignment, text provides the story surrounding the photographs.
Photograph section I. Flight over Purple Heart Valley.
Lieutenant Michael Strok flew me all over the front; Below us lay the Volturno; "Uncle Joe" cannon is the major general...the WAC is Captain Bagby; With a french ambulance driver is Brigadier General Theodore Roosevelt; Lieutenant General Brehon Somervell;
Photograph Section II. *The Wreck of Naples; Little boy on father's shoulders; Giving their wrecked home some privacy; Children and soldiers can always laugh;*

The indestructible social unit; Only a few could afford these modern, comfortable, bombproof cliff dwellings; The factories went underground before the people; Colored soldiers shared the hard work of reconditioning Naples Harbor; Give an American engineer a bulldozer and he can do anything; The Germans were skillful, too; Technical Sergeant Salvatore Benelli in diving suit; When the harbors were cleared and the LST's were loading, questions were forbidden; The bombers came at twilight; After the bombers, the engineers and quartermaster troops went into action; The Germans, destroying a cave factory, left this tangle of cable and pipe; Italian engineers saved some of the machinery, wanted to go on building planes; Professor Raffaele Polispermi, chief engineer of the underground airplane factory;

Photograph Section III. Combat Engineers. *T/5 Thurman S. Peedin, 30; Mines are everywhere. Hunting them is dangerous; Private Elmer Kuhlman, 23 and Private Edwardo Martinez, 32; A mine is a mutilating weapon; This is called a 'beehive' and contains a charge of TNT; Armies have to have roads; A bigger bridge will follow; This is a troublesome bridge; It was built to pass combat traffic; PFC Ivan B. Harvey, 25; First Lieutenant Tom Farrell, 23; Fra Mario, known as "Friar Tuck"; Morning in the monastery courtyard; Sergeant Berthold L. Sadkins is studying aerial photographs;*

Photograph Section IV. Bailey Bridge.

Quick patch for war-zone roads: the Bailey Bridge, a great wartime invention; It goes together like a Meccano set; Fifty men doing fifty things; Built on one side, the bridge is pushed across the river;

Cleaning up with dynamite; Waiting for this bridge were supplies for two divisions; Locking the bridge in place; Finished in 6 ½ hours the bridge makes a fine splint;

Photograph Section V. The Service Forces.

Digging a trench; Church is any day a soldier can go; "Many are the Hearts..." Washday for a mechanized army; Army bread is absolute tops; Salvage depots like this one save money; A parts trailer carries everything; A bulldozer; Why the Army waited; "When I get home I'm going to the Automat..." Someone always said, "What I'd like is a big, juicy steak." The Army requires vast maintenance, from watches to tanks." Mobile water point; Big rifles and little rifles, both need repairs; Delousing station; The Piper Cub pilots made fine quarters out of the crates their planes came in; Not even the engineers could figure out...the sculpture; "Dear Mon--I broke the camera!"

On this trip Padgitt and I lived on C rations; When the German shell hit this antiaircraft truck; Propaganda is a weapon too; These are Fighting Frenchmen; These are Fighting Americans; Nerve ganglion;

Photograph Section VI. The Quality of Mercy.

Army doctors determine their strategy from X-ray films; This boy could not swallow because of his wound; Doctors have victories as well as generals; This is, literally a picture of the shock of battle; "Of course it hurts, son." When you know you may need blood yourself tomorrow, you give it freely; Oxygen is for the desperately wounded; Mud wears out ambulances; Many wounded need many ambulances; Walking mends the convalescent's morale as well as his body...even in mud; To a

surgeon this is a great sculpture; Home is a long hop...and a maybe; They walk in beauty--every damned one of them; Wherever there has been a frontier, American women have always been willing; "Clean Sheets, too."
Photograph Section VII. Big Shoot.
Too big for a courthouse square; A lanyard pulls about as hard as a sticky door; Rolling with the punch; Speaking for 130,000,000 of us; He must calculate how much the earth will turn under a moving shell; What a city room is to a newspaper, this fire direction center is to a battery of Long Toms; The gun flashes in the foreground are from our artillery; The barrage on the enemy-held mountain in the distance; H-hour was at 5:30 a.m.; At sunrise smoke shells were fired to provide a smoke screen for the infantry; Security patrol; These were the most forward observers on the Fifth Army front; The observers for mobile guns are watching; Sugar mule, sugar mule, where are you now? Men, mules and machines all struggling forward together.

176. Bourke-White, Margaret. "Trip to the Front: Correspondents Get Plenty of Mud and Vodka," *Life,* 17 November 1941, 33-39.

177. Bourke-White, Margaret. "Women in Lifeboats," *Life,* 22 February 1943, 48-54.

178. Bourke-White, Margaret. "'You Have Seen Their Faces': How the Pictures Were Made," *Popular Photography* 2, 3 (March 1938): 16+.

179. "Bourke-White, Margaret," *Current Biography*, 1971. p. 460.

180. "Bourke-White's 25 Years," *Life*, 16 May 1955, 16.

181. Brown, Theodore M. *Margaret Bourke-White: Photojournalist*. Ithaca, NY: Cornell University Press, 1972. 136 p. Bibliography: 109-119.
Includes two articles by Bourke-White, "Dust Changes America," and "Photographing This World."
Brown's text continues throughout the volume. It provides biographical material, and an analysis of Bourke-White's photographs in relationship to their historical and social context.
Nitrogen Plant, I.G. Farben Industry, 1930, frontispiece; *Logs,* Lake St. John, Canada, 1937, p. 16; *Ford Motor Company*, 1931, p. 18; *Baker Dormitory*, Cornell University, c. 1926, p. 18; *Praying Mantises*, 1939, p. 21; *Ore-Loading*, Great Lakes, 1929, p. 22; *Football Stadium*, Cornell Univerity, c. 1926, p. 25; *Barnes Hall,* Cornell University, c. 1926, p. 25; *Pouring the Heat*, c. 1930, p. 32; *Terminal Tower Building*, Cleveland, c. 1928, p. 33; *Watch Hands*, 1930, p. 34; *Gang Saw*, 1931, p. 35; *Diamond-Toothed Rotor*, 1931, p. 35; *Hogs,* 1930, p. 36, 37; *Tomorrow's Officers*, 1933, p. 3; *Locomotive Cranes*, 1930, p. 38; *World's Largest Dam*, Dnieperstroi, 1930, p. 39; *A Generator Shell*, 1930, p. 40; *A Workers' Club*, Moscow, 1930, p. 41; *Assembling a Turbine*, 1930, p. 41; *Stalin's Great Aunt*, c.

1931, p. 42; *Semionova: Première Ballerina*, c. 1931, p. 43; *A Priest*, c. 1931, p. 44; *Ekaterina Dzhugashvili: Mother of Stalin*, c. 1931, p. 45; *In the Storehouse*, 1930, p. 46; *Hydro-Generators*, Niagara Falls Power Co., c. 1930, p. 47; *Lansdale, Arkansas*, 1936, p. 48; *The Drought*, 1934, p. 50, 51; *Sweetfern, Arkansas*, 1936, p. 55; *Life* cover, November 23, 1936, p. 56; *Dam*, Fort Peck, Montana, 1936, p. 57; *Taxi-Dancers*, 1936, p. 59; *Steel Liner*, 1936, p. 60, 61; *Louisville Flood*, 1937, p. 61; *Winston Churchill*, 1940, p. 62; *Parachutes*, *Life*, March 22, 1937, p. 66; *Yazoo City, Mississippi*, 1936, p. 68; *East Feliciana Parish*, Louisiana, 1936, p. 69; *Hood's Chapel*, Georgia, 1936, p. 70; *Happy Hollow*, Georgia, 1937, p. 72; *Peterson, Alabama*, 1936, p. 73; *McDaniel, Georgia*, 1936, p. 73; *Exminster, South Carolina*, 1936, p. 74-75; *Locket, Georgia*, 1936, p. 77; *Brownsville, Tennessee*, 1936, p. 78; *Rose Bud, Arkansas*, 1936, p. 79; *Augusta, Georgia*, 1936, p. 80; *Matthews, Georgia*, 1936, p. 81; *Moscow*, 1941, p. 82; *Josef Stalin*, 1941, p. 84; *Buchenwald*, April 1945, p. 85;*Life*, March 1, 1943, p. 86; *City Treasurer and Family*, Leipzig, Spring 1945, p.87; *Leipzig-Mochau*, Spring 1945, p. 88, 89; *Nüremberg*, Spring 1945, p. 90; *Gold Miners, Nos. 1139 and 5122*, Johannesburg, South Africa, 1950, p. 92; *Old Indian Woman*, 1947, p. 93; *Johannesburg Resident*, 1950, p. 93; *The Great Migration*, 1947, p. 94; *Indian Dead*, Calcutta, 1946, p. 95; *Vultures Eating Indian Dead*, Calcutta, 1946, p. 96; *Old Indian Woman*, 1947, p. 96; *Mahatma Gandhi*, 1946, p. 96; *Village School*, Kolomna, Volga Region, c. 1931, p. 97; *Belmont, Florida*, 1936, p. 99; *Steel Liner*, 1936, p. 101; *Migrating Snow Geese*, 1952, p. 102.

182. Caldwell, Erskine and Margaret Bourke-White. *North of the Danube*. New York: Viking Press, 1939. Reprinted Da Capo Press, 1977. 136 p.
 Collaborative work combing text and photographs to describe life in Eastern Europe.

Carpathian Ruthenia: following page 16: *Maria Badzova; Ukrainian Architecture; Curb Market; Talmudic Scholars; The Huculs' Sunday Beer; Masarykova; Gypsy Mother; Spring in the Ukraine;* Carpathian Ruthernia: following page 32: *Carpathian Peasants; Old Man and His Seed Potatoes; Home; Supper; Young Man of the Carpathians; Mountain Shepherdess; Ukrainian School; South of Polish Hills;*
Slovakia: following page 48: *On a Slovak Plateau; Gooseherdess, Ganders and Geese; Neat Steppe Oxen; Paprika Sower; The Reapers and Gleaners; Hungarian Boss and Slovak Peasants; Worker in the Vineyard; Girl of the High Tatras;*
Slovakia: following page 64: *Girls and Sugar Beets; Field-Workers' Dormitory; Hungarian Landlord at Ease; Country Peddler; Krasna Horka; Details of Office Building; Peace in the Ghetto; Katerina Krizanova;*
Moravia: following page 80: *Czecho-Slovak Freeman; Baroque; Bat'a factory Workers' Homes; Street Corner; Refugee from Vienna; Escape from Germany; Nazi Stormtroopers' Training Class; Miner's Son;*
Moravia: following page 96: *Soldier of the First Republic; Trees of the Moravian Forest; Husbandry; Highlanders; Peasant; The Hay Wagon; Woman of the Wheatlands; Autumn Harvest;*

Bohemia: following page 112: *Angels and Locomotives; Spa; Town Square; Home Workers: Toys for the 5 & 10; Home Workers: Lace from the Erzebirge; She Shook Hands with Konrad Henlein; Sieg Heil!; Vejvodova;*
Bohemia: following page 128: *Czech School Girl; Thirteenth Century Towns; Charles Bridge; Street Market; Hussite Town Hall--Vladislav Gothic; Sewing Sequin Purses; Forging Skoda Cannon; Czech Tinsmith.*

183. Caldwell, Erskine and Margaret Bourke-White. *Say, Is This the U.S.A.* New York: Duell, Sloan and Pearce, 1941. 182 p.

A collaboration of text and photographs to view America of the future, showing people in all walks of life, all over the country.

[Train near large silos] Hutchinson, Kansas, p. 5; *[Aerial view of farm]* Whitewater, Kansas, p. 7, 9; *[Farmer checking wheat]* Annelly, Kansas, p. 11; *[Harvesting grain]* Ladysmith, Kansas, p. 13; *[A horse-driven wagon]* McClains, Kansas, p. 15; *[Farmer in straw hat]* Mound Ridge, Kansas, p. 17; *[Locomotive on track]* Dodge City, Kansas, p. 19, 21; *[Trainman signalling from the train]* Spearville, Kansas, p. 23; *[Conductor entering items in a book]* Offerle, Kansas, p. 25; *[Sheep crowded in a pen]* Bellefont, Kansas, p. 27; *Three-year-old Dominie and Dandy Anxiety XLI, four thousand pounds of food on eight legs,* Kansas City, Missouri, p. 29; *Sixteen-year-old Future Homemakers of America,* Kansas City, Missouri, p. 31; *Fifteen-year-old Future Farmer of America,* Kansas City, Missouri, p. 33; *[Muddy road to farm]* Broadland, South Dakota, p. 35; *[Farmer with pitchfork]* Wolsey, South Dakota, p. 37; *[Dried-up crops]* Virgil, South Dakota, p. 39; *Hutterians children in school,* Byron Lake, South Dakota, p. 41; *Three girls in a Hutterian colony studying their German lesson,* Byron Lake, South Dakota, p. 43; *The foreparents of this little Aryan girl has to flee from Austria to Russia two hundred years ago,* Byron Lake, South Dakota, p. 45; *Young Hutterian study English grammar and American history,* Byron Lake, South Dakota, p. 47; *[Grain elevators and train tracks]* Pretty Prairie, Kansas, p. 49; *[By a printing press]* Pretty Prairie, Kansas, p. 51, 53; *[Portrait of an old man]* Pretty Prairie, Kansas, p. 55; *[Costumed men of a fraternal order]* Pretty Prairie, Kansas, p. 57, 59; *[Uniformed man with saxophone]* Omaha, Nebraska, p. 61; *[Rotary - Men's chorus]* Provo, Utah, p. 63; *[Billboard for Provo, Utah]* p. 65; *[Main Street at the foot of the mountains]* Provo, Utah, p. 67; *[Students of Brigham Young University]* Provo, Utah, p. 69; *[Portrait of a man]* Elko, Nevada, p. 71; *[Smiling men in doorway]* Elko, Nevada, p. 73; *[Men at the roulette table]* Elko, Nevada, p. 75; *[Men at a card game]* Elko, Nevada, p. 77; *[At the craps table]* Elko, Nevada, p. 79; *[Stores in town]* Elko, Nevada, p. 81; *[In costume at the Lady's Literary Club]* Elko, Nevada, p. 83; *[Woman with a lasso]* San Diego, California, p. 85; *[Woman with sailors]* San Diego, California, p. 87; *A local booking agent,* San Diego, California, p. 89; *[Four shows night, seven nights a week]* San Diego, California, p. 91; *[Sailor on Shore Patrol]* San Diego, California, p. 93; *[Sitting with sailors]* San Diego, California, p. 95; *[Young woman putting on make-up]* San Diego, California, p. 97; *[Girl Scouts unfurling a large American flag]* Tucson, Arizona, p. 99; *They teach Indian, Mexican, Chinese, and Spanish children to speak English,*

Tucson, Arizona, p. 101; *[Singing in school]* Tucson, Arizona, p. 103; *[Children and teacher dancing in school]* Tucson, Arizona, p. 105; *[Girls playing baseball in school]* Tucson, Arizona, p. 107; *[Young women on horseback]* p. 109; *[Checking out a small plane's engine]* Tucson, Arizona, p. 111; *[Soldiers in training]* Tucson, Arizona, p. 113, 115; *They come to the auction* , Texarkana, Texas, p. 117; *[Checking a horse's mouth]* Texarkana, Texas, p. 119; *[Horse traders]* Texarkana, Texas, p. 121, 123; *[At an auction]* Texarkana, Texas, p. 125, 127; *[Two men in cowboy boots and hats]* Texarkana, Texas, p. 129; *[Abandoned train station]* Soso, Mississippi, p. 131; *[Old couple waiting on train platform]* Soso, Mississippi, p. 133; *Grinding corn meal*, Soso, Mississippi, p. 135; *[Men at the barbershop]* Soso, Mississippi, p. 137; *[Loading wood]* Soso, Mississippi, p. 139; *[Black children in schoolroom]* Soso, Mississippi, p. 141; *[Older Black children in school]* Soso, Mississippi, p. 143; *[Young Black Boy]* Soso, Mississippi, p. 145; *[Man with chimpanzee]* Sarasota, Florida, p. 147; *Training the big cats to take their cues and leap through hoops*, Sarasota, Florida, p. 149; *[Man with an elephant]* Sarasota, Florida, p. 151; *[Locking up a man in jail]* Saluda, South Carolina, p. 153; *[Men by wood stove]* Saluda, South Carolina, p. 155; *[Man sitting in chair]* Saluda, South Carolina, p. 157; *[Main Street]* Saluda, South Carolina, p. 159; *[Spools of thread in a factory]* Lowell, Massachusetts, p. 161; *[Fixing a thread on a loom]* Lowell, Massachusetts, p. 163; *[A handscraftsman with a wooden toy]* St. Johnsbury, Vermont, p. 165; *[Main street and center square]* St. Johnsbury, Vermont, p. 167; *[Large open furnace in factory]* Chicago, Illinois, p. 169; *[Welders]* Cedar Rapids, Iowa, p. 171; *[Listing of jobs]* New York, New York, p. 173; *[Statue of Liberty from its base]* New York, New York, p. 175.

184.　　Caldwell, Erskine. *You Have Seen Their Faces*. Photographs by Margaret Bourke-White. New York: Duell, Sloan and Pearce, 1937. 189 p.
　　　　A photographic and critical exploration of the sharecroppers and tenant farm system in the South. Short essay by Bourke-White on the type of equipment she used to take the photographs.
[Woman and child sitting on steps near large columns, Clinton, Louisiana] p. 23; *[Parents and children pulling small wagons, Ringgold, Georgia]* p. 21; *[Black boy and dog in newspapered room, East Felician Parish, Louisiana]* p. 19; *[Young child eating a watermelon, Summerside, Georgia]* p. 17; *[Black man sleeping by picked tobacco, Statesboro, Georgia]* p. 15; *[Farm couple, Maiden Lane, Georgia]* p. 13; *[Old Black men sitting on bench by river, Natchez, Mississippi]* p. 11; *[Boy pushing plow, Elbow Creek, Arkansas]* p. 9; *[Picking Cotton, Lake Providence, Louisiana]* p. 33; *[Man with hat, Fairhope, Louisiana]* p. 35; *[Cotton plants surrounding shack, Marion Junction, Alabama]* p. 37; *[Large Black woman sitting on wooden steps with infant and girl, Ocelot, Georgia]* p. 39; *[Old Black woman cooking at fireplace, Pee Dee, South Carolina]* p. 41; *[Old Black woman, smiling, Atoka, Tennessee]* p. 43; *[Young Black girl and crippled boy in chair in newspapered room, Belmont, Florida]* p. 45; *[Young Black man, Porter, Arkansas]* p. 47; *[Middle-aged man in hat, Tupelo, Mississippi]* p. 57; *[Man and pair of horses, plowing, Iron Mountain, Tennessee]* p. 59; *[Middle-aged farm woman in*

bonnet, Hamilton, Arkansas] p. 61; *[Smiling young boy with stray hat, Ozark, Arkansas]* p. 63; *[Young woman planting seeds, Highlands, Tennessee]* p. 65; *[Children in School, Harrisburg, Arkansas]* p. 67; *[Local politician giving speech, Caxton, Mississippi]* p. 69; *[Middle-aged man with guitar in newspapered room, Marshall, Arkansas]* p. 71; *[Middle-aged Black man, Arlington, Tennessee]* p. 83; *[Shacks plastered with advertising signs, Montgomery Alabama]* p. 85; *[Old Black woman sitting by fireplace, Johns, Mississippi]* p. 87; *[Crowded Black schoolroom, Scotts, Arkansas]* p. 89; *[Black man in raincoat, Augusta, Georgia]* p. 91; *[Young Black child selling crickets, Augusta, Georgia]* p. 93; *[of Black men and women by desk, Bosporus, Mississippi]* p. 95; *[Young Black person in jail, St. Tammany Parish, Louisiana]* p. 97; *[Old man by rooster sign, Nettleton, Arkansas]* p. 99; *[Man by doorway of wooden shack, Nettleton, Arkansas]* p. 101; *[Poor family at dinner table, Okefenokee Swamp, Georgia]* p. 103; *[Poor woman nursing child, Okefenokee Swamp, Georgia]* p. 105; *[Guard watching prisoners working in trench, Hood's Chapel, Georgia]* p. 107; *[Chain gang at rest, Hood's Chapel, Georgia]* p. 109; *[Chained Black prisoner sleeping, Hood's Chapel, Georgia]* p. 111; *[Chained prisoners' legs, Hood's Chapel, Georgia]* p.113; *[Parishioners and preacher in Black Church, College Grove, Tennessee]* p. 115; *[Young Black girls with bowls, College Grove, Tennessee]* p. 117; *[Black men on bench, College Grove, Tennessee]* p. 119; *[Preaching in a Black church]* p. 121, 123; *[Painting a sign about Jesus, Augusta, Georgia]* p. 125; *[Preaching in a White church, Exminster, South Carolina]* p.127, 129; *[Old couple, YazooCity, Mississippi]* p. 147; *[Woman with children, Dahlonega, Georgia]* p. 149; *[Wooden shack, missing a side, Natchez, Mississippi]* p. 151; *[Man with few teeth, McDaniel, Georgia]* p. 153; *[Poor woman holding child, McDaniel, Georgia]* p. 155; *[Poor family in shack, Peterson, Alabama]* p. 157; *[Old couple with child, Sweetfern, Arkansas]* p. 159; *[Poor woman sitting on town mattress with baby, Happy Hollow, Georgia]* p. 161; *[Sign - Look now is the day of Salvation, Hull, Georgia]* p. 171; *[Man lying on mattress, Matthews, Georgia]* p. 173; *[Plowed field, Brownsville, Tennessee]* p. 175; *[Two old women sitting on porch, Lansdale, Arkansas]* p. 177; *[Old, broken car by tree, Rose Bud, Arkansas]* p. 179; *[Middle-aged couple in house, Locket, Georgia]* p. 181; *[Portrait of a woman, Locket, Georgia]* p. 183; *[Portrait of a man, Locket, Georgia]* p. 185.

185. Callahan, Sean, ed. *The Photographs of Margaret Bourke-White.* Introduction by Theodore M. Brown, and Foreword by Carl Mydans. Greenwich, CT; New York Graphic Society, 1972. 208 p. Chiefly photographs. Bibliography: p. 203-208.

Includes numerous photographs of Bourke-White, from childhood through her retirement in 1970.

The Cleveland Years, 1928-1929:
Terminal Tower, Cleveland, 1928, p. 28, 29; *J.P. Burton Estate,* 1928, p. 30; *A Preacher and His Parishioners, Cleveland,* 1928, p. 30; *High Level Bridge, Cleveland,* 1929, p. 31; *Niagara Falls Power Company,* 1928, p. 32; *Otis Stell, Cleveland,* 1928, p. 32; *200-ton Ladle, Otis Steel, Cleveland,* 1929, p. 32; *Pouring*

the Heat, Detroit, 1929, p. 33*;*
The Fortune Years, 1929-1936:
Ore Loading Docks, Superior, Wis., 1929, p. 34*; Glass Blower, Corning, N.Y.,*
1929, p. 35*; Hogs, Swift & Co., Chicago,* 1929, p. 36, 37; *Pig Dust,* 1929, p. 38*;*
Coffee-Plantation Workers, Brazil, 1936, p. 39; *Indiana Limestone,* 1931, pl. 40,
41*; The Bayonne Bridge,* 1933, p. 42*; The George Washington Bridge,* 1933, p. 43*;*
Pierce-Arrow, 1931, p. 44*; Ore being poured into pigs, Alcoa,* 1934, p. 44*; Union*
Fork & Hoe, 1934, p. 44*; Bauxite, mother of aluminum, Alcoa,* 1934, p. 44*; WOR,*
radio transmitting tower, 1935, p. 45*; Goodyear Tire,* 1934, p. 46*; Bar at "21,"*
1933, p. 47*; Dust, Just Dust, South Dakota,* 1934, p. 48*; Drought Erosion, South*
Dakota, 1934, p. 49*; Sierra Madre,* 1935, p. 50*; The Weaver, American Woolen*
Co., 1931, p. 52*; Plow Blades, Oliver Chilled Plow Co.,* 1930, p. 52*; Watch Hand,*
Elgin Watch, 1930, p. 52*; Theater Guild, New York,* 1935, p. 53*; Log Rafts,*
International Paper, 1937, p. 54*; Lumberjack, International Paper Co.,* 1937, p.
55; *Log Jam, International Paper Co.,* 1937, p. 55*; Still Life, International Paper*
Co., 1937, p. 55*; Oxford Paper, Rumford, Me.,* 1932, p. 56*; Capitol Steps,*
Washington, 1935, p. 58*; Supreme Court Building, Washington,* 1935, p. 58*; Steps,*
Washington, 1935, p. 58*; President Franklin D. Roosevelt,* 1935, p. 59*; American*
Woolen Co., Lawrence, Mass., 1935, p. 60*; Dolls in a Store Window,* 1929, p. 61;
Royal Typewriter, 1934, p. 61*; Today's Troops, Tomorrow's Officers, Germany,*
1932, p. 62*; Portrait of a Sailor, Germany,* 1930, p. 63*; Gen. Hans Von Seeckt,*
Germany, 1932, p. 63*; Ammonia Storage Tanks, I.G. Farben,* 1930, p. 64*;*
Generator Stator, AEG, 1930, p. 64*; The Bremen at Bremerhaven,* 1930, p. 65*;*
Garment District, New York, 1930, p. 66-67*;*
Soviet Russia, 1930-1932:
Soviet Serenade, 1931, p. 68*; A Workers' Club in Moscow,* 1930, p. 69*; Col. Hugh*
L. Cooper, 1930, p. 70*; The Bridge,* 1930, p. 71*; Waiting Their Turn; The*
Children's Clinic, Moscow, 1931, p. 72*; The Steppe, Ukraine,* 1930, p. 73*; The*
Kremlin, Moscow, 1931, p. 73*; Stalin's Great-Aunt, Didi-Lilo,* 1932, p. 74*; Village*
School, Kolomna, Volga Region, 1932, p. 75*; Soviet Schoolroom* 1931, p. 76;
Nursery in Auto Plant, Moscow, 1931, p. 77*; A Foreman, Tractorstroi,* 1930, p. 78*;*
World's Largest Dam, Dnieperstroi, 1930, p. 79*; World's Largest Blast Furnace,*
Magnitogorsk, 1931, p. 79*; Stalin's Mother, Tiflis,* 1932, p. 80*; Tovarisch Mikhail,*
A Bricklayer, 1931, p. 80*; A Priest,* 1931, p. 81*; Chain Belt Movement,* 1931, p. 82*;*
Semionova, Premiere Ballerina, 1931, p. 83*; Textile Mill, Moscow,* 1930, p. 84*; In*
the Quarry, Novorossisk, 1930, p. 84*; Women Loading Crushed Rock, Novorossisk,*
1930, p. 84*; Steel Worker, Magnitogorski,* 1931, p. 85*; A Generator Shell,*
Dnieperstroi, 1930, p. 85*; Inspecting the Lace, Moscow,* 1930, p. 85*; Borscht,*
Georgia, 1932, p. 86*; Iron Puddler, Stalingrad,* 1930, p. 87; *Woman with Meat,*
Magnetnaya, 1931, p. 88*;*
"You Have Seen Their Faces" 1936 :
Lansdale, Arkansas, p. 90*; Sweetfern, Arkansas,* p. 91*; Yazoo city, Mississippi,* p.
92*; Maiden Lane, Georgia,* p. 93*; Locket, Georgia,* p. 93*; College Grove,*
Tennessee, p. 94*; Ringgold, Georgia,* p. 96*; Okefenokee Swamp, Georgia,* p. 97*;*
Rose Bud, Arkansas, p. 98*; East Feliciana Parish, Louisiana,* p. 99*; Hood's*

Chapel, Georgia, p. 100, 101; *Clinton, Louisiana,* p. 102; *Statesboro, Georgia,* p. 103; *Iron Mountain, Tennessee,* p. 104;
Life begins, 1936-1940:
First cover of Life, 1936, p. 107; *Wind Tunnel Construction,* 1936, p. 106; *Fort Peck Dam,* p. 108; *10,000 Montana Relief Workers Make Whoopee on Saturday Night,* p. 109; *The Law Totes a Gun,* p. 110; *This is Wheeler, Montana,* p. 110; *The New West's New Hotspot Is a Town Called "New Deal,"* p. 112; *The Only Idle Bedsprings In "New Deal" Are the Broken Ones,* p. 112; *Uncle Sam Takes Care of the Indians: The Little Lady. Herself,* p. 113; *Life In the Cowless Cow Town Is Lush But Not Cheap,* p. 113; *Lt. Col. T.B. Larkin Is Boss,* p. 114; *Bar X,* p. 114; *Ruby's Place,* p. 114; *One-Fourth of the Missouri River Will Run Through This Steel "Liner,"* p. 114; *Major Clark Kittrell Is No. 2,* p. 115; *Ed's Place,* p. 115; *Ruby Herself,* p. 115; *[At the Bar]* p. 117; *[Mother With Children]* p. 117; *Paprika Sower, Slovakia,* p. 118; *Nazi Storm Troopers' Training Class, Moravia,* 1938, p. 119; *Czech Schoolgirl, Bohemia,* 1938, p. 119; *Fieldworkers' Dormitory, Slovakia,* 1938, p. 120; *Peasant, Moravia,* 1938, p. 121; *Henlein Family, Czechoslovakia,* 1938, p. 122; *Gypsy Mother, Carpathian Ruthenia,* 1938, p. 124; *Apple Seller, Bohemia,* 1938, p. 124; *Prince Festetic's Library, Hungary,* 1938, p. 126; *Flood Victim, Churchill Downs, Kentucky,* p. 128; *Edouard Daladier, French Prime Minister,* 1938, p. 129; *Cordell Hull, Secretary of State,* 1938, p. 129; *Wendell Wilkie, Presidential Candidate,* 1940, p. 129; *Conversation Club, "Middletown, U.S.A.,"* 1937, p. 130; *Pocahontas Lodge, Muncie, Indiana,* 1937, p. 132; *Order of Odd Fellows, Pretty Prairie, Kansas,* 1940, p. 133; *Praying Mantes,* 1939, p. 134; *Golden Eagle,* 1940, p. 135; *Horned Owl,* 1940, p. 135; *At the Time of the Louisville Flood,* 1937, p. 136;
The War in Europe, 1941-1945:
Buchenwald Inmates, Germany, 1945, p. 138; *Essen Steel Worker, Germany,* 1945, p. 139; *Buchenwald,* 1945, p. 141; *Leipzig-Mochau,* 1945, p. 140, 141; *Stalin Smiling, Moscow,* 1941, p. 143; *General George S. Patton, Luxemburg,* 1945, p. 142; *Winston Churchill, London,* 1940, p. 143; *Cassino Valley, Italy,* 1946, p. 144; *Brig. Gen. Joe Atkinson, North Africa,* 1943, p. 145; *Bombing of Moscow,* 1941, p. 146; *Nuremberg,* 1945, p. 146; *Air Raid over Tunis,* 1943, p. 147; *Göring in Defeat,* 1945, p. 148; *Nazi Suicides,* 1945, p. 149; *Benediction, Moscow,* 1941, p. 151; *Zhukov Shows His Medals, Berlin,* 1945, p. 150; *The Living Dead of Buchenwald, April, 1945,* p. 152;
The India Years, 1946-1948:
The Monsoon Failed This Year, India, 1945, p. 154; *Princely India,* 1947, p. 155; *A Sikh Family, Pakistan,* 1947, p. 156; *The Great Migration, Pakistan,* 1947, p. 157; *Misery of the Dispossessed, India,* 1947, p. 158; *Too Weak to Stand, India,* 1946, p. 160; *Vultures of Calcutta, India,* 1946, p. 160; *The Emigrant Train, Pakistan,* 1947, p. 162; *A Village Beauty, India,* 1946, p. 164; *Vallabhbhai Patel, India,* 1946, p. 165; *Jawaharlal Nehru, India,* 1946, p. 165; *Mohammed Ali Jinnah, Pakistan,* 1948, p. 165; *Gandhi Spinning, India,* 1946, p. 166; *The Village Well, India,* 1946, p. 167; *Toward Mecca, India,* 1946, p. 168; *Grass Sellers, India,* 1946, p. 168; *The Moneylender's House, India,* 1946, p. 170; *The Maharajah of*

Bikaner, India, 1946, p. 171; *Sikh Bathing, India,* 1946, p. 172; *Death's Tentative Mark, India,* 1946, p. 173; *The Spinner, India,* 1946, p. 174;
The Later Life Years, 1950-1956:
Shantytown Dweller, South Africa, 1950, p. 177; *South African Miners,* 1950, p. 176; *Johannesburg, South Africa,* 1950, p. 178; *Dairy Farmers, Piermont, New Hampshire,* 1950, p. 180; *Round Barn, Piermont, New Hampshire,* 1950, p. 180; *Morning Mist, Sunderland, Mass.,* 1950, p. 182; *The Orderly River, Hadley, Mass.,* 1950, p. 183; *Protective Pattern, Walsh, Colorado,* 1954, p. 184; *Theatening [sic] Storm, Hartman, Colorado,* 1954, p. 185; *South Korean Villages,* 1952, p. 186, 187; *Weeping Women, Korea,* 1952, p. 189; *B-36 at High Altitude,* 1951, p. 190; *Bomb Bay of B-36,* 1951, p. 191; *The Face of Liberty, New York,* 1952, p. 192; *San Jacinto Monument, Texas,* 1952, p. 193; *Beach Riders, Fort Funston, California,* 1952, p. 194; *The Jesuits, Florissant, Missouri,* 1954, p. 195; *Coney Island Parachute Jump, New York,* 1952, p. 196; *Beach Accident, Coney Island, New York,* 1952, p. 197; *Queen Elizabeth, New York Harbor,* 1952, p. 198; *San Francisco Bay,* 1952, p. 199; *Snow Geese, Back Bay, Virginia,* 1952, p. 200.

186. Canavor, Natalie and Cheryl Wiesenfeld. "Margaret Bourke-White: A Retrospective," *Popular Photography* 72, 5 (May 1973): 84-90.

187. Gayn, Mark. "With Notebook and Camera in Russia," *The Saturday Review of Literature,* 22 August 1942, 10.

188. Goldberg, Vicki. "In Hot Pursuit: The Life and Times of Margaret Bourke-White," *American Photographer* 16, 6 (June 1986): 38-61.

189. Goldberg, Vicki. *Margaret Bourke-White.* New York: Harper & Row, 1986. 426 p. Bibliography: p. 415-416.
 This biography is partially based on the few remaining diaries of Bourke-White. It is illustrated by family photographs and several pictures of Bourke-White by other photographers.
Terminal Tower, Cleveland, 1928, fig. 15; *"Hot Pigs," Otis Steel, Co.,* c. 1927-28, fig. 16; *Molten slag overflows from ladle, Oits Steel Co.,* c. 1927-28, fig. 17; *Arc welder, Lincoln Electric Company,* 1929, fig. 18; *Plow blades, Oliver Chilled Plow Co.,* 1929, fig. 19; *Tractorstroi, U.S.S.R.,* 1930, fig. 20; *Dam at Dnieprostroi, U.S.S.R.,* 1930, fig. 21; *International Paper and Pulp Co.,* 1930, fig. 22; *Maurice Hindus,* fig. 23; *In Russia,* 1932, fig. 24; *NBC mural, Rockefeller Center, New York City,* 1933, fig. 27; *First issue of Life,* 1936, fig. 29; *Taxi dance,* 1936; fig. 30; *Flood victims, Louisville, Kentucky,* 1937, fig. 37; *Conversation club, Muncie, Indiana,* 1937, p. 32;
from: *You Have Seen Their Faces:* Belmont Florida, 1937, fig. 33; *Maiden Lane, Georgia,* 1936-37, fig. 34;
Down South with Erskine Caldwell, fig. 35; *Nazi Rally, Czechoslovakia,* 1938, fig. 36; *"Boss" Hague,* 1938, fig. 37; *Soldier in Soviet tank, U.S.S.R.,* 1941, fig. 39; *German air raid, Moscow,* 1941, fig. 40; *Brigadier General J. Hampton Atkinson,*

Tunisia, 1943, fig. 42; *Jerry Papuart*, 1941-42, fig. 43; *Night barrage, south of Bologna, Italy*, 1944, fig. 44; *Buchenwald, Germany*, 1945, fig. 45; *Mainz from the air, Germany*, 1945, fig. 46; *The great migration, Pakistan*, 1947, fig. 47; *Frank Moraes*, fig. 48; *Gandhi, India*, 1946, fig. 49; *Gold miners, South Africa*, 1950, fig. 50; *With Alexander Schneider*, fig. 51; *Nin Churl Jin and his mother, Korea*, 1952, fig. 52; *San Jacinto Monument from a helicopter*, 1952, fig. 53.

190. Goldberg, Vicki. "Margaret Bourke-White: The Formative Years," *Timeline* 5, 4 (1988): 2-17.

191. Gross, Jozef. "Changing the World," *British Journal of Photography* 136 (April 6, 1989): 16-19.

192. Hebert, William. "Margaret Bourke-White Goes to Hollywood," *Popular Photography* 13, 6 (December 1943): 24-27+.

193. "The Hudson River: Autumn Peace Broods Over America's Rhine," *Life*, 2 October 1939, 57-65.

194. Kelley, Etna M. "Margaret Bourke-White: Around the World with *Life's* Dauntless, Indefatigable Camerawoman," *Popular Photography* 31, 2 (August 1952): 34-42+.

195. LaFarge, John. *A Report on the American Jesuits*. Photographs by Margaret Bourke-White. New York: Farrar, Straus and Cudahy, 1956. 237 p.

 Text is of the history of the Jesuits and their place in American religious and secular life. Essay by Margaret Bourke-White indicates that this project began as a photographic essay for *Life* magazine.

Followers of St. Ignatius of Loyola, p. 3; *Seismologist and Geologist: Rev. Daniel Linehan, S.J.*, p. 4; *The late Rev. Daniel A. Lord, S.J., playwright and prolific author*, p. 5; *Waterfront Priest: Rev. Dennis J. Comey, S.J. and pier officials*, p. 6; *Foreign Service School: Rev. Frank L. Fadner, S.J.*, p. 7; *Honduras Missionary: Rev. Gregory B. Sontag, S.J.*, p. 8; *In the "Father's Hut": Rev. Urban Kramer, S.J. tells stories*, p. 9; *Theologian: Rev. John Courtney Murray, S. J.*, p. 10; *Aviator: Rev. John J. Higgins, S.J., chief flying instructor*, p. 11; *Fisherman: Rev. John P. Sullivan, S.J. fishing off San Pedro Cay*, p. 12; *On Mission Rounds: Rev. John T. Newell, S.J. on horseback*, p. 13; *Oldest Jesuit: Rev. Laurence J. Kenny, S.J. who was 91 on Columbus Day 1955*, p. 14; *Examination of Conscience*, p. 29; *Graveyard of pioneer American Jesuits, St. Stanislaus Seminary, Florissant, Mo.*, p. 53; *Gravestone of Father Peter de Smet*, p. 54; *Seminarian's desk in ascetory, or study-hall*, p. 63; *Master of Novices conducting a class*, p. 64; *Novices at humble tasks in the kitchen*, p. 65; *First vows*, p. 66; *Practicing baptism on doll*, p. 68; *Ceremony of Ordination: Priests-to-be lie prone in gesture of humility*, p. 77; *Parents and close relatives at the moment of anointing*, p. 78; *The laying on of*

hands, p. 79; *A newly ordained priest blessing and kissing his parents*, p. 81; *A first Mass*, p. 82; *The blessing of a new priest*, p. 83; *A young girl receives her priest-uncle's first blessing*, p. 84; *Registration day at St. Louis University*, p. 93; *The late Rev. Alfred J. Barrett, S. J. conducting and outdoor poetry class, Fordham campus*, p. 94; *Rev. Bernard R. Hubbard S. J. and students at the University of Santa Clara*, p. 95; *Rev. Raymond Feeley, S. J. and some students in his course at San Francisco University*, p. 96; *A Jesuit lay brother feeding chickens at Florissant, Mo.*, p. 117; *Laymen's Retreats: Jesuit retreatants at El Retiro, California*, p. 133, 134; *Jesuit retreatants at Loyola House, Morristown, N.J.*, p. 136; *Rev. Richard J. Scannell, S. J., has been chaplain at Alcatraz Federal Penitentiary*, p. 143; *Rev. Bernard R. Hubbard, S. J., the well-known "Glacier Priest,"* p. 144; *Rev. Francis J. Heyden, S. J., expert on eclipses*, p. 145; *Rev. Alphonse M. Schwitalla, S. J., Dean Emeritus, Saint Louis Univ. School of Medicine*, p. 146; *Rev. Francis A. DiBenedetto, S. J., Professor of Physics*, p. 147; *Rev. George H. Dunne, S. J., and Mr. Alton Thomas, executive secretary of the Urban League of Phoenix*, p. 148; *The late Rev. William D. O'Leary, S. J., director of the radio station WWL, New Orleans*, p. 149; *Father Dunne and Mr. Thomas visiting the students of Phoenix High School*, p. 150; *Father Denis Come talking to Philadelphia longshoremen*, p. 156; *Descending into the ship's hold to inspect controversial cargo*, p. 157; *Rev. John Ryder, S.J., celebrating Mass in the Byzantine rite*, p. 167; *The Holy Eucharist shown under the species of both bread and wine*, p. 168, 169; *The Chanting of the Gospel*, p. 170; *Members of the congregation coming forward to kiss the cross*, p. 171; *Father Ryder shown behind image screen*, p. 172; *Fathers watching the children of Minas-Deroro, British Honduras rehearsing in the square*, p. 188; *Rev. Robert L. Hodapp, S. J., in a classroom in Belize*, p. 190; *Rev. John M. Knopp, S. J., Father Superior of the Honduras Mission*, p. 191; *Most Rev. David F. Hickey, S.J. watches girls decorate picture of Our Lady of Guadalupe*, p. 192; *The people of Belize in an evening candlelight procession for Our Lady of Guadalupe* p. 193; *Rev. Marion M. Ganey, S. J. talking to the fishermen*, p. 194; *Blessing the children at Minas de San Antone*, p. 194; *The old Spanish Cathedral in the village of Minas-Deroro*, p. 195; *Father Newell blessing water and seed corn*, p. 196; *Rev. William Ulrich, S.J. and Mayan Indians of British Honduras*, p. 197; *Father Ganey sailing to San Pedro Cay*, p. 198; *The late Father Daniel Lord*, p. 208; *Father Daniel Lord accompanying some young members of the Sodality of Our Lady*, p. 209; *Father Daniel Linehan leading a field crew through the Maine woods*, p. 218; *Interpreting the seismograms*, p. 219; *Celebrating Mass in the woods*, p. 220; *Father William Ulrich supervising hog-weighing at San Antonio*, p. 223; *Father Gregory Sontag uses sound amplifier to announce his arrival at Sittee River mission and greeted by parishioners*, p. 226, 227; *The sacraments of Baptism and Penance are administered by Father Sontag*, p. 228, 229; *Rev. John LaFarge, S. J.*, p. 235; *Novices gathering grapes from the vineyard of the Sacred Heart Novitiate*, p. 237.

196. "Margaret Bourke-White Aids 'Choosing-A-Career' Conference: A Talk on Her Photographic Career," *The Camera* 49, 2 (August 1934): 109-113.

197. Marks, Robert W. "Portrait of Bourke-White," *Coronet Magazine*, January 1939, 163-174.

198. Nicholson, Chuck. "The Ideal Photojournalist (California Museum of Photography, Riverside; Exhibit)," *Artweek* 27 May 1989, 11-12.

199. "Photomurals in NBC Studios, R.C.A. Building, Radio City, New York: Photographs by Margaret Bourke-White," *Architectural Record* 76, 2 (August 1934): 129-138.

200. "Portfolio on Paper: Driving Logs From Forest to Factory," *Life,* 5 July 1937, 24-29.

201. Reilly, Rosa. "Why Margaret Bourke-White Is at the Top," *Popular Photography* 1, 3 (July 1937): 14-15+.

202. Rivers, W. L. "Focussing a Wide Angle Lens on Life," *Saturday Review*, 29 June 1963, 25.

203. Ross, Jeanette. "Transcending Personality," *Artweek,* 11 January 1990, 13-14.

204. "Senate and Senators," *Life,* 14 June 1937, 17-27.

205. Shortal, Helen. (National Museum of Women in the Arts, Washington, D.C.; Exhibit) *New Art Examiner* 17 (January 1990): 43-44.

206. Silverman, Jonathan. *For the World to See: The Life of Margaret Bourke-White.* Preface by Alfred Eisenstadt. New York: Viking Press, 1983. 224 p. Chronology. Bibliography: p. 216.
 The biographical essay that accompanies the photographs also includes quotes from Bourke-White's writings. Many of the photographs are from the Margaret Bourke-White Archives in the George Arents Research Library for Special Collections, Syracuse University.
Commuters Waiting for Streetcars, Cleveland, 1929, p. 11; *First National Bank, Boston,* 1929, p. 14; *International Harvester,* 1933, p. 15; *Open-hearth Mill, Ford Motor Company, Detroit,* 1929, p. 16; *Republic Steel,* 1929, p. 17; *Chrysler Corporation,* 1929, p. 20; *Erie Railroad,* c. 1931, p. 21; *Mine Passage, Hudson Canal,* 1931, p. 22; *Limestone Quarry, Indiana,* 1931, p. 23; *George Washington Bridge Under Construction,* c. 1931, p. 24; *Empire State Building,* c. 1931, p. 25; *Street Scene, New York City,* c. 1931, p. 26; *Detail of a La Salle,* c. 1933, p. 27; *Wheat Field and Smokestacks in the Ruhr Valley, Germany,* 1930, p. 30; *In Russia,* 1932, p. 33; *Sergei Eisenstein Having a Shave on the Terrace of Margaret Bourke-White's Studio,* 1930, p. 37; *Butcher, Germany,* 1931, p. 38; *Workmen in the AEG Plant, Germany,* 1930, p. 39; *Tractorstroi, USSR,* 1930, p. 40; *Electrazavod,*

USSR, 1930, p. 41; *Dam at Dnieperstroi, USSR*, 1930, p. 42; *Magnitogorsk, USSR*, 1931, p. 43, 44; *Ballet School Students, Moscow*, 1931, p. 45; *Moscow Nursery*, 1931, p. 46; *Mother and Child, USSR*, 1932, p. 47; *Machine Dance, Moscow Ballet School*, 1931, p. 48; *Marina Semyonova, Leading Ballerina of the Moscow Opera*, 1931, p. 49; *German Army on Maneuvers*, 1932, p. 50; *General Hans von Seeckt, Germany,*1932, p. 51; *Stalin's Mother*, 1932, p. 55; *Goodyear Tire Advertisement*, c. 1933 p. 57; *Gargoyle Outside Margaret Bourke-White's Chrysler Building Studio*, 1930, p. 58; *A Corner of the Studio*, 1930, p. 59; *Interior of a Wurlitzer Organ*, 1931, p. 60; *Grain Elevator Pipes*, 1932, p. 61; *International Paper Company*, 1933, p. 62; *Detail of a Royal Typewriter*, 1934, p. 63; *Delman Shoes*, c. 1933, p. 66; *Street in the Garment Center, New York City*, 1930, p. 67; *The Vanitie in a Practice Spin, Newport*, 1934, p. 68; *Yacht Endeavour at Newport*, 1935, p. 69; *NBC Mural, Rockefeller Center, New York City*, 1934, p. 71; *Margaret Bourke-White with a Mural Photograph of an Experimental Television 'Eye,"* 1934, p. 82; *Microphones*, 1934, p. 83; *Radio Loudspeakers*, 1934, p. 84; *Airplane Wings*, 1934, p. 85; *Igor Sikorsky with a Plane He Designed for Pan American Airways*, 1934, p. 86; *Detail of a TWA Plane*, 1934, p. 87; *DC-3 Over Manhattan*, 1934, p. 88; *Biplane*, c. 1934, p. 89; *"You Gave Us Beer, Now Give Us Water,"* *Dust Bowl*, 1935, p. 90; *Waiting. Dust Bowl*, 1935, p. 91; *Home Scenes, Dust Bowl*, 1935, p. 92, 93; *On the Road*, 1936, p. 94; *Belmont, Florida*, 1936, p. 95; *Statesboro, Georgia*, 1936, p. 96; *Tobacco Farmer*, 1936, p. 97; *Johns, Mississippi*, 1936, p. 98; *Chain Gang, Hood's Chapel, Georgia*, 1936, p. 99; *Sharecroppers*, 1936, p. 100, 101; *Madame Chiang Kai-shek, Chungking*, 1941, p. 107; *Harry L. Hopkins, Head of the U.S. Lend-Lease Program, with Stalin in Moscow*, 1941, p. 109; *Steelworker, Life, August 9, 1943*, p. 113; *Former Hudson's Bay Company Post Manager Charles T. Gaudet, Fort Norman, N.W.T. Canada*, 1937, p. 122; *Mother Superior of the Sisters of Charity Hospital, Fort Smith, N.W.T., Canada*, 1937, p. 123; *Flood Victims, Louisville, Kentucky*, 1937, p. 124; *Taxi Dancers, Fort Peck, Montana*, 1936, p. 125; *Czechoslovakian Soldiers*, 1938, p. 126; *Farmer in Czechoslovakia*, 1938, p. 127; *Nazi Rally, Reichenberg, Bohemia*, 1938, p. 128; *Skoda Works, Pilsen, Bohemia*, 1938, p. 129; *Hitler Youth, Moravia*, 1938, p. 130; *Talmud Class, Czechoslovakia*, 1938, p. 131; *Arms Drill at Eton College, England*, 1939, p. 132; *Tower Bridge During the Blackout, London*, 1940, p. 133; *USSR*, 1941, p. 134, 135; *The Kremlin During a Night Air Raid*, 1941, p. 136; *Awaiting Rescue Off North Africa*, December 1942, p. 138; *Air Raid Over Tunis*, 1943, p. 139; *Brigadier General Joseph Atkinson, North Africa*, 1943, p. 140; *Waist Gunners, England*, 1942, p. 141; *Martha Raye Entertaining the Troops in North Africa*, 1943, p. 142; *Harbor at Naples*, 1944, p. 143; *Wounded G.I., Cassino Valley Italy*, Winter 1943-44, p. 144; *Lieutenant Colonel Paul W. Sanger Operating in the 38th Evacuation Hospital, Cassino Valley*, Winter 1943-44, p. 145; *Cave Dwellers Outside Naples*, 1944-45, p. 146; *Naples*, 1944-45, p. 147, 148; *Father and Son, Naples*, 1944-45, p. 149; *Shopping Center of Cologne After Bombardment*, 1945, p. 156; *German Bunker Outside Würzburg*, 1945, p. 157; *Field Marshall Hermann Wilhelm Göring After His Surrender in 1945*, p. 158; *General George S. Patton, Luxembourg*, 1945, p. 159; *Survivors, Frankfurt*, 1945,

p. 160; *Suicides, Leipzig,* 1945, p. 161; *Buchenwald,* 1945, p. 162; *Citizens of Weimar View Buchenwald,* 1945, p. 163; *Erla Death Camp,* 1945, p. 164, 165; *Buchenwald,* 1945, p. 166; *Erla,* 1945, p. 167; *Mahatma Gandhi,* 1946, p. 177; *Jawaharlal Nehru,* 1946, p. 178 ; *Mohammed Ali Jinnah,* 1947, p. 179; *Refugee Camp, New Delhi,* 1947, p. 180; *Refugees, India,* 1947, p. 181; *India,* 1947, p. 182; *Mahatma Ghandi With His Granddaughter and Grandniece,* 1947, p. 184; *Mourners at Gandhi's Funeral Pyre,* 1948, p. 185; *Protester, South Africa,* 1950, p. 196; *Miners Signing Work Contracts, South Africa,* 1950, p. 197; *Men's Quarters, South Africa,* 1950, p. 198; *Amalaita Fights, South Africa,* 1950, p. 199; *South Africa,* 1950, p. 200, 201; *Herero Women, Windhoek, South-West Africa,* 1950, p. 202; *Gold Miners, South Africa,* 1950, p. 203; *University Professor, Tokyo,* 1952, p. 204; *May Day Riot, Tokyo,* 1952, p. 205; *Head of North Korean Soldier,* 1952, p. 206; *Temple Mourner, South Korea,* 1952, p. 207; *Capture Guerillas, South Korea,* 1952, p. 208; *Nim Churl-Jin With His Mother, South Korea,* 1952, p. 209; *Bridge Construction, New York Thruway,* 1954, p. 210; *Levittown, Pennsylvania,* 1956, p. 211; *Jesuit Seminarians, Florissant, Missouri,* 1953, p. 213; *Strategic Air Command Flight,* 1951, p. 214.

207. Smith, C. Zoe. "An Alternative View of the 30s: Hine's and Bourke-White's Industrial Photos," *Journalism Quarterly* 60, 2 (1983): 305-310

208. Snyder, Robert E. "Margaret Bourke-White and the Communist Witch Hunt," *Journal of American Studies* 19, 1 (1985): 5-25.

209. Snyder, Robert E. "Erskine Caldwell and Margaret Bourke-White: You Have Seen Their Faces," *Prospects* 11 (1986): 393-405.

210. "The Telephone Company: A.T. & T. Is Biggest Private Enterprise," *Life,* 17 July 1939, 56-63.

211. "10,000 Montana Relief Workers Make Whoopee on Saturday Night," *Life,* 23 November 1936, 9-17.

212. Ward, Geoffrey, C. "History for the World to See," *American Heritage* 37, 6 (1986): 10,12.

213. Whitman, Alden, "Margaret Bourke-White, Photojournalist, Is Dead," *New York Times,* 28 August 1971, I:1.

214. "White, Margaret Bourke," *Current Biography,* 1940, p. 862.

Bransfield, Susan
Braunstein, H. Terry

Breil, Ruth
 See also #1070
Brennan, Mrs. L. L.
 See also #1038

Bridges, Marilyn, 1948-
 See also #1015, 1041, 1058

215. Bridges, Marilyn. *Planet Peru: An Aerial Journey Through a Timeless Land*. Introduction by Fernando Belaunde Terry, Historical Commentary by John Hyslop, Afterword and Photography by Marilyn Bridges. New York: Professional Photography Division, Eastman Kodak/Aperture Foundation, 1991. 108 p.
 All photographs are accompanied by explanatory and descriptive notations.
Eroded Adobe, Túcume, 1988, p. 2; Porters, Inka Trail, 1988, p. 4-5; Desert Military Installation, Pisco Valley, 1989, p. 6-7; Moray, 1989, p. 9; Pouring Pisco, above Ollantaytambo, 1988, p. 10; Wiñay Wayna, 1988, p. 11; Twin Cinder Cones, Andagua Valley, 1989, p. 12; Alpacas, 1988, p. 14; Statuary, Tiwanaku, 1989, p. 14; Men Knitting In a Small Village Plaza, Taquile Island, Lake Titicaca, 1988, p. 15; Chulpa, Sillustani, 1989, p. 16; Camellones, Lake Titicaca, 1988, p. 16; Monoliths, Ollantaytambo, 1988, p. 17; Intiwatana, Pisaq, 1988, p. 18; Ollantaytambo, 1989, p. 19; Island of the Sun From the West, Lake Titicaca, 1989, p. 20; Island of the Sun From the Northeast, Lake Titicaca, 1989, p. 21; Tiwanaku, 1989, p. 22; Cemetery Near Tiwanaku, 1989, p. 23; Saqsawaman, Overlooking Suzco, 1989, p. 24-25; Valley of the Volcanoes #1, Andagua, 1989, p. 26; Valley of the Volcanoes #2, Andagua, 1989, p. 27; Cabanaconde, Colca Valley, 1989, p. 28; Village of Madrigal, 1989, p. 29; Village of Lari, Colca Valley, 1989, p. 30; Terracing, Madrigal, Colca Valley, 1989, p. 31; Sacred Lake, Near Chinchero, 1989, p. 32; Jagged Walls, Saqsawaman, 1989, p. 33; Kenqo, 1989, p. 34; Suchuna, Saqsawaman, 1989, p. 34; Pisaq, 1989, p. 35; Machu Picchu and Urubamaba River, 1989, p. 35; Machu Picchu, 1989, p. 36; Machu Picchu and the Peaks of the Andes, 1989, p. 37; Moray and Plain, 1989, p. 38; Moray From the Perpindicular, 1989, p. 39; Chinchero, 1989, p. 40; Tipón, 1989, p. 41; Mouth of the Volcano #1, Andagua Valley, 1989, p. 42; Mouth of the Volcano #2, Andagua Valley, 1989, p. 43; Cerro Azul, Cañete Valley, 1988, p. 44; Tambo Colorado, 1989, p. 46; Power Pole, Pueblo Joven, North of Pachacamac, 1989, p. 46; Dog, Mercado, Lima, 1989, p. 47; Spiral With Van, Mazca, 1987, p. 48; Paredones, Nazca, 1988, p. 49; Pueblos Jovenes, South of Lima, 1989, p. 50; Boys Flying Kite, El Salvador, South of Lima, 1989, p. 51; Profile of Hummingbird, Nazca, 1987, p. 51; Carhua, 1989, p. 52; Candelabra, Paracas, 1989, p. 53; Ancient Arrow, South of Ica, 1989, p. 54; Sand Dunes and Truck on Coastal Pan-American Highway, Near Chala, 1989, p. 55; Pahacamac, 1989, p. 56-57; Trapezoid Over Hill, Nazca, 1987, p. 58; Duck, Nazca, 1987, p. 59; Tail Feathers On Plateau, Nazca, 1988, p. 60; Ray Centers Among Lines, Nazca, 1988, p. 61; Pathway to Infinity, High

Overview, Nazca, 1988, p. 62; *Ray Center, Nazca,* 1988, p. 63; *Apra and Arrows, Nazca,* 1989, p. 64-65; *Feathers On Pampa, Nazca,* 1988, p. 66; *Killer Whale and Ray Center, Nazca,* 1988, p. 66; *Pampa Above Ingenio Valley, Nazca,* 1988, p. 67; *Intersecting Trapezoids, Nazca,* 1988, p. 67; *Lizard Spliced By Pan American Highway, Nazca,* 1988, p. 68; *Trapezoid With Extension, Nazca,* 1988, p. 69; *Inca Kola, Near Lima,* 1988, p. 70; *Town of Nazca,* 1988, p. 71; *Experiment in Desert Living, Pisco Valley,* 1989, p. 72; *Huacachina,* 1989, p. 73; *Man On Highway, Near Lima,* 1988, p. 74-75; *Desertscape, Near Carhua,* 1989, p. 76; *Ray God and Cats, Ica,* 1989, p. 77; *Segment of Inka Highway, Near Quebrada de la Vaca,* 1989, p. 78; *Pockmarks, Pisco Valley,* 1989, p. 79; *Field Systems, Atiquipa,* 1989, p. 80; *Kawachi, Nazca,* 1988, p. 81; *Cinder-Block Factory, Just South of Lima,* 1989, p. 82; *La Centinela, Chincha Valley,* 1989, p. 83; *Factory, Chimbote,* 1989, p. 84; *Urban Development, Lambayeque Valley,* 1988, p. 86; *Bird, Chan Chan,* 1989, p. 87; *Church, Huanchaco,* 1989, p. 87; *Paramonga,* 1989, p. 88; *Walls, Chan Chan,* 1989, p. 89; *Chankillo, Casma Valley,* 1989, 90; *Unidentified Hilltop Site, Chicama Valley,* 1989, p. 91; *Chotuna, Lambayeque Valley,* 1988, p. 92; *Sipan, Lambayeque Valley,* 1988, p. 93; *Chan Chan,* 1989, p. 94-95; *Ancient Ridged Fields, Casma Valley,* 1989, p. 96; *Pacatnamú Valley's Edge,* 1988, p. 97; *Eroded Pyramids, Pacaatnamú,* 1989, p. 98; *Great Walls of Peru, Santa Valley,* 1989, p. 99; *Huanchaco,* 1989, p. 100-101; *El Purgatorio, Lambayeque Valley,* 1988, p. 102; *Pyramid of the Moon, Moche Valley,* 1989, p. 103; *Pyramid of the Sun,, Moche Valley,* 1989, p. 103; *Cerro Sechín, Casma Valley,* 1989, p. 104; *Unexplored Ruins, Viru Valley,* 1989, p. 105;

216. Bridges, Marilyn. *Sacred and Secular: A Decade of Aerial Photography.* New York: International Center of Photography, 1990. 63 p. Chiefly illustrations.

217. Bridges, Marilyn. *Sacred and Secular: The Aerial Photography of Marilyn Bridges.* New York: Voyager, 1998.
 Computer laser optical disc + guide. Includes 100 black-and-white images.

218. Bridges, Marilyn. *This Land is Your Land: Across America by Land.* New York: Aperture, 1997. 106 p.

219. Dolin, Penny Ann. "Exhibitions: Marilyn Bridges," *American Photographer* 5, 4 (October 1980): 21-22.

220. Goldberg, Vicki. "An Intimacy With the Land: The Aerial Photography of Marilyn Bridges," *Archaeology* 44, 6 (November/December 1991): 32-39.

Bright, Deborah
 See also #1055, 1062

Brigman, Anne W., 1869-1950
See also #1000, 1009, 1022, 1026, 1027, 1053, 1058, 1061, 1063

221. Brigman, Anne. "Awareness," *Design* (June 1936): 17-19.

222. Brigman, Annie W. "The Glory of the Open," *Camera Craft* 33, 4 (April 1926): 155-163.

223. Brigman, Annie W. "A Jury and a Salon," *Camera Craft* 37, 3 (March 1930): 126-128.

224. Brigman, Annie W. "Just a Word," *Camera Craft* 15,3 (March 1908): 87-88.

225. Brigman, Anne. *Songs of a Pagan*. Caldwell, ID: Caxton Printers, Ltd., 1949. 90 p.
 Poems illustrated with photographs by the author.
Self Portrait, 1928, p. 7; *Sonatina*, p. 13; *Fantasia*, p. 15; *The Breeze*, p. 17; *The Amazons*, p. 19; *Pan*, p. 21; *The Fairy Lake*, p. 23; *The Wind Harp*, p. 25; *Sierra Night*, p. 27; *The Hamadryads*, p. 29; *Wind and Tide*, p. 31; *The Limpid Pool*, p. 33; *The Witches*, p. 35; *Sanctuary*, p. 37; *Harlequin*, p. 39; *The Dryad*, p. 41; *Rhythm*, p. 43; *Invictus, p. 45; Harp of the Winds*, p. 47; *The Dying Cedar*, p. 49; *Onward*, p. 51; *The Soul of the Blasted Pine*, p. 53; *Lady Macbeth*, p. 55; *Minor*, p. 57; *"By the Wind,"* p. 59; *Ballet de Mer*, p. 61; *Sun Dazzle*, p. 63; *The Strength of Loneliness*, p. 65; *Ebb Tide*, p. 67; *Solstice*, p. 69; *Wings*, p. 71; *Madonna*, p. 73; *The Sandpipers*, p. 75; *El Doloroso*, p. 77; *Judgment Seat*, p. 79; *Gray Day*, p. 81; *The Singing Sea*, p. 83; *Infinitude*, p. 85; *Tryst*, p. 87.

226. Brigman, Annie W. "What 291 Means to Me," *Camera Work* 47 (July 1914): 17-20.

227. Ehrens, Susan. *A Poetic Vision: The Photographs of Anne Brigman*. Santa Barbara, CA: Santa Barbara Museum of Art, 1995. 96 p. Bibliography: p. 93-96.

228. Hamilton, Emily J. "Some Symbolic Nature Studies from the Camera of Annie W. Brigman," *The Craftsman* (September 1907): 660-666.

229. Heyman, Therese Thau. *Anne Brigman: Pictorial Photographer/Pagan/Member of the Photo-Secession*. Exhibition Catalogue. Oakland: Oakland Museum, 1974. 18 p. Includes a descriptive chronology.
The Source, 1906, p. 5; *Minor*, 1910, p. 7; *The Cleft of the Rock*, 1912, p. 9; *The Soul of the Blasted Pine*, 1907, p. 11; *The Bubble*, 1905, p. 12; *The Hamadryads*, p. 13; *Quest (Elizabeth Nott and husband)*, p. 14.

Brooke, Kaucyila
 See also #1055, 1062
Brooks, Charlotte
 See also #1058
Brooks, Eileen
 See also #1008
Brooks, Linda
 See also #1055
Brown, Alberta H.
 See also #1040
Brown, Beatrice
 See also #1058
Brown, Gillian
 See also #1006

Brown, Laurie (Lawrie?)
 See also #1041

230. Dowell, Carol. "Plantscapes: The Photography of Lawrie Brown," *Darkroom Photography* 8,6 (October 1986): 34-37.

231. "The Jungle Look," *American Photographer* 20, 6 (June 1988): 13.

Brown, Nancy
 See also #1069
Brundege, Barbara
 See also #1039
Brush, Gloria Defilipps, 1947-
 See also #1058

Bubley, Esther, 1921-
 See also #1009, 1013, 1058

232. Bubley, Esther. *Esther Bubley on Assignment: Photographs Since 1939: An Exhibition.* [Buffalo, NY]: Bethune Gallery, University at Buffalo, 1989. 24 p. Includes bibliographical references. Chiefly illustrations.
 A short biographical essay accompanies the photographs.
Little boy on a street car, Washington, D.C., 1943, fig. 1; *Gum machines,* 1945, fig. 2; *Girl sitting alone in the Sea Grill and Bar, Washington, D.C.,* 1945, fig. 3; *Waiting for a bus at the Memphis Terminal,* 1943, fig. 4; *Nursery School pupils at Bayway Community Center, Elizabeth, NJ,* 1944, fig. 5; *Tomball, Texas,* 1945, fig. 6; *Soldiers in photobooth, Washington, D. C.,* 1943, fig. 7; *Optometrist Shop, New York,* 1945, fig. 8; *Worker resting on car, Texas,* 1945, fig. 9; *Catatonic schizophrenia patient, New Jersey,* Ladies Home Journal, 1949, fig. 10; *18 year old*

JoAnn Holt, Rochmont, NC, Ladies Home Journal, 1950, fig. 11; *The McKay family, Topeka, Kansas, Ladies Home Journal,* 1951, fig. 12; *Choir Boy with toy gun, Brooklyn, NY, Life Magazine,* 1951, fig. 13; *Marianne Moore,* 1953, fig. 14; *The Congressman and the Baby take a Trip,* 1952, fig. 15; *Cheltenham Ladies College,* 1954, fig. 16.

233. Bubley, Esther. *Esther Bubley's World of Children in Photographs.* New York: Dover Publications, 1981. 105 p. Chiefly illustrations.

234. Bubley, Esther. *A Mysterious Presence: Macrophotography of Plants.* New York: Workman Publishing Co., 1979. 182 p.

235. Dieckmann, Katherine. "A Nation of Zombie: Government Files Contain the Extraordinary, Unpublished Photographs that Esther Bubley Took on One Look Bus Ride Across Wartime America," *Art in America* 77 (November 1989): 55-61.

236. Ellis, J. "Esther Bubley: FSA Documentarist," *History of Photography* 20, 3 (Fall 1996): 265-270.

237. "The Photographers: Esther Bubley," http://www.clpgh.org/exhibit/photog6.html

Buehrmann, Elizabeth, 1886-1954
 See also #1058

238. Goodman, H. "Elizabeth Buehrmann, American Pictorialist," *History of Photography* 19, 4 (Winter 1995): 338-342.

239. Miller, J. "Elizabeth Buehrmann Letters," *History of Photography* 13, 2 (1989): 187.

Bulin, Marion
 See also #1071
Bullaty, Sonia
 See also #1069

Bullock, Edna
 See also #1007

240. Bullock, Edna. *Edna's Nudes.* Santa Barbara: Capra Press, 1995. 112 p. Bibliography: p. 105-106.

Bumgarner, Gay
 See also #1039

Bundy, Rhodina B. (Mrs. O.C.)
　　See also #1038
Burns, Marsha, 1945-
　　See also #1007, 1012, 1058

Burson, Nancy, 1948-
　　See also #1008, 1011, 1058

241.　Burson, Nancy. *Composites: Computer-Generated Portraits*. New York: Beech Tree Books, 1986. 95 p.

242.　Edwards, Owen. "Portraits with Bursonality: Nancy Burson's Latest Composites Bid Reality Adieu," *American Photographer* 22, 5 (May 1989): 26-28.

243.　Kaplan, Michael and Evelyn Roth. "Altered States: Nancy Burson's Witty Visual Statements Question the Foundations of Our Most Basic Notions" *American Photographer* 15, 1 (July 1985): 68-73.

Butler, Linda, 1947-
　　See also #1058
Butler, Lynn
　　See also #1034
Buttfield, Helen
　　See also #1069
Cade, Cathy
　　See also #1062

Caffery, Debbie Fleming, 1948-
　　See also# 1008, 1015, 1058, 1063

244.　Caffery, Debbie Fleming. *Carry Me Home: Louisiana Sugar Country Photographs*. Washington, D.C.: Smithsonian Institution Press, 1990. 119 p.

245.　Hagen, Charles. "Debbie Fleming Caffery: A Land and Its People," *Aperture* 115 (Summer 1989): 10-15.

Cahn, Elinor B.
　　See also #1000

Callis, Jo Ann, 1940-
　　See also #1008, 1017, 1058, 1063

246.　Callis, Jo Ann. *Jo Ann Callis*. Tokyo: Gallery Min, 1986. 86 p. Chiefly

illustrations.

247. Clothier, P. "Jo Ann Callis," *Artnews* 95, 4 (1996): 141.

248. Cutajar, Mario. "Raising the Dead," *Artweek* 22, 16 (1991): 11.

249. Kandel, S. "Jo Ann Callis," *Arts Magazine* 66, 1 (1991): 91.

250. Koplos, J. "Jo Ann Callis," *Art in America* 79, 12 (December 1991): 123-124.

251. Levinson, Joel D. "Hot Shots: Jo Anne Callis," *Darkroom Photography* 2, 1 (January/February 1980): 15.

Cameron, Evelyn, 1868-1928
See also #1038, 1058

252. Lucey, Donna. *Photographing Montana, 1894-1928: The Life and Work of Evelyn Cameron.* New York: Alfred A. Knopf, 1990. 250 p. Bibliography: p. 239-242.
Sheep Rancher, Montana, 1905, frontispiece; *Fourth of July picnic*, 1908, xiv; *Spectacular buttes in the badlands*, c. 1900, xviii; *Goshawk with its prey*, 1906, p. 2; *Nest of a red-tailed hawk*, p. 3; *A professional hunter, Michael Lavy*, 1902, p. 4; *Charles McKay's remote cattle ranch on the eastern Montana prairie*, 1905, p. 5; *Reno Walters and his family on the cable-drawn ferry on the Yellowstone River*, before 1910, p. 6; *Downtown Fallon and its denizens*, 1904, p. 7; *Blocks of pertrified trees*, p. 8; *Ewen Cameron settles an account with Reno Walters*, 1902, p. 11; *Range horses that roamed freely over eastern Montana's open grassland*, p. 15; *XIT cowboys at midday during the fall roundup of cattle*, pl. 16; *The three Stith children in front of J. W. Stith's hardware store*, 1899, p. 18; *A view from the badlands toward the Yellowstone River*, p. 19; *Evelyn's brother Alec Flower stands next to an impressive harvest of cabbages*, 1898, p. 21; *A portrait of the Tusler family*, 1898, p. 22; *the Williams sisters in the roundup cook tent*, 1910, p. 27; *An unidentified man on the prairie with two horses*, p. 29; *The Terry Hotel*, p. 31; *An unidentified family in front of their log house*, p. 33; *Family portrait of the Hamlins and the Braleys*, 1902, p. 34; *An ice cream party at the home of Alice Hamlin*, 1902, p. 35; *Mr. and Mrs. Pope and their son Elmer*, 1902, p. 36; *Watching cattle being loaded onto railroad cars*, 1899, p. 39; *A handler steadies "Sir Elmore,"* p. 42; *An unidentified horse ranch in eastern Montana*, p. 43; *Ed Bright reaches through a fence to vaccinate one of the cows*, 1899, p. 46; *A roundup wagon packed with supplies*, 1910, p. 47; *Roundups were visited by the representatives of distant ranches*, p. 48; *Charlie Clement with his pack of deer hounds*, p. 49; *XIT cowboys on the Montana range*, p. 50; *[On the range]* 1904, p. 51; *Ewen, J.H. Price, Janet Williams, and her sister Mabel, at Price's horse ranch*, 1909, p. 52; *Janet Williams and Zip, her favorite horse*, 1911, p. 53; *The three Buckley sisters,*

Mabel, May, and Myrtle, in their corral, p. 54; *A steer-roping contest on the Fourth of July*, 1910, p. 55; *Ewen poses with a pronghorn antelope he shot*, 1890s, p. 56; *During hunting, one of the horses*, p. 59; *A group of XIT cowboys crossing the Yellowstone on the Fallon Ferry*, 1904, p. 61; *A large buck shot by Ewen*, 1899, p. 69; *Ewen on a hunting trip through the badlands*, 1899, p. 70; *Dead coyote in a wolf's den*, p. 73; *The solitary camp of a wolfer who earned his living trapping coyotes and wolves*, p. 73; *A hunting trophy*, p. 74; *The second Eve Ranch*, 1902, p. 78; *Evelyn with a young golden eagle against a backdrop of badlands buttes*, p. 79; *Workmen hoisting the final pine log for a new room in the ranch house*, 1908, p. 80; *Evelyn kneading a panful of dough in her kitchen*, 1904, p. 83; *Cattle strung single file along the badlands hills after a 42-hour blizzard*, 1904, p. 85; *Each August, prairie hay was cut and stacked for winter feed by haying outfits that went from ranch to ranch*, p. 87; *Ewen at breakfast*, 1903, p. 91; *Evelyn milking a cow*, 1904, p. 93; *Evelyn poses in her vegetable garden with an array of squash*, p. 94; *A dead bittern*, 1902, p. 97; *A goshawk perches on Ewen's hand*, 1907, p . 99; *Effie and Major Philip S. Dowson sit with Evelyn next to a cedar grove*, 1903, p. 103; *Two wolf cubs*, 1907, p. 106; *Jetta Gray, A Scottish woman who lived near one of the ranches*, p. 107; *Ewen with their two wolves*, p. 108; *The Heywood Daly Ranch*, p. 113; *Paul Rnn, Sr., checks on one of his family's bands of sheep*, p. 114; *The Union Church, the town of Terry's first permanent house of worship*, c. 1906, p. 117; *[Evelyn standing on top of her horse]*, p. 118; *Evelyn mounts prints on cardboard in the kitchen of her ranch house*, p. 120; *The Scott and Gipson families in the yard of the Gipson's house*, p. 123; *A golden eagle's nest atop a badlands butte*, p. 126; *A young eaglet*, p. 127; *Evelyn feeding a grasshopper to one of the many wild birds which she and Ewen tamed*, p. 129; *Ida Archdale feeds her proghorn antelopes*, p. 130; *Evelyn on a petrified tree in the badlands*, p. 133; *Cowboys on horseback and in rowboats prodded the cattle to swim across the Yellowstone River*, 1904, p. 134, 135; *Reno Walters and his brother with their band of sheep*, 1902, p. 136; *Nels and Sam Undem shepherding their new flock in the lambing season*, p. 137; *Caked with dirt and sweat, this group of sheepshearers was photographed inside the pens*, p. 138; *Lucille and Paul with the first bicycle in Terry and a goat-drawn wagon*, p. 139; *George Burt purchased the first automobile in the area*, 1904, p. 140; *George Burt, and his young son Paul, stand amidst wool clipped with steam-driven mechanical shears*, p. 141; *An impromptu boxing match in early summer*, 1905, p. 142; *The log shack where the cooks and children worked and slept for weeks during sharing season*, p. 143; *Nels Undem with his flock of sheep*, 1905, p. 145; *Alfred Wright visits her herder and wether band of 3,000 sheep after an early morning snowfall*, 1905, p. 146; *The small sheep wagon where the herder lived in the fall and spring months*, p. 147; *Nels Undem at his lambing camp*, 1904, p. 148; *The annual shearing at Powder Bridge*, 1905, p. 149; *This shearer hunches over a sheep in front of sacks of wool*, p. 150; *A stream-driven traction engine drags sixty-five sacks of newly shorn wool*, p. 151; *A baby rests its hand on a smiling big brother*, p. 154; *An infant, its thin patch of hair carefully parted, and the family dog*, p. 154; *[Children and the family cow]* p. 155; *[Young girl at her dolls' tea party]* p. 155; *Postmistress Susie Snow and her*

husband in front of their combination log house and post office, p. 157; *Terry's Main Street*, c. 1910, p. 158; *The Central Cafe, which had such trappings of civilization as lace curtains in the windows*, c. 1910, p. 159; *Railroad workers with a handcar they used to transport themselves up and down the line*, p. 161; *Two Italian railroad workers pose for their portraits*, p. 162; *The wedding celebration of a German-Russian couple*, 1912, p. 164; *A line of wagons proceeds across the prairie for the funeral of a setter, Mrs. Kist*, 1913, p. 165; *Mrs. Wist's burial*, p. 165; *A case threshing machine, which is separating grain from its husks*, p. 166; *A group inspecting the threshing of the Whaley's crop*, p. 167; *Unidentified farmers in their Sunday clothes*, p. 168; *J. D. Johnson in front of his barn*, 1913, p. 169; *Mabel Williams brings water to the threshing crew at work on her family's farm*, 1909, p. 170; *The tiny homestead of a farming couple*, p. 171; *Ned Hogmire holds a pair of horses*, 1909, p. 172; *The interior of a typical Montana homestead of the early 1900s, with a bare dirt floor and log posts supporting the roof*, p. 173; *In the Buckley sisters' corral*, p. 175; *Yound German-Russian woman plowing the field*, 1912, p. 176; *Another German-Russian woman, Rosie Roesler, built this homestead*, c. 1912, p. 177; *[Teacher and children by log schoolhouse]* 1907, p. 180; *The Williams sisters and Evelyn on Dolly to advertise her photography business*, 1910, p. 183; *[Portrait of a young boy standing on a chair]* p. 185; *Janet Williams and a young coyote*, 1911, p. 186; *Ewen, Mabel, Roy, and Janet Williams*, p. 187; *[Group portrait of German picnickers]* 1913, p. 188, 189; *Unidentified mother and children*, p. 190; *Jack Rice in an armchair*, 1913, p. 191; *Unidentified family group*, p. 192; *Unidentified mother and daughter*, p. 193; *Portrait taken on some patriotic occasion*, p. 194; *Whipple's ferry was used as a dance floor during the town's Fallon's Fourth of July celebration*, 1903, p. 195; *[Portrait of a young child]*, p. 196; *Ewen and a mounted grey trumpeter swan*, 1914, p. 197; *Two of the most prominent Britons in eastern Montana were Effie and Philip Dowson*, p. 198; *Effie Dowson at the Cross S Ranch*, 1897, p. 201; *Kathleen Lindsay, an Irish expatriate, riding sidesaddle*, p. 204; *Evelyn introduced the divided skirt to Montana*, p. 205; *J. H. Price, a horse rancher, was one of the stalwarts of the British community then living in Montana*, 1902, p. 209; *The Cross S Ranch, photographed at sunset*, 1902, p. 212; *The sitting room at the Corss S Ranch, photographed through an open window*, p. 213; *Ida Archdale in the sitting room of her ranch house*, p. 215; *The Archdales raised horses and cattle at their Fiddleback Ranch*, p. 216; *A group of British rancers gathers on the porch*, 1907, p. 216; *Lance Irvine sits on a horse' neck to restrain it as J.H. Price apples his Crown W brand*, p. 218; *Group of men*, p. 219; *J. H. Price, formerly a professor at Oxford, was one of the Montana ranchers who made a great deal of money selling horses to the British Army*, p. 220; *Evelyn and Janet Williams*, 1910, p. 222; *Ewen drive across the prairie*, p. 225; *Hoar frost has turned the landscape brittle in this view of the Eve Ranch*, p. 229; *[Railroad tracks through Marsh, Montana]* p. 230; *On dark days, light for the classroom at the Marsh school was provided by the oil lamp suspended from the ceiling*, p. 231; *Marsh's combined general store and post office*, p. 232; *The opening of the German Lutheran church in Marsh*, 1920, p. 233; *Evelyn sits with a coyote on her lap*, p. 237.

253. "Montana Album," *Americana* 18 (January/February 1991): 33-37.

Campbell, Carolee
 See also #1070
Carr, Kathleen Thormod
 See also #1039
Carrey, Bobbi
 See also #1006, 1061, 1070
Carroll, Pamela
 See also #1055, 1070
Carroll, Patty
 See also #1063, 1070
Casananve, Martha
 See also #1055
Caulfield, Patricia
 See also #1070
Chadwick, Helen
 See also #1015

Chapelle, Dickey, 1919-1965

254. Chapelle, Dickey. "I Roam the Edge of Freedom," *Coronet* 52 (February 1961): 129-141.

255. Chapelle, Dickey. *What's a Woman Doing Here? A Reporter's Report on Herself.* New York: Ziff-Davis, 1961. 285 p.
 Autobiographical account of Chapelle's work throughout the world as a correspondent for the U.S. Armed Forces.
Self-Portrait, 1942; Panama Canal Zone, Artillerymen, 1942; Cutting barbed wire, 1942; Iwo Jima, ferrying the wounded, 1945; View from the well deck of the U.S.S. Samaritan; The Dying Marine, Iwo Jima, 1945; Pfc. Johnnie Hood; View from the Marine field hospital; Pfc. George Bebbington waiting his turn for treatment; Looking across the Marine field hospital and runways; The cemetery of the war dead on Guam, 1945; Lt. Cmdr. John S. Cowan, in the field, 1945; Treatment of combat fatigue; Hungarian refugee family escaping on foot, 1956; Hungarian refugee making her way across a rope-and-log bridge, 1956; My welcome home from the Red prison, 1957; Algerian Bedouin youngster, 1957; Defendant in Algeria; Removing the handcuffs of the convicted Algerian Paratrooper in plane over Lebanon, 1958; Major Sam Cox, in Lebanon, 1958; In one of Castro's command posts; Lt. Cypriano, a platoon leader in Castro's forces, 1958.

256. Chapelle, Dickey. "With the Paratroopers," *The Readers' Digest* 80 (February 1962): 292-298.

257. Ostroff, Roberta. *Fire in the Wind: The Life of Dickey Chapelle.* New

York: Ballantine Books, 1992. Bibliography: p. 391-395. 408 p.

Charlesworth, Sarah E.
See also #1008
Chester, Sharon
See also #1039
Chung, P. K.
See also #1071

Chwatsky, Ann, 1942-

258. Chwatsky, Ann. "Sisters," *U.S. Camera* (Fall 1977): 59-61.

Clay, Maude Schuyler
See also #1063
Clemens, Karen
See also #1006
Cohen, Joyce Tenneson
See **Tenneson, Joyce**
Cohen, Lynne
See also #1058, 1063
Coleman, Judy
See also #1012
Collins, Marjory
See also # 1013, 1058
Cones, Nancy Ford
See also #1058
Conklin, Honor
See also #1006
Connell, Priscilla
See also #1039
Conner, Lois
See also #1024, 1033, 1063

Connor, Linda, 1944-
See also #1008, 1030, 1053, 1058, 1063

259. Connor, Linda. *Linda Connor.* Washington, D.C.: The Corcoran Gallery
of Art, 1983. Bibliography: p. 27-28. 30 p.

260. Connor, Linda. *Linda Connor Visits: November 1 - December 31, 1996.*
Syracuse, NY: Robert B. Menschel Photography Gallery., 1996. 22 p.
Unpaged. Chiefly illustrations.
Catalogue of an exhibition with an introductory essay by Jeffrey Hoone.
Tomb Doorway, Petra, Jordan, 1995; *Hand, Mystery Valley, Utah,* 1995; *Machu*

Picchu, Peru, 1984; *Apollo, Mount Nemrut, Turkey,* 1992; *Banares, India,* 1979; *Sleeping Baby, Katmandu, Nepal,* 1980; *Stones, Kau Desert, Hawaii,* 1991; *Blind Musician, Kashmir, India,* 1985; *Tree, Japan,* 1988; *Farmer Washing Spinach, China,* 1993; *Young Man Callused by Prostrations, Tibet,* 1993; *Spirit Door, Egypt,* 1989; *Tree Decorated with Ceremonial Cloth, Bali,* 1991; *Petroglyph and Star Trails, Sonora, Mexico,* 1991; *Entwined Buddha, Ayuthaya, Thailand,* 1988; *Dolmen, Ireland,* 1986; *Votive Candles, Chartres, Cathedral, France,* 1989; *The Patient One, Lamayuru, Ladakh, India,* 1988; *Ceremony, Sri Lanka,* 1979; *Sacred Text, Ethiopian Church, Jerusalem,* 1995.

261. Connor, Linda. *Luminance.* Carmel Valley, CA: Woodrose Publishing in association with the Center for Photographic Art, 1994. Unpaged. Chiefly 35 illustrations.
 Short essay by Rebecca Solnit that describes Connor's creative process of taking and developing her photographs.

Open Wall, Christian Chapel, Cappadocia, Turkey, 1992; *Ceremony, Sri Lanka,* 1979; *Coptic Monastery, Egypt,* 1989; *Forest Floor, Brittany, France,* 1983; *Muhammad Ali Mosque, Cairo, Egypt,* 1989; *Afternoon, Lake Namtso, Tibet,* 1993; *Morning, Lake Namtso, Tibet,* 1993; *Monk with Offering, Phiyang Monastery, Ladakh, India,* 1993; *Open Dome, Caravansary, Turkey,* 1992; *Shirt, Banaras, India,* 1979; *Monastery Kitchen, Tibet,* 1993; *The Patient One, Lamayuru Monastery, Ladakh, India,* 1988; *Petrogylphs and Star Trails, Sonora, Mexico,* 1991; *Tibetan Shadow and Cairn, Lake Namtso, Tibet,* 1993; *Pre-Historic Cave, Tsankawee, New Mexico,* 1988; *BedrockBuddha, Sri Lanka,* 1979; *Stream, Connecticut,* 1981; *Votive Candles,Chartres Cathedral, France,* 1989; *Vajra, Zanskar, Ladakh, India,* 1985; *Stream, North Carolina,* 1986; *Mudra, Mindroling Monastery, Tibet,* 1993; *Crocodile, Valley of the Kings, Egypt,* 1989; *In the Shadows of the Pyramids, Egypt,* 1989; *Standing Stone, Dingle, Ireland,* 1986; *Rio Grande Taos, New Mexico,* 1989; *Window, Christian Chapel, Cappadocia, Turkey,* 1992; *Statues, Kharjaraho, India,* 1979; *Petroglyphs, Puako, Hawaii,* 1986; *Moon Rise, India,* 1979; *Waterfall, China,* 1993; *Passage, Drepung Monastery, Tibet,* 1993; *Nun Saying Prayers in Her Family Kitchen, Ladakh, India,* 1988; *Sun Dog, California,* 1981; *Stone with Hieroglyphics, Egypt,* 1989; *Spirit Door, Egypt,* 1989.

262. Connor, Linda. *Spiral Journey: Photographs 1967-1990.* Preface by Denise Miller-Clark, Introduction by Rebecca Solnit. Chicago: Museum of Contemporary Photography, Columbia College Chicago, 1990. 67 p. Bibliography: p. 19.
 Critical essay by Solnit which interprets and explains Connor's photographic exploration of the sacred.

Lotus, Kashmir, India, 1985, cover, pl. 44; *Hennaed Hand, Nepal,* 1980, fig. 1; *Entwinned Buddha, Ayuthaya, Thailand,* 1988, fig. 2, pl. 33; *Buddha's Footprints, India,* 1979, fig. 3; *Baby Feet,* 1978, fig. 4; *My Hand with My Mother's,* 1987, fig. 5; *Family,* 1988, fig. 6; *Bureau Top, Norwalk, Connecticut,* 1967, pl. 1; *Family Portraits on My Grandmother's Bed, Stoneham, Massachusetts,* 1967, pl. 2; *My*

Mother with Heart and Thorns, 1967, pl. 3; *All American Landscape*, 1968, pl. 4; *My Parents in a Basket*, 1969, pl. 5; *Chicago Homage*, 1968, pl. 6; *Confirmation, Chicago*, 1968, pl. 7; *Woman and Landscape*, 1968, pl. 8; *Birth of Venus*, 1971, pl. 9; *Maine Forest*, 1971, pl. 10; *A Page from Jean's Book*, 1983, pl. 11; *Leaf*, 1972, pl. 12; *River, Georgia*, 1977, pl. 13; *Man at Hot Springs, Baja, Mexico*, 1975, pl. 14; *Foot and Hand*, 1975, pl. 15; *Yucatan, Mexico*, 1976, pl. 16; *Girl, Guatemala*, 1976, pl. 17; *Chairs, Yosemite, California*, 1975, pl. 18; *Child's Room*, 1976, pl. 19; *Fish*, 1975, pl. 20; *Antlers, Wyoming*, 1974, pl. 21; *Tree, Santa Cruz, California*, 1975, pl. 22; *Nude with Net, West Indies*, 1976, pl. 23; *Ceremony, Sri Lanka*, 1979, pl.24; *Kachina Kiva, Utah, 1982*, pl. 25; *Petroglyphs, Puuloa, Hawaii*, 1986, pl. 26; *Religious Effigies, Banaras, India*, 1979, pl. 27; *Blind Musician, Kahsmir, India*, 1985, pl. 28; *Moonrise, India*, 1979, pl. 29; *Journal with Goddessess, Tymor*, 1984, pl. 30; *Sora*, 1985, pl. 31; *Sleeping Baby, Kathmandu, Nepal*, 1980, pl. 32; *Hindu Woman with Tattoos, India*, 1979, pl. 34; *Dots and Hands, Fourteen Window Ruin, Utah*, 1987, pl. 35; *Kapo Kohe Lele, Ancient Ceremonial Cave for Pele, Goddess of the Volcano, Puna, Hawaii*, 1986, pl. 36; *Dolmen, France*, 1989, pl. 37; *Horns and Prayer Flags, Tiktse Monastery, Ladakh, India*, 1985, pl. 38; *Smiling Monk, Ladakh, India*, 1985, pl. 39; *Banaras, India*, 1979, pl. 40; *Cloud and Corral, Alta Plano Peru*, 1984, pl. 41; *Jain Nuns, India*, 1979, pl. 42; *Coptic Monastery, Egypt*, 1989, pl. 43; *Veiled Woman, India*, 1979, pl.45; *Hoof, Kathmandu, Nepal*, 1980, pl. 46; *The Patient One, Lamayuru Monastery, Ladakh, India*, 1985, pl. 47; *Black Canyon of the Gunnison, Colorado*, 1987, pl. 48; *Monk's Residence, Zanskar, India*, 1985, pl. 49.

263. Desmarais, Charles. "Linda Connor," *California Museum of Photography Bulletin* 2, 2 (1983):1-15.

264. Grundberg, Andy and Julia Scully. "Currents: American Photography Today," *Modern Photography* 45, 8 (August 1981): 102-105+.

265. Palmer, Rebecca. "Knowledge of the Earth. (San Jose Institute of Contemporary Art, California)," *Artweek* 9 January 1988, 10-11.

266. Webster, Mary Hull. "A Conversation with Linda Connor (interview)," *Artweek* 17 December 1992, 4-5.

Content, Marjorie, 1895-1984
 See also #1058, 1063

267. Quasha, Jill. *Marjorie Content: Photographs.* Essays by Ben Lifson, Richard Eldridge and Eugenia P. Janis. New York: Norton, 1994. 159 p. The biographical and critical essays on the life and work of Content are augmented with numerous quotations from her personal letters and a chornology.
Susan Loeb, 1930, Front Jacket; *Self-Portrait,* c. 1928, Back Jacket; *From*

Washington Square, New York, c. 1928, pl. 1; *Paris--Rain, Winter,* 1931, pl. 2; *Washington Square, New York,* c. 1928, pl. 3, 5, 7; *Amaryllis,* 1931, pl. 4, 9; *Backyard, 38 West 10th Street, New York,* 1931, pl. 6; *Mary Hamlin's Courtyard, Taos, Summer,* 1933, pl. 8; *Amaryllis,* 1931, pl. 9; *Anthurium in Vase,* 1931, pl. 10; *Piano Strings,* c. 1928, pl. 11; *Chess Pieces,* c. 1928, pl. 12; *Cigarette Pack with Matches,* c. 1928, pl. 13; *Calla Lily and Leaf,* 1931, pl. 14; *Bruce Christen,* c. 1926, pl. 15; *Cigarettes on Tray,* c. 1928, pl. 16; *Vat 69,* c. 1928, pl. 17; *From the Windows of Doctors Hospital, New York, Winter,* 1933, pl. 18, 19; *Jean Toomer, 39 West 10th Street, New York, Spring,* 1934, pl. 20; *Steamship Pipes, Paris, Winter,* 1931, pl. 21; *Helen Herendeen,* c. 1926, pl. 22; *Jade Tree Leaves,* c. 1928, pl. 23; *Marsden Hartley,* c. 1929, pl. 24; *Consuelo Kanaga,* c. 1928, pl. 25; *Self-portrait,* c. 1928, pl. 26; *Bulbs,* 1931, pl. 27; *Water Lily,* c. 1928, pl. 28; *Calla Lily,* 1931, pl. 29, 35; *Lola Ridge,* 1935, pl. 30, 68; *Susan Loeb,* 1930, pl. 31, 32, 33, 34; *Ferns,* c. 1934, pl. 36; *Chaunce Dupee and Jean Toomer, Portage, Wisconsin,* Summer 1934, pl. 37; *Budding Amaryllis,* 1931, pl. 38; *Edward Bright,* c. 1930, pl. 39; *Pussywillows,* c. 1928, pl. 40; *Skies at Mill House, Doylestown, Pennsylvania,* 1941, pl. 41; *Moon with Clouds, Wading River, Long Island,* c. 1928, pl. 42; *Las Trampas Church, New Mexico,* Summer 1932, pl. 43; *Rock Form,* Summer 1932, pl. 44; *Tent Caterpillar,* c. 1928, pl. 45; *Church in Woodbury, Connecticut,* January 2, 1933, pl. 46; *Quebec,* October 1937, pl. 47, 48; *At Georgia O'Keeffe's Ghost Ranch, New Mexico,* 1935, pl. 49; *Cornstalk, Taos,* Summer 1933, p. 50; *Adam Trujillo and His Son, Taos,* Summer 1933, pl. 51; *Kachinas at Juan Mirabel's Taos,* Summer 1933, pl. 52; *Hill Behind Alice Evans House, Tesuque, New Mexico,* Summer 1935, pl. 53; *Big Springs, Whiteriver, Arizona,* c. 1933, pl. 54; *Maria Trujillo and Her Daughter, Taos,* Summer 1933, pl. 55; *Wild Plums, Taos,* Summer 1933, pl. 56; *Adam Trujillo and His Son, Taos,* Summer 1933, pl. 57; *Navajo Women at Red Lake, Arizona,* c. 1933, pl. 58, 59; *Navajo Women at Sheep Dip, Shonto, Arizona,* c. 1933, pl. 60, 61; *Grand Canyon,* c. 1932, pl. 62, 63, 64, 65; *Genus Baird, Fort Defiance, Arizona,* Summer 1932, pl. 66; *Canyon de Chelly,* Summer 1932, pl. 67; *Juan Mirabel's Oven, Taos,* Summer 1933, pl. 69; *Blue Canyon Rock Form,* Summer 1932, pl. 70; *Gordon Grant,* 1932, pl. 71; *Kansas,* Summer 1934, pl. 72; *Many Glacier, Canada,* Summer 1931, fig. 32; *Darien, Connecticut,* c. 1933, fig. 33; *At Alfred Stieglitz's, Lake George, New York, Spring* 1932, fig. 34; *Cleaning Up the farm, Doylestown, Pennsylvania,* 1936, fig. 35; *Rice's Sale, Solebury, Bucks County, Pennsylvania,* c. 1941, fig. 36, 38; *Mill House, Butcher House (later Content's darkroom), and the Mill, Doylestown, Pennsylvania,* January 1936, fig. 37; *Jean Toomer and Lin Davenport Pitching Wheat, Doylestown, Pennsylvania,* July 1937, fig. 39; *Michael Carr with Susan Loeb,* c. 1923, fig. 6; *Jim and Susan Loeb, New City, New York,* c. 1923, fig. 7; *Susan Loeb, New City, New York,* c. 1923, fig. 8; *Henry Varnum Poor's Hands and Palette,* Winter 1933, fig. 9; *Leon Fleischman,* fig. 10; *Alice Evans and Jean Toomer at Horse Show in Santa Fe,* Summer 1935, fig. 11; *Jean Toomer, 39 West 10th Street, New York, Spring* 1934, fig. 12; *Georgia O'Keeffe, Alcalde, New Mexico,* 1934, fig. 13; *Margot ("Argie") Toomer, Three Years Old,* March 1935, fig. 14.

Cook, Diane
 See also #1071

Cook, Kathleen Norris
 See also #1039

Cook, Mariana, 1955-

268. Cook, Mariana. *Fathers and Daughters in Their Own Words.* Introduction
 by William Styron. San Francisco: Chronicle Books, 1994. 131 p. Chiefly
 illustrations.
 A eclectic portfolio of portraits of fathers and daughters with texts written
 by the sitters themselves.
Isi and Judith Beller, Paris, 1992, frontispiece; *William, Paola, Alexandra, and
Susanna Styron,* 1991, p. 7, 10, 11, 12; *Yvon Lambert and Eve Lavril,* 1992, p. 15;
Charles and Alice Waters, 1992, p. 16; *Stratis and Electra Haviaras,* 1992, p. 17;
Israel and Tanya Gelfand, 1990, p. 21; *Paul A. Volcker and Janice Zima,* 1992, p.
23; *Jacques and Bethsabée Attali,* 1992, p. 24; *Carlos and Natasha Fuentes,* 1992,
p. 26; *General Colin L. Powell, Linda, and Annemarie Powell,* 1992, p. 29; *Billy
and Caroline Copley,* 1992, p. 30; *Arthur Schlesinger, Jr., and Christina
Schlesinger,* 1992, p. 34; *Yo Yo and Emily Ma,* 1992, p. 35; *André and Isabelle
Jammes,* 1991, p. 37; *Mark and Madeline Bromley,* 1992, p. 39; *Senator George
McGovern, Mary and Susan McGovern,* 1992, p. 40; *P. Adams, Sky, Miranda, and
Augusta Sitney,* 1990, p. 43; *Joshua and Stella Baer,* 1991, p. 45; *David and
Challee Ankrum,* 1991, p. 46; *Judge William Steele Sessions and Sara Sessions,*
1992, p. 49; *Charles and Carola Bell,* 1991, p. 50; *The Very Reverend James Parks
Morton and Sophia Morton,* 1992, p. 53; *Gareth and Arabella Lewis,* 1993, p. 54;
Derek, Elizabeth and Anna Walcott, 1990, p. 57; *Jack and Caroline Lang,* 1992,
p. 59; *Leo Castelli and Nina Sundell,* 1992, p. 61; *D. W. Gearen and Darlyn
Dugas,* 1991, p. 62; *Colin and Ruby Salmon,* 1993, p. 64; *Cornelius and Cybèle
Castoriadis,* 1991, p. 67; *Paul and Cora Gilroy,* 1992, p. 68; *Dustin H. Heuston,
Hilary, Kelley, and Kary Hueston, Kimberly B. H. Sorenson, and Heather Rosett,*
1992, p. 70; *Chien Chung and Olivia Pei,* 1993, p. 73; *Jack and Celetia Peregrina
Loeffler,* 1991, p. 75; *Paul E. Corbello and Paula Derwin,* 1991, p. 76; *Allen and
Annie Shawn,* 1992, p. 79; *The Honorable Harry A. Blackmun and Nancy
Blackmun Coniaris,* 1993, p. 81; *Vincent and Aleksandra Crapanzano,* 1991, p. 84;
James Vincent and Jon Marie Gearen, 1991, p. 86; *Michael and Amanda Klück,*
1991, p. 89; *Peter and Chloe Marlow,* 1992, p. 90; *Chinua, Chinelo, and Nwando
Achebe,* 1992, p. 92; *Niccolo Tucci and Maria Gottlieb,* 1991, p. 95; *Dan and
Johanna Welch,* 1993, p. 97; *Thomas, Luned, and Rosamund Palmer,* 1991, p. 98;
Sir Eduardo Paolozzi and Emma Paolozzi, 1992, p. 101; *Tom and Anita Kirn,*
1992, p. 103; *Claus and Cosima von Bulow,* 1992, p. 104; *Jay and Barbara
McDonald,* 1992, p. 106; *Hari Jiwn Singh Khalsa, Sarab Shakti Kaur and Hari
Amrit Kaur Khalsa,* 1991, p. 109; *Jacques, Sara, and Lola Seguela,* 1992, p. 110;
Isodoro and Rebeca Mauleón, 1991, p. 113; *Harold and Isabel Evans,* 1992, p.

114; *Milton, Nancy, and Alice Wexler,* 1992, p. 116; *Ron and Sadie Cooper,* 1991, p. 119; *John Walker III and Gillian Walker,* 1992, p. 120; *Eric and Elizabeth Orr,* 1991, p. 122; *Vernon Jordan, Jr., and Vickee Jordan Adams,* 1992, p. 124; *Senator Bill Bradley and Theresa Anne Bradley,* 1992, p. 127; *John A. Cook and Mariana Cook,* 1990, p. 129.

269. Cook, Mariana Ruth. *Manhattan Island to My Self.* New York: Mariana Ruth Cook, 1977. 48 p.
 The author states that these photographs were made to pay homage to the philosophical spirit of Henry David Thoreau, in the search for quiet moments in a city island.

Carl Schurz Park puddle, pl. 1; *Winter view from my bedroom window,* pl. 2; *Looking east on 54th Street,* pl. 3; *Fifth Avenue home of Ruth Myer Cook before her death in 1967,* pl. 4; *Spring morning in Central Park,* pl. 5; *Boat pond,* pl. 6; *General Motors Building on the Plaza,* pl. 7; *The Museum of Primitive Art,* pl. 8; *Independence Day,* pl. 9; *Eleven Wall Street,* pl. 10; *West 57th Street,* pl. 11; *Bleecker Street between Macdougal and Avenue of the Americas,* pl. 12; *Bergdorf Goodman window,* pl. 13; *Pretzel vendor on the Plaza,* pl. 14; *Central Park Pond,* pl. 15; *South Street Seaport Museum,* pl. 16; *Sculpture garden at the Museum of Modern Art,* pl. 17; *Mad Hatter's foot, Alice in Wonderland statue in Central Park,* pl. 18; *Sunday on the Carl Schurz Parl boardwalk,* pl. 19; *Self-made portrait at home,* pl. 20.

Cook, Susan
 See also #1070

Corbit, Julia.

270. Corbit, Julia. *Julia's Book.* Gardena, CA: Xenos Books, 1979. 93 p.
 Chiefly illustrations.
 Plates are accompanied by an illustrated autobiographical essay. Corbit's short comments explain the titles.

Grandma Ogata, pl. 1; *Easter Bonnet,* pl. 2; *Oh Boy,* pl. 3; *Autumn,* pl. 4; *Deserted,* pl. 5; *Mother Love,* pl. 6; *Mrs. Elizabeth Jones and Her Grandchild,* pl. 7; *Sad Little Joe,* pl. 8; *Pleasant Lady,* pl. 9; *Help Yourself,* pl. 10; *A Fella's Friend,* pl. 11; *Max,* pl. 12; *Josenhans,* pl. 13; *A Little Loving,* pl. 14; *Evil Eyes,* pl. 15; *When My Ship Comes In,* pl. 16; *Pond Pals,* pl. 17; *Big and Little,* pl. 18; *El Capitan,* pl. 19; *The Big Boss,* pl. 20; *Kaptan Churchill,* pl. 21; *Jimmy,* pl. 22; *Gentle Persuasion,* pl. 23; *Siesta,* pl. 24; *The Laguna Greeter,* pl. 25; *Tryout, pl. 26; My Son, Paul, and His Boys, Jimmy and Tommy,* pl. 27; *Old Wheels in Front of a Blacksmith Shop,* pl. 28; *Rims of Light,* pl. 29; *Mother and Child,* pl. 30; *Magnolias,* pl. 31; *Recollection,* pl. 32; *Southern Gentleman,* pl. 33; *First Steps,* pl. 34; *Down the Lonesome Road,* pl. 35; *My Grandfather's* Bible, pl. 36; *Evening Light,* pl. 37; *Quiet Time,* pl. 38; *Young Mother,* pl. 39; *The Old Butterfield Coach Station,* pl. 40; *Gabriel,* pl. 41; *Innocence,* pl. 42; *Patty Cake, Patty Cake,* pl. 43;

Jake Qualls, pl. 44; *A Fine Lady,* pl. 45; *The Inquirer,* pl. 46; *Jimmy,* pl. 47; *Don't Tell,* pl. 48; *Memories,* pl. 49; *Claudia,* pl. 50; *Charlie,* pl. 51; *A Good Outlook,* pl. 52; *Fryers,* pl. 53; *Let Me Sleep, Please,* pl. 54; *The Amish Enjoy a Little Joke,* pl. 55; *Norman,* pl. 56; *Sandra,* pl. 57; *The Fisherman,* pl. 58; *Hard Times,* pl. 59; *Waiting,* pl. 60; *Girl from the Orient,* pl. 61; *Elizabeth,* pl. 62; *Hazel,* pl. 63; *Sing for Your Supper,* pl. 64; *Looking Right at You,* pl. 65; *Tracey,* pl. 66; *Pioneer Woman,* pl. 67; *Flight,* pl. 68; *Meditation,* pl. 69.

Corinne, Tee
> See also #1062

Corpron, Carlotta M., 1901-1988
> See also #1008, 1054, 1058, 1061

271. *Carlotta Corpron: Designer With Light.* Ft. Worth, TX?: Golden Triangle Communications, 1980. Video recording, 30 minutes. Interview.

272. Corpron, Carlotta M. "Light as a Creative Medium," *Art Education* 15, 5 (May 1962): 4-7.

Cory, Kate
> See also #1058

Cosindas, Marie, 1925-
> See also #1008, 1058

273. Cosindas, Marie. *Marie Cosindas, Color Photographs.* Boston: New York Graphic Society, 1979. 143 p.

274. Kinser, H. M. "How to Get the Most Out of Polacolor," *Popular Photography* 57, 1 (July 1965): 96-97.

275. "Marie Cosindas: Portfolio," *Infinity* 15 (December 1966): 13-20.

276. Martin-Turner, Maureen. "Cosindas and Colour," *Camera* (Switzerland) 46, 9 (September 1967): 27+.

277. Merkin, Richard. "The Woman as Photographer: Marie Cosindas," *Camera* (Switzerland) 46, 9 (September 1967): 20-27.

278. Wolfe, Tom. "The Polychromatic Mini-Microwave Projecting Astral Fantasist," *American Photographer* 1, 3 (August 1978): 28-35.

Cowin, Eileen
> See also #1000, 1007, 1008, 1034, 1058

279. Cowin, Eileen. *Eileen Cowen*. Tokyo: Gallery Min, 1987. 74 p. Chiefly illustrations.

Cox, Frances M.

280. "The Naked Ladies of Pittsburgh," *Camera 35* 26, 10 (October 1981): 12.

281. Wilhelm, Susan. *Frances Cox: Existentialism at 35mm*. Philadelphia, PA: Department of Journalism, Temple University, 1984. In *Philadelphia People* 2, 2 (Fall 1984): 26, 28.

Crampton, Nancy
 See also #1072

Crane, Barbara, 1928-
 See also # 1000, 1008, 1053

282. Crane, Barbara. *Barbara Crane; The Evolution of a Vision*. Baltimore: Albin O. Kuhn Library and Gallery, University of Maryland, 1983. 20 p. Chiefly illustrations.

283. Crane, Barbara. *Barbara Crane: Photographs 1948-1980*. Tucson: Center for Creative Photographer, University of Arizona, 1981. 124 p. Chiefly illustrations.
 Includes a photographer's statement, an essay by Estelle Jussim, "Imagination, Phototechnics, and Chance: The Work of Barbara Crane, and an essay by Paul Vanderbilt, "Recollections."
Carmel, California, 1948, p. 15; *Tanglewood, Massachusetts*, 1949, p. 16; *Staten Island Ferry, New York*, 1950, p. 16; *Marvin Cheresh of Sterling Automotive Corporation*, 1963, p. 17; *Mr.Feingold, Mr. Pape, and Mr. Brinn of Qualitech Corporation*, 1963, p. 17; From *Human Form,1964-1969*: *Human Form*, 1965, p. 19, 20, 21, 22, 24; *No Tattoo*, 1967, p. 23; *Human Form*, 1964, p. 25; *Torso in Movement*, 1965, p. 26; *Shadow People*, 1968, p. 27; *Textured Human Forms*, 1967, p. 28; *Century-man-plant*, 1967, p. 29; *Multiple Human Forms*, 1969, p. 30; *Wrigley People*, 1967, p. 31; From *Neon*, 1969: *Neon Cowboy*, Las Vegas, Nevada, 1969, p. 33; *Neon Series*, 1969, p. 34, 35, 36, 37; From *Repeats*, 1974-1979: *Shortscape*, Chicago, 1974, p. 41; *Zig Zag*, 1974, p. 41; *Dan Ryan Expressway*, 1975, p. 40; *The Crust,* St. Luc, Switzerland, p. 40; *Italian Wash I*, Tiovoli, Italy, 1975, p. 40; From *Whole Role*, 1968-1978: *Cosmic Forms II*, 1968, p. 43; *Tar Findings*, 1975, p. 44; *Rowboats,* Lincoln Park, Chicago, Illinois, 1978, p. 45; *Albanian Soccer Players*, Montrose Park, Chicago, Illinois, 1975, p. 46; *Pigeons*, Grant Park, Chicago, Illinois, 1975, p. 47; From *Wrightsville Beach, North Carolina*, 1971, p. 49-51; From *Combines,* 1974-1975: *Computer Revelation,* 1974, p. 53; *Blurred Tree*, 1974, p. 54; *Winged Tree*, 1974, p. 55; *Phantom Image I*, 1975, p. 56; *Phantom Image II*, 1975, p. 57; From *Murals: Baxter/Travenol Labs,*

Deerfield, Illinois, 1975: *Bicentennial Polka*, 1975, p. 59; *Bus People*, 1975, p. 60; *Victorian Assembly*, 1975, p. 61; *Just Married*, 1975, p. 62; *Boardwalk*, 1975, p. 63; From *Petites Choses*, 1974-1975, p. 65-69; From *People of the North Portal*, 1970-1971, p. 71-77; From *Architecture: Chicago Commission on Historic and Architectural Landmarks*, 1972-1979: *Door Detail,William O. Goodman House*, p. 79; *Staircase to Preston Bradley Hall, The Chicago Public Library Cultural Center*, 1976, p. 80; *Main Staircase, The Art Institute*, 1977, p. 81; From *Chicago Loop*, 1976-1978, p. 83-87; From *Chicago Beaches and Parks*, 1972-1978, p. 89-97; From *Commuter Discourse*, 1978, p. 99-107; From *Polaroid Polacolor 2*, 1979-1980: *On the Fence* Series,Tucson, 1979, *Pigeon Feathers,* p. 109; *How to Make Book*, 1980, p. 110; *Mardi Gras Gift from Richard Owen*, p. 111; *Santa Barbara*, Tucson, Arizona, 1980, p. 112; *Refrigerator*, Tucson, Arizona, 1980, p. 113; *Grandma to Be*, 1980, p. 114; *Syracuse Pants*, 1980, p. 115; *Diptych* from *Tucson Portfolio II*, 1980, p. 116; *Papago Cemetery, Mission San Xavier del Bac,* Tucson, Arizona, 1979-1980, p. 117; *Maricopa County Fair*, Phoenix, Arizona, 1980, p. 118; *Swap Meet*, Phoenix, Arizona, 1980, p. 118; *Tanque Verde Swap Meet*, Tucson, Arizona, 1980, p. 119.

Creates, Marlene
 See also #1055
Crigler, Cynthia
 See also #1071
Crosby, Susan Camp
 See also #1006
Cryor, Cary Beth
 See also #1000, 1040
Culver, Joyce
 See also #1006

Cunningham, Imogen, 1883-1976
 See also #1008, 1026, 1053, 1058, 1061, 1063, 1069

284. Berding, Christina. "Imogen Cunningham and the Straight Approach." *Modern Photography* 15, 5 (May 1951): 36+.

285. Cooper, Thomas Joshua, and Gerry Badger. "Imogen Cunningham: A Celebration." *British Journal of Photography Annual 1977*: 126-139.

286. Cunningham, Imogen. *After Ninety*. Introduction by Margaretta Mitchell. Seattle: University of Washington Press, 1977. 111 p. Bibliography: p. 109. Chiefly illustrations.
My Father At Ninety, 1936, pl. 2; *John Roeder's Shrine*, 1961, pl. 27; *John Roeder,* 1961, pl. 28; *John Roeder and Sculpture*, 1961, pl. 29; *Little John*, 1976, pl. 30; *Niallo*, 1973, pl. 31; *Young Lym Wong*, 1975, pl. 32; *Dr. Leo Eloesser*, 1975, pl. 33; *The Brand Sisters,* 1975, pl. 34; *Edyth Fredericks*, 1974, pl. 35; *Ruth Penington*

and Her Father, 1974, pl. 36*; Carl Sullivan,* 1975, pl. 37*; Yee At Marshall,* 1975, pl. 38; *Helen Salz,* 1975, pl. 39; *Florence Minard,* 1975, pl. 40; *Joel Hildebrand,* 1975, pl. 41; *Hotel Couple,* 1950s, pl. 42; *The Laurence Arnsteins,* 1975, pl. 43; *Clarence Burr,* 1975, pl. 44; *Age and Its Symbols,* 1958, pl. 45; *Griswold Morley Through the Window,* 1963, pl. 46; *Griswold Morley,* 1963, pl. 47; *Jessie Luca,* 1975, pl. 48; *Emmy Lou Packard and Her Mother, Mrs. Walter E. Packard,* 1975, pl. 49; *Marjorie Fairfield-Osborn,* 1975, pl. 50; *Martha Eidler,* 1975, pl. 51; *Bryan G. Morisset,* 1975, pl. 52; *Raimey At Marshall,* 1975, pl. 53; *Ralph Cheese,* 1975, pl. 54 *Tom Roberts,* 1975, pl. 55; *Dr. Cookingham,* 1976, pl. 56; *Eugene V. Block,* 1976, pl. 57; *Roi Partridge and Cow's Skull,* 1975, pl. 58; *Roi Partridge,* 1975, pl. 59; *Bill Hawken,* 1975, pl. 60; *Frances Chidester,* 1975, pl. 61; *Jo Sinel,* 1964, pl. 62; *Rudolph Schaeffer,* 1976, pl. 63; *Rose Krasnow,* 1976, pl. 64; *Peter Krasnow,* 1976, pl. 65; *Maria Kolisch,* 1973, pl. 66; *Lester Rowntree,* 1972, pl. 67; *Fritz Steinmann,* 1975, pl. 68; *Fritz Steinmann Somersault,* 1975, pl. 69; *Dr. J. C. Geiger,* 1976, pl. 70; *Augustus Locke,* 1975, pl. 71; *August Sander,* 1960, pl. 72; *The Rope Maker,* 1930s, pl. 73; *Finnish Market Woman,* 1961, pl. 74; *Danish Woman Sewing Braid,* 1961, pl. 75; *Napping in the Library Restroom,* 1955, pl. 76; *Walter D. Bunnell,* 1975, pl. 77; *Nannie Escola,* 1971, pl. 78; *Old Norton In Bed,* 1968, pl. 79; *Old Norton Going To the Laundry,* 1968, pl. 80; *Buy Rainbo Bread,* 1950s, pl. 81; *Mother Lode Country Workman,* 1963, pl. 82; *Woman on a German Train,* 1960, pl. 83; *Gold Rush Country Workman,* 1963, pl. 84; *Three Ages of Woman,* 1972, pl. 85; *"Convalescent" Man,* 1975, pl. 86; *"Convalescent" Woman,* 1975, pl. 87; *Bill Adams Resisting the Camera,* 1951, pl. 88; *Bill Adams,* 1951, pl. 89; *Umakichi Asawa,* 1966, pl. 90; *Haru Asawa,* 1966, pl. 91; *Ruth Elkus,* 1965, pl. 92; *Arthur and Lillie Mayer,* 1976, pl. 93; *Alice Eastwood,* 1953, pl. 94; *Mrs. Bander,* 1968, pl. 95; *Chan Doh Kim,* 1976, pl. 96; *Karl Struss,* 1976, pl. 97; *Irene "Bobbie" Libarry,* 1976, pl. 98; *Dr. Eleanor Bancroft,* 1951, pl. 99; *Nuns At the Sacred Heart/Oakwood,* 1976, pl. 100-105; *Isaac Burns Cunningham and Susan Elizabeth Cunningham,* 1936, pl. 106; *My Father After Ninety,* 1936, pl. 107.

287. Cunningham, Imogen. *Imogen Cunningham Papers, 1903-1991.* Archives of American Art. Smithsonian Institution.

288. Cunningham, Imogen. *Imogen Cunningham: The Modernist Years.* Tokyo: Treville, 1993. Unpaged.
 Short biographical essay by Richard Lorenz in English and Japanese.
Magnolia Blossom, 1925; *Calla,* late 1920s; *Black and White Lilies,* 1925; *Eclipse,* 1921; *Water Hyacinth 2,* 1920s; *Agave Design 1,* 1920s; *Aloe,* 1925; *Agave Design 2,* 1920s; *Spines,* 1925; *Rubber Plant,* c. 1929; *Banana Plant,* late 1920s; *Kelp,* c. 1930; *Stapelia,* 1928; *Leaf Pattern,* late 1920s; *Roi Partridge with Shadow of a Hand,* 1922; *Joseph Sheridan, Painter,* 1929; *Edward Weston and Margrethe Mather,* 1922; *Henry Cowell, Composer,* 1926; *Twins Facing Left,* c. 1930; *Helena Mayer, Fencer 2,* 1935; *Martha Graham 19,* 1931; *Martha Graham, Dancer,* 1931; *Alfred Stieglitz, Photographer,* 1934; *Frida Kahlo Rivera, Painter and Wife of Diego Rivera,* 1931; *Three Eggs,* c. 1928; *Still life with Josef Hoffmann Vases and*

Rudolf Schaeffer Design, late 1920s; *The Three Harps*, 1937; *Signal Hill*, 1927; *Oil Tanks*, 1940; *Shredded Wheat Water Tower*, 1928; *Mills College Amphitheater*, c. 1920; *Ear*, 1929; *Abalone Shells*, 1926; *Tent Shell and Volcano*, 1932; *Feet of Paul E. Maimone 2*, late 1920s; *Snake (Negative)*, 1927; *Spiral Back*, 1929; *Nude*, 1932; *Zebra*, 1920; *Her and Her Shadow*, 1936; *Portia Hume* 2, c. 1930; *Triangles*, 1928.

289. Cunningham, Imogen. *Oral History Interview*. Sound Recording. 1975. Archives of American Art. Smithsonian Institution.

290. Cunningham, Imogen. *Portraits, Ideas and Design: And Related Material*. 1959-1961. Archive. 215 leaves. 1 microfilm reel. Transcript of 1959 interview. Berkeley: Regional Cultural History Project, General Library, University of California, Berkeley, 1961.

291. Cunningham, Imogen. *Imogen! Imogen Cunningham Photographs 1910-1973.* Text by Margery Mann. Seattle: University of Washington Press, 1974. 110 p. Bibliography: p. 109-110.
 Published in connection with an exhibition shown at the University of Washington, 1974. Short historical essay on Cunningham's career as a photographer precedes the photographs. Comments by Cunningham accompany the photographs and a chronology is included.

Portrait of Clare, 1910, p. 21; *The Dream*, 1910, p. 22; *The Vision*, 1910, p. 23; *The Plea*, 1910, p. 24; *Clare and Floating Seeds*, 1910, p. 25; *The Voice of the Wood*, 1910, p. 26; *The Supplicant*, 1910, p. 27; *Sun and Wind*, 1910, p. 28; *Auf Wiedersehen*, 1912, p. 29; *The Offering*, 1912, p. 30; *By the Waters*, 1912, p. 31; *Pierrot Betrübt*, 1910, p. 32; *Recollections of the Past*, 1912, p. 33; *On Mount Rainier 1-5*, 1915, p. 34-38; *Northwest Native*, 1934, p. 41; *My Mother*, 1923, p. 42; *My Father, Mother, and Bossy*, 1923, p. 43; *My Sons in the Mountains*, 1924, p. 44; *Rondal and Padraic*, 1930, p. 45; *Bath*, 1925, p. 46; *Her and Her Shadow*, 1936, p. 47; *Birdcage and Shadows*, 1921, p. 48; *Edward Weston and Margrethe Mather, Photographer 1*, 1923, p. 51; *Edward and Margrethe 2-3*, 1923, p. 52, 53; *Henry Cowell, Composer*, 1926, p. 54; *Jane and Alice and Imogen*, 1940, p. 55; *Wallace Berry*, 1931, p. 56; *Spencer Tracy*, 1932, p. 57; *Warner Oland*, 1932, p. 58; *Sherwood Anderson*, 1927, p. 59; *Martha Graham 1-5*, 1931, p. 60-64; *Agave Design 1-2*, 1920s, p. 67, 68; *Agave, 1920s*, p. 69; *Water Hyacinth 1-2*, 1920s, p. 70, 71; *Magnolia Blossom*, 1925, p. 72; *Magnolia Bud*, 1920s, p. 73; *Aloe*, 1920s, p. 74; *Wandering Jew*, 1920s, p. 75; *Three Vegetables*, 1946, p. 76; *False Hellebore*, 1926, p. 77; *Sycamore Trees*, 1923, p. 78; *Mrs. Asawa*, 1966, p. 81; *Chris through the Curtain*, 1972, p. 82; *Dennis*, 1972, p. 83; *Alice Marie and Margaret Rutherford on Haight Street*, 1967, p. 84; *The Lady and the Tiger*, 1973, p. 85; *Niallo*, 1973, p. 86; *Palmer*, 1934, p. 87; *Judy Dater*, 1972, p. 88; *Ansel Adams*, 1953, p. 89; *A Visit to Dr. Sooy*, 1973, p. 90; *Brassaï*, 1973, p. 91; *Morris Graves in His Leek Garden*, 1973, p. 93; *Pentimento*, 1973, p. 93; *Eiko*, 1971, p. 94; *Eiko's Hands*, 1971, p. 95; *Chris*, 1972, p. 96; *Remembrance of Things Past*, 1970-73, p. 99; *Hands and <u>Aloe plicatilis</u>*, late 1960s, p. 100; *Another Arm*, 1973,

p. 101; *My Lady at Home,* 1972, p. 102; *Fence in Mendocino,* 1971-73, p. 103; *Self-portrait,* 1972, p. 104; *My Label,* 1973, p. 105.

292. Dater, Judy. *Imogen Cunningham: A Portrait.* Boston: New York Graphic Society, 1979.
182 p.

Introduction by Dater. Interviews: *The Family & the Mills College Years:* Padraic and Marjorie Partridge, Roi Partridge, Roger Sturtevant, Rondal Partridge, Part I, Gryffyd and Janet Partridge and Yao Shen; *Group f/64 & the Early Photographic Circle*: Brett Weston, Willard Van Dyke, Ansel Adams, Part I; *Some Old Friends*: Mai K. Arbegast, Barbara and David Myers, Stephen Goldstine; *The Photographers*: Morley Baer, Rondal Partridge, Part II, Ansel Adams, Part II, Arnold and Augusta Newman, Laura Gilpin and David Donoho, Pirkle Jones and Ruth Marion Baruch, Chris Johnson, Leo Holub; *Filmmakers...Friends*: James Broughton, Peg Frankel, Fred Padula, Blanche Pastorino, Ann Hershey; *Historians, Curators, Dealers*: Beaumont Newhall, Anita Ventura Mozley, Margery Mann, Helen Johnston, Lee D.Watkin; *Business Matters*: Arthur Shartsis, Part I, Danne McFarr, Tom Eckstrom, Part I, Adrian and Joyce Wilson; *After Ninety*: Tom Eckstrom, Part II, Arthur Shartsis, Part II, Jack Welpott. Portraits by Judy Dater and others, accompany the text of the interviews.

Roi Partridge, c. 1915, p. 13; *Judy Dater*, 1974, p. 15; *Roger Sturtevant*, c. 1922, p. 30; *Imogen and Gryff*, c. 1917, p. 35; *The garden at 1331 Green Street*, 1950, p. 50; *The Savonarola Look (Barbara Cannon Myers)*, 1960, p. 53; *Chris*, 1972, p. 71; *Michael as Steppenwulf*, p. 73; *Shreaded Wheat Tower*, 1928, p. 92; *Adrian Wilson*, 1963, p. 116; *The Dream*, 1910, pl. 1; *Veiled Woman*, 1910-1912, pl. 2; *On Mount Rainier 6*, 1915, pl. 3; *Roi Partridge, Etcher*, 1915, pl. 4; *On Mount Rainier 7*, 1915, pl. 5; *Family on the Beach*, c. 1910, pl. 6; *Shells*, c. 1930, pl. 7; *Twins with Mirror*, 1923, pl. 8; *John Butler and His Mural*, 1912, pl. 9; *Magnolia: Variations on a Theme*, 1920s, pl. 10; *Magnolia Blossom*, 1925, pl. 11; *Brett Weston*, 1923, pl. 12; *Edward Weston and Margrethe Mather*, 1923, pl. 13; *Pregnant Woman*, 1959, pl. 14; *Flax*, n.d., pl. 15; *Succulent*, 1920s, pl. 16; *Hands of Sculptor Robert Howard*, n.d., pl. 17; *Frida Kahlo Rivera, Painter and Wife of Diego Rivera*, 1937, pl. 18; *Martha Graham, Dancer, 4*, 1931, pl. 19; *Robert Irwin, Executive Director of American Foundation for the Blind*, 1933, pl. 20; *Datura*, n.d., pl. 21; *Blind Sculptor*, 1952, pl. 22; *Mrs. Strong*, 1935, pl. 23; *Theodore Roethke, Poet*, 1959, pl. 24; *James Stephen, Writer*, 1935, pl. 25; *Shen Yao, Professor of Linguistics at the University of Hawaii*, 1938, pl. 26; *Two Callas*, c. 1929, pl. 27; *Roberta*, 1959, pl. 28; *Leaf Pattern*, before 1929, pl. 31; *Nude*, 1923, pl. 32; *Two Sisters*, 1928, pl. 33; *Banana Plant*, before 1929, pl. 34; *Side*, 1930s, pl. 35; *Magnolia Bud*, 1920s, pl. 41; *Three Vegetables*, 1946, pl. 42; *Lyle Tuttle, Tattoo Artist*, 1976, pl. 43; *Stan*, 1959, pl. 44; *Helena Mayer, Fencer*, 1935, pl. 45; *Gertrude Stein, Writer*, 1937, pl. 46; *Irene ("Bobbie") Libarry*, 1976, pl. 47; *The Poet and His Alter Ego (James Broughton, Poet and Filmmaker)*, 1962, pl. 48; *Woman in Sorrow*, 1964, pl. 49;

Minor White, Photographer, 1963, pl. 50; *Alfred Stieglitz, Photographer*, 1934, pl. 51; *Ansel Adams, Photographer*, 1975, pl. 52; *Wynn Bullock, Photographer*, 1966, pl. 53; *Roi with Horse's Skull*, 1975, pl. 54; *Navajo Rug*, 1968, pl. 55; *Morris Graves, Painter*, 1950, pl. 56; *Morris Graves in His Leek Garden*, 1973, pl. 57; *My Father at Ninety*, 1936, pl. 58; *My Mother Peeling Apples*, c. 1910, pl. 59; *The Unmade Bed*, 1957, pl. 60.

293. Hall, Norman. "Imogen Cunningham: Sixty Years in Photography," *Photography* (London) 15 (May 1960): 20-25.

294. "Imogen Cunningham: A Portfolio," *Untitled* 7/8 (1974): 4-9.

295. *Imogen Cunningham: Never Give Up*. New Almaden, CA: Wolfe Video, 1975, 1993. Videocassette, 28 minutes. Autobiographical study.

296. *Imogen Cunningham: Selected Texts and Bibliography*. Edited by Amy Rule. Boston: G.K. Hall & Co., 1992. 194 p.
 Essay entitled: "A Life in Photography," was written by Richard Lorenz; also included is an extensive chronology. Many of the texts are excerpts. Texts by Cunningham: "About Self-Production of Platinum Prints for Brown Tones," (1910); "Photography as a Profession for Women," (1913); "Letter to Edward Weston, 27 July 1920"; "Camping Diary, 1 August 1927, 27 Augusst 1928, 27 July 1929 [an excerpt]"; "Letter to Consuelo Kanaga, 2 October 1935"; "Letter to Ansel Adams, 1 August 1949"; "Somtimes I Wonder [lecture] (1952)"; "Letter to Helen Gee, 25 March 1956"; "Letter to George M. Craven, 12 March 1958"; "Letter to Paul Strand, 18 March 1960"; "European Travel Journal, 7 May 1960 [an excerpt]"; "Excerpts from the lengthy interview with Edna Tartaul Daniel for the University of California Regional Cultural History Project, 1961"; "Letter to Ansel Adams, 10 February 1964"; The Photographer in Relation to His Time [lecture] (1968)"
 Many of the texts are excerpts. Texts about Imogen Cunningham: Halderman, E. Isabelle. "Successful Seattle Business Women: Miss Imogene [sic] Cunningham," *Seattle Post-Intelligencer*, 1913, 2; Raftery, John H. "An Artist of the Camera: A Brief Account of the Work of Imogen Cunningham, of Seattle," *Seattle Post-Intelligencer Magazine* (11 May 1913) 6; Maschmedt, Flora Huntley, "Imogen Cunningham - An Appreciation," *Wilson's Photographic Magazine*, 51, 3 March 1914): 96-99, 113-120. Weston, Edward. "Imogen Cunningham, Photographer," *The Carmelite* 7 April 1930, 7; Berding, Christina, "Imogen Cunningham and the Straight Approach" *Modern Photography* 15, 5 (May 1951): 36-41, 96-98; White, Minor. "An Experiment in 'Reading' Photographs: A Consolidation of Readings by Students at the Rochester Institute of Technology ," *Aperture* 5, 2 (1957): 51-71; Mann, Margery. "Imogen Cunningham," *Infinity* 15, 11 (November 1966): 4-11, 25-27; Newhall,

Beaumont. "Introduction to *Imogen Cunningham: Photographs, 1921-1967.*"; Cooper, Thomas Joshua and Gerry Badger. "Imogen Cunningham: a Celebration," *British Journal of Photography Annual 1977* (1978): 126-139; Mozley, Anita Ventura. "Imogen Cunningham," from *Imogen Cunningham: A Portrait*, by Judy Dater (Boston: New York Graphic Society, 1979); Albright, Thomas. "The Cunningham Paradox," *San Francisco Chronicle*, 6 March 1983, 11, 13.

Bibliography: p. 149-182.

Monographs, articles, exhibition reviews, and memoirs; Published interviews with Imogen Cunningham; Films about Imogen Cunningham; Major collections of Imogen Cunninghams' photographs, additional collections and international collections; and Major collections of manuscripts or other archival materials.

Self Portrait, 1910, facing p. 1; *The Wind*, 1910, p. 7; *Edward Weston and Margrethe Mather*, 1922, p. 14; *Susan Elizabeth Cunningham*, 1921, p. 16; *Nude*, 1923, p. 17; *Magnolia Blossom (Tower of Jewels)*, 1925, p. 18; *Snake*, 1927, p. 20; *Leaf Pattern*, 1929, p. 23; *Martha Graham 2*, 1931, p. 24; *Ear*, 1929, p. 26; *San Francisco Evangelist Gathering Crowd*, 1946, p. 30; *Irene 'Bobbie' Libarry*, 1976, p. 34; *Phoenix Recumbent*, 1968, p. 90; *Fageol Ventilators*, 1934, p. 146; *Miss Cann and Gryffyd*, 1916, p. 11; *Shredded Wheat Tower*, 1928, p. 22; *Under the Queensborough Bridge*, 1934, p. 28; *Paris*, 1961, p. 32; *My Father, Mother, and Bossy*, 1923, p. 33; *Morris Graves*, 1973, p. 129.

297. Jay, Bill. "Imogen Cunningham." *Album* (London) 5 (June 1970): 22-38.

298. Lorenz, Richard. *Flora.* Boston: Bulfinch Press Book, 1996. 160 p.
Bibliography: p. 159.
The section, "Notes on plates," reproduces all of the plate images in reduced version and provides the reader with full botanical names and descriptions of the plants and flowers. The initial essay on the botanical photography of Cunningham traces the development of her career within the context of these images, and incorporates botanical images of other photographers working at the same time. Includes a chronology.

Clare with Narcissus, 1910, fig. 3; *The Honesty Plant*, 1912, fig. 4; *On Mount Rainier 6*, 1915, fig. 5; *Gryff with Nasturtiums*, 191 6, fig. 6; *Boys with Cut Flowers*, 1919, fig. 7; *Twins Picking Foxglove Buds*, 1919, fig. 8; *At Point Lobos 2*, 1921, fig. 9; *Succulents, Point Lobos*, 1921, fig. 10; *Seaweed 2, Carmel*, 1921, fig. 11; *Pine Tree*, early 1920s, fig. 13; *The First Magnolia*, c. 1923, fig. 14; *Roi Partridge at Donner Pass*, 1925, fig. 16; *Faucaria Tigrina*, 1920s, fig. 22; *Still Life, Pineapple and Bananas*, 1920s, fig. 23; *Avocado Pit*, 1920s, fig. 30; *Three Protea*, 1935, fig. 33; *Tree in the Sierra 1-4*, 1932, fig. 34-37; *Roi in the Alabamas*, 1923, fig. 38; *Aloe Shoots*, 1920s, fig. 39; *Driftwood, Beach in Oakland*, 1930s, fig. 43; *Coconut*, 1920s, fig. 44; *Carrot*, 1940s, fig. 45; *Colletia Cruciata, Design for a Screen*, 1939, fig. 46; *Smoke Tree*, c. 1941, fig. 47; *1331 Green Street Garden*, 1951, fig. 48; *Self-portrait, Grass Valley*, 1946, fig. 49; *Leaves*, 1940s-1950s, fig.

50; *Confusion in the Forest*, 1951, fig. 52; *Hands with Aloe Plicatilis*, 1960, fig. 53; *Stuart Wheeler Double*, 1961, fig. 54; *Taiwan Leaves 2*, 1963, fig. 55; *Ruth Asawa's New Expression with Metal*, 1963, fig. 56; *Dream Walking*, 1968, fig. 57; *Lily*, 1960s, fig. 68; *Tree Near Temple Emmanuel*, 1965, fig. 69; *Pentimento*, 1973, fig. 60; *Self-portrait*, 1913, pl. 1; *This Is My Garden*, 1910-1915, pl. 2; *At Point Lobos*, 1921, pl. 3; *Thorn Apple*, c. 1921, pl. 4; *Joshua Tree*, 1922, pl. 5; *Tree at Donner Pass*, 1925, pl. 6; *Flax*, 1920s, pl. 7; *Calla*, c. 1925, pl. 8; *Callas*, c. 1925, pl. 9; *Two Callas*, c. 1925, pl. 10; *Magnolia Blossom*, 1925, pl. 11; *Magnolia Blossom, Tower of Jewels*, 1925, pl. 12; *Aloe*, 1925, pl. 13; *Aloe*, 1920s, pl. 14; *Cabbage*, 1925, pl. 15; *Echeveria 2*, 1920s, pl. 16; *Palm Plants*, 1925, pl. 17; *Spines*, c. 1925, pl. 18; *Agave Design 2*, 1920s, pl. 19; *Agave Design 1*, 1920s, pl. 20; *Plant Pattern*, 1920, pl. 21; *False Hellebore*, 1926, pl. 22; *Celery 2*, c. 1925, pl. 23; *Leaf Pattern*, late 1920s, pl. 24; *Magnolia: Variations on a Theme*, 1920s, pl. 25; *Banana Flower 2*, late 1920s, pl. 26; *Banana Plant*, late 1920s, pl. 27; *Wandering Jew*, 1920s, pl. 28; *Tuberose*, 1920s, pl. 29; *Iris*, 1920s, pl. 30; *Billbergia*, 1925, pl. 31; *Ghost Plant*, 1920s, pl. 32; *Stapelia 2*, 1928, pl. 33; *Stapelia in Glass*, 1928, pl. 34; *Stapelia Flower*, 1928, pl. 35; *Colletia Cruciata 7*, 1929, pl. 36; *Rubber Plant*, late 1920s, pl. 37; *Aeonium*, 1920s, pl. 38; *Hen and Chickens*, 1929, pl. 39; *Magnolia Bud*, 1920s, pl. 40; *Black Lily*, 1920s, pl. 41; *Black and White Lilies 3*, 1920s, pl. 42; *Blossom of Water Hyacinth 2*, 1920s, pl. 43; *Water Hyacinth 1*, 1920s, pl. 44; *Agave*, 1920s, pl. 45; *Sedum Cristate*, 1920s, pl. 46; *Canna 2*, 1920s, pl. 47; *Fatsia Papyrifera*, 1930, pl. 48; *Mother-in-law's Tongue*, c. 1930, pl. 49; *Echeveria*, c. 1930, pl. 50; *Wild Buckwheat*, late 1920s, pl. 51; *Kelp*, c. 1930, pl. 52; *Pitcher Plant*, c. 1930, pl. 53; *Calla Leaves*, c. 1930, pl. 54; *Maple Leaf Pattern for Screen*, 1932, pl. 55; *Amaryllis*, 1933, pl. 56; *Amaryllis Flower*, 1933, pl. 57; *Flowering Cactus*, c. 1930, pl. 58; *Datura*, c. 1930, pl. 59; *Agave*, c. 1930, pl. 60; *Calla with Leaf*, c. 1930, pl. 61; *Jack-in-the-Pulpit, Virginia*, 1934, pl.. 62; *Tobacco*, 1934, pl. 63; *Fatsi Japonica*, 1930s, pl. 64; *Dusty Miller*, 1930s, pl. 65; *Fungus in the Basement, Harbor View*, 1930s, pl. 66; *Pregnant Onion 2*, 1934, pl. 67; *Dutch Iris*, 1930s, pl. 68; *Lilies*, 1930s, pl. 69; *Coleus*, 1930s, pl. 70; *Davidia*, 1930s, pl. 71; *Hydrangea*, 1930s, pl. 72; *Acacia Flowers*, 1930s, pl. 73; *Eucalyptus Flowers*, 1930s, pl. 74; *Tulip Tree 2*, 1934, pl. 75; *Blossom of Protea*, 1935, pl. 76; *Araujia Seed Pod*, 1940, pl. 77; *Fuchsia*, 1940, pl. 78; *Pansies*, 1940s, pl. 79; *Daffodils*, 1940s, pl. 80; *Matilija Poppy*, 1940s, pl. 81; *Aspens--Horizontal*, c. 1942, pl. 82; *Geraniums in Variety*, 1950s, pl. 83; *Fireworks Plant*, 1965, pl. 84; *Ornamental Kale*, 1976, pl. 85; *Three Vegetables*, 1946, pl. 86; *Chestnut Leaves*, 1940s, pl. 87; *Leaves*, 1948, pl. 88; *Sycamore Trees*, 1949, pl. 89; *Sparmannia Africana*, early 1950s, pl. 90; *Grasses 2*, 1952, pl. 91; *Tree Roots*, 1950s, pl. 92; *Araujia*, 1953, pl. 93; *Money Plant*, 1956, pl. 94; *Exploding Seed Pod*, 1963, pl. 95; *Papaver Orientale*, 1965, pl. 96; *Wild Mustard, Pescadero Beach*, 1966, pl. 97; *Daisies, Pescadero Beach*, 1966, pl. 98; *Self-Portrait, Arcata*, 1968, pl. 99; *Hand and Leaf of Voodoo Lily*, 1972, pl. 100.

299. Lorenz, Richard. *Imogen Cunningham: Ideas Without End: A Life in*

Photographs. San Francisco: Chronicle Books, 1993. 180 p. Bibliography: p. 173-178.

Cunningham, a pioneer of modern photography, had a professional career that spanned almost half of the history of photography itself. This retrospective review of her work chronicles the people and places that were of the greatest influences on her, and it includes a chronological survey of her body of work.

Susan Elizabeth Johnson Cunningham, c. 1923, fig. 1; *Isaac Burns Cunningham 2*, c. 1923, fig. 2; *Marsh, Early Morning*, 1905-1906, fig. 3; *Herr Docktor Robert Luther*, 1909-1910, fig. 6; *Notre Dame*, 1910, fig. 7; *Along the Thames Embankment*, 1910, fig. 8; *Reflections*, 1910, fig. 9; *Roi Partridge, Etcher*, 1915, fig. 12; *The Bather*, 1915, fig. 14; *Pierrot Betrübt*, 1910, fig. 16; *Gryff's First Birthday*, 1916, fig. 17; *Rondal and Padraic*, 1919, fig. 18; *4540 Harbor View*, c. 1920, fig. 19; *Adolf Bolm Ballet Intime Dancers*, 1921, fig. 20; *Edward Weston and Margrethe Mather*, 1922, fig. 21; *The First Magnolia*, c. 1923, fig. 26; *Buttons*, c. 1925, fig. 30; *Still Life*, 1920s, fig. 31; *Hand of Gerald Warburg*, 1929, fig. 34; *Yreka*, 1929, fig. 35; *Martha Graham 44*, 1931, fig. 36; *Cary Grant*, 1932, fig. 37; *Hands of Laura LaPlante*, c. 1931, fig. 39; *Chinatown, New York City*, 1934, fig. 40; *Coon Saw*, 1934, fig. 41; *Dorothea Lange and Paul Taylor*, 1939, fig. 43; *Gertrude Stein, San Francisco 2*, 1935, fig. 44; *Photomontage of Herbert Hoover and Franklin D. Roosevelt*, c. 1935, fig. 46; *Three Harps*, 1935, fig. 47; *San Francisco Window*, 1938, fig. 49; *Washington Square*, 1945, fig. 50; *Sailor, Montgomery Street*, 1945, fig. 51; *1331 Green Street*, 1947, fig. 52; *Discrimination at a Rummage Sale*, 1948, fig. 54; *Clown, Barnes Circus*, 1950s, fig. 55; *Nuns at a Calder Show*, 1953, fig. 56; *On McAllister Street*, c. 1950, fig. 57; *Geary Street, contact sheet*, 1956, fig. 58; *Wall Street, New York City*, 1956, fig. 59; *Transport, New York City*, 1956, fig. 60; *Stephen Spender*, 1957, fig. 61; *Muriel Rukeyser*, 1957, fig. 62; *Arata Ranch, Moss Beach*, 1958, fig. 63; *Paris*, 1961, fig. 64; *A Man Ray Version of Man Ray*, 1961, fig. 66; *Still Life*, 1963, fig. 67; *Ruth Asawa's New Expression with Metal*, 1963, fig. 68; *Civil Rights March, San Francisco*, 1963, fig. 69; *Hasbury*, 1967, fig. 70; *Hamboldt*, 1968, fig. 71; *Warning*, 1970, fig. 72; *My Label*, 1973, fig. 73; *My Father, Mother, and Bossy*, 1923, fig. 74; *Nun at Sacred Heart, Oakwood*, 1976, fig. 75; *Pentimento*, 1973, fig. 76; *Self-portrait*, c. 1906, pl. 1; *Maryla Patkowska, Dresden*, 1909-10, pl. 2; *Children with Birdcage*, 1909-10, pl. 3; *The Dom, Dresden*, 1909-10, pl. 4; *Trafalgar Square*, 1910, pl. 5; *Mrs. Herbert Coe, Seattle*, 1910, pl. 6; *Morning Mist and Sunshine*, 1911, pl. 7a; *In Moonlight*, 1911, pl. 7b; *Eve Repentant*, 1910, pl. 8; *Ben Butler*, 1910, pl. 9; *The Dream*, 1910, pl. 10; *By the Waters*, 1912, pl. 11; *This Is My Garden*, 1910-15, pl. 12; *Boy with Incense*, 1912, pl. 13; *On Mount Rainier*, 1912, pl. 14; *Tante Mia*, 1912-14, pl. 15; *On Mount Rainier 8*, 1915, pl. 16; *Ron, Pad, and Gryff*, 1919, pl. 17; *Birdcage and Shadows*, 1921, pl. 18; *Mills College Amphitheater*, c. 1920, pl. 19; *Zebra*, c. 1921, pl. 20; *At Point Lobos*, 1921, pl. 21; *Morning Glory*, c. 1921, pl. 22; *Johan Hagemeyer*, 1922, pl. 23; *Edward Weston and Margrethe Mather 3*, 1922, pl. 24; *Twins with Mirror 2*, 1923, pl. 25; *Roi Partridge and John Butler*, c. 1923, pl.. 26; *John Butler with Mask*, c. 1923, pl. 27; *Nude*, 1923, pl. 28; *Sherwood*

Anderson and Elizabeth Prall 2, c. 1923, pl. 29; *Eclipse,* 1923, pl. 30; *Susan Elizabeth Cunningham,* c. 1923, pl. 31; *Agave Design 1,* 1920s, pl. 32; *Agave Design 2,* 1920s, pl. 33; *Spines,* c. 1925, pl. 34; *Aloe,* 1925, pl. 35; *Water Hyacinth,* 1920s, pl. 36; *Flax,* 1920s, pl. 37; *Magnolia Blossom,* 1925, pl. 38; *False Hellebore,* 1926, pl. 39; *Two Callas,* c. 1925, pl. 40; *Black and White Lilies,* late 1920s, pl. 41; *Banana Plant,* late 1920s, pl. 42; *Leaf Pattern,* late 1920s, pl. 43; *Abalone Shells,* c. 1926, pl. 44; *Hands of Henry Cowell,* 1926, pl. 45; *Alta,* late 1920s, pl. 46; *Roi Partridge with Navajo Rug,* c. 1927, pl. 47; *Three Eggs,* c. 1928, pl. 48; *Signal Hill,* 1928, pl. 49; *Shredded Wheat Water Tower,* 1928, pl. 50; *Snake (Positive),* 1921, pl. 51; *Snake (Negative),* 1927, pl. 52; *Triangles,* 1928, pl. 53; *Roi Partridge,* c. 1927, pl. 54; *Two Sisters,* 1928, pl. 55; *John Bovingdon 2,* 1929, pl. 56; *Side,* 1929, pl. 57; *John Bovingdon,* 1929, pl. 58; *Feet of Paul Maimone 2,* late 1920s, pl. 59; *Eye of Portia Hume,* c. 1930, pl. 60; *Ear,* 1929, pl. 61; *Portia Hume 2,* c. 1930, pl. 62; *Twins Facing Left,* c. 1930, pl. 63; *Frida Kahlo,* 1931, pl. 64; *Two Holer, Yreka,* 1929, pl. 65; *Shells,* 1930, pl. 66; *Kelp,* c. 1930, pl. 67; *Tree,* 1932 pl. 68; *Calla Leaves,* c. 1930, pl. 69; *Echeveria,* c. 1930, pl. 70; *Joseph Sheridan, Painter,* 1931, pl. 71; *Martha Graham 2,* 1931, pl. 72; *Nude,* 1932, pl. 73; *Umbrella Handle and Hand,* 1932, pl. 74; *Robert Irwin, Executive Director of American Foundation for the Blind,* 1933, pl. 75; *Marian Simpson, Painter,* 1934, pl. 76; *Under the Queensboro Bridge,* 1934, pl. 77; *Rebecca, Hume, Virginia 2,* 1934, pl. 78; *Rebecca's Boys, Hume, Virginia,* 1934, pl. 79; *Alfred Stieglitz 3,* 1934, pl. 80; *Gertrude Stein,* 1935 pl. 81; *Fageol Ventilators,* 1934, pl. 82; *Helene Mayer, Fencer,* 1935, pl. 83; *Herbert Hoover with His Dog,* 1935, pl. 84; *On the Nickel Ferry,* c. 1935, pl. 85; *Deckhands, Nickel Ferry, Oakland,* c. 1935 pl. 86; *Alida and Her Friends,* 1935 pl. 87; *My Father at Ninety,* 1936, pl. 88; *Junk,* 1935, pl. 89; *Clouds, Mount Hamilton Observatory,* 1937, pl. 90; *Mount Hamilton Observatory,* 1937, pl. 91; *Tea at Foster's,* 1940s, pl. 92; *San Francisco Evangelist Gathering the Crowd,* 1946, pl. 93; *Watchers of the Evangel Meeting, San Francisco* 1946, pl. 94; *Pattern of Stone and Stucco, near Rough and Ready,* 1947, pl. 95; *Log on Beach,* 1948, pl. 96; *Rock, Drake's Bay,* 1955, pl. 97; *Morris Graves, Painter,* 1950, pl. 98; *Ansel Adams, Yosemite Valley,* 1953, pl. 99; *Sunbonnet Woman,* c. 1950, pl. 100; *Boy Selling Newspapers, San Francisco,* c. 1950, pl. 101; *Boy in New York,* 1956, pl. 102; *Two Girls, San Francisco,* c. 1950, pl. 103; *The Unmade Bed,* 1957, pl. 104; *Pregnant Nude,* 1959, pl. 105; *August Sander, Photographer, and His House, Leuscheid, Germany,* 1960, pl. 106; *Paris Street,* 1960, pl. 107; *People on the Road, Germany,* 1960, pl. 108; *Self-portrait, Denmark,* 1961, pl. 109; *Twins, Poland,* 1961, pl. 110; *Reflection at Sudbury Hill, England,* 1960, pl. 111; *Cars with Raindrops, Holmen Kollen, Norway,* 1961, pl. 112; *Self-portrait, Mendocino,* 1965, pl. 113; *The Poet and His Alter Ego (James Broughton, Poet and Filmmaker),* 1962, pl. 114; *Dream Walking,* 1968, pl. 115; *Doll with Doll between Legs,* c. 1970, pl. 116; *Morris Graves 2,* 1973, pl. 117; *Three Ages of Woman,* 1972, pl. 118; *Irene "Bobbie" Libarry,* 1976, pl. 119; *Feet of Irene "Bobbie" Libarry,* 1976, pl. 120.

300. Maschmedt, Flora Huntley, "Imogen Cunningham - An Appreciation,"

Wilson's Photographic Magazine, 51, 3 (March 1914): 96-99, 113-120.

301. Mann, Margery. "Imogen Cunningham," *Infinity* 15, 11 (November 1966): 4-11, 25-28.

302. Mann, Margery. "Imogen Cunningham: An Exclusive Selection of New Prints Reflects a Great Career," *Popular Photography* 68, 5 (May 1971): 102-105.

303. Mitchell, Margaretta K. "After Ninety," *Popular Photography* 81, 4 (October 1977): 126-135+.

304. Oren, Michel. "On the Impurity of Group f/64 Photography," *History of Photography* 15 (Summer 1991): 119-127.

305. "Photographs by Imogen Cunningham." *Creative Camera* (London) no. 85 (July 1971): 222-231.

306. Porter, Allan. "Homage to Imogen [Special Imogen Cunningham Issue]," *Camera* (Switzerland) 54, 10 (October 1975): 5-44.

307. *Portrait of Imogen.* New York: New Day Films, 1987. Videocassette, 28 minutes.

308. Squiers, Carol, "A New Look at an Old Favorite: Cunningham Reconsidered," *American Photo* 4 (July/August 1993): 18.

Cypis, Dorit
 See also #1055

Dahl-Wolfe, Louise, 1895-1989
 See also # 1008, 1025, 1026, 1028, 1054, 1058, 1061

309. Dahl-Wolfe, Louise. *Louise Dahl-Wolfe: A Photographer's Scrapbook.* Preface by Frances McFadden. New York. St. Martin's/Marek, 1984. 145 p.
 Autobiographical essay accompanies the following photographs by Dahl-Wolfe. Also included are her personal comments on the images, quotations from people she had worked with over the years, and several photographs of Dahl-Wolfe at work.
The Travelers, Oaxaca, Mexico, 1947, frontispiece; *Louise,* 1951, p. v; *Liz Gibbons as Photographer,* 1938, p. vi; *Early San Francisco Skyline,* 1930, p. 2; *Meyer "Mike" Wolfe, Kairouan, Tunisia,* 1928, p. 6; *Eggplants,* 1931, p. 7; *Calla Lilies,* 1931, p. 8; *Apples,* 1931, p. 8; *Mrs. Ramsey, Tennessee, (Tennessee Mountain Woman),* 1933, p. 9; *William Edmonson, Sculptor, Nashville,* 1933, p. 10; *Hands*

on Music, Nashville, 1932, p. 10; Ophelia, Nashville, 1932, p. 11; Negro in the Theater, Nashville, 1932, p. 12; Sophie Gimbel's Customers' Dummies, 1936, p. 14; Mike with his Painting <u>Burnt House</u> for the WPA, 1933, p. 15; Mike Wolfe, 1931, p. 15; My New York Studio, 1935, p. 16; Crown Rayon, My First Account, 1934, p. 17; John Sloane, New York, 1933, p. 18; Edward Hopper, New York, 1933, p. 19; <u>Harper's Bazaar</u> Staff in Paris, 1956, p. 20; Carmel Snow, 1940s, p. 22; Frances McFadden, Managing Editor, <u>Harper's Bazaar</u>, 1938, p. 23; Carmel with Christine Holbrook, her sister, editor of <u>Better Homes and Gardens</u>, 1940s, p. 23; George Davis, literary editor, <u>Harper's Bazaar</u>; Alexey Brodovitch, art director; and Diana Vreeland, fashion editor, 1943, p. 23; Mary Sykes in Puerto Rico, 1938, p. 24; Turkish Promotion Shot, 1952, p. 25; Everyone helps prepare a Turkish set for shooting, 1952, p. 25; Diana Vreeland, 1942, p. 26; Diana Vreeland with model Bijou Barrington, Arizona, 1942, p. 26; Andrém Gremela with model Canary Islands, c. 1953, p. 27; Liz Gibbons, Cuba, 1941, p. 27; Bébé Berard, Paris, 1946, p. 28; Starlet Joan Fontaine, Hollywood, 1938, p. 29; Mosaic Courtyard, Brazil, 1947, p. 32; Ball Gown, Paris, Dior, 1950, p. 34; Harry Easton, my assistant, on the scene, 1955, p. 37; Evelyn Tripp in Gjoia del Colle, Italy, 1955, p. 37; Japanese Bath, 1954, p. 38; Hat by Paulette, Paris, 1950, p. 40; Mary Jane Russell in Dior Swan Hat, Paris, 1949, p. 41; Lisa Fonssagrives in Hattie Carnegie's King Tut Hat, 1945, p. 43; Dior Hats by the Seine, 1953, p. 43; Young Lauren Bacall, 1943, p. 44; Georgia Hamilton sitting on Chac-Mool, Temple of Warriors, Yucatán, Mexico, 1952, p. 45; Night Bathing, 1939, p. 46; Lisa Fonssagrives at Wendy's Pool, 1945, p. 47; Liz Gibbons at The Creamery, 1940, p. 48; Lizzie Gibbons, reflection, 1941, p. 49; Lud, Paris, 1946, p. 50; Ann Keeble, Charleston, South Carolina, 1939, p. 51; Dappled Nude, 1940s p. 52; Lady Margaret Strickland, 1939, p. 54; Suzy Brewster, Miami, Florida, 1941, p. 55; Wanda Delafield, Frank Lloyd Wright House, Phoenix, Arizona, 1942, p. 55; Society woman Millicent Rogers, 1946, p. 56; Suzy Parker in Dior Hat, Tuileries, Paris, 1950, p. 57; Luki in Balenciaga coat, Paris, 1953, p. 58; Suzy Parker by the Seine, costume by Balenciaga, 1953, p. 59; Mary Jane Russell in Dior dress, Paris, 1950, p. 60; Mary Jane Russell in a Balenciaga gown embroidered with beads, Paris, 1951, p. 60; Panorama of Paris, Suzy Parker in Jacques Fath gown, 1953, p. 61; Luki in Balenciaga dress, Paris, 1951, p. 62; Luki, Paris, 1955, p. 63; Liz Benn and balloons, 1948, p. 63; Twins at the beach, 1955, p. 64; Rubber bathing suit, California, 1940, p. 65; Jean Patchett in Granada, Spain, 1953, p. 66; Lisa in the boat, 1955, p. 67; Mary Jane Russell on Leopard Sofa, Paris, 1951, p. 68; Halter Dress by Brigance, 1954, p. 69; Natalie in Grès Coat, Kairouan, 1950, p. 70; Natalie in Hammamet, 1950, p. 71; <u>Plan de Paris</u>, Mary Jane Russell in Dior Dress, 1951, p. 72; Opening Day for Trade Buyers, Dior's, 1946, p. 74; In the Paris Studio, with Carmel, late 1950s, p. 75; Exhausted from Working the Collections, 1947, p. 75; Louvre Shoot for <u>Harpers's Bazaar</u>, 1946, p. 76; Christian Dior at His Millhouse, Outside Paris, 1946, p. 78; Coco Chanel, 1954, p. 79; Cristobal Balenciaga, 1950, p. 80; Jacques Fath and Model Bettina, 1950, p. 80; Mizza Bricard, Co-designer with Dior, 1950s, p. 81; Main Bocher, on the Roof of the Waldorf Astoria, New York, 1939, p. 82; Mme. Vionnet, 1952, p. 82;

Claire McCardell, p. 83; *In My New York Studio*, 1938, p. 84; *Betty Threat*, 1947, p. 90; *Recollection Cathedral, Antigua*, 1952, p. 90; *Balcony of Museum of Modern Art*, 1940, p. 91; *Margaret Bourke-White*, 1942, p. 92; *Cecil Beaton*, 1950, p. 93; *John Rawlings of Vogue with Louise*, 1940s, p. 94; *Horst with Louise*, 1940s, p. 94; *Brassaï Making French Salad at My Home*, p. 95; *Birds*, 1976, p. 96; *Hazel Kingsbury and Her Husband, Photographer Paul Strand*, 1974, p. 97; *Walls Have Ears, series for the government war effort*, 1942, p. 98; *Goodbye to All That, Louise Macy in Wave Uniform*, 1943, p. 101; *Five Star Mother, Nashville*, c. 1943, p. 100; *Keep the Home Fires Burning, June Vincent*, 1942, p. 103; *Our Twenty-fifth Anniversary*, p. 104; *Christopher Isherwood and W. H. Auden, Central Park*, 1938, p. 109; *Carole Lombard, Hollywood, "on the lot,"* 1938, p. 110; *Vivian Leigh, Dressing Room, Gone With the Wind*, 1938, p. 111; *Marlene Dietrich in Destry Rides Again*, 1938, p. 111; *Paul Muni*, 1939, p. 112; *Orson Welles*, 1938, p. 112; *Dolores del Rio, Hollywood*, 1938, p. 113; *Paul Robeson in The Emperor Jones*, 1933, p. 114; *Boris Karloff*, 1941, p. 115; *Yves Montand, Paris*, 1946, p. 115; *Bette Davis, Hollywood*, 1938, p. 116; *Gypsy Rose Lee in Her New York Apartment*, 1942, p. 117; *Paulette Goddard, Hollywood*, 1940, p. 117; *Dr. Ernest Jones, Biographer of Freud*, c. 1958, p. 118; *Edward R. Murrow*, 1953, p. 118; *Spencer Tracy*, 1945, p. 119; *André Malraux*, early 1950s, p. 119; *Lotte Lenya*, 1940s, p. 120; *Lotte Lenya and Kurt Weill*, 1935, p. 120; *Ben Schultz and Son Alexander*, 1960, p. 121; *Patricia Morrison*, 1940, p. 122; *Greer Garson*, c. 1942, p. 123; *Talullah Bankhead*, 1942, p. 124; *Fannie Brice and Bea Lillie*, 1945, p. 125; *Harry Easton and Otto Fenn, My Assistants, as Fanny Brice and Bea Lillie*, 1945, p. 125; *Mae West, Hollywood*, 1944, p. 126; *Katharine Cornell in The Doctor's Dilemma*, 1950, p. 126; *Alfred Lunt and Lynn Fontanne*, 1946, p. 127; *Raymond Massey and Gertrude Lawrence in Pygmalion*, 1945, p. 127; *Wanda Landowska, New York*, 1945, p. 128; *Elsie de Wolfe (Lady Mendl), Paris*, 1946, p. 128; *Edith Sitwell, New York*, 1951, p. 129; *Maureen Stapleton in The Rose Tattoo, New York*, 1951, p. 130; *Celebrating Call Me Madam, New York*, 1950, p. 130; *Hume Cronym and Jessica Tandy, New York*, 1949, p. 131; *Carson McCullers*, 1940, p. 132; *Colette, Paris*, 1951, p. 133; *Pierre Monteux*, 1954; *Triptych of Jimmy Durante*, 1945, p. 135; *Isamu Noguchi, New York*, 1955, p. 136; *Kenneth Tynan*, 1954, p. 136; *Maxwell Anderson and Walter Huston*, 1938, p. 137; *Eudora Welty*, early 1950s, p. 138; *Jean Cocteau, Paris*, 1955, p. 139; *Return to Kairouan*, 1950, p. 142.

310. Dahl-Wolfe, Louise. *Papers, c. 1908-c.1985.* University of Arizona. Center for Creative Photography.

311. Eauclaire, Sally. *Louise Dahl-Wolfe: A Retrospective Exhibition.* Washington, D. C.: National Museum of Women in the Arts, 1987. Bibliography: p. 63-64. 64 p.

312. Edwards, Owen. "Exhibitions: Wit...and Wisdom: Dahl-Wolfe was the Universal Fashion Photographer," *American Photographer* 11,6

(December 1983): 24-31.

313. Goldberg, Vicki. "Louise Dahl-Wolfe," *American Photographer* 6, 6 (June 1981): 38-47.

314. Walther, Gary. "Out-of-Fashion," *Camera Arts* 2, 6 (October 1982): 30-39.

Dalzell, Pat
 See also #1000
D'Amico, Alicia
 See also #1008
Daniels, Tessie
 See also #1006

Dater, Judy, 1941-
 See also #1000, 1004, 1007, 1008, 1011, 1026, 1041, 1053, 1058,1061, 1065

315. *Body and Soul: Ten American Women*. Text by Carolyn Coman, Photographs by Judy Dater. Boston: Hill & Company, 1988.136 p.
 The ten women, all from diverse backgrounds, are: Susan Butcher, Doreen Lopes, Geraldine Fitzgerald, Vickie Singer, "Mo" Anderson, Barbara Bane, Gloria Vadeboncoeur, Celia Alvarez, Belle de Jour, Maggie Ross.

316. Dater, Judy. *Judy Dater: Twenty Years*. Introduction by James L. Enyeart. University Press of Arizona, 1986. 128 p. Bibliography and selected list of exhibitions: p. 123-128.
 This catalog was published in connection with a twenty-year, survey exhibition at the de Saisset Museum, 1964 to 1985, University of Santa Clara; the introductory essay provides critical commentary on the development of Dater's work.
Imogen's Things, 1971, p. 2; *Alabaster Bust,* 1964, p. 3; *Anna,* 1964, p. 4; *Statue, Cross, and Hand, Italy,* 1976, p. 5; *Dead Deer,* 1966, p. 6; *At Napoleon's Tomb, Paris,* 1967, p. 7; *Lovers,* 1964, p. 8; *Siechi,* 1964, p. 9; *Daydreams,* 1973, p. 13; *Nehemiah,* 1975, p. 14, 15; *Jim Hendrickson,* 1978, p. 16; *Aarmour Starr,* 1972, p. 17; *Beaumont Newhall,* 1977, p. 18; *John Szarkowski,* 1978, p. 19; *Ansel Adams,* 1977, p. 20; *Patrick Nagatani,* 1978, p. 24; *Peter Bunnell,* 1977, p. 25; *Young Man, Tokyo,* 1978, p. 26; *Salah Jahine, Cairo,* 1980, p. 27; *Stonecutter, Pietra Santa, Italy,* 1976, p. 28; *Hide,* 1978, p. 29; *Bernie,* 1978, p. 30; *Sandy,* 1975, p. 31; *Minor White,* 1975, p. 33; *Kathleen Kelly,* 1972, p. 35; *Sabine,* 1973, p. 36; *Gwen,* 1972, p. 37; *Laura Mae,* 1973, p. 38; *Imogen Cunningham,* 1971, p. 39; *Maria and Legend,* 1971, p. 40; *Kathleen and China,* 1972, p. 41; *Twinka Thiebaud, Actor, Model, Writer,* 1970, p. 43; *Maria Theresa,* 1974, p. 44; *Woman and Dog, Beverly Hills,* 1972, p. 45; *Imogen and Twinka,* 1974, p. 47; *Libby,* 1971, p. 48; *Maggie*

Wells, Painter, 1970, p. 49; *Joyce Goldstein,* 1969, p. 50; *Janet Stayton, Painter,* 1971, p. 51; *Susan Remy,* 1971, p. 52; *Valerie Duval,* 1969, p. 53; *Sharon Moore,* 1970, p. 54; *Woman From the Marshall Hotel,* 1966, p. 55; *Arles Suite, No. 2,* 1976-78, p. 57; *Arles Suite, Nos. 1-7,* 1976-78, p. 58-59; *Torso and Serape,* 1981, p. 61; *Susie, 1983,* p. 62; *Bill,* 1983, p. 63; *Cowboy Boots and Neon,* 1979, p. 65; *Fourth of July, No. 1,* 1984, p. 67; *Five A.M. Luxor,* 1979, p. 71; *Covered Car,* 1979, p. 72; *Pepsi Stand and Pyramid,* 1979, p. 73; *Two Young Men, Cairo,* 1979, p. 74; *Man With Water Pipe, Cairo,* 1979, p. 75; *Seven-Up Vendors, Cairo,* 1979, p. 78; *Nazli Rizk,* 1980, p. 79; *Kamal El Mallakh,* 1980, p. 80; *Inis and Amal,* 1980, p. 81; *Wedding, Cairo,* 1979, p. 83; *Excerpts From Teenage Diary, No. 2,* 1982, p. 87; *Ms. Clingfree,* 1982, p. 89; *Leopard Woman,* 1982, p. 90; *The Magician,* 1982, p. 91; *Eating,* 1982, p. 92; *Scream,* 1982, p. 93; *Queen of the Night,* 1982, p. 95; *Somewhere Over the Rainbow Blues,* 1985, p. 96, 97, 99; *Self-portrait Sequence, Nos.1-7,* 1982, p. 101-107; *Man With Pastels,* 1984, p. 111; *Woman and Bird,* 1984, p. 112; *Woman With Western Shirt,* 1984, p. 113; *Man With Pencil,* 1984, p. 114; *Woman Drawing,* 1984, p. 115; *Sculptor,* 1984, p. 117.

317. "Judy Dater," *Camera* (Switzerland) 49, 4 (April 1970): 16-23.

318. "Judy Dater," *Place* 3, 1 (June 1973): 144-152.

319. Lufkin, Liz. "Judy Dater (interview)," *American Photographer* 17 (December 1986): 76-80, 82.

320. Mowbray, Clare. "Interview: Conversation with Judy Dater," *Photographer's Forum* 3, 4 (September 1981): 30-38.

321. Senti, Richard. "Masters of Photography: The Many Faces of Judy Dater," *Darkroom Photography* 5, 7 (November 1983): 22-31.

322. Sobieszek, Robert A. "MS: Portraits of Women by Judy Dater and Jack Welpott," *Image* 16, 1 (March 1973): 11-12.

323. Tamblyn, Christine. "The Photographer's Progress. (de Saisset Museum, Santa Clara, California; exhibit)," *Artweek* 17 (May 31, 1986): 11-12.

324. Webster, Mary Hull. "Judy Dater at CCAC. (Oliver Art Center, California College of arts and Crafts, Oakland, California; exhibit)," *Artweek* 27 (August 1996):17-18.

325. Welpott, Jack. "Judy Dater & Jack Welpott: A Collaboration," *Untitled* 7/8 (1974): 34+.

326. Welpott, Jack and Judy Dater. *Women and Other Visions.* Introductory essay by Henry Holmes Smith. Dobbs Ferry, NY: Morgan and Morgan,

1975. 115 p. Chiefly illustrations.

A collaboration between a man and a woman photographer which produced a portfolio of work on "womanness," as Welpott calls it.

Untitled, 1972, p. 1; *Untitled,* 1964, p. 2; *Self-portrait,* 1965, p. 4; *Lucia,* 1972, p. 5; *Apsen,* 1969, p. 7; *Katy,* 1969, p. 9; *Indian Girl,* 1964, p. 11; *Gwen (torso),* 1972, p. 12; *Self-portrait, Arles, France,* 1973, p. 14; *Tony,* 1968, p. 15, 17; *Barbara DeZonia,* 1973, p.18; *Janet Stayton, Painter,* 1971, p. 19; *Anna,* 1964, p. 23; *Anna, Pregnant,* 1968, p. 26; *Edna,* 1968, p. 30; *Three Women,* 1966, p. 31; *Valerie Duval,* 1969, p. 35; *Helene Aylon, Painter,* 1974, p. 36; *Topaz,* 1969, p. 37; *Joyce Goldstein,* 1969, p. 40; *Sharon Moore,* 1971, p. 41; *Maggie Wells, Painter,* 1970, p. 43, 44; *Maria Theresa,* 1974, p. 48; *Twinka Thiebaud, Actress, Model,* 1970, p. 50, 52; *Maria Moreno,* 1971, p. 53; *Maria and Legend,* 1971, p. 55; *Woman and Daughters, Beverly Hills,* 1972, p. 56; *Gael and Rachel,* 1971, p. 57; *Kathleen and China,* 1972, p. 60; *Maureen,* 1972, p. 61, 62; *Valerie Van Cleve,* 1972, p. 64, 65; *Cheri,* 1972, p. 69; *Wally and Nadine, Arles, France,* 1973, p. 72; *Wally, Arles, France,* 1973, p. 73; *Marie Smoking,* 1972, p. 79; *Jill St. Amant,* 1974, p. 82; *Woman and Dog, Beverly Hills,* 1972, p. 84; *Laura Mae,* 1973, p. 85; *Libby,* 1971, p. 86; *Tex,* 1973, p. 87, 88; *Aarmour Starr,* 1972, p. 92; *Kathleen Kelly,* 1972, p. 95; *Susan Remy,* 1971, p. 97; *Gwen,* 1972, p. 98; *Imogen Cunningham,* 1972, p. 100; *Imogen and Twinka, Yosemite,* 1974, p. 102.

327. *The Woman Behind the Image: Photographer Judy Dater.* John Stewart Productions. 16mm, 27 minutes, 1981.

Davenport, Alma
 See also #1000
Davis, Billie Louise Barbour
 See also #1040
Davis, Lenore
 See also #1040
Davis, Lynn
 See also #1017
Davis, Martha L.
 See also #1039
Deadman, Patricia
 See also #1055

DeCock, Liliane, 1939-
 See also #1008, 1053, 1058

328. DeCock, Liliane. *Liliane DeCock Photographs.* Foreword by Ansel Adams. Fort Worth: Amon Carter Museum, 1973. 48 p. Chiefly illustrations.

Adams' essay is a short critique of the work of Liliane DeCock.

Church, Taos Pueblo, New Mexico, 1965, pl. 1; *Detail, Church, Isletta Pueblo,*

New Mexico, 1970, pl. 2; *Detail, Taos Pueblo, New Mexico,* 1970, pl. 3; *Ovens, Taos Pueblo, New Mexico,* 1970, pl. 4; *White Gate, Laguna Pueblo, New Mexico,* 1970, pl. 5; *Detail, Church, Laguna Pueblo, New Mexico,* 1970, pl. 6; *Rear of Church, Ranchos de Taos, New Mexico,* 1972, pl. 7; *At the Base of Acoma, New Mexico,* 1970, pl. 8; *Evening, Taos, New Mexico,* 1970, pl. 9; *Storm near Santa Fe, New Mexico,* 1965, pl. 10; *Stormfront, Nevada,* 1970, p. 11; *Sun and Pole,* 1969, p. 12; *Barn and Smokestacks, Moss Landing, California,* 1968, p. 13; *Grain Elevator, Pendleton, Oregon,* 1965, pl. 14; *Barns, Sierra City, California,* 1965, p. 15; *Two Barns, Los Banos, California,* 1968, pl. 16; *Church Doorway, Butte, Montana,* 1969, pl. 17; *Church Near Glen Ullin, North Dakota,* 1969, pl. 18; *Spring, Tres Pinos, California,* 1967, pl. 19; *Montana,* 1969, pl. 20; *Abandoned House, Pennsylvania,* 1967, pl. 21; *Barn, Maryland,* 1967, pl. 22; *Near San Juan Bautista, California,* 1967, pl. 23; *Storm Near Howe, Idaho,* 1969, pl. 24; *Barn, Montana,* 1965, pl. 25; *Rosalia, Washington,* 1969, pl. 26; *House and Barn, Northern New York,* 1967, pl. 27; *Downieville, California,* 1967, pl. 28; *Rock and Hills, California,* 1968, pl. 29; *Irrigation,* 1969, pl. 30; *Moonrise, Death Valley, California,* 1971, pl. 31; *Burned Wall, San Pablo, Colorado,* 1969, pl. 32; *Shore Acres, Oregon,* 1971, pl. 33; *Dewdrops On Leaf,* 1969, pl. 34; *Wildcat Fall, Yosemite Valley,* 1968, pl. 35; *San José Beach, Carmel, California,* 1970, pl. 36; *Pond and Algae,* 1969, pl. 37; *El Capitan, Winter, Yosemite Valley,* 1968, pl. 38; *Ted and Jon Organ,* 1970, pl. 39; *Mark Citret,* 1970, pl. 40; *Belle Mettler,* 1968, pl. 41; *Gerry Sharpe,* 1967, pl. 42; *Eric Morgan,* 1972, pl. 43; *Vermont,* 1972, pl. 44.

Deltin, Toni
Dena
Diamond, Aviva
Diamond, Ethel
Dibert, Rita

Dorfman, Elsa

329. Dorfman, Elsa. *Elsa's Housebook: A Woman's Photojournal.* Boston: David R. Godine, 1974. 78 p.
 An autobiographical diary in which Dorfman describes the people being photographed.
1973, the beginning of the year, p. 5; *Myself, at home,* p. 6; *Paul Blackburn at home, 1966,* p. 7; *Gary Snyder at M.I.T.,* 1971, p. 8; *Gordon Cairnie on his birthday,* August 1970, p. 9; *Harvey Silverglate,* 1973, p. 11; *Martha Davidson,*

1974, p. 12; *The front of the house*, Summer 1974, p. 15; *Allen Ginsburg*, p. 16, 17; *Allen Ginsburg and Ed Sanders*, 1972, p. 18; *Allen Ginsburg on Sunday morning*, 1973, p. 19; *Allen Ginsburg and Gregory Corso*, 1973, p. 20; *Allen Ginsburg and Peter Orlovsky*, 1973, p. 21; *Gail Shuman Gordon*, 1973, p. 22; *Norman Gordon*, 1973, p. 23; *Gail Beckwith Mazur*, 1974, p. 24; *Ilene Lang*, 1974, p. 25; *Harvey Silverglate*, p. 26; *Harvey and me at two in the morning, a full moon's light*, 1970, p. 27; *Harvey Silverglate and Gail Mazur, a Saturday afternoon*, 1974, p. 28; *Harvey Silverglate on Sunday morning*, 1973, p. 29; *My sister Janie Power's salad*, 1974, p. 31; *Abbott Meadaer*, 1973, p. 31; *Mark Mirsky*, 1973, p. 32; *Joanne Kyger*, 1970, p. 33; *Lawrence Ferlinghetti and Gordon Cairnie at the Grolier*, 1972, p. 34; *Lawrence Ferlinghetti*, 1972, p. 35; *Bob Creeley*, 1974, p. 36; *Harry Rand*, 1974, p. 37; *Robert Creeley talking to Nancy Howe*, 1972, p. 37; *Robert Creeley*, 1973, p. 38; *Ed Lang on Saturday morning*, 1974, p. 39; *Eila Kokkinen*, 1974, p. 40; *Charles Olson, on the right, and friends*, 1965, p. 41; *Me, my susters Sandy & Janie, my nieces, Julie and Lizzy Power*, 1974, p. 42; *My sister Sandy Dorfman on Christmas Day*, 1973, p. 42; *Janie Dorfman Power*, 1974, p. 43; *Bob Creeley and Robert Duncan*, 1972, p. 44; *Robert Bly, IngerGrytting, and Tova Vogt*, 1972, p. 45; *Ken Irby, Robert Duncan and Anne Waldman*, 1972, p. 46; *Anne Waldman*, 1972, p. 47; *Robert Bly*, 1972, p. 47; *Robert Duncan*, 1972, p. 48; *David O'Connell and Patricia O'Connell*, 1972, p. 49; *Alan Lelhuk*, 1974, p. 50; *Willy Williams*, 1973, p. 51; *John Limon*, 1973, p. 53; *Seymour Simcke and Anya*, 1972, p. 53; *Christina Wylie and Nikki*, 1972, p. 54; *Bobbie Creeley*, 1973, p. 55; *Molly and Ralph Hoagland*, 1973, p. 56; *Hannah Green in the backyard*, 1971, p. 57; *Chris Long*, 1971, p. 58; *Tom Pickard*, p. 59; *Harriet Rosenstein*, 1973, p. 60; *Abbott Meader*, 1971, p. 60; *Nancy Meader after breakfast*, 1972, p. 61; *Andrea Dworkin*, 1974, p. 62; *Andrew Wylie*, 1972, p. 63; *Andrew Wylie and Victor Bockris*, 1973, p. 64; *Victor Bockris*, 1972, p. 64; *Jennifer Meader*, 1974, p. 65; *My sister Janie Power and her daughter Lizzy*, 1973, p. 66; *Nancy and Jennifer Meader*, 1974, p. 67; *My sister Janie Power and Julie*, 1974, p. 67; *Deborah Gordon, the first house picture*, 1965, p. 68; *Mike Mazur*, 1974, p. 69; *Lee Harwood*, 1973, p. 71; *Bobbi Carrey*, 1973, p. 74; *Bobbi Carrey, her first new picture*, 1974, p. 75; *Jay Hutchinsonin the backyard*, 1973, p. 75; *My mother, Elaine Kovitz Dorfman*, 1973, p. 76; *My father, Arthur Dorfman and my mother, Elaine*, 1973, p. 77.

330. *Elsa Dorfman, Impressions*. Washington, D.C.: Public Television Library, 1975. Videocassette, 29 minutes.
Dorfman shows examples of her work and discusses feminist photography.

Dorr, Nell, 1893 or 1895 - 1988
See also #1054, 1058, 1061

331. Dorr, Nell. *The Bare Feet*. Greenwich, CT: New York Graphic Society, 1962. Unpaged. Chiefly illustrations.
Photographs of the people of the village of Teotitlan del Valle in the

Valley of Oaxaca, Mexico.
[Carved statues][Group of people][Church statuary][Vase of flowers][Boys by a stream][Herding sheep][Woman with child on lap][Young girl][Child in hanging cradle][Old woman][Woman making tortillas][Braided woman weaving][A baby][Child herding sheep][Carved head][Woman holding child, wrapped in blanket][Old woman in marketplace][Woman carrying bundle][Flower seller in market][Child by baskets and sheep][Getting water from well] [Children] [Kneeling at church][Girls in white dresses, with veils][Shepherds and flocks]

332. Dorr, Nell. *In a Blue Moon.* New York: G.P. Putnam & Sons, 1939.
Collection of untitled photographs, taken on the Florida Keys in 1929, of flowers and nude children and young women.

333. Dorr, Nell, *Life Dance.* Text by Joan Hardee. Allendale, NJ: Alleluia, 1975. Unpaged.
A joint project in words and pictures that chronicled, in human terms, the birth and acceptance into the family of Joan's sixth child.
[Portrait][Couple dancing][Mother and child at sink][Father and child in pajamas][Mother and child in in kitchen][[On the couch][Father and daughter at table][Mother reading to child][Father and child at breakfast table][Mother in bathrobe, near daughters on couch][Father reading to child][Pruning a tree][Father and daughters sitting in tree][Father and child looking at flower blossoms][Father in hospital scrubs][Birth of a baby][Family with newborn] [Child looking at new baby][Breastfeeding, with other children][Mother and infant][Children in long dresses] [Wedding][Children in costume in the woods]

334. Dorr, Nell. *Mother and Child.* Oakland, CA: The Scrimshaw Press, 1972.
Originally published: New York: Harper & Brothers, 1954. Unpaged.
Collection of untitled photographs and poems.
From "The Story": "Here are pictures of my children, my children's children and my god-children. These are our rooms, our houses and our lands...."

335. Dorr, Nell. *Night and Day.* Greenwich, CT: New York Graphic Society, 1968. 97 p.
Excerpts of poems and quotations accompany the photographs.
[Birds on table] p. 10; *[Woman coming from the sea]* p. 13; *[Women's faces]* p. 14-16; *[Women with child]* p. 27; *[Doll on cross]* p. 35; *[Man and boy in straw hats]* p. 37; *[Native American man]* p. 49; *[Man holding his head]* p. 51; *[Ocean waves]* p. 69; *[Grandfather clock]* p. 76; *[Forest]* p. 79; *[Mother nursing a baby]* p. 84;

336. Mayer, Grace. "Interview with Nell Dorr," *Infinity* 12 (December 1963): 4-14+.

337. Mitchell, Margaretta. "Nell Dorr," *Popular Photography* 76, 3 (March 1975): 98-107+.

Downs, Emma Alice
 See also #1040
Drucker, Barbara
 See also #1071
Duarte, Carlota
 See also #1055
Duckworth, Jacqui
 See also #1062
Dugger, Donna
 See also #1057
DuMetz, Barbara
 See also #1040
Eckert, Mary A.
 See also #1038
Eddy, Sarah J.
 See also #1058
Edelson, Mary Beth
 See also #1006, 1007, 1053
Ehrlich, Pauline
 See also #1013
Eleta, Sandra
 See also #1008
Emmons, Chansonetta
 See also #1058, 1061
Emond, Suzanne
 See also #1006
Enos, Chris
 See also #1006, 1007
Es, Winifred
 See also #1057

Ess, Barbara
 See also #1008, 1017, 1063
338. Ess, Barbara. *Barbara Ess: Art at the Edge*. Atlanta: High Museum of Art, 1992. 24 p.
 Illustrated exhibition catalogue.

339. Ess, Barbara. *Barbara , Photography Installation and Books, 1978-1991*. Queens, NY: Queens Musuem of Art, 1993. 35 p.
 Illustrated exhibition catalogue.

Evans, Ina
See also #1071
Ewald, Wendy
See also #1072
Facio, Sara
See also #1008
Fairbrother, Fay
See also #1055
Fallan, Anne-Catherine
See also #1006
Faller, Marion
See also #1007, 1053
Farley, Kathleen A.
See also #1071
Farnsworth, Emma J., 1860-1952
See also #1022, 1058

340. Murray, William. "The Farnsworth Exhibition," *Camera Notes* 1 (January, 1898): 82-83.

Fastman, Raisa
See also #1071

Fay, Irene, 1914-1986

341. Fay, Irene. *Daybook from a Kitchen Drawer*. New York: Adama Books, 1985?
Book of her photographs and recipes.

342. Fay, Irene. *Irene Fay: Photographs 1936-1984.* Petaluma, CA: Singer Photography, 1995?
41 p. Chiefly illustrations.
Contains a short biographical essay and an autobiographical essay by Fay. *NY street snow scene*, c. 1970s, cover; *Collage*, c. 1978, p. 2; *Stefan as bridge*, c. 1936, p. 9; *Stefan drying himself after swim*, c. 1936, p. 10; *Woman with veil*, c. late 1930s, p. 11; *Self Portrait*, c. 1930s, p. 12; *Lola, New Kingston, New York*, 1970, p. 13; *Rosalie behind mask*, c. 1982, p. 14; *Lisette Model*, c. 1970s, p. 14; *Emilie's hair*, 1979, p. 15; *Glowing nightgown--her own*, c.1978, p. 16; *Independent bathing suit*, 1979, p. 17; *Hanger on the line*, c. 1978, p. 18; *His shirt*, c. 1978, p. 19; *On the line--apart of the night*, 1978, p. 20; *Jani and bird cage*, c. 1947, p. 21; *Ann*, 1978, p. 22; *Diving together, Jani and Rosalie*, 1983, p. 23; *Boat at dock*, c. 1980, p. 24; *Boat and sun spots*, 1980, p. 24; *Dock with life preservers*, c. 1980, p. 25; *Ann's hands on dock*, 1969/75, p. 26; *The strong glove*, 1982, p. 26; *Daisies in evening light*, 1975, p. 27; *Anthurium*, 1986, p. 27; *Rosalie's first birthday*, 1977, p. 28; *Rosalie Fay Barnes*, 1979, p. 29; *Boy begging behind wire door*, 1971, p. 30;

Two men on boardwalk, c. 1960s, p. 31; *NY snow scene through bars*, c. 1970s, p. 32; *View from 25 5th Avenue, NY*, c. 1970s, p. 33; *Skaters, Arosa, Switzerland*, 1949, p. 34; *Snow scene II--with bicycle vendors*, c. 1970s, p. 35; *Doll with head*, c. 1970s, p. 36; *Brighton. Louis Tussaud's outside window*, c. 1970s, p. 36; *A very neat kitchen drawer*, 1969, p. 37; *Gate on Moorhead Lane*, 1980, p. 38; *Vain dreams on Oxford Street*, 1967, p. 39; *Window cleaner England*, c. 1970s, p. 40; *Man's hat in river--II*,c. 1974, p. 41.

Fellman, Sandi, 1952-
> See also #1000, 1006, 1058

343. Brown, Susan L. "Against the Grain: Photographs by Sandi Fellman," *Camera Arts* 2, 5 (September 1982): 64-79.

344. Roth, Evelyn. "Exterior Decorations: Sandi Fellman's Photographs of Japanese Tattoo Culture Prove that Beauty is Truly Skin-deep," *American Photographer* 17, 5 (November 1986): 66-71.

Fentress, Heather Parr
> See also #1039

Ferrill, Mikii
> See also #1040, 1062

Ferrato, Donna, 1949-
> See also #1058

345. *Donna Ferrato*. 1993. Video recording, 120 minute.
> "Teleconference at the Rochester Institute of Technology, School of Photographic Arts and Sciences. Photographer Donna Ferrato explains her techniques and approach to photography by showing samples of her work, including those on domestic violence in America. A question and answer segment follows."oclc

Fessler, Ann
> See also #1055

Filter, Karen, 1956-
> See also #1012

346. Roth, Evelyn. "Filtering the '50s: A Euphoric, Albeit Retroactive Look at a Fabulous Decade," *American Photographer* 17, 6 (December 1986): 60-65.

Fisher, Elaine
> See also #1006

Fisher, Shirley I.

347. Fisher, Shirley I. "Techniques for Multiple Printing: How to Make Your Own Cosmic Journey," *Petersen's Photographic* 6, 11 (March 1978): 57-60.

348. "Shirley I. Fisher: Cosmic Journey," *Petersen's Photographic* 6, 11 (March 1978): 49-56.

Flaherty, Frances Hubbard
 See also #1000
Fleischmann, Trude
 See also #1058
Fletcher, Christine B.
 See also #1058
Fliers, Amani
 See also #1071
Flynn, Kathe
 See also #1071
Fong, Pamela
 See also #1071
Fox, Flo
 See also #1070, 1072
Foy, Marjorie
 See also #1072
Frank, Jo Ann
 See also #1061
Fraser, Jean
 See also #1062

Freedman, Jill, 1939-
 See also #1008, 1069

349. Busch, Richard. "Jill Freedman: Circus Days," *Popular Photography* 78, 6 (June 1976): 88-97+.

350. Freedman, Jill. *Circus Days.* New York: Harmony Books, 1975. 128 p. Text by Freedman describes her two months traveling with the circus. The photographs document the daily life for circus people: putting up the tent, the elephants, the clowns, the roust-abouts and the performance.

351. Freedman, Jill. *Firehouse.* Garden City, NY: Doubleday, 1977. 144 p.

352. Freedman, Jill. *Old News: Resurrection City.* New York: Grossman Publishers, 1970. 138 p.

A photographic documentation of the Poor Peoples Campaign and the erection of "Resurrection City" in Washington after the death of Martin Luther King, Jr. Some text accompanies the photographs.

353. Freedman, Jill. *Street Cops*. New York: Harper and Row, 1981. 255 p. Chiefly illustrations.
Photographs of New York City Police on the job, with explanatory text to accompany the photographs.

354. Goldsmith, Arthur. "Jill Freedman: Street Cops," *Popular Photography* 89, 3 (March 1982): 98-107+.

355. Kalmus, Yvonne. "Jill Freedman's Street Gallery," *Camera 35* 17, 8 (November 1973): 52-61+.

Freeman, Emma B.
 See also #1058
Friedenriech, Eileen
 See also #1072

Fries, Janet, 1949-

356. Poli, Kenneth. "Janet Fries: Personal Images/Personal Color," *Popular Photography* 84, 2 (February 1979): 104-107+.

Frisse, Jane Courtney
 See also #1070

Frissell, Toni, 1907-1988
 See also #1008, 1054, 1058

357. "American Aces: Toni Frissell," *U.S. Camera* 1, 7 (December 1939): 38-42+.

358. Frissell, Toni. "Assignment to England," *Popular Photography* 12 (May 1943): 20-21, 78-79.

359. Frissell, Toni. *The Happy Island*. Story by Sally Lee Woodall. New York: T.J. Maloney, 1946. 72 p.
[Ride to the beach in a carriage], p. 9; [Children carrying their lunch boxes on the beach], p. 11; [Hide and seek among the caves], p. 12, 16; "Castles built in the soft pink sand," p. 14; "Wings made of aprons," p. 15; "Bananas look delicious," p. 19; "Riding Pinocchio," p. 20; "Riding in the carriage with the fringe on top," p. 21; "Shirley and Adrianna set out for a wedding," p. 22; "Bicycles go everywhere," p. 24; "But the guests come in carriages instead of cars," p. 26;

"Shirley and Adrianna see the bride and groom," p. 27; *[Fish market]*, p. 29;
[Walking by the houses], p. 31; *"There is a bicycle stand on the main street,"* p.
32; *"and a soda pop man,"* p. 33; *"And best of all a tiny train,"* p. 34; *"Oh, it's a
beautiful morning!"* p. 36; *"They go by carriage,"* p. 37; *"The Fish in the
aquarium,"* p. 38; *"the turtles are large enough to ride,"* p. 39; *[Fishing off the
footbridge]*, p. 40; *[Drinking soda pop]*, p. 43; *"Every child in Bermuda knows
about boats,"* p. 44; *"On the ruins of Fort Gates,"* p. 45; *[In a sailboat]*, p. 47;
"Boys hung around the piers fishing," p. 48; *"or rowing boats,"* p. 49; *"or just
watching,"* p. 50; *"he's only 92,"* p. 51; *[The white-haired old man]* p. 53;
[Swimming,] p. 55-63; *"you fly,"* p. 64; *"you drip water,"* p. 65; *"the wind blows
you dry,"* p. 66; *"and you look out to see,"* p. 67; *[clouds]*, p. 71.

360. Frissell, Toni. *The King Ranch, 1939-1944: A Photographic Essay.*
 Introduction and captions by Holland McCombs. Fort Worth, TX: Amon
 Carter Museum of Western Art; and Dobbs Ferry, NY: Morgan and
 Morgan, 1975. 142 p. Chiefly illustrations.
Kineños, frontispiece, pl. 79; *The stable*, pl. 1; *The "Big House" at King Ranch*, pl.
2; *A vaquero's rough-riding work clothes drying in the wind*, pl. 3; *Robert Justus
Kleberg, Jr. and Helen Campbell*, pl. 4; *Helen and Bob Kleberg on horseback*, pl.
5; *Roping a young Quarter Horse*, pl. 6; *Helen and Bob Kleberg riding quietly into
a herd of cattle*, pl. 7; *Robert J. Kleberg, Jr., and his cousin Caesar Kleberg
studying herd of cattle*, pl. 8; *Richard Mifflin Kleberg, Jr., stands at a gate*, pl. 9;
King Ranch <u>vaguero</u> stands herd on cattle at the roundup, pl. 10; *Maj. Tom
Armstrong focuses on distant game inspection*, pl. 11; *Tom Tate at herdside relaxes
with the ever-present tin cup of coffee*, pl. 12; *Henrieta Kleberg Armstrong almost
always wore a wild turkey feather in her hunting hat*, pl. 13; *A Kineño <u>vaguero</u>
leads the herd through the sacahuiste*, pl. 14; *Moving cattle in a big King Ranch
pasture is sometimes as it was in the days of the trail drives of the 1870s*, pl. 15;
Holding the "herd," pl. 16; *Turning a herd to be held for roundup work*, pl. 17;
Kineño <u>vagueros</u> holding roundup herd, pl. 18; *Moving herd of mixed cattle into
roundup grounds*, pl. 19; *A herd is rounded up and moved out of the mesquite*, pl.
20; *Like a lon sentry, a relaxed <u>vaguero</u> stands guard of the "cut,"* pl. 21; *A
<u>vaguero</u> and his young helper saddling up a fresh mount from the <u>remuda</u>*, pl. 22;
Bob Kleberg "working cattle," pl. 23; *Hard riding and roping*, pl. 24; *Roping and
pulling in a calf to be branded*, pl. 25; *A calf bolting for the herd*, pl. 26; *Clouds of
dust hover over the herd*, pl. 27; *Pushing crossbred cattle into a chute of a pasture
corral*, pl. 28; *Cow camp cook, Jacinto Rivas, keeps the coffee brewing*, pl. 29; *This
cow camp cook prepares coffee and breakfast*, pl. 30; *Richard Kleberg, Sr.,* pl. 31;
*Roundup chuck wagons and water wagons trundled over sandy roads by six-mule
teams*, pl. 32; *Stand-up chuck wagon breakfast*, pl. 33; *During dry times roundup
is a dusty game*, pl. 34; *Cutting horse and <u>vaguero</u> come eyeball-to-eyeball with a
spooky cow that run out of herd*, pl. 35; *Closing in on a galloping calf which has
been cut from the herd*, pl. 36; *When a cut-out calf heads for the brush the race is
on*, pl. 37; *Bringing out a calf to be branded*, pl. 38; *<u>Vagueros</u> afoot close in for the
mugging*, pl. 39; *This crossbread calf has an entire first team of <u>vagueros</u> off*

balance, pl. 40; *The horse holds a taut line on a calf that must be branded and doctored*, pl. 41, 42; *King Ranch horse and rider hold fast to a roped calf*, pl. 43; <u>*Vagueros*</u> *work together and develop coordination and cooperation*, pl. 44; *Throwing a calf for branding*, pl. 45; *Moving cattle through the sacahuiste at roundup time*, pl. 46; *Julian Saenz, a forger, makes a Running W branding iron*, pl. 47; *Heating branding irons out in the pasture at roundup time*, pl. 48; *Roundup gear and water truck at herdside*, pl. 49; *The tough, leather chaps safeguard both hide and clothes of the horseman as he rides through the scratchy, thorny bush*, pl. 50; *All hands eat the same fare*, pl. 51; *The water wagon or truck is the oasis of roundup*, pl. 52; *Pablo Piña washing away dust and grit*, pl. 53; *Cool cup in hand,* <u>*vaquero*</u> *José Silguero cleanses his mouth before drinking*, pl. 54; *Sixto Mendietta, a typical King Ranch* <u>*vaquero*</u>, pl. 55; *At a pen chute, doses of phosphorus for cattle*, pl. 56; *Examining close-up the broad backs of cattle*, pl. 57; *King Ranch dosed cattle spoon to cud with minerals*, pl. 58; *Kleberg studies animals he is using in experiments*, pl. 59; *Taking a coffee break at one of the pens*, pl. 60; *Robert Justus Kleberg, Jr.,* pl. 61; *King Ranch Quarter Horses*, pl. 62; *King Ranch horses*, pl. 63, 64; *Quarter Horse mares and foals in a typical King Ranch horse corral*, pl. 65; *Quarter Horse mares and foals*, pl. 66; *Bob Kleberg and Quarter Horse yearlings in a corral*, pl. 67; *Quarter Horses in breeding bands*, pl. 68; *Bob Kleberg "gentling" a King Ranch colt in the traditional manner*, pl. 69; *Mixed-company horses and cattle*, pl. 70; *Mounted on the best of the breed*, pl. 71; *The late Lauro Cavazos, manager of the Santa Gertrudis Division, shows off one of his favorite mounts of that time*, pl. 72; *Bob, Dick Kleberg, Jr. and Lauro Cavazos riding past one of the headquarters stables*, pl. 73; *Bob Kleberg and Lauro Cavazos with two young colts*, pl. 74; *Roundup scenes under scudding skies of the vast expanses of the King Ranch, Texas*, pl. 75; *King Ranch thoroughbreds, winners of every major race in the country*, pl. 76; *The conformation and muscling of this young foal indicates that he will be able to whirl*, pl. 77; *A buggy and gray trotters are driven down a sandy road*, pl. 78; *Nephew of Bob Kleberg, and his fellow small fry* <u>*Kineños*</u> *rest and watch roundup from shade of truck*, pl. 80; *Members of King Ranch cow camp*, pl. 81; *King Ranch* <u>*vagueros*</u> *and horses*, pl. 82; *King Ranch boy*, pl. 83; *Here a pretty sporty* <u>*corrida*</u> *(outfit of cowhands) gets a variety of action inside a King Ranch corral*, pl. 84; *Two cowhands in brush jackets and chaps*, pl. 85; *This young cowhand is at practice--rope-wise and ready*, pl. 86; *Little Bobby Shelton helping skin a beef*, pl. 87; *Two young Klebergs getting early training at herd-side*, pl. 88; *On the King Ranch the kids were never too young to start wanting to work at the roundups*, pl. 89; *Throwing a loop*, pl. 90; *Throwing the calf for branding*, pl. 91; *A young* <u>*vaquero*</u>, pl. 92; *Vicente Davila is a third generation* <u>*Kineño*</u> <u>*vaquero*</u>, pl. 93; *This classic face of Juan Dominguez, is a fineness of character, a quality of gentility*, pl. 94; *An* <u>*abuela*</u>, *(grandmother) of an old King Ranch family*, pl. 95; *The day the nuns visited the school at the Norias Division*, pl. 96; *Longtime King Ranch chef José Alegría*, pl. 97; *The daughter of a King Ranch weaver*, pl. 98; *One of the stable masters*, pl. 99; *A weaving shop*, pl. 100; *Watering troughs like these are all over the ranch*, pl. 101; *Norias Division's famed Sam Chesshire and some of his best trained bird dogs*, pl.

102; *Mounted Ed Durham, longtime manager of the Norias Division, with one of his bloodhounds,* pl. 103; *Ed Durham releasing bloodhound,* pl. 104; *One of the vast King Ranch pastures,* pl. 105; *This ox is trained to stand gentle as a nucleus for the "cut,"* pl. 106.

361.　Frissell, Toni. *Photographs, 1933-1967.* Introduction by George Plimpton; Foreword by Sidney Frissell Stafford. New York: Doubleday, 1994. 153 p.

Consists primarily of photographs selected from the Frissell archive of the Prints and Photographs Division, Library of Congress. Plimpton's biographical essay incorporates interviews, diary entries and letters of Frissell; and excerpts of her writings are found throughout the book. Includes many photographs of Toni Frissell, and her family.

Weeki Wachee Spring, Florida, 1947 Frontispiece; Toni Frissell's daughter Sidney as "The Wind" in *A Child's Garden of Verses,* South Hampton, Long Island, p. vii; *Mrs. C. Ruckelshaus, New York, Vogue,* February 1938, p. 2; *Model Sydney Kraus at Marineland Florida, Vogue,* December 1939, p. 4; *Tryall Plantation, Jamaica, Harper's Bazaar,* October 1948, p. 5; *Peru, Harper's Bazaar,* January 1952, p. 6; *Sculling Off Jamaica, Harper's Bazaar,* October 1948, p. 8; *Mrs. Douglas Burden Surf Casting, Vogue,* May 1938, p. 10; *Vogue,* August 1935, p. 3; June 1938, p. 11; January 1939, p. 7; June 1940, p. 16; November 1940, p. 9; May 1942, p. 12; August 1944, p. 17; *Harper's Bazaar,* February 1947, p. 23; 1948, p. 21; August 1949 p. 14; January 1950, p. 24; February 1950, p. 15; July 1951, p. 13; *White Pigeons in Dovecote at St. James, Long Island,* February 1961, p. 18; *Dolphin Tank, Marineland Florida, Vogue,* October 1939, p. 19; *Bikini-clad Model Dovima, Montego Bay, Jamaica, Harper's Bazaar,* May 1947, p. 20; *Model Evelyn Tripp on the Steps of the Lincoln Memorial, Washington, D.C.,* 1954, p. 22; *Bermuda,* June 1945, p. 25; *"Crazy with the Heat," Vogue,* July 1937, p. 26; Toni Frissell's daughter Sidney as "Alice in Wonderland," Medway Planation, South Carolina, 1947, p. 27; *Victoria Station, London, Harper's Bazaar,* 1951, p. 28; *At the Swedish-American Line Pier, New York, Harper's Bazaar,* November 1949, p.29; *Abandoned Child, Bittersweet, England,* January 1945, p. 30; *Boy with Shaven Head in Children's Prison* c. 1945?, p. 30; *American Soldier, Red Bull Regiment, Italy, Easter Sunday,* 1945, p. 32; *Graveyard,* 1945, p. 33; *German Prisoners of War Taken by the 10th Mountain Division, Monte Belvedere, Italy,* Spring 1945, p. 34; *Wounded Airman of the Eighth Air Force, Pinetree, England,* January 1945, p. 35; *Italy,* 1945, p. 36; *Old Woman Chestnut Seller Reading of Franklin D. Roosevelt's Death, Italy,* April 1945, p. 37 *The Siegfried Line, Rhône Valley,* 1945, p. 38, 39; *Eighth Air Force Briefing Room, Pinetree, England,* January 1945, p. 40; *Red Cross Worker with Wounded Soldier, England* 1942, p. 41; *Boy Sitting in the Rubble of His Home Where His Parents Lie Buried After a V-2 Bomb Hit, London,* January 1945, p. 42; *The Homeless Victims of War, London,* 1945, p. 43; *Two Youngsters in Children's Prison,* 1945?, p. 43; *Berlin, 1961, Saturday Review* October 1967, p. 44; *Berlin Wall,* October 1961, p. 45; *Ground Crewman of the Red-Tailed Mustangs, 332nd Fighter Pilot Squadron, the*

All-Black Outfit of the Fifteenth Air Force, Italy, March 1945, p. 46; *Red-Tailed Mustang's Briefing Room,* 1945?, p. 47; *Lovers Along the Seine, Paris,* March 1964, p.48; *Baron Guy de Rothschild and His Wife Marie-Hélène,* February 1961, p. 49; *Alida Lessard With Her Daughter Laura, Granddaughter and Great-Granddaughter of Stanford White,* June 1963, p. 50; *Mrs. John Huston and Her Daughter Angelica,* March 1959, p. 51; *The Duke and Duchess of Windsor, Palm Beach,* May 1950, p. 52; *Doris and Yul Brynner, Florida,* April 1962, p. 53; *Lovers Near the Thames, London,* 1962, p. 54; *Elizabeth Taylor, Mike Todd, and Their Infant Daughter Liza,* September 1957, p. 55; Toni Frissell's son Varick Bacon in "Wintertime" in *A Child's Garden of Verses,* p.56; Toni Frissell's Granddaughter Brent Brookfield Loyer, May 1963, p. 57; *Coco the Poodle Walking Down the Streets of New York, Life,* December 1949, p. 58; *"I Want to Go Home," Courchevel, France,* March 1964, p. 59; "Autumn Fires" from *A Child's Garden of Verses,* p. 60; *Linda and Pam Peyton at Caroline Church, Setauket, New York,* June 1958, p. 61; *St. Augustine, Florida,* 1939, p. 62; *Portugal,* 1946, p. 63; *John Scully, Future Founder of Apple Computers, St. James, Long Island,* 1946, p. 64; *Vermont,* September 1960, p. 65; *Long Island Sound,* 1957, p. 66; *On the Beach,* July 1947, p. 67; "My Shadow" from *A Child's Garden of Verses,* p. 68; Toni Frissell's Daughter Sidney on the Cover of *A Child's Garden of Verses,* p. 69; *Natalie White, Stanford White's Great-Granddaughter, Long Island,* June 1963, p. 70; *Stephanie White, Another of Stanford White's Great Granddaughters, Long Island,* August 1957, p. 71; *Frederic Koltay With Dog Winston,* May 1957, p. 72; *Gertrude Legendre's Springer Spaniel on a Leopard-Skin Rug,* 1961, p. 72; *Vermont,* 1960, p. 73; *Toni Frissell's Grandson Montgomery Brookfield, Drinking Ginger Ale,* 1963, p.74 ; *Trevor Huxley in a Barn on the Stanford White Estate, "Box Hill,"* May 1961, p. 75; *Blenheim Palace, the Family Seat of the Dukes of Marlborough,* 1950, p. 76; *Sir Winston Churchill in His Robes of the Order of the Garter on Coronation Day,* 1953, p. 77; *Nannies in the Park, London,* 1963, p. 78; *The Honorable Reginald Wynn, London,* 1950, p. 79; *Michael Asator Family in Front of Bruen Abbey, England,* 1953, p. 80; *John Jacob Aster Children at Hatley Park, England,* 1953, p. 81; *Harper's Bazaar,* July 1950, p. 82; *Lord Hailey, Coronation Day, London,* 1953, p. 83; *The Duchess of Marlborough in Her Coronation Robes at Blenheim Palace, Coronation Day,* 1953, p. 84; *The Duke of Marlborough After the Coronation Service, London,* June 1953, p. 85; *Sir Winston Churchill's Grandchildren Leaving the Birthday Party of His Granddaughter Emma Soames, London,* 1953, p. 86; *The Honorable Charles Spencer-Churchill, Youngest Child of the Duke and Duchess of Marlborough, at Blenheim Palace,* 1950, p. 87; *Lady Churchill at Hyde Park Gate on Her Seventy-Eighth Birthday,* 1963, p. 88; *Sir Winston Churchill at Blenheim,* 1950, p. 89; *Brother and Sister at Cricket Match at Eton,* 1950, p. 90; *Lord Albemarle at Londonderry House, London,* 1950, p. 91; *Horses and Cattle at Dawn, King Ranch, Texas,* 1943, p. 92; *Cubbing at Dawn, Unionville,* 1954, p. 93-94; *The Meath Hunt, Ireland. Whips Dodo Dunne and David Durnew Takes Hounds Across the River,* 1956, p. 96; *Cubbing at Unionville, Pennsylvania,* October 1953, p. 97; *The Earl of Cadogan in Action at the Blenheim Peasant Drive, England,* 1956, p. 98; *Clamming at Dusk,*

St. James, Long Island, 1944, p. 99; *Cutting a Calf from the Herd*, p. 100; *Climbers, Zermatt, Switzerland*, p. 101; *Skiing at Monte Rosa Glacier, Switzerland*, April 1957, p. 102; *The King Ranch, Texas*, December 1967, p. 103; *Surf Casting, Nantucket*, August 1957, p. 104; *Duck Hunter Setting Out Decoys, California*, 1959, p. 104; *The Matterhorn, Zermatt, Switzerland*, p. 105; *Hunter and Dove, Medway Plantation, South Carolina*, December 1953, p. 106; *Fox Hunter Smoking, Unionville*, November 1949, p. 107; *Dawn on the Oklahoma Track, Saratoga, New York*, 1963, p. 108; *Famous Horse Breeder Ambrose Clark*, 1953, p. 109; *Foxhounds Before the Hunt*, November 1956, p. 110; *Foxhounds at the End of a hunt, Unionville*, 1953, p. 111; *"Mr. and Mrs. Morgan Wing of Millbrook, New York. Mr. Wing Is Master of the Sandamona Beagle Pack,"* 1952, p. 112; *Mr. and Mrs. Edgar Scott*, 1949, p. 113; *Ticker Tape Parade for Presidential Candidate Richard M. Nixon, New York*, 1960, p. 114; *President Franklin D. Roosevelt, Camp Oglethorpe Chattanooga, Tennessee*, 1943, p. 115; *South Carolina*, December 1962, p. 116; *New Orleans*, December 1962, p. 117; *Port Arthur, Texas*, November 1962, p. 118; *Coast Guard Auxiliary*, August 1957, p. 119; *Jamaica*, 1948, p. 120; *Calypso Player at Round Hill, Jamaica*, January 1957, p. 121; *Washington, D. C.* June 1957, p. 122; *Charleston, South Carolina*, November 1962, p. 123, 126, 127; *Nuns Clamming on Long Island*, September 1957, p. 124; *Portuguese Girl*, April 1946, p. 125; *Mrs. Stanford White and Her Great Granddaughter Suzannah Lessard*, 1949, p. 128; *Mr. and Mrs. Harold Vanderbilt at Tea in Lantana, Florida, with His Sister Mme. Jacques Balsan and Her Granddaughter and Great-Grandson*, January 1950, p. 129; *Dinner at "Heron Bay," the Home of Ronald and Marietta Tree, Barbados*, February 1961, p. 130; *Mrs. Walter B. Allan, Mill Reef Club, Antigua, British West Indies*, p. 132; *Konrad Adenauer*, October 1961, p. 133; *Lauri Peters, Actress in the Stage Production of "The Sound of Music,"* July 1960, p. 135; *Gloria Vanderbilt at Her Home in Connecticut*, 1966? p. 135; *Mike Todd at the Jones Beach Theater on Long Island*, 1952, p. 136; *Senator John F. Kennedy and Jacqueline Bouvier on Their Wedding Day, Newport, Rhode Island*, September 1953, p. 137; *Mary Martin During the Run of "South Pacific" on Broadway*, 1949? p. 138; *Lilli Palmer and Her Husband, Rex Harrison*, 1950, p. 139; *Gloria Guinness, Her Daughter Dolores Guinness, and Her Grandson Loel Guinness, Palm Beach*, April 1962, p. 140; *Kirk Douglas, Kloster, Switzerland*, 1954, p. 141; *William Styron*, 1968? p. 142; *Mrs. John Pringle and Michael Duplaix at the William S. Paley Cottage, Round Hill Jamaica*, 1957? p. 143; *Miss Charlotte Haxall Noland, Founder of Foxcroft School, in Sidesaddle Habit, Middleburg, Virginia*, 1949, p. 144; *Mrs. Lucy Lynn in Formal Fox-Hunting Sidesaddle Attire at Foxcroft School, Thanksgiving Day*, 1953, p. 145; *Irving Berlin*, 1942? p. 146; *Beatrice Lillie*, 1948? p. 147; *Mme. Jacques Balsan, the Former Consuelo Vanderbilt, Duchess of Marlborough, at Home Near Palm Beach*, May 1950, p. 148; *The Duke of Windsor, Golfing*, May 1953, p. 149.

362. Frissell, Toni. *Toni Frissell's Mother Goose*. New York: Harper, 1948. 95 p.

Mother Goose rhymes illustrated by photographs of children at play.

363. Frissell, Toni. "Toni Frissell, Portfolio," *Infinity* (December 1967): 4-11.

364. Frissell, Toni. "Tony Frissell Bacon: 'Now I'm Sixty-Six and I Love It,'" *Vogue* (June 1973): 140-145.

365. Stevenson, Robert Louis. *A Child's Garden of Verses*. New York: U.S. Camera, 1944.

366. Talbot, Michael. "Toni Frissell--Outdoor Specialist," *Popular Photography* 5 ,4 (October 1939): 32-33+.

Fullerton, Jennie
 See also #1038
Galembo, Phyllis
 See also # 1006, 1072
Gallagher, Carole
 See also #1055

Galton, Beth, 1953-

367. Galton, Beth. *Say Cheese!: Taking Great Photographs of Your Children.* Boston: Little, Brown, 1993. 150 p.
 A how-to book for taking photographs of children, with numerous examples by Galton.

Gammell, Linda
 See also # 1053
Gamper, Gisela
 See also #1071
Garner, Gretchen
 See also # 1058

Gee, Helen, 1926-

368. Bezner, L. C. "Helen Gee in the Limelight - Expanding Exhibitions of Photography," *History of Photography* 20, 1 (Spring 1996): 78-81.

369. Gee, Helen. *Limelight: A Memoir: A Greenwich Village Photography Gallery and Coffeehouse in the Fifties.* Albuquerque: University of New Mexico Press, 1997. 303 p. Includes a Limelight Chronology.
 According to these memoirs, Gee ran the "biggest and busiest coffeehouse in New York *and* the first photography gallery in the country." p. 5. This work chronicles the life of Gee, the efforts of Gee to open the Limelight,

and stories of the photographers and exhibitions that made the Gallery a center of creative activity.

370. Gee, Helen. *Papers, 1939 - (ongoing)*. University of Arizona. Center for Creative Photography.

371. Gee, Helen. *Photography of the Fifties: An American Perspective*. Tucson: Center for Creative Photography, University of Arizona, 1980. 161 p.
Catalog of an exhibition held at The International Center of Photography, New York, 1980, and at other institutions.

372. Gee, Helen. *Reminiscences of Helen Gee*, 1982. Columbia University. Oral History Research Office.

373. Gee, Helen. *Stieglitz and the Photo-secession: Pictorialism to Modernism, 1902-1917*. Trenton: New Jersey State Museum, 1978. 54 p.
Catalog of an exhibition held at the New Jersey State Museum, 1978.

374. Gee, Helen. "Where the Life Is," *Camera Arts* 2, 2 (March/April 1982): 50-63.

Geesaman, Linda
See also # 1053
Gerstein, Roz
See also #1072
Gever, Martha
See also #1062

Gilpin, Laura, 1891-1979
See also #1026, 1027, 1053, 1054, 1058, 1061, 1063, 1074

375. Adams, Robert. "An Enduring Grace: The Photographs of Laura Gilpin. (Amon Carter Museum, Forth Worth, Texas; traveling exhibit)," *Aperture* 110 (1988): 72-76.

376. "The Early Works of Laura Gilpin, 1917-1932," *Center for Creative Photography. University of Arizona. Research Series*. Number 13 (April 1981). 51 p.
Brief essay by Terence R. Pitts which discusses Gilpin's early publications.
Sculptor Brenda Putnam at Marble Cutters Watching Work on Memorial for Ann Simon, 1917, pl. 1; *Mariposa Lily*, 1922, pl.2; *Ducks on Pond*, 1921, pl. 3; *Roses in Vase*, 1926, pl. 4; *Marcy Dalton Fowler*, 1919, pl. 5; For the Eliza Morgan Swift poem "On the Prairie," 1917 or 1921, pl. 6; *Sunrise on the Desert*, 1924, pl. 7;

Flowers in a Vase/Narcissus,1928, pl. 8; *The Frosted Pine, Colorado*, 1927, pl. 9; *Cathedral Spires*, 1919, pl. 10; *Nurse Watching Children Taking Sunbaths*, 1925, pl. 11; from *Winning Health in the Pike's Peak Region*, 1925, pl. 12; *Dominoes*, 1930, pl. 13; *A Child's Portrait*, c. 1930, pl. 14; *Portrait*, 1931, pl. 15; *A Problem For Students To Make a Still Life of a Pair of Scissors, Two Books, and a Ball of String*, 1930, pl. 16; *The Little Medicine Man*, 1932, pl. 16; *Ranchos de Taos Church*, 1930, pl. 18; *Chaco Canyon, Pueblo Bonito*, 1930, pl. 19; *Broken Flute Cave, Cove area, Arizona*, 1931, pl. 20; *Bryce Canyon #2*, 1930, pl. 21; *Temple of KuKulcan*, 1932, pl. 22; *Temple of KuKulcan, Chichén Itzá*, 1932, pl. 23; *Sisal Plant*, 1932, pl. 24

377. Faris, J. C. "Laura Gilpin and the 'Endearing' Navajo," *History of Photography* 21, 1 (Spring 1997): 60-66.

378. Forster, Elizabeth W. *Denizens of the Desert: A Tale in Word and Picture of Life Among the Navaho Indians*. The letters of Elizabeth W. Forster and Photographs by Laura Gilpin. Edited with an introduction by Martha A. Sandweiss. Albuquerque: University of New Mexico, 1988. 140 p. Bibliographical notes: p. 29-31.
 The letters from Forster, a health care worker, provide a personal account of life in a small Navaho community where she stayed from 1931 to 1933. The two women later collaborated on editing the letters and photographs for a joint publication. The introduction further discusses Forster's life among the Navahos and the continuing friendship and careers of these two women.

Elizabeth Forster, c. 1930s, p. 1; *Hardbelly's Hogan*, 1932, p. 5; *Laura Gilpin, self-portrait*, c. 1928, p. 7; *Elizabeth Forster with weaver*, 1932, p. 10; *Elizabeth Forster and Navaho Child*, 1932, p. 15; *Elizabeth Forster and Navaho Women*, 1932, p. 17; *Francis Nakai and Family*, 1950, p. 23; *Mrs. Hardbelly*, 1953, p. 25; *Elizabeth Forster and Paulina Barton's sister near Red Rock*, 1950, p. 26; *Shiprock from the west*, 1932, p. 40; *Hogan in Red Rock Cove*, 1932, p. 42; *Navaho covered wagon*, 1934, p. 46; *Mrs. Francis and corn*, 1933, p. 53; *The Ute woman*, 1934, p. 55; *Timothy Kellywood and his family*, 1932, p. 63; *Hogan near Red Rock, winter*, 1932, p. 67; *Mrs. Francis*, 1932, p. 71; *Timothy's mother, Lukachukai*, 1933, p. 76; *Mary weaving on outdoor loom, Red Rock*, 1933, p. 83; *Group in corral*, 1932, p. 89; *Navaho woman and child in hogan*, 1932, p. 91; *The summer shelter in the Cove*, 1934, p. 101; *Red Rock Trading Post*, 1932, p. 105; *Setah Begay, Navaho medicine man*, 1932, p. 108; *Navahos by firelight*, 1933, p. 113; *Timothy Kellywood*, 1932, p. 117; *Navaho Jim's Hogan*, 1932, p. 127; *Little Medicine Man*, 1932, p. 136; *Shepherds of the Desert*, 1934, p. 139.

379. Gilpin, Laura. *The Enduring Navaho*. Austin and London: University of Texas Press, 1968. 264 p. Bibliography: p. 255-256.
 Includes a Navaho pronunciation guide and a chronology of important dates in Navaho history. Gilpin's association with the Navaho people goes

back to 1930 when she traveled with her friend Elizabeth Warham Forster to the reservation in Arizona. It was Gilpin's stated purpose to create, by this book, a visual picture and explanatory text to help others understand the ways and energy of the Navaho people. She describes their art, their ceremonies, and their way of life.

[Corn and feathers], p. 3; *[Rock paintings]*, p. 7, 8; *[Corn tassel]*, p. 9; *Sisnaajiní (Mount Blanca), Sacred Mountain of the East*, p. 11; *Tsoodzil (Mount Taylor), Sacred Mounting of the South*, p. 13; *Doko'oosliíd (San Francisco Peaks), Sacred Mountain of the West*, p. 15; *Monument Valley*, p. 17; *[Male's profile]*, p. 20; *[Family in covered wagon]*, p. 21; *Lilly Benally*, p. 22; *Timothy Kellywood and his family*, p. 24; *[Woman and child]*, p. 25; *The quiet overhead light in a hogan*, p. 27; *Portrait of a young boy*, p. 28; *Costume of the 1930's*, p. 29; *Woman carrying her son and two lambs*, c. 1932, p. 30; *Grandfather and grandson*, p. 31; *Elizabeth Forster in Hardbelly's hogan*, 1932, p. 32; *[Woman in shawl]*, p. 33; *The women...*, p. 35; *...as we found them in 1955*, p. 36, 37; *Navaho twins*, p. 38; *Georgie Garcia*, p. 39; *Tom Navaho*, p. 40; *May Adson*, p. 41; *An old Navaho woman*, p. 42; *A portrait of Navaho Mountain*, p. 43; *Ason Kinlichine*, p. 44; *The letter*, p. 45; *A typical Navaho posture*, p. 46; *Irene Yazzie*, p. 47; *Luke Yazzie*, p. 48; *Portrait of Sam Yazzie*, p. 49; *Ned Hatathli's daughter and friend*, p. 51; *A young Navaho mother*, p. 52; *Bah Francis*, p. 53; *The summer shelter in the Cove*, 1934, p. 54; *The Ute Woman*, p. 54; *[Woman with lamb]*, p. 57; *[Riding on the pasture]*, p. 61; *Sunrise over the desert*, p. 62; *A hexagonal hogan near Red Rock*, p. 64; *An upright log and mud plaste hogan in the Checkerboard area*, p. 64; *A round stone hogan near Little Shiprock*, p. 66; *Interior of Harriet Cadman's hogan*, p. 67; *Interior of horizontal log hogan in the Cove Area*, p. 68; *Washing dishes under a brush shelter*, p. 69; *The summer hogan of Old Lady Long Salt*, p. 70; *A Navaho costume of the 1880's*, p. 72; *[Family in shade of covered wagon]*, after page 72; *Tying a "chongo,"* p. 73; *[Old woman by wagon wheel]*, p. 74; *Timothy's mother, who lives near Lukachukai*, p. 75; *Washburn Begay's hogan on the mountain*, p. 76; *[Sheep in the pasture]*, p. 77; *Making a baby-board*, p. 78; *Watching her grandchild*, p. 79; *The trading post of Shonto is nestled in a small canyon of red sandstone*, p. 81; *Selling piñon nuts to the trader*, p. 82; *[Men and women at the trading post]*, p. 82, 83; *Trading post barn*, 83; *Red Rock trading post with original dirt floor*, 1932, p. 84; *Examining wool*, p. 85; *Filling water barrels at the Valley Store*, p. 86; *Women returning from a trip to the trading post*, p. 87; *Charles Dickens marking jewelry in the pawn room of the Bruce Bernard Trading Post*, after p. 88; *Roman Hubbell in his trading post*, p. 89; *Family on a burro*, p. 90; *Men on the range*, p. 91; *The little shepherd*, p. 92; *During the long drought this boy brought his sheep eight miles to the nearest water*, p. 94; *Bringing home a flock of sheep on a windy day*, p. 95; *The nutritious grama grass of the West*, p. 95; *Flocks of sheep are gathered prior to shipping to market*, p. 96; *Sheep brought to trading post*, after p. 96; *The ever increasing use of trucks and cars is fast diminishing the use of the long-loved horse*, p. 98; *Navaho fences have very ingenious construction*, p. 100; *The Nakai family with a crop of melons on the bank of the San Juan River*, p. 102; *An irrigator turning water from a new source onto*

previously unbroken soil, p. 103; *Irrigating a newly plowed field*, p. 104; *[Woman hold corn]*, after p. 104; *Winowing beans on a small farm*, p. 105; *Agricultural exhibit at the Shiprock Fair*, p. 105; *Drying freshly cut alfalfa*, p. 106; *The first appointed Navaho to the National Park Service staff*, p. 107; *The ancient cliff dwelling of Beta-ta-kin in the Navajo National Monument*, p. 108; *The upper end of Canyon de Chelly from the air*, p. 110; *Canyon de Chelly*, after p. 112; *Many small farms cover the floor of Canyon del Muerto*, p. 113; *A corn field and hogan at the foot of the soaring cliffs*, p. 114; *After a rain in Canyon de Chelly*, p. 116; *Canyon del Muerto joins Canyon de Chelly a short distance above the mouth*, p. 117; *The White House cliff dwelling in Canyon de Chelly*, 1930, p. 119; *Drying peaches in Canyon del Muerto*, after p. 120; *Display of wool with native plants used for dyes*, before p. 121; *[Jewelry]*, p. 121; *[Pounding the roots of the yuca plant for soap]*, p. 124; *Wool is still carded by hand*, p. 125; *at age 94, Old Lady Long Salt of Navaho Mountain was still spinning her wool*, p. 127; *[Spinning wool]*, after p. 128; *Daisy Tauglechee produces many of the finest rugs*, p. 129; *The weaver is dyeing wool in a solution made from a native plant called Navaho Tea*, p. 130; *This woman is preparing to dye wool with the yellow root of the Holly-grape*, p. 130; *A weaver*, p. 131; *Weaving*, p. 132, 133; *The skilled hands and the fine yarn of Daisie Tauglechee*, p. 135; *The fine major weaves of the Navaho*, after a p. 137; *[Silver belt buckles]*, p. 137, 138, after p. 144; *A silversmith at work*, 1934, p. 139; *Silver bracelets*, p. 140, 143, 144, 146, 148; *Taking a cast medallion from the mold*, p. 141; *In recent years Navaho women have also become silversmiths*, p. 142; *Soldering silver squash blossoms for a necklace*, p. 145; *Carving a mold for a bracelet*, p. 145; *Earrings*, p. 147; *Ned Hatathli, first Navaho manager of the Arts and Crafts Guild*, p. 149; *Ambrose Roanhorse with his class at Fort Wingate school*, p. 150; *Pottery*, p. 151; *One of the few remaining potters*, p. 152; *Woven basket*, p. 153; *Navaho basketmakers are dwindling in number*, p. 154; *Harrison Begay--one of the many fine artists*, p. 156; *Necklace*, p. 157; *The Navaho make use of ceremonial gatherings to discuss either tribal or local problems*, 1934, p. 163; *Meeting in the Tribal Council building at Window Rock*, p. 164; *Navaho women casting their votes at the poll*, p. 165; *Chairman Sam Ahkeah, 1946-1954*, p. 166; *Chairman Paul Jones, 1954-1962*, p. 167; *Maurice McCabe, treasurer of the Tribe*, 1954, p. 168; *Annie Wauneka*, 1954, p. 170; *Wearing the Freedom Medal*, 1964, p. 171; *A classroom at the Crystal school with Navaho teacher Ester Henderson*, p. 172; *Children at the Red Rock Day School*, p. 173; *the clinic at Many Farms conducted by Cornell University*, p. 175; *A Navaho trained nurse at the Fort Defiance Hospital*, p. 175; *Herbert Blatchford in the field*, p. 177; *At work with a counselor*, p. 177; *Nancy Rose Benally when a student at the University of New Mexico*, p. 1178; *Anthropologist Shirley Sells as a ranger at Canyon de Chelly*, p. 178; *Men leaving Gallup for work on the railroad*, p. 179; *A young man operating large road-building equipment*, p. 180; *Agnes Draper, a skilled typist*, p. 180; *A waitress in a Gallup restaurant*, p. 180; *Captain William Yellowhair, Navaho Police Force, Tuba City*, p. 181; *Judge Hadley's court at Tuba City*, p. 182; *Navaho women and children gather scant fodder for their sheep in the Checkerboard Area*, p. 183; *The meeting at Counselor*,

New Mexico, p. 184; *In the dry Checkerboard Area, where the going is rough*, p. 186; *In the pine forest of the Chuska Mountains*, p. 187; *The old lumber plant at Sawmill was out in the open*, p. 188; *Monument Valley*, p. 189; *Looking west to the Monument Valley silhouette from the desert area near the uranium mines*, p. 190; *A worker in the uranium mine on top of the Lukachukai Mountains*, p. 192; *Sorting uranium or at the Shiprock processing plant*, p. 193; *An oil pumping station near the Four Corners*, p. 194; *Much Navaho wealth come from oil*, p. 195; *Roping a calf*, p. 197; *The Navaho gather on the hill for the Gallup Ceremonial*, p. 198; *Awaiting the entry at the Gallup Intertribal Ceremony*, p. 199; *Behind the scenes at the Gallup Ceremonial*, p. 200; *Women in covered wagon*, after p. 201; *[Onlookers at the Ceremonial]*, p. 201, 202; *Outside the exhibit area at the Shiprock Fair*, p. 203; *A family argument at the Shiprock Fair*, p. 203; *Rodeo events at Shiprock Fair*, p. 204, 205; *The Grand Entry at the Window Rock Fair*, p. 206; *The Window Rock arena, 1953*, p. 207; *The Window Rock arena, 1964*, p. 207; *Shiprock Fair*, after p. 208; *Overlooking the fairgrounds from the Community Center*, p. 209; *The Community Center*, p. 209; *[Woman and child seated on stone steps near empty bottles]*, p. 210; *[Holding a gourd rattle]*, p. 213; *A medicine man with his paraphernalia*, p. 214; *Sand painting*, p. 215; *[Doing a sand painting]*, p. 216; *[Women and children by a covered wagon]*, after p. 216; *[Fire Dance at night]*, p. 219; *The medicine man up on the mountain*, p. 221; *A medicine woman*, p. 222; *A modern medicine man and his children*, p. 223; *Making fry bread at Blessingway, Crownpoint*, after p. 224, 226; *The Blessing ceremony at Crownpoint school*, p. 225; *Navaho gathering for a Squaw Dance, 1934*, p. 227; *Drum*, p. 228; *Bringing in the stick to be trimmed*, p. 229; *The women go to the shelter*, p. 230; *Racing off with the Rattle Stick*, p. 231; *Bread making at the Squaw Dance*, p. 232; *The cook shelter for the Enemyway*, p. 233; *Gathering for the Dance*, p. 234; *The "He" rain*, p. 236; *The "She" rain*, p. 237; *Sand painting at a Yeibichai Ceremony*, p. 238; *[Rainbow over a field of flowers]*, after p. 240; *Wood for the bonfires*, p. 241; *The dance ground for the Nightway*, p. 241; *Awaiting the night ceremonial*, p. 242, 243; *The long prayer at the Nightway*, p. 244; *A Yeibichai mask*, p. 246; *[Portraits]*, p. 248, after p. 248; 249.

380. Gilpin, Laura. *Laura Gilpin, Retrospective: 1910-1974*. Santa Fe: Museum of New Mexico, 1974. 16 p.
 An exhibition catalog which includes brief comments by Anne Noggle, Ansel Adams, Paul Strand and Beaumont Newhall, and a photograph of Gilpin taken in 1971 and biographical notes.
The Visiting Nurse, 1924, p. 5; *A Navaho Family*, 1950, p. 7; *Campo Santo*, 1961, p. 9; *A Chance Meeting in the Desert*, 1950, p. 11; *Navaho Sacred Mountain of the East*, 1953, p. 12; *Picuris Church*, 1962, p. 13; *The Covered Wagon*, 1934, p. 14; *Big and Little Shiprock*, 1950, p. 15; *The Rio Grande Yields Its Surplus to the Sea, Texas and Mexico*, 1947, cover.

381. Gilpin, Laura. "The Need for Design in Photography," *The American Annual of Photography* (1926): 154-156.

382. Gilpin, Laura. *The Pueblos: A Camera Chronicle*. New York: Hastings House, 1941. 124 p.
Short historical and descriptive text accompany the photographs of Native Americans and their dwellings.

The Water hole, Acoma, frontispiece; *[Cave of the basket makers]* p. 15, 16; *[Mesa Verde National Park]*, p. 17; *[Cliff Canyon]*, p. 18; *[Spruce Tree House]*, p. 19; *[Balcony House]*, p. 21, 23; *View from Balcony House*, p. 25; *Square Tower House*, p. 27; *[Cliff dweller maiden]*, p. 29, 31; *[Grinding corn]*, p. 33; *[Sun Temple]*, p. 36; *[View from Sun Temple]*, p. 37; *[Buildings of Mesa Verde]*, p. 39; *[Round Tower of Cliff Palace]*, p. 41; *[A priest ascends to a vantage point]*, p. 42; *[Landscape on and about Mesa Verde]*, p. 43; *[Shiprock]*, p. 44, 71; *Mount Taylor*, p. 45; *[Square Tower group]*, p. 46; *[The great pueblos]*, p. 47; *[Rear wall and small kiva]*, p. 49; *[Subterranean kiva]*, p. 51; *[Pueblo Bonito, Chaco Canyon]*, p. 53, 55, 57; *[Rooms of Bonito]*, p. 59; *[Keet Seel]*, p. 60, 61; *[Be-ta-takin]*, p. 62, 65; *[Decorated pottery]*, p. 63; *[White Hosue of the Canyon de Chelly]*, p. 67; *[Canyon de Chelly]*, p. 69; *[Rito de los Frijoles]*, p. 73; *Old woman of Acoma*, p. 75; *[Village of San Ildefonso]*, p. 79; *[This portal faces the public square]*, p. 81; *[Suspended baby cradle]*, p. 82; *[Woman moulding pottery]*, p. 83; *[Polishing the pottery]*, p. 85; *[Mother and child]*, p. 87; *[Religious ceremonial dances]*, p. 88; *[Corn dance]*, p. 89; *[Returning to the kiva]*, p. 91; *[Women of Santa Clara]*, p. 93; *[Modern decorated jar from the Pueblo of Zia]*, p. 94; *[Terraced Pueblo of Taos]*, p. 95; *[Outside ladders of Taos]*, p. 96; *[Ovens for baking bread]*, p. 97; *[Taos man wearing white sheet]*, p. 99; *[Taos woman]*, p. 101; *[Taos man on horseback]*, p. 103; *[Catholic mission in Taos]*, p. 104; *[Carrying corn to the roof of the mission]*, p. 105; *[Taos Pueblo]*, p. 106; *[Laguna Mission]*, p. 107; *[Interior of the Mission San José de Laguna]*, p. 108, 109; *[Costume of the Laguna woman]*, p. 111; *[Ácoma]*, p. 113, 115, 117, 123; *Ácoma Mission*, p. 119; *Ácoma Mission and Convento*, p. 119; *[Patio of the Convento]*, p. 121; *[Dwellings of the Ácoma Indians]*, p. 122; *[Pueblo man]*, p. 123.

383. Gilpin, Laura. *The Rio Grande: River of Destiny; an interpretation of the river, the land, and the people*. New York: Duell, Sloan and Pearce, 1949. 243 p. Chiefly illustrations. Bibliography: p. 241-242.
Includes a chronology of the Rio Grande, facts about the Rio Grande and a Glossary of Spanish words. From the preface, this is a "portrait of the river" accompanied by descriptive text by Gilpin. The text continues throughout the book as it describes the photographs, it also provides the reader with the history of the region and the river.

Spruce cones, p. 1; *[Stony Pass]* p. 4-6; *Nature's own rock garden,* p. 7; *[The Timberline]* p. 8-9; *[Two burros]* p. 10; *[Evergreens and aspens]* p. 11; *[Beaver dams]* p. 12; *[Small canyons]* p. 13; *[Whittling cowboys and their horses]* p. 14; *[Cowboy and horse]* p. 15; *[Meadow and Rio Grande Pyramids]* p. 16; *[The River]* p. 17; *[Snow and a single tree]* p. 18; *[Snow on the forest]* p. 19; *[Englemann Spruce]* p. 20; *[Open meadows]* p. 21; *[Herd of cattle]* p. 22; *[Flock of resting sheep]* p. 23; *[Bristol Head guards the Upland Valley]*, p. 24; *Cowboy*

boot, p. 25; *[The valley widens into broad natural-hay meadows]* p. 26; *[The mountain sheriff]* p. 27; *[The cowboy's trappings]* p. 28; *[Old ranch house]* p. 29; *[Group of horses]* p. 30; *[Cattle come down from the hills to drink at the river's edge]* p. 31; *[The river is a fisherman's paradise]* p. 32; *[A flash of sunlight precedes a thunderstorm]* p. 33; *[Tall spruce border the river]* p. 34; *[Creede, a mining town]* p. 35; *[Ore chutes on overhead cables]* p. 36; *[Old-time prospector still roams the hill]* p. 37; *[Mines and freight cars]* p. 38; *[River passes through Wagon Wheel Gap]* p. 39; *[The forest ranger visits the lumber camps]* p. 40; *[Lumberjacks]* p. 41; *[Forester's marking axe]* p. 42; *[The river approaches the San Luis Valley]* p. 43; *[Sheep drive]* p. 44; *[Inspecting the sheep]* p. 45; *[Farm at the base of the mountains]* p. 46; *[Bison skull]* p. 47; *[Ditches to control the water]* p. 48; *[The river]* p. 49; *[Sangre de Cristo Range]* p. 51; *[Ski Hi Stampede, the annual rodeo]* p. 52; *[Bucking broncho]* p. 53; *[Contestants swap stories near the chutes]* p. 53; *[Elizabeth Pfeiffer, one of the few living first settlers]* p. 54; *[Irrigating the potato field]* p. 55; *[Potato harvesting]* p. 56; *[Farmer inspects his crop]* p. 57; *[Tracks in the sand dunes]* p. 59; *[Old Fort Massachusetts]* p. 60; *[Trees of the Red River plateau]* p. 62; *[Carreta]* p. 63; *[Taos drum]* p. 69; *[Sangre Crito Mountains]* p. 70; *[The river cuts its way through the mass of lava]* p. 71; *[Taos pueblo]* p. 72; *[Ruins of the old church at Taos pueblo]* p. 73; *[Ships' anchors in the cemetery at Taos]* p. 74; *[Desert west of Taos]* p. 75; *[Taos Mountain]* p. 76; *[The Mission Church of Ranchos de Taos made of adobe]* p. 77; *[Rio Grande Gorge looking north toward the low hills]* p. 78; *[The Rio Grande Gorge widens]* p. 79; *[The remains of old Spanish flour mills, millstones]* p. 80; *[Chili peppers hanging out to dry]* p. 81; *[Outdoors ceremony dedicating a commemorative cross]* p. 82; *[Dancing feet]* p. 83; *[Indian man in the corn field]* p. 85; *[Women gather the husks and sort the ears]* p. 86; *[Corn in many colors]* p. 87; *[Tunyo--the Black Mesa]* p. 88; *[Woman and child standing in pueblo]* p. 89; *[Man and woman in native dress]* p. 91; *[Women and children of pueblo]* p. 93; *[Painting pottery]* p. 94; *[Firing pottery]* p. 94; *[Baking bread in the horno]* p. 95; *[Ceremonial dances]* p. 96-99; *[Statue of the patron saint carried back to the church]* p. 100; *[Small boy in ceremonial dance costume]* p. 101; *[Jémez Mountains and Valle Grande]* p. 102; *[Pajariot Plateau of hardened volcanic ash]* p. 103; *[The Rio Grande twists through White Rock Canyon]* p. 104; *[Ruins in the Frijoles Canyon]* p. 105 ; *[Stone walls of the ruins]* p. 106; *La Conquistadora,* p. 107; *[A Franciscan padre]* p. 109; *[Tiny village of Rio Chiquito]* p. 112; *[Little Church of San Pedro]* p. 113; *[Interior of church, with it primitive native art]* p. 114; *[Carved figure of San Pedro, stands in niche]* p. 115; *[Inlaid cross in the churchyard]* p. 116; *[Carver, George López]* p. 117; *[Young girl under fruit tree]* p. 118; *[Children by flowering tree]* p. 119; *[Great bags of sheared fleeces pile up]* p. 120; *[Flock of sheep]* p. 121; *[Ponderosa pines]* p. 122; *[Aspen intermingle with spruce and fir]* p. 123; *[Santa Fe]* p. 125; *[Crafts on display at the portal of the Governor's Palace]* p. 126; *[Great stone reredos in the new Church of Cristo Rey]* p. 127; *[Summer thunderstorms]* p. 128; *[The modern acequia madre (mother ditch) as it swings from the river to irrigate the farms]* p. 130; *[Man by river]* p. 131; *[San Felipe, by the river's edge]* p. 132; *[Horse in time of drought]* p. 133;

[Bend in the river] p. 134; *[From the crest of the Sandia Mountains]* p. 136; *[The white sands]* p. 137i; *[Albuquerque]* p. 139; *[Clouds]* p. 141; *[The river during spring run-off]* p. 142; *[The dam]* p. 143; *[Moonlight on the water]* p. 144; *[The shores of Elephant Butte Lake]* p. 145; *[Lake Caballo, another storage lake]* p. 146; *[Mount Robledo and the ruins of Fort Shelden]* p. 147; *[New Mexico desert]* p. 148; *[River bed, parched and dry]* p. 149; *[In the Mesilla Valley, long-staple cotton is grown]* p. 150; *[Long sacks of cotton]* p. 151; *[Picking cotton in the fields]* p. 151; *[Near Mesilla, seed onions]* p. 152; *[Front of adobe houses]* p. 153; *[Boy on burro]* p. 154; *The Alamo,* p. 155; *The Great Spanish Dagger,* p. 160; *Juárez flower vendors,* p. 161; *[Bridges of the Southern Pacific Railroad]* p. 162; *[El Paso]* p. 163; *[A copper refinery]* p. 164; *[A cement factory]* p. 165; *[Cartload of flowers]* p. 166; *[Interior of the mission of Nuestra Señora de Guadalupe de El Paso]* p. 167; *[Older homes of Juárez]* p. 168; *[Irrigated farm]* p. 169; *[Bales of cotton]* p. 170; *[Old adobe walls, and knarled trees]* p. 171; *[Arch of cottonwoods]* p. 172; *Last of the Longhorns,* p. 173; *[Río Conchos]* p. 174; *[Ojinaga, a small Mexican town]* p. 175; *[Farmer riding his burro]* p. 176; *[Ojinaga's church]* p. 177; *[A simple adobe house]* p. 178; *[Ruin of the old mission]* p. 179; *[Border patrol on guard in a jeep]* p. 180; *[Paradise Valley]* p. 181; *[Wide open range]* p. 182; *[Cattle ranch]* p. 183; *[Cattle herd]* p. 184; *[The <u>remuda</u>, group of remount horses]* p. 184; *[Cooking during the roundup]* p. 184; *[The roundup]* p. 185; *[Cowboy, with lasso, on horseback]* p. 186; *[Old man sitting on ground, eating]* p. 187; *[The plant, ocotillo]* p. 188; *[The Big Bend of the Rio Grande]* p. 189; *[The sotol with its beautiful, fierce sawtooth edges]* p. 190; *[In the Big Bend, there are great areas of eroded desert land]* p. 191; *[Elena Canyon]* p. 192; *[Mariscal, another canyon]* p. 193; *[Leaving Mariscal Canyon, hot, dry, fossil-filled banks]* p. 194; *[Man by cactus]* p. 195; *[Boquillas Canyon through the Sierra del Carmen]* p. 197; *[Saloon in the town of Langtry]* p. 198; *Maguey Plant,* p. 199; *[Angora goats in a pen]* p. 201; *[Live oaks]* p. 202; *[Rich farmland]* p. 203; *[The river]* p. 204; *[Bridge to Laredo]* p. 205; *[Mesquite tree and white thistle-poppy]* p. 206; *[Town of Guerrero on the banks of the RíoSalado]* p. 207; *[Suspension bridge from Roma]* p. 208; *[The chaparral, where every growing plant has thorns and spines]* p. 209; *[Entrance to the dam, Presa Marte Gómez]* p. 210; *[Town of Ceerralvo, the oldest settlement in the Valley of the Rio Grande]* p. 211; *[Boy by team of oxen pulling loaded cart]* p. 212; *[Cerralvo's plaza with it sycamores]* p. 213; *[Swamp cypress trees]* p. 214; *[Women and children by open door]* p. 215; *[Davis Landing]* p. 216; *[Oil drilling]* p. 217; *The Spanish bayonet guards its gorgeous bloom,* p. 218; *Ebony tree,* p. 219; *[Tall palm trees]* p. 220; *[Grapefruit tree]* p. 221; *[Sorting and packing grapefruits]* p. 222-223; *[Water pumping stations]* p. 224; *[Field worker picking lettuce]* p. 225; *[City of Brownsville]* p. 226; *[Palms border highway]* p. 227; *[Busy port ships]* p. 228; *[Bridge over the river]* p. 229; *[Cattle cool themselves in a small pool of the river]* p. 230; *[Woman near birdcage]* p. 231; *[Water control equipment]* p. 232; *[The ebony tree of the Delta]* p. 233; *[Fisherman repairing net]* p. 234; *[Small fishing boats]* p. 235; *[The river reaches the sea]* p. 236; *Old light house--Port Isabel,* p. 237.

384. Gilpin, Laura. *Temples in Yucatán: A Camera Chronicle of Chichén Itzá*.
New York: Hastings House, 1947. 124 p. Bibliography: p. 124.

Photographs, taken between 1932 and 1946, of the most important
restored Mayan temples and buildings. Each photograph is accompanied
by explanatory and descriptive material. Includes a Mayan calendar and
chronology of Chichén Itzá.

Standard Bearer at the Top of the Stairway to the Temple of the Warriors,
frontispiece; *Temple of the Two Lintels*, p. 14; *Mask of Itzamna, the Sky God*, p. 14;
East Corner, Temple of the Two Lintels, p. 15; *West Corner, Temple of the Two
Lintels*, p. 16; *Temple of the Four Lintels*, p. 17; *Temple of the Interior Atlantean
Columns, p. 18; Atlantean Column in Portal at Chichén Itzá, p. 19; Temple of the
Initial Stages*, p. 20; *Casa de Las Monjas*, p. 27; *Casa de Las Monjas from the
Iglesia*, p. 28; *A Corner of the Monjas, Partially Excavated*, p. 29; *The East Annex*,
p. 30; *A Maya Boy at the Home of His Ancestors*, p. 31; *Doorway of the East
Annex*, p. 32; *Vista Between the East Annex and the Iglesia*, p. 33; *Caracol from
the Iglesia*, p. 34; *The Caracol*, p. 35; *The Caracol,, Showing Incense Burners*,
1932, p. 36; *The Caracol though a Corbel Arch*, p. 37; *The Caracol from the Casa
Colorada*, 1932, p. 38; *The Temple of the Kukulcán from the Caracol*, p. 39; *The
Casa Colorada*, p. 40; *The Temple of Kukulcán*, p. 43; *Stairway to the Temple of
Kukulcán*, p. 44; *Sunlight and Shadow on the Balustrade of the North Stairway*, p.
45; *The Serpent Heads at the Base of the Balustrade*, p. 46; *The Red Jaguar
Throne*, p. 47; *The Turquoise Plaques*, p. 48; *The Top Platform*, p. 49; *Door to
Inner Room of the Temple of Kukulcán*, p. 50; *The Temple of the Jaguars from the
Top Platform*, p. 51; *The Dance Platform*, p. 52; *The Panels of the Dance Platform*,
p. 53; *North Stairway to the Dance Platform*, p. 54; *The Road to the Sacred Well*,
p. 55; *The Well of Sacrifice*, p. 56; *Group of Maya at the Well of Sacrifice*, p. 57;
The Great Ball court, p. 58-59, 61; *The Great Ball Court Frieze*, p. 62; *Cornice of
the Temple of the Jaguars*, p. 63; *The Great Serpent Columns of the Temple*, p. 64;
*The Umpire's Box above the Ring on the West Wall, p. 65; Plumed Serpent Column
and Carved Door Jamb*, p. 66; *The Cornice of the Temple of the Jaguars*, p. 67;
The Ring in the West Wall, 1946, p. 68; *The Ring in the East Wall*, 1932, p. 69; *The
North Temple*, p. 70; *The Rear Elevation of the Temple of the Jaguars and the
Lower Temple of the Jaguars*, p. 71; *The Lower Temple of the Jaguars during
Reconstruction*. 1932, p. 72; *The Great Plaza of Northern Chichén Itzá*, p. 73; *The
Tzompantli Parapet with the Temple of Kukulcán beyond*, p. 75; *Detail, Tzompantli
Parapet*, p. 76; *The Chac Mool of the Tzompantli*, p. 77; *The Platform of the
Eagles*, p. 78, 80; *Detail of the Platform of the Eagles*, p. 79; *The Tzompatli
Platform*, p. 81; *The Temple of the Warriors*, p. 83; *Temple of Kukulcán from the
West Colonnade*, p. 84; *Group of Maya at the Dais in the West Colonnade*, p. 85;
The Temple of Kukulcán at Evening from the Temple of the Warriors, p. 86; *Corner
of the West Colonnade by the Stairway*, p. 87; *The Chac Mool at the Head of the
Stairway*, p. 88; *The Altar of Sacrifice*, p. 89; *The Plumed Serpent Heads*, p. 90;
The Plumed Serpent Columns of the West Portal, p. 91; *Serpent-bird Panel on the
South Wall*, p. 92; *View from the Temple of the Warriors Portal*, p. 93; *Southwest
Corner of the Temple of the Warriors*, p. 94; *Temple of the Warriors Frieze*, p. 95;

The Temple of the Warriors from the Temple of Kukulcán, p. 97; *The Turquoise Plaque*, p. 98; *The North Colonnade*, p. 99; *Maya of Today*, p. 100; *A Group of Maya at the Entrance to the North Colonnade*, p. 101; *In the Group of a Thousand Columns*, p. 102; *The Front Hall of the Market Place*, p. 103; *Dais in the Front Hall of the Mercado*, p. 104; *Peristyle Court in the Mercado*, p. 105, 106; *A Child Brings Home Dried Sisal Stumps for Fuel*, p. 108; *A Street of Dzitas*, p. 109; *A Native House*, p. 110; *A Street in the Village of Piste*, p. 111; *A Laundry in Piste*, p. 112; *A Young Woman Making Tortillas*, p. 113; *Grinding Stone with Metate and Mano Stones*, p. 114; *Along a Village Street*, p. 114; *A Group of Maya Women*, p. 115; *Maya Woman in Characteristic Native Dress*, p. 116; *The Henequen Plant, Sisal*, p. 117; *On a Henequen Plantation*, p. 118; *The Fibers Are Spread on the Drying Rack*, p. 119; *[Driving a native cart]*, p. 120; *The Church of San Ysidro at Chichén Itzá*, p. 123.

385. Hill, Phil and Tom Cooper, "Camera Interview: Laura Gilpin," *Camera* 55, 11 (November 1976): 11+.

386. Hust, Karen. "'The Landscape (Chosen by Desire)': Laura Gilpin Renegotiates Mother Nature," *Genders* 6 (1989): 20-48.

387. *Laura Gilpin: An Enduring Grace*. Fort Worth, TX: The Museum, 1986. Videocassette, 27 min.
"Documents the life and work of Laura Gilpin, who photographed the American Southwest and its native peoples for more than sixty years. Includes historic film footage, home movies, interviews, and Gilpin's own photographs."oclc

388. Mezy, Phiz. "Masters of the Darkroom: An Interview with Laura Gilpin," *Darkroom Photography* 2, 1 (January/February 1980): 30-34.

389. Norwood, Vera. *The Photographer and the Naturalist: Laura Gilpin and Mary Austin in the Southwest.* Working Paper #6. Tucson, AZ: Southwest Institute for Research on Women, 1981. 37 p.
Study of the response to the Southwest by the writer Austin and Gilpin, one of the first women to photograph the frontier landscape and the Native Americans.

390. Norwood, Vera. "The Photographer and the Naturalist: Laura Gilpin and Mary Austin in the Southwest," *Journal of American Culture* 5, 2 (1982): n.p.

391. Sandweiss, Martha A. *Laura Gilpin (1891-1979): Photographer of the American Southwest*. Dissertation. Yale University, 1985. 406 p. Bibliography: p. 375-398.

392. Sandweiss, Martha A. *Laura Gilpin: An Enduring Grace*. Fort Worth, TX: Amon Carter Museum, 1986. 339 p. Chronological bibliography: p. 275-315.

Catalog of the exhibition held at the Amon Carter Museum, 1986 and various other places. A third of the catalog draws upon the letters, photographs and written material contained in the Laura Gilpin collection of the Amon Carter Museum to chronicle the life and the career of this important photographer of the Southwest.

Cloister at the San Diego Exposition, 1915, p. 20; *Brenda Putnam Working on a Portrait Bust of Laura Gilpin*, 1921, p. 25; *Snowstorm, Central Park, New York*, 1917, p. 31; *Elizabeth Forster*, 1918, p. 34; *Gilpin Family*, 1921, p. 35; *Landscape Class, Broadmoor Art Academy*, 1920, p. 36; *Harold Bauer Playing Beethoven*, 1925, p. 43; *House of the Cliff Dweller, Mesa Verde, Colorado*, 1925, p. 45; *Square House Tower, Mesa Verde, Colorado*, 1925, p. 46; *Security Building, Denver, Colorado*, 1927, p. 49; *Hardbelly's Granddaughter*, 1933, p. 55; *Boy with Sheep*, 1932, p. 56; *Mrs. Francis Nakai*, 1932, p. 57; *Stairway, Temple of Kukulcan*, 1932, p. 62; *Helen Freeman in <u>Camille</u>*, 1932, p. 63; *Laguna Indian Pueblo, Interior of Mission San Jose*, 1938, p. 64; *Old Woman of Acoma*, 1939, p. 68; *A B-29 Bomber Leaving the Factory*, 1944, p. 74; *Rio Grande before a Storm*, 1945, p. 80; *Live Oak Tree*, 1946, p. 83; *Elizabeth Forster and Paulina Barton's Sister near Red Rock*, 1950, p. 87; *Group in Hogan Door, Red Rock*, 1950, p. 89; *Navaho Sacred Mountain of the East*, 1953, p. 90; *A Navaho Summer Hogan*, 1953, p. 91; *Hubert and Floyd Laughter*, 1954, p. 93; *Making Cast Silver, Pine Springs, Arizona*, 1950, p. 95; *Navaho Shepherd Boy*, 1950, p. 96; *Navaho Twins*, 1954, p. 100; *Meeting in a Hogan, Counselor, New Mexico*, 1953, p. 103; *Tying a Tsiiyéél*, 1954, p. 104; *Air Shot of Canyon de Chelly, Arizona*, 1972, p. 107; *Canyon de Chelly, Arizona*, 1964, p. 109; *At the Draper Farm*, 1975, p. 111; *Gladys McConnell Fowler and Son George*, 1914, pl. 1; *Still Life with Peaches*, 1912, pl. 2; *Self-Portrait*, c. 1912, pl. 3; *Portrait*, 1910, pl. 4; *Washington Square, New York*, 1916, pl. 5; *The Prelude*, 1917, pl. 6; *Sailboat Race, Nova Scotia*, 1919, pl. 7; *Recruiting Scene, New York City*, 1917, pl. 8; *Brenda Putnam and Marble Cutters, New York*, 1917, pl. 9; *Edith Farnsworth*, 1917, pl. 10; *The Prairie*, 1917, pl. 11; *Padraic Column*, 1919, pl. 12; *The Spirit of the Prairie*, 1921, pl. 13; *Cathedral Spires*, 1919, pl. 14; *Snow Coral*, 1924, pl. 15; *Sunrise on the Desert*, 1921, pl. 16; *Ghost Rock, Garden of the Gods, Colorado*, 1919, pl. 17; *Brenda Putnam*, 1921, pl. 18; *Betsy's Aspens*, 1921, pl. 19; *Emma Miller Gilpin*, c. 1912, pl. 20; *Three Ceramic Pots*, 1941, pl. 21; *Apple Blossoms*, 1941, pl. 22; *Margaret Carlson*, 1921, pl. 23; *Barbara Mayor*, 1923, pl. 26; *The Babe*, 1927, pl. 24; *The Flower Garden*, 1927, pl. 25; *Farnsworth-Hazelhurst Wedding, Colorado Springs, Colorado*, 1926, pl. 27; *George William Eggers*, 1926, pl. 28; *Fishermen at Concarneau, France*, 1922, pl. 29; *Interior of Chartres Cathedral*, 1922, pl. 30; *Chartres Cathedral*, 1922, pl. 31; *A Visiting Nurse*, 1924, pl. 32; *Grace Church, Colorado Springs*, 1928, pl. 33; *Corley Road Tunnel*, 1925, pl. 34; *A Problem for Students to Make a Still Life of a Pair of Scissors, Two Books, and a Ball of String*, 1930, pl. 35; *Cave of the Winds*, 1925, pl. 36; *Roses in Vase*, 1928, pl. 37; *Model in Fortuny Gown*, 1925, pl. 38; *Lillian

Gish in Camille, Central City, Colorado, 1932, pl. 39; *Mrs. Hendrie,* 1930, pl. 40; *U.S. Supreme Court Justice McReynolds,* 1934, pl. 41; *Joy Krebbs,* 1930, pl. 42; *Hubbard Phelps, Los Alamos School, New Mexico,* 1933, pl. 43; *Louisa Graham,* 1936, pl. 44; *White Iris,* 1926, pl. 45; *Rain Drops on Lupin Leaves,* c. 1931, pl. 46; *Narcissus,* 1928, pl. 47; *Sunrise, Grand Canyon,* 1930, pl. 48; *Bryce Canyon,* 1930, pl. 49; *Colorado Sand Dunes,* c. 1946, pl. 50; *Zion Canyon,* 1930, pl. 51; *Bryce Canyon, no. 2,* 1930, pl. 52; *Sunburst, the Castillo, Chichén Itzá,* 1932, pl. 53; *Temple of the Warriors, Chichén Itzá,* 1932, pl. 54; *Temple of the Warriors from the Castillo, Chichén Itzá,* 1932, pl. 55; *Top Platform of the Castillo, Chichén Itzá,* 1932, pl. 56; *North Colonnade, Chichén Itzá,* 1932, pl. 57; *Steps of the Castillo, Chichén Itzá,* 1932, pl. 58; *Sisal Plant, Yucatán,* 1932, pl. 59; *Maya Women, Yucatán,* 1932, pl. 60; *Casa Blanca, Canyon de Chelly,* 1930, pl. 61; *Navaho Madonna,* 1932, pl. 62; *A Navaho Silversmith,* 1934, pl. 63; *The Ute Woman,* 1934, pl. 64; *Shepherds of the Desert,* 1934, pl. 65; *Sunrise from the Lukachukai Mountains, Arizona,* 1934, pl. 66; *Navaho Covered Wagon,* 1934, pl. 67; *Navaho Woman, Child, and Lambs,* 1932, pl. 68; *Shiprock, New Mexico,* 1932, pl. 69; *Setah Begay, Navaho Medicine Man,* 1932, pl. 70; *The Little Medicine Man,* 1932, pl. 71; *Ethel Kellywood,* 1932, pl. 72; *Navaho Weaver,* 1933, pl. 73; *Hardbelly's Hogan,* 1932, pl. 74; *Navaho Woman and Child in Hogan,* 1932, pl. 75; *Timothy Kellywood and His Family,* 1932, pl. 76; *Shiprock from the North Rim of Mesa Verde,* 1926, pl. 77; *Mrs. Francis Nakai and Son,* 1932, pl. 78; *Navaho Family under Tree,* 1932, pl. 79; *Red Rock Trading Post, Arizona,* 1932, pl. 80; *Navahos by Firelight,* 1933, pl. 81; *Water Hole, Acoma, New Mexico,* 1939, pl. 82; *San Ildefonso Potters,* 1925, pl. 83; *Laguna Pueblo Mission, New Mexico,* 1924, pl. 84; *Taos Ovens, New Mexico,* 1926, pl. 85; *The Gate, Laguna, New Mexico,* 1924, pl. 86; *Round Tower, Cliff Palace, Mesa Verde, Colorado,* 1925, pl. 87; *Grandmother and Child, San Ildefonso, New Mexico,* 1925, pl. 88; *Balcony House, Mesa Verde, Colorado,* 1924, pl. 89; *Chaco Canyon, Pueblo Bonito,* 1931, pl. 90; *Pueblo Bonito, Chaco Canyon, New Mexico,* 1931, pl. 91; *At the San Ildefonso Pueblo, New Mexico,* 1927, pl. 92; *Tony Peña, San Ildefonso Pueblo, New Mexico,* 1945, pl. 93; *Cliff Dwellers of Betatakin, Arizona,* 1930, pl. 94; *Governor, Taos Pueblo, New Mexico,* 1971, pl. 95; *Storm from La Bajada Hill, New Mexico,* 1946, pl. 96; *Church at Picuris Pueblo, New Mexico,* 1963, pl. 97; *A Campo Santo,* 1961, pl. 98; *Near Rinconada,* 1946, pl. 99; *Door at Ranchos de Taos Church,* 1947, pl. 100; *Georgia O'Keeffe,* 1953, pl. 101; *Santo, San José de Chama,* 1938, pl. 102; *Near Chimayo, New Mexico,* 1948, pl. 103; *Tommy Dickerson with Chicken,* 1944, pl. 104; *New Mexico Santo,* 1957, pl. 105; *Peter Goodwin,* 1960, pl. 106; *White Sands, New Mexico, no. 3,* 1947, pl. 107; *The Friendly People of Cerralvo, Mexico,* 1949, pl. 108; *Near the Old Comanche Trail, Big Bend National Park,* 1946, pl. 109; *South Park, Colorado,* 1941, pl. 110; *Rabbit Ear Pass, Colorado,* 1937, pl. 111; *Paradise Valley, near the Big Bend, Texas,* 1946, pl. 112; *White Sands, New Mexico,* 1945, pl. 113; *Sotol Plant,* 1946, pl. 114; *Rio Grande Yields Its Surplus to the Sea,* 1947, pl. 115; *A Navaho Family,* 1950, pl. 116; *A Navaho Court,* 1954 pl. 117; *Classroom at Crystal with a Navaho Teacher,* 1954, pl. 118; *Hubert and Floyd Laughter,* 1954, pl. 119; *Irene Yazie, Pine Springs, Arizona,* 1952, pl. 120; *Navaho*

Grandmother, 1951, pl. 121; *Modern Medicine Man, Goldtooth Begay, Round Rock, Arizona,* 1951, pl. 122; *Florence at Long Salt Hogan,* 1953, pl. 123; *Big and Little Shiprock, New Mexico,* pl. 124; *A Chance Meeting in the Desert,* 1950, pl. 125; *Mrs. Hardbelly,* 1953, pl. 126.

393. Sauter, Mary C. "Laura Gilpin's Work," *Camera Craft* 29, 9 (September 1922): 419-421.

394. Vestal, David. "Laura Gilpin, Photographer of the Southwest," *Popular Photography* 80, 2 (February, 1977): 100-105+.

395. Witthus, Rutherford W. "The Artist and the Architects: Laura Gilpin Photographs Fisher and Fisher Buildings of 1920s Denver," *Colorado Heritage* 4 (1986): 2-18.

396. "Camera Chronicles of Laura Gilpin," *Persimmon Hill* (1978): 66-79.

Glasbow, Debra
 See also #1039
Gledhill, Caroline Evans
 See also #1058
Gluck, Barbara
 See also #1070
Gold, L. Fornasieri
 See also #1070
Goldberg, Beryl
 See also #1070

Golden, Judith, 1934-
 See also #1006, 1007, 1008, 1011, 1019, 1020, 1058, 1073

397. Fischer, Hal. "Judith Golden," *Artforum* 20, 4 (1981): n.p.

398. Golden, Judith. *Cycles, a Decade of Photographs.* San Francisco: Friends of Photography, 1988. 51 p. Bibliography: p. 51.
 Includes a chronology and a short biographical essay that analyzes the techniques of Golden's mixed media photographs exemplifying the body of her work with masking and facades. Also includes an interview with Judith Golden.
From the <u>Chameleon Series</u>, 1975:*Chameleon,* pl. 1; *Sweet Sue,* pl. 2; *New Year's Eve at the Waldorf-Astoria with Truman Capote,* pl. 3; *Frankly, My Dear, I Don't Give a Damn,* pl. 4; *Star Struck,* pl. 5; *Motorcycle Man,* pl. 6; *Faye Dunaway, Warm,* pl. 7; From the <u>Magazine Series</u>, 1975, pl. 8; From <u>Magazine Makeovers</u>, 1976: *Rhinestones,* pl. 9; *Summer Changeover,* pl. 10; *Body,* pl. 11; *Plays It Hot,* pl. 12.

From _People Magazine_, 1976-1978: _Ringo, Goldie Hawn, Mary Hartman, David Bowie_, pl. 13; From _Ode To Hollywood_, 1977-1978: _Alexander the Great_, pl. 14; _Bombay Clipper_, pl. 15; _These Thousand Hills_, pl. 16; _The Warriors_, pl. 17; From _Portraits of Women_, 1980-1981: _Debra_, pl. 18; _Karen, Naomi, Robin, Dorothy_, pl. 19; From _The Elements_, 1984-1986: _Earth_, pl. 20; _Air_, pl. 21; _Fire_, pl. 22; _Water_, pl. 23; From _Persona_, 1982-1985: _Persona X_, pl. 24; _Persona XI_, pl. 25; _Persona XV_, pl. 26; _Persona XIII_, pl. 27; From _Cycles_, 1984-1985: _Cycles I_, Front Cover; _Cycles III_, Back Cover; _Cycles VIII_, pl. 28; _Cycles V_, pl. 29; _Cycles VII_, pl. 30; _Cycles VI_, pl. 31; _Cycles X_, pl. 32.

Goldin, Nan, 1953-
> See also #1015, 1028, 1055, 1058, 1063

399. Goldin, Nan. _The Ballad of Sexual Dependency_. New York: Aperture, 1986. 147 p. Chiefly illustrations.
> Portfolio is introduced with a brief essay by Goldin.

Greer and Robert on the Bed, New York City, 1982, frontispiece; _Nan on Brian's Lap, Nan's Birthday, New York City_, 1981, p. 11; _The Duke and Duchess of Windsor,Coney Island Wax Musuem_, 1981, p. 12; _The Parents at a French Restaurant, Cambridge, Mass._, 1985, p. 13; _Susan and Max Sunbathing on the Beach, Provincetown, Mass._, 1976, p. 14; _C.Z. and Max on the Beach, Truro, Mass._, 1976, p. 15; _Suzanne and Brian on the Bench, Coney Island_, 1982, p. 16; _Suzanne and Philippe on the Bench, Tompkins Square Park, New York City_, 1983, p. 17; _Suzanne on the Train, Wuppertal, West Germany_, 1984, p. 19; _Trixie on the Cot, New York City_, 1979, p. 20; _Vivienne in the Green Dress, New York City_, 1980, p. 21; _Self-Portrait in Blue Bathroom, London_, 1980, p. 22; _Suzanne with Mona Lisa, Mexico City_, 1981, p. 23; _Sandra in the Mirror, New York City_, 1985, p. 24; _Suzanne in the Green Bathroom, Pergamom Museum, East Berlin_, 1984, p. 25; _Sharon, Provincetown, Mass._, 1982, p. 26; _Millie with the Cheeseburger Radio at Home, New York City_, 1980, p. 27; _Edwige behind the Bar at Evelyne's, New York City_, 1985, p. 28; _Cookie at Tin Pan Alley, New York City_, 1983, p. 29; _Butch in the Pension Florian, West Berlin_, 1984, p. 30; _Shelley on Her Sofa, New York City_, 1979, p. 31; _Lynelle on My Bed, New York City_, 1985, p. 32; _Suzanne on Her Bed, New York City_, 1983, p. 33; _Joan at Breakfast, Provincetown, Mass._, 1977, p. 34; _Ryan in the Tub, Provincetown, Mass._, 1976, p. 37; _Roommate, New York City_, 1980, p. 38; _Self-Portrait in Bed, New York City_, 1981, p. 39; _Rebecca at the Russian Baths, New York City_, 1985, p. 40; _Greer on the Bed, New York City_, 1983, p. 41; _Suzanne in Yellow Hotel Room, Hotel Seville, Merida, Mexico_, 1981, p. 42; _Suzanne in the Parent's Bed, Swampscott, Mass._, 1985, p. 43; _Brian on the Bowery Roof, New York City_, 1982, p. 45; _Mark in the Red Car, Lexington, Mass._, 1979, p. 46; _French Chris on the Convertible, New York City_, 1979, p. 47; _Dieter on the Train, Sweden_, 1984, p. 48; _Brian in the Cabaña, Puerto Juarez, Mexico_, 1982, p. 49; _Anthony by the Sea, Brighton, England_, 1979, p. 50; _Brian in the Hotel Room, Merida, Mexico_, 1982, p. 51; _Mod Kid with Dog, London_, 1980, p. 52; _Roommate as Napoleon, New Year's Eve, New York City_, 1980, p. 53; _Dieter with the Tulips,_

Munich, 1984, p. 54; *Brian's Birthday, New York City*, 1983, p. 55; *Brian in Hotel Room with Three Beds, Merida, Mexico*, 1982, p. 56; *Brian with the Flintstones, New York City*, 1981, p. 57; *Nat on the Bed, London*, 1978, p. 58; *Brian on the Phone, New York City*, 1981, p. 59; *Max Dirt, New York City*, 1981, p. 60; *Kenny with Tattoo, New York City*, 1980, p. 61; *Kenny in His Room, New York City*, 1979, p. 62; *Kowald on My Bed, New York City*, 1984, p. 63; *Dieter on the Bed, Stockholm*, 1984, p. 64; *Thomas Shaving, Boston*, 1977, p. 65; *Tony's Back, Cambridge, Mass.*, 1977, p. 66; *Brian with His Head in His Hands, Merida, Mexico*, 1982, p. 69; *Mark and Mark, Boston*, 1978, p. 71; *Warren and Jerry Fighting, London*, 1978, p. 72; *Skinhead Dancing, London*, 1978, p. 73; *Boys Pissing, New York City*, 1982, p. 74; *Brian at a Shooting Gallery, Merida, Mexico*, 1982, p. 75; *Getting High, New York City*, 1979, p. 76; *Mark Tattooing Mark, Boston*, 1978, p. 77; *Bobby and Scott at Jones Beach, New York*, 1981, p. 78; *Scarpota at the Knox Bar, West Berlin*, 1984, p. 79; *Bruce with His Portrait, New York City*, p. 80; *Brian's Face, West Berlin*, 1984, p. 81; *Nan After Being Battered*, 1984, p. 83; *April Crying at 7th and B, New York City*, 1985, p. 84; *Heart-shaped Bruise, New York City*, 1980, p. 85; *Ectopic Pregnancy Scar, New York City*, 1980, p. 86; *Suzanne Crying, New York City*, 1985, p. 87; *Susan in the Dune Buggy, Provincetown, Mass.*, 1976, p. 88; *J. and C.Z. in the Car, New York City*, 1984, p. 89; *Käthe and Pit, West Berlin*, 1984, p. 90; *Chrissie and Sandy on the Beach, Provincetown, Mass.*, 1976, p. 91; *Kiki and Maggie in the Sonesta Hotel, Cambridge, Mass.*, 1985, p. 92; *Butch and Jane, New York City*, 1982, p. 93; *Times Square, New York City*, 1984, p. 94; *"Variety" Booth, New York City*, 1983, p. 95; *Empty Bed in a Whorehouse, New York City*, 1979, p. 96; *Shelley Leaving the Room, New York City*, 1979, p. 97; *The Parent's Wedding Photo, Swampscott, Mass.*, 1985, p. 98; *Cookie and Vittorio's Wedding, New York City*, 1986, p. 99; *Skinhead with Child, London*, 1978, p. 101; *Cookie with Max in the Hammock, Provincetown, Mass.*, 1977, p. 102; *Max with Richard, New York City*, 1983, p. 103; *Antonia, New York City*, 1985, p. 104; *Little Max with a Gun, New York City*, 1977, p. 105; *Mexican Kid at Carnival, Merida, Mexico*, 1982, p. 106; *The Queen of the Carnival, Merida, Mexico*, 1982, p. 107; *Picnic on the Esplanade, Boston*, 1973, p. 109; *Twisting at My Birthday Party. New York City*, 1980, p. 110; *Monopoly Game, New York City*, 1980, p. 111; *The James Brown Party at the Mudd Club, New York City*, 1980, p. 112; *Bea with Blue Drink, O-Bar, West Berlin*, 1984, p. 113; *Robin and Kenny at Boston/Boston, Boston*, 1978, p. 114; *Dieter and Wolfgang at the O-Bar, West Berlin*, 1984, p. 115; *Flaming Car, Salisbury Beach, N.H.*, 1979, p. 116; *Sun Hits the Road, Shandaken, N.Y.*, 1983, p. 117; *Kim and Mark in the Red Car, Newton, Mass.*, 1978, p. 119; *Philippe M. and Risé on Their Wedding Day*, 1978, p. 120; *Philippe H. and Suzanne Kissing at Euthanasia, New York City*, 1981, p. 121; *Patrick and E.K. at the Gallery, New York City*, 1985, p. 122; *Kiki and Scarpota, West Berlin*, 1984, p. 123; *David with Butch Crying at Tin Pan Alley, New York City*, 1981, p. 124; *Buzz and Nan at the Afterhours, New York City*, p. 125; *Oopie and Chrissie, Provincetown, Mass.*, 1977, p. 126; *Bruce on Top of French Chris, Fire Island, N.Y.*, 1979, p. 127; *Mary and David Hugging, New York City*, 1980, p. 128; *The Hug, New York City*, 1980, p. 129; *Nan and Dickie in*

the York Motel, New Jersey, 1980, p. 130; *Friend Tied Up with His Dogs, Boston,* 1978, p. 131; *Me on Top of My Lover, Boston,* 1978, p. 132; *Man and Woman in Slips, New York City,* 1980, p. 133; *Roommates in Bed, New York City,* 1980, p. 134; *Skinhead Having Sex, London,* 1978, p. 135; *Nan and Brian in Bed, New York City,* 1983, p. 137; *Couple in Bed, Chicago,* 1977, p. 138; *Empty Beds, Boston,* 1979, p. 139; *Valentine's Day, New York City,* 1983, p. 140; *Twin Graves, Isla Mujeres, Mexico,* 1982, p. 141; *Mexican Couple a Week Before Their Second Divorce, Progesso, Yucatán, Mexico,* 1981, p. 142; *Skeletons Coupling, New York City,* 1983, p. 143.

400. Goldin, Nan. *Desire By Numbers.* San Francisco: Artspace Books, 1994. 35 p.

401. Goldin, Nan and David Armstrong. *A Double Life.* New York: Scalo, 1994. 182 p. Chiefly illustrations.
 Includes short biographical essays by Goldin and Armstrong on their lifestyles and life together. The black and white photographs are by Armstrong, those in color are by Goldin.

Ivy at Myrtle St., Boston, 1972, frontispiece; *Susan in the Photo Booth, Kennybunkport, Me.,* 1974, frontispiece; *David and Tommy in the Kitchen, Myrtle St., Boston,* 1973, frontispiece; *David on Charles St., Boston,* 1972; frontispiece; *David on the Roof, Grove St., Boston,* 1972, frontispiece; *David and Tommy in Bed, Provincetown, Ma.,* 1973, frontispiece; *David and Tommy in the Sand Dune, Cape Cod, Ma.,* 1972, frontispiece; *David at the Lindemann's House, Lexington, Ma.,* 1970, frontispiece; *Suzanne as a Ghost, Fayette St., Boston,* 1971, frontispiece; *David at the Refrigerator, Myrtle St., Boston,* 1972, frontispiece; *David on Pleasant St., Cambridge,* 1974, p. 15; *Bruce Bleaching his eyebrows, Pleasant St., Cambridge,* 1975, p. 16; *Bea on Grove St., Boston,* 1972, p. 18; *Chrissy on motel room, Georgia,* 1977, p. 20; *Cookie at Sharon's birthday party with Lisette and Genaro, Provincetown,* 1976, p. 22; *Max, Muffy and Peter at Sharon's birthdaty party,Provincetown,* 1976, p. 24; *Sharon in purple shirt, NYC,* 1980, p. 26; *Richard at Boatslip beach, Provincetown,* 1977, p. 28; *Ryan in bed, Anthony St., Provincetown,* 1976, p. 32; *Philippe and Babette at the A-House, Provincetown,* 1976, p. 33; *David by the pool at The Back Room, Provincetown,* 1976, p.34; *Suzanne with Marlboros, NYC,* 1980, p. 38; *Greer in her tub, NYC,* 1983, p. 41; *Cookie laughing, NYC,* 1985, p. 42; *Sisters, Boston,* 1978, p. 44; *David and Kevin at a party, NYC,* 1978, p. 46; *Rene at the Mudd Club, NYC,* 1979, p. 49; *Max and Juan at Slugger Anne's Bar, New Year's Day, NYC,* 1979, p. 51; *Robin at breakfast, Boston,* 1977, p. 56; *Tommy at his window, Boston,* 1977, p. 57; *Tomas and me in the bathtub,Boston,* 1977, p. 58; *Janet with Kenny, Boston,* 1978, p. 59; *Smokey car, New Hampshire,* 1979, p. 62; *Bruce in his car, NYC,* 1981, p. 63; *Mary at St. Elizabeth St., NYC,* 1980, p. 64; *Millie with Babe, NYC,* 1980, p. 66; *Johnny and Chi-Chi, at "Front St.," Provincetown,* 1981, p. 68; *Genaro with a snowball, The Back Room, Provincetown,* 1979, p. 70; *Costas on the bed, Mudd Club,* 1980, p. 70; *Nan and Janet on the Bowery, NYC,* 1979, p. 73; *David and*

Daniel, Mudd Club, NYC, 1980, p. 76; *French Chris at the Drive-in, N.J.,* 1979, p. 78; *Risé on my bed, NYC,* 1988, p. 80; *Risé and Monty kissing, NYC,* 1988, p. 82; *Patrick and Teri in bed, NYC,* 1987, p. 87; *Brian B. after coming, NYC.,* 1983, p. 88; *Nan at her bottom, Bowery, NYC,* 1988, p. 106; *David on pink sofa, Bowery, NYC,* 1983, p. 106; *Cookie on my bed, Bowery, NYC,* 1988, p. 107; *Nan crying, Baltimore, Md.,* 1986, p. 108; *Self-portrait on my bed, The Lodge, Belmont,* 1988, p. 108; *Siobhan on the street, Boston,* 1989, p. 110; *Tommy in the Garden, Boston,* 1989, p. 111; *Kimberly in the Hotel Sonesta, Cambridge,* 1990, p. 112; *Shellburne in the tub, Squam, N.H.,* 1990, p. 113; *Matt and Lewis laughing, Cambridge,* 1988, p. 114; *My parents on their 50th anniversary, Swampscott, Ma.,* 1989, p. 115; *Sharon and Cookie on the bench, Provincetown,* 1989, p. 116; *Max and Richard at Cookie's funeral, NYC,* 1989, p. 117; *David on his bed, Nantucket, Mas.,* 1990, p. 120; *David Wojnarowicz at home, NYC,* 1990, p.122; *Tommy in the light, Cambridge,* 1989, p. 124; *Self-portrait in bed with Siobhan , NYC,* 1990, p. 128; *Siobhan nude at the A-House, Provincetown,* 1990, p. 129; *Effi in Siobhan's studio, NYC,* 1991, p. 131; *Bruce in the towel, Berlin,* 1992, p. 133; *Gina at Bruce's dinner party, NYC,* 1991, p. 134; *Jack in his studio, NYC,* 1991, p. 136; *Cody at home, NYC,* 1991, p. 138; *Guy in front of the Funk-U Club, NYC,* 1991, p. 140; *David on the Bowery, NYC,* 1991, p. 143; *Jojo and Bruce in Kirk's hospital room, NYC,* 1993, p. 144; *Giles and Gotscho at home, Paris,* 1992, p. 147; *Käthe and Edda, Berlin,* 1992, p. 149; *Kathleen at the Odeon, NYC,* 1993, p. 151; *Amanda at the sauna, Hotel Savoy, Berlin,* 1993, p. 152; *David in bed, Leipzig, Germany,* 1992, p. 155; *Geno on my bed, Berlin,* 1992, p. 156; *Joachim Sartorius in my room at Bel Ami, Berlin,* 1991, p.159; *Piotr at Nürnberger Eck, Berlin,* 1993, p.163; *Detlev and Mirko at the Spiegelzelt, Berlin,* 1993, p. 164; *Self-portrait in my blue bathroom, Berlin,* 1991, p. 174; *Siobhan at the Paramount Hotel, NYC,* 1993, p. 175; *Fiona after breast surgery, NYC,* 1991, p. 176; *Gotscho at the kitchen table, Paris,* 1993, p. 177; *Alf at my Bon Voyage party, NYC,* 1991, p. 178; *Alf at the hospital, Berlin,* 1993, p. 178; *Alf, August 18, 1993, Berlin,* p. 179; *David in the van, Bad Herzfield, Germany,* 1992, p. 180; *Self-portrait on the train, Germany,* 1992, p. 181.

402. Goldin, Nan. *I'll Be Your Mirror.* New York: Whitney Museum of Art, 1996. 491 p. Includes bibliographical references: p. 483-488.

403. Goldin, Nan. *Tokyo Love: Spring Fever.* With Nobuyoshi Araki. Tokyo, Japan: OHTA Pub. Co., 1994. 208 p. Chiefly illustrations.
 All illustrations are studio portraits of young Japanese women.

404. Holborn, Mark. "Nan Goldin's Ballad of Sexual Dependency," *Aperture* 103 (Summer 1986): 38-47+.

405. "Insert: Nan Goldin," *Parkett* 42 (1994): 123-136.

Gordon, Bonnie
 See also #1007

Grace, Della
 See also #1062
Green, Renee
 See also #1055
Greenberg, Phyllis
 See also #1039

Greenfield, Lois, 1949-
 See also #1058

406. Ewing, William A. *Breaking Bounds: The Dance Photography of Lois Greenfield.* San Francisco: Chronicle Books, 1992. 120 p.
 Portfolio of dance photographs augmented by an interview with Greenfield.
Jamey Hampton, Ashley Roland, Daniel Ezralow, Sheil Lehner, ISO Dance Company, 1990, pl. 1; Molissa Fenley, *Provenance Unknown*, 1988, pl. 2; Gail Gilbert, David Parson, *Explorations on a Theme: Expulsions from Paradise*, 1990 pl. 3-9; Jeanne Bresciani, *Water Study*, Jeanne Bresciani & The Isadora Duncan International Institute Dancers, 1987, pl. 10; Lynn Aaron, *Ah Scarlatti*, Feld Ballets/NY, 1989, pl. 11; Buffy Miller, *Ion*, Feld Ballets/NY, 1990, pl. 12; Janet Panetta, 1984, pl. 13; Colleen Mulvihill, 1985, pl. 14; Frey Faust, *The Uninvited*, The Parsons Dance Company, 1987, pl. 15; Sally Silvers, *Flap*, 1989, pl. 16; Diane Madden, 1987, pl. 17; Trisha Brown, *Water Motor*, The Trisha Brown Dance Company, 1988, pl. 18; Jeanette Stoner, *Salon*, Jeanette Stoner & Dancers, 1989, pl. 19; Stephanie Skura, *Big Waves*, Stephanie Skura & Company, 1989, pl. 20; Maureen Fleming, *Sphere*, Maureen Fleming Performance, 1991, pl. 21-26; Desmond Richardson, Alvin Ailey American Dance Theater, 1991, pl. 27-29; David Parsons, 1982, pl. 30; Ashley Roland, 1988, pl. 31; Ashley Roland, 1986, pl. 32; David Parsons, 1986, pl. 33; Janine Capozzoli 1978, pl. 34; Daniel Ezralow, Ashley Roland, Iso Dance Company, pl. 35, 36, 37; Bill T. Jones, Arthur Aviles, *D-Man in the Waters*, Bill T. Jones/Arnie Zane & Company, 1988, pl. 38; Koma, Eiko, *Thirst*, Eiko & Koma, 1985, pl. 39; Jeffrey Neeck, Lynn Aaron, *Savage Glance*, Feld Ballets/NY, 1991, pl. 40; Larissa McGoldrick, Michael Cole, *August Pace*, Merce Cunningham Dance Company, 1989, pl. 41; David Marsden, Sarah Stead, *There's Something About You That's Different*, Joan Lombardi Dance Company, 1986, pl. 42; Adee, Daniel Ezralow 1983, pl. 43;
David Parsons, Denise Roberts, The Parsons Dance Company, 1988, pl. 44, 45, 50; Robert Weber, Andrea Weber, 1989, pl. 46; Robert Weber, 1989, pl. 47; John Gallagher, Ashley Roland, Iso Dance Company, 1991, pl. 48; 1988, pl. 49; Henry Beer, Paula Gifford, Peter Larose, Elizabeth Streb, Jorge Collazo, Elizabeth Streb/Ringside Inc., 1988, pl. 51; Paula Gifford, Elizabeth Streb, Peter Larose, Henry *Beer, Float*, Elizabeth Streb/Ringside Inc., 1988, pl. 52, 53; Daniel McIntosh, Elizabeth Streb, Jane Setteducato, Nancy Alfaro, Elizabeth Streb/Ringside Inc., 1988, pl. 54; David Parsons, 1982, pl. 81, 83; 1983, pl. 55; 1986, pl. 60; 1990, pl. 84-87; Daniel Ezralow, 1982, pl. 56, 58; Daniel Ezralow,

David Parsons, 1983, pl. 57, 61, 62; 1982, pl. 80; Buffy Miller, *Ion,* Feld Ballets/NY, 1990, pl. 59; Ashley Roland, 1988, pl. 63, 64; 1990, pl. 82; Daniel Ezralow, Ashley Roland, Iso Dance Company, 1990, pl. 65; David Parsons, Daniel Ezralow, Ashley Roland, 1986, pl. 66; 1987, pl. 68; Ashley Roland, Daniel Ezralow, Jamey Hampton, 1990, pl. 67; Julie West, Poonie Dodson, Amy Pivar, Bill T. Jones, *Freedom of Information,* Bill T. Jones/Arnie Zane & Company, 1983, pl. 69; Bill T. Jones, Janet Lilly, Arnie Zane, Amy Pivar, *Freedom of Information,* Bill T. Jones/Arnie Zane & Company, 1983, pl. 70; Adam Battelstein, Vernon Scott, John Mario Sevilla, Kent Lindemer, Pilobolus Dance Theater, 1990, pl. 71; Adam Battelstein, Kent Lindemer, Jude Woodcock, Pilobolus Dance Theater, 1991, pl. 72; Daniel Ezralow, Ashley Roland, Jamey Hampton, Sheila Lehner, ISO Dance Company, 1990, pl. 73; Daniel Ezralow, Ashley Roland, Jamey Hampton, Morleigh Steinberg, ISO Dance Company, 1987, pl .74,75; Paula Gifford, Adoplho Pati, C. Batenhorst, Mark Robison, *Ground Level,* Elizabeth Streb/Ringside Inc. 1991, pl. 76; Akiko Ko, Arthur Aviles, Heidi Latsky, *Chatter,* Bill T. Jones/Arnie Zane & Company, 1988, pl. 77; Janet Lilly, Arthur Aviles, Heidi Latsky, *Chatter,* Bill T. Jones/Arnie Zane & Company, 1988, pl. 78; Janet Lilly, Bill T. Jones, Heidi Latsky, *Chatter,* Bill T. Jones/Arnie Zane & Company, 1988, pl. 79.

407. *Lois Greenfield & William Ewing.* Video recording, 28 minutes. New York: ARC Videodance, 1987.
"Discussion of the current and historical perspectives on dance photography as an art form." oclc

Groover, Jan, 1943-
See also #1008, 1012, 1015, 1017, 1028, 1058, 1063

408. Ellis, Stephen. "Jan Groover Robert Miller Gallery, New York; Exhibit," *Art in America* 74, 7 (July 1986): 115.

409. Gookin, Carbo. "Robert Miller Gallery, New York; exhibit," *Artforum* 31 (January 1993): 82-83.

410. Gookin, K. "Jan Groover," *Artforum* 31, 5 (January 1993): 82-83.

411. Groover, Jan. *Jan Groover: Photographs.* Introduction by John Szarkowski. Boston: Little, Brown, 1993. 68 p. Chiefly illustrations.
Essay by Szarkowski, "Thoughts on Evans and Weston, Lange, Cartier-Breson, and Jan Groover," presents a critical survey of Groover's work, with particular emphasis on her development as an artist, as represented in this collection of photographs.
Untitled, 1986, pl. 1; *Statue with Bird,* 1981, pl. 2; *Untitled,* 1975-1992, pl. 3-59.

412. Groover, Jan. *Pure Invention--the Tabletop Still Life: Photographs.* Washington: Smithsonian Institution Press, 1990. 63 p.

413. Groover, Jan. "The Medium Is the Use," *Artforum* 12, 3 (November 1973): 79-80.

414. Grundberg, Andy and Julia Scully. "Currents: American Photography Today," *Modern Photography* 43, 9 (September 1979): 82-85+.

415. Hagen, Charles. "Jan Groover," *Artforum* 25, 10 (1987): 119-120.

416. Hart, Russell, "Jan Groover's Journey," *American Photo* 4 (March/April 1993): 18.

417. *Jan Groover: Tilting in Space.* New York: Checkerboard Foundation, 1994.
Video recording, 30 minutes.
"This films provides an intimate examination of her work and its progression from triptychs and still-lifes to her recent work in France. Images from Groover's life and art are woven together with insights from various people." oclc

418. Jones, Bill. "Legal Fictions," *Arts Magazine* 66 (November 1991): 46-51.

419. Kismaric, Susan. *Jan Groover.* New York: Museum of Modern Art, 1987. 59 p. Unpaged. Bibliography: p. 58-59.
Catalog of the Exhibition, which was shown at the Museum of Modern Art and other places, 1987-1988. Contains 35 untitled plates of photographs and an introduction explaining the processes and concepts of Groover's work.

420. Kozloff, M. "Jan Groover: Melancholy Modernist," *Art in America 75,* 6(June 1987): 144-147.

421. Lifson, Ben. "Jan Groover's Embrace," *Aperture* 85 (1981): 34-43.

422. Livingston, Kathryn. "Still Lifes Run Deep," *American Photographer* (June 1987): 22, 24.

423. Nicholson, Chuck. "Approaching Technology. (University Art Museum, California State University, Long Beach)," *Artweek* 19(December 3, 1988): 11.
Exhibition catalogue.

424. Sheets, Hilarie M. "Jan Groover (Janet Borden, New York; exhibit)," *Art News* 95 (October 1996): 138.

425. Squiers, Carol, "Jan Groover," *American Photographer* 22 (March 1989):

38-43.

426. Teesdale, Cathy. "Groover's in the Heart," *British Journal of Photography* 140 (June 3, 1993): 20-21, with cover.

Groosman, Mildred
 See also #1000
Grunbaum, Dorien
 See also #1070, 1072
Grundstein, Margaret
 See also #1071
Gunterman, Mattie
 See also #1058
Gurdjian, Annette
 See also #1071
Gwenwald, Morgan
 See also #1062
Haber, Sandra L.
 See also #1012
Hackett, Linda
 See also #1071

Hagaman, Dianne, 1950-

427. Hagaman, Dianne. *How I learned Not to Be a Photojournalist.* Lexington: University Press of Kentucky, 1996. 149 p. Illustrations. Includes bibliographical references: p.148-149.
 Photographs are accompanied by an essay by Hagaman. According to the author, "What began as a photographic study of alcoholism and Native Americans became a study of religion and hierarchy. What began as an exercise in conventional photojournalism became an exploration of new ways of visually representing my understanding of social life. What follows is a description of those transformations." (p. 13)
Outside the Chief Seattle Club, fig. 1, 2-5; *Chief Seattle Club,* fig. 6; *Lobby, Union Gospel Mission,* fig. 7; *Evening service, Union Gospel Mission,* fig. 8, 9, 10, 12, 15; *Matt Talbot Day Center,* fig. 11; *Morning service, Bread of Life Mission,* fig. 13, 14; *Evening service, Bread of Life Mission,* fig. 16; *Dining room, Bread of Life Mission,* fig. 17; *Newlyweds, Bread of Life Mission,* fig. 18; *Mission worker, Bread of Life Mission,* fig. 19; *Resident, Women's Shelter, Lutheran Compass Center,* fig. 20; *Salvation Army Officers with their grandchildren, Easter Sunday, Harbor Light Center,* fig. 21; *Evening meal, Peniel Mission,* fig. 22; *Men's dorm, Lutheran Compass Center,* fig. 23; *Easter sunrise procession, Pioneer Square,* fig. 24; *Gethsemane Lutheran Church,* fig. 25; *World Mission room, Gethsemane Lutheran Church,* fig. 26; *Sunday Bible school, Highland Park Church of the Nazarene,* fig. 27; *Meeting room, Highland Park, Church of the Nazarene,* fig. 28; *Women's Bible*

study group, private home, fig. 29; *Sunday service, Kent Church of the Nazarene,* fig. 30; *Ordination to the priesthood, St. James Cathedral,* fig. 31; *Korean Community Christian Church,* fig. 32; *Mass broadcast live from Rome, Our Lady of Fatima Church,* fig. 33; *Funeral reception for Michael Otto, Holy Names Academy,* fig. 34, 35; *Memorial service for Mary Witt, Lutheran Compass Center,* fig. 36; *Interfaith Celebration with Archbishop Raymond Hunthausen, Hec Edmondson Pavilion,* fig. 37; *Christian Boy's Choir, Hec Edmondson Pavilion,* fig. 38; *Billy Graham Phone Crusade, North Seattle Church of the Nazarene,* fig. 39, 40; *Children's Church, Christian Faith Center,* fig. 41, 42; *The Josephinium,* fig. 43; *Wedding, Central Lutheran Church,* fig. 44; *Reception following First Communion, St. Mary's Church,* fig. 45; *Nursery, Christian Faith Center,* fig. 46; *Palm Sunday procession, Central Lutheran Church,* fig. 47; *Good Friday demonstration, U.S. Naval Base at Bangor,* fig. 49, 50; *Child dedication, Christian Faith Center,* fig. 51; *Faith Healing, Seattle Center Coliseum,* fig. 52, 53, 54; *Our Lady of Fatima Church,* fig. 56; *St. John Catholic Church,* fig. 57; *Eighth annual Archbishop Oscar Romero Procession,* fig. 58; *St. James Cathedral,* fig. 59.

Hager, Jenny
> See also #1039

Hahn, Betty, 1940-
> See also #1007, 1008, 1053, 1058, 1061

428. *Betty Hahn.* Cincinnati, OH: Lightborne Communications, 1983. Videorecording. 30 minutes. Interviewer, Paul Schranz. "Internationally recognized for her experimentation with gum-bichromate, Van Dyck Brown-print and cyanotype, Betty Hahn discusses her introduction to the world of non-silver printing by her mentor Henry Holmes Smith." oclc

429. Bloom, John. "Interview with Betty Hahn," *Photo Metro* 5, 51 (August 1987): 8-17.

430. Hahn, Betty. *Betty Hahn, Inside and Outside.* Bethlehem, PA: Lehigh University Art Galleries, 1988. 20 p. Includes bibliographical references.

431. Yates, Steven A. *Betty Hahn: Photography or Maybe Not.* Albuquerque: University of New Mexico Press, 1995. 198 p. Includes bibliographical references: p. 197-198.
 Catalog of an exhibition that opened at the Museum of Fine Arts, Museum of New Mexico, Santa Fe, 1995. Essays by Steven Yates, "Late Modern, Postmodern, and After: The Photographic Pluralism of Betty Hahn"; Dana Asbury, "Riding the Range: The Straight Photographs of Betty Hahn;" and David Haberstich, "The Early Years." Illustrated chronology, catalogue of works, collections, and selected exhibition history.
From *The Wasted Film Triology,* 1972, *Bracketed Exposure (detail),* p. 2, pl. 103;

Strip of Six, pl. 104; *1,000 Dusty Negatives*, pl. 104; *Red Building (detail)*, 1973, p. 12; *Kodak Tri-X Pan Film*, 1968, p. 15; *Betty, Passport Photo*, 1970, p. 28, *Dan, Passport Photo*, 1970, p. 13; *Lettuce*, 1972, p. 30; *Bristol Garden*, 1972, p. 31; from the series *Passing Shots*, 1978, *Albuquerque, NM (white horse head) (Detail)*, p. 38, pl. 29; *Palm Shadow, Garden of the Alcazar, Seville*, 1983, p. 41; *Botanical Layout: Carnation*: 1988, p. 42; *Chicago Family: Grandmother*, 1979, p. 44; *Firecrackers, Madrid Botanical Garden*, 1983, pl. 54; *Painted Rose, Alice Springs, Australia*, 1986, pl. 55; *Hothouse Flowers, Kyoto Botanical Gardens, Kyoto, Japan*, 1984, pl. 56; *Tubac, AZ (flowers)*, 1976, pl. 57; *White Blossoms,Kyoto Botanical Gardens,Kyoto, Japan*, 1984, pl. 58; *San Diego, CA (seed pod)*, 1978, pl. 59; *Fuschias (detail) Cairns, Australia*, 1986, before pl. 71; *Fish Pond, Garden of Alhambra*, Granada, 1983, pl. 77; *Banana Plant in Sunlight, Lisbon*, 1983,pl. 79; *Fuschias, Cairns, Australia*, 1986, pl. 80; *Grass in Water, Tokyo, Japan*, 1984, pl. 81; *Azaleas, Part I, Perth, Australia*, 1986, pl. 82; *San Diego, CA (parrot feathers)*, 1978, pl. 83; *Black and White Composition, Lisbon*, 1983, pl. 84; *T or C, NM (blue chairs)*, 1978, pl. 93; *Mick-a-Matic* Camera, c. 1969, pl. 14; *St. Petersburg, FL (elephant ear)*, 1975, pl. 15; *San Diego, CA (polar bear)*, 1978, pl. 16; *St. Petersburg, FL (flamingo)*, 1975, pl. 17; *St. Petersburg, FL (swan tail)*, 1975, pl. 18; *Maui, HI (palm tree)*, 1978, pl. 19; *San Diego, CA (eagle head)*, 1978, pl. 20; *Yellow Flower, Williams's Garden, Sydney, Australia*, 1986, pl. 21; *Kangaroo Paws,Perth , Australia*, 1986, pl. 22; *Green Valley, AZ (penny)*, 1976, pl. 23; *Los Angeles, CA (sidewalk, flowers)*, 1978, pl. 24; *View of Intersection, Seville*, 1983, pl. 25; *Path at Shugakuin Palace, Kyoto, Japan*, 1984, pl. 26; *Maui, HI (beach view)*, 1978, pl. 27; *Construction Barrier. Sydney, Australia*, 1986, pl. 28; *Koi in Sun, Yoyogi Park, Tokyo, Japan*, 1984, pl. 30; *Fuschias and Chairs, Cairns, Australia*, 1986, pl. 100; *Red Tulips,Kyoto Botanical Gardens, Kyoto, Japan*, 1984, pl. 101; *Greenhouse, Waterlilies #11, Kyoto, Japan*, 1984, pl. 102; *6 or 7 clues connected to a case involving contributory negligence*, 1980, p. 47; *Exhibit G: Cowboy Boot Assaulted*, from the series *Crime in the Home*, 1982, p. 50; *Scene of the Crime*, 1979, p. 51; *Ehrlichman Surveillance*, 1982, p. 51; *Frame 5* from *Man Coming Into Focus*, 1988, p. 55; *My Sisters-Negative and Positive*, 1965, pl. 1; *Bather, A Senseless Duplication*, 1967, pl. 2; *Inner Rainbow*, 1968, pl. 3; *Processed by Kodak*, 1968, pl. 4; *Girl by Four Highways*, 1968, pl. 5; from the series <u>*Commemoratives*</u>, 1971: *Airmail Stamp* and *Ten Cent Stamp*, pl. 6; *Yard*, pl. 7; from the series <u>*Cut Flowers*</u>: *Variation with Four*, 1978, pl. 8; *Study for Quadrant*, 1979, pl. 9; *Cut Flowers: 6*, 1979, pl. 10; *Quadrant Variation #2*, 1979, pl. 11; from the series *B Westerns*: *Hoofbeats*, 1993, pl. 12; *Tequila Sunrise*, 1993, pl. 13; from the series *Who Was That Masked Man? I Wanted to Thank Him*: *Stymied*, 1975, pl. 31; *Untitled*, 1974, pl. 32; *Phantom Stallion*, 1972, pl. 33; *Starry Night*, 1975, pl. 34; *Untitled*, 1977, pl. 35; *New Mexico Sky*, 1976, pl. 36; *Starry Night Variation*, 1977, pl. 37; *In Trouble*, 1975, pl. 38; *Disillusioned*, 1976, pl. 39; *New Mexico Sky Variation*, 1976; pl. 94; Details from *Appearance*, 1984, pl. 42; *New Mexico Sky*, 1994, pl. 43; *Starry Night*, 1994, pl. 44; *Museum Garden*, 1973, pl. 45; *Dark Garden*, 1973, pl. 46; *Greenhouse Portrait (Bea Nettles)*, 1973, pl. 47; *Iris Variation #6*, 1985, pl. 48; *Blue Amaryllis #2*, 1987, pl. 49; *Chrysanthemum*

with Watermark, 1982, pl. 51; *Cut Flower Variation*, 1979, pl. 53; Frame #11 from *Circumstances of Awakening: Berlin*, 1990, pl. 60; *Leaves*, 1979, pl. 61; *Peony I*, 1979, pl. 62; *Peony II*, 1979, pl. 63; *Amaryllis Belladonna*, 1980, pl. 64; *Stargazer Lily*, 1988, pl. 65; *Calceolaria*, 1980, pl. 66; *Anemone Pavonina*, 1980, pl. 67; *Gladiola*, 1988, pl. 68; *Tulip*, 1980, pl. 69; *African Daisy*, 1979, pl. 70; *A Funny Trip #1*, 1965, pl. 71; *Steve,Pilot*, 1971, pl. 72; *No. 5 Silver*, 1970, pl. 73; *No. 1 Blue*, 1970, pl. 74; *Iris with Red*, 1982,pl. 75; *Ellen II,* 1970, pl. 76; *Cut Flowers: Roses*, 1979, pl. 78; *Ultra Red and Infra Violet*, 1967, pl. 87; *Road and Rainbow*, 1971, pl. 88; *Mejo, Passport Photo*, 1971, pl. 89; *Broccoli*, 1972, pl. 90; *Cauliflower*, 1972, pl. 91; *A Ben Day Day*, 1967, pl. 92; *Morning Mum*, 1979, pl. 95; *Cut Flower Variation*, 1979, pl. 96; *Red Iris*, 1985, pl. 97; *Gold Iris*, 1985, pl. 98; *Hot Flower*, 1979, pl. 99; *Soft Daguerreotype*, 1973, pl. 106; *Chicago Family: Aunt*, 1979, pl. 111; *A Japanese Collage in 5 Parts*, 1988, pl. 113; *Shinjuku*, 1984, pl. 114; *Cirumstances of Awakening, Berlin*, 1990, pl. 115; *A Case of XX*, 1981, pl. 116; *Arrival of Departure (After Hitchcock)*, 1987, pl. 117; *Collect from Berlin*, 1991, pl. 118; *Detail* from *Crim ein the Home, Exhibit J: Suspect in Fingerprint Lab*, 1982, pl. 170.

Halsey, Louise E., 1872-1962

432. Halsey, Louise E. *Louise E. Halsey: An American Pictorialist*. Text by Peter E. Palmquist. Catalog of an exhibition January 10-30, 1985. Arcata, CA: Reese Bullen Gallery, Humboldt State University, 1985. 25 p.
 Includes a biographical essay of Halsey, her relationship to Clarence H. White and the Photo-secessionist movement and an analysis of the photographs in the exhibition.

Halverson, Karen
 See also #1063
Hamilton, Jeanne
 See also #1070
Hamilton, Virginia
 See also #1070
Hammid, Hella
 See also #1071
Hanscom, Adelaide see **Leeson, Adelaide Hanscom**
Harleston, Elise Forrest
 See also #1026, 1040, 1058
Harold-Steinhauser, Judith
 See also #1058
Harrington, Diane
 See also #1070
Hart, Sarah
 See also #1055
Hartley, Lara

Hewitt, Mattie Edwards, d. 1956

433. Hewitt, Mattie Edwards. *Portrait of an Era in Landscape Architecture*:
The Photographs of Mattie Edwards Hewitt. Bronx, NY: Wave Hill, 1983.
24 p. Illustrations. Bibliography: p.23.
Catalogue of exhibition, September 15-November 30, 1983.
*Home of D. W. McCord, East Hampton, New York; William R.. Coe, "Planting
Fields," Oyster Bay, New York.*

Heyman, Abigail, 1942-
See also #1006, 1007, 1008, 1015, 1058, 1061

434. "Abigail Heyman," *Creative Camera* (London) 157 (July 1977): 236-243.

435. Heyman, Abigail. *Butcher, Baker, Cabinetmaker: Photographs of Women
at Work*. Text by Wendy Saul. New York: Thomas Y. Crowell, 1978. 44
p.
Children's book illustrating the various careers in which women can be
found.
Pilot, p. 1; *Astronaut,* p. 2; *Artist,* p. 3; *Letter carrier,* p. 4; *Architect,* p. 5; *Lawyer,*
p. 6; *Shopping for vegetables,* p. 7; *Holding a child,* p. 8; *Running hurdles,* p. 9;
Fire Fighter, p. 10; *Farmer,* p. 12; *Shop owner,* p. 13; *Miner,* p. 14; *Radio
Reporter,* p. 15; *Biologist,* p. 16; *Veterinarian,* p. 17; *Taxi cab driver,* p. 18;
Butcher, p. 19; *Carpenter,* p. 20; *Pumping gasoline,* p. 22; *Clown,* p. 23; Zoo
Keeper, p. 24; *Painter,* p. 26, 27; *State Senator,* p. 31; *Truck driver,* p. 32;
Orchestra conductor, p. 34; *Girl playing drums,* p. 35; *Pediatrician,* p. 36; *Girl
with stethoscope,* p. 37; *Children at play,* p. 38; *Photographer,* p. 44; *Writer,* p. 44.

436. Heyman, Abigail. *Dreams & Schemes: Love and Marriage in Modern
Times*. New York: Aperture, 1987. 111 p.
Introductory essay on the meaning of weddings and marriage for Heyman,

and what she has witnessed as photographer, participant and guest.
[Bride having train adjusted in hallway] frontispiece; *[Columns at stairway, with bows and cupids]*p. 6; *[Bride in shabby room]* p. 11; *[Young man adjusting tie near curtained window]* p. 18; *[Bride checking eye makeup in ornate mirror]* p. 19; *[Bride trying on veil in room filled with other veils]* p. 20; *[Man in tuxedo pacing in room]* p. 21; *[Series of photographs as man and woman change from everyday to wedding clothes]* p. 22; *[Mother and bride talking]* p. 26; *[Two guests on folding chairs]* p. 27; *[Bride near old woman in bathrobe]* p. 28; *[Four older women looking at young woman in mirror]* p. 29; *[Three women with unsmiling bride]* p. 30; *[Small table under crystal chandelier]* p. 34; *[Long rows of identical chairs and tables set with silverware]* p. 35; *[Folding chairs in garden]* p. 36; *[Man carrying woman, in room with folding chairs]* p. 38; *[Bridal party looking at crying child]* p. 41; *[Man in uniform pointing at woman in bridal party]* p. 43; *[Man (father?) hugging bride in living room]* p. 44; *[Parents of the bride, in kitchen, watching photographer taking pictures]* p. 45; *[Man touching cheek of young woman]* p. 47; *[Long line of brides and grooms]* p. 49; *[Bride holding arms of parents]* p. 51; *[Young man holding hands of older woman]* p. 53; *[Series of photographs of couple standing before Justice of the Peace]* p. 54, 55; *[Child sitting on man's lap, with guests]* p. 57; *[Unsmiling bridal couple]* p. 59; *[Bridal couple kneeling at altar]* p. 63; *[Boy watching groom put ring on bride's finger]* p. 65; *[Bridesmaid with bouquet sitting on bench]* p. 67; *[Hundreds of bridal couples bowing]* p. 68; *[Old man playing violin on old bench]* p. 71; *[Couple, with young boy, kissing in hallway]* p. 72; *[Men, women and children]* p. 73; *[Guests dancing as unsmiling bride sits in chair]* p. 74; *[Man in sunglasses making a toast at reception]* p. 76; *[Making a toast with the maid]* p. 77; *[Men and women drinking]* p. 78; *[Men in conversation]* p. 80; *[Laughing women]* p. 81; *[Man putting money in woman's lap]* p. 82; *[Bride and guests holding plates]* p. 82; *[Old man kissing bride]* p. 83; *[Man and Woman smoking near picket fence]* p. 85; *[Senior citizen couple getting married]* p. 86; *[Senior citizen women dancing around bride]* p. 87; *[Bride and groom in limousine]* p. 88; *[Man and woman in silly hats, kissing]* p. 91; *[Men with arms raised]* p. 95; *[Guests falling on floor]* p. 96; *[Bride and groom lifted on chairs]* p. 97; *[Man and woman kissing near balloons]* p. 98; *[Sleeping dog with bow on collar]* p. 99; *[Man and woman embracing]* p. 101; *[Bride and groom by wedding cake]* p. 103; *[Young man on chair, old man sitting on lawn]* p. 105; *[Bride holding young girl on her lap]* p. 107; *[Young men embracing and crying]* p. 109; *[Bride and mother? embracing by empty dishes]* p. 111.

437. Heyman, Abigail. *Growing Up Female: A Personal Photo Journal.* New York: Holt, Rinehart and Winston, 1974. Unpaged.
 Heyman begins the personal statement that accompanies the photographs by stating that "this book is about women, and their lives as women, from one feminist's point of view."
[Girl holding purse with her teeth][Little girl looking in bathroom mirror][Woman looking in bathroom mirror][Girl playing dress-up in attic][Girl near tree][Dress

of coins in window][Young Native American? with braces][Girl with pacifier][Old woman in beauty parlor][Old woman with umbrella][Two old women on park bench][Old woman near lingerie display][Young beauty contestants][Baton twirler][Young womnan with football][Man and child reading][Footbally player hugging cheerleader][Man playing piano][Crowd of young people][Couple embracing on hood of car][Couple embracing][Kissing][Couples dancing] [Standing in line][At a covention in cowboy hats][Woman lying on beach][Man wearing suggestive buttons][Nude woman performing in bar][Young woman in a gynecological self-help group][Having sex in bed][Line for marriage applications][Bride and guests][Couple with dog][Back of older couple][Couple strolling in street, all dressed-up][Sad woman and dinner table with children][Old nun sitting on chair][Couple on two ends of a porch][Couple in bed with infant][Giving birth][Woman on hammock with child][Girll pushing baby carriage][Mothers and children gathered on street][Two women on beach, at water's edge][Women and children in park sandbox][Having an abortion][Couple on park bench with infant][Mother hugging children on dining room floor][Woman with children in park][Women with baby carriage][Women photographing baby][Mother with girl on tricycle][Woman driving with child on lap][Black child playing with white doll][Woman putting makeup on in lavatory][Woman with rollers in hair][Woman changing child's diaper][Woman standing by boxes of pamphlets][Children dressed as doctors][Maid sitting on four-poster bed][Fancy dining room with women][Lunch in a cafeteria][Father with children and carriage][Shoppers at sale table][Men walking from office buildings][Women marching in military coats][Parochial schoolgirls leaving one girl behind][Playing bingo][Playing slot machines][In rollers in the supermarket][In the laundromat][At the kitchen table][Sitting on a beach wall, with a bike]

Hinkley, Caroline
 See also #1055
Hiser, Cherie
 See also #1006

Hoban, Tana
 See also #1008, 1009, 1069

438. Hoban, Tana. "Letter to a Young Photographer," *Popular Photography* 33, 1 (July 1953): 57-58+.

439. Hoban, Tana. "Tana Hoban on Child Photography," *Modern Photography* 15 ,2 (February 1951): 34-39+.

440. Leisten, Rita. "Hidden Faces," *Popular Photography* 23, 4 (October 1948): 66-67+.

441. "Tana Hoban Explores the Teen-Age World with Natural Light and a
 Wide Lens Aperture," *Popular Photography* 29, 3 (September 1951): 66-
 71.

Hofer, Evelyn
 See also #1058
Honey, Nancy
 See also #1008, 1010
Hornung, Christine
 See also #1072
Hougtaling, Susan
 See also #1072
Howard, Master Sergeant Grendel A. Jackson
 See also #1063
Hughes, Mariah
 See also #1000
Hurley, Patricia
 See also #1006
Irvine, Edith
 See also #1058
Jackson, Ann Elizabeth
 See also #1040
Jackson, Vera
 See also #1040

Jacobi, Lotte, 1896-1990
 See also #1005, 1008, 1058, 1061, 1063, 1072

442. Goldberg, Vicki. "Lotti Jacobi," *American Photographer* 2, 3 (March
 1979): 22-31.

443. Halley, Anne. "Photographs by Lotte Jacobi: Shaker Women in New
 Hampshire," *Massachusetts Review* 24, 1 (1983): 113-124.

444. Jacobi, Lotte. *Lotte Jacobi*. Edited by Kelly Wise. Danbury, NH: Addison
 House, 1978. 187 p.
 James A. Fasanelli provides a biographical and critical essay entitled:
 "Lotte Jacobi: Photographer." "Foreword: Gentle Persuasions and a
 Benign Predator's Eye" by Kelly Wise discusses Jacobi's style of
 portraiture and place in photographic circles.
Self-portrait, Berlin, c. 1930, frontispiece; *Head of a Dancer*, Berlin, c. 1929, p. 9,
135; *Peter Lorre*, Actor, Berlin, c. 1932, p. 9, 33; *Erich Reiss*, Publisher, Deering,
N.H., 1950, p. 10, 75; *Albert Einstein*, Physicist, Princeton, N.J., 1938, p. 10, 94-
105; *Egon Erwin Kisch*, Journalist, Berlin, c. 1930, p. 11; *Paavo Nurmi*, Olympic
Marathon Runner, Berlin, 1930, p. 11; *Minor White*, Photographer, Deering, N.H.,

c. 1962, p. 12; *Paul Caponigro*, Photographer, Deering, N.H., c. 1965, p. 12, 92; *Photogenic*, New York, n.d., p. 13; *Mia Jacobi*, mother, New York, c. 1940, p. 16; *Sigismund Jacobi*, father, Berlin, c. 1930, p. 17; *Bemchen's Hands*, Berlin, n.d., p. 18; *Odenwald, Germany*, c. 1928, p. 19; *Church in Bavaria, Germany*, 1924, p. 19; *With the Film Group, Munich*, c. 1926, p. 20; *Josef Scharl*, Munich, 1926, p. 22; *Leo Katz*, artist, New York, c. 1977, p. 24; *John Frank Hunter*, son of Lotte Jacobi, Deering, N.H., c. 1955, p. 26; *Elizaeth Walmsley*, Native American, Deering, N.H., 1970, p. 27; *Gerhart Hauptmann*, Dramatist, Berlin, 1933, p. 31; *Kurt Weill*, Composer, Berlin, 1928, p. 32; *Max Hölz*, Revolutionary, Berlin, c. 1930, p. 34; *Martin Buber*, Writer, Odenwald, 1928, p. 35; *Käthe Kollwitz*, Painter, Berlin, c. 1930, p. 37; *Leo Slezak*, Singer, Berlin, c. 1930, p. 37; *Arnold Zweig*, Writer, Berlin, c. 1930, p. 38; *Franz Lederer*, Actor, Berlin, c. 1929, p. 39; *Bruno Walter*, Conductor, Berlin, c. 1930, p. 40; *Wilhelm Furtwängler*, Conductor, Berlin, c. 1930, p. 41; *Ernesto De Fiori*, Sculptor, with *Mady Christians*, Actress, Berlin, c. 1930, p. 42; *Max Pechstein*, Artist, with his wife, Berlin, c. 1930, p. 43; *Max Liebermann*, Artists, Berlin, 1931 p. 44, 45; *Erwin Piscator,* Director, *Fritz Lang*, Director, *Reinhold Schunzel*, Actor, at Nollendorf Theatre, Berlin, c. 1929,p. 46; *Erich Mendelsohn*, Architect, Berlin, c. 1930, p. 47; *Karl Kraus*, Poet and Critic, Berlin, c. 1930, p. 48; *Max Planck*, Physicist, Berlin, c. 1930, p. 49; *Carl Von Ossietzky*, Writer, Nobel Prize WinnerI, Berlin, 1933, p. 51; *General Kurt Von Schleicher*, Tiergarten, Berlin, c. 1930, p. 51; *Erich Mühsam*, Poet, Berlin, 1929, p. 52; *Konstantin Stanislavski*, Director, Berlin, c. 1920, p. 53; *Karl Radek*, Journalist, Russian Revolutionary, Moscow, 1933, p. 54; *Henri Barbusse*, Writer, Moscow, 1933, p. 55; *Karl Valentin and Liesl Karlstadt*, Comedians, Berlin, c. 1930, p. 56; *Carl Zuckmayer*, Dramatist, and his family, Berlin, c. 1930, p. 57; *Marinetti*, Italian Poet, Berlin, 1929, p. 59; *Georg Grosz*, Artist, Berlin, c. 1929, p. 59; *Egon Erwin Kisch*, Journalist, Berlin, c. 1930, p. 60; *Lorenz Hart,* Lyrics writer, New York, c. 1950, p. 61; *Barbara Morgan*, Photographer, New York, 1944, p. 62; *Berenice Abbott*, Photographer, New York, c. 1943, p. 63; *Peter Pears*, Singer and *Benjamin Britten*, Composer, Long Island, New York, 1939, p. 64; *W. H. Auden*, Poet, New York, 1946, p. 65; *Theodore Dreiser*, Writer, New York, 1944, p. 66; *Nancy Newhall*, Writer, New York, 1943, p. 67; *Max Reinhardt*, Director and wife, *Helen Thimig*, Actress, New York, 1936, p. 68; *Max Reinhardt*, death portrait, New York, 1943, p. 69; *Eleanor Roosevelt*, New York, 1944, p. 70; *Marianne Moore*, Poet, New York, 1945, p. 71; *Henriette Szold*, Zionist, Founder of Hadassah, New York, c. 1938, p. 72; *Chaim Weizmann*, First President of Israel, New York, 1948, p. 73; *Ilja Ehrenburg*, Writer, New York, c. 1947, p. 74; *Karin Horney*, Psychoanalyst, New York, c. 1947, p. 76; *William E. DuBois*, Historian, and wife *Shirley Graham*, Writer, New York, c. 1950, p. 77; *Paul Robeson*, Actor, Singer, New York, c. 1952, p. 78; *Pablo Casals*, Cellist, Marlboro, VT, 1967, p. 79; *Paul and Hazel Strand*, Photographers, Orgéval, France, 1963, p. 80; *Sir Thomas Beecham*, Conductor, New York, c. 1942, p. 81; *Abraham Heschel*, Rabbi, New York, c. 1955, p. 82; *Minor White, Photographer*, Deering, N.H., c. 1962, p. 83; *Albert Renger-Patzsch*, Wamel, Germany, c. 1963, p. 84; *Edward Steichen*, Photographer in the Museum of Modern Art Sculpture Court, New York, c. 1960,

p. 85; *Otto Steinert*, Photographer, Essen, Germany, 1963, p. 86; *Stanley William Hayter*, Artist, Paris, 1963, p. 87; *Frances Flaherty*, Photographer, Brattleboro, VT, c. 1962, p. 88; *May Sarton*, Poet, Nelson, NH, 1970, p. 89; *Loren Eiseley*, Poet, Philadelphia, PA, c. 1973, p. 90; *Scott Nearing*, Writer, Harborside, Maine, 1973, p. 91; *Thomas Mann*, and his wife, *Katja*, Princeton, NJ, c. 1936, p. 106; *Thomas Mann*, Writer, c. 1936, p. 107, 109; *Heinrich Mann*, Writer, Berlin, c. 1930, p. 108; *Klaus Mann*, Writer, New York, c. 1939, p. 108; *Albert Einstein and Thomas Mann*, Princeton, NJ, 1938, p. 110; *Alfred Stieglitz*, Photographer, New York, 1938, p. 111-114; *Marc Chagall*, Artist, New York, 1942, p. 115, 116; *Ida Chagall*, New York, 1945, p. 117; *Marc Chagall* and his daughter *Ida*, New York 1945, p. 118; *Robert Frost*, Poet, Ripton, VT, 1959, p. 119-122; *Berlin, Germany*, c. 1928, p. 124; *Berlin, Germany*, c. 1932, p. 125; *Berlin, Germany, the old City*, c. 1928, p. 126; *Posen, Germany*, c. 1918, p. 127; *Hamburg, Germany*, c. 1934, p. 128-132; *Hans Albers*, Actor, Berlin, c. 1930, p. 134; *Tilla Durieux*, Actress, Berlin, c. 1930, p. 136; *Lil Dagover*, Actress, Berlin, c. 1930, p. 137; *Grete Mosheim*, Actress, Berlin, c. 1930 p. 138; *Lotte Lenya*, Actress, Berlin, c. 1930, p. 139; *Erich Karow*, Comedian, Berlin, c. 1930, p. 140; *Harold Kreutzberg*, Dancer, Berlin, c. 1930, p. 141; *Emil Jannings*, Actor, Berlin, c. 1930, p. 142; *Trudi Shoop*, Dancer and *Grock,* Clown, Berlin, c. 1931, p. 143; *Sokolff(?)* Actor, Berlin, c. 1930, p. 144; *Richard Tauber and Vera Schwarz*, Opera Singers, Berlin, c. 1930, p. 145; *Les Fratellini*, French Circus Family, Berlin, c. 1930, p. 146; *Michols, Siskin, and Granach*, Actors, Berlin, c. 1929, p. 147; *Willy Fritsch and Emil Jannings*, Actors, Berlin, c. 1932, p. 148; *Laszlo Moholy-Nagy*, Photographer, c. 1929, p. 149; *Fritz Kortner, Maria Bard, and Hans Albers*, in <u>Rivalen</u>, Berlin, c. 1930, p. 150; <u>*Revolte im Erziehungsheim*</u>, Drama, Berlin, c. 1930, p. 151; *Mary Wigman*, Dancer Berlin, c. 1930, p. 152; *Claire Dauroff*, Dancer, Berlin, c. 1928, p. 153; *Alex Von Swain and Partner*, Dancers, Berlin, c. 1930, p. 154; *Lieselotte Felger*, Dancer, Berlin, c. 1930, p. 155; *Pauline Koner*, Dancer, c. 1937; *Photogenics*, 1946-55, p. 158-187.

445. Jacobi, Lotte. "Lotte Jacobi: Photogenics," *Aperture* 10, 1 (1962): 4-16.

446. Pfanner, H. and G. Samson. "Lotte Jacobi, German Photographer and Portraitist in Exile," *Germanic Review* 62, 3(1987): 109-117.

447. Savio, Joanne. "A Visit With Lotte Jacobi," *Women Artists News* 11 (June 1986): 26-27.

448. Simson, Emily. (Ledel Gallery, New York; Exhibit) *Art News* 83 (November 1984): 178+.

449. Sturman, John. (Photofind Gallery, New York; Exhibit) *Art News* 86 (Summer 1987): 215.

Jahoda, Susan
 See also #1055

Jaques, Bertha Evelyn
　　　See also #1058
Jefferson, Louise
　　　See also #1040
Jenkins, Susan Worth
　　　See also #1039
Jennings, De Ann
　　　See also #1006
Johnson, Belle
　　　See also #1058
Johnson, Ellen Foscue
　　　See also #1072

Johnston, Frances Benjamin, 1864-1952

450.　　Doherty, Amy S. "Frances Benjamin Johnston 1864-1952," *History of Photography* 4, 2 (April 1980): 97-111.

451.　　"Frances Benjamin Johnston: Her Photographs of Our Old Buildings," *Magazine of Art* (September 1937): 548-555.

452.　　Johnston, Frances Benjamin. "What a Woman Can Do With a Camera," *The Ladies Home Journal* (September 1897): 6-7.

453.　　Johnston, Frances Benjamin. *Frances Benjamin Johnston: Women of Class and Distinction.* Glenn, Constance W. And Leland Rice, eds. Introduction by Anne E. Peterson. Long Beach, CA: California State University. The Art Museum and Gallery, 1979. 96 p.
　　　An exhibition catalog which provides a glimpse of some of the women of Washington's aristocracy. Peterson provides a short biographical essay, and Rice discusses the portraits themselves. Each portrait is accompanied by a brief biographical sketch.
The Misses Pauncefote, Daughters of Lord and Lady Pauncefote, at Home, Playing Bridge at the British Embassy, c. 1893, cover; *Self-Portrait,* Frontispiece; *Francis Benjamin Johnston's Studio,* p. 12; *Frances Folsom Cleveland,* 1897, p. 23; *Letitia Green Stevenson,* 1896, p. 25; *Letitia Ewing Stevenson and Julia Stevenson Jardin,* 1896, p. 27; *Ida Saxton McKinley,* 1897, p. 29; *Jennie Tuttle Hobart,* 1897, p. 31; *Margaret Sarah Cecilia Stewart Sherman,* 1897, p. 33; *Cornelia Washburn Gage,* 1897, p. 35; *Caroline Pitts Brown,* c. 1897, p. 37; *Lady Pauncefote, Nee Selina Maud Fitzgerald,* c. 1893, p. 39; *Lillian Pauncefote on the Occasion of Her Marriage to Robert Bromley,* 1900, p. 41; *Madame Wu Ting Fang,* 1897, p. 43; *Madame Wu, the Wife of Chinese Minister We Ting Fang, and Their Son Wu Chow Tsu,* 1897, p. 45; *Alice Hay,* c. 1898, p. 47; *Helen Hay,* c. 1898, p. 49; *Edith Kermit Carow Roosevelt,* 1902, p.51; *Edith Kermit Carow Roosevelt and Quentin,* 1902,

p. 53; *Ethel Carow Roosevelt*, 1902, p. 55; *Alice Lee Roosevelt (Longworth)*, 1902, p. 57, 59, 61, 63; *Cornelia Cole Fairbanks*, c. 1897-98, p. 65; *Edith Cassidy Fairbanks*, 1905, p. 67; *Adelaide Fairbanks Timmons,* 1905, p. 69; *Lillian May Langham Von Sternberg*, 1903, p. 71; *Elise Richards Jusserand*, 1903, p. 73; *Corinne Nicholson Metcalf,* 1905, p. 75; *Helen Herron Taft*, 1905, p. 77; *Countess Marguerite Cassini*, 1904, p. 79; *Baroness Elizabeth Rosen*, 1906, p. 81; *Phoebe Pyle*, 1896, p. 83; *Ida Minera Tarbell*, 1898, p. 85; *Susan Brownell Anthony*, 1900, p. 87; *Frances Eliza Hodgson Burnett*, 1895, p. 89; 1906, p. 91.

454. *"I Won't Make a Picture Unless the Moon is Right--": Early Architectural Photography of North Carolina by Frances Benjamin Johnston and Bayard Wootten.* Raleigh, NC: Preservation/NC, 1994. 15 p. Illustrations.
Catalogue of an exhibition held at the Bellamy Mansion Museum of History and Design Arts grand opening gala.

455. Johnston, Frances Benjamin. "Elizabeth Brownell," *The Ladies Home Journal* 19, 2 (January 1902): 1.

456. Johnston, Frances Benjamin. "Emma J. Farnsworth," *The Ladies Home Journal* 18, 9 (August 1901): 1.

457. Johnston, Frances Benjamin. "Eva Lawrence Watson (Mrs. Martin Schutze)," *The Ladies Home Journal* 18, 11 (October 1901): 5.

458. Johnston, Frances Benjamin. "Frances and Mary Allen," *The Ladies Home Journal* 18, 8 (July 1901): 13.

459. Johnston, Frances Benjamin. "Gertrude Käsebier, Professional Photographer," *Camera Work* 1 (January 1903): 20.

460. Johnston, Frances Benjamin. *The Hampton Album; 44 photographs from an album of Hampton Institute.* with a note on the photographer by Lincoln Kirstein. New York: Museum of Modern Art, 1966. 55 p.
Foreword describes how these photographs were originally made by Johnston as a part of the exhibition to demonstrate contemporary life of the American Negro, for the Paris Exposition of 1900. It continues with an analysis of the photographs, and a biographical essay on Johnston.
Stairway of Treasurer's Residence. Students at work, cover, 47; *Southern Waterfront,* p. 1; *About 400 Students in Memorial Chapel,* p. 2; *The Old Folks at Home,* p. 12; *A Hampton Graduate at Home,* p. 13; *The Old-Time Cabin,* p. 14; *A Hampton Graduate's Home,* p. 15; *The Old Well,* p. 16; *The Improved well (three Hampton grandchildren)* p. 17; *Saluting the Flag at the Whitier Primary School,* p. 18; *Primary Class studying plants. Whittier School,* p. 19; *Kindergarten Children washing and ironing,* p. 20; *Thanksgiving Day lesson at the Whittier,* p. 21; *Adele*

Quinney. Stockbridge tribe. A girl whose every physical measurement is artistically correct, p. 22; *John Wizi, Sioux, Son of Chief Wizi of Crow Creek, S. D.*, p. 22; *Class in American History*, p. 23; *Geography, Studying the Seasons*, p. 24; *Literature--Lesson on Whittier. Middle Class. 1899*, p. 25; *Geography. Studying the cathedral towns*, p. 26; *Field work in sketching. (Agriculture work)*, p. 27; *Geography. Lesson on land formation on the beach at Old Point*, p. 28; *A sketch class at work*, p. 29; *Arithmetic. Lesson under a student mason*, p. 30; *Agriculture. Plant life. Study of plants or a 'plant society,'* p. 31; *Arithmetic. Measuring and pacing*, p. 32; *Trade School, Mechanical Drawing*, p. 33; *Indian Orchestra*, p. 34; *A Foot-ball Team*, p. 35; *Agriculture. Plant Life. Studying the Seed*, p. 36; *Agriculture. Plant life. Experiments with plants and soil*, p. 37; *History. A class at Fort Monroe*, p. 38; *Agriculture. A class judging swine*, p. 39; *Physics. The Screw as applied to the cheese press*, p. 40; *Agriculture. Butter-making*, p. 41; *Agriculture. Animal life. Studying the horse*, p. 42; *Geography. Lesson on local industries--lumber and coal at School wharf*, p. 43; *Agriculture. Sampling milk*, p. 44; *A class in manual training. Bent iron and tin*, p. 45; *Trade School. Brick laying*, p. 46; *A class in dress-making*, p. 48; *Trade School. Shoe-making*, p. 49; *Agriculture. Mixing fertilizer*, p. 50; *Serving the dinner*, p. 51; *The Post-graduate Class of 1900*, p. 52.

461. Johnston, Frances Benjamin. "Miss Mathilde Weil," *The Ladies Home Journal* 18, 7 (June 1901): 9.

462. Johnston, Frances Benjamin. "The New Idea of Teaching Children," *The Ladies Home Journal* 17, 2 (January 1900): 20-21.

463. Johnston, Frances Benjamin. *The Papers of Frances Benjamin Johnston*. Wilmington, DE: Scholarly Resources, 1995. 37 microfilm reels.

464. Johnston, Frances Benjamin. *A Talent for Detail: The Photographs of Frances B. Johnston from 1889 to 1910*. Edited with an essay by Pete Daniel and Raymond Smock. New York: Harmony, 1974. 182 p.
 This collection of Johnston's work is introduced by a "photobiography," combining many images of Johnston throughout her life, and a biographical essay. The text that accompanies her images seeks to explain their individual circumstances and the history behind the people and the institutions Johnston had captured on film.

Frances Johnston selling tintypes at a Virginia county fair, 1903, p. 6; *The Green Room at the white House*, 1890, p. 8; *The Green Room, redecorated*, 1893, p. 9; *Wives of Cleveland's cabinet photographed in Johnston's Washington studio: Olive Harmon, Jane P. Frances, M.J. Carlisle, Agnes, P. Olney, Frances Cleveland, Nannie H. Wilson, Juliet K. Lamont, Leila Herbert*; January 4, 1897; p. 10; *Johnston working in the basement of her Washington studio*, 1895, p. 12; *Motoring*, 1904, p. 14; *Wading at La Ciobat, France*, 1905, p. 15; *The studio, behind 1332 V Street, N.W.*, c. 1895, p. 16; *A twelve-by-sixteen skylight dominated one side of*

the studio, p. 18; *Wall opposite the skylight*, p. 19; *The Push*, p. 20; *Entertaining friends before the studio fireplace*, c. 1895, p. 21; *Mills Thompson*, p. 22, 24, 25; *At the Georgetown Convent of the Order of Visitation Nuns*, 1900, p. 28; *At the laying of the cornerstone of the Memorial Continental Hall in Washington (DAR)*, April 19, 1903, p. 29; *The proper Victorian*, p. 30; *Self-portrait*, c. 1896, p. 31; *Self portrait*, 1936, p. 33; *The courtyard of her New Orleans home*, 1940s, p. 34; *Stacks of money at the United States Bureau of Printing and Engraving*, 1890, p. 38; *Whitening process*, 1880s, p. 41; *Destruction of the dies*, 1880s, p. 41; *Coining press*, 1880s, p. 41; *Breaker boys at Kohinoor Mines*, 1891, p. 43; *Men and machines scrape the earth of its iron wealth at the Mesaabi Range*, 1903, p. 44; *Ore dock worker*, 1903, p. 46; *A miner*, 1903, p. 47; *The tugboat <u>Joe Harris</u>*, p. 48; *Loading iron ore*, p. 49; *[Women going to work in Lynn, Massachusetts]*, 1895, p. 50; *[Woman by sewing machine]*, 1895, p. 51; *[Woman by stacks of shoes]* 1895, p. 52; *[Woman sewing shoes]*, 1895, p. 53; *Woman working in a cigar-box factory*, 1910, p. 54, 55, 56; *Admirl George Dewey examines Johnston's work aboard the battleship <u>Olympia</u>*, 1899, p. 59; *Admiral Dewey at his desk*, 1899, p. 60; *The Admiral's quarters*, 1899, p. 61; *Admiral Dewey on the deck of the <u>Olympia</u> with his Bob*, 1899, p. 62; *Frances Johnston in the crew's mess of the <u>Olympia</u>*, 1899, p. 63; *Dancing sailors*, 1899, p. 64; *Fencing on the deck*, 1899, p. 65; *An elaborate patriotic tatoo*, 1899, p. 65; *Below decks*, 1899, p. 66; *One of Johnston;s competitors, possibly J.C. Hemment*, 1899, p. 67; *Two officers relax with one of Johnston's traveling companions beneath the <u>Olympia</u>'s big guns*, 1899, p. 67; *President McKinley, the "Buffalo pose,"* 1901, p. 69; *President and Mrs. McKinley with Exposition president John G. Milburn touring the Pan American Exposition grounds*, September 5, 1901, p. 70; *Addressing the Exposition*, September 5, 1901, p. 71; *The "last posed photograph" of President McKinley*, 1901, p. 71; *The "last photograph ever taken of President McKinley," with John G. Milburn and George B. Cortelyou*, September 6, 1901, p. 72; *President Theodore Roosevelet dedicting the McKinely Monument in Canton, Ohio*, October 1907, p. 73; *Sioux Indian Chiefs with William Jenning Bryan at the Pan American Exposition, F. T. Cummings, General Manager of the Exposition; High Hawk; Jack Red Cloud; Blue Horse; Little Wound; William Jennings Bryan*, p. 74; *A rainy day at the Pan American Exposition. At the right is the Electricity Building*, p. 75; *World's Columbian Exposition, Construction began in July 1891. Here craftsmen prepare ornate scrollwork*, p. 77; *Worlds' Columbian Exposition*, 1893, p. 78-81; *Louisiana Purchase Exposition*, c. 1904, p. 83-85; *Stretching and yawning, Second Division School, Washington, D. C.*, 1899, p. 86; *Students boarding a trolley*, 1899, p. 88; *Trolley windows frame their faces*, 1899, p. 89; *Science class studying water vapor, Second Division School*, 1899, p. 90; *Boys on their mark at a Central High School boy's track meet*, 1899, p. 91; *A class in painting, Central High School, Washington, D. C.*, 1899, p. 92, 93; *Class of Sixth Division at a Fine Prints Exhibition in the Library of Congress*, 1899, p. 93; *Hampton students sketching a boat*, 1899, p. 96; *Students at work on the stairway of the treasurer's residence*, 1899, p. 97; *Students study a classmate in full tribal costume*, 1899, p. 98, 99; *[Poor black family at dinner]*, 1899, p. 100; *Hampton graduate's family at dinner*

table, 1899, p. 101; *[Black children of rural Virginia]*, 1899, p. 102, 103; *[Poor blacks by wooden shack]*, p. 104; *[Black farmers by barn]*, 1899, p. 105 ;*[Old black man with water barrel]*, 1899, p. 106; *[Black family near hogs hanging from pole]*, 1899, p. 107; *[Black children and turkey]*, 1899, p. 108, 109; *[Black women doing wash in barrels]*, 1899, p. 110; *Captain Richard Henry Pratt at Carlisle Indian School*, 1900, p. 111; *Indians at the Carlisle infirmary*, 1900, p. 112; *Indians debating "the Negro question,"* 1900, p. 113; *Students in a history class at Tuskegee*, 1902, p. 114; *Booker T. Washington*, 1906, p. 117; 118; *Booker T. Washington, Jr.*, 1906, p. 119; *Tuskegee's twenty-fifth anniversary celebration, Robert C. Ogden, William Howard Taft, Booker T. Washington, Andrew Carnegie*, 1906, p. 120; *Tuskegee faculty council, Robert R. Taylor, R. M. Atwell, Julius B. Ramsey, Chaplain Edgr J. Penny, M. T. Driver, William Maberry, George Washington Carver, Jane E. Clark, Emmett J. Scott, Booker T. Washington, Warren Logan, John H. Washinton*, 1902, p. 121; *Students whitewashing a fence at Tuskegee Institute*, 1902, p. 122; *Students cultivating onions*, 1906, p. 122; *Woodwork shop*, 1906, p. 123; *Millinery class*, 1906, p. 123; *Students at Snow Hill Institute*, 1902, p. 124; *In the collard patch near Snow Hill*, 1902, p. 125; *Picking the schools cotton crop at Mt. Meigs Institute in Alabama*, 1902, p. 126; *Cotton being suctioned in a gin near Tuskegee*, 1902, p. 127; *Frances Johnston at the mouth of Mammoth Cave*, c. 1892, p. 129; *Hotel near the cave*, c. 1892, p. 130; *On the Echo River in Mammoth Cave*, c. 1891, p. 131; *[Graffiti and stacks of rock left by tourists in Mammoth Cave]*, 1892, p. 132; *Couple sitting in cave's bridal chamber*, 1892, p. 133; *Fording the the Firehole River at Yellowstone National Park*, 1903?, p. 135; *Frances Johnston at Yellowstone National Park*, 1903?, p. 136; *Tourists examining geysers at Yellowstone*, 1903?, p. 137; *Joe Knowles, Johnston' driver at Yellowstone National Park*, 1903?, p. 138; *Mule skinner at Yellowstone*, 1903?, p. 138; *Early Yellowstone traffic jam*, 1903?, p. 139; *Lower Falls of the Yellowstone*, 1903?, p. 140; *Mark Twain*, 1906, p. 141, 161; *Joel Chandler Harris*, 1905, p. 142; *Susan B. Anthony*, 1900, p. 145; *Susan B. Anthony in her study*, p. 147; *President and Mrs. Roosevelt*, December 18, 1902, p. 148; *Alice Roosevelt in the White House conservatory*, December 18, 1902, p. 150; *Alice Roosevelt on horseback*, 1902, p. 151; *Alice Roosevelt in riding clothes*, 1902, p. 151; *Quenton Roosevelt and a playmate, Rosewell Flower Pinckney*, 1902, p. 152; *Quentin and Kermit Roosevelt with the White House police*, 1902, p. 153; *Theodore Roosevelt in his Rough Riders uniform*, 1898, p. 154; *Theodore Roosevelt and the Rough Riders*, 1898, p. 155; *Theodore Roosevelt, Jr., with his parrot Eli in the White House conservatory*, 1902, p. 156; *Alexander Graham Bell*, p. 157; *Ida Saxton McKinley*, p. 158; *President William McKinley*, 1898, p. 159; *Jacob August Riis*, p. 160; *Jane E. Clark was dean of the women's department at Tuskegee Institute from 1902 to 1906*, p. 162; *Andrew Carnegie*, 1905, p. 163; *Phoebe Apperson Hearst, mother of newspaper magnate William Randolph Hearst*, p. 164; *George Washington Carver*, 1906, p. 165; *Booker T. Washington, Booker T. Washington, Jr., E. Davidson Washington*, 1906, p. 166; *Margaret James Murray Washington, Booker T. Washington's third wife, was "lady Principal" and later dean of women at Tuskegee Institute*, p. 167; *Mrs. John Philip Sousa and*

daughters, 1904, p. 168; *John Philip Sousa*, p. 169; *Helen Hay (Mrs. Payne Whitney) was the daughter of Secretary of State John Hay*, p. 170; *John Milton Hay was United States Secretary of State*, 1898-1905, p. 171; *Richard Hovey*, p. 172; *Julia Marlowe, actress*, 1898?, p. 173; *General Leonard Wood*, p. 173; *Benjamin Ryan Tillman, Senator*, p. 174; *Albert Jeremiah Beveridge*, 1905, p. 175; *Jane Cowl, actress*, 1908, p. 176; *Gifford Pinchot, a champion of conservation, was the first professional forester in America*, p. 177; *"The Critic,"* c. 1900, p. 178; *Neith Boyce Hapgood, a novelist and journalist*, p. 179; *[Children lined up for the iceman]*, frontispiece.

465. Johnston, Frances Benjamin. "What a Woman Can Do With a Camera," *The Ladies Home Journal* (September 1897): 6-7.

466. Johnston, Frances Benjamin. "The Work of Mrs. Gertrude Käsebier," *The Ladies Home Journal* 18, 6 (May 1901): 1.

467. Johnston, Frances Benjamin. "Zaida Ben-Yusuf," *The Ladies Home Journal* 18, 12 (November 1901): 13.

468. "Miss F. B. Johnston's Exhibit," *Photo-Era* ii (April, 1899): 292.

469. Murray, William M. "Miss Frances B. Johnston's Prints," *Camera Notes* 2, 4 (April 1899): 167-168.

469.1 Nichols, Frederick Doveton. *The Architecture of Georgia*. Photographs by Van Jones Martin and Frances Benjamin Johnston. Drawings by Frederick Spitzmiller. Edited by Mills Lane. Savannah: The Beehive Press. 1976. 436 p.
 This volume is a part of what was to be a complete survey of the most important and representative pre-Civil War architecture of Georgia. Interior, exterior and architectural details are represented by hundreds of photographs.

470. Vanderbilt, Paul. "Frances Benjamin Johnston," *Journal of the AIA* (November 1952): 224-228.

471. Watts, Jennifer A. "Frances Benjamin Johnston: The Huntington Library Portrait Collection," *History of Photography* 19 (Autumn 1995): 252-262.

472. White, Gleeson. "An American Photographer," *The Photogram* 4, 46 (October 1897): 285-291.

Johnston, Joyce
 See also #1006

Jones, Julia
 See also #1040
Kaida, Tamarra
 See also #1055, 1071
Kajn, Deborah
 See also #1071

Kanaga, Consuelo, 1894-1978
 See also #1054, 1058, 1063

473. Berger, Maurice. "Subjective Documentarian," *Art in America* 82 (January 1994): 51,53, 55.

474. Kalina, Judith. "From the Icehouse: A Visit with Consuelo Kanaga," *Camera 35* 16, 10 (December 1972): 52-55+.

475. Kanaga, Consuelo. *Consuelo Kanaga Photographs: A Retrospective*: May 14-31, 1974. New York: Lerner-Heller Gallery. 1974. 32 p.
 This catalogue of an exhibition also includes three short essays: "Autobiographical Note" and "Some personal observations by Kanaga on photography" and some observations on Kanaga's work.
Child in Tennnesse, 1948, cover; *Hands*, 1930, back cover; *Young Girl, Tennessee*, 1948, p. 5; *Amy Murray*, 1936, p. 6; *Anny Mae Meriweather*, 1936, p. 7; *Downtown, New York*, 1924, p. 8; *New York El*, 1924, p. 9; *New York East Side*, 1935, p. 10; *Seddie Anderson's Wagon*, 1925, p. 11; *Sunflower*, 1942, p. 12; *Dew on Clover*, 1925, p. 13; *Colt*, 1940, p. 14; *Ducks*, 1945, p. 15; *Margaret*, 1962, p. 18'; *Nude*, 1928, p. 19; *William* Edmundson, 1950, p. 20; *Milton Avery*, 1950, p. 21; *Poor boy*, 1928, p. 22, 23; *The Question*, 1950, p. 24; *Fire*, 1925, p. 25; *The Widow Watson*, 1925, p. 26; *Hundred Poorest*, 1928, p. 27; *San Francisco kitchen*, 1930, p. 28; *Ivory Soap*, 1925, p. 29; *Camelia*, 1940, p. 30; *End of an Era*, 1925, p. 31; *Alfred Stieglitz*, 1936, p. 32.

476. Lowe, Sarah M. and Barbara Head Millstein. *Consuelo Kanaga: An American Photographer*. New York: Brooklyn Museum in Association with University of Washington Press, 1992. 223 p. Bibliography: p. 212-215. Includes a chronology.
 Published on the occasion of the exhibition *Consuelo Kanaga: An American Photographer*, a special exhibition at The Brooklyn Museum, this catalogue of Kanaga's photographs are enhanced by a lengthy biographical essay. The images, which are divided into categories, are prefaced by critical essays which compare Kanaga's techniques to that of other photographers and provide valuable information on her work.
Hands, 1930, pl. 1; Tenements (New York), 1939, pl. 2; *Man with Rooster (New York)*, mid-late 1930s, pl. 3; *Annie Mae Merriweather*, 1935, pl. 4; *Fire (New York)*, 1922, pl. 5; *[Mother with Children](New York)*, 1922-24, pl. 6; The Widow Watson (New York), 1922-24, pl. 7; *The Bowery (New York)*, 1935, pl. 8; *[Man on*

Bench]/(New York), 1920s, pl. 9; *Malnutrition (New York)*, 1928, pl. 10; *Tenement, Child on Fire Escape]/(New York)*, mid-late 1930s, pl. 11; *[Sheep Herder]/(North Africa)*, 1928, pl. 12; *[Man on Donkey]/(North Africa)*, 1928, pl. 13; *[Two Donkeys]/(North Africa)*, 1928, pl. 14;*[Baby's Feet]/(North Africa)*, 1928, pl. 15; *[Man on Horizon]/(North Africa)*, 1928, pl. 16; *[Horizon with Domes]/(North Africa)*, 1928, pl. 17; *[Telephone Pole Against the Sky]/(North Africa)*, 1928, pl. 18; *[Woman on a Street, Kairouan]/(North Africa)*, 1928, pl. 19; *[Two Camels]/(North Africa)*, 1928, pl. 20; *[Two Children]/(North Africa)*, 1928, pl. 21, 22; *[Young African]/(North Africa)*, 1928, pl. 23; *[Arab]/(North Africa)*, 1928, pl. 24; *Bedouin Girl (North Africa)*, 1928, pl. 25; *Annie Mae Merriweather*, 1935/36, pl. 26; *[Native American Child]/(New Mexico)*, 1950s, pl. 28, 67; *School Girl (St. Croix)*, 1963, pl. 28; *[Young Girl in Profile]/(from Tennessee Series)*, 1948, pl. 29; *Frances with a Flowers*, c. early 1930s, pl. 30; *Eluard Luchel McDaniel*, 1931, pl. 31, 48; *Zelda Benjamin*, 1941, pl. 32; *Erica Lohman*, c. 1920s, pl. 33; *Wharton Esherick*, 1940, pl. 34; *Kenneth Spencer*, 1933, pl. 35; *Portrait of a Man*, c. 1930s, pl. 36; *Wallace in His Studio*, mid-late 1930s, pl. 37; *Harvey Zook*, c. 1940, pl. 38; *Kenneth Spencer*, 1933, pl. 39; *Morris Kantor*, 1938, pl. 40; *Portrait of a Woman (M.C.)*, pl. 41; *Eiko Yamazawa*, mid-late 1920s, pl. 42; *Harry Shokler*, late 1920s-early 1930s, pl. 43; *Milton Avery*, 1950, pl. 44; *Frances (with Daisies)(New York)*, 1936, pl. 116; *Nude*, 1928, pl. 46; *Portrait of a Woman*, c. 1930s, pl. 47; *Langston Hughes*, c. 1930s, pl. 49, 50; *[Chinatown]/(San Francisco)*, late 1910s-early 1920s, pl. 51; *New York El*, 1924, pl. 52; [Pier 27](from Downtown New York Series), 1922-24, pl. 53; *[Horse-Drawn Wagon]/(from Downtown New York Series)*, 1922-24, pl. 54; *[Tug and Barge, East River]/(from Downtown New York Series)*, 1922-24, pl. 55; *[West Street with Truck]/(from Downtown New York Series)*, 1922-24, pl. 56; *Downtown, New York*, 1924, pl. 57; *[Anchors]/(San Francisco)*, pl. 58; *[San Marco]/(Venice)*, 1927, pl. 59; *[Piazza San Marco]/(Venice)*, 1927, pl. 60; *[Gondolas]/(Venice)*, 1927, pl. 61; *[Stairs]/(Perugia)*, 1927, pl. 62; *[Winding Road in Park]*, 1927, pl. 63; *[Towers, Germany]*, 1927, pl. 64; *After Years of Hard Work (Tennessee)*, 1948, pl. 65; *Mr. and Mrs. Stanley, the Adirondacks (The Front Parlor)*, 1936, pl. 66; *[Native American Women with Wooden Poles]/(New Mexico)*, 1950s, pl. 67; *[Native American Children]/(New Mexico)*, 1950s, pl. 69; *[Rodeo]/(New Mexico)*, 1950s, pl. 70; *Gus Weltie(High Tor, New York)*, pl. 71; *[Farm Family]*, c. 1930s, pl. 72; *Cornelia Street Kitchen*, 1944, pl. 73; *San Francisco Kitchen*, 1930, pl. 74; *[Window Pane with View of City Yard]*, c. 1930s or 1940s, pl. 75; *Seddie Anderson's Farm*, 1920s, pl. 76; *[Clapboard Schoolhouse]*, pl. 77; *[Child's Grave Marker]*, pl. 78; *Ghost Town (New Mexico)*, 1950s, pl. 79; *[Barbed Wire Fence]/(Florida)*, 1950, pl. 80; *[Girl with Double-Heart Ring]/(Tennessee)*, 1948, pl. 81; *Mother and Son or The Question (Florida)*, 1950, pl. 82; *Young Girl, Tennessee*, 1948, pl. 83; *Young Girl (White Blouse), Tennessee*, 1948, pl. 84; *[Young Mother with Baby Girl]/(Florida)*, 1950, pl. 85; *[Woman with Child]/(Tennessee)*, 1948/50, pl. 86; *[Child with Apple Blossoms]/(Tennessee)*, 1948, pl. 87; *[Boy with Gun]*, 1948/50, pl. 88; *Norma Bruce(Florida)*, 1950, pl. 89; *She Is a Tree of Life to Them (Florida)*, 1950, pl. 90; *Milking Time*, 1948, pl. 91; *[Young Woman]/(from the Muck Workers series,*

Florida), 1950, pl. 92; *[Field Workers](from the Muck Workers series, Florida)*, 1950, pl. 93; *William Edmondson (Tennessee)*, 1950, pl. 94; *Camelia in Water*, 1927/28, pl. 95; *Give Us This Day*, pl. 96; *[Roses]*, pl. 97; *[Plant and Gauze Curtain]*, pl. 98; *House Plant*, 1930, pl. 99; *[Flowers in Water]*, pl. 100; *Glasses and Reflections*, 1948, pl. 101; *[Architectural Abstraction, New York]*, 1930s or 1940s, pl. 102, 103; *[Snow on Clapboard]*, pl. 104; *Creatures on Rooftop*, 1937, pl. 105; *[City Roofs]*, pl. 106; *Birches*, mid-1960s, pl. 107; *Sunflower*, 1942, pl. 108; *Photographing into Water*, 1948, pl. 109; *[Lily Pads]*, 1948, pl. 110; *Abstraction*, 1948, pl. 111, 112; *Amos Ream Kanaga, Sr.*, fig. 4; *Portrait of a Woman*, fig. 9, 10; *May [Spear?] c. early 1920s*, fig. 12; *Dahl, Wolfe, Kanaga, McCarthy in Tunisia*, fig. 14; *Albert Bender*, c. 1929, fig. 15; *Frances*, c. early 1930s fig. 16; *Eluard Luchell McDaniel*, 1931, fig. 17; *Marvin (Chick) Brown*, fig. 18; *May Day Parade, Union Square*, 1937, fig. 20; *East Side (New York)*, 1935, fig. 21; *[Tenements](New York)*, mid-late 1930s, fig. 22; Cover of *Labor Defender*, January 1936, fig. 23; *Two Women, Harlem*, mid-late 1930s, fig. 24; *Girl at Easter (New York)*, mid-late 1930s, fig. 25; *Wally, mid-1930s*, fig. 27; *Stieglitz at Lake George*, 1936, fig. 28; *Interior of Kanaga's Studio*, fig. 30; *She Is a Tree of Life, II(Florida)*, 1950, fig. 31; *William Edmondson (Tennessee)*, 1950, fig. 32; *Barbara Deming*, fig. 35; *Stairs (Lacoste, France)*, mid-1960s, fig. 35; *Alexander Bing*, fig. 37; *Amy Oliver*, fig. 39; *Poor Boys (New York)*, 1928, fig. 41; *Malnutrition (New York)*, 1928, fig. 42; *Poor Boy (New York)*, 1928, fig. 43; *Ray Robinson (Albany, Georgia)*, 1963, fig. 43; *Kate Maxwell*, fig. 44; *March Avery, 1950s*, fig. 45; *Sargent Johnson, 1934*, fig. 46; *W. Eugene Smith and Aileen*, 1974, fig. 47; *Self-portrait with Bottles*, fig. 48; *Mark, Rothko*, 1951, fig. 49; *Countee Cullen*, c. 1930s, fig. 50; *[San Francisco Stock Exchange]*, late 1910s-early 1920s, fig. 51; *[Three Russian Girls](San Francisco)*, late 1910s-early 1920s, fig. 52; *[Russian Woman with a Child](San Francisco)*, late 1910s-early 1920s, fig. 53; *[Consolidated Fisheries](San Francisco)*, late 1910s-early 1920s, fig. 54; *[Fishermen's Net](San Francisco)*, late 1910s-early 1920s, fig. 55; *[Old Ship Hotel, Battery Street](San Francisco)*, late 1910s-early 1920s, fig. 56; *Kathryn Hume*, 1920s or 1930s, fig. 57; *[Bottles in Window at the Icehouse]*, after 1940, fig. 58; *Seddie Anderson*, c. 1920s, fig. 59; *[Three Children]*, 1949/50, fig. 60; *[Farmer and Mule](Florida)*, 1950, fig. 61; *[Field Worker](from the Muck Workers series, Florida)*, 1950, fig. 62; *[Madonna in Bell Jar]*, fig. 63; *[Architectural Abstraction, New York]*, 1930s or 1940s, fig. 64, 65; *Portrait of a Child*, fig. 67; *Self-portrait in Striped Shirt*, fig. 68; *New York Skyline*, c. mid-1930s, fig. 69; Cover of *20th Century Americanism*, fig. 70; *Imogen Cunningham*, fig. 71; *Marjorie Content*, fig. 72; *Clouds and Mesa*, fig. 73.

Käsebier, Gertrude, 1852-1934
> See also #1000, 1017, 1022, 1026, 1058, 1061, 1063

477. "Art and Bread and Butter Photography," *Studio Light* 3 (November 1911): 3-4.

478. Bayley, R. Child. "A Visit to Mrs. Käsebier's Studio," *Wilson's Photographic Magazine* 40 (February 1903): 73-74.

479. Bunnell, Peter C. "Gertrude Käsebier," *Arts in Virginia* 16 (Fall 1975): 2-15, 40.

480. Caffin, Charles H. "Mrs Käsebier and the Artistic-Commercial Portrait," *Everybody's Magazine* 4 (May 1901): 480-495.

481. Caffin, Charles H. "Mrs. Käebier's Work--an Appreciation," *Camera Work* I (January 1903): 17-19.

482. Cram, R. A. "Mrs. Käsebier's Work," *Photo-Era* 4 (May 1900): 131-136.

483. Dow, Arthur K. "Mrs. Gertrude Käsebier's Portrait Photographs," *Camera Notes* (July 1899): 22-23.

484. Edgerton, Giles. [pseud. Mary Fanton Roberts] "Photography as Emotional Art: A Study of the Work of Gertrude Käsebier," *Craftsman* (April, 1907): 80-93. Reprinted in Peter E. Palmquist, *Camera Fiends and Kodak Girls: 50 Selections by and About Women in Photography, 1840-1930*. New York: Midmarch Arts Press, 1989.

485. Garner, Gretchen. "Gertrude Käsebier and Helen Levitt," *Art Journal*, 51 (Winter, 1992):83-85, 87.

486. Goldberg, Vicki. "The Käsebier File: Rediscovery in Progress," *American Photo* 3 (May/June 1992): 16.

487. Hervey, Walter L. "Gertrude Käsebier--Photographer," *Photo-Era* 62 (March 1929): 131-132.

488. Hartmann, Sadakichi. "Gertrude Käsebier," *Photographic Times* 32 (May 1900): 195-199.

489. Holm, Ed. "Gertrude Käsebier's Indian Portraits," *The American West* 10 (July 1973): 38-41.

490. Homer, William Innes. *A Pictorial Heritage: The Photographs of*

Gertrude Käsebier. Wilmington: Delaware Art Museum, 1979. 63 pages. This is an exhibition catalog with a critical preface to the work of Käsebier and several essays on her early childhood, marriage, career as a professional photographer, philosophy and methods as a portrait photographer and other methods and techniques she employed.

Gertrude Käsebier [the photographer's daughter] at Crécy-en-Brie, France, 1894, p. 14; *La Grand-mère*, 1894, p. 22; *Portrait of Miss N. (Evelyn Nesbitt)*, c. 1898, pl. 5; *[Portrait of an Indian Holding Implement]*, c. 1898, pl. 11; *Zit-Kala-Za*, c. 1898, pl. 14; *Blessed Art Thou Among Women*, 1899, pl. 15; *Flora*, c. 1899, pl. 18; *The Manger*, c. 1899, pl. 19; *The Picture Book (Instruction)*, c. 1899, pl. 20; *The Sketch*, c. 1899, pl. 21; *Serbonne*, 1901, pl. 30; *The Bat*, 1902, pl. 33; *Mrs. R. Nursing Baby*, c. 1905, pl. 50; *The Bride*, before 1906, pl. 51; *[View in Newfoundland]*, 1912, pl. 72; *Yoked and Muzzled: Marriage*, c. 1915, pl. 75; *In Times of Peace*, pl. 79; *Major Daniels*, pl. 80.

491. Johnston, Frances Benjamin. "Gertrude Kasebier, Professional Photographer," *Camera Work* 1 (January 1903): 20.

492. Käsebier, Gertrude."An Art Village," *The Monthly Illustrator* 4 (April, 1895): 9-17.

493. Kasebier, Gertrude. "Peasant Life in Normandy," *The Monthly Illustrator* 3 (March 1895): 269-275.

494. Kasebier, Gertrude."Studies in Photography," *The Photographic Times* 30 (June, 1898): 269-272.

495. Käsebier, Gertrude. "To Whom It May Concern," *Camera Notes* 3 (January, 1900): 121-122.

496. Keiley, Joseph. "Gertrude Käsebier." *Camera Work* 20 (1907): 27-31.

497. Keiley, Joseph. "Mrs. Käsebier's Prints," *Camera Notes* (July, 1899): 34.

498. Michaels, Barbara L. *Gertrude Käsebier: The Photographer and Her Photographs*. New York: Harry N. Abrams, 1992. 192 p. Bibliography: p. 179-183.
 Michaels combines and text and photographs to reevaluate Käsebier's portraits and studies of mothers and children in relation to the progressive ideas of the turn of the century. This critical study examines the relationships with Stieglitz, Steichen, the Photo-Secessionists and other important photographers of the day.

Portrait of the Photographer, c. 1899, p.2; *The Sketch*, 1906, fig. 67, p. 6; *[First Photograph]*, c. 1885, fig. 3; *In Grandpa's Orchard*, c. 1893, fig. 6; *The Old Mower and His Wife*, 1894, fig. 7; *La Grand-mère*, 1894, fig. 8; *Arthur W. Dow,*

1896-98, fig. 9; *Portrait of a Boy,* 1897, fig. 10; *The Red Man,* 1902, fig. 11; *Profile of Iron Tail with headdress,* 1898, fig. 12; *Iron Tail,* 1898, fig. 13; *Samuel Lone Bear,* 1898-1901, fig. 15; *Samuel Lone Bear,* 1898, fig. 7; *Joe Black Fox,* 1898-1901, fig. 18; *American Indian Portrait (Joe Black Fox),* 1898-1901, fig. 19; *Willie Spotted Horse,* c. 1901, fig. 20; *Zitkala-Sa,* 1898, fig. 22, 23, 24; *Mother and Child (*alternately titled *Adoration or The Vision),* 1897, fig. 27; *Flora (*alternately titled *Portrait Study, The Velvet Mantle, The Florentine Boy),* c. 1897, fig. 28; *Blessed Art Thou Among Women,* 1899, fig. 29; *The Heritage of Motherhood,* 1904, fig. 30; *The Manger,* 1899, fig. 31; *"When there is so much smoke there is always a little fire,"* c. 1906, fig. 35; *Alvin Langdon Coburn,* c. 1902, fig. 36; *Charles H. Caffin,* c. 1900, fig. 37; *Mark Twain,* 1900, fig. 42; *Jacob A. Riis,* 1901, fig. 43; *Booker T. Washington,* 1901, fig. 44; *Dorothy Trimble Tiffany,* 1899, fig. 33; *Harmony (Family),* 1901, fig. 45; *Theodate Pope,* 1902, fig. 46, 48; *Alfred Stieglitz,* 1902, fig. 49; *Emmeline Stieglitz and Katherine (Kitty) Stieglitz,* late 1899-early January 1900, fig. 50; *Mother and Child,* c. 1903, fig. 51; *Mother and Child (Decorative panel),* 1899, fig. 54; *Real Motherhood,* 1900, fig. 56; *Edward Steichen,* 1901, fig. 58; *Serbonne (A Day in France),* 1901, fig. 59; *The Bat,* 1902, fig. 60; *Portrait--Mrs. Philip Lydig,* c. 1904, fig. 61; *Happy Days,* 1903, fig. 62; *The Picture-Book,* 1903, fig. 64; *Gertrude O'Malley and Charles O'Malley, Newport, R.I.,* 1903, fig. 65; *The Road to Rome,* 1903, fig. 66; *Black and White,* 1903, fig. 68; *Portrait of Baron de Meyer,* 1903, fig. 69; *Auguste Rodin,* 1905, fig. 71, 72, 73; *Portrait of Stanford White,* c. 1903, fig. 78; *Portrait (Miss N.),* 1902, fig. 79; *Josephine (Portrait of Miss B.),* 1903, fig. 82; *Williams Glackens,* c . 1907, fig. 83; *John Sloan,* 1907, fig. 84; *Robert Henri,* c. 1907, fig. 85; *Arthur B. Davies,* c. 1907, fig. 86; *Portrait of Everett Shinn,* c. 1907, fig. 88; *Portrait of Rose O'Neill,* c. 1907, fig. 89; *The Silhouette,* 1906, fig. 90; *Portrait of Eulabee Dix (Becker),* c. 1905, fig. 91; *Bungalows,* c. 1907, fig. 92; *The Simple Life,* c. 1907, fig. 93; *Thanksgiving, Oceanside,* before 1910, fig. 94; *[Gertrude Käsebier O'Malley playing billiards],* c. 1909, fig. 95; *[Hermaine Käsebier Turner photographing Mason and Mina Turner on the roof],* c. 1909, fig. 96; *Lolly Pops,* 1910, fig. 97; *The Rehearsal,* c. 1912,. fig. 98; *[Fishing banks, Newfoundland],* 1912, fig. 99; *[Newfoundland],* 1912, fig. 100; *Newfoundland, Petty Harbour (Wharf Rats),* 1912, fig. 101; *Newfoundland Trip,* 1912, fig. 102; *Clarence H. White and Family,* 1908, fig. 103; *Sunshine in the House,* 1913, fig. 104; *The Hand That Rocks the Cradle,* 1913, fig. 105; *The Widow,* 1913, fig. 107; *Portrait of Mabel Dodge,* 1915, fig. 108; *The Bride,* 1905 or before, fig. 109; *Yoked and Muzzled--Marriage,* 1915 or before, fig. 110, 111; *The Pathos of the Jackass,* 1912-1916, fig. 112.

499. Michaels, Barbara L. "Rediscovering Gertrude Käsebier," *Image* 19(Summer 1976): 20-31.

500. O'Mara, Jane Cleland. "Gertrude Käsebier: The First Professional Woman Photographer 1852-1934," *The Feminist Art Journal* (Winter 1974-75): 18-23.

501. Tighe, Mary Ann. "Gertrude Käsebier Lost and Found," *Art in America* 65 (March 1977): 94-98.

502. Watson, Eva Lawrence. "Gertrude Käsebier," *American Amateur Photographer* 12 (May 1900): 219-220.

Kasten, Barbara
 See also #1000, 1007, 1012, 1017, 1058, 1063
Katchian, Sonia
 See also #1072

Keegan, Marcia K.
 See also #1069

503. Keegan, M. K. and Frontier Photographers. *Enduring Culture: A Century of Photography of the Southwest Indians*. Santa Fe, NM: Clear Light Publishers, 1990. 120 p. Chiefly illustrations.
 After a short essay on Keegan's insight into Native American culture, and having photographed in the southwest for some thirty years, she skillfully juxtaposes images by the earlier frontier photographers with her own and documents a rejuvenation of the traditional ways of life. Brief biographical sketches of the early frontier photographers follow the photographs. Also following are Keegan's descriptions of the plates, explanations of the customs and dress of the people she photographed.
Canyon de Chelly, 1972, pl. 2; *Laguna Pueblo*, 1972, pl. 4; *Acoma Woman at Waterhole*, 1970, pl.; 6; *Trina Encino from Acoma Pueblo*, 1974, pl. 8; *Taos Pueblo*, 1969, pl. 10; *Corn Dance Santa Clara Pueblo*, 1986, pl. 12; *Hopi Girl*, 1987, pl. 14; *Frank C. Romero from Taos Pueblo*, 1970, pl. 16; *Buffalo Herd, Taos Pueblo*, 1970, pl. 18; *Buffalo Dancers, Nambe Pueblo*, 1969, pl. 20; *Buffalo Dance, San Ildefonso Pueblo*, 1973, pl. 22; *Bernice Roybal from San Ildefonso Pueblo*, 1980, pl. 24; *Acoma Pueblo*, 1972, pl. 26; *Lucy Martinez, San Ildefonso Pueblo*, 1972, pl. 28; *Dancers Entering Kiva, Nambe Pueblo*, 1971, pl. 30; *Bernice at Kiva, San Ildefonso Pueblo*, 1971, pl. 32; *Eagle Dance, Laguna Pueblo*, 1970, pl. 34; *Kiowa Boy*, 1978, pl. 36; *Navajo Basket Makers*, 1970, pl. 38; *Julia Roybal and Alice Martinez Baking Bread*, 1974, pl. 40; *Taos Pueblo*, 1970, pl. 42; *Farmers from Taos Pueblo*, 1969, pl. 44; *Replastering an Adobe House, Taos Pueblo*, 1969, pl. 46; *Woman Winnowing Corn, San Juan Pueblo*, 1972, pl. 48; *Leandro Bernal of Taos Pueblo*, 1974, pl. 50; *Geronima Archuleta from San Juan Pueblo*, 1980, pl. 52; *Navajo Woman Combing Hair*, 1972, pl. 54; *Cottonwood Tree at San Ildefonso Pueblo*, 1987, pl. 56; *Corn Dance, San Ildefonso Pueblo*, 1979, pl. 58; *Deer Dance San Ildefonso Pueblo*, 1973, pl. 60; *The Peter Garcia Family, San Juan Pueblo*, 1980, pl. 62; *Jutta Cajero from Jemez Pueblo*, 1986, pl. 64; *Christine and Bernadette Eustace from Zuni Pueblo Making Fry Bread*, 1978, pl. 66; *Rose Naranjo Making Pottery, Santa Clara Pueblo*, 1980, pl. 68; *Lucy and Richard Martinez Firing Pottery, San Ildefonso Pueblo*, 1972, pl. 70; *Dancer from Nambe*

Pueblo, 1972, pl. 72; *Apache Mountain Spirit Dancer*, 1976, pl. 74; *Navajo Hogan, Monument Valley*, 1972, pl. 76; *Darlene Martinez San Ildefonso Pueblo*, 1988, pl. 78; *Dixon Palmer, Kiowa Indian*, 1978, pl. 80; *Dancers and Drummers, San Ildefonso Pueblo*, 1974, pl. 82; *Comanche Dance, San Ildefonso Pueblo*, 1974, pl. 84; *Corn Dance, San Juan Pueblo*, 1974, pl. 86; *End of Corn Dance, Santa Clara Pueblo*, 1989, pl. 88.

Kelly, Mary
 See also #1055
Kemmler, Florence B.
 See also #1058
Kendal, Marie Hartig
 See also #1058
Kenneday, Elizabeth
 See also #1071
Kessler, Eve
 See also #1006

Khornak, Lucille

504. Khornak, Lucille. *Fashion Photography: A Professional Approach*. New York: Amphoto, 1989. 144 p. Illustrations.
 Khornak, model-turned-photographer, has written a comprehensive, and heavily illustrated, career guide for the field of fashion photography.

505. Khornak, Lucille. *Fashion 2001*. New York: Viking Press, 1982. 111 p. Accompanying the photographs of fashion for the year 2001 are design sketches and analyses of the future of fashion provided by the fashion designers themselves.

506. Khornak, Lucille. *The Nude in Black and White: Creative Approaches to Photographing the Nude*. New York: Amphoto, 1993. 144 p. Illustrations. A portfolio of nudes accompany and illustrate the instructive text.

507. Schaub, Grace. "Lucille Khornak," *Photographer's Forum* 9, 4 (September 1986): 7-16.

Kleefeld, Claudia
 See also #1071
Klein, Sardi
 See also #1070, 1072
Klochko, Deborah
 See also #1000

Klute, Jeannette.

See also #1061

508. "Jeannette Klute's Flower Studies," *Popular Photography* 34, 1 (January 1954): 38+.

509. Klute, Jeannette. *Woodland Portraits*. Boston: Little, Brown, 1954. 36 p. 50 color plates

Knorr, Karen
 See also #1008
Koga, Mary
 See also #1061
Kogan, Deborah
 See also #1071
Kolko, Berenice
 See also #1008
Krasner, Carin
 See also #1071
Kreisher, Katharine
 See also #1071

Krementz, Jill, 1940-
 See also #1058, 1069

509.1 Krementz, Jill. *The Writers' Image: Literary Portraits*. Boston: Godine, 1980. 124 p.

509.2 Shenker, Israel. *Words and Their Masters*. Photographs by Jill Krementz. Garden City, NY: Doubleday, 1974. 308 p.

Krensky, Jane
 See also #1071
Kruger, Barbara, 1945-
 See also #1015, 1055, 1058

Kuehn, Karen 1959-

510. "Cornering John Waters: Mondo Bizarro," *American Photo* 2 (September/October 1991): 30.

511. Kaplan, Michael, "New York Stories," *American Photographer* 23 (July 1989): 26-37.

Lacy, Suzanne
 See also #1055

Ladd, Sarah Lake
 See also #1001
Lake, Suzy
 See also #1008
Lally, Diane
 See also #1071

Land-Weber, Ellen
 See also #1061

512. Greenberg, Jane. "Ellen Land-Weber," *Modern Photography* 38, 11 (November 1974): 136-137.

513. Land-Weber, Ellen. "Processes: Copy Machines," *Modern Photography* 44, 9 (September 1980): 100-101.

514. Land-Weber, Ellen. "3M Montage to Create Dream-Like Images Using Modern Technology," *Petersen's Photographic* 5, 1 (May 1976): 72-76.

Landgraf, Susan
 See also #1071
Landworth, Tracey
 See also #1071

Lange, Dorothea, 1895-1965.
 See also #1008, 1009, 1013, 1026, 1028, 1037, 1053, 1058, 1061, 1063

515. Benson, John. "The Dorothea Lange Retrospective, The Museum of Modern Art, New York." *Aperture* 12, 4(1965): 40-57.

516. Coke, Van Deren. "Dorothea Lange, Compassionate Recorder," *Modern Photographer* 37, 5 (May 1973): 90-95.

517. Coles, Robert. "The Human Factor: The Life and Work of Dorothea Lange," *Camera Arts* 3, 2 (February 1983): 34-49+.

518. Coles, R. "Dorothea Lange and the Politics of Photography," *Raritan: A Quarterly Review* 1, 2 (1981): n.p.

519. Costanzo, Diane Di. "Houk Friedman Gallery, New York; exhibit," *Art News* 93 (September 1994): 168. Illustrated.

520. Curtis, J. C. "Dorothea Lange 'Migrant Mother' and the Culture of the Great Depression," *Winterthur Portfolio: A Journal of American Material Culture,* 21, 1 (1986): 1-20.

521. Deschin, Jacob. "Dorothea Lange and Her Printer," *Popular Photography* 59, 1 (July 1966): 28, 30, 68, 70.

522. Deschin, Jacob. "Lange and Conrat--a Relationship of Conflict But Great Productivity," *Popular Photography* 70, 6 (June 1972): 32, 38.

523. Deschin, Jacob. "'This Is The Way It Is--Look At It! Look At It!'" *Popular Photography* 58, 5(May 1966): 58+

524. Dixon, Daniel. "Dorothea Lange," *Modern Photography* 16 (December 1952): 68-77, 138-41.

525. *Dorothea Lange: Photographs of Lifetime*. Essay by Robert Coles, Afterword by Therese Heyman. Millerton, NY: Aperture, 1982. 183 p. Includes chronology and bibliography: p. 180-182.
 This is a comprehensive collection of Lange's photographic images, from the early portraits to the photographs she took as she traveled in her later years. Coles' biographical essay explores Lange's methods and accomplishments. Lange's own observations accompany the photographs.
Hopi Indian, New Mexico, c. 1923, p. 2; *Mrs. Kahn, San Francisco*, 1931, p. 11; *Katten Portrait, San Francisco*, 1934, p. 11; *Ethel Benedict*, 1916, p. 12; *Workers Unite, San Francisco*, 1934, p. 14; *San Francisco*, 1934, p. 14; *Howard Street, San Francisco*, 1934, p. 15; *Migratory Worker's Kitchen near Shafter, California*, Nov. 1936, p. 18; *Family near Sacramento*, May 1935, p. 18; *North Beach District, San Francisco*, 1936, p. 19; *Lunchtime for Peach Pickers, Musella, Georgia*, 1936, p. 19; *Migrant Mother, Nipomo, California*, 1936, p. 20-21; *Waiting for Relief Checks, Calipatria, California*, 1937, p. 22; *Rural Oklahoma*, 1938, p. 22; *Tenant Farmers, Hardeman County, Texas*, June 1937, p. 23; *Ex-tenant Farmer on Relief Grant, Imperial Valley, California*, 1937, p. 24; *Family on the Road, Oklahoma*, 1938, p. 25; *Farmers at Tobacco Auction, Douglas, Georgia*, 1938, p. 25; *FSA Loan Recipient, Malheur County, Oregon*, 1938, p. 28; *Elm Grove, Oklahoma*, c. 1938, p. 28; *Revival Meeting in a Garage, Dos Palos, CA*, 1938, p. 29; *Shacktown, Elm Grove, OK*, 1936, p. 29; *Crossroads Store, Rural Georgia*, 1938, p. 30; *Plantation Worker, Memphis, TN*, 1938, p. 30; *Tobacco Sharecropper, Southern Georgia*, 1938, p. 31; *Tucks' Filling Station, Route 501, Person County, NC*, 1939, p. 32; *Corner of Tobacco Farmer's Front Room, Person County, NC*, 1939, p. 33; *Outside FSA Grant Office, Calipatria, CA*, 1939, p. 33; *Gunlock County, UT*, 1953, p. 34; *Amana Society, Iowa*, 1941, p. 36; *Judge Fox, Oakland, CA*, 1957, p. 37; *At Steep Ravine*, Spring 1961, p. 38; *Paul Taylor and Poulie, Steep Ravine*, Spring 1961, p. 38; *Dyanna Taylor, Steep Ravine*, Spring 1961, p. 39; *White Angel Bread Line, San Francisco*, 1932, p. 45; *The General Strike, San Francisco*, 1934, p. 47; *Demonstration, San Francisco*, 1934, p. 48-49; *Man Beside Wheelbarrow, San Francisco*, 1934, p. 50; *Unemployed Men on Howard Street, San Francisco*, 1937, p. 51; *May Day Listener, San Francisco*, 1934, p. 53; *Salvation Army, San*

Francisco, 1939, p. 54; *Funeral Cortege, End of an Era in a Small Valley Town, CA*, 1938, p. 55; *Hop Harvesting, Wheatland, CA*, 1935, p. 57-59; *Family on the Road, Midwest*, c. 1938, p. 60; *Three Generations of Texans*, 1935, p. 61; *Oklahoma Drought Refugees*, 1935, p. 62; *Ditched, Stalled, and Stranded, San Joaquin Valley, CA*, 1935, p .63; *Housing for Migrant Workers, Coachella Valley, CA*, 1935, p. 64; *Dairy Co-op Officials*, 1935, p.,65; *Back, 1938*, p. 66-67; *Jobless on Edge of Pea Field, Imperial Valley, CA*, 1937, p. 69; *Carrot Fieldworkers, probably the San Joaquin Valley*, c. 1935, p. 70; *Filipinos Cutting Lettuce, Salinas, CA*, 1935, p. 70; *Hoe Cutter, near Anniston, AL*, 1936, p. 71; *Drought Refugees from Oklahoma, Blythe, CA*, 1936, p. 73; *Texas Panhandle*, 1938, p. 74; *The Sheriff of McAlester, Oklahoma, in Front of the Jail*, 1936, p. 75; *Migrant Mother, Nipomo, California*, 1936, p. 77; *FSA Rehabilitation Clients. Near Wapato, Yakima Valley, Washington*, 1939, p. 78; *Alabama Farm*, c. 1938, p. 79; *Woman of the High Plains, Texas Panhandle*, 1938, p. 80; *Damaged Child, Shacktown, Elm Grove, Oklahoma*, 1936, p. 81; *Drought Farmers, Sallisaw, Sequoyah, Oklahoma*, 1936, p. 82; *Tractored Out, Childress County, Texas*, 1938, p. 83; *Plantation Overseer and His Field Hands, near Clarksdale, Mississippi*, 1936, p. 85; *Alabama Farm*, c. 1938, p. 86; *Crossroads Store, Alabama*, 1937, p. 87; *Turpentine Dippers, Georgia*, 1937, p. 88; *By the Chinaberry Tree, near Tipton, Georgia*, 1938, p. 89; *Waterboy, Mississippi Delta*, 1938, p. 90; *Greenville, Mississippi*, 1938, p. 91; *Near Eutaw, Alabama*, 1936, p. 92; *Ex-Slave with a Long Memory*, 1937, p. 92-93; *Family Farmstead Nebraska*, 1940 p. 95; *Rural Rehabilitation Client, Tulare County, California*, 1938 p. 96; *Church on the Great Plains, South Dakota*, c. 1938 p. 97; *Gunlock County, Utah*, 1953, p. 98; *South Dakota*, 1939, p. 99; *One-Room School, Baker County, Oregon*, 1939, p. 100; *Ma Burnham, Conway, Arkansas*, 1938, p. 101; *Hands, Maynard and Dan Dixon*, c. 1930, p. 102; *Woman of the High Plains, Texas Panhandle*, 1938, p. 103; *Rebecca Dixon, Sausalito, California*, 1954, p. 105; *Abandoned Farm, near Dalhart, Texas*, 1938, p. 106; *Grain Elevator, Everett, Texas*, 1938, p. 107; *Homeless Family, Oklahoma*, 1938, p. 109; *J.R. Butler, President of the Southern Tenant Farmers' Union, Memphis, Tennessee*, 1938, p. 110; *Grayson, San Joaquin Valley, California*, 1938, p. 111; *Mexican Migrant Fieldworker, Imperial Valley, California*, 1937, p. 112; *The Road West, New Mexico*, 1938, p. 113; *Ball Game, Migrant Camp, Shafter, California*, 1938, p. 114; *Kern County, California*, 1938, p. 115; *Pea-Pickers' Tent, near Calipatria, California*, 1938, p. 116; *Mother and Children, on the Road, Tulelake, Siskiyou County, California*, 1939, p. 117; *Jake Jones's Hands, Gunlock County, Utah*, 1953, p. 118; *Riverbank Gas Station*, c. 1940, p. 119; *Tenant Farmers without Farms, Hardman County, Texas*, 1937, p. 120-121; *Migratory Cotton Picker, Eloy, Arizona*, 1940, p. 122; *On the Great Plains, near Winner, South Dakota*, 1938, p. 123; *San Francisco, California*, 1939, p. 125; *Shipyard Construction Workers, Richmond, California*, 1942, p. 126; *Shipyard Worker, Richmond, California*, 1942, p. 127; *End of Shift, Richmond, California*, 1942, p. 128; *Argument on Trailer Court*, 1944, p. 129; *New York City*, 1952, p. 130; *Walking Wounded, Oakland, California*, 1954, p. 131; *Pledge of Allegiance at Rafael Weill Elementary School a Few Weeks Prior to Evacuation, San Francisco,*

1942, p. 133; *Toquerville, Utah,* 1953, p. 134, 140; *Gothic Doorway, Toquerville, Utah,* 1953, p. 135; *Café near Pinhole, California,* 1956, p. 136; *U.S. Highway 40, California,* 1956, p. 137; *Woman from Berryessa Valley, California, Memorial Day,* 1956, p. 139; *Berryessa Valley, California,* 1956, p. 141; *Country Road, County Clare, Ireland,* 1954, p. 143; *Irish Child, County Clare, Ireland,* 1954, p. 144; *Ireland,* 1954, p. 145, 147; *Boy in Landscape, Ireland,* 1954, p. 146; *Black Maria, Oakland,* c. 1955-57, p. 148; *Public Defender in Court, Oakland, California,* 1957, p. 149; *The Defendant, Alameda County Courthouse, California,* c. 1955-57, p. 150; *Public Defender, Alameda County Courthouse, California,* c. 1955-57, p. 151; *Andrew, Berkeley,* 1959, p. 153; *John and Helen, Berkeley,* 1952, p. 154; *First Born, Berkeley,* 1952, p. 155; *Winter, California,* 1955, p. 156; *Bad Trouble over the Weekend,* 1964, p. 157; *Paul's Birthday, Berkeley,* 1957, p. 158; *Gunlock, Utah,* 1953, p. 159; *Nile Village, Egypt,* 1963, p. 160; *Egypt,* 1963, p. 161; *Pathan Warrior Tribesman, Khyber Pass,* 1958, p. 162; *Nepal,* 1958, p. 163; *Nile Delta, Egypt,* 1963, p. 164; *Egyptian Village,* 1963, p. 165; *Hand, Indonesian Dancer, Java,* 1958, p. 166; *Korean Child,* 1958, p. 167; *Berkeley,* 1957, p. 168; *Under the Trees,* 1959, p. 169; *San Francisco,* 1956, p. 173.

526. *Dorothea Lange: A Visual Life.* Videorecording. Valley Ford, CA: Pacific Pictures, 1994. 46 minutes.
"Brings to life five decades of American history with photographs and insights by Dorothea Lange, revealing her passion for her work and her commitment to record the rapidly changing face of the 20th century." oclc

527. Gelber, S. M. "The Eye of the Beholder, Images of California by Dorothea Lange and Russell Lee," *California History* 64, 4 (1985): 264-271.

528. Goldberg, Vicki, "Six Stories That Made a Difference," *American Photo* 2 (September/October 1991): 80-88.

529. Goldsmith, Arthur. "A Harvest of Truth," *Infinity* 15, 3 (March 1966): 22-30.

530. Green, Philip, and Robert Katz. *Dorothea Lange, Part One: Under the Trees,* and *Part Two: The Closer For Me.* KQED Film Unit Production: June 1965. 16mm b/w, sound, 30 minutes each part.

531. Herz, Nat. "Dorothea Lange in Perspective: A Reappraisal of the Farm Security Administration and an Interview," *Infinity,* 12 (April 1963): 5-11.

532. Heyman, Therese Thau. *Celebrating a Collection--The Work of Dorothea Lange.* With contributions by Daniel Dixon, Joyce Minick and Paul Schuster Taylor. Oakland, CA: The Oakland Museum, 1978. 97 p.
Includes a "Guide to the Dorothea Lange Collection - Contact Sheets, Study Prints, Microfilms, Lange's Manuscripts and Projects, Journals and

Correspondence, Interviews, Unpublished Studies on Dorothea Lange." and a Selected Bibliography. The Oakland Museum's collection of over 40,000 original negatives, prints and memorabilia of Lange's allowed for the development of the exhibition on which this catalog was based. The essays discuss her focus on the family, the photographs of the early years, 1895-1935 and a survey of the later years from 1934 to 1965. Photographs are arranged by theme and are accompanied by short essays.

Wallen Portrait, San Francisco, 1930, p. 21; *Roger Sturtevant Portrait, San Francisco,* c. 1931, p. 22; *P. Wallen Portrait, San Francisco,* 1930, p. 23; *Raentsh Portrait, San Francisco,* 1932, p. 24; *Southwest,* c. 1930, p. 25; *Mended Stockings, San Francisco,* 1934, p. 26; *Man Beside Wheelbarrow, San Francisco,* 1934, p. 27; *Three Generations of Texans,* 1935, p. 28; *Imperial Valley, California,* 1935, p. 29; *Old Man at Night, Alabama,* 1938, p. 30; *Field Laborers, Coachella, California,* 1935, p. 31; *Oklahoma Drought Refugees,* 1935, p. 32; *Bound for California, Oklahoma,* 1938, p. 33; *Paul's 62nd Birthday, Berkeley,* 1957, p. 34; *Amana Society, Iowa,* 1941, p. 35; *Ruby From Arkansas,* 1935, p. 36; *Asparagus Workers, California,* 1940, p. 37; *Egypt,* 1963, p. 38; *Trees, Berkeley,* 1957, p. 39; *Homeless Family, Oklahoma,* 1938, p. 41; *Workers Talking, San Francisco,* 1934, p. 44; *Crossroads Store, Georgia,* 1938, p. 44; *North Texas,* 1937, p. 44; *Kahn Portrait, San Francisco,* 1931, p. 45; *Roi Partridge, San Francisco,* 1925, p. 45; *Salz Portrait, San Francisco,* c. 1932, p. 45; *Goldberg Portrait, San Francisco,* 1930, p. 46; *McCullough Portrait, San Francisco,* 1930, p. 46; *Katten Portrait, San Francisco,* 1934, p. 46; *Plantation Worker, Memphis, Tennessee,* 1938, p. 47; *May Day Listener, San Francisco,* 1934, p. 47; *Migrant Cotton Picker, Eloy, Arizona,* 1940, p. 47; *Katten Portrait, San Francisco,* c. 1927, p. 48; *Maynard Dixon at His Easel,* c. 1920, p. 48; *Mother's Day, Daisies,* 1934, p. 48; *Ross Taylor, Driven and Angry,* 1935, p. 49; *Hands, Maynard and Dan Dixon,* c. 1930, p. 49; *Southwest,* c. 1930, p. 51; *Crowd, San Francisco,* 1934, p. 51; *The General Strike (Policeman) San Francisco,* 1934, p. 51; *Maynard Dixon in the Southwest,* c. 1922, p. 52; *Clausen Portrait, San Francisco,* 1932, p. 53; *Tacchella Portrait, San Francisco,* 1934, p. 53; *Haas Brothers Portrait, San Francisco,* 1929, p. 53; *Mrs. Kahn and Child, San Francisco,* 1928, p. 54; *M. Schindlerm, Portrait, San Francisco,* 1935, p. 54; *L. Woodian Portrait, San Francisco,* 1934, p. 54; *"Workers Unite," Survey Graphic, San Francisco,* 1934, p. 56; *First Food Line Distribution, San Francisco,* 1933, p. 56; *Howard Street, San Francisco,* 1934, p. 57; *White Angel Breadline, San Francisco,* 1933, p. 57; *Woman at Microphone, San Francisco,* 1934, p. 58; *Demonstration Signs, San Francisco,* 1934, p. 58; *San Francisco, California,* 1934, p. 58; *Streetcar Faces, San Francisco,* 1934, p. 58; *Pea Contractor, Nipomo, California,* 1935, p. 58; *Melon Fields, Nipomo, California,* 1935, p. 58; *Migrant Mother (1), Nipomo, California,* 1936, p. 60; *Migrant Mother (2), Nipomo, California,* 1936, p. 60; *Migrant Mother (3), Nipomo, California,* 1936, p. 60; *Migrant Mother (4), Nipomo, California,* 1936, p. 61; *Unemployed Exchange Association (UXA) Oroville, California,* 1934, p. 63; *Melon Field Workers, California,* c. 1938, p. 63; *L. Heyneman Portrait, San Francisco,* 1929, p. 64; *Clayburgh Children Portrait, San Francisco,* 1924, p. 64; *Woman and Child,*

Oklahoma, 1938, p. 65; *Drought Refugees, Near Shafter, California,* 1935, p. 65; *Child in Pea Pickers' Camp, Near Stockton, California,* 1935, p. 66; *Housing for Migrant Workers, Coachella Valley, California,* 1935, p. 66; *Apricot Pickers' Camp, Yuba County, California,* 1935, p. 67; *Hop Harvesting, Wheatland, California,* 1935, p. 67; *Drought Refugee, Near Marysville, California,* 1935, p. 68; *San Joaquin Valley, California,* 1935, p. 68; *Family on the Road, Oklahoma,* 1938, p. 69; *Drought Refugee Family, Imperial Valley, California,* 1935, p. 69; *Plantation Workers, Alabama,* 1938, p. 70; *Killing Time, Mississippi,* 1938, p. 70; *Relief, Arvin, California,* 1940, p. 71; *Kids on Roof, Arkansas,* 1938, p. 71; *Coachella Valley, California,* 1935, p. 71, 74; *Porch, South Dakota,* 1941, p. 72; *Dairy Co-op Officials,* 1935, p. 72; *Loaded Cart, Oklahoma,* 1938, p. 72; *Unemployed Exchange Association, Oroville, California,* 1934, p. 73; *Campaign Sign, Elm Grove, Oklahoma,* 1938, p. 73; *Tomato Picker, Coachella Valley, California,* 1935, p. 73; *Bindlestiff Near Yuma, Arizona,* 1935, p. 74; *Man Selling Call-Bulletin, San Francisco,* 1934, p. 75; *Cottage Gardens, Self-help Housing Project, San Bernardino, California,* 1935, p. 75; *Carrying, Mississippi,* 1938, p. 75; *Payday, Richmond, California,* 1942, p. 75; *On the Ferry,* 1943, p. 76; *Moviegoers in Wartime Boom Town, Richmond, California,* , 1942, p. 76; *Sunday in Summer, Toquerville, Utah,* 1953, p. 76; *Drawing in Dirt, Shafter Camp, California,* 1938, p. 77; *Man With Cap, California,* 1934, p. 77; *Librarian, Mississippi,* 1938, p. 77; *Grapes of Wrath, Billboard, California,* 1940, p. 78; *Tom Collins and Migrant Family, Shafter, California,* 1935, p. 78; *Near Winters, California,* 1935, p. 78; *Cotton Pickers, San Joaquin Valley, California,* 1937, p. 79; *Mexican Frontier, Corpus Christi, Texas,* 1938, p. 79; *Drought Refugees, Near Marysville, California,* 1935, p. 80; *Woman of the High Plains, Texas Panhandle,* 1938, p. 80; *Pickers and Cotton Wagon Near Corcoran, California,* 1937, p. 81; *On U.S. 80 Near El Paso, Texas,* 1938, p. 81; *Judge Fox, Oakland, California,* 1957, p. 82; *Attorney Interviews His Client, Oakland, California,* 1957, p. 82; *Defendant's Wife, Oakland, California,* 1957, p. 82; *Public Defender in Court, Oakland, California,* 1957, p. 83; *Public Defender, Alameda County Courthouse, California,* 1957, p. 83; *Officer's Badge, Oakland, California,* 1957, p. 83; *Kern County, California,* 1937?, p. 84; *Funeral Cortege, End of An Era in Small Valley Town,* 1938, p. 84; *Potato Camp, Edison, California,* 1938, p. 84; *Kern County, California, Small independent gas station during the cotton strike,* 1938, p. 85; *Pea Picker, Imperial County, California,* c. 1938, p. 85; *Greene County, Georgia, Couple born in slavery on an abandoned 28-family plantation,* 1937, p. 85; *Two Women, Nepal,* 1958, p. 86; *Women Carrying Jugs, Egypt,* 1963, p. 86; *Slippers, Korea,* 1958, p. 86; *Boy in Landscape, Ireland,* 1954, p. 87; *Children, Korea,* 1958, p. 87; *Couple With Cow, Ireland,* 1954, p. 87; *Sign, Oakland, California,* 1950, p. 88; *Chinatown, Sand Francisco,* 1945, p. 88; *Consumers, Powell and Market Streets, San Francisco,* 1950, p. 88; *Cafe, Richmond, California,* 1942, p. 89; *Cable Car, San Francisco,* 1956, p. 89; *Ship Scalers Union Meeting, San Francisco,* 1946, p. 89.

533. Heyman, Therese Thau. "Looking at Lange Today," *Exposure: The*

Journal of the Society of Photographic Education 16, 2 (Summer 1978): 26-33.

534. Heyman, Therese Thau and Joyce Minick. "Dorothea Lange: Witness and Recorder of the Great Age of Reform," *American Photographer* 2, 2 (February 1979): 44-56.

535. Krim, Arthur. "Mother Road, Migrant Road: Dorothea Lange on U.S. 66." (from Tour 10, in Colorado: a guide to the highest state, compiled by the Workers of the Writers' Program of the Works Project Administration (sic) in the State of Colorado; book excerpt) *Landscape* 31, 2 (1992): 16-18.

536. Lange, Dorothea. "The American Farm Woman," *Harvester World* 51, 11 (November 1960): 2-9.

537. Lange, Dorothea. *Dorothea Lange.* Essay by Christopher Cox. Millerton, NY: Aperture, 1981. 96 p. Bibliography: p. 96. Brief Chronology.
 Short essay that examines the influences on Lange's life and photographic career and a discussion of the subjects she chose to photograph.
Family Farmstead, Nebraska, 1940, cover; *Tractored Out, Childress County, Texas,* 1938, frontispiece; *White Angel Breadline, San Francisco, California,* 1933, p. 13; *General Strike, San Francisco, California,* 1934, p. 15; *May Day Listener, San Francisco, California,* 1934, p. 17; *Ball Game, Migrant Camp, Shatter, California,* 1938, p. 19; *Child and Her Mother, Wapato, Yakima Valley, Washington,* 1939, p. 21; *California,* 1937, p. 23; *Grain Elevator, Everett, Texas,* 1938, p. 25; *Family Farmstead, Nebraska,* 1940, p. 27; *Waiting for Relief Checks, Calipatria, California,* 1937, p. 29, 31; *Newspaper Stand, San Francisco, California,* 1939, p. 33; *Drought Refugees Hoping For Cotton Work, Blthye, California,* 1936, p. 35; *Hoe Cutter, Near Anniston, Alabama,* 1936, p. 37; *Migrant Mother, Nipomo, California,* 1936, p. 39; *Woman Called "Queen," North Carolina,* 1939, p. 41; *Abandoned Farm Near Dalhart, Texas,* 1938, p. 43; *Wife of Migrant Laborer, Near Childress, Texas,* 1938, p. 45; *Resident, Conway, Arkansas,* 1938, p. 47; *Six Tenant Farmers Without Farms, Hardeman County, Texas,* 1938, p. 49; *Church On the Great Plains, South Dakota,* c. 1938, p. 51; *One-Room School, Baker County, Oregon,* 1939, p. 53; *Spring Plowing, Cauliflower Fields, Guadalupe, California,* 1937, p. 55; *Damaged Child, Shacktown, Elm Grove, Oklahoma,* 1936, p. 57; *Filipinos Cutting Lettuce Salinas, California,* 1935, p. 59; *Migrant Field Worker, Cotton Strike Leader, Kern County, California,* 1938, p. 61; *Holtville, California,* 1937, p. 63; *Migrant Road, U.S. 54 Near El Paso, Texas,* 1938, p. 65; *Farm Security Administration Migrant Camp, Gridley, California,* 1939, p. 67; *Young Girl, Cotton Picker, Arizona,* 1941, p. 69; *Ditched, Stalled, and Stranded, San Joaquin Valley, California,* 1935, p. 71; *Waiting for Relief Checks, Calipatria, California,* 1937, p. 73; *Drought Farmers,* 1936, p. 75; *Kern County, California,* 1938, p. 77; *Dairy Co-op Officials,* 1935, p. 79; *On The Great Plains,*

Near Winner, South Dakota, 1938, p. 81; *Oak, Berkeley, California*, 1957, p. 83; *Procession Bearing Food To the Dead, Upper Egypt*, 1963, p. 85; *Indonesian Dancer, Java*, 1958, p. 87; *Couple With Cow, Ireland*, 1954, p. 89; *Funeral Cortège, End of an Era In a Small Valley Town, California*, 1938, p. 91; *Walking Wounded, Oakland, California*, 1954, p. 93.

538. Lange, Dorothea. *Dorothea Lange: A Visual Life*. Edited by Elizabeth Partridge. Washington, D.C.: Smithsonian Institution Press, 1994. 168 p. Essays included: "A Woman of Our Generation," by Linda A. Morris; "Paul and Dorothea," by Clark Kerr; "Dorothea Lange and the War Relocation Authority: Photographing Japanese Americans," by Roger Daniels; "Peculiar Grace: Dorothea Lange and the Testimony of the Body," by Sally Stein; "Ansel Adams Remembers Dorothea Lange: An Interview" by Therese Heyman; "Afterword," by Daniel Dixon and a section of photographs, "Dorothea Lange: Her Words and Images."

Migrant Agricultural Works in Marysville, California, Migrant Camp Trying to Figure Out His Year's Earnings, October 1935, Back cover, fig. 5.6; *"You Ain't Looking Fer Money Is You?"* July 4, 1939, Opposite Contents; *Mormon Mother*, 1953, fig. 2.1; *Mormon Mother's Road*, 1953, fig. 2.2; *Dave Tatsumo*, 1942, fig. 2.3; *The Public Defender, Alameda County Courthouse*, 1954, fig. 2.4; *Woman from Berrysea Valley, California, Memorial Day*, 1956, fig. 2.5; *Cemetery, Berryessa Valley, California*, 1956, fig. 2.6; *Open Graves, Berryessa Valley, California*, 1956, fig. 2.7; *Unemployed Exchange Association, Oroville, California*, 1934, fig. 3.3; *Loading Cotton, California*, 1936, fig. 3.4; *Some of the First Group of Japanese Americans to be Evacuated from San Francisco Waiting...for buses*, April 6, 1942, fig. 4.1; *Issei Mother*, May 8, 1942, fig. 4.2; *A Sharecropper's Cabin, Coahoma County, Mississippi*, 1937, fig. 5.1; *A Park in the Downtown Area, Jacksonville, Florida*, July 1936, fig. 5.3; *Campaign Posters in Garage Window, Just Before Primary, Waco, Texas*, June 1938, fig. 5.4; *Windshield of a Migratory Agricultural Laborer's Car, in a Squatter's Camp near Sacramento*, November 1936, fig. 5.5; *Waiting for the Semimonthly Relief Check at Calipatria, Imperial Valley, California*, 1937, fig. 5.7; From *An American Exodus*, 1939, fig. 5.8, 5.9, 5.10; *Watching a Ball Game, Shafter Migrant Camp, California*, June 1938, fig. 5.11; *The Son of a Tenant Farmer Hanging Up Strung Tobacco inside the Barn, Granville, North Carolina*, July 1939, fig. 5.12; *Sharecropper Resting on the Porch after Tobacco Harvest*, July 1938, fig. 5.13; *Migratory Cotton Picker, Eloy, Arizona*, 1940, fig. 5.14; *Woman of the High Plains, Texas Panhandle*, 1938, fig. 5.15; *Torso, San Francisco*, 1923, fig. 6.2; *My Mother, the "Wiz,"* 1920s, fig. 6.3; *Gertrude Clausen Holding Nancy*, 1932, fig. 6.4; *Roi Partridge, San Francisco*, 1925, fig. 6.5; *Maynard Dixon on Wall*, 1920s, fig. 6.6; *Maynard and Son*, 1920s, fig. 6.7; *Hopis on Trail to Plaza*, 1920s, fig. 6.8; *Woman and Chickens, Taos, New Mexico*, 1931, fig. 6.7; *Southwest*, 1920s, fig. 6.10; *Navaho Mother and Child*, 1931, fig. 6.11; *Waiting for Semimonthly Relief Check, Imperial Valley, California*, 1937, fig. 6.12; *White Angel Breadline, San Francisco, California*, 1933, fig. 6.13; *Mexican Grandmother Harvesting Tomatoes, California*, 1938, fig.

6.14; *Field Worker's Home by a Frozen Pea Field, California*, 1937, fig. 6.15; *Migrant Mother, Nipomo, California*, 1936, fig. 6.16; *Looking for Work in the Pea Field, California*, 1936, fig. 6.17; *Planting Cantaloupe, Imperial Valley, California*, 1937, fig. 6.18; *Bindlestiff, Napa Valley, California*, 1938, fig. 6.19; *Undernourished Cotton Picker's Child, Kern County, California*, 1938, fig. 6.20; *Fifty-Seven-Year-Old Sharecropper Women, Mississippi*, 1937, fig. 6.21; *Man on Farm-All Tractor, Childress County, Texas*, 1938, fig. 6.22; *Never Been Out of Mississippi*, 1936, fig. 6.23; *Cafe, Richmond, California*, 1942, fig. 6.24; *End of the Shift, Richmond Shipyards*, 1943, fig. 6.25; *Richmond, California*, 1942, fig. 6.26; *One Nation Indivisible, San Francisco*, 1942, fig. 6.27; *Manzanar Relocation Center*, 1942, fig. 6.28; *Grandfather and Grandson, Manzanar*, 1942, fig. 6.29; *Man with Sledgehammer*, 1951, fig. 6.30; *Pickets on Market Street, Western Union Telegraphers Strike*, May 1952, fig. 6.31; *Church Service, Toquerville, Utah*, 1953, fig. 6.32; *Gunlock, Utah*, 1953, fig. 6.33; *Hands, Two Boys and Grandfather, Ireland, detail*, 1954, fig. 6.34; *Cattle Day in Ennistymon Market, Ireland*, 1954, fig. 6.35; *Patrick Flanagan Selling Sheep, Ireland, detail*, 1954, fig. 6.36; *Irish Child*, 1954, fig. 6.37; *Egyptian Shepherd Boy*, 1963, fig. 6.38; *Palestinian Child*, 1958, fig. 6.39; *Korea*, 1958, fig. 6.40; *Vietnamese Mother and Child*, 1958, fig. 6.41; *Egyptian Village*, 1963, fig. 6.42; *Egyptian Woman in Doorway*, 1963, fig. 6.43; *Veiled Women*, c. 1963, fig. 6.44; *Pathan Warrior Tribesman, Khyber Pass*, 1958, fig. 6.45; *Egyptian Farmer*, 1963, fig. 6.46; *Procession Bearing Food to the Dead, Upper Egypt*, 1963, fig. 6.47; *Woman on Stairs, Indonesia, detail*, 1958, fig. 6.48; *Friend and Neighbor*, 1944, fig. 6.49; *Gregor Running to the Park*, 1955, fig. 6.50; *The Kitchen Sink Corner*, Summer 1957, fig. 6.51; *Andrew at Steep Ravine*, 1957, fig. 6.52; *Paul Carrying Lisa*, 1962, fig. 6.53; *Bad Trouble over the Weekend*, 1964, fig. 6.54; *Andrew, Berkeley*, 1957, fig. 6.55; *Paul, Briefcase, and Umbrella*, 1957, fig. 6.56; *Trees, Berkeley*, 1957, fig. 6.57.

539. Lange, Dorothea. *Dorothea Lange: Farm Security Administration Photographs, 1935-39, Vol. I. and II*. Howard M. Levin and Katherine Northrup, ed. Glencoe, IL: The Text-Fiche Press, 1980.

540. Lange, Dorothea and Paul Schuster Taylor. *An American Exodus*. New York: Reynal & Hitchcock, 1939; Revised ed. New Haven; Yale University Press, 1969. Reprint ed., New York: Arno Press, 1975. 147 p. Essay by Taylor called "Focus" looks at the original publication of 1939 and the continuing social injustice and flow of "human tide" into the cities, some thirty years later. Also included is the original essay by Lange and Taylor that prefaced the photographs. An essay introduces each section of photographs, and this edition includes additional quotes and notes taken down in the fields.

U.S. 54 in Southern New Mexico, frontispiece; *The empire of cotton stretches across the South from the Atlantic to the Pacific.*, p. 19; *Hoe culture, Alabama*, 1937, p. 20; *"The South is poor, the land is poor...." Alabama*, 1937, p. 21; *"Hit's a hard git-by...." Macon County, Georgia*, 1937, p. 21; *Migratory cotton picker*

paid 75 cents per 100 pounds, San Joaquin Valley, California, 1938, p. 22; *Couple born in slavery, on an abandoned twenty-eight-family plantation, Greene County, Georgia,* 1937, p. 23; *"The Committee's examination of the agricultural ladder...."* *Georgia,* 1937, 24; *"The Collapse of the plantation system...." Georgia,* 1937, p. 25; *The Delta is the most concentrated cotton-growing section of the deep South, Pulaski County in the Arkansas Bottoms,* 1938, p. 31; *Cotton workers, swept from the land, fill the towns, Memphis, Tennessee,* 1937, p. 34; *At the bridgehead, 5 A.M., bound for a day's work on the Arkansas Delta, Memphis, Tennessee,* 1937, p. 34; *"They come off the plantations 'cause they ain't go nothin' to do...." Memphis, Tennessee,* 1938, p. 35; *"Right smart empty houses on that place...." Mississippi Delta,* 1937, p. 35; *Hoers going back to work after lunch on a Delta plantation, Mississippi,* 1937, p. 36; *"The country's in an uproar now--its in bad shape." on U.S. 80 near El Paso, Texas,* 1938, p. 37; *"I know about fifteen families from Senath that's gone to California." southeast Missouri,* 1938, p. 38; *One man and 4-row cultivator do the work of 8 men and 8 mules" Mississippi Delta,* 1937, p. 39; *"If you see my grandsons in California tell 'em you met up with Ma Burnham of Conway, Arkansas."* 1938, p. 45; *There are many small cotton farms in eastern Oklahoma, on U.S. 62, Oklahoma,* 1938, p. 46; *"There's lots of ways to break a man down." Oklahoma,* 1938, p. 46; *On forty acres of Black Jack and Post Oak, near Henryetta, eastern Oklahoma,* 1938, p. 47; *"We're bound for Kingfisher, Oklahoma, to work in the wheat..." family with seven children from Paris, Arkansas, on the highway near Webber Falls,* 1938, p. 48; *Supper time on Highway 1, Oklahoma,* 1936, p. 49; *"We started from Joplin, Missouri, with $5." Oklahoma,* 1938, p. 50; *"I'm going where the climate fits my clothes." Oklahoma,* 1938, p. 51; *Returning from California, Canadian County, Oklahoma,* 1938, p. 52; *"Whole families go to Los Angeles..." Muskogee County, Oklahoma,* 1938, p. 53; *Agricultural depression, years of drought, de-population, Caddo, Oklahoma,* 1938, p. 54; *Stricken farmers, idle in town during the great drought, Sallisaw, Oklahoma,* 1936, p. 54; *Homeless family...walk from county to county in search of the meager security of relief, Oklahoma,* 1938, p. 55; *With four- and six-mule teams drawing two row outfits..., Texas,* 1939, p. 61; *"The chief advantage of a tractor..." Childress County, Texas,* 1938, p. 62; *The treeless landscape is strewn with empty houses, near Olustee, southwestern Oklahoma,* 1938, p. 63; *Tractors replace not only mules, but people, Childress County, Texas,* 1938, p. 64; *All displaced tenant farmers, North Texas,* 1937, p. 66; *Farmed all his life, Hardeman County, Texas,* 1938, p. 67; *"The whole works of us is in it right now." southwestern Oklahoma,* 1938, p. 68; *"I let 'em all go." Texas,* 1937, p. 68; *"After that I don't know, I've got to make a move..." Texas Plains,* 1938, p. 69; *"They turned the land loose when they left." Coldwater, Texas,* 1938, p. 75; *Grain elevators, barbed wire, and gang plows on the high plains, Everett, Texas,* 1938, p. 76; *"Section after section dried up and blowed away." Dallam County, Texas,* 1937, p. 77; *"It's made good one time." Coldwater district, Texas,* 1938, p. 78; *"Every dime I've got is tied up right here...." Goldwater district, Texas,* 1938, p. 79; *"No, I didn't <u>sell</u> out back there. I <u>give</u> out." Cimarron County, Oklahoma, Panhandle,* 1938, p. 79; *Coldwater District, Dalhart, Texas,* 1937, p. 80; *"If you die, you're dead--that's*

all." Texas Panhandle, 1938, p. 81; *Three families, fourteen children on U.S. 99, San Joaquin Valley, California,* 1939, p. 87; *Tenant farmer from Cook County, Texas, squatting in the brush with six children, Wasco California,* 1938, p. 88; *Oklahoma family entering California on U.S. 99 through the desert, California,* 1937, p. 88; *Entered California the night before, and encamped along U.S. 80 near Holtville, Imperial Valley, California,* 1939, p. 89; *Pick peas for a cent a pound, twenty-eight pounds to the hamper, near Niland, California,* 1939, p. 90; *"A machine to tie the carrots?" Imperial Valley, California,* 1939, p. 91; *Gang labor and piece rates in an open-air food factory, near Calipatria, California,* 1939, p. 91; *Migrants in an agricultural labor contractor's camp, Nipomo, California,* 1936, p. 92; *Squatter camp on outskirts of Holtville, Imperial Valley, California,* 1937, p. 92; *One hundred fifty families in squatter camp on the flats at the potato sheds, Edison, California,* 1938, p. 92; *Auto camp tent space, water, and electric light--$1 a week, Tulare County, California,* 1938, p. 93; *Waiting for work on the edge of the pea fields. Holtville, California,* 1937, p. 94; *Auto camp cabins $4 a week...., Kern County, California,* 1937, p. 95; *No work, Calipatria, California,* 1937, p. 96; *The relief load at the paymaster's window rose from 188 families...., Calipatria, California,* 1937, p. 97; *Bound for Nipomo, California,* 1936, p. 98; *Hungry boy, Shafter, California,* 1938, p. 99; *Oklahoma child with cotton sack ready to go into field with parents at 7 A.M., Kern County, California,* 1936, p. 99; *"I want to go bak where we can live...." Brawley, California,* 1939, p. 100; *Farmer who left Nebraska, Calipatria, California,* 1939, p. 101; *Cotton farm near Corcoran, California,* 1937, p. 102; *Industrialized agriculture, Salinas, California,* 1939, p. 103; *Gang of Filipino lettuce cutters, Salinas, California,* 1935, p. 103; *Intensive, large-scale, and highly seasonal agriculture...., near Westley, California,* 1938, p. 104; *Company housing on a large potato and cotton ranch, southern San Joaquin Valley, California,* 1938, p. 105; *Small independent gas station during cotton strike, Kern County, California,* 1938, p. 106; *Kern County, California,* 1938, p. 107; *On the city dump, Bakersfield, California,* 1935, p. 109; *Thirteen million unemployed fill the cities in the early thirties, San Francisco,* 1934, p. 117; *New Deal--line-up for social security payments to employed; San Francisco,* 1936, p. 118; *First defense--then war, Oakland, California,* 1942, p. 119; *Work for all-- now--regardless of sex or race, Richmond, California,* 1942, p. 120; *Love and..., Richmond, California,* 1942, p. 121; *...hate, Richmond, California,* 1944, p. 121; *City in transition, Oakland, California,* 1942; *Aspiration--to join the suburban sprawl, Pleasanton, California,* 1945, p. 123; *Urban syndrome? U.S. 40, California,* 1956, p. 124; *Urban syndrome. Emeryville, California,* 1955, p. 125; *Bright lights in the city, Richmond, California,* 1942, p. 126; *Free-wheeling, Oakland, California,* 1951, p. 126; *End of the shift--whither? Richmond, California,* 1942, p. 127; *Loneliness of the crowd, Pinole, California,* 1956, p. 128; *Resurrection of hope, Oakland, California,* 1940, p. 128; *Women in crowd,* p. 129.

541. Lange, Dorothea. "The Assignment I'll Never Forget: Migrant Mother," *Popular Photography* 46, 2 (February 1960): 42-43, 128.

542. Lange, Dorothea. *Dorothea Lange*. Introduction by George P. Elliott. New York: The Museum of Modern Art, 1966. 112 p. Chiefly illustrations. Includes a chronology and a selected bibliography.

Hopi Indian, New Mexico, c. 1923, p. 15; *Mexican-American, San Francisco*, 1928, p. 16; *Adele Raas, San Francisco*, c. 1920, p. 17; *Torso, San Francisco*, 1923, p. 18; *John, San Francisco*, 1931, p. 19; *White Angel Breadline, San Francisco*, 1933, p. 20; *Andrew Furuseth, San Francisco*, 1934, p. 21; *Street Demonstration, San Francisco*, 1933, p. 22; *Funeral Cortege, End of an Era in a Small Valley Twon, California*, 1938, p. 23; *Tractored Out, Childress County, Texas*, 1938, p. 24; *Migrant Mother, Nipomo, California*, 1936, p. 25; *Ditched, Stalled and Stranded, San Joaquin Valley, California*, 1935, p. 26; *Damaged Child, Shacktown, Elm Grove, Oklahoma*, 1936, p. 27; *Migratory Cotton Picker, Eloy, Arizona*, 1940, p. 28; *Child and Her Mother, Wapato, Yakima Valley, Washington*, 1939, p. 29; *Young Migratory Cotton Picker, Casa Grande, Arizona*, 1940, p. 30; *Woman in Migratory Labor Camp, California*, 1938, p. 31; *Six Tenant Farmers Without Farms, Hardman County, Texas*, 1938, p. 32; *A Half-hour later, Hardman County, Texas*, 1938, p. 33; *Back*, 1938, p. 34; *Back*, 1935, p. 35; *Jobless On Edge of Peafield, Imperial Valley, California*, 1937, p. 36; *Kern County, California*, 1938, p. 37; *Woman of the High Plains, Texas Panhandle*, 1938, p. 38; *Texas Panhandle*, 1938, p. 39; *J.R. Butler, President of the Southern Tenant Farmers' Union, Memphis, Tennessee*, 1938, p. 40; *Grayson, San Joaquin Valley, California*, 1938, p. 41; *Sharecroppers, Eutah, Alabama*, 1937, p. 42; *Ex-Slave With Long Memory, Alabama*, 1937, p. 43; *Hoeing, Near Yazoo City, Missouri*, 1937, p. 44; *One Man, One Mule, Greene County, Georgia*, 1937, p. 45; *Water Boy, Mississippi Delta*, 1938, p. 46; *Greenville, Mississippi*, 1938, p. 47; *Plantation Overseer and His Field Hands, Mississippi Delta*, 1936, p. 48; *Crossroads Store, Alabama*, 1937, p. 49; *By the Chinaberry Tree, Near Tipton, Georgia*, 1938, p. 50; *Sheriff, Waggoner, Oklahoma*, 1937, p. 51; *On the Great Plains, Near Winner, South Dakota*, 1938, p. 52; *The Road West, New Mexico*, 1938, p. 53; *Richmond, California*, 1942, p. 54; *One Nation Indivisible, San Francisco*, 1942, p. 55; *Shipyard Construction Workers, Richmond, California*, 1942, p. 56; *Richmond, California*, 1942, p. 57; *Argument in Trailer Court*, 1944, p. 58; *Oakland, California*, 1942, p. 59; *Shipyard Worker, Richmond, California*, 1942, p. 60; *End of Shift, Richmond, California*, 1942, p. 61; *Toquerville, Utah*, 1953, p. 62, 63; *Spring in New York*, 1952, p. 64; *Spring in Berkeley*, 1951, p. 65; *Man Stepping From Curb*, 1956, p. 66; *Gunlock, Utah*, 1953, p. 67; *Rebecca Dixon, Sausalito*, 1954, p. 68; *Oak, Berkeley*, 1957, p. 69; *Winter, California*, 1955, p. 70; *Bad Trouble Over the Weekend*, 1964, p. 71; *John and Helen, Berkeley*, 1955, p. 72; *Andrew, Berkeley*, 1959, p. 73; *First Born, Berkeley*, 1952, p. 74; *Second Born, Berkeley*, 1955, p. 75; *"Guilty, Your Honor," Alameda County Courthouse, California*, c. 1955-57, p. 76; *Black Maria, Oakland*, c. 1955-57, p. 77; *The Defendant, Alameda County Courthouse, California*, c. 1955-57, p. 78; *The Public Defender, Alameda County Courthouse, California*, c. 1955-57, p. 79; *Walking Wounded, Oakland*, 1954, p. 80; *Terrified Horse, Napa County, California*, 1956, p. 81; *Cafe Near Pinhole, California*, 1956, p. 82; *U.S. Highway #40, California*, 1956, p. 83; *County Clare, Ireland*, 1954, p. 84; *Country*

Road, County Clare, Ireland, 1954, p. 85; *Irish Child, County Clare, Ireland*, 1954, p. 86; *Story Teller, County Clare, Ireland*, 1954, p. 87; *Rainy Day, County Clare, Ireland*, 1954, p. 88; *Pathan Warrior Tribesman, Khyber Pass*, 1958, p. 89; *Pakistani Youth, Karachi*, 1958, p. 90; *Foot of Priest, Burma*, 1958, p. 91; *Indonesia*, 1958, p. 92; *Hong Kong*, 1958, p. 93; *Korean Child*, 1958, p. 94; *Hand, Indonesian Dancer, Java*, 1958, p. 95; *Campesino, Venezuela*, 1960, p. 96; *Procession Bearing Food To the Dead, Upper Egypt*, 1963, p. 97; *Woman in Purdah, Upper Egypt*, 1963, p. 98; *Architectural Detail, Upper Egypt*, 1963, p. 99; *Nile Village, Egypt*, 1963, p. 100; *Nile Delta, Egypt*, 1963, p. 101; *Egyptian Village*, 1963, p. 102.

543. Lange, Dorothea. *Dorothea Lange Looks at the American Country Woman*. Commentary by Beaumont Newhall. Fort Worth: Amon Carter Museum, 1967. 72 p.

The brief introduction by Lange indicates that these photographs were taken between the mid-1930s and the mid-1950s. Most of the photographs are accompanied by a second photograph which describes the home or environment in which these women "of the American soil" lived. She has included a short autobiographical statement and an example of typical field documentation. Newhall's essay, "The Questing Photographer: Dorothea Lange," is also included.

Early Californian, Sausalito, California, 1954, p. 15; *The woman called "Queen" on a Sunday morning at church-time*, North Carolina, 1939, p. 17; *Church-time*, North Carolina, 1939, p. 19; *Farm wife lives on the Great Plains*, Nebraska, 1940, p. 21; *Family farmstead*, Nebraska, 1940, p. 23; *Bessie, daughter of Zion, mother of three*, Toquerville, Utah, 1953, p. 25; *Toquerville is a town with no bank, no movie house, no garage, no motel, no cafe*, Toquerville, Utah, 1953, p. 27; *Woman of the high plains "if you die, you're dead--that's all,"* Texas Panhandle, 1938, p. 29; *Drought years*, Texas Panhandle, 1938, p. 31; *Young girl cotton picker, she migrates with her family from crop to crop, and lives under conditions of deprivation*, Arizona, 1941, p. 33; *She picks in these broad field of cotton and lives in one of these cabins*, Arizona, 1941, p. 35; *Mary Ann Savage was a faithful Mormon all her life*, Toquerville, Utah, 1931, p. 37; *Man years later, in 1953, her gravestone was photographed as it stood in the village graveyard*, Toquerville, Utah, 1953, p. 38; *Friend and neighbor who makes "the world's best apple pie," and who knows everything going on for miles around*, Northern California, 1944, p. 41; *She practiced the household arts of her generation*, Utah, 1953, p. 43; *Young mother*, Gunlock, Washington County, Utah, 1953, p. 45; *The church is the center of the life*, Gunlock, Washington County, Utah, 1953, p. 47; *Like many others on the Great Plains from Scandinavia, she homesteaded where her sons now farms*, South Dakota, 1939, p. 47; *This is the family farmstead*, South Dakota, 1939, p. 51; *Ex-slave with a long memory*, Alabama, 1938, p. 53; *[Log cabin with falling roof]* Alabama, 1938, p. 55; *Mormon mother who says she's "been looking up at that old black ridge" since 1877*, Gunloock, Washington County, Utah, 1953, p. 57; *This is the road that runs through her far-west village*, Gunloock, Washington County,

Utah, 1953, p. 59; *"She's a Jim-Dandy,"* Tulare County, California, 1938, p. 61; *Woman of the Far West welcomes friends gathering on Memorial Day in the old cemetery*, Berryessa Valley, California, 1956, p. 63; *Home place*, Monticello, California, 1956, p. 65; *Ma Burnham from Conroy Arkansas*, Arkansas, 1938, p. 67; *Arkansas*, 1938, p. 69.

544. Lange, Dorothea. "Irish Country People," *Life* 21 (March 1955): 135-43.

545. Lange, Dorothea. *The Making of a Documentary Photographer*, an oral history interview conducted in 1960 and 1961 by Suzanne Riess (Berkeley: Regional Oral History Office, Bancroft library, University of California, Berkeley, 1968.

546. Lange, Dorothea. "Migrant Mother: A Famed Photojournalist Tells of the Picture That Symbolized an Era," *Popular Photography* 46, 2 (February 1960): 42+.

547. Lange, Dorothea. *The Photographs of Dorothea Lange.* Introduction by Keith F. Davis with contributions by Kelle A. Botkin. Kansas City, MO: Hallmark Cards, 1995.

Morning Glory, Toquerville, Utah, 1953, p. 2; *Torso, San Francisco*, 1923, p. 13; *Young Indian Girl, Southwest*, c. 1930, p. 14; *Portrait of a Young Hopi Indian, New Mexico*, c. 1923, p. 15; *New Mexico*, c. 1931, p. 17; *White Angel Breadline, San Francisco*, 1933, p. 19, 20, 21; *Street Demonstration, San Francisco*, 1933, p. 23; *Street Meeting--The Audience Listens, San Francisco Waterfront Strike*, 1934, p. 25; *May Day Demonstrations, San Francisco Civic Center*, 1934, p. 26; *Demonstrators*, c. 1934, p. 27; *May Day Demonstrations, San Francisco*, 1933, p. 29; *Against the Wall, San Francisco*, 1934, p. 31; *Unemployed, Howard Street, San Francisco*, 1934, p. 32; *Scene Along "Skid Row," Howard Street, San Francisco*, February 1937, p. 33; *Mother and Child*, 1934, p. 34; *A Sign of the Times--Depression--Mended Stockings, Stenographer, San Francisco*, 1934, p. 35; *The Road West, U.S. Route 54 in Southern New Mexico*, 1938, p. 37; *Bound for Matanuska Colony, Alaska*, May 1935, p. 38; *Oklahoma Family on Highway Between Blythe and Indio, California*, August 1936, p. 39; *Paul Taylor in Migrant Labor Camp, Coachella Valley*, 1935, p. 40; *Squatter's Camp, Imperial Valley*, April 1935, p. 41; *Oklahomans in Public Camp on Relief, Coachella Valley*, February 1935, p. 42; *Eighty-year-old Woman Living in a Squatter's Camp...California*, 1936, p. 43; *Migrant Mother, Nipomo, California*, March 1936, p. 45; *Refugee From Drought, Dust, Depression, near Sacramento, California*, November 1936, p. 47; *Texas Farmer Looking for Work in the Carrot Harvest, Coachella Valley*, February 1937, p. 48; *Ex-Tenant Farmer on Relief Grant in the Imperial Valley, California*, March 1937, p. 49; *Child and Her Mother, FSA Rehabilitation Clients, near Wapato, Yakima, Washington*, 1939, p. 51; *Funeral Cortege, End of an Era in a Small Valley Town, California*, 1938, p. 52; *Death in the Doorway, Grayson, San Joaquin Valley, California*, 1938, p. 53; *Migratory*

Cotton Picker, Eloy, Arizona, November 1940, p. 55; *Cotton Wagon, Eloy, Arizona,* November 1940, p. 56; *Migrant Worker Camp, Eloy, Arizona,* November 1940, p. 57; *Rural Rehabilitation Client, Tulare County, California,* November 1938, p. 59; *San Francisco Social Security Office,* January 1938, p. 60; *San Francisco,* January 1939, p. 61; *Entering the State of Georgia,* 1936, p. 63; *The Sheriff of McAlester, Oklahoma, Sitting In Front of the Jail,* August, 1936, p. 64; *Plantation Overseer, Mississippi Delta, near Clarksdale, Mississippi,* July 1936, p. 65; *Hoeing Cotton, near Yazoo City, Mississippi,* June 1937, p. 66; *By the Chinaberry Tree, Tipton, Georgia,* 1938, p. 67; *Ex-slave with a Long Memory, Alabama,* 1937, p. 59; *Ma Graham, an "Arkansas Hoosier," Born in 1855, Conway, Arkansas,* June 1938, p. 71; *Sharecropper Who Receives $5 a month "furnish" from the Landowner, Macon County, Georgia,* July 1937, p. 72; *Tractored Out, Childress County, Texas,* June 1938, p. 73; *Former Texas Tenant Farmers Displaced from their land by tractor farming, Hardeman County, Texas,* 1937, p. 75; *Farm Family which just sold its year's crop at tobacco auction, Douglas, Georgia,* July 1938, p. 76; *J.R. Butler, President of the Southern Tenant Farmers' Union , Memphis, Tennessee,* 1938, p. 77; *The Congregation Gathers after the service to talk, Wheeley's Church, North Carolina,* July 1939, p. 78; *Church of the High Plains, near Winner, South Dakota,* 1938, p. 79; *Pledge of Allegiance at Rafael Weill Elementary School, San Francisco,* April 1942, p. 81; *Grandfather and Grandchildren awaiting evacuation bus, Hayward, California,* May 1942, p. 82; *Grandfather and Grandson, Japanese Relocation Camp, Manzanar, California,* 1942, p. 83; *Trailer Court, near Richmond, California,* c. 1943-44, p. 85; *Day Sleeper, 1D, Richmond, California,* c. 1942-44, p. 86; *Argument in a Trailer Court, Richmond, California,* 1944, p. 87; *Street Encounter, Richmond, California,* c. 1943, p. 88; *Oakland, California,* c. 1951, p. 89; *New York City,* 1952, p. 90; *McCarthy Dies,* May 5, 1957, p. 90; *Consumer Relations, San Francisco,* 1952, p. 91; *Cable Car, San Francisco,* 1956, p. 92; *Man Stepping Off Cable Car, San Francisco,* 1956, p. 93; *The Defendant, Alameda County Courthouse, California,* 1957, p. 95; *The Witness,* 1957, p. 96; *Leaving Courtroom After Conviction,* 1957, p. 97; *Black Maria, Oakland,* 1957, p. 99; *Hutterite Bible, west of Vermillion, South Dakota,* 1941, p. 101; *Lydia Wall,* 1944, p. 103; *Young Mother, Gunlock, Washington County, Utah,* 1953, p. 104; *Mother and Child, Gunlock, Washington County, Utah,* 1953, p. 104; *Gravestone, St. George, Utah,* 1953, p. 105; *Elderly Woman, Clare County, Ireland,* 1954, p. 107; *Berkeley, California,* 1959, p. 108; *Winter, California,* 1955, p. 109; *Third Born,* 1958, p. 111; *Egypt,* 1963, p. 113; *Korea,* c. 1958, p. 114; *Woman's Foot, Vietnam,* 1958, p. 115; *Indonesian Dancer, Java,* 1958, p. 117; *Saigon Market,* 1958, p. 119; *Palestinian Child,* 1958, p. 121; *Korean Child,* 1958, p. 123.

548. Lange, Dorothea. "Remembrance of Asia," in *Photography Annual 1964* pp. 50-59. New York: Ziff-Davis, 1963.

549. Lange, Dorothea. "Three Mormon Towns," *Life* 6 (September 1954): 91-100.

550. Lange, Dorothea and Margaretta Mitchell. *To a Cabin*. New York: Grossman, 1973. 126 p.

This book was originally only an idea of Lange's, and she was ultimately unable to complete this project before her death. It was left to her friend Mitchell to collect the photographs from the family scrapbooks and museum files that would document the legacy of her cabin in the life of Lange's family. Mitchell also incorporated her own photographs of the family and the place to complete the volume.

[Man running on dirt road, after small child] p.8; 120,125. *[Small cabin overlooking the sea]*, p. 13; *[Several cabins overlooking the sea, view from a cliff]*, p. 14; *[Looking up at the cabins from the beach]*, p. 15; *[Pebbles on the beach at low tide]*, p. 16; *[Wave coming across the beach]*, p. 17; *[Two children on boulder overlooking the surf]*, p. 18; *[Children on boulders looking out at sea]*, p. 19; *[Children and dog on hillside]*, p. 20. *[Boy with pail, shovel and dog]*, p. 21; *[Man fishing at base of large boulder]*, pl. 22; *[Children walking across the large rocks near the sea]*, p. 23; *[Children's drawings over wood bookshelf]*, p. 36; *[Girl reading in bed]*, p. 37; *[Young girl reading in bed]*, p. 38; *[Six children reading on a bed]*, p. 39; *[Boy writing in notebook]*, p. 40; *[Girl resting head on hands and reading]*, p. 41; *[Coal burning stove and tea kettle]*, p. 42; *[Kitchen]*, p. 43; *[Two straw baskets hanging on hook]*, p. 44; *[Hat and coat hanging on hook]*, p. 45; *[Oil lamps on table]*, p. 46; *[Lighting the oil lamps]*, p. 47; *[Sawing wood outside of the cabin]*, p. 69; *[Girl walking with magazine]*, p. 70; *[Man carrying young boy]*, p. 71; *[Women drinking from white cup]*, p. 72; *[Profile of man]*, p. 73; *[Mother kissing daughter]*, p. 74; *[Boy]*, p. 75; *[Outstretched hand holding shells]*, p. 76; *[Girl lying in grass]*, p. 77; *[Tea kettle and frying pan]*, p. 78; *[Legs in sand]*, p. 79; *[Feet near rock crevices]*, p. 81; *[Man and boy on beach]*, p. 82; *[Children and adult playing in surf]*, p. 83; *[Standing with young child in surf]*, p. 84; *[Young girl running on beach]*, p. 85; *[Little child in large coat and hat, walking on dirt road]*, p. 120; *[Object on beach]*, p. 125.

551. Lange, Dorothea and Daniel Dixon. "Photographing the Familiar," *Aperture* 1, 2 (1952): 4-15.

552. Lange, Dorothea and Pirkle Jones. "Death of a Valley," *Aperture* 8, 3 (1960): 127-65.

553. Lorentz, Pare. "Dorothea Lange: Camera with a Purpose," In *U.S. Camera 1941: America*, vol., pp. 93-116, 229. New York: Duell, Sloan & Pearce, 1941.

554. Mann, Margery. "Dorothea Lange," *Popular Photography* 66, 3 (March 1970): 84-85+.

555. Meltzer, Milton. *Dorothea Lange: A Photographer's Life*. New York:

Farrar, Straus, Giroux, 1978. 399 p. Bibliography: p. 385-391.

A full-length biography of Lange that is based on numerous interviews and correspondence with people who knew her best, her family, her friends, her collaborators and her associates. Meltzer uses Lange's own writings to enhance the text.

Constance Dixon, c. 1923, p. 109; *Maynard Dixon*, c. 1921, p. 109; *Man with cap*, c. 1924, p. 111; *Hopi Indian, New Mexico*, c. 1923, p. 110; *John, San Francisco*, 1931, p. 113; *Mexican-American, sn Francisco*, 1928, p. 112; *White Angel Bread Line, San Francisco*, 1933, p. 116-117; *Andrew Furuseth, San Francisco*, 1934, p. 119; *Street Demonstration, San Francisco*, 1933, p. 118; *Depression, San Francisco*, 1934, p. 122; *Migrant Mother, Nipomo, California*, 1936, p. 212-213; *Woman of the Plains*, 1938, p. 217; *Ex-Slave, Alabama*, 1937, p. 216; *Six Tenant Farmers without Farms, Texas*, 1938, p. 218-219; *Ditched, Stalled, and Stranded, San Joaquin Valley, California*, 1935, p. 220-221; *Plantation Owner and His Fields Hands, Mississippi Delta*, 1936, p. 222-223; *Homeless*, 1937, p. 225; *Tractored Out, Childress County, Texas*, 1938, p. 224; *Migrant Homes*, 1938, p. 224; *San Francisco*, 1939, p. 226; *Walking Wounded, Oakland*, 1954, p. 263; *Bad Trouble over the Weekend*, 1964, p. 262; *Hoe Culture, Alabama*, 1937, p. 265; *Spring in Berkeley*, 1951, p. 264; *Terrified Horse, Berryessa Valley*, 1956, p. 267; *The Big Cat, Berryessa Valley*, 1956, p. 267; *Migrants entering California*, 1936, p. 266; *Rebecca Chambers, Sausalito, California*, 1954, p. 266; *Steep Ravine, California*, p. 269; *The Oak outside Dorothea's window*, 1957, p. 276.

556. Meltzer, Milton. "Using Oral History: A Biographer's Point of View," *Oral History Review* (1979): 42-46.

557. Morrison, Chester. "Dorothea Lange: Friend of Vision," *Look* 22 March 1966, 34-38.

558. Nixon, Bruce. "A Nation in Upheaval (San Francisco Museum of Modern Art; exhibit)," *Artweek* 21 July 1994, 18-19.

559. Ohrn, Karin B. *A Nobler Thing: Dorothea Lange's Life in Photography.* PhD Dissertation, Indiana University, 1977. 386 p. Bibliography: p. 372-385.

560. Ohrn, Karin Becker. "What You See Is What You Get: Dorothea Lange and Ansel Adams at Manzanar," *Journalism History* 4, 1 (1977): 14-22, 32.

561. Ohrn, Karin B. *Dorothea Lange and the Documentary Tradition.* Baton Rouge: Louisiana State University Press, 1980. 277 p. Bibliography: p. 263-272.

The photographs, from those taken to document the Depression, through her travels in Egypt, are accompanied by a biography and re-examination

of Lange's work in relationship to her life. Included for this examination are segments of interviews and Lange's own writings.

Adele Raas, pl. 1; *Clayburgh Children*, pl. 4; *Soquel Creek*, pl. 6; *White Angel Breadline*, pl. 7; *General Strike, San Francisco*, pl. 8; *"Workers Unite,"* pl. 9; *Unemployed Exchange Association*, pl. 10; *"Where is Tranquililty, California?"* pl. 11; *Bob Lemmon, Ex-Slave*, pl. 13-14; *Plantation Overseer and Field Hands*, pl. 15; *A Director of the Mineral King Cooperative Farm*, pl. 22; *Women of the Mineral King Cooperative Farm*, pl. 23; *Tractored Out*, pl. 27; *Displaced Tenant Farmers*, pl. 28-29; *Migrant Mother*, pl. 31-35; *Dust Bowl Farm*, pl. 37; *Woman of the Texas Panhandle*, pl. 38; *Drought-stricken Farmers*, pl. 39; *Champion Hog Picker*, pl. 42; *Auto Camp*, pl. 44; *Amish People*, pl. 45; *Japanese American Neighborhood*, pl. 46; *Crowd of Onlookers on the First Day of Evacuation*, pl. 47; *Japanese American Grandfather*, pl. 48; *Mother and Baby Await Evacuation Bus*, pl. 49; *Members of the Mochida Family*, pl. 50; *Baggage of Evacuees*, pl. 51; *Evacuees in Train Car*, pl. 52; *Mother and Children at the Door of Their Room*, pl. 53; *Mrs. Fujita's Vegetable Garden*, pl. 54; *Tanforan Assembly Center Barracks*, pl. 58, 64; *Young Man at Manzanar Relocation Center*, pl. 61; *Field Laborers Hoeing Corn*, pl. 63; *Shipyard Workers at the End of a Shift*, pl. 65; *Tenth Street Market*, pl. 66; *Freedom of Speech*, pl. 67; *Freedom of Worship*, pl. 68; *John, Helen, Gregor. First Born*, pl. 71; *Martin Pulich, Public Defender*, pl. 75; *Public Defender Talking to a Client*, pl. 76; *Woman of the Berryessa Valley*, pl. 79; *Farm Auction, Berryessa Valley*, pl. 80; *At Steep Ravine*, pl. 81; *People of County Clare, Ireland*, pl. 82; *Market, County Clare, Ireland*, pl. 83; *"Irish Country People,"* from *Life*, pl. 84-85; *Horse Play*, pl. 86; *"Three Mormon Towns,"* from *Life*, pl. 87; *U.S. Highway #40*, pl. 88; *Defendant, Alameda County Courthouse*, pl. 89; *The Family at Steep Ravine*, pl. 90; *Touloume Camp*, pl. 91; *Andrew*, pl. 92; *Street Scenes, Karachi*, pl. 93; *Pakistani Youth*, pl. 94; *Egyptian Village*, pl. 95; *Dyanna's Hand*, pl. 96; *Indonesian Dancer*, pl. 97; *Indonesian Market*, pl. 98; *The Family at Steep Ravine*, pl. 99; *Street in Saigon*, pl. 100; *Bad Trouble over the Weekend*, pl. 101; *Korea*, pl. 102; *Korean Child*, pl. 103.

562. Owen, Alan. "Photographic Portraits That Epitomize Their Eras," *Connoisseur* 216 (April 1986): 56-62.
 Lange describes how she approached the making of this classic photograph, "Migrant Mother" and the article continues with an acknowledgment of the importance of this image and the real life story of Mrs. Florence Thompson, the unnamed woman in the photograph. Also included is the text of cablegram sent by President Reagan upon the death of Mrs. Thompson.

563. Page, Homer. "A Remembrance of Dorrie," *Infinity* (November 1965): 26.

564. Smith, W. Eugene. "One Whom I Admire: Dorothea Lange," *Popular Photography* 58, 2 (February 1966): 86-88.

565. Taylor, Paul S. "Migrant Mother," *American West* (May 1970*)*:43-46.

566. Van Dyke, Willard. "The Photographs of Dorothea Lange--a Critical Analysis," *Camera Craft* XLI (October 1934): 461-467.

567. White, Minor. "Dorothea Lange," *Aperture* 12, 3 (1965): 132.

Larisch, Kathleen
 See also #1070
Larrabee, Constance Stuart, 1914-
 See also #1000
Larson, Kristine
 See also #1058
Larson, Lisa
 See also #1009
Lasko, Katrina
 See also #1006
Lauren, Jilly
 See also #1071

Lavenson, Alma, 1897-1989
 See also #1058, 1063

568. Ehrens, Susan. "Interview with Alma Lavenson," *Photo Metro* 5, 43 (October 1986): 13-20.

569. Fuller, Patricia G. *Alma Lavenson*. Riverside, CA: California Museum of Photography, 1979. 56 p. Bibliography: p. 56.
 A exhibition catalog of photographs with a short essay on the influence of other photographers and the history of Lavenson's photographic work
Tailing Wheels, Kennedy Mine, Jackson Gate, 1949, front cover; *Self-portrait,* 1932, facing page; *Grain Elevators,* 1929, p. 3; *Consuela Kanaga,* 1933, p. 4; *Imogen Cunningham,* 1945, p. 5; *Tree in Winter,* 1932, p. 6; *Hand of an Etcher,* 1932, p. 7; *Zion Canyon,* 1927, p. 12; *Masts and Funnels,* 1930, p. 13; *Calla Leaf,* 1931, p. 14; *Chrysanthemum,* 1931, p. 15; *Tank,* 1931, p. 16; *Calaveras Dam I,* 1932, p.17; *Calaveras Cement Works,* 1933, p. 18; *Tanks, Standard OilCo.,* 1931, p. 19; *Stacks-Chevrolet Plant,* 1933, p. 20; *Eucalyptus Leaves,* 1933, p. 21; *Haystacks,* 1940, p. 22; *Fence and Eucalyptus,* 1941, p. 23; *Ruined Building, Virginia City,* 1943, p. 24; *San Ildefonso Indians,* 1944, p. 25; *Side Show,* 1944, p. 26; *Mending the Ropes,* 1946, p. 27; *Burnt-out House,* 1946, p. 28; *Farm near Morro Bay,* 1949, p. 29; *False Helebore,* 1949, p. 30; *Artichoke Field,Carmel Valley,* 1949, p. 31; *Gertrude's House,* 1958, p. 32; *Gertrude's Shelf,* 1958, p. 33; *Stonecutter's Yard,* 1959, p. 34; *Tin Market, Mexico City,* 1959, p. 35; *Chichicasatenango,* 1959, p. 36; *Man with a Sickle, Madeira,* 1962, p.37; *Spiral, Tomar, Portugal,* 1962, p. 38; *Danish Farmwife,* 1962, p. 39; *Shop Window, Avila,*

Portugal, 1962,p. 40; *Old Age in Mykonos*, 1967, p. 41; *Doorway with Vines, Nevada City*, 1934, p. 44; *Hydraulic Erosion near Nevada City*, 1934, p. 45; *Building with Poplar Trees, French Corral*, 1939, p. 46; *Sprial Staircase, Weaverville*, 1938, p. 47; *Barn, North Bloomfield*, 1939, p. 48; *Mine, Melones*, 1940, p. 49; *Second Hand Store, Sonora*, 1940, p. 50; *Fire House, Nevada City*, 1946, p. 51; *Old Building, El Dorado*, 1947, p. 52; *Stone Wall near Ben Hur*, 1950, p. 53.

570. Lavenson, Alma. *Alma Lavenson's Photographs*. Edited by Susan Ehrens. Berkeley, CA: Wildwood Arts, 1990. 160 p.

571. Lavenson, Alma. "Virginia City: Photographing a Ghost Town," *U.S. Camera* 1, 10 (June-July 1940): 52-53+.

Lee, Betty
 See also #1055
Lee, Jin
 See also #1055

Leen, Nina
 See also #1009

571.1 Leen, Nina. *Images of Sound*, New York: Norton, 1977.

571.2 Leen, Nina. *Love, Sunrise and Elevated Apes*. New York: Norton, 1974.

571.3 Leen, Nina. *Women, Heroes, and a Frog*. New York: Norton, 1970.

Leen, Sarah E.
 See also #1072

Leeson, Adelaide Hanscom, 1876-1932
 See also #1058, 1061, 1063

572. Browning, Elizabeth Barrett. *Sonnets From the Portuguese*. With Photographic Illustrations by Adelaide Hanscom Leeson. New York: Dodge, 1916.

573. Fitzgerald, Edward, translator. *The Rubáiyát of Omar Khayyám*. With Illustrations by Adelaide Hanscom. New York: Dodge, 1905.

574. Hanscom, Adelaide. "Four Prints of Children," *Camera Craft* 7, 1 (May 1903): 13-17.

575. James, George Wharton. "Miss Hanscom's Studies of the *Rubáiyát*,"

Sunset Magazine (March 1906): 507-510.

576. Leeson, Adelaide Hanscom. *Adelaide Hanscom Leeson: Pictorialist Photographer: 1876-1932*. Carbondale, IL: University Museum. Southern Illinois University at Cardondale, 1981. 34 p. Bibliography: p. 19.
Catalogue for the first retrospective exhibition of her work. Begins with an essay on the Pictorialist era, 1892 to 1914, when these photographers tried to distinguish their photographs from snapshots by embellishing the image, and produce photographs that had a visual or psychological effect. Catalogue continues with an essay on Leeson's contribution to photography, especially through her illustrations for the *Rubáiyát of Omar Khayyám*. Contains several portaits of Leeson.
An illustration from the Rubáiyát of Omar Khayyám, p. 20, 22, 23, 24, 25; An illustration from Elizabeth Barrett Browning's Sonnet's From the Portuguese, p. 21, 25; A portrait of Louise Keeler and her infant son Leonarde, "Mother and Child" series, p. 26; Leeson's daughter posing for the "Nursery Rhyme Series," p. 27; A photograph with hand applied watercolor paint, p. 28; "Hail! King of Day" from Triumph of Light, 1905, p. 31; Charles Keeler as "Herald" from Triumph of Light, 1905, p. 31

577. Miller, Dorothy. "The Artist in Kern River Canyon," *Sunset Magazine* 12, 2 (December 1903): 129-134.

578. "Successful Photographer of Children," *The Craftsman* 7 (January 1905): 460-465.

Lehmann, Minette
See also #1007, 1070

Leibovitz, Annie, 1949-
See also #1026, 1058, 1063

579. Abdoh, Reza. "Last Word," *American Theatre* 12, 6 (July 1995): 88.

580. *Annie Leibovitz: Words and Images*. Boston: Institute of Contemporary Art, 1992. Videorecording. 13 minutes.

581. *Annie Leibovitz Celebrity Photographer*. Chicago: Home Vision Arts, 1993.
Videocassette, 51 minutes.

582. "Annie Leibovitz Talks About Portraiture," *Creative Camera* 234 (June 1984): 1402-1407.

583. Aulich, James. "Leibovitz in Sarajevo," *History of Photography* 18

(Autumn 1994): 291-292.

584. Bolz, Diane M. "A Framer of Popular Culture," *Smithsonian* 22 (July 1991): 134.

585. Brantley, Ben. "Annie's Eye," *Vanity Fair* 54 (September 1991): 204-213.

586. Cameron, Dan. "Self Determination," *Vogue* (July 1994): 152-159+.

587. Clothier, P. "Annie Leibovitz," *Artnews* 87, 3 (1988): 211.

588. Groer, Anne. "Shooting Star," *Washingtonian* 26 (April 1991): 74-79.

589. Hagen, Charles. "Annie Leibovitz Reveals Herself," *Artnews* 91, 3 (March 1992): 90-95.

590. Harris, Melissa. "Annie Leibovitz," *Aperture* 133 (Fall 1993): 4-13.

591. Kanner, Bernice. "Annie in Adland," *New York* (March 14, 1988): 24+.

592. Kaplan, Michael. "Privileged Communications: Annie Leibovitz Shoots a Who's Who of Cardholders," *American Photographer* 20, 2 (February 1988): 76-79.

593. Karmel, P. "Annie Leibovitz," *Art in America* 72, 4 (1984): n.p.

594. Lange, George. "Riding Shotgun with Annie," *American Photographer* 12, 1 (January 1984): 56-59.

595. Leibovitz, Annie. "Annie Leibovitz," *Aperture* 133 (Fall 1993): 4-13.

596. Leibovitz, Annie. *Annie Leibovitz Photographs, 1970-1990: An Exhibition.*New York: International Center of Photography, 1991. Chiefly illustrations. 12 p.
The essay by W. Hartshorn, "Annie Leibovitz: The Magazine As Muse," discusses the development of Leibovitz's magazine work, while the essay "Annie Leibovitz and the Portrait Tradition in Photography," by W. F. Stapp, discusses Leibovitz's portraiture and her place in the tradition.

American Soldiers and the Queen of the Negritos, Clark Air Force Base, the Philippines, 1968; *Tammy Wynette, Lakeland, Florida*, 1971; *Louis Armstrong, Queens, New York*, 1971; *Tennessee Williams, Key West, Florida*, 1974; *Mick Jagger, Buffalo, New York*, 1975; *Patti Smith, New Orleans*, 1978; *Muhammad Ali, Chicago*, 1978; *Robert Penn Warren, Fairfield, Connecticut*, 1980; *Tess Gallagher, Syracuse, New York*, 1980; *John Lennon and Yoko Ono, New York City*, December 8th, 1980; *Peter Tosh, New York City*, 1982; *John Malkovich, New York City*, 1984;

Sam Shepard, Santa Fe, New Mexico, 1984; *Beth Henley, Jackson, Mississippi*, 1987; *Willem Dafoe, New York City*, 1987; *Bruce Springsteen, Asbury Park, New Jersey*, 1987; *Ella Fitzgerald, Beverly Hills*, 1988; *Peter Sellars, New York City*, 1989; *Peter Matthiessen, Sagaponack, New York*, 1990; *Mikhail Baryshnikov, Brussels*, 1990.

597. Leibovitz, Annie. *Annie Leibovitz: Photographs, 1970-1990*. New York: HarperCollins, 1991. 232 p.

Includes a list of photographs with indication of the original publication source, e.g. *Vanity Fair* and the text of a conversation between Leibovitz and Ingrid Sischy.

American Soldiers and the Queen of the Negritos. Clark Air Force Base, The Philippines, 1968, p. 6; *Kibbutz Amir, Israel*, 1969, p. 13; *Rachel Leibovitz, Waterbury, Connecticut*, 1974, p. 14; *Marilyn and Samuel Leibovitz, Silver Spring, Maryland*, 1975, p. 15; *Marilyn Leibovitz, Ellenville, New York*, 1974, p. 16; *Samuel Leibovitz*, Ellenville, New York, 1974 and Silver Spring, Maryland, 1972, p. 17; *Highway 101*, California, 1973, p. 18; *Annie Leibovitz and Bobby Steinbrecher*, Highway 101, California, 1974, p. 19; Houston, Texas, 1973, p. 20; *On the Road with Jackson Browne*, Iowa, 1976, p.21; *Antiwar Demonstration*, San Francisco, 1970, p. 22; *John Lennon*, New York City, 1970, p.23; *Tammy Wynette*, Lakeland, Florida, 1971, p. 24; *George Jones*, Lakeland, Florida, 1971, p. 25; *Louis, Armstrong*, Queens, New York, 1971, p. 26, 27; *Jerry Garcia*, New York City, 1973, p. 28-29; *Paul Kantner, Grace Slick, and China*, Bolinas, California, 1971, p. 30; *David Harris and Joan Baez*, Los Altos, California, 1971, p. 31; *Christmas*, Soledad Prison, California, 1971, p. 32-33; *Ken Kesey's Farm*, Eugene, Oregon, 1974, p.34-35; *Bill Graham*, San Francisco, 1974, p. 36; *The Grateful Dead*, San Rafael, California, 1972, p. 37; *Duane and Greg Allmann*, Ventura, California, 1971, p. 38; *On the Road with Alice Cooper*, Roanoke, Virginia, 1972, p. 39; *Dripping Springs Reunion*, Texas, 1972, p. 40-41; *Waylon Jennings*, 1972, p. 40; *Hank Snow*, 1972, p. 41; *Ray Charles*, Baltimore and San Francisco, 1972, p. 42-43; *Hugh Hefner*, Los Angeles, 1973, p. 44; *Lily Tomlin*, Los Angeles, 1973, p. 45; *Richard Pryor*, Los Angeles, 1974, p. 46; *Marvin Gaye and Jan Hunter*, San Diego, California, 1974, p. 47; *Joe Dallesandro and Joe, Jr.*, New York City, 1971, p. 48; *Divine*, San Francisco, 1972, p. 49; *Jamie Wyeth*, New York City, 1975, p. 50; *Andy Warhol*, New York City, 1976, p. 51; *Waiting for Guru Maharaji Ji, William Hobby Airport*, Houston, Texas, 1974, p. 52-53; *Roman Polanski*, Los Angeles, 1974, p. 54; *Maria Schneider and Friend*, San Francisco, 1973, p. 55; *Apollo 17, the Last Moon Shot*, Cape Kennedy, Florida, 1972, p. 56, 57; *Sly Stone*, Highway 5, California, 1973, p. 58-59; *Tennessee Williams and Maria St. Just*, Key West, Florida, 1974, p. 60, 61; *Jane Wenner*, New York City, 1976, p. 62; *Jann Wenner*, Barbados, 1975, p. 62; *Hunter S. Thompson and Jann Wenner*, New York City, 1976, p. 63; *Hunter S. Thompson's Kitchen*, Aspen, Colorado, 1987, p. 64; *Hunter S. Thompson*, Dulles Airport, Washington, D.C., 1972, p. 65; *Ron Kovic*, Santa Monica, California, 1973, p. 66-67; *George McGovern's Campaign Train*, Sacramento, California, 1972, p. 68; *Blair Clark, Walter Cronkite, and Theodore*

H. White, New Hampshire, 1972, p. 69; *Senator Edmund Muskie*, New Hampshire, 1972, p. 69; *Richard Nixon's Resignation*, Los Angeles and Washington, D.C., 1974, p. 70; *Dan Rather in Lafayette* Park, 1974, p. 71; *Nixon Leaving the White House*, Washington, D.C., 1974, p. 72-73; *The Rolling Stones*, Buffalo, New York , and Memphis, Tennessee, 1975, p. 74, 75; *Cleveland, Ohio*, 1975, p. 76-77; *Andy Warhol and Mick Jagger*, Montauk, Long Island, 1975, p. 78; *Andy Warhol, Truman Capote, and Robert Frank*, New Orleans, 1972, p. 78; *Andy Warhol, Lee Radziwell, and Truman Capote*, New York City, 1972, p. 78; *Mick Jagger*, Kansas, 1972, p. 68; *Ahmet Ertegun*, Beverly Hills, 1971, p. 78; *Earl McGrath, Mick Jagger, and Ahmet Ertegun*, New York City, 1975, p. 78; *Bianca Jagger*, Kansas, 1972, p. 79; *Keith Richards*, Toronto, 1977, p. 80-81; *The Rolling Stones on the Road*, 1975, p. 82, 83; *The Rolling Stones*, Philadelphia, 1975, p. 84-85; *Mick Jagger*, Chicago, 1975, p. 86; *Mick Jagger, Keith Richards, and Bill Wyman*, New York, 1975, p. 87; *Mick Jagger*, Southampton, Long Island, and Buffalo, New York, 1975, p. 88, 89; *Arnold Schwarzenegger*, Johannesburg and Capetown, South Africa, 1976, p. 90, 91; *Cesar Chavez*, La Paz, California, 1976, p. 92; *Linda Ronstadt*, Malibu, California, 1976, p. 93; *Tom Hayden and Jane Fonda*, San Francisco, 1978, p. 96; *Brian Wilson*, Malibu, California, 1976, p. 97; *Jimmy Carter's Presidential Campaign*, Plains, Georgia, 1976, p. 94, 95; *Sam Donaldson and Billy Carter*, 1976, p. 94, 95; *Keith Moon Backstage*, Oakland, California, 1976, p. 98; *Bob Dylan*, Hollywood, 1978, p. 99; *Patti Smith on Tour*, St. Louis, Dallas, and New Orleans, 1978, p. 100, 101; *John Gregory Dunne and Joan Didion*, Mailbu, Malibu, California, 1978, p. 102; *Sally Rand*, New York City, 1978, p. 103; *Richard Avedon*, Palo Alto, Califonria, 1976, p. 104; *Muhammad Ali*, Chicago, 1978, p. 105; *Norman Mailer*, Bar Harbor, Maine, 1974, p. 106; *Alice Springs and Helmut Newton*, Paris, 1976, p. 107; *Rickie Lee Jones*, California, 1979, and Mattituck, New York, 1981, p. 108, 109; *Robert Penn Warren*, Fairfield, Connecticut, 1980, p. 110; *Tess Gallagher*, Syracuse, New York, 1980, p. 111; *Jim Carroll and His Parents*, New York City, 1980, p. 112; *Laurie Anderson*, New York City, 1982, p. 113; *John Lennon and Yoko Ono*, New York City, December 8, 1980, p. 114; *Yoko Ono*, Strawberry Field, New York City, 1981, p. 116-117; *Peter Tosh*, New York City, 1982, p. 118; *Christo*, New York City, 1981, p. 119; *Lauren Hutton*, Oxford, Mississippi, 1981, p. 121; *Steve Martin*, Beverly Hills, 1981, p. 122; *John Belushi and Dan Aykroyd*, Hollywood, 1979, p. 123; *Bette Midler*, New York City, 1979, p. 124; *Liberace and Scott Thorson*, Las Vegas, 1981, p. 126, 127; *Pele*, Purchase, New York, 1981, p. 128; *Jerzy Kosinki*, New York City, 1982, p. 130; *Peter Brook*, Paris, 1981, p. 131; *Amanda Plummer*, New York City, 1982, p. 133; *Sissy Spacek*, Charlottesville, Virginia, 1982, p.134; *Clint Eastwood*, Burbank, California, 1980, p.135; *Greg Louganis*, Los Angeles, 1984, p. 137; *Carl Lewis*, Houston, Texas, 1983, p. 138; *Evelyn Ashford*, El Mirage Dry Lake, California, 1988, p. 139; *Sam Shepard*, Santa Fe, New Mexico, 1984, p. 140, 141; *Bruce Springsteen*, New York City, 1984, and Asbury Park, New Jersey, 1987, p. 142, 143; *Steve Rubell and Ian Schrager*, New York City, 1986, p. 144; *Jerry Hall*, New York City, 1985, p. 145; *Whoopi Goldberg*, Berkeley, California, 1984, p. 147; *John Malkovich*, New York City, 1984, p.148; *Tom Waits*, New York City,

1985, p.149; *Sting,* Lucerne Valley, California, 1985, p. 150-151; *Diane Keaton,* Los Angeles, 1986, p. 152; *Isabella Rossellini and David Lynch,* New York City, 1986, p. 153; *David Byrne and Robert Wilson,* New York City, 1988, p. 154; *David Byrne,* Los Angeles, 1986, p. 155; *Malcolm McLaren and Blue Boy,* Point Dume, California, 1985, p. 157; *Suzanne Farrell,* New York City, 1986, p. 158; *Klaus Maria Brandauer,* Altaussee, Austria, 1986, p. 159; *Keith Haring,* 1986, p. 160, 161, 162; *Jackie and Joan Collins,* 1987, p. 164; *Dennis Hopper,* 1987, p. 165; *Willem Dafoe,* 1987, p. 166; *Philip Glass,* New York City, 1987, p. 168; *William Wegman and Fay Ray,* New York City, 1988, p. 170; *Philippe Petit,* New York City, 1989, p. 171; *Willie Shoemaker and Wilt Chamberlain,* Malibu, California, 1987, p. 172; *The Reverend Al Sharpton, Primadonna Beauty Salon,* Brooklyn, New York, 1988, p. 173; *Marla Maples,* New York City, 1990, p. 174; *Ivana and Donald Trump,* Plaza Hotel, New York City, 1988, p. 175; *Arnold Schwarzenegger,* Malibu, California, 1988, p. 176; *Sammy Davis, Jr.,* Las Vegas, 1989, p. 177; *Ella Fitzgerald,* Beverly Hills, 1988, p. 178; *Paul Taylor with Kathy McCann, Kate Johnson, Christopher Gillis, and Elie Chaib,* New York City, 1990, p. 180; *Kirby Puckett,* Orlando, Florida, 1988, p.181; *Christopher Walken,* New York City, 1988, p. 183; *Jessye Norman,* New York City, 1988, p. 184-185; *Randye Travis,* Nashville, Tennessee, 1987, p. 186; *Jodie Foster,* Malibu, California, 1988, p. 187; *Magic Johnson,* Los Angeles, 1989, p.188, 189; *Miles Davis,* New York City, 1989, p. 190, 191; *Twyla Tharp,* New York City, 1989, p. 192; *David Bowie,* Atlanta, Georgia, 1990, p. 193; *Robert Wilson,* New York City, 1989, p. 194, 195; *Peter Sellars,* New York City, 1989, p. 196, 197; *Michael Jackson,* Los Angeles, 1989, p. 198-199; *Darci Kistler and Robert La Fosse,* New York City, 1990, p. 200-201; *Oliviero Toscani and His Son Rocco,* Cecina, Italy, 1990, p. 202; *Beth Henley,* Jackson, Mississippi, 1987, p. 203; *Roseanne Barr and Tom Arnold,* Malibu, California, 1990, p. 204-205; *Rob Reiner,* Los Angeles, 1989, p. 206; *John Cleese,* London, 1990, p. 207; *Christian Lacroix,* Arles, France, 1990, p. 208; *Andrée Putnam,* New York City, 1989, p. 209; *Peter Matthiessen,* Sagponack, New York, 1990, p. 210-211; *Barbara Kruger,* New York City, 1990, p. 212; *Jeff Koons,* Munich, 1990, p. 213; *The Dalai Lama,* Washington, New Jersey, 1990, p. 214; *Václav Havel,* Prague, 1990, p. 215; *Susan Sontag,* Long Island, New York, 1990, p. 216-217; *Mikhail Baryshnikov,* New York City, 1989, and Florida, 1990, p. 218, 219; *Mark Morris,* New York City, 1989, p. 220; *Mikhail Baryshnikov and Mark Morris,* New York City, 1988, p. 221; *Baryshnikov and Morris,* Brussels, Belgium, 1990, p. 222-223; *The White Oak Dance Project,* Florida, 1990, p. 224, 225; *Mark Morris,* Cumberland Island, Florida, 1990, p.226-227; *Dancers,* Florida, 1990, p. 228-229.

598. Leibovitz, Annie. "Gallery of Glory: A Portfolio by Annie Leibovitz," *Time* 148 (July 22, 1996): 78-85.

599. Loke, M. "Annie Leibovitz," *Artnews* 90, 10 (December 1991): 122.

600. McGrath, Roberta. "Of Stars and Family Values. (National Portrait

Gallery, London; Exhibit)," *Women's Art Magazine* 57 (March/April 1994): 6-8.

601. Madoff, Steven Henry. "What Makes Her Click," *Artnews* 87, (September 1988): 125-127.

602. Meehan, Joseph. "The Public Eye," *British Journal of Photography* 141 (February 17, 1994): 20-22.

603. Neil, Andrew, "Washington Monument," *Vanity Fair* 421 (September 1995): 188.

604. Nicolson, Adam. "Annie Get Your Gun," *Modern Painters* 7 (Spring 1994): 50-51.

605. "The Olympics," *Time* 148 (July 22, 1996): 68-70+.

606. Perlman, M. "Annie Leibovitz," *Artnews* 83, 1 (1984): np.

607. Raedeke, Paul. "Interview with Annie Leibovitz," *Photo Metro* 4, 40 (June/July 1986): 24-32.

608. Rieff, David. "Sarajevo the Besieged," *Vanity Fair* 56 (October 1993): 241-251.

609. Shames, Laurence. "On the Road with Annie Leibovitz," *American Photographer* 12, 1 (January 1984): 38-55.

610. Smith, C. Zoe. *The Diva of Rock 'n' Rap Images Annie Leibovitz*. TCI Cablevision of Missouri, 1993. Videorecording.
Speech given at the First International Conference on Rock 'n' Rap, February 6, 1993, at the University of Missouri-Columbia.

611. Snowden, Lynn. "American Express: Do You Know Me? Becomes You Should Know Me," *Graphis* 44 (March/April 1988): 32-49.

612. Suderberg, Erika. "Between Artifice and Myth. (G. Ray Hawkins Gallery, Los Angeles; Exhibit)," *Artweek* 18 (December 26, 1987): 11.

613. Van Biema, David. "The Eye of Annie Leibovitz," *Life* 17 (April 1994): 46-50+.

614. Wilson, Rhonda. "Star Wars: Annie Out to Launch," *The Photographic Journal* 134 (May 1994): 190-192.

Lemieux, Annette
 See also #1008

Lennard, Erica, 1950-
 See also #1008

615. Dickey, Page. *Breaking Ground: Portraits of Ten Garden Designers.*
 Photographs by Erica Lennard. New York: Artisan, 1997. 208 p. Chiefly
 illustrations.
 Dickey's text accompanies the hundreds of color photographs of the
 gardens by: Dan Pearson, a colorist in the English garden; Nancy Goslee
 Power, Bold design in the southern California garden; Madison Cox,
 Urban geometry; Patrick Chassé, East meets West: Oriental influences in
 the garden; Alain David Idoux, Land art in Provence; Steven Martino,
 Desert gardening; Ron Lutsko, Native plants and patterns in Northern
 California; Nancy McCabe, New England cottage tradition updated; Piet
 Oudolf, The plantman's garden in Holland; and Louis Benech, Rethinking
 the French formal garden.

616. Finnegan, Patrick. (Govinda Gallery, Washington, D. C.; Exhibit), *New
 Art Examiner* 13 (January 1986): 57-58.

617. "French Afternoons: Portfolio Erica Lennard," *Camera 35* 20, 2 (April
 1976): 58-61.

618. Haus, Mary. "Digging Art," *Art News* 93 (January 1994): 25.

619. Lennard, Erica. *Artists' Garden: From Claude Monet to Jennifer Bartlett.*
 New York: H. N. Abrams, 1993. 208 p.

620. Lennard, Erica. *Classic Gardens.* Introduction by William Howard
 Adams. New York: Lustrum Press, 1982. 126 p. Chiefly illustrations.
 Adams' introduction focuses on the idea and perceptions of the great
 gardens, and Lennard's black and white images of the details and
 fragments of them.
Rambouillet, p. 7; *Versailles,* p. 9, 11, 13, 15, 17, 19, 21; *Versailles, Potager de
Roi,* p. 23, 25; *Versailles, Petit Trianon,* p. 27; *Marly-le-Roi,* p. 29, 31, 33, 35; *Parc
de Sceaux,* p. 37, 39, 41, 43; *Tuileries,* p. 45; *Chantilly,* p. 47, 49; *Chateau de
Brecy,* p. 51; *Villandry,* p. 53; *Compeìgne,* p. 55, 57; *Chateau de Raray,* p. 59;
Courances, p. 61; *Giverny,* p. 63, 65; *Chateau de Montgeoffroy,* p. 67; *Parc de St.
Cloud,* p. 69, 71, 73; *Villa d'Este,* p. 75, 77, 79, 81, 83, 85; *Villa Lante,* p. 87, 89,
91, 93; *Villa Valmarana dei Nani,* p. 95; *Bomarzo,* p. 97; *Villa Rotunda,* p. 99;
Giardini Giusti, p. 101, 103; *Blenheim,* p. 105, 107, 109, 111; *Sisinghurst,* p. 113;
Rousham, p. 115; *Cliveden,* p. 117, 118; *Oxford Botanical Garden,* p. 121; *Hever
Castle,* p. 123; *Hush Heath,* p. 125; *Parc de Sceaux, Self-Portrait,* p. 127.

621. Lennard, Erica and Elizabeth Lennard. *Sunday*. New York: Lustrum Press, 1973. 34 p.

[Boy playing with blocks] p. 3; [Boy on tricycle] p. 7; [Boy with binoculars on tricycle] p. 9; [Girl in white face, sailing small boat] p. 11; [Women in white face on sailboat] p. 13; [Women in white face, holding bicycle] p. 15; [Girl at sea shore] p. 17; [Women by shore] p. 19; [Children on roller skates] p. 21; [Child on forest floor] p. 23; [Child flying small kite] p. 25; [Women with umbrella. 27; [Women with teddy bear outside of leopard cage] p. 29; [Boy at restaurant table] p. 31; [Adults and children at tea party] p. 33.

622. Lennard, Erica. *Women, Sisters*. Afterword by Marguerite Duras, Text by Erica Lennard. Indianapolis: Bobbs-Merrill, 1978. Unpaged.

[Mannequin]; *Elizabeth, California*, spring, 1970; *Elizabeth, Mill Valley, California*, winter, 1973; *Elizabeth, France*, autumn, 1972; *Elizabeth, Hollywood*, spring, 1972; *Elizabeth, California*, winter 1973 (2); *Elizabeth, Stinson Beach*, California, 1973; *Elizabeth, Lindos, Greece*, summer, 1973; *Elizabeth and Linda*, Hollywood, spring, 1973; *Catherine, Paris*, winter, 1974; *Elizabeth, Paris*, winter, 1974; *Catherine, Cannes*, spring 1974; *Lisa, New York City*, winter 1973; *Catherine, traveling*, autumn, 1974; *Catherine, Milan*, winter, 1974; *Elizabeth, les Grands Esclans, France*, spring 1974; *Catherine, Deauville*, winter 1974; *Anne, Neauphle-le-Château, France*, summer 1974; *Catherine, Paris*, winter 1974; *Leslie, California*, summer 1974; *Laura, New York City*, autumn, 1974; *Tessa, New York City*, autumn 1974; *Elizabeth, New York City*, winter 1974; *Racquel, Paris*, winter 1974; *Mona and Valérie, Paris*, winter 1974; *Mona, Paris*, winter 1974; *Carole, San Francisco*, winter 1975; *Tessa, New York City*, winter 1975; *Marcia, New York City*, winter 1975; *Constance, California*, winter 1975; *Tessa, New York City*, winter 1975; *Elizabeth, California*, spring 1975; *Elizabeth and Ichabod, California*, winter, 1975; *Elizabeth, Arles*, summer 1975; *Kyra, Paris*, spring 1975; *My three friends, Stinson Beach, California*, spring 1975; *Crossing the Channel*, summer 1975.

623. Lennard, Erica. *Writers' Houses*. Prologue by Marguerite Duras. Text by Francesca Premoli-Droulers. New York: Vendome Press, 1995. 199 p. Chiefly illustrations.

Numerous photographs of large and intimate spaces, and exterior and interior sections of the homes of famous writers: Karen Blixen (Isak Dinesen) at Rungstedlung, Jean Cocteau at Milly-l-Forét, Gabriele D'Annunzio at Gardone, Carlo Dossi at Dosso Pisani, Lawrence Durrell at Sommières, William Faulkner at Oxford, Mississippi, Jean Giono at Manosque, Knut Hamsun at Nörholm, Ernest Hemingway at Key West, Hermann Hesse at Montagnola, Selma Lagerlöf at Mårbacka, Giuseppe Tomasi di Lampedusa, Pierre Loti at Rochefort, Alberto Moravia at Sabaudia, Vita Sackville-West at Sissinghurst, Dylan Thomas at Laugharne, Mark Twain at Hartford, Virginia Woolf at Rodmell, William

Butler Yeats at Thoor Ballylee, and Marguerite Yourcenar on Mount Desert Island.

624. Murray, Joan. "Separate Paths. (Thackery and Robertson, San Francisco; Exhibit)," *Artweek* 17 (September 20, 1986): 15-16.

Leonard, Joanne, 1940-
See also #1006, 1007, 1008, 1020, 1061, 1067

625. Jordan, Jim. "A Wary Romanticism. (Jeremy Stone Gallery, San Francisco: Exhibit)," *Artweek* 16 (March 9, 1985): 16.

626. Leonard, Joanne. *Inside and Beyond.* Catalogue essay by Lucy R. Lippard. Austin, TX: Laguna Gallery Art Museum, 1980. 16 p.
Critical essay on Leonard's themes and photo-collage series, interspersed with comments by Leonard.
Memo Center and Bee, 1979-80, frontispiece; *Can Opener and Blender with Starry Sky*, 1979, cover; *Sad Dreams on Cold Mornings*, 1971; from the *Journal Series*, 1973; *Kitchen Countertop: Two Electric Can Openers*, 1978; *Iris with Stars and Moon*, 1979; *Julia Daydreaming*, 1977.

627. Leonard, Joanne. "Photographs by Joanne Leonard," *Creative Camera* (January 1973): 6-9.

Lepkoff, Rebecca
See also #1058

Levitt, Helen, 1918-
See also #1008, 1015, 1017, 1058, 1063

628. Baker, L. "Helen Levitt," *Artnews* 91, 3 (March 1992): 138.

629. Bennett, Edna R. "Helen Levitt's Photographs: Children of New York and Mexico," *U.S. Camera* 6, 4 (May 1943): 14-17.

630. Dieckmann, Katherine. "Mean Streets," *Art in America* 78, 5 (1990): 222-229, 263.

631. Delson, S. *"The Moviegoer,"* *Artforum* 30, 4 (December 1991): 76-77.

632. Frank, Peter. "Tales of the City Told By a Lens-Poet of the Sidewalk (Los Angeles County Musuem of Art; Traveling Exhibit)," *Art & Antiques* 17 (March 1994): 118.

633. Hellman, Roberta and Marvin Hoshino, "Helen Levitt," *Arts Magazine* 56,

2 (1981): np.

634. Hellman, Roberta and Marvin Hoshino, "The Photographs of Helen Levitt," *Massachussets Review* 14, 4 (Winter 1978): 729-742.

635. Hopkinson, Amanda. "Street Cred," *British Journal of Photography* 140 (April 22, 1993): 26-27.

636. *In the Street*. New York: Arthouse, 1996. Videorecording. 16 minutes. "Videocassette release of film footage originally photographed between 1941 and 1952." "An extension of the filmmakers' work on the documentary film *The Quiet One* which was concerned with the urban environment." oclc

637. Levitt, Helen. *Helen Levitt: Mexico City*. Essay by James Oles, in Spanish and English. Published by the Center for Documentary Studies in association with W. W. Norton, 1997. 141 p. Bibliography: p. 137-139. Oles' essay, "Helen Levitt's Other City," chronicles the numerous important photographers that have documented the poor of Mexico and the conditions Levitt found as she photographed the city's inhabitants in 1941. The essay is augmented by photographs by Evans, Cartier-Bresson, Weston and others.

638. Levitt, Helen. *Helen Levitt Color Photographs*. Edited by Hellman, Roberta and Marvin Hoshino. El Cajon, CA: Grossmont College, 1980. 32 p. Introduction to this exhibition catalog is a short critical essay on Levitt's color photographs. *[Baby with painted-on mustache, sitting on window ledge]; [Girl looking under car]; [Hot dog street vendor]; [Man leaning on truck]; [Old woman in knit hat]; [Two old women talking]; [Trucks and deliverymen]; [Old woman with cane, on stoop]; [Young man watching newspaper-covered tv]; [Woman in uniform, sitting outside with small dog]; [Man reading newspaper on street]; [Man leaning on parking meter]; [Boys blowing plastic bubbles]; [Children playing near graffiti-filled walls]; [Children leaning on gumball machines]; [Man crouching on sidewalk, with hands in pot]; [Man by red truck]; [Boy on stoop, near small poodle]; [Child on window sill, talking to man in street]; [Woman near magazine stand]; [Two men by wooden door]; [Three roosters and kitchen chairs]; [Woman in black, with dog].*

639. Levitt, Helen. *In the Street: Chalk Drawings and Messages, New York City, 1938-1948*. With an essay by Robert Coles. Durham, NC: Duke University Press, 1987. 105 p. All the photographs are of chalk drawings on sidewalks and buildings, of fat men and guns, children, and lovers and messages on the walls.

640. Levitt, Helen. *A Way of Seeing*. With an essay by James Agee. Durham, NC: Duke University Press, 1989. 84 p. of plates. Third edition with 20 additional photographs.

[Chalk drawing on a frame] pl. 1; *[Chalk drawings]* pl. 2, 3; *[Child as make-believe knight]* pl. 4; *[Children at window sill]* pl. 5; *["Button to secret passage"]* pl. 6; *[Small children in masks]* pl. 7; *[Boys acting]* pl. 8; *[Climbing a tall tree]* pl. 9; *[Child with handkerchief]* pl. 10; *[Hiding on stoop]* pl. 11; *[Children and Ice Man]* pl. 12; *[Playing in wooden box]* pl. 13; *[Boy with ball on head]* pl. 14; *[Open fire hydrant and children]* pl. 15; *[Picking up broken mirror]* pl. 16; *[Bending over carriage]* pl. 17; *[Kneeling at street corner]* pl. 18; *[Two friends]* pl. 19; *[Fighting on top of doorway]* pl. 21; *[Doll carriage and children]* pl. 22; *[Children and ribbon]* pl. 23; *[Twirling circle of ribbon]* pl. 24; *[Play acting]* pl. 25; *[Fighting with tree branch in empty lot]* pl. 26, 27; *[Sliding down poll]* pl. 30; *[Crouching near stoop lion]* pl. 31; *[Playing with toy gun on stoop]* pl. 32; *[Jumping from steps]* pl. 33; *[Boys dancing together]* pl. 34; *[Bending over]* pl. 35; *[Girl holding man from behind]* pl. 36; *[Playing with toy guns]* pl. 37; *[Chalk, "Bill Jones Mother is a Home"]* pl. 38; *[Boy with toy gun]* pl. 39; *[Trying to lift brother]* pl. 42; *[Consoling friend]* pl. 43; *[Looking under car]* pl. 44; *[Mother and daughter by barrel]* pl. 47; *[Women talking]* pl. 48; *[Men not talking]* pl. 51; *[Seated old couple]* pl. 52; *[Girl holding boy on car]* pl. 53; *[Girl with lily]* pl. 54; *[Man holding infant]* pl. 55; *[Women and children]* pl. 56; *[Girl under heavy curtains]* pl. 57; *[Man on open fire hydrant]* pl. 60; *[Girls on truck]* pl. 61; *[Boys hugging]* pl. 62; *[Teenage boy and fat girl]* pl. 63; *[Woman laughing]* pl. 64; *[Woman carrying milk bottles]* pl. 65; *[Couple by front door]* pl. 66; *[Looking at rubble]* pl. 67; *[Woman watering with hose]* pl. 68; *[Men sitting on sewing machines]* pl. 69; *[Man with bathtub on truck]* pl. 70; *[Old man on beach]* pl. 71; *[Nuns by wooden pier]* pl. 72; *[Crossing street near grocery]* pl. 73; *[Old men on chairs, curbside]* pl. 76; *[Old woman knitting while walking]* pl. 77; *[Seated women talking]* pl. 78; *[Man walking dog]* pl. 79; *[Man sitting on truck, talking to himself]* pl. 80; *[Old man holding baby]* pl. 83; *[Dalmatian at foot of stoop]* pl. 84; *[Playing behind table]* pl. 85; *[Young girl walking to woman]* pl. 86.

641. Maddow, Ben. "New York City: Helen Levitt," *Aperture* 19, 4 (1975): 36-43.

642. Mossin, Andrew. "Agee and the Photographer's Art," *Aperture* 100 (Fall 1985): 73-75.

643. Phillips, Sandra S. and Hambourg, Maria Morris. *Helen Levitt*. San Francisco: San Francisco Museum of Modern Art, 1991. 84 p.
 Published on the occasion of the exhibition *Helen Levitt*, organized by the San Francisco Musuem of Art. Essay by Phillips traces Levitt's relation to the history of urban photography and her artistic relationship to other artists with interests in children's lives. The essay by Hambourg is more biographical and traces Levitt's photographic history.

Central Park, New York, 1936, fig. 35; *Untitiled,* 1936-38, fig. 36, 37; *New York,* 1936, fig. 38, 39, 40; *Florida,* c. 1938, fig. 41; *New York,* 1946, fig. 44; Untitled detail from film footage of three gypsy boys, 1944-45, fig. 46; Untitled detail from film footage of Yorkville parade, 1944-45, fig. 47; *New York,* c. 1940, fig. 48; *New York,* c. 1938, pl. 1, 4, 9, 10, 11; *New York,* 1938, pl. 2, 5, 6, 15, 18, 24, 33; *New York,* 1940, pl. 3, 27, 37, 38, 44; *New York,* 1939, pl. 7, 8, 22, 25, 28, 34, 36, 41, 46; *New York,* 1942, pl. 12; *New York,* c. 1939, pl. 13, 16, 17, 19; *New York,* c. 1940, pl. 14, 30, 40; *New York,* c. 1945, pl. 20, 23, 31, 32, 43, 47, 48; *New York,* c. 1942, pl. 21, 26, 29, 35, 39, 45; *New York,* 1944, pl. 42; *Mexico,* 1941, pl. 49, 50, 51, 52; *New York,* 1983, pl. 53; *New York,* 1985, pl. 54; *New York,* 1981, pl. 55; *New York,* 1978, pl. 56, 77; *New York,* 1982, pl. 57, 59, 60; *New York,* 1986, pl. 58; *New York,* 1959, pl. 61, 62; *New York,* 1972, pl. 63, 65, 69, 73, 74, 75, 76, 78, 81, 84; *New York,* 1980, pl. 64; *New York,* 1974, pl. 66; *New York,* 1971, pl. 67, 68, 71, 72, 79, 80, 82, 83.

644. Phillips, Sandra S. "Helen Levitt's Cropping," *History of Photography* 17 (Spring 1993): 121-125.

645. *The Quiet One.* Mayer-Burstyn, 1989, 1948. Videorecording. 63 minutes. Written and edited by Helen Levitt.
 "An award-winning documentary filmed on the streets of Harlem in the late 1940's which shows the devastating psychological effects of life in the ghetto on a ten year-old boy named Donald." oclc

646. Soby, James T. "The Art of Poetic Accident: The Photographs of Cartier-Bresson and Helen Levitt," *Minicam Photography* 6, 7 (March 1943): 28-31, 95.

647. Tillim, S. "Photography and Remembrance," *Artforum* 30, 4 (December 1991): 74-78.

Lewis, Mrs. J. B.
 See also #1000
Lewis, Ritz Kurtz
 See also #1071
Lewison, Brenda J.
 See also #1071
Lidz, Jane

648. *Historic American Buildings Survey. [Santa Clara County, California]: Photographs, Historical and Descriptive Date.* Washington, D.C.: National Park Service, Department of the Interior, 1936-1980. 2 Volumes, loose leaf.

649. Lidz, Jane. *One of a Kind.* New York: A & W., 1982. 32 p. Chiefly

illustrations.
Photographic essay on the life of Lidz's dog Zak.

650. Lidz, Jane. *Rolling Homes: Handmade Houses On Wheels*. New York: A
 & W Visual Library, 1979. 96 p. Chiefly illustrations.
 Color portfolio of the interiors and exteriors of handmade houses. Some
 of the houses had been buses, some had been trucks, all are still mobile.

651. Moore, Charles Willard. *Water and Architecture*. Photographs by Jane
 Lidz. New York: H. N. Abrams, 1994. 224 p. Chiefly illustrations.
 Throughout the centuries, architecture has been used in conjunction with
 water. The text and photographs are accompanied by documentary
 illustrations and architectural plans.
*Private home built within late medieval fortifications with modern renovations,
Bornos Spain, p. 1, 177; Solana, Westlake, TX, p. 2, 29, 112; Wateridge Marketing
Pavilion, San Diego, p. 4, 130, 132; Château de Chenoceaux, spanning the river
Cher, France, p. 8-9; Rites of Spring Fountain: Love (The Lips), Paris, p. 11; Trevi
Fountain, Rome, p. 12-13, 24-25; Byodo-in, Kyoto, Japan, p. 14; Venice, p. 26-27;
Lighthouse, San Giorgio, Venice, p. 28; Saiho-ji, Kyoto, p. 30-31; Bank of China,
Hong Kong, p. 32; Villa Lante, Bagnaia, Italy, p. 33; Fort Worth Water Gardens,
TX, p. 34, 36-37; Ryoan-ji, Kyoto, p. 35; Ritual Baths, Sebatu, Bali, p. 50; Avenue
of the One Hundred Fountains, Villa d'Este, Tivoli, Italy, p. 51-52; Farnese
Fountain, Rome, p. 53; Saint Francis Woods, San Francisco, p. 54; Tartarughe
Fountain, Rome, p. 55; Plaza de España, Seville, Spain, p. 56-57, 96-97; Fountain
of the Four Rivers, Rome, p. 58; Il Moro Fountain, Rome, p. 59; Barcaccia
Fountain, p. 60; Fountain of Joy, Siena, p. 61; Villa de'Este, Tivoli, p. 62-63;
Waterfalls at L'Esposizione Universale di Roma, Rome, p. 64; Generalife,
Granada, Spain, p. 65; Hyatt Regency Scottsdale at Gainey Ranch, Scottsdale, AZ,
p. 66; HemisFair Park, San Antonio, TX, p. 67; Fountain Place, Dallas, TX, p. 68-
69; Prometheus, Rockefeller Center, New York City, p. 70; Rites of Spring
Fountain: The Firebird, Paris, p. 71; Fort Worth Water Gardens, TX, p. 72-73;
Precious Belt Bridge, Suzhou, China, p. 74-75; Venice, p. 86-87; River Walk, San
Antonio, TX, p. 88-89; Lu Zhi, China, p. 90; Suzhou, China, p. 91-93; Bruges,
Belgium, p. 94; Lower Slaughter, Wiltshire, England, p. 95; Ponte Vecchio,
Florence, Italy, p. 98-99; Pulteney Bridge, Bath, England, p. 100; Palladian
Bridge, Bath, England, p. 101; The Thames, Westminster Bridge and Big Ben,
London, p. 102-103; San Giorgio Maggiore and campanile, Venice, p. 104; The
Thames, Blackfriars Bridge and St. Paul's, London, p. 105; The Seine, Pont Neuf,
and Île de la Cité, Paris, p. 106; Bangkok, Thailand, p. 107; Near the Grand Canal,
Suzhou, China, p. 108-109; Kintai Bridge, Iwakuni, Japan, p. 110; Hoover Dam,
Arizona-Nevada border, p. 111; Salk Institute for Biological Studies, La Jolla, CA,
p. 113; Brion Cemetery, San Vito d'Altivole, Italy, p. 114-115; Court of the Lions,
The Alhambra, Granada, Spain, p. 116-117; Jefferson Memorial, Washington,
D.C., p. 118-119; Washington Monument, Washington, D.C., p. 131; Plaza Tower,
Costa Mesa, CA, p. 133; Lap pool, private home built within medieval fortifications*

with modern renovations, p. 134; *Pink House, Miami, FL*, p. 135; *World's Fair Wonder Wall, New Orleans, LA*, p. 136-137; *Court of the Myrtles, The Alhambra, Granada*, p. 138; *Roman Pool (indoor) Hearst Castle, San Simeon, CA*, p. 139, 141; *Neptune Pool (outdoor) Hearst Castle, San Simeon, CA*, p. 140; *King's Bath, Bath, England*, p. 142; *Roman Bath and Abbey, Bath, England*, p. 143; *Claude Monet's water garden, Giverny, France*, p. 144, 146; *Stourhead Gardens, Wiltshire, England*, p. 145; *Shugaku-in, near Kyoto, Japan*, p. 147; *Phoenix Hall, Byodo-in, Kyoto*, p. 148-149; *Zhouzheng Yuan, Suzhou, China*, p. 150, 211; *Temple West Garden, Suzhou, China*, p. 151; *Reflection of Kinkaku-ji, Kyoto*, p. 152; *Pool, Amandari, Ubud, Bali*, p. 153; *Tokyo Sea Life Park, Japan*, p. 154-155, 178-179, 214-215; *Sandcastle, San Francisco, CA*, p. 166; *Mont-Saint-Michel, Normandy, France*, p. 167-169; *Tanah Lot, Bali*, p. 170; *Ulu Danu, Lake Bratan, Bali*, p. 171; *Lopez Island docks, San Juan Islands, Washington*, p. 172; *Philipsburg, Sait Maarten, Dutch West Indies*, p. 173; *Levi Strauss Plaza, San Francisco, CA*, p. 174; *Heian Jingu, Kyoto*, p. 175; *Oceanside Civic Center, CA*, p. 176; *Seattle Aquarium, Washington*, p. 180; *"Shark Experience," Marine World Africa U.S.A., Vallejo, CA*, p. 181; *Maritime Theater, Hadrian's Villa, Tivoli, Italy*, p. 182; *Cultural Center Plaza, Kowloon, Hong Kong*, p. 183; *Palazo Ducale and campanile, Venice*, p. 184; *Hong Kong*, p. 185; *Portofino, Italy*, p. 186; *Port de Gustavia, Saint Barthélemy, French West Indies*, p. 187; *Sea Ranch Condominium, Sea Ranch, CA*, p. 188-189; *Cruise ship, Caribbean*, p. 190; *Golden Gate Bridge, San Francisco, CA*, p. 191; *Torii Gate, near Mayajima Island, Inland Sea, Japan*, p. 192-193; *"Water Use" Fountain, Costa Mesa, CA*, p. 194-195; *Fallingwater, Bear Run, Pennsylvania*, p. 196; *Jefferson Memorial, Washington, D.C.*, p. 205; *Customs House and Santa Maria dell Salute, Venice*, p. 206-207; *Grand Wailea Resort, Maui, Hawaii*, p. 208-209; *Bang Pa-in, Thailand*, p. 210; *The Mirage, Las Vegas*, p. 212; *Roman Bath, Bath, England*, p. 213.

Liftin, Joan
 See also #1070
Lindroth, Linda
 See also #1006

Lipper, Susan
 See also #1008

652. Badger, Gerry. "Southern Discomfort. (Tell the Women We're Going--the Appalachian Portraits of Susan Lipper: Photographer's Gallery, London; Exhibit)," *British Journal of Photography* 141 (February 17, 1994): 12-13.

653. Lipper, Susan. *Grapevine: Photographs by Susan Lipper*. Manchester, England: Cornerhouse, 1994. 111 p. Chiefly illustrations.
 A series of photographs taken over five years, in Grapevine, West Virginia. This work also includes the transcript of interviews recorded in

1993.

[Deer hanging from basketball pole] p. 9; *[Elvis blanket hanging on a clothesline]* p. 11; *[Trailer in woods]* p. 13; *[Man with pistol near broken ambulances]* p. 15; *[Women in towel, combing hair]* p. 17; *[Doll on large chair]* p. 19; *[Woman holding young boy]* p. 21; *[Women with string of fish, near parked cars]* p. 23; *[Man drinking beer]* p. 24; *[Looking out window with bullet holes]* p. 25; *[Bearded man at cafe table]* p. 27; *[Women talking at kitchen table]* p. 29; *[Shirtless boy near trees]* p. 31; *[Fresh produce sign in trees]* p. 33; *[Boy opening bottle]* p. 35; *[Girl holding pumpkin on pillow, while sitting on couch]* p. 37; *[Television set on]* p. 39; *[Hands with cigarettes and lighter]* p. 45; *[Man with ski mask watching tire burn]* p. 47; *[Man bending over]* p. 49; *[Boy near man on mattress]* p. 50; *[Man and woman 'wrestling']* p. 51; *[Barbie dolls, without clothes, hanging on shower rack]* p. 53; *[Baby in bathtub]* p. 55; *[Photographs and certificates over fish tank]* p. 57; *[Man reading newspaper and woman smoking]* p. 59; *[Man holding child upside down]* p. 61; *[Inhaling smoke of another]* p. 63; *[Man behind cracked truck window]* p. 65; *[Smoking man with gun and dead rabbit]* p. 66; *[Fire near parking lot]* p. 67; *[Raccoons snarling]* p. 69; *[Masked and hooded member of the Christian Knights]* p. 71; *[Old car with dark spots near wooden porch]* p. 73; *[Man in rubber mask]* p. 74; *[Snake on bed]* p. 75; *[Man showing stomach scars]* p. 77; *[Deer crossing road]* p. 79; *[Man with ball, in bedroom]* p. 81; *[Shirtless man drinking beer]* p. 83; *[Men on porch with beer and rifle]* p. 85; *[Pitching horseshoes in woods]* p. 87; *[Young girl on porch]* p. 89; *[Black dogs on porch]* p. 91; *[Drinking beer in swimming pool]* p. 93.

654. Smith, Caroline. "Across the Great Gender Divide, (Interview)" *Women's Art Magazine* 61 (November/December 1994): 18-19.

Little Turtle, Carm, 1952-
 See also #1029, 1055

655. *Carm Little Turtle Slide Lecture, November 2, 1992.* Albuquerque, NM: Oral History Program, University of New Mexico, 1992. Videorecording, 120 minutes.
 "Carm Little Turtle is a Native American Photographer whose work captures contemporary Native American humor. She also addresses the commercialization of her heritage by contemporary culture." oclc

656. Pontello, Jacqueline M. "Carm Little Turtle," *Southwest Art* 20 (April 1991): 120.

Livingston, Jacqueline
 See also #1006
Lloyd, Susan G.
 See also #1072
Logan, Fern
 See also #1040

Lohrke, Deborah
>See also #1055

Loomis, Maurine
>See also #1025

Lopez, Martina
>See also #1000

Louise, Ruth Harriet
>See also #1058

Lynne, Jill
>See also #1006, 1070

Lyons, Joan
>See also #1007, 1008

Macadams, Cynthia
>See also #1004

657. MacAdams, Cynthia. "Emergence," *Camera 35* 23, 5 (June 1978): 58-65+.

658. MacAdams, Cynthia. *Rising Goddess*. Dobbs Ferry, NY: Morgan and Morgan, 1983. 115p. Chiefly illustrations.
Preface by Kate Millett and introduction by Margaretta K. Mitchell describing the nude photographs of women both "in nature and *as* nature."

McCutchen, Mrs. Charles
>See also #1009

McKenna, Rollie (Rosalie Thorne), 1918?-

659. Burchard, Peter. *Harbor Tug*. Photographs by Rollie McKenna. 1975. 62 p.
Children's book on the work of the harbor tug.

660. *The Days of Dylan Thomas*. Film. Distributed by McGraw-Hill Book Company, 1965.

661. "Five Portraits by Rollie McKenna," *U.S. Camera Annual* (1955): 68-72.

662. McKenna, Rollie. *Artists at Large: Photographs By Rollie McKenna*. Exhibition and catalogue organized by Robert M. Doty; with a preface by John Malcolm Brinnin. Manchester, NH: Currier Gallery of Art, c. 1982. 18 p. Bibliography: p. 18.
Dame Edith Sitwell,, cover; *Eudora Welty and John Malcolm Brinnin,* 1954; *Anne Sexton,* 1961; *Robert Frost,* 1951; *Roman Vishniac,* 1959; *The Hands of Helen Keller,* 1958; *Helen Keller in her garden,* 1958; *Dylan Thomas, in his study,* 1953;

Caitlin, Aeron and Colm Thomas, 1953; *James Dickey*, 1969; *Tom Wolfe*, 1970; *Titina Maselli*, c. 1954; *James Merrill*, 1969; *Alexander Calder*, 1958.

663. McKenna, Rollie. "Free-Wheeling Portraiture," *Popular Photography* 47, 5 (November 1960): 74-77, 101-103.

664. McKenna, Rollie. *Rollie McKenna: A Life in Photography.* Foreword by Richard Wilbur. New York: Alfred A. Knopf, 1991. 279 p.
 An autobiographical portfolio of work accompanied by McKenna's explanations of her attitude as she took the pictures as well as the important events in her life. The following are included with the photographs: Technical notes, a Chronology, lists of exhibitions and a short bibliography.

Maria Sozzani (Mrs. James Brodsky), 1990 p. iii; *James Earl Jones as* The Emperor Jones, 1960 p. iv; *Galway Kinnel*, 1961, p. v; *Florida*, c. 1950 p. vi; *Greece*, 1972 p. vii; *Ann Taylor and her daughter, Alyssa*, 1970 p. viii; *Colm Thomas, Dylan Thomas on, Laugharne, Wales*, 1953 p. ix; *Lovers beside the Seine, Paris*, 1950 p. x; *Mrs. Edward Palmer York, Stonnington, Connecticut*, c. 1964 p. xi; *The Boboli Gardens, Florence, Italy*, 1951 p. xii; *John Malcolm Crinnin*, p. xiii; *[Landscape of wooden shacks]* p. 11; *[Eudora Welty and remaining columns of plantation]* p. 12; *[Wooden church, St. Peter Baptist]* p. 13; *[Old Black woman crossing street]* p. 14; *[Wooden store, Pearson Merc. Co.]* p. 15; *[Fat man in hat]* p. 16; *[Fat woman in jacket]* p. 17; *[Bottles on the tips of tree branches]* p. 18; *[Black mother and children on porch]* p. 19; *[Colored Cafe]* p. 20; *[Club Desire]* p. 21; *[Spirit of cooperation]* p. 21; *Bel and Roger Generelly, Rye Beach, New Hampshire*, 1933, p. 24; *With Helen Taggart, 1936*, p. 25; *Jack Hulburd*, c. 1938, p. 26; *Victor Corse Thorne*, c. 1940, p. 27; *[Knitting by the Baptistery in Siena, 1951]* p. 33; *[Young fishing guide, Bahamas, 1960]* p. 35; *[Black woman with crying baby and young boy, Mississippi, 1954]* p. 37; *[Nude in outdoor shower, Key West, 1989]* p.39; *A Penitente Cemetery in Talpa, New Mexico* p.41; *Thorne House in Taos, New Mexico*, 1940 p.43; *[Bleached skulls with horns]* p.45; *[Old Mission Church in Nambé]* p.47; *[Mary Lou Aswell]* p.48; *[Agi Sims]* p.48; *[Honorable Dorothy Brett]* p. 49; *[Andrew Dasburg, 1962]* p. 50; *[Winfield Townley Scott]* p. 51; *[Witter Bynner, 1962]* p. 52; *[Laura Gilpin, 1977]* p. 53; *In the Vassar Lab*, 1941, p. 55; *[Small Plane over Water]*, p. 56; *Daniel W. Jones*, 1940, p. 57; *An Old-law Tenement on Eighty-eighth Street in New York*, c . 1948, p. 60; *Marcel Lajos Breuer*, c. 1946, p. 61; *Connie Breuer*, c. 1946, p. 62; *[New York Skyline]*, early 1950s, p. 63; *[Times Square]*, early 1950s, p. 64; *[New York Skyscrapers]*, early 1950s, p. 65; *[Three people on a park bench]*, early 1950s, p. 66; *[Sleeping on a bin on Beekman Street]*, early 1950s, p. 67; *[Woman's face]*, n.d., p. 68; *[Rumpled newspaper on street]*, p. 69; *[Playing bocce in front of the United Nations]*, early 1950s, p. 70; *[Interior of Guggenheim Museum]*, 1959?, p. 71; *Professor Richard Krautheimer*, c. 1950, p. 73; *Millbrook, New York*, 1948, p. 74; *Fontainebleu*, 1948, p. 75; *Pamela Preston, Venice*, 1948, p. 76; *John Cranko and Henry Leighton*, p. 77; *Poistano*, 1948, p. 77; *[Italy]*, 1948, p. 79; *[Shadow of*

Michelangelo's David], 1948, p. 80; *[Torre dell'Orologio]*, 1948, p. 81; *Self-portrait*, 1949, p. 83; *Main Hall, Vassar College*, 1948, p. 84; *With Danny Jones*, 1949, p. 85; *[Vassar College graduates]*, 1965, p. 87; *[Freshman with suitcases passing through Taylor Gate]*, c. 1965, p. 88; *[Women students on floor with record player]*, c. 1965, p. 89; *[Class meeting under a tree, Vassar]*, c. 1965, p. 90; *[Taking notes in class, Vassar]*, c. 1965, p. 91; *Madame Laure, Paris*, 1950, p. 93; *Don Perry on the* <u>Liberté</u>, 1950, p. 94; *"Otsy" in Switzerland*, 1950, p. 95; *Truman Capote and John Malcolm Brinnin, Venice*, 1950, p. 95; *Angelo, Sacristan of San Lorenzo, and His Family*, 1950, p. 96; *Self-Portrait at the Berchielli*, 1950, p. 97; *Venice*, 1950, p. 98; *[Alberti's Santa Maria Novella in Florence]*, c. 1950, p. 99; *[The Duomo]*, c. 1950, p. 101; *[Brunelleschi's aedicula]*, c. 1950, p. 100; *[In Florence, San Lorenzo interior]*, c. 1950, p. 102; *Detail of the entrance door of San Spirito in Florence designed by Brunelleschi*, c. 1950, p. 103; *Detail of the "Gates of Paradise" at the Baptistery in Florence designed by Ghiberti*, c. 1950, p. 104; *[Villa Malcontenta]*, 1950, p. 104; *[Villa Rotonda, near Vicenza]*, 1950, p. 105; *Piazza dell'Erbe*, 1950, p. 106; *[Ghiberti's Solomon Panel from the "Gates of Paradise" at the Baptistery]*, 1950, p. 107; *Sant' Andrea in Mantua*, 1950, p. 108; *Palladop's Loggia del Capitano in Vicenza*, 1950, p. 109; *[On the Grand Canal, in Venice, the Venetian Gothic Ca' d'Oro]*, 1950, p. 110; *San Marco's Domes*, 1950, p. 111; *[Bedouin man in desert hunting with a hawk]*, 1950, p. 113; *[Dasman Palace, Kuwait]*, 1950, p. 114; *[Ezzat, in a* <u>dishdasha</u>, *leaning against a car]*, 1950, p. 115; *[Two men holding falcons]*, 1950, p. 116; *[Men with falcons, standing in a convertible]*, 1950, p. 117; *[Releasing the falcons]*, 1950, p. 118; *[Fires by the tent]*, 1950, p. 119; *[Man smoking hubble-bubbles on the curb, Kuwait City]*, 1950, p. 120; *[Silhouette of a Kuwaiti]*, 1950, p. 121; *Detail from the "Gates of Paradise" by Ghiberti*, c. 1951, p. 123; *David Wright*, 1951, p. 124; *At Dylan Thomas's Boat House, Laugharne, Wales*, 1953, p. 125; *Dylan Thomas*, c. 1953, p. 127; *[Dylan's Mother Florence and her granddaughter Aeron]*, c. 1953., p. 128; *[Dylan Thomas' house, "The Boat House"]*, c. 1953., p. 128; *[The village of Laugharne]*, c. 1953, p. 129; *[Walking in the sand]*, c. 1953, p. 130; *[Aeron, Colm and Caitlin in the wood]*, c. 1953, p. 131; *Dylan Thomas*, c. 1953, p. 133; *[John, Dylan and Caitlin]*, c. 1953, p. 134; *Dylan Thomas*, c. 1953, p. 135; *Caitlin Thomas*, 1957, p. 136; *Dylan Thomas*, c. 1953, p. 137; *Robert Graves at the Poetry Center*, 1951, p. 139; *Truman Capote at the Poetry Center*, 1951, p. 139; *Sir Herbert Read at the Poetry Center*, 1951, p. 139; *Elizabeth Bishop*, 1951, p. 140; *Elizabeth Bishop*, 1954, p. 141; *Elizabeth Bishop*, 1969, p. 141; *Marianne Moore*, 1951, p. 143; *John Betjeman*, 1961, p. 144; *David Gascoyne*, p. 145; *Dr. Edith Sitwell*, 1953, p. 147; *Jean Garrigue*, 1952, p. 148; *Robert Frost*, p. 149; *T.S. Eliot*, p. 151; *Ezra Pound*, 1968, p. 152; *Thornton Wilder*, p. 153; *James Dickey*, p. 154; *Derek and Margaret Walcott*, 1969?, p. 155; *Henry-Russell Hitchcock*, 1954, p. 157; *Bullfight in Lima, Peru*, 1954, p. 158; *Crucifix by Mathais Goeritz, Mexico*, c. 1954, p. 159; *Tile Wall, Elementary School Pedregulho, Rio de Janeiro by Candido Portinari*, 1954, p. 160; *Caracas, Venezuela*, 1954, p. 161; *Elementary School Pedregulho, Rio de Janeiro*, 1954, p. 163; *Nova Cintra, Bristol and Nova Caledonia Apartment Houses*, 1954, p. 164; *[Oscar Niemeyer's house]*, 1954, p.

165; *[Interior of Max Cetto's house, Mexico]*, 1954, p. 166; *[The façade, Central Library of the National Autonomous University of Mexico]*, 1954, p. 167; *Edmund Wilson*, 1957, p. 169; *The Staff of the Museum of Modern Art*, 1960, p. 170; *Fire at MOMA*, April 15, 1958, p. 171; *Katherine Anne Porter*, 1956, p. 172; *Eleanor Roosevelt*, 1961, p. 173; *[Senior Citizens Dancing]*, late 1950s, p. 175; *[Hands of Helen Keller and Polly Thompson]*, c. 1956, p. 176; *[Helen Keller and Polly Thompson]*, c. 1956, p. 177; *[Helen Keller in a garden]*, c. 1956, p. 178; *[Helen Keller with her dog]*, c. 1956, p. 179; *[High voltage X-ray machine]*, 1956, p. 180; *["Dead room" used to test speakers]*, 1956, p. 180; *[Light bulb being tested]*, 1956, p. 181; *Rudolf Serkin and Alexander Schneider*, 1958, p. 182; *[Young cellist practicing]*, 1958, p. 183; *Roman Vishniac*, late 1950s, p. 184, 185; *[Museum of Modern Art Sculpture Garden covered in snow]*, c. 1957, p. 187; *[Georgia O'Keeffe and René d'Harnoncourt]*, c. 1958, p. 188; *[At the Jackson Pollock show]*, 1958, p. 188; *Edward Steichen, Suzy Parker, and Richard Avedon*, late 1950s, p. 189; *[Child painting]*, 1958-1962, p. 190; *[Alfred H. Barr, Jr. and Gaston Lachaise's buxom nude]*, 1956-1962, p. 191; *Henry Sanford Thorne*, c. 1954, p. 193; *At Bang Bang in 1960*, p. 194; *Henry*, c. 1956, p. 194; *The Bang Bang Club*, 1960, p. 195; [Guide on skiff], p. 196; *Bonefishing*, p. 197; *Marino Marini*, 1951, p. 200; *Henry Moore*, 1951, p. 201; *Alexander Calder in His Studio*, 1958, p. 202; *Alexander Calder*, 1958, p. 203; *Derek Jacobi, age 16*, 1957, p. 204; *Erick Hawkins, age 77, as Captain Ahab*, 1986, p. 205; *Lizzie Spender*, 1969, p. 206; *Bill Brandt*, 1953, p. 206; *Roberto Burle Marx*, 1954, p. 208; *John Piper*, p. 209; *Titina Maselli*, 1953, p. 210; *John Minton*, p. 211; *John Osborne*, 1957, p. 212; *Tom Wolfe*, p. 213; *Danny Jones*, c. 1966, p. 215; *Patricia Duell Willson*, 1962, p. 216; *Gini, Vicki, Pud and Freer Willson, Pat's Children*, 1967, p. 217; *Stonington, Connecticut, from the air*, 1964, p. 218; *Pat*, 1964, p. 219; *Stonington*, 1964, p. 219; *Heidi and Louis MacNeice*, 1954, p. 220; *With Howard Moss, John Brinnin and Bill Read*, 1961, p. 221; *Louise Bogan*, c. 1953, p. 222; *Joseph Brodsky*, 1990, p. 222; *With Peter Burchard*, 1974, p. 223; *Tug-Boat in New York*, 1974, p. 223; *[Pilings, remnants of a pier]*, p. 224; *[Crates and a dog]*, 1960s-1970s, p. 226; *[Man with net]*, 1960s-1970s, p. 227; *[On the pier]*, 1960s-1970s, p. 227; *[Stonington, Library Square]*, 1960s-1970s, p. 228; *[Stonington, cocktail party near the harbor]*, 1960s-1970s, p. 229; *[Sudden squall in the harbor]*, 1960s-1970s, p. 230; *[Waves battering the window]*, 1960s-1970s, p. 231; *[Herring gulls in flight]*, 1960s-1970s, p. 232; *[Moonlight on the water]*, 1960s-1970s, p. 233; *Rollie and Pat*, 1969, p. 235; *Pat*, 1980, p. 235; *Ann Taylor at Loch Ness*, 1981, p. 236; *Lilo Raymond*, 1985, p. 237; *Bel Bacon Pope, Rollie's Mother at seventy five and eighty-five*, p. 238; *Marie-Claire Blais, the Novelist and Playwright*, 1986, p. 239; *John Hersey, the Writer*, 1989, p. 240; *Shrimp Boat*, p. 240; *A Kiss from Captiva at Grassy Key, Marathon*, p. 240; *Pelicans*, p. 241; *James Merrill the poet in 1953, 1969 and 1990*, p. 243; *W. H. Auden*, 1951, p. 244; *W. H. Auden*, 1969, p. 245; *Elizabeth Hardwick*, 1962, p. 246; *Elizabeth Hardwick*, 1969, p. 247; *W. S. Merwin*, 1960, p. 248; *W. S. Merwin*, 1969, p. 249; *Anne Sexton*, 1961, p. 250; *Anne Sexton*, 1968, p. 251; *Robert Lowell*, 1951, p. 252; *Robert Lowell*, 1969, p. 253; *Richard Wilbur*, 1951, p. 254; *Richard Wilbur*, 1986, p. 255; *Barbara*

Howes, 1953, p. 256; *Barbara Howes*, 1969, p. 257; *Leonard Bernstein*, 1957, p. 258; *Leonard Bernstein* 1989 p. 259; *Thom Gunn*, 1957, p. 260; *Thom Gunn*, 1969, p. 261; *Alison Lurie*, 1961, p. 262; *Alison Lurie*, 1986, p. 263; *John Berryman*, 1951, p. 264; *John Berryman*, 1969, p. 265; *Robert Graves*, 1961, p. 266; *Robert Graves*, 1969, p. 267.

665. McKenna, Rollie. *Portrait of Dylan: A Photographer's Memoir.* Introduction by John Malcom Brinnin. Owings Mills: MD, 1982. 111 p. This is a compilation of photographs taken in Laugharne, Carmarthenshire in Wales of Dylan Thomas and his family, only two months before his death. There is text throughout the volume, with untitled photographs of his family, the town, events in Thomas' life, Thomas and cast rehearsing Under Milk Wood, the cemetery where he is buried, and quotes from his writings.

666. McKenna, Rollie. "Why Can't a Women?" In : *Yachting Under Sail.* New York: Yachting Publishing Co., 1960: 38-41.

667. *The Modern Poets: An American-British Anthology.* Edited by John Malcolm Brinnin and Bill Read. Photographs by Rollie McKenna, 1970. 428 p.

Dannie Abse, p. 1; *Conrad Aiken*, p. 5; *Kingsley Amis*, p. 12, 15; *W. H. Auden*, p. 15; *Robert Bagg*, p. 21; *George Barker*, p. 24; *John Berryman*, p. 29; *John Betjeman*, p. 31; *Elizabeth Bishop*, p. 35; *Louise Bogan*, p. 42; *Philip Booth*, p. 46; *John Malcolm Brinnin*, p. 49; *John Ciardi*, p. 53; *Tram Combs*, p. 57; *Hilary Corke*, p. 62; *Alan Dugan*, p. 72; *Richard Eberhart*, p. 75; *T. S. Eliot*, p. 78; *D. J. Enright*, p. 94; *Irving Feldman*, p. 97; *Robert Fitzgerald*, p. 103; *Robert Frost*, p. 109; *Jean Garrigue*, p. 116; *David Gascoyne*, p. 122; *W. S. Graham*, p. 125; *Robert Graves*, p. 128; *Thom Gunn*, p. 135; *Michael Hamburger*, p. 143; *John Heath-Stubbs*, p. 147; *Anthony Hecht*, p. 150; *Daniel Hoffman*, p. 158; *John Hollander*, p. 161; *Barbara Howes*, p. 166; *Ted Hughes*, p. 170; *Randall Jarrell*, p. 174; *Elizabeth Jennings*, p. 180; *Galway Kinnell*, p. 183; *Stanley Kunitz*, p. 187; *Joseph Langland*, p. 192; *Philip Larkin*, p. 196; *John Lehmann*, p. 201; *Cecil DayLewis*, p. 206; *Robert Lowell*, p. 210; *Archibald Macleish*, p. 219; *Louis Macneice*, p. 223; *James Merrill*, p. 228; *W. S. Merwin*, p. 232; *Marianne Moore*, p. 236; *Howard Moss*, p. 245; *Howard Nemerov*, p. 251; *Sylvia Plath*, p. 255; *William Plomer*, p. 259; *John Crowe Ransom*, p. 273; *Henry Reed*, p. 279; *Alastair Reid*, p. 282; *Anne Ridler*, p. 285; *Theodore Roethke*, p. 292; *Muriel Rukeyser*, p. 299; *Delmore Schwartz*, p. 303; *Winfield TownleyScott*, p. 308; *James Scully*, p. 311; *Anne Sexton*, p. 316; *Karl Shapiro*, p. 321; *Louis Simpson*, p. 327; *Edith Sitwell*, p. 333; *William Jay Smith*, p. 338; *W. D. Snodgrass*, p. 341; *Stephen Spender*, p. 346; *George Starbuck*, p. 351; *Wallace Stevens*, p. 355; *May Swenson*, p. 364; *Dylan Thomas*, p. 371; *John Wain*, p. 379; *Robert Penn Warren*, p. 383; *Vernon Watkins*, p. 388; *Richard Wilbur*, p. 393; *William Carlos Williams*, p. 401; *David Wright*, p. 408.

McLaughlin-Gill, Frances, 1919-
 See also #1058, 1070
MacNeil, Wendy Synder, 1943-
 See also #1007, 1058, 1063
Mandel, Rose, 1910-
 See also #1058
Mandelbaum, Ann
 See also #1006, 1070, 1072

Mann, Sally, 1951-
 See also #1008, 1010, 1033, 1036, 1052, 1058, 1063

668. "Art Exhibit," *Art in America* 75 (January 1987): 140.

669. Aukeman, Anastasia. "Sally Mann," *Art in America* 81, 2 (February 1993): 113-114.

670. *Blood Ties: The Life and Works of Sally Mann*. Sydney, N.S.W.: SBS, 1995. Videorecording, 33 minutes.
 Lecture exploring the life of Sally Mann.

671. Coleman, A.D. "Child Minders," *British Journal of Photography* 140 (April 22, 1993): 28-29.

672. Douglas, Anna. "Blood Ties (Interview)," *Women's Art Magazine* 59 (1994): 20-21.

673. Eugenides, Jeffrey. "'Hayhook': A 1989 Photograph by Sally Mann," *Artforum* 33, 4 (December 1994): 56-57.

674. Gordon, M. "Sexualizing Children, Thoughts on Sally Mann," *Salmagundi - A Quarterly of the Humanities and Social Sciences*, 111 (Summer 1996): 144-145.

675. Harris, Melissa. "Truths Told Slant," *Artforum* 30 (Summer 1992):102-4.

676. Jenkins, Steven, "Motherly Love (Center for Photographic Art, Carmel, California; exhibit)," *Artweek* 24 (June 3, 1993): 19.

677. Jones, Kristin M. "Sally Mann. (Houk Friedman, New York; exhibit)," *Artforum* 34 (December 1995): 86-87.

678. Mann, Sally. *At Twelve: Portraits of Young Women*. Introduction by Ann Beatie. New York: Aperture, 1988. 54 p. Unpaged. Chiefly illustrations.
[Girl in slip, sitting on couch];[Girl in bathing suit on lawn chair]; [Girls holding

a portrait of themselves]; [Girl holding baseball bat, leaning against brick wall]; [Girl in floral shirt]; [Girl leaning against blankets in clothesline]; [Girl in nightgown on small suspension bridge]; Sherry and Sherry's grandmother, both a twelve years old; Pre-teen Miss Rockbridge gets braces; [Girl on couch in Calvin Klein shirt]; [Girl in knit cap]; [Girl, on crutches, in ballet costume]; [Girl in strapless dress on pedestal]; [Back of girl with braid]; [Two girls leaning against tree]; [Girl, face hidden by leaves, leaning against tree]; [Girl holding bottle of Tab]; [Girl by battle mural]; [Girl in car with cracked windshield]; [Girl on hood of car]; [Girl pretending to hang herself]; [Girl in white shirt near deer carcases]; [Girls on backyard swings]; [Girl and guys under trees]; [Girls on front steps]; [Girl on bed with an infant]; [Woman fixing hair of girl in party dress]; [Girl sitting by car, near kissing couple][Semi-nude pregnant woman leaning on sink]; [Naked child lying on woman on lounge chair]; [Girl sitting in front of clothesline full of jeans]; [Girl in cowboy hat and western shirt]; [Girl in shorts near man in dirty shirt]; [Girl on front porch with father]; [Girl sitting on father's lap].

679. Mann, Sally. *Captured Images, Sally Mann.* Radford University Galleries, 1989.
 Videocassette, 28 minutes. Mann's discussion of her work as a photographer.

680. Mann, Sally. *Immediate Family.* Introduction by Sally Mann. Afterword by Reynolds Price. New York: Aperture, 1992. Chiefly illustrations. Unpaged.
 Mann's short autobiographical essay talks about her childhood and that of her own children, as they are growing up in southwestern Virginia.

Blowing Bubbles, 1987; *Torn Jeans,* 1990; *Naptime,* 1989; *Damaged Child,* 1984; *Sunday Funnies,* 1991; *The Ditch,* 1987; *Jessie at 6,* 1988; *Emmett Afloat,* 1988; *Tobacco Spit,* 1987; *The Two Virginias #1,* 1988; *Winter Squash,* 1988; *The Two Virginias #2,* 1989; *He is Very Sick,* 1986; *Emmett,* 1985; *The Hot Dog,* 1989; *Drying Morels,* 1988; *Dirty Jessie,* 1985; *Night-blooming Cereus,* 1988; *Rodney Plogger at 6:01,* 1989; *The 42-pound Squash,* 1989; *Emmett at Halloween,* 1988; *Virginia Asleep,* 1988; *Easter Dress,* 1986; *Yard Eggs,* 1991; *The Two Virginias #4,* 1991; *Flour Paste,* 1987; *Squirrel Season,* 1987; *Fallen Child,* 1989; *Jessie and the Deer,* 1985; *Virginia at 4,* 1989; *Last Light,* 1990; *Crabbing at Pawley's,* 1989; *Jessie Bites,* 1985; *Gorjus,* 1989; *At Charlie's Farm,* 1990; *Jessie at 5,* 1987; *Virginia at 3,* 1988; *The New Mothers,* 1989; *Jessie's Cut,* 1985; *Virginia in the Sun,* 1985; *Pox,* 1986; *Popsicle Drips,* 1985; *Holding the Weasel,* 1989; *Emmett's Bloody Nose,* 1985; *Kiss Goodnight,* 1988; *The Alligator's Approach,* 1988; *The Terrible Picture,* 1989; *The Wet Bed,* 1987; *Crossed Sticks,* 1988; *Hayhook,* 1989; *Emmett, Jessie, and Virginia,* 1990; *Emmett, Jessie, and Virginia,* 1989; *Emmett and the White Boy,* 1990; *White Skates,* 1990; *Hangnail,* 1989; *Coke in the Dirt,* 1989; *Candy Cigarette,* 1989; *The Last Time Emmett Modeled Nude,* 1987; *Sorry Game,* 1989; *Arundo Donax,* 1988.

681. Mann, Sally. *Mother Land: Recent Landscapes of Georgia and Virginia.* New York: Edwynn Houk Gallery, 1997. 59 p.

682. Mann, Sally. "Sally Mann: Correspondence with Melissa Harris (landscape photographs)," *Aperture* 138 (Winter 1995): 24-35.

683. Mann, Sally. *Second Sight: The Photographs of Sally Mann.* D. R. Godine, 1983. 59 p.

684. Mann, Sally. *Still Time.* New York: Aperture, 1994. 80 p.
 This work was originally an exhibition catalogue, that was expanded to include some earlier and later works.
[Woman with camera] frontispiece; *From The Dream Sequence,* 1971; *[Two women]* p. 9; *[Women in shadows]* p. 10, 11; *Landscapes, 1972-1973; [Valley and mountains and clouds]* p. 13; *[Trees by water]* p. 14; *[Out-of-focus sheep]* p. 15; *[Street and stone wall]* p. 16; *Landscapes, 1973-1974; [Trees in snow]* p. 19; *[Wood shack]* p. 20; *[Trees]* p. 21; *[Meadow]* p. 22; *From The Lewis Law Portfolio, 1974-1976; [Wall and shadows]* p. 24; *[Vine and tree trunk]* p. 25; *[Shadows on wall]* p. 26; *[Stone structures]* p. 27; *Portraits of Women, 1976-1977; [Woman and masks]* p. 29; *[Two young women on couch]* p. 30; *[Woman and child]* p. 31; *Platinum Prints, 1978-1980; [Foot on sheet]* p. 33; *[Open blouse]* p. 34; *[Arm and sleeve]* p. 35; *[Skirt between legs]* p. 36; *[Buttocks and fingers]* p. 37; *[Hand]* p. 38; *Cibachromes, 1981-1983; [Red flowers]* p. 41; *[Fruit]* p. 42; *[Yellow flowers]* p. 43; *[Orange shapes]* p. 44; *8 x 10 Polaroids, 1983,* p. 46-49; *20 x 24 Polaroids, 1984,* p. 51-52; *From At Twelve, 1983-1985; [Young girl in slip, sitting on couch]* p. 54; *[Young girl with older man]* p. 55; *[Girl by torn portrait]* p. 56; *[Person wearing wool hat]* p. 57; *[Girl leaning of semi-nude pregnant woman]* p. 59; *[Female to look like hanging, near collie]* p. 60; *[Young person and shadow of tree]* p. 61; *From Immediate Family, 1984-1991; Damaged Child,* p. 63; *The Wet Bed,* p. 64; *The Last Time Emmett Modeled Nude,* p. 65; *Emmett, Jessie, and Virginia,* p. 67; *The Perfect Tomato,* p. 68; *Cherry Tomatoes,* p. 69; *Candy Cigarette,* p. 70; *At Charlie's Farm,* p. 71; *Night-blooming Cereus,* p. 72; *Family Color, 1990-1991; [Girl with raspberries on fingers]* p. 75; *[Children by a mud hole]* p. 76; *[Stitching a wound in bedroom]* p. 77; *[Boy with blood/paint on mouth and chest]* p. 78; *[Nude girl playing cards]* p. 79.

685. Shimon, J. and Lindemann, J. "Blood Relatives: The Family in Contemporary Photography, (Milwaukee Art Museum)" *New Art Examiner* 19 (September 1991): 41-42. .

686. Williams, Val. "Fragile Innocence," *British Journal of Photography* 139 (October 15, 1992): 10.

687. Woodward, Richard B. "The Disturbing Photography of Sally Mann," *The New York Times Magazine,* (27 September 1992): 28-36.

Maricevic, Vivienne
See also #1072

Mark, Mary Ellen, 1940-
See also #1000, 1005, 1008, 1015, 1017, 1026, 1058, 1061, 1063, 1070

688. "American Visions," *American Photo* 2 (May/June 1991): 88-99.

689. Bailey, Ronald H. "Ward 81: Mary Ellen Mark's Poignant Scrapbook," *American Photographer* 1, 1 (June 1978): 44-56.

690. Bultman, Janis. "Street Shooter: An Interview with Mary Ellen Mark," *Darkroom Photography* 9, 1 (January/February 1987): 18-25.

691. Coleman, A. D. "Full Marks? (25 years: International Center of Photography Midtown, New York; Exhibit)," *British Journal of Photography* 139 (February 13, 1992): 21

692. Dolgoff, Stephanie. "The Real India," *American Photo* 4 (November/December 1993): 28.

693. Fulton, Marianne. *Mary Ellen Mark: 25 Years*. Published in association with the International Museum of Photography at George Eastman House. Bulfinch Press, 1991. 192 p. Bibliography: p. 185-191.
This volume was produced to accompany an international exhibition of Mark's photograph. The lengthy essay by Fulton, while biographical in nature, states that the selection of photographs is of the best of Mark's black and white work. It includes many quotes by Mark on her work, and exploration of the meaning of her images, and the backgrounds from which they came, and several portraits of Mary Ellen Mark.
Children Picking Flowers at Special School for Blind Children No. 5, Kiev, Ukraine, USSR, 1987, opposite title page; *Wealthy Retirement Community,* Santa Barbara, California, 1985, opposite contents; *Dispensary just outside Calcutta,* Mother Teresa's Missions of Charity, Calcutta, India, 1981, p. 37; *Blind Orphan at Sishu Bhawan,* Mother Teresa's Missions of Calcutta, India, 1980, p. 38; *Leprosy Patient with Her Nurse,* National Hansen's Disease Center, Carville, Louisiana, 1990, p. 39; *Mary Frances in Ward 81,* Oregon State Hospital, Salem, Oregon, 1976, p. 41; *Special School for Blind Children No. 5,* Kiev, Ukraine, USSR, 1987, p. 43; *Two Boys in Shanti Nagar Leprosy Colony,* Mother Teresa's Missions of Charity, Bengal, India, 1981, p. 44; *Jake,* School for the Blind, Watertown, Massachusetts, 1990, p. 45; *Home for the Dying,* Mother Teresa's Missions of Charity, Calcutta, India, 1980, p. 46; *Goudi at the Home for the Dying,* Mother Teresa's Missions of Charity, Calcutta, India, 1981, p. 47; *Women Dancing to Records, Ward 81,* Oregon State Hospital, Salem, Oregon, 1976, p. 49; *Jeanette in*

Labor, Cumberland Hospital, Brooklyn, New York, 1978, p. 50; *Beth in "Time Out," Ward 81*, Oregon State Hospital, Salem, Oregon, 1976, p 51; *Mary Frances Peeking from Her Tub, Ward* 81, Oregon State Hospital, Salem, Oregon, 1976, p. 51; *Retarded Women in the Shower,* Il Cottolengo Hospital, Turin, Italy, 1990, p. 52; *Retarded Women,* Il Cottolengo Hospital, Turin, Italy, 1990, p. 53; *Patients at the Second Mental Hospital of Chongqing, China,* 1989, p. 54; *Patients in Restraints at the Second Mental Hospital of Chongqing, China,* 1989, p. 55; *Devotee at a Muslim Shrine,* Utta Pradesh, India, 1989, p. 57; *Blind Children Bathing,* Sarnath, India, 1989, p. 59; *Karen,* Perkins School for the Blind, Watertown, Massachusetts, 1990, p. 60; *Lewis in a Shelter for the Homeless,* Miami, Florida, 1986, p. 61; *Home for the Dying,* Mother Teresa's Missions of Charity, Calcutta, India, 1980, p. 62; *Mother Teresa at the Home for the Dying,* Mother Teresa's Missions of Charity, Calcutta, Indian, 1980, p. 63; *Laurie in the Ward 81 Tub,* Oregon State Hospital, Salem, Oregon, 1976, p. 64; *Heroin Addict on the Toilet,* London, England, 1969, p. 67; *Fighting Street Boys,* Khartoum, Sudan, 1988, p. 68; *Glue Addicts,* Khartoum, Sudan, 1988, p. 69; *Lillie with Her Rag Doll,* Seattle, Washington, 1983, p. 70; *Relatives,* Tunica, Mississippi, 1990, p. 71; *Christopher,* Sandgap, Kentucky, 1990, p. 72; *Gypsy Camp,* Barcelona, Spain, 1987, p. 73; *Young Couple,* South Bronx, New York, 1987, p. 74; *"Rat" and Mike with a Gun,* Seattle, Washington, 1983, p. 75; *South Dallas, Texas,* 1988, p. 76; *Runaway Girls on Pike Street,* Seattle, Washington, 1983, p. 77; *Robert Taylor Home,* Chicago, Illinois, 1987, p. 78; *Nestor,* Mission, Texas, 1990, p. 79; *Katy, an Autistic Child,* Norwalk, Connecticut, 1987, p. 80; *Robinsville, Mississippi,* 1990, p. 81; *Andrew Walker, 101 Years Old, with His Granddaughter Lakeisha,* Cleveland, Mississippi, 1990, p. 83; *Hollywood Boulevard,* Hollywood, California, 1987, p. 85; *Charlie Coffee and Mickey Hickey,* Redfern Section of Sydney, Australia, 1987, p. 86; *Marilyn Cargil and René Riley,* Redfern Section of Sydney, Australia, 1987, p. 87; *Paula and Verenis at the Valley Shelter,* Los Angeles, California, 1987, p. 88; *Ernest McQuinlan's Boxing Club,* Sydney, Australia, 1987, p. 89; *Shirley with Her Son Ricky at the Gilbert Hotel,* Hollywood, California, 1987, p. 90; *Jeanette Sleeping,* Brooklyn, New York, 1978, p. 91; *Heroin Addict behind a Door,* London, England, 1969, p. 92; *Heroin Addicts,* London, England, 1969, p. 93; *Peter, from Perkins School for the Blind, Looking for Birds on Cape Cod, Massachusetts,* 1990, p. 95; *People Gathered Outside the Home for the Dying,* Mother Teresa's Missions of Charity, Calcutta, India, 1981, p. 96; *Jesse with His Dog,* Runtley, Los Angeles, 1987, p. 97; *Arrested Drug Suspect,* South Dallas, Texas, 1988, pl. 99; *The Damm Family in Their Car,* Los Angeles, California, 1987, p. 100; *Crying Twins,* Middlesboro, Kentucky, 1988, p. 103; *English Child,* London, England, 1965, p. 104; *Street Child,* Trabzon, Turkey, 1965, p. 105; *Amanda and Her Cousin Amy,* Valdese, North Carolina, 1990, p. 107; *Children's Fashion Show,* Miami Beach, Florida, 1986, p. 108; *Gibbs Senior High School Prom,* Saint Petersburg, Florida, 1986, p. 109; *Tattooed Man at Aryan Nations Congress,* Hayden Lake, Idaho, 1986, p. 110; *Halloween Boy,* Texas, 1983, p. 111; *Marlon Brando during the Filming of <u>Apocalypse Now</u>,* Philippines, 1977, p. 112; *Young Boy with Mickey Mouse Ears,* Lutu Village, Yunnan Province,

China, 1985, p. 113; *Bridesmaids,* Sydney, Australia, 1987, p. 114; *Chess by the Beach,* Sochi, USSR, 1987, p. 115; *Luis Buñuel during the Filming of Tristana,* Toledo, Spain, 1970, p. 116; *The Man Who Won the Mustache Contest,* Istanbul, Turkey, 1965, p. 117; *Loyalty Day Parade,* New York City, 1967, p. 118; *Coney Island,* Brooklyn, New York, 1983, p. 119; *South Dallas, Texas,* 1988, p. 121; *Grand Wizard at Aryan Nations Congress,* Hayden Lake, Idaho, 1986, p. 123; *Maurice, and Extra in the Paris Opera,* Paris, France, 1988, p. 124; *Federico Fellini on the Set of Fellini Satyricon,* Rome, Italy, 1969, p. 125; *Husband and Wife,* Harlan County, Kentucky, 1971, p. 126; *Acadian Wedding,* Lafayette, Louisiana, 1972, p. 127; *Boy with His Sister at "Club Culture,"* Madrid, Spain, 1984, p. 128; *Women's Bar,* Upper East Side, New York City, 1977, p. 129; *Disco,* Long Island, New York, 1977, p. 129; *Blind Children with Sighted Baby at the Special School for Blind Children No. 5,* Kiev, Ukraine, USSR, 1987, p. 130; *Gypsy Camp,* Barcelona, Spain, 1987, p. 131; *"Tiny" in Her Halloween Costume,* Seattle, Washington, 1983, p. 133; *Girl with Ashes at the Burning Ghat,* Benares, India. 1989, p. 134; *Brother and Sister at the Black Sea,* Sochi, USSR, 1987, p. 135; *Shanti Nagar Leprosy Colony,* Mother Teresa's Mission of Charity, Bengal, India, 1981, p. 136; *Shepherds's Village,* Jodhpur, India, 1989, p. 137; *Carrie Copas,* Portsmouth, Ohio, 1989, p. 138; *Gorky Park Circus,* Moscow, USSR, 1987, p. 139; *Classroom,* Kiev, Ukraine, USSR, 1987, p. 139; *Hydrocephalic Girl with Her Sister,* Il Cottolengo Hospital, Turin, Italy, 1990, p. 141; *Hispanic Girl with Her Brother,* Dallas, Texas, 1987, p. 142; *Dancing School,* East Orange, New Jersey, 1988, p. 143; *"Pagan," a Runaway from Arizona,* Hollywood, California, 1987, p. 144; *Vicky,* Mission, Texas, 1990, p. 145; *Contestants for the National Senior Olympics,* Saint Louis, Missouri, 1989, p. 146; *Callie and Harvey Flannery,* McKee, Kentucky, 1990, p. 147; *Edgar Bergen and Charlie McCarthy,* Los Angeles, California, 1978, p. 148; *Contortionist with Her Puppy Sweety,* Great Raj Kamal Circus, Upleta, India, 1989, p. 151; *Acrobats Practicing,* Great Bombay Circus, Limbdi, India, 1990, p. 152; *Veeru and Usman with Moti the Performing Vulture,* Great Jumbo Circus, Mangalore, India, 1989, p. 153; *Dr. Hari Prakash, His Son Shasi, and Their Performing Monkey Guju,* Great Bombay Circus, Limbdi, India 1990, p. 154; *Ringmaster A. Rehman with His Dog Rosy,* Great Famous Circus, Calcutta, India, 1989, p. 155; *Shavanaas Begum with Her Three-year-old Daughter, Parveen,* Great Gemini Circus, Perintalmanna, India, 1989, p. 156; *Gloria and Ravi the Animal Trainer with His Bear Gemini,* Great Gemini Circus, Perintalmanna, India, 1989, p. 157; *Hippopotamus and Performer,* Great Rayman Circus, Madras, India, 1989, p. 159; *Two Brothers Tulsi and Basant,* Great Famous Circus, Calcutta, India, 1989, p. 160; *Jahir Ali the Magician with His Son Mukhtar, at a Sideshow near the Great Lion Circus,* Bulandshahr, India, 1989, p. 161; *Acrobats Jayanti and Sunita Preparing for a Show,* Great Apollo Circus, Goa, India, 1989, p. 162; *Gloria and Raja,* Great Gemini Circus, Perintalmanna, India, 1989, p. 163; *Arhun with His Chimpanzee Mira,* Great Royal Circus, Gujarat, India, 1989, p. 164; *Venkesh on Lucky Donkey,* Great Jumbo Circus, Mangallore, India, 1989, p. 165; *Clowns Bathing,* Great Royal Circus, Junagadh, India, 1989, p. 166; *Usman the Clown with William and Albert, who Have Been Inspired by John*

Wayne, Great Jumbo Circus, Magalore, India, 1989, p. 167 ; *Acrobats Practicing,* Great Amar Circus, Delhi, India, 1989, p. 168; *Shanu and Tulsi Warming Up,* Great Bharat Circus, Uttar Pradesh, India, 1989, p. 169; *Acrobat Sleeping,* Great Famous Circus, Calcutta, India, 1989, p. 170; *Chitra and Tracey Practicing,* Great Bombay Circus, Limbdi, India, 1990, p. 171; *Pinky and Shiva Ji with Laxmi in the Background,* Great Royal Circus, Junagadh, India, 1990, p. 172; *Great Jumbo Circus,* Mangalore, India, 1989, p. 173; *Rani, Star of the Dog Act,* Great Bombay Circus, Limbdi, India, 1990, p. 174; *Pinky, Sunita, and Ratna,* Great Royal Circus, Gujarat, India, 1989, p. 175; *Ram Prakash Singh with His Elephant Shyama,* Great Golden Circus, Ahmedagad, India, 1990, p. 176; *Burlesque Comic in His Dressing Room,* Forty-Second Street Theater, New York City, 1968, p. 192.

694. Hallett, Michael. "Capturing the Human Condition. (Mary Ellen Mark, 25 Years: Royal Photographic Society, Bath, England; Exhibit)," *British Journal of Photography* 140 (July 22, 1993): 18-19.

695. Jordan, Jim. "Examining an Illness," *Artweek* 117 (May 17, 1986): 10.

696. Lima, Marcelo. (Cultural Art Center; Exhibit) *New Art Examiner* 20 (December 1992): 30.

697. Mark, Mary Ellen. *A Cry for Help: Stories of Homelessness and Hope.* Introduction by Andrew Cuomo and Preface by Robert Coles. New York: Simon & Schuster, 1996. 103 p.
 The introduction by Cuomo looks at the continuing problem of homelessness, government's inability to solve this social problem, and the response to the crisis by H.E.L.P., Housing Enterprise for the Less Privileged. Coles' preface continues the discussion of the lives of children who have no real place to call their own, and the importance of Mark's photographs to continue the dialogue. The photographs are accompanied by personal comments on being homeless.
Katiyah Sutten and Anthony Garrett, Astoria Pool, Bronx, p. 15; *Shanáe Vaugh Palmer and friend,* p. 17; *Andrews "Buddha" Morrison,* p. 19; *Hector, Jessica, and Pablo Sanchez,* p. 21; *Jaime Molina and Teresita Ortiz,* p. 22; *Anthony Garrett and friend, Astoria Pool, Bronx,* p. 25; *Annette and Pamel Worth,* p. 26; *Francheska and Frances Sanchez,* p. 29; *Jose, Xavier, and Jocelyn Rivera, Krystal Santiago and Cynthia Maldonado,* p. 33; *Andrea and Anthony Garrett,* p. 35; *Kenya and Precious Jackson,* p. 37; *Jazmen and Michelle Fournier,* p. 39; *Amy and Anthony James Penny,* p. 40; *Stephanie Fournier and Nelson Newman,* p. 43; *Biana and Margie "Cookie" Cross,* p. 45; *Jonathan and Noel Cruz,* p. 46; *Vashira and Tashira Hargrove,* p.47; *Nellie Torres, Yasmine Nieves, and Bianca Nunez,* p. 49;*Elgie McGee, Jr., daughter Nylivia McGee, and son Ronald Booker,* p. 51; *Elizabeth and Amy Penny,* p. 52; *Carla and Jake Aragona,* p. 55; *Irene Ayala and Enrique Andaverde,* p. 57; *Nelson Newman and Hector Sanchez,* p. 58; *Cortney and Amanda Joyce,* p. 60; *Amanda Barberra,* p. 61; *Brooke Vaughan,* p. 63;

Rafael Cruz and Marita, p. 65; *Hector and Pablo Sanchez*, p. 66; *Yaritza Mateo*,
p. 69; *Natalie and Erika Escobar Ahay*, p. 71; *Edward Simmons and son Edward*,
p. 72; *Diamond Settles*, p. 73; *Elizabeth Sanchez and daughter Melissa Rodriguez*,
p. 75; *Kelly Flores*, p. 77; *Adam and Andrews "Buddha" Morrison*, p. 78; *Robin
and Azizuddin Clark*, p. 79; *Edgardo Figueria*, p. 81; *Jennifer Garcia*, p. 83;
Matthew Richardson, p. 85; *Hector Roman and Crystal McKeller*, p. 87; *Tony
Congema*, p. 89; *William and Jennifer Wachenfeld*, p. 91; *Joey Purificato*, p. 93;
Matthew Burke, p. 94; *Keyona and Mashon Baines*, p. 97; *Keyona Baines*, p. 99.

698. Mark, Mary Ellen. *Falkland Road: Prostitutes of Bombay*. New York:
 Knopf, 1981. Unpaged.
 Photographs of the girls, women, men and children of the Falkland Road
 brothels and cages. Introductory essay by Mark which offers some insight
 into the lives of some of the girls she has befriended.
*Cages on Falkland Road at night; Nepalese girls waiting for customers; Cages;
Alleyway behind Falkland Road; Champa, a transvestite madam; Several times a
day the madam and her girls have tea; The brothel hallway at night; A madam at
one of the more expensive houses with her girls; Tarana, a transvestite, with a
potential customer; At the entrance to a transvetite cage; Lalita, the madam of this
house; I would hear voice from behind the curtains; Rgini, a transvestite; Kamla
with a potential customer; Nepalese girls taking their afternoon nap; Mid-
afternoon; The girls bathe, very thoroughly, at least once a day;*

699. Mark, Mary Ellen. "Falkland Road," *American Photographer* 6, 4 (April
 1981): 60-68.

700. Mark, Mary Ellen. *Indian Circus*. Foreword by John Irving. San
 Francisco: Chronicle Books, 1993. 107 p.
 Preface by Mark includes her discussion and observations on the Indian
 circuses and segments of interviews by the circus people she
 photographed.
Crowd outside Circus. Amar Circus, Delhi, 1989, frontispiece; *Usman with His
Son. Jumbo Circus, Bombay*, 1992, p. 19; *Pinky and Ratna Preparing for the Show
at Great Royal Circus. Himmatnagar*, 1989, p. 20; *John Paul at Lion Circus.
Bilsanda*, 1989, p. 21; *Mira, Shfali, and Pushpa at Famous Circus. Calcutta*, 1989,
p. 22; *Jyotsana Riding on Vahini the Elephant. Amar Circus, Delhi*, 1989, p. 23;
*Ram Praakash Singh with His Elephant Shyama. Great Golden Circus,
Ahmedabad*, 1990, p. 25; *Hippopotamus and Performer. Great Rayman Circus,
Madras*, 1989, p. 26; *Jumbo Circus. Mangalore*, 1989, p. 27; *Acrobats Rehearsing
Their Act at Great Golden Circus. Ahmedabad*, 1989, p. 29; *Acrobats Practicing.
Bharat Circus, Bulandshahar*, 1989, p. 30; *Bombay*, 1974, p. 31; *Anarkali with a
Trainer. Apollo Circus, Goa*, 1989, p. 32; *Shavanaas Begum, with Her Three-year-
old Daughter, Parveen. Gemini Circus, Perintalmanna*, 1989, p. 33; *Rani, Star of
the Dog Act. Great Bombay Circus, Limbdi*, 1990, p. 34; *Acrobats Practicing at
Apollo Circus. Goa*, 1989, p. 35; *Gloria and Ravi, a Trainer, with His Bear*

Gemini. Gemini Circus, Perintalmanna, 1989, p. 37; *Pinky, Sunita, and Ratna. Great Royal Circus, Gujarat*, 1989, p. 38; *Shyamala Riding Her Horse, Badal, at Great Rayman Circus, Madras*, 1989, p. 39; *Contortionist with Sweety the Puppy. Raj Kamal Circus, Upleta*, 1989, p. 40; *Pinky, Shiva Ji, and Laxmi. Great Royal Circus, Junagadh*, 1990, p. 41; *Usman the Clown with William and Albert, Who Have Been Inspired by John Wayne. Jumbo Circus, Mangalore*, 1989, p. 43; *Gloria and Raja, Gemini Circus, Perintalmanna*, 1989, p. 44; *Pratap Singh, Wild-Animal Trainer, with His Lion Tex at Great Royal Circus. Junagadh*, 1990, p. 45; *Usman at Jumbo Circus. Mangalore*, 1989, p. 47; *Gemini Circus, New Delhi*, 1992, p. 48; *Bombay*, 1978, p. 49; *K. Kunjaram at Great Oriental Circus. Kanpur*, 1989, p. 51; *Bharat Circus. Bulandshahar*, 1989, p. 52; *Shanu. Bharat Circus. Uttar Pradesh*, 1989, p. 53; *Great Golden Circus. Ahmedabad*, 1990, p. 55, 60, 66, 70; *Apollo Circus. Goa*, 1989, p. 56, 82; *Great Royal Circus. Junagadh*, 1990, p. 57; *Acrobats Practicing at Famous Circus, Calcutta*, 1989, p. 59; *Rajni Practicing at Deepak Circus. Calicut*, 1989, p. 61; *Ratna Practicing at Great Royal Circus. Junagadh*, 1990, p. 62; *Acrobat Sleeping. Famous Circus, Calcutta*, 1989, p. 63; *Jumbo Circus. Bombay*, 1974, p. 64, 85; *Shanu and Tulsi Warming Up. Bharat Circus, Uttar Pradesh*, 1989, p. 65; *Gemini Circus. Pereinalmanna*, 1989, p. 67, 71, 91, 105; *Famous Circus. Calcutta*, 1989, p. 69; *Raja as a Baby. Gemini Circus. Bombay*, 1974, p. 73; *Great Royal Circus. Junagadh*, 1990, p. 74, 100; *National Circus. Gujarat*, 1989, p. 75; *Arjun with His Chimpanzee Mira. Great Royal Circus, Gujarat*, 1989, p. 76; *Dr. Elephant at Bharat Circus. Bulandshahar*, 1989, p. 77; *Kalappa, Caretaker of Nadi the Bull, with Two Chimpanzees, Jambo and Mira. Great Royal Circus*, 1989, p. 78; *Ram Pyare at Empire Circus. Calcutta*, 1989, p. 79; *Clowns Bathing. Great Royal Circus, Junagadh*, 1990, p. 81; *Transvestite and Child Clown. Lion Circus, Bilsanda*, 1989, p. 83; *Ringmaster A. Rehman with His Dog Rosy. Famous Circus, Calcutta*, 1989, p. 86; *Veeru and Usman with Moti, the Performing Vulture. Jumbo Circus, Mangalore*, 1989, p. 87; *Twin Brothers Tulsi and Basant. Famous Circus, Calcutta*, 1989, p. 89; *Famous Circus, Calcutta*, 1989, p. 90; *Venkesh on Lucky Donkey. Jumbo Circus, Mangalore*, 1989, p. 92; *Amar Circus. Delhi*, 1989, p. 93; *Jumbo Circus. Mangalore*, 1989, p. 95, 96, 101; *Lion Circus. Bilsanda*, 1989, p. 97; *Chitra and Tracy, and Tulsi Das at Great Bombay Circus. Limbdi*, 1990, p. 99; *Gemini Circus, New Delhi*, 1992, p. 103;.

701. Mark, Mary Ellen. *An Interview with Mary Ellen.* Maine Photographic Workshops, 1989.
 Sound cassette, 60minutes, of an interview during the 1989 International Photography Congress.

702. Mark, Mary Ellen. "Mary Ellen Mark Interview," *Aperture* 146 (Winter 1997): 42-51.

703. Mark, Mary Ellen. *Mother Teresa's Mission of Charity in Calcutta.* Carmel: Friends of Photography, 1980. 48 p. Chiefly illustrations.

Introduction by David Featherstone. Journal entries accompany many of the photogrpahs.

Mother Teresa, Shishu Bhawan, Calcutta, 1980, p. 4; *[Boy Sleeping in Middle of Road], Calcutta,* 1981, p. 13; *People Gathered Outside the Home for the Dying,* 1981, p. 14; *Dispensary just outside of Calcutta,* 1981, p. 15; *Mother Teresa in Nirmal Hriday, the Home for the Dying,* 1980, p. 16; *Home for the Dying,* 1980, p. 17-23; *Nurses tending deceased patient at the Kennedy Center for Retarded and Psychotic Women,* 1980, p. 24; *Morgue at the Home for the Dying,* 1980, p. 25; *Shishu Bhawan (Children's Orphanage),* 1980, p. 26; *Blind Orphan at Shishu Bhawan,* 1980, p. 27; *Mother Teresa at Shishu Bhawan,* 1980, p. 28; *Mother Teresa at Prem Dan,* 1980, p. 29; *Retarded Children at Prem Dan,* 1981, p. 30; *Retarded and Psychotic Women at Prem Dan,* 1980, p. 31; *Two children whose parents are lepers, at Shanti Nagar--Peace Village,* 1981, p. 32; *Shanti Nagar Leprosy Hospital,* 1981, p. 33; *Mother Teresa giving communion in the Mother Hosue,* 1981, p. 34; *Postulants combing and drying their hair at Prem Dan,* 1981 p. 35; *Sisters praying at the Home for the Dying,* 1980, p. 36; *Blind girl at the Home for the Dying,* 1980, p. 37; *Home for the Dying,* 1980, p. 38, 41, 43, 44, 46; *Iranian volunteer in the Home for the Dying,* 1981, p. 39; *Mother Teresa, Meerut,* 1981, p. 40; *Two blind patients at Prem Dan,* 1981, p. 42; *Goudi at the Home for the Dying,* 1981, p. 45; *Mother Teresa at the Home for the Dying, Calcutta,* 1980, p. 47.

704. Mark, Mary Ellen. *Passport.* Lustrum Press, 1974. Unpaged. Chiefly illustrations.
 This portfolio of work includes an interview with Mark by Eleanor Lewis in New York City, June 15, 1974 and a portrait of Mark.

Turkish Immigrants, Istanbul; Juhu Beach, Bombay; English Polar Bear, Aged 85; Bathers in the Ganges; Legless Beggar, Bombay; Iranian Gypsy; Eastern Royalty, Nice; Benares; Mike Haley, Assistant Director, Nassau; Rajasthani Woman; Street Child, Trabzon, Turkey; The Man Who Won the Mustache Contest, Istanbul; Tuareg, Zinder, Niger; Algerian Casbah; Muslim Mother with Sleeping Child, Bombay; Child in Fundamentalist Church, IFE, Nigeria; Gasoline Station Owner's Daughter, Zaria, Nigeria; Mother with Powdered Baby, IFE, Nigeria; To the Slaughterhouse, Agades, Niger; From the Slaughterhouse Agades, Niger; Tuareg with Albino Camer, Tamanrasset, Algeria; Child Woodcutter, Agades, Niger; Esfahan, Iran; Passenger on Nepali Ferry; Farmer, El Golea, Algeria; Gypsies, Ainsalah; Spanish Cafe near Granada; Iranian Bicyclist; A Women with Her Cat, France Wedding Couple, Brittany; Old Couple, Carcassonne, France; Shepherd, Near Toulouse, France; Roadbuilders, El Oued, Algeria; Mourning Mother, Oxaca, Mexico; Indian Child, San Cristobal, Mexico; Confession, San Cristobal, Mexico; Hospital Cemetery, Mexico; Desert Dancers, Niger; Iranian Jugglers; Beggar, Katmandu; School for Sadhus, Benares; English Runaway, Goa, India; Australian Couple, Goa, India; Hash Smokers, Goa, India; Bombay Restaurant; Stoned in Bombay; Stoned in Afghanistan; Young Bangladesh Soldier; Bangladesh Prisoner; Bihari Prisoners, Bangladesh; Bangladesh Prisoner; Protestant Resistance Leader,

Belfast; Mourning Mother, Londonderry; Belfast Children (2); Catholic Woman, Belfast; English Child, London; English Junkies, London (5); Central Park, New York (2); Sisters, Central Park; Burlesque Comedian, Backstage, Broadway; Body Builder, New York; Broadway Hotel, New York; Cockettes, San Francisco; Stripper, Hollywood; Feminist Demonstration, New York; Peter Brooke, Sahara; Federico Fellini, Rome; Francois Truffaut, Grenoble; Luis Bunuel, Toledo; Hollywood Extras --"The Day of the Locust" (6); Canadian Couple; Appalachian Couple; Acadian Couple; Wisconsin Couple (In Florida); Loyalty Day Parade, New York; Appalachian Family; Appalachia (3); WACs in Training, Anniston, Alabama (3).

705. Mark, Mary Ellen. *The Photo Essay: Photographs*. Washington, D.C.: Smithsonian Institution, 1990. 64 p. Chiefly illustrations.
 Includes an interview with Mark.

Famine victim, relief camp, Korem, Ethiopia, 1985, p. 19; Relief camp, Korem, Ethiopia, 1985, p. 21, 22, 23; Bulawayo, Mantabeleland, Zimbabwe, 1983, p. 25; School Christmas show, Harare, Zimbabawe, 1983,p. 26; Department store Santa Claus, Harare, Zimbabawe, 1983, p. 27; Puppeteer and his son, India, 1979, p. 29; Dog Trainer, India, 1979, p. 30; Monkey trainer's daughter, India, 1981, p. 31; Snake charmers, New Delhi, India, 1981, p. 33; Transvestite prostitute with his boyfriend, Falkland Road, Bombay, India, 1978, p. 39; Jennifer Turk and Samantha Brais at Camp Goodtimes, a summer camp for children with cancer, Malibu, California, 1984, p. 41; Camp Goodtimes, Malibu, California, 1984, p. 42, 43; Rio de Janeiro, Brazil, 1989, p. 45, 47, 48, 49; Harry Hessell, 104 years old, ex-window washer from New York, South Beach, Florida, 1979, p. 51, 52; Esther and Al Kline in their apartment, Miami Beach, Florida, 1979, p. 53; Exercise group, South Beach, Florida, 1979, p. 54; Senior citizens center, Miami Beach, Florida, 1979, p. 55; Carrie Copas, ten years old, Portsmouth, Ohio, 1989, p. 57; Jake Holsinger with Carrie and Jamie, Portsmouth, Ohio, 1989, p. 59.

706. Mark, Mary Ellen. *Portraits*. Forword by May Panzer. Washington, D.C.: Smithsonian Institution, 1997. 47 p.
 Short critical essay on the selection and juxtaposition of the portraits in this catalogue.

Clayton Moore, the former Lone Ranger, Los Angeles, 1992, pl. 1; Edward Simmons, Halloween, South Bronx, New York, 1993, pl. 2; John Irving with his wife, Janet, Vermont, 1994, pl. 3; Jeff Gillam and Stacy Spivey, McKee, Kentucky, 1990, pl. 4; Jesse Damm and his dog Nick, Llano,California, 1995, pl. 5; Jeff Bridges on the set of <u>American Heart</u>, Seattle, 1991, pl. 6; Ganges River, India, 1989, pl. 7; Boy George, New York City, 1993, pl. 8; Lakiesha, South Dallas, 1988, pl. 9; Lillian Gish, New York City, 1987, pl.10; François Truffaut, Grenoble, 1969, pl. 11; Paddy Joyce, Travellers encampment, Finglas, Ireland, 1991, pl. 12; Chrissy Damm and Adam Johnson, Llano, California, 1994, pl. 13; Henry Miller and Twinka, Pacific Palisades, Los Angeles, 1975, pl. 14; Jodhpur, India, 1990, pl. 15; Jodie Foster, Los Angeles, 1994, pl. 16; Kevin Costner on the set of <u>Wyatt</u>

Earp, Santa Fe, New Mexico, 1993, pl. 17; *Thomas Joyce, Travellers encampment, Finglas, Ireland*, 1991, pl. 18; *Clinton Albright with his father, Santa Clara, California*, 1992, pl. 19; *EdgerBergen and Charlie McCarthy, Los Angeles*, 1978, pl. 20; *Marvin Gavin, Dublin*, 1991; pl. 21; *Liam Neeson, New York City*, 1993, pl. 22; *James Bay, Canada*, 1992, pl. 23, 30, 42; *Agnes Martin, Galisteo, New Mexico*, 1992, pl. 24; *National Circus of Vietnam, Lenin Park, Hanoi*, 1994, pl. 25, 46; *Federico Fellini on the set of Fellini Satyriconi, Rome*, 1969, pl. 26; *Flea, New York City*, 1994, pl. 27; *Jesse Damm, Llano, California*, 1994, pl. 28; *James Cagney on the set of Ragtime, London*, 1981, pl. 29; *Margaret Joyce, Travellers encampment, Finglas, Ireland*, 1991, pl. 31; *Johnny Depp, Los Angeles*, 1993, pl. 32; *Milos Forman, Warren, Connecticut*, 1993, pl. 33; *José "Pepe" Diaz and his son Jerry with their horse Grain of Gold, San Antonio*, 1991, pl. 35; *Sylvester Stallone, Los Angeles*, 1991, pl. 35; *Benares, India*, 1989, pl. 36, 47; *Edward Furlong, Los Angeles*, 1991, pl. 37; *Craig Scarmardo and Cheyloh Mather at the Boerne Rodeo, Texas*, 1991, pl. 38; *Special school no. 5 for blind children, Kiev, Ukraine*, 1987, pl. 39; *Woody Allen and Mia Farrow on the set of Alice, Astoria, Queens*, 1991, pl. 40; *Diane Arbus, New York City*, 1969, pl. 41; *Jean-Claude Van Damme, New York City*, 1994, pl. 43; *Kelly Flores, Halloween, South Bronx, New York*, 1993, pl. 44; *Luis Buñel with his wife Jean, Mexico City*, 1971, pl. 45.

707. Mark, Mary Ellen. *The Searching Eye*. Media Loft, 1992.
 Videocassette, 24 minutes.

708. Mark, Mary Ellen. *Streetwise*. New York: Aperture, 1991. 75 p.
 From the film *Streetwise* photographed by Mark, Angelika Films, 1987.
 Videocassette 92 minutes.

709. Mark, Mary Ellen. *Ward 81*. Photographs by Mary Ellen Mark and text by
 Karen Folger Jacobs with an Introduction by Milos Forman. New York:
 Simon Schuster, 1979. 96 p.
 Ward 81 is the women's security ward of the Oregon State Hospital. Mark
 and Jacobs spent 36 days locked in the ward, the statements of the patients
 and photographs are the results of this investigation.
 [Photographs of the women of the ward: with burns, in restraints, in showers, on beds, near wired windows, etc.]

710. Moorman, Margaret. "Mary Ellen Mark," *Artnews* 88, 4 (April 1989):
 152-153.

711. Porter, Allan. "Mary Ellen Mark," *Camera* (Switzerland) 56, 9
 (September 1977): 24-32.

712. Ritchen, Fred. "Off Camera, On Film: Photographs by Mary Ellen Mark,"
 Camera Arts 3, 3 (March 1983): 50-59+.

713. Squiers, Carol. "Field Notes," *American Photographer* 21 (October 1988): 56-63.

Martin, Jackie, 1903-1969

714. Martin, Jackie. *Jackie Martin: The Washington Years.* Syracuse: Syracuse University, 1986. 24 p.
 This is an exhibition catalogue which includes a biographical essay entitled, "Portrait of a Photojournalist," by Maxine T. Edwards, and a second essay, "Modern Girl," by Mary Warner Marien, tries to find the place in the history of photojournalism for Martin. Several portraits of Martin taking pictures are included.
At President Roosevelt's Inauguration, p. 5; Winston Churchill, 1941, p. 6; Fannie Hurst at the Chicago Democratic Convention, 1940, p. 9; King George, President Roosevelt, General Edwin M. Watson, the President's Miliary Aide, Mrs. Roosevelt and Queen Elizabeth, are shown at Union Station, 1939, p. 10; 76 year old Mrs. Morris, 1936, p. 13; William Randolph Hearst and Eleanor Patterson, p. 17; Clarence Darrow as he testifies, p. 18; Bernard Baruch, p. 21; FDR opens Congress, 1935, p. 22.

Martin, Louise
 See also #1040
Mather, Margrethe, c. 1885-1952
 See also #1058, 1063

Matheson, Elizabeth
 See also #1072

714.1. Matheson, Elizabeth. *Elizabeth Matheson.* Raleigh: North Carolina Museum of Art, 1990. 12 p.

Mathis, Jill
 See also #1000

Matthews, Kate, 1870-1956.
 See also #1061

715. Matthews, Kate. *Kate Matthews and the Little Colonel.* Louisville, KY: Lithocraft, c. 1963. 15 p. Chiefly portraits.
 "Photographs which Kate Matthews took of her associates and relatives in Peewee Valley--the prototype for characters in the Little Colonel series."oclc

716. Matthews, Kate. *Kate Matthews, Photographer.* Louisville: University of Louisville, Allen R. Hite Art Institute, 1956.

Mayes, Elaine
>See also #1008

Meiselas, Susan, 1948-
>See also #1008, 1055, 1058, 1063

717. *Living at Risk: The Story of a Nicaraguan Family.* New York: TVR, 1985. Videorecording. 59 minutes.
>"Documentary depicting the Nicaraguan crisis five years after Samosa through the daily lives of five brothers and sisters from a middle-class family." oclc

718. Meiselas, Susan. *Carnival Strippers.* New York: Farrar, Straus, and Giroux, 1976. 148 p.
>Portfolio of photographs, accompanied by interviews with the women of the "girl show" and some of their audience. Meiselas states in her introduction that "the girl show is a business, and carnival stripping is competitive and seasonal," and she wanted to "present an account of the girl show that portrayed what I saw and revealed how the people involved felt about what they were doing."

719. Meiselas, Susan. *Kurdistan: In the Shadow of History.* With chapter commentaries by Martin van Bruinesen. New York: Random House, 1997. 390 p.
>With an introduction by Meiselas, this is a sourcebook and assemblage of current and historical images, oral histories, memoirs and photographs; an important visual and textual archive of information on the Kurds.

720. Meiselas, Susan. *Learn to See: Source Book of Photography Projects by Teachers and Students.* Cambridge, MA: Polaroid Foundation, 1974. 110 p.
>Chapters include: "Strategies" to Teaching: 5 Points of View, and 101 Projects from the Field and Technical Information. Illustrated with examples of the projects.

721. Meiselas, Susan. *Nicaragua, June 1978-July 1979.* Edited with Claire Rosenberg. New York: Pantheon Books, 1981. 100 p. Chiefly illustrations.
>Photographic chronicle of Nicaragua during the end of the Somoza regime, the insurrection and the final offensive. Includes a chronology of Nicaraguan history, and excerpts of letters, interviews, official communications, etc.

Traditional Indian dance mask...adopted by the rebels, pl. 1; *Main street of rural town, Santo Domingo,* pl. 2; *Woman washing laundry in sewer of downtown*

Managua, pl. 3; *Harvesting sugar cane near León*, pl. 4; *Loading one hundred pound sacks of grain, Granada*, pl. 5; *Country club, Managua*, pl. 6; *President Anastasio Somoza Debayle opening new session of the National Congress, June 1978*, pl. 7; *Anastasio Somoza Portocarrero, twenty-seven-year-old son of the president, head of the elite infantry training school*, pl. 8; *New recruits to National guard practice blindfolded dismantly of a U.S.-made M-16 rifle*, pl. 9; *Children harassing Guards around bonfire in Matagalpa, June 1978*, pl. 10; *Recurits pass by official state portrait of Anastasio Somoza Debayle*, pl. 11; *National Guard on duty in Matagalpa*, pl. 12; *Martketplace in Diriamba*, pl. 13; *"Cuesta del Plomo,"* pl. 14; *Wall graffiti on Somoza supporter's house burned in Monimbo*, pl. 15; *Residential neighborhood in Matagalpa*, pl. 16; *Car of a Somoza informer burning in Managua*, pl. 17; *Studnet demonstration broken up by National Guard using tear gas, Managua, June 1978*, pl. 18; *Burial of worker, with flag of FSLN, in Diriamba*, pl. 19; *A funeralprocession in Jinotepe for assassinated student leaders*, pl. 20; *Coffins of students being carried in the street of Jinotepe*, pl. 21; *Motorcycle brigade, followed by a crow of one hundred thousand people, leading Los Doce into Monimbo, July 5, 1978*, pl. 22; *Youths practicing throwing contact bombs in forest surrounding Monimbo*, pl. 23; *First day of popular insurrection, August 26, 1978*, pl. 24; *Muchachos (young rebels) holding barricade in Matagalpa*, pl. 25; *Awaiting couterattack by the Guard in Matagalpa*, pl. 26; *Muchacho wearing Spider Man mask in Masaya, September, 1978*, pl. 27; *Young boy killed during fighting*, pl. 28; *Estelí, the fifth day of continuous bombing, September, 1978*, pl. 29; *National Guard entering Estelí*, pl. 30; *Seizing government construction truck in Masaya*, pl. 31; *Muchacho withdrawing from commercial district of Masaya after three days of bombing*, pl. 32; *Townspeople taking goods from burned-out store in Estelí*, pl. 33; *Fleeing the bombing to seek refuge outside of Estelí*, pl. 34; *Monimbo woman carring her dead husband home to be buried in their backyard*, pl. 35; *Body being burned by the Red Cross to prevent the spread of disease, Masaya*, pl. 36; *Returning home, Masaya, September 1978*, pl. 37; *Toward Sandinista training camp in the mountains north of Estelí*, pl. 38; *Breakfast, rice*, pl. 39; *Woman instructor teaching marksmanship to woman volunteer*, pl. 40; *Guard patrol in Masaya beginning house-to-house search for Sandinistas*, pl. 41; *Searching everyone traveling by car, truck, bus or foot*, pl. 42; *Guard on daily patrol in the countryside, February 1979*, pl. 43; *Paramillitary forces, as extension of National Guard search for weapons*, pl. 44; *Wall calling for popular democratic government by the MPU (United People's Movement)* pl. 45; *Waiting at the central police station headquarters for missing relatives, Managua*, pl. 46; *Popular forces begin final offensive in Masaya, June 8, 1979*, pl. 47; *National Guardsmen trapped on main street of Masay*, pl. 48;*National Guard reinforcements entering Masaya beseiged by FSLN*, pl. 49; *Muchachos take over neighborhood and out on captured National Guard uniforms, Managua, June 1979*, pl. 50; *Street fighter in Managua*, pl. 51; *Sandinistas distributing arms captured from the National Guard garrison in Matagalpa*, pl. 52; *Population of San Isidro and Sandinistas after surrender of local National Guard, June 13, 1979*, pl. 53; *Serving food to Sandinistas holding the barricades in Managua*, pl. 54; *Sandinista in a home in Estelí*, pl. 55;

Sandinistas in the streets of Estelí, pl. 56; *One hour after the taking of San Isidro,* pl. 57; *Sandinistas on daily rounds in Estelí neighborhood,* pl. 58; *Neighborhood bomb shelter dug under street,* pl. 59; *Children rescued from a house destroyed by a 1,000-pound bomb dropped in Managua,* pl. 60; *National Guards taken prisoner-of-war in Sebaco,* pl. 61; *Sandinista barricade,* pl. 62; *Final assault on the Estelí National Guard headquarters, July 16, 1979,* pl. 63; *Sandinistas at the walls of the Estelí National Guard headquarters,* pl. 64; *Body of National Guardsman, killed during the taking of Jinotepe, being burned with the official state portrait of President Somoza,* pl. 65; *On the road to Managua,* pl. 66; *Near the central plaza, Managua,* pl. 67; *Entering the central plaza in Managua to celebrate victory, July 20, 1979,* pl. 68; *In the central plaza, renamed Plaza de la Revolucion,* pl. 69; *Father collecting remains of assassinated son, identified by a shoe lying nearby,* pl. 70; *Wall, Managua,* pl. 71.

722. Meiselas, Susan. "Susan Meiselas. (Kurdish Project)," *Aperture* 133 (Fall 1993): 24-33.

723. *Pictures From a Revolution.* New York: Kino Video, 1991. Videorecording. 93 minutes.
 Meiselas returns to Nicaragua 10 years after the Sandinista victory.

724. Ritchin, Fred. "The Photography of Conflict," *Aperture* 97 (Winter 1984): 22-27.

725. Ritchin, Fred. "Susan Meiselas: The Frailty of the Frame, Work in Progress," *Aperture* 108 (Fall 1987):32-4.

726. Shames, Laurence. "Susan Meiselas: When Latin America Revolutions Hold the News, She Often Holds the Negatives," *American Photographer* 6, 3 (March 1981): 42-55.

727. Squiers, Carol. "Foreign Intrigue. (Why European magazines are getting the best of U.S. photojournalism)" *American Photographer* 19 (September 1987): 54-63.

728. *Susan Meiselas.* Boulder: University of Colorado, Academic Media Services, 1992. Videorecording. 40 minutes.
 A series of interviews, including one with Susan Meiselas.

729. Welch, Ted. "A Sense of Direction: Susan Meiselas Tells Ted Welch About Projects In Which She Is Actively Involved," *British Journal of Photography* July 11, 1991): 12-13.

Mendieta, Ana
 See also #1007

Menschenfreund, Joan
 See also #1070
Meredith, Ann
 See also #1062, 1071
Metzner, Sheila
 See also #1017
Mieth, Hansel, 1909-
 See also #1058
Miller, Barbara A.
 See also #1039
Miller, Dora
 See also #1040

Miller, Lee, 1907-1977
 See also #1008, 1009, 1028, 1058, 1063

730. Davis, M. "Lee Miller -- Bathing with the Enemy," *History of Photography* 21, 4 (Winter 1997): 314-318.

731. Gross, Jozef. "Lee Miller, Photographer: Model of Talent and Beauty," *British Journal of Photography* 136(June 15, 1989):10-13.

732. Hopkinson, Amanda. "Miller's Tale. (ICA, London,)" *British Journal of Photography* 139 (September 10, 1992): 63.

733. Goldberg, Vicki, "A Woman at War: Lee Miller, correspondent," *American Photo* 3 (July/August 1992): 16.

734. Jenkins, Steven. "Substance Speaks for Itself. (San Francisco Museum of Modern Art; exhibit)," *Artweek* 21 (March 8, 1990): 16-17.

735. Johnson, W. E. "The (Nine?) Lives of Lee Miller, 1907-1977," *Arts Review* 38 (August 1, 1986): 424.

736. Livingston, Jane. *Lee Miller, Photographer*. New York: The California/International Arts Foundation and Thames and Hudson, 1989. 171 p.
 Published on the occasion of the exhibition: "Lee Miller, Photographer." Photographs are accompanied by a lengthy biographical and critical essay, interspersed with passages from Miller's and Penrose's, son and husband's writings, and a chronology by Antony Penrose. Contains numerous portraits of Lee Miller taken by Man Ray, Edward Steichen and Arnold Genthe, among others.
Lee Miller, Self Portrait, 1932, cover; *Sculpture in Window, Paris,* c. 1929, p. 22-

23; *Nude Bent Forward, Paris,* c. 1931, p. 24; *Man Ray Shaving,* c. 1929, p. 26; *Rat Tails,* c. 1930, p. 29; *Carousel Cows,* c. 1930, p. 29; *Ironwork, Paris,* c. 1929, p. 30; *Chairs, Paris,* c. 1929, p. 32; *Architectural View, Paris,* c. 1929, p. 33; *Unknown Woman, Solarized Portrait,* 1930, p. 34; *"Exploding Hand,"* c. 1930, p. 36; *Scent Bottles, New York,* 1933, p. 38; *Man Ray,* 1931, p. 41; *Floating Head, Portrait of Mary Taylor, New York,* 1933, p. 42; *Dorothy Hill, Solarized Portraits, New York,* 1933, p. 44; *Tanja Ramm, Paris,* 1931, p. 45; *Street in Cairo,* 1937, p. 49; *The Estate House of Abboud Pasha, Arcamant, Qena, Egypt,* c. 1936, p. 50; *Restaurant Table, Cairo,* c. 1936, p. 51; *Portrait of Space, near Siwa,* 1937, p. 52; *Cotton Struggling to Escape from Scake to become Clouds, Asyut, Egypt,* 1936, p. 53; *Picnic, Mougins, France,* 1937, p. 55; *Sculpture by Max Ernst on the Wall of the House in St. Martin d'Ardeche,* 1939, p. 56; *Man Ray and Ady, Mougins, France,* 1937, p. 57; *Revenge on Culture from* Grim Glory, 1940, p. 59; *Dolphin Court, London during the Blitz, from* Grim Glory, 1940, p. 60; *Nonconformist Chapel, Camden Town, London, from* Grim Glory, 1940, p. 61; *Henry Moore Making Sketches for his Series of Drawings Titled "Sleepers."* 1940, p. 65; *Casualty Awaiting Evacuation from a Normandy Field Hospital, Frame,* 1944, p. 66; *Normandy, Field Hospital, France,* 1944, p. 67; *U.S. Bombs exploding on the Fortress of St. Mâlo, France,* 1944, p. 68; *Model Preparing for a Millinery Salon after the Liberation of Paris,* 1944, p. 70; *Paris Fashion,* 1944, p. 72; *Paris under Snow,* 1945, p. 73; *Jean Cocteau,* 1944, p. 75; *Freed Dachau Prisoners Scavenging in the Rubbish Dump,* 1945, p. 78; *Trains at Dachau; Prisoner have died on the short march to camp,* 1945, p. 79; *Dachau, Germany: Humans Remains in a Cremation Furnace,* 1945, p. 80; *Dachau, Germany: Beaten Prison Guards,* April 30, 1945, p. 81; *Dachau, Germany: Dead Prisoners,* April 30, 1945, p. 82; *Buchenwald, Germany: Prison Guard after Suicide,* April 1945, p. 84; *Buchenwald, Germany: Beaten Prison Guard,* April 1945, p. 85; *Buchenwald, Germany: Guards Beaten by Liberated Prisoners,* April 1945, p. 87; *Dachau, Germany: Murdered Prison Guard,* 1945, p. 88; *Funeral Pyre of the Third Reich: Hitler's House at Berchtesgaden in Flames,* 1945, p. 90; *Child Dying, Vienna,* 1945, p. 93; *Laszlo Bardossy Facing the Firing Squad, Budapest,* 1946, p. 94; *Max Ernst and Dorothy Tanning, Arizona,* 1946, p. 98; *Saul Steinberg at Farley Farm,* c. 1954, p. 99; *Picasso at Chateau de Vauvenargue,* c. 1960, p. 101; *Picasso's Studio, Villa la California,* 1956, p. 100; *Picasso, Vallauris,* 1954, p. 102; *Tanja Ramm, Paris,* 1931, p. 105; *Walkway, Paris,* c. 1929, p. 106; *Nude with Wire Mesh Sabre Guard,* c. 1930, p. 107; *Inez, Duthie,* c. 1931, p. 108; *Dorothy Hill, Solarized Portrait, New York,* 1933, p. 109; *Guerlain, Paris,* c. 1930, p. 110; *Untitled (Hand Reaching for Umbrella Fringe),* c. 1929, p. 111; *Caged, Birds, Paris,* c . 1930, p. 112; *Untitled (Trees and Shadows),* c. 1929, p. 113; *Sabots on Parched Earth,* c . 1930, p. 114; *Woman with Hand on Head, Paris,* 1931, p. 115; *Joseph Cornell,* 1933, p. 116; *Work by Joseph Cornell,* 1933, p. 117; *Virgil Thompson, New York,* 1933, p. 118; *Gertrude Lawrence, New York,* 1933, p. 119; *Bleached Shells of Snails Marooned by the Receding Waters of the Nile, Egypt,* c. 1936, p. 120; *From the Top of the Great Pyramid, Egypt,* c. 1938, p. 121; *The Monasteries of Dier Simon and Dier Barnabas, Egypt,* c. 1936, p. 122; *Oasis Village, Egypt,* c. 1936,

p. 123; *Stairway, Cairo*, 1936, p. 124; *Egypt*, c. 1936, p. 125; *Roland Penrose with Mumps, London*, 1941, p. 126; *Life Photographer David E. Scherman Equipped for the War in Europe, London*, 1942, p. 127; *Dylan Thomas*, 1943, p. 128; *Brighton Beach, England*, 1937, p. 129; *Graham Sutherland, England*, 1940, p. 130;

From *Grim Glory*: *A London Cafe Wrecked in the Blitz*, 1940, p. 131; *WRVS Billet, England*, c. 1941, p. 132; *The Well Known Art Dealer Freddie Mayor Doing His Rounds as an Air Raid Warden, London*, 1940, p. 133; *The Roof of St. James's Piccadilly, Destroyed in the Blitz*, 1940, p. 134; *Paddington, London*, 1940, p. 135; *Roof of University College, London*, 1940, p. 136; *English Plumbing at its Most Fascinating*, c. 1940, p. 137; *Picasso's Studio*, 1944, p. 138; *Paul Delvaux and René Magritte, Brussels*, 1944, p. 140; *René Magritte*, 1944, p. 141; *Colette, Age 71, in Her Apartment at 9 Rue de Beaujolais, Paris*, 1944, p. 142; *Marlene Dietrich in Paris, with the U.S.O. to Entertain the Troops*, 1944, p. 143; *Surgical Team Working in a Normandy Field Hospital, France*, 1944, p. 144; *Loading Casualties into the Dakota in Normandy Beachhead*, 1944, p. 145; *Ludwigshaven Chemical Works after Allied Bombing*, 1945, p. 146; *Cologne Cathedral, Germany*, 1944, p. 147; *Liberated Prisoners Waits in Cologne Gestapo for His Official Release, Germany*, 1945, p. 148; *Dachau*, 1944, p. 149; *Suicided Member of the Burgomeister's Staff, Leipzig, Germany*, 1945, p. 150; *Hitler's Desk in His House at Prinzregentenplatz 27, Munich, Germany*, 1945, p. 151; *Victory Celebration in the Tivoli Gardens, Copenhagen*, 1945, p. 153-3; *Giorgio Morandi*, 1948, p. 154; *Joan Miro Visiting London Zoo*, c. 1964, p. 155; *Roof Top Study*, c. 1956, p. 157; *Picasso at Villa la California*, 1956, p. 158; *Paul and Dominique Eluard with Picasso near St. Tropez*, 1951, p. 159; *Picasso and Roland Penrose, Villa la California*, 1955, p. 160; *Igor Stravinsky, Hollywood*, 1946, p. 161; *Georges Limbour and Jean Dubuffet at Farley Farm*, 1959, p. 162; *Picasso, Hôtel Vaste Horizon, Mougins, France*, 1937, p. 163.

737. "Lee Miller and Photographic Surrealism," *Creative Camera* 8 (1986): 10-11.

738. Lyford, Amy J. "Lee Miller's Photographic Impersonations, 1930-1945: Conversing With Surrealism," *History of Photography* 18 (Autumn 1994): 230-241.

739. Miller, Lee. *Lee Miller's War: Photographer and Correspondent With the Allies in Europe, 1944-45*. Boston: Little Brown, 1992. 208 p. Illustrated.
David E. Scherman dressed for war, p. 7; *Operating Theater, 44th Evac. Hospital*, p. 14; *'...smoke or chat to see if he's real.'* p. 16; *Bad burns case, 44th Evac. Hospital*, p. 18; *Staff mess, 44th Evac. Hospital*, p. 20; *Nurse, exhausted after a long shift, 44th Evac.*, p. 21; *Surgeon and anaesthetist, 44th Evac. Hospital*, p. 22; *Ablution facilities, 4th Evac. Hospital*, p. 24; *Off-duty nurses relaxing, 44th Evac. Hospital*, p. 25; *Collecting Station*, p. 26; *Medics attend a casulaty*, p. 27; *Normandy village ruined by the fighting*, p. 29; *Surgeon using a bronchoscope*,

44th Evac. Hospital, p. 28; *Securing stretchers inside evacuation aircraft*, p. 30; *Loading wounded into evacuation aircraft*, p. 31; *Women greeting GIs with hand made flags, Dinard*, p. 32; *Ruined street*, p. 35; *Young Marquis soldier*, p. 34; *Sapeurs-pompiers*, p. 37; *'Pixie Twins,'* p. 37; *Old Malo burning from the OP in the Hôtel Ambassadeurs*, p. 38; *Woman collaborator with her children*, p. 41; *Staff in US Civil Affairs headquarters*, p. 42; *Major Speedie US 83rd Div. in the 329 Rgt. CP at the Hôtel Univers during preparations for the final assault*, p. 43; *US troops directing mortar fire from Hôtel Ambassadeurs*, p. 45; *US troops being briefed by Captain Patterson before the final assault on the citadel*, p. 47; *Aerial bombardment of the citadel*, p. 49; *Polish GIs after the assault*, p. 50; *Place Châteaubriand*, p. 51; *Old St. Malo*, p. 52; *Children scramble to reach Fred Feekart's chocolate ration*, p. 55; *Fred Feekart with German nurse POWs, near Dinan*, p. 56; *US P38 in a Napalm strike on the citadel*, p. 58; *Colonel von Aulock bids farewell to his men*, p. 59; *Surrendered German troops file out of the citadel*, p. 60; *German officers leaving the citadel*, p. 63; *Wounded allied soldier freed from the citadel*, p. 62; *Women found guilty of collaboration, Rennes*, p. 64; *Victory celebrations at Maison Paquin*, p. 66; *Mlle. Christiane Poignet, law student*, p. 68; *Gis and mademoiselles*, p. 69; *Leaving the Pierre et René hairdressing salon with wet curls and a turban*, p. 70; *Cyclists powering the hairdryers at Salon Gervais*, p. 71; *Place de la Concorde*, p. 71; *Children celebrating on a burned-out car*, p. 72; *Picasso in his studio*, p. 74; *Nusch and Paul Eluard in Zervos' apartment*, p. 75; *Jean Marais talks to some admirers from the window of Cocteau's apartment in the Palais Royal*, p. 76; *Jean Cocteau, Nusch Eluard, unknown, Bébé Berard*, p. 77; *Maurice Chevalier*, p. 79; *US service women at a fashion salon*, p. 81; *Models relaxing before a fashion show*, p. 82; *Paquin's navy-blue woolen dress. Place de la Concorde*, p. 83; *Children and GIs on flak wagon outside Notre Dame*, p. 83; *Bruyère's quilted windbreaker*, p. 84; *Paquin's designer M. Castillo*, p. 85; *German soldiers clamber up the steps to cross, Beaugency Bridge*, p. 86; *German prisoners*, p. 88, 91; *Loire bridge at Orleans*, p. 90; *Marlene Dietrich*, p. 95; *Fred Astaire*, p. 96; *The veiled Eiffel Tower from the Palais de Chaillot*, p. 98; *Pissoir with posters*, p. 99; *Surreal views of the Jardins des Tuileries*, p. 100, 101; *Champagne bottles and jerry cans on the balcony of Lee Miller's room*, p. 102; *Montmatre*, p. 103; *Colette and her husband Maurice Goudeket*, p. 104; *Colette*, p. 108; *Lee Miller and friends*, p. 111; *Young evacuee*, p. 112; *US soldiers horse around with children*, p. 114; *'...black and white cows ebbed and flowed.'* p. 117; *Refugees say a last prayer at a wayside shrine*, p. 118; *'...Military Expediency,'* p. 119; *'...ancient grandmothers who had become household fixtures'* - *being cheered*, p. 120; *Maesy Bastion, interpreter and explainer to the US Civil Affairs Team*, p. 121; *US troops watching the attack*, p. 123; *The town of Echternach, with Germany beyond, the day before the attack*, p. 122; *Sgt. Berners encounters a mobile hay rick*, p. 124; *Pigs on the move*, p. 125; *'Jean Perier...the littlest GI in the Army,'* p. 126; *Chow time*, p. 128; *Shop window typically displaying photographs of the Grand Duches of Luxembourg and her Consort*, p. 131; *Company leaving their position 400 yds. away at the forest edge to be replaced by a relieving force who will make a night attack*, p. 132; *Vosges mountain village*, p. 134; *The roads are*

crammed with refugees - tanks come up and as often as not pile in the ditch, p. 136; *Infantry waiting for the attack*, p. 137; *The platoon which took the mill rests for a while on the wheat bags*, p. 138; *An eighteen-year-old Parisian boy, white with fright at the thought of going into battle for the first time*, p. 138; *German prisoners marching rearwards in full view of th enemy, while a platoon of French advance up the ditch*, p. 139; *US tanks advance concealed by the smoke screen*, p. 140; *The bridge which broke under the weight of a tank*, p. 141; *French Legionnaires set up housekeeping in a wrecked courtyard*, p. 142; *"Stand Against Rumor,"* p. 143; *General 'Iron Mike' O'Daniel of the 3rd Infantry Division decorates a member of the regiment for field bravery*, p. 144; *Panorama of Neuf Brisach*, p. 146; *Artillery officers map places for their guns*, p. 146; *Civilians fight fires with a hand pump in the remains of their home, Neuf Brisach*, p. 147; *Nuns search for their padre among the debris of their ruined church*, p. 149; *Ruined farmhouse on the Colmar plains*, p. 151; *Strasbourg sculptures*, p. 152, 153; *David E.Scherman talking shop with Russian cameraman*, p. 157; *Lee Miller and Russian women soldiers*, p. 157; *Russian women soldiers aboard a US truck*, p. 157; *US and Russian Generals pose for the press*, p. 157; *Russian troops*, p. 156; *Buchenwald*, p. 160; *Dummy tied to the whipping stall for the benefit of German visitors*, p. 162; *A party of German visitors being conducted on a camp tour, Buchenwald*, p. 163; *Beaten SS prison guard*, p. 164; *Suicided SS prison guard*, p. 165; *Defiant SS prison guard in cell*, p. 165; *French girl and Belgian boy liberated from Gestapo jail, Cologne*, p. 166; *The far side of the Rhine, across Hohenzellern Bridge is still held by enemy troops,Cologne*, p. 167; *New street signs supplant the old in Aachen*, p. 168; *Wreckage of a factory for making half-track vehicles, Frankfurt*, p. 169; *Passengers queue for the ferry to cross the river Main, Frankfurt*, p. 170; *Sealed wreckage of air raid shelter*, p. 171; *Bombed chemical plant, Ludwigshaven*, p. 172; *Liberated slave labourers from a chemical plant await repatriation, Ludwigshaven*, p. 173; *US troops in Leipzig*, p. 175; *The Napoleonic Monument, scene of an enemy ambush, Leipzig*, p. 176; *The daughter of the Burgomaster of Leipzig suicided with her parents as the allies took the city*, p. 177; *Liberated American POWs*, p. 178; *Nuremberg*, p. 180; *Women cooking over open fire*, p. 181; *The trains bringing the prisoners to the camp were long enough to extend past villas outside the camp, Dachau*, p. 182; *Rail truck containing dead prisoners, Dachau*, p. 182; *GIs examine a rail truck load of dead prisoners, Dachau*, p. 183; *Dead SS guard floating in the canal beside the camp, Dachau*, p. 184; *Prisoners in three tier bunks, Dachau*, p. 185; *Newly dead bodies piled outside the huts awaiting disposal, Dachau*, p. 185; *The Angora rabbit farm, an industry of the prison, Dachau*, p. 185; *Prisoners pile corpses on a horse drawn cart, Dachau*, p. 185; *Prisoners await the distribution of bread, Dachau*, p. 186; *Prisoners scavenge on the camp rubbish dump, Dachau*, p. 187; *US artillery and German prisoners outside Hitler's apartment in Prinzregentenplatz, Munich*, p. 192; *Lt. Col. Grace 179th Reg. 45th Div., trying to phone Berchtesgaden from Hitler's former apartment*, p. 193; *David E. Scherman photographing in the Konigsplatz Mausoleum, Munich*, p. 194; *Wilhelm Guillon, 76, the hausmeister of the Stermeckerbrau Haus, Munich*, p. 196; *The banqueting hall of the Hofbrau Haus with the mural old Munich*, p. 197; *Eva*

Braun's villa in Wasserburgerstrasse, Munich, p. 199;*The funeral pyre of the Third Reich - the Eagles Nest in flames, Berchtesgaden*, p. 201; *Schloss Lindhof, built by 'Mad' King Ludwig II 1874-78*, p. 202; *German POWs marching, Bavaria*, p. 203.

740. Morris, Susan. (Zelda Cheatle Gallery, London, Exhibit) *Arts Review* (London) 41(May 19, 1989): 366.

741. Myers, T. R. "Lee Miller," *Arts Magazine*, 65, 1(September 1990): 93.

742. Nakhnikian, E. "Klinefelter, Lee Miller 100th Birthday (Tribute)," *History of Photography*, 16, 1 (Spring 1992): 78-79.

743. Penrose, Antony. *The Lives of Lee Miller*. New York: Thames and Hudson, 1989. 216 p.
 Biographical essay, with passages from her writings, makes up half of the book, with the other half being Miller's photographs. Work also includes numerous photographs of Lee Miller, from childhood to adulthood.
Man Ray. Paris, c. 1930, p. 23; *Fashion Study.* Paris, 1932, p. 24; *Walkway.* Paris, p. 25; *Nude Bent Forward.* Paris, c. 1931, p. 27; *Solarized Photograph.* Paris, 1930, p. 35; *Tanja Ramm, Paris,* p. 34; *Nimet Eloui Bey, Aziz's first wife.* Paris, 1931, p. 39; *'Floating Head'* New York, 1933, p. 45; *Woman With Hand on Head.* Paris, 1931, p. 46; *Dorothy Lee.* Paris, 1933, p. 47; *Scent bottles.* New York, 1933, p. 49; *Lilian Harvey, film star.* New York, 1933, p. 50; *John Rodell, literary agent and one of Lee's boyfriends.* New York, 1933, p. 51; *John Houseman, impresario.* New York, 1933, p. 51; *'Prince Mike Romanoff'* New York, 1933, p. 51; *Virgil Thomson, composer.* New York, 1933, p. 51; *Portrait of an unknown woman.* New York, 1933, p. 52; *Portrait inscribed by Lee, 'Gertrude Lawrence'* New York, 1933, p. 53; *Object by Joseph Cornell.* New York, 1933, p. 54; *Joseph Cornell, the Surrealist artist, combined with one of his objects.* New York, 1933, p. 55; *Self-portrait, for a fashion article on headbands.* New York, 1932, p. 57; *Turbulent clouds,* New York, 1934, p. 58; *Cotton sacks.* Asyut, c. 1936, p. 62; *From the top of the Great Pyramid.* Egypt, c. 1938, p. 63; *Bollard.* Alexandria, 1936, p. 65; *Mafy Miller.* Cairo, 1937, p. 66; *Aziz's house.* Cairo, n.d., p. 67; *Stairway.* Cairo, c. 1936, p. 68; *'Portrait of Space'.* Near Siwa, 1937, p. 69; *Sand tracks.* Red Sea, c. 1936, p. 71; *Aziz, fishing.* Egypt, c. 1935, p. 72; *Nusch and Paul Eluard, Roland Penrose, Man Ray and Ady.* Mougins, France, 1937, p. 76; *'Black Satin and Pearls Set'* Cairo, c. 1935, p. 78; *Eileen Agar.* England, 1937, p. 79; *Oasis Village.* Egypt, c. 1939, p. 81; *Monastery of Wadi Natrun.* Egypt, c. 1935, p. 82; *Statue beside the Suez Canal.* Egypt, c. 1938, p. 83; *Blocked doorway.* Syria, 1938, p. 84; *'Cock Rock"* Egypt, 1939, p. 85; *Dead child.* Romania, 1938, p. 87; *'On the Road".* Romania, 1938, p. 88; *Tree crosses in a cemetery.* Romania, 1938, p. 89; *Bernard Burrows inflating an airbed.* Red Sea, 1938, p. 90; *Roland Penrose in Egypt,* 1939, p. 92; *Mafy Miller, unknown, George Hoyningen-Huene, Roland Penrose.* Near Siwa, 1939, p. 92; *'Steam Dhow'* Egypt, c. 1936, p. 93; *Rear view of camel.* Egypt, c. 1938, p. 94; *Leonora Carrington and Max Ernst at Saint-*

Martin-d'Ardèche, 1939, p. 96; [At entrance of bomb shelter, women wearing masks] 1940, p. 99; *Roland Penrose's first wife Valentine,* Hampstead, 1940, p. 100; *Roland Penrose suffering from mumps*. Hampstead, 1940, p. 100;

From <u>Grim Glory</u>: *'Remington Silent'*, 1940, p. 102; *'Eggceptional Achievement'* London, 1940, p. 103; *'Nonconformist Chapel', Camden Town*, 1940, p. 104; *'Bridge of Sighs'*, 1940, p. 105; *The Shattered Roof of University College, London, reflected in a pool of rainwater,* 1940, p. 106; *'Revenge on Culture'*, 1940, p. 107; *'One Night of Love'*, 1940, p. 108;*ATS searchlight operators*, London, 1943, p. 110; *ATS searchlight operators on the target*, 1943, p. 110; *Henry Moore, sketching in Holborn underground station in London during the Blitz*, 1940, p. 111; <u>Life</u> *photographer Dave Scherman, suitably equipped for the war in Britain,* 1942 p. 112; *Humphrey Jennings, Surrealist painter.* London, 1941, p. 115; *Field hospital in Normandy,* 1944, p. 119; *Bombs bursting on the fortress of Saint Malo,* 1944, p. 121; *Picasso and Lee in Picasso's studio during the liberation of Paris,* 1944, p. 123; *Hôtel Scribe.* Paris, 1944, p. 125; *Model preparing for a millinery salon after the liberation of Paris,* 1944, p. 128; *Colette, aged 71, embroidering in her apartment,* Paris, 1944, p. 129; *Moroccan replacement troops to join the fighting in the Colmar region of Alsace,* 1945, p. 132; *United States tank crew and infantry billeting in an Alsace farmyard,* 1945, p. 133; *Dead [German] soldier,* Cologne, 1945, p. 134; *Daughter of the burgomaster of Leipzig,* 1945, p. 135; *Statues covered by camouflage nets,* Germany, 1945, p. 136; *The locomotives and the eerie stillness of this landscape,* Germany, 1945, p. 137; *Dave Scherman and a Soviet cameraman,* Torgau, 1945, p. 138; *Dachau.* April 30, 1945, p. 140; *United States medics from Rainbow Company with a dead prisoner at Dachau,* 1945, p. 141; *The funeral pyre of the Third Reich. Hitler's House at Berchtesgaden,* 1945, p. 143; *German boy,* p. 144; *Farmyard in Denmark,* 1945, p. 146; *The Viennese singer Rosl Schwaiger,* Leopoldskron Castle, 1945, p. 149; *The marionettes of Hermann Aicher,* Salzburg, 1945, p. 150; *Statues queue in the shelter where they were moved for safe keeping,* Vienna, 1945, p. 151; *Child dying in Vienna's splendidly equipped children's hospital,* 1945, p. 153; *Nijinsky in Vienna with his devoted wife, Romola,* 1945, p. 154; *Opera star Irmgard Seefired...in the burned out Vienna Opera House,* 1945, p. 155; *Major General O.K. Edgecombe, OBE, MC, and his wife,* Budapest, 1945, p. 159; *'Field of Blood,'* Budapest, 1945, p. 161; *Hungarian aristocrats,* Budapest, 1945, p. 162; *Sigismund Strobl, whose sculptures were in much demand by the Allies,* Budapest, 1945, p. 164; *The 'wondrous old dame' Lee was photographing,* 1946, p. 165; *László Bardossy, fascist ex-Prime Minister of Hungary, facing the firing squad,* Budapest, 1946, p. 167; *'The prying eyes of Sibiu,'* Romania, 1946, p. 169; *Harry Brauner recording a song by Maritza, the Romanian folk-singer,* 1946, p. 171; *Queen Helen the Queen Mother in her palace at Sinaia, Romania,* 1946, p. 173; *The cemetery at Sinaia,* 1946, p. 175; *Homeless girls in Bucharest,* 1945, p. 176; *Isamu Noguchi, the Japanese sculptor, in his studio,* New York, 1946, p. 179; *Max Ernst and Dorothea Tanning,* Arizona, 1946, p. 180; *Mafy and Erik Miller,* Los Angeles, 1946, p. 181; *Man Ray and Roland Penrose in Man Ray's studio,* Los Angeles, 1946, p. 181; *View from the Farley Farm,* 1952, p. 187; *Roland Penrose with Timmie O'Brien at Farley Farm,*

and Tony Penrose at Farley Farm, 1950, p. 190; *Valentine Penrose charming both a grass snake and Tony, Farley Farm,* c. 1952, p. 191; *Saul Steinberg, the New York cartoonist,* Farley Farm, 1959, p. 192; *Philippe and Yen Hiquily at Farley Farm,* c. 1962, p. 193; *Roland Penrose, Sonia Orwell and John Hayward in the amusement arcade,* 1955, p. 199; *Joan Miró at London Zoo,* c. 1964, p. 208; *Antoni Tàpies in his studio,* Barcelona, 1973, p. 209.

744. Wells, Liz. "Sons and Mothers," *British Journal of Photography* 133 (October 10, 1986): 1163.

Miller, Linda Joan
 See also #1070
Millner, Sherry
 See also #1055
Min, Yong
 See also #1055
Mitchell, Margaretta K., 1935-
 See also #550, 1007, 1058
Moberley, Connie
 See also #1070

Model, Lisette, 1901-1983
 See also #1005, 1008, 1009, 1025, 1056, 1058, 1061, 1063

745. Abbott, Berenice. "Lisette Model," *Camera*(Switzerland) 56, 12 (December 1977): 4+.

746. Abbott, Berenice. "Lisette Model," *Camera 35* 25, 2 (15 February 1980): 22-27, 80.

747. Coleman, A. D. "Heavyweight Reputation. (National Gallery of Canada, Ottawa; traveling exhibit,)" *British Journal of Photography* 139 (July 18, 1991): 25.

748. Cravens, R. H. "Notes for a Portrait of Lisette Model," *Aperture,* 86 (1982): 52-65.

749. Grande, J. K. "Model Lisette," Artforum 29, 7 (1991): 139.

750. Harris, Lin. "A Last Interview with Lisette Model," *Camera Arts* 3, 6 (June 1983): 14-16+.

751. Homberger, Eric. "Transcending the Agendas: Gender and Photography," *Word & Image* [Great Britain] 7, 4 (1991): 377-382.

752. "Lisette Model," *Camera* (Switzerland) 50, 3 (March 1971): 34-45.

753. McAlpin, Mary Alice. "Lisette Model," *Popular Photography* 49, 5 (November 1961): 52-53+.

754. McQuaid, James. *Interview with Lisette Model: Conducted in New York City on January 28-30, 1997.* 475 p.
"Transcription of tape recorded interviews conducted for the Oral History Project of the International Musuem of Photography at George Eastman House." oclc

755. Model, Lisette. "Feet," *U.S. Camera* 1, 14 (February 1941): 52.

756. Model, Lisette. *Lisette Model.* Tucson, AZ: Center for Creative Photography, University of Arizona, 1977. 20 p. Chiefly illustrations.

757. Model, Lisette. *Lisette Model.* Preface by Berenice Abbott. Millerton, NY: Aperture, 1979. 109 p. Chiefly illustrations. Includes a chronology. Bibliography: p. 106-108.
Coney Island, Standing, 1942, front cover; *Man Sleeping Near the Seine, Paris,* 1937, back cover; *Fifth Avenue,* 1940s, p. 7; *Fashion Show, Hotel Pierre,* c. 1957, p. 2-3; *New York,* n.d., p. 4-5; *Promenade des Anglais,* 1937, p. 11, 17, 23, 25, 33, 35, 37, 59; *Famous Gambler, Monte Carlo,* 1937, p. 13; *Blind Man, Paris,* 1937, p. 15; *Monte Carlo,* 1937, p. 19; *New York,* 1950s, p. 20-21; *Circus Man, Nice,* 1937, p. 27; *Fifty-Seventh Street, New York,* 1970, p. 28-29; *Newspaperman, Paris,* c. 1938, p. 31; *Fifth Avenue,* 1950s, p. 39; *French Riviera,* 1937, p. 41; *Man Sleeping Near the Seine, Paris,* 1937, p. 43; *Banker, Wall Street,* c. 1945, p. 45; *Avignon, 1966,* p. 46-47; *San Francisco,* c. 1947, p. 49; *Dolls, Venezuela,* 1954, p. 50-51; *Ringling Brothers Circus, New York,* c. 1956, p. 53; *Coney Island, Reclining,* 1942, p. 54-55; *Bois de Bologne,* 1938, p. 57; *French Riviera,* 1937, p. 61; *Lower East Side, New York,* 1940s, p. 63; *Nice,* 1937, p. 64-65; *Lower East Side, New York,* 1950s, p. 67, 69; *Fifth Avenue,* n.d., 78-79, 92-93; *Opening Night, San Francisco Opera,* early 1950s, p. 81; *Couple Dancing, Sammy's Bar, New York,* n.d., p. 83; *Fifth Avenue,* late 1940s, p. 85; *New York,* n.d., p. 87; *Fifty-Seventh Street, New York,* 1970, p. 88-89; *Sailor and Girl, Sammy's Bar, New York,* c. 1940, p. 91; *Hermaphrodite, Forty-Second Street Flea Circus,* New York, 1940s, p. 95; *Sammy's Bar, New York,* n.d., p. 96-97, 99; *Broadway Singer, Metropolitan Café, New York,* n.d., p. 101; *Trento, Italy,* p. 104-105.

758. Model, Lisette. *Lisette Model: A Retrospective [exhibition].* New Orleans: New Orleans Musuem of Art, 1981. 90 p. Chiefly illustrations.
Includes very brief comments by Model, and a chronology.
Coney Island, Standing, 1942, pl. 1; *Coney Island, Reclining,* 1942, pl. 2; *Monte Carlo,* 1937, pl. 3; *Promenade des Anglais,* 1937, pl. 4, 5, 8-13; *French Riviera,*

1937, pl. 6, 7, 23; *Famous Gambler, Monte Carlo*, 1937, pl. 14; *Man Sleeping Near the Seine, Paris*, 1937, pl. 15; *Woman in Flowered Dress, Riviera*, 1937, pl. 16; *Blind Man, Paris*, 1937, pl. 17; *Bois de Bologne*, 1938, pl. 18; *Circus Man, Nice*, 1937, pl. 19; *Woman Mending, Paris*, 1938, pl. 20; *Newspaper Man, Paris*, 1938, pl. 21; *Woman With Veil, San Francisco*, 1947, pl. 22; *Bag Lady, Paris*, 1939, pl. 24; *Woman With Shawl, Lower East Side*, 1950, pl. 25; *Old Woman, Lower East Side*, 1940, pl. 26; *Four Women, Nice*, 1937, pl. 27; *Black Dwarf, Lower East Side*, 1950, pl. 28; *Lower East Side, 1950*, pl. 29, 32, 35, 37; *Petty Labor, NYC*, 1940, pl. 30; *Lower East Side*, 1940, pl. 31, 34, 36, 72-74; *Fifth Avenue*, 1940, pl. 38-41; *Little Man, Lower East Side*, 1940, pl. 42; *World War II Rally, Lower East Side*, c. 1943, pl. 43, 44; *The Murray Hill Hotel, NYC*, 1940, pl. 45-49; *Singer at Sammy's Bar*, 1940, pl. 50; *At Sammy's, NYC*, 1940, pl. 51; *Couple Dancing*, 1940, pl. 52; *Never a Dull Moment, Sammy's Bar*, 1940, pl. 53; *Sammy's Bar*, 1940, pl. 54, 58; *Singer at Sammy's*, 1940, pl. 55; *Sailor and Girl, Sammy's Bar*, 1940, pl. 56; *Two Singer's, Sammy's Bar*, 1940, pl. 57; *Fashion Show, Hotel Pierre, NYC*, 1940, pl. 59; *Singer at the Cafe Metropole, NYC*, 1940, pl. 60; *Paris*, 1938, pl. 61; *Fifth Avenue*, 1940, pl. 62; *Wall Street*, 1940, pl. 63; *Opening Night, San Francisco*, 1950, pl. 64; *New York City*, 1950, pl. 65; *Opening Night, San Francisco Opera*, 1950, pl. 66; *The Wallendas, NYC*, 1950, pl. 67; *Circus NYC, 1950*, pl. 68, 70, 71; *Hermaphrodite*, 1940, pl. 69; *The Dog Show*, 1950, pl. 75-77; *Gallagher's People, NYC*, 1945, pl. 78-80; *Dolls, Venezuela*, 1954, pl. 81, 82; *Flea Market, Paris*, 1953, pl. 83; *Avignon*, 1953, pl. 84; *Running Legs, NYC*, 1940, pl. 85-96; *Reflection, NYC*, pl. 97-100; *Reflection, San Francisco*, 1950, pl. 101; *Reflection, Fifth Avenue* 1940, pl. 102; *57th Street*, 1970, pl. 103; *Reflection, NYC*, pl. 104; *Sculpture, Rome*, 1966, pl. 105; *Rome, 1966*, pl. 106-108, 111-115; *Trento, Inlay*, 1966, pl. 109; *St. Peters, Rome*, 1966, pl. 110.

759. "Outlook--Lisette Model: Keeping the Legend Intact," *Infinity* 22, 1 (January 1973): 14.

760. "Photographs by Lisette Model," *Creative Camera* (November 1969): 386-395.

761. "Pictures by a Great Refugee Photographer, Lisette Model," *U.S. Camera* 5, 10 (October 1942): 24-25.

762. Porter, Allan. "Lisette Model," *Camera* (Switzerland) 56, 12 (December 1977): 3-43.

763. Rodriguez, Julian. "Role Model? (Photographers' Gallery, London; exhibit,)" *British Journal of Photography* 139 (February 6, 1992): 12.

764. Thomas, Ann. *Lisette Model*. Ottawa: National Gallery of Canada, 1990. 362 p. Illustrated. Bibliography: p. 340-345.
 Published in conjunction with an exhibition held at the National Gallery

of Canada, 1990-1996.

The ten chapters that precede the plates are an integral part of this work. Not only do they provide biographical information on Model, but also are an extensive discussion of the photographers and artists that influenced her work. Numerous photographs by these influential artists are interspersed throughout the text, as are many photographs of Model. Includes a chronology, list of exhibitions, list of the illustrations and an index of names and titles.

French Gambler, French Riviera, 1934?, pl.1; *New York*, 1940-1941, pl. 2; *Delancy Street*, New York, 1942?, pl. 3; *International Refugee Organization Auction*, New York, 1948, pl. 4, 139, 140, 141, 142; *Cardinal*, Nice, 1933-1938, pl. 5; *Westminster KennelClub Dog Show*, New York, February 1946, pl. 6, 31, fig. 72,; *Pedestrian*, New York, c. 1945, pl. 7; *Coney Island Bather*, New York, 1939-1941, pl. 8; *Bois de Boulogne*, Paris, 1933-1938, pl. 9; *Woman with Veil*, San Francisco, 1949, pl. 10; *Circus Man*, 1933-1938, pl. 11; *Olga Seybert*, Nice, 1933-1938, fig. 16; *Florence Henri*, Paris, 1933-1938, fig. 17; *Paris*, 1933-1938, fig. 18; *Promenade des Anglais*, Nice, 1934, fig. 21, 22, 23, 24, pl. 12, 22, 46, 47, 48, 49, 50, 51, 52, 53, 54, 55, 58; *Nice*, 1933-1938, fig. 29; *Blind Man in Front of Billboard*, 1933-1938, pl. 13; *Blind Man Seated on Sidewalk*, Paris, 1933-1938, pl. 14; *Blind Man Walking*, Paris, 1933-1938, pl. 15; *Evsa Model*, Nice, 1935-1938, fig. 32; *12 rue Lalande, Paris,* 1953, fig. 35; *Luba Ash and Mania Zimmerman*, 1947, fig. 36; *Trudi Schönberg Greissle*, New York, 1940-1947, fig. 38; *Opening of "Masters of Abstract Art" Exhibition at H. Rubinstein's New Art Center*, 1942, fig. 40; *Wall Street*, New York, 1939, fig. 42; *Reflections, Bergdorf Goodman*, New York, 1939-1945, fig. 44; *Window, Lower East Side*, New York, 1939-1945, fig. 45, 46; *Window, Bonwit Teller*, New York, 1939-1940, fig. 47; *Reflections, Hunter Shop*, New York, c. 1950, fig. 48; *Window*, San Francisco, 1949, fig. 49; *Reflections, Legs in Bergdorf Goodman Window*, New York, 1939-1945, fig. 53; *Valeska Gert in "Death,"* New York, 1940?, fig. 57, pl. 16; *Valeska Gert, Olé"* 1940, pl. 17; *Pearl Primus in "Hard Times Blues,"* New York, 1943, fig. 58, pl. 18; *Café Metropole*, New York, c. 1946, pl. 19; *Weegee (Arthur H. Fellig)*, New York, c. 1945, pl. 20; *"Sammy's on the Bowery,"* Harper's Bazaar, September 1944, fig. 60, p. 81; *Mrs. Cavanaugh and a Friend at an Opening of the Metropolitan Opera*, New York, c. 1943, fig. 61; *Lower East Side*, New York, 1939-1942, fig. 64, pl. 28, 29, 64, 81, 83, 84, 85, 86, 87, 88, 89, 90, 105, 112; *Lower East Side, Riis House*, New York, 1944, fig. 65; *Crowd, War Rally*, New York, 1942, fig. 66; *They Honor Their Sons*, New York, 1939-1942, pl. 21; *Dorothy Wheelock Edson and Wesley Edson*, New York, c. 1945, fig. 67; *Albert-Alberta, Hubert's Forty-second Street Flea Circus.* New York, c. 1945, fig. 68, pl. 27; *Robert and Peter Oppenheimer*, San Francisco, 1946, fig. 74; *Imogen Cunningham*, San Francisco, 1946, fig. 75; *Ansel Adams*, 1946, fig. 78; *Ansel Adams and students*, San Franciso, 1949, fig. 82; *San Francisco*, 1949, fig. 83; *Sammy's*, New York, 1940-1944, fig. 96, pl. 30, 107, 108, 109, 110, 111, 116, 119, 121; *Times Square,* New York, c. 1954, fig. 98; *Window*, New York, c. 1951, fig. 99; *Bernini's Fountain of the Four Rivers, Piazza Navona*, Rome, 1953, fig. 100; *Hans Hofmann*, Provincetown, 1952, fig. 103; *Billie*

Holiday, New York, 1959, fig. 104; *Rome,* 1953, fig. 105, 107, 108, 109, pl. 179, 180, 181, 182, 183, 184; *House Façade,* Trento, 1953, fig. 106; *Caracas,* 1954, fig. 110; *Maracibo Woman,* Venezuela, 1954, fig. 111; *Beatrice Wood,* Ojai, 1966, fig 114; *Las Vegas,* 1966, fig. 115, 116; *War Rally,* New York, 1941-1942, pl. 23; *Percy Pape, The Living Skeleton,* New York, 1945, pl. 24; *Lucerne,* 1977, fig. 125; *Self-Portrait,* Lucerne, 1977, fig. 126; *Window,* Lucerne, 1978, fig. 127; *Nice,* 1982, fig. 129; *Evsa,* New York, 1970-1975, fig. 130; *Coney Island,* New York, 1939-1941, pl. 25; *Running Legs, Fifth Avenue,* New York, 1940-1942, pl. 26; *St. Regis Hotel,* New York, c. 1945, fig. 134; *Vincesses Zoo,* Paris, 1933-1938, pl. 32, 33, 34, 35, 36; *Man with Pamphlets,* Paris, 1933-1938, pl. 37; *Woman Reading,* France, 1933-1938, pl. 38; *Sleeping on Montparnasse,* Paris, 1933-1938, pl. 39; *Sleeping by the Seine,* Paris, 1933-1938, pl. 40; *Young Man Asleep on Sidewalk,* Paris, 1933-1938, pl. 41; *Peanut Vendor,* Nice, 1933-1938, pl. 42; *Man Mending Net,* Nice, 1933-1935, pl. 43; *Woman with Basket,* Nice, 1933-1938, pl. 44; *Destitute Woman Seated on Bench,* France, 1933-1938, pl. 45; *French Riviera,* 1934?, pl. 57; *First Reflection,* New York, 1939-1940, pl. 59; *Man in Restaurant, Delancey Street,* New York, 1939-1945, pl. 60; *We Mourn Our Loss,* New York, 1945, pl. 61; *Chicken and Glamour,* New York, 1939-1942, pl. 62; *Window,* New York, 1939-1945, pl. 63, 70; *Window,* San Francisco, 1949, pl. 65; *Reflections, Rockefeller Center,* New York, c. 1945, pl. 66; *Window, Bergdorf Goodman,* New York, 1939-1945, pl. 67; *Window, Bonwit Teller,* New York, 1939-1940, pl. 68; *Reflections,* New York, 1939-1945, pl. 69, 73, 74; *Window, Bridal Couple,* New York, 1939-1945, pl. 71; *Reflections, Fifty-seventh Street,* New York, 1939-1940, pl. 72; *Pedestrian,* New York, c. 1945, pl. 75, 76, 77, 79, 80; *Wall Street,* New York, 1939-1941, pl. 78; *New York,* c. 1945, pl. 82; *Running Legs, Forty-second Street,* New York, 1940-1941, pl. 91, 98; *Running Legs,* New York, 1940-1941, pl. 92, 93, 94, 95, 96, 97, 99, 100, 101, 103; *Running Legs, Fifth Avenue,* New York, 1940-1941, pl. 102; *New York,* 1939-1945, pl. 104, 106; *Metropolitan Opera,* New York, 1943?, pl. 113; *Hanka Kelter,* New York, 1945?, pl. 114; *Nick's,* New York, 1940-1944, pl. 115; *Female Impersonators,* c.1945, pl. 117, 118; *Gallagher's,* New York, 1945, pl. 120, 125; *Fashion Show, Hotel Pierre,* New York, 1940-1946, pl. 122, 128; *Asti's,* New York, 1945-1946, pl. 123; *Restaurant,* New York, 1945, pl. 124; *Diana Vreeland,* New York, c. 1945, pl. 126; *St. Regis Hotel,* New York, c. 1945, pl. 127, 129; *Lighthouse, Blind Workshop,* New York, 1944, pl. 130, 131, 132, 133; *Circus,* New York, pl. 134, 135, 136, 137, 138; *Opera,* San Francisco, 1949, pl. 143, 144, 146; *Dorothea Lange,* San Francisco, 1946, pl. 147; *Evsa Model,* New York, c. 1950, pl. 148; *Henry Miller,* San Francisco, 1946, pl. 149; *Frank Sinatra,* New York, 1939-1944, pl. 150; *Murray Hill Hotel,* New York, 1940-1947, pl. 151, 152, 153, 154; *Dylan Thomas,* New York, 1953?, pl. 155; *J. Robert Oppenheimer,* San Francisco, 1946, pl. 156; *Edward Weston,* San Francisco, 1946, pl. 157; *Reno,* 1949, pl. 158, 161, 162, 163, 164, 165, 166; *Street at Night,* Reno, 1949, pl. 159; *Harold's,* Reno, 1949, pl. 160; *Belmont Park,* New York, 1956, pl. 167; *Ella Fitzgerald,* c. 1954, pl. 168; *Erroll Garner,* New York Jazz Festival, 1956-1961, pl. 169; *Bud Powell,* New York Jazz Festival, 1956-1958, pl. 170; *John Lewis,* New York Jazz Festival, 1956-1961, pl. 171; *Louis Armstrong,* 1954-1956, pl. 172;

Horace Silver, Newport Jazz Festival, 1954-1957, pl. 173; *Fritzie Scheff*, 1948 or 1949, pl. 174; *Percy Heath*, New York Jazz Festival, 1956-1961, pl. 175; *Chico Hamilton*, Newport Jazz Festival, 1956, pl. 176; *Percy Heath and Gerry Mulligan*, Music Inn, Lenox, c. 1957, pl. 177; *Newport Jazz Festival, Opening*, 1954 or 1956, pl. 178; *Studio of Armando Reverón*, Venezuela, 1954, pl. 185, 186, 187, 188.

765. Vestal, David. "Lisette Model: The Much Admired Photographer/Teacher Talks About Her Long, Illustrious Career, Her Famous Friends, and Her First Book," *Popular Photography* 86, 5 (May 1980): 114-119+.

Modica, Andrea
See also #1063

766. Modica, Andrea. *Photographs: August 30- September 21*. Miami, FL: Miami Dade Community College, North Campus Gallery, 1988. 14 leaves of plates.

767. Modica, Andrea. *Treadwell: Photographs*. Preface by Maria Morris Hambourg; essay by E. Annie Proulx. San Francisco: Chronicle Books, 1996. 85 p. Chiefly Illustrations.
Although Treadwell is an actual place in rural New York State, this collection of untitled, often disturbing, often mysterious, photographs are the story of caputred moments of the human condition in hard situations.

Mogul, Rhoda
See also #1070
Molnar, Lynette
See also #1062

Morath, Inge, 1923-
See also #1058, 1072, 1008

768. Goldberg, Vicki. "Portraits," *American Photographer* 20 (February 1988): 22-23.

769. Hallett, Michael. "A Sense of Place," *British Journal of Photography* 139 (January 2, 1992): 8-9.

770. Lenton, Martyn. "An RPS Audience With Inge Morath," *The Photographic Journal* 134 (December 1994): 451.

771. Miller, Arthur. "Issyk-Kul: A Conversation With Gorbachev," *Aperture* (Fall 1987): 70-74.

772. Miller, Arthur. *Chinese Encounters*. Photographs by Inge Morath. New

York: Penguin Books, 1981. Reprint of the 1979 ed. Published by Farrar, Straus, Giroux. 252 p.

This work is a collaboration between a noted playwright and a photographer that documents their encounter with China and her people in 1978. Miller's text indicates that this was a time in recent Chinese history when he felt the Chinese people would feel comfortable speaking openly. Morath's photographs document the contradictions and difficulties of the Chinese struggle to become a modern nation.

Wall poster "Democratic Wall," Chang An Avenue, Peking, frontispiece, p. 142; *Qiao Yu*, p. 10; *Ming tomb, Peking*, p. 11; *Kun Ming Lake*, p. 12, 13; *Ci Xi's Marble Boat, Summer Palace, Peking*, p. 14; *Jin Shan*, p. 15, 19; *Zheng Zenyao and Jin Shan*, p. 16; *Tien An Men Square, Peking*, p. 22; *Frank Coe, Peking*, p. 25; *Sol Adler, Peking*, p. 27; *Line at bookstore, Peking*, p. 28; *Su Guang, Qiao Yu, Arthur Miller*, p. 30; *Tai Ji Quan: morning exercises, Peking*, p. 31; *First encounter, Peking*, p. 33; *Arthur Miller, Ai Xuan, Su Guang at the Sun Yat-sen mausoleum, Nanjing*, p. 35; *Ai Xuan*, p. 36; *Inner Courtyard, Peking*, p. 40; *Chang An Avenue, Peking*, p. 44, 59; *Wang Fujing Street, Peking*, p. 45; *Reception room factory for generators, Peking*, p. 48; *Factory for generators, Peking*, p. 49; *William Hinton*, p. 55; *Walking tractor*, p. 56; *Children clapping for foreigners, Yanan*, p. 63; *Tailor's, Yanan*, p. 64; *Hulling rice, May 7 Cadre School, Nanniwan*, p. 64; *Operating room, May 7 Cadre School, Nanniwan*, p. 65; *Arthur Miller, train ride, Xian-Nanjing*, p. 70; *Su Guang, train ride, Xian-Nanjing*, p. 71; *West Lake*, p. 74; *The White Snake*, p. 75; *Xue Xien*, p. 76; *The Little Green Snake*, p. 77; *Roadside, Guangxi Zhuang Autonomous Region*, p. 79; *Professor Yang, Xian-Nanjing-Shanghai express*, p. 80; *Bookstore, Xian*, p. 83; *Eighth Route Army veteran, Nanniwan*, p. 85; *Jing Zhenyuan, painter*, p. 89; *Wu Lingshen, Jing Zhenyuan, Wu Junfa, painters*, p. 89; *Li River, Guilin*, p. 90; *Su Shuyang*, p. 92; *Arthur Miller betwen Cao Yu and Su Shuyang, after performance of* <u>Loyal Hearts</u> *at the Peking People's Art Theater*, p. 93; *Cao Yu, China's great playwright*, p. 94; *Arthur Miller with members of the cast of* <u>Bi An</u> *and director Huang Zuolin, the Shanghai People's Art Theater*, p. 95; *Huang Zuolin*, p. 96; *Huang Zongying, actress*, p. 101; *Rewi Alley*, p. 104; *The Bund, Shanghai*, p. 106; *Street scene, Shanghai*, p. 107; *Talitha Gerlach*, p. 108; *Kindergarten, Shanghai*, p. 111; *Peking, Corner tower, wall, and moat surrounding the Old Palace*, p. 113; *Peking, Inside the former Imperial Palace*, p. 114; *Detail, nine-dragon screen in polychrome glazed tiles*, p. 114; *Peking, Imperial Palace*, p. 115; *Terrace and gateway leadning to the Hall of Perfect Harmony*, p. 116; *Peking, Imperial Palace Museum*, p. 118, 119; *Peking, Tien An Men, or the Square of the Gate of Heavenly Peace*, p. 120, 121; *Peking. Old-style house in the western part of town*, p. 122; *Peking. Gate and decorative wall surrounding an inner courtyard*, p. 123; *Peking near the Drum Tower*, p. 124; *Peking. West Chang An Avenue, 6:30 a.m.*, p. 127; *Peking. On and around Chang An Avenue, from early morning to late at night*, p. 128, 129; *Peking. Encounters in the narrow side streets--called Hu Tung--of the city*, p. 130, 131; *Peking. Wang Fujing Street, the city's main shopping thoroughfare*, p. 133; *Eager customers line up in front of a bookstore*, p. 132;

Friendship: a guide explains the workings of a new mechanical loom, p. 204; *Along the waterfront near the Bund, people pose in front of a new poster*, p. 205; *Hangzhou region. Members of Mei Jia Wu tea production brigade picking Long Jing cha*, p. 206; *Reception room of the tea production brigade in house of a former landlord*, p. 208; *Hangzhou, Tiger Spring. Delicate screen in front of a tearoom*, p. 210; *Marine posing with symbol of Tiger Spring*, p. 211; *Mei Jia Wu village. Old man looking after his grandson*, p. 213; *Hangzhou. Silk Mill*, p. 214, 215, 216; *Hangzhou. Pavilions overlooking West Lake*, p. 218; *Hangzhou. Bas-relief of a Buddha*, p. 220; *Hangzhou. Interior of Ling Yin Si temple*, p. 223; *Arthur Miller and interpreter Su Guang at the foot of a Yuan dynasty sculpture*, p. 224; *Two demons...as they appeared in a Shanghai production of the famous old opera*, p. 226; *Guilin. The Returned Pearl Cave, an engraving*, p. 228; *Guilin. Street scenes*, p. 230-233; *Landscape with water buffaloes outside Guilin*, p. 235; *Guangxi Zhuang Autonomous Region. Peasants on the roads between villages*, p. 236, 237; *Guilin. Courtyard just off the street in the old part of town near the river*, p. 238; *Guilin. On the banks of the Li River, a man waters his vegetable plot*, p. 239; *Guangxi Zhuang Autonomous Region. Boat traffic on the Li River*, p. 240; *Boat harbor, Li River, near Guilin*, p. 242; *Li River landscape*, p. 244; *Fishing boat on the Li River*, p. 246; *Guilin. The town's big new opera house, a performance*, p. 248; *Guilin. A baby waiting for his father's return, inside the ingenious structure built on top of his motorbike*, p. 249; *View of the Pearl River from Sha Mian Island*, p. 250; *Loads of baskets arrive for local stores*, p. 251; *Guangzhou. The former Franco-British concession of Sha Mian still has a nineteenth-century colonial air about it*, p. 252; *Sha Mian Island. Future gymnasts and acrobats indulge in a little open-air training*, p. 253; *Sha Mian Island. Two workmen chopping up a banyan tree with a handsaw*, p. 252; *Foshan, details from the Zu CiMiao Taoist temple*, 254, 255.

773. Morath, Inge. *Inge Morath: Fotografien 1952-1992.* Text by Kurt Kaindl and Margit Zuckriegl. Salzburg: O. Miller, 1992. 160 p. Chiefly illustrations. In German and English. Bibliography: p. 160.
 The introductory biographical essay includes numerous photographs of Morath and critical overviews of her photographic experiences. The concluding essay, "To Be in the World: On the Photographic Oevre of Inge Morath," briefly discusses the dualism of her photographs as documents and creative entities.

The Parents, Edgar and Mathilde Morath near Schladming, Austria, 1957, p. 7; *Jerusalem*, 1960, p. 13; *A picture from the first roll of film, Venice*, 1951, p. 150; *Children of Cavedwellers, Gaudix, Andalusia*, 1954, p. 5; *Dona Mercedes Formica on her balcony, Calle de Recoletos, Madrid*, 1955, p. 30; *Two Seminarists crossing the Gran Via, Madrid*, 1954, p. 31; *Siesta of the Lottery vendor, Plaza Mayor, Madrid*, 1955, p. 32; *6 a.m. Patio. Hotel Alfonso XIII, Sevilla*, 1954, p. 33; *Peasant at the Fair of San Firmin, Pamplona*, 1954, p. 34; *Jewelery stall. Fair of San Firmin. Pamplona*, 1954, p. 35; *Early morning. Square in front of "House of Pilaturs,"Sevilla*, 1954, p. 36; *Two "Giants," ready for the evening procession,*

tower over a peasant woman,Vigo, 1955, p. 37; *Three generations in flamenco costumes, waiting for the departure of the Rocio Procession, Sevilla,* 1955, p. 38; *Bridesmaid's hairdo, Navalcan, Castille,* 1955, p. 39; *The First Communion dress, La Alberca, Castille,* 1955, p. 40; *Evening Stroll, Jerez de la Frontera, Andalusia,* 1954, p. 41; *Oxendrivers dance to the music blaring from the radio of a passing car, Rocio Procession, Almonte, Andalusia,* 1955, p. 42; *Nap of the oxendriver, Rocio Procession, Almonte, Andalusia,* 1955, p. 43; *The owner's daughter, Café-Bar,Chinchon, Castille,* 1955, p. 44; *Entrance to saddle maker's shop, Tordesillas, Castille,* 1955, p. 45; *The Bullfighter Antonio Ordonez getting dressed for the Corrida, Pamplona,* 1954, p.46; *Forgotten shoes, Venice,* 1955, p. 48; *Wood and coal delivery,Venice,* 1955, p. 49; *Musicians on their way to a wedding, Rukă, Moldavia,* 1958, p. 50; *The Church of the "Three Saints," Yasi, Moldavia,* 1958, p. 51; *Building a hydroelectrical dam, Bicaz, Moldavia,* 1958, p. 52; *Steel factory,Ploesti, Moldavia,* 1958, p. 53; *Bratislava,* 1958, p. 54; *Market stalls with wedding dresses, Warsaw,* 1965, p. 54; *"Tinkers" - Irish gypsies - arriving at Puck Fair, Killorglin,County Kerry,* 1954, p. 58; *Two pig farmers,Puck Fair, Killorglin,County Kerr,* 1954, p. 59; *Visitor at Puck Fair, Killorglin, County Kerr,* 1954, p. 60; *Pub, Killorglin, County Kerr,* 1954, p. 61; *Getting ready for the foxhunt, Killcock, County Kildare,* 1954, p. 62; *Mrs. Eveleigh Nash,Buckingham Palace Mall, London,* 1953, p. 65; *On the way to the financial district, London,* 1953, p. 66; *Debutante at a fitting Bond Street, London,* 1958, p. 67; *Ex-servicemen, Sheperd's Market, London,* 1953, p. 68; *Children in Battersea, London,* 1953, p. 69; *Wheel barrows for Covent Garden Market, Thames embankment, London,* 1953, p. 70; *Spectators waiting for the July 14th Parade, near the Bastille, Paris,* 1953, p.73; *Waitress in a Café-Bar, Rue St. Paul, Paris,* 1955, p. 74; *Fashion show: "The Beauty and the Beast," Paris,*1954, p. 75; *Before the Auction, Galerie Drouot, Paris,* 1954, p. 76; *Memorial service fro Sarah Bernard, Pére Lachaise Cemeterym Paris,* 1954, p. 77; *Rue des Rosiers, Paris,* 1954, p. 78; *"Hotpants" Enghien,* 1954, p. 79; *Street,Butte, Montmartre, Paris,* 1957, p. 80; *Lake Constanz,* 1959, p. 82; *Gothic gables, Rhineland,* 1957, p. 83; *Blutasse, Vienna,* 1957, p. 84; *Strudelhofstiege, Vienna, ,* 1980, p. 85; *Stairway in Prince Eugen Palace. Himmelpfortgasse,Vienna,* 1958, p. 86; *Room on the upper floor of the Basiliskenhaus, Vienna,* 1980, p. 87; *Schloss Klessheim, Salzburg,* 1991, p. 88; *Shepherd in his cloak which doubles as a tent, Caspian Sea,* 1956, p. 90; *Dancing Bedouins,South of Baghdad,* 1956, p. 90; *"Zou-Khane" ritual exercises, Teheran,* 1956, p. 92; *Three wives and their parrots, Shiraz,* 1956, p. 93; *Streetmusicians, Isfahan,* 1956, p. 94; *Peasants near Caspian Sea,* 1956, p. 95; *Fasting men in the Friday Mosque during Ramadan, Isfahan,* 1956, p. 96; *Promenade along the Royal Square, Isfahan,* 1956, p. 97; *Winter landscape nearCaspian Sea,* 1956, p. 98; *Early morning on Chang An Avenue, Beijing,* 1978, p. 101; *Triptych in the room of a member of the "Double Bridge Commune" with Zhou Enlai,Mao Zedong and Hua Guofeng, Beijing,* 1978, p. 102; *Telling of atrocities committed during the Cultural Revolution, shortly after the fall of the "Gang of Four," Beijing,* 1978, p. 103; *Carpentershop, "May Tenth School," Nanniwan near Yenan,* 1978, p. 104; *PLA (Peoples Liberation Army) soldiers on*

a Yuan Dynasty statue of a Maitreya, Hangzhou near Westlake, 1978, p. 105; *"Piatnitza"- Sleigh drawn by five horses, South of Moscow,* 1965, p. 107; *Fyodor Dostoyevsky's grandson,Andrei Dostoyevsky, St.Petersburg,* 1967, p.108; *Corner in Leo Tolstoy's bedroom with Photograph of his wife,Sophie Behrens and the simple peasant clothes he wore in his last years,* 1965, p. 109; *Salon in the house of the writer Lev Kassil, Moscow,* 1965, p. 110; *The painter Pavel Korin stands in front of his paintings, Moscow,* 1965, p. 111; *Maya Plisetkaya in her dressing room, Bolshoi Theater, Moscow,* 1967, p. 112; *The poet Yevgeny Yevtushenko with his wife Masha, Moscow,* 1988, p. 113; *Scene at Moscow's traditional Sunday morning birdmarket, Moscow,*1989, p. 114; *Return from the Datsha.Train from Lomonosov to St.Petersburg,*1989, p. 115; *Young actors performing Mikhail Bulgakov's logn forbidden satire,* 1988, p. 116; *After mass,Danilov Monastery, Moscow,* 1989, p. 117; *Ghosttown, Tonopah, Nevada,* 1960, p. 120; *Little Rock, Arkansaw [sic],* 1960, p. 121; *The carpenter and farmer John Coyle at his daughter's wedding, Roxbury, Connecticut,* 1972, p. 122; *Having donated their house to the Historical Society, the couple walks it to its new location, Shelton,Connecticut,* 1971, p. 123; *Window washers, 48th Street, New York City,* 1958, p. 124; *Street in Harlem near Fort Tyron Park, New York City,* 1958, p. 125; *Magnum bookkeepers, Sharon Goldberg and Barbara Rosman, New York City,* 1965 p. 126; *Cardgame: Gjon Mili, Michel Chevalier and Otto Preminger, 23rd Street, New York City,* 1958, p. 127; *Beauty Class, Fifth Avenue, New York City,* 1958, p. 128; *Encounter on Times Square, New York City,* 1957, p. 129; *Saul Steinberg in his yard, New York City,* 1959, p. 131; *Young woman in fur coat,* 1961, p. 132; *Car passengers,* 1962, p. 133; *Saul Steinberg with nose mask,* 1966, p. 134; *Jean Arp, Paris,* 1956, p. 135; *Alberto Giacometti, Paris,* 1958, p. 136; *Jean Cocteau,St.Jean Cap Ferrat,* 1956, p. 137; *Henry Moore, Much Hadam, Hertfordshire,* 1954, p. 138; *Alexander Calder, Roxbury, Connecticut,* 1964, p. 139; *Marily Monroe during the filming of "The Misfits,"Reno, Nevada,* 1960, p. 140; *Gloria Vanderbilt, New York City,* 1956, p. 141; *Chojun Otani, Kyoto,* 1970, p. 142; *Louise Bourgeois, New York City,* 1982, p. 143; *Arthur Miller, Roxbury, Connecticut,* 1963, p. 144; *Lola Ruiz Vilató, the sister of Pablo Picasso, with two of her children, Lolita and Jaime, Barcelona,*1954, p. 145.

774. Morath, Inge. [Photographer, Inge Morath comments on her subjects: Janet Flanner, Alexander Calder, Arthur Miller, Marilyn Monroe, William Styron, Jayne Mansfield, Lola Picasso, Eleanor Roosevelt and Adlai Stevenson in a double portrait, Isaac Stern and Vladimir Horowitz together.] 1987.
 Sound recording, 15 min. "Broadcast on CBS-TV (Sunday Morning), April 5, 1987." oclc

775. Morath, Inge. *Portraits.* Photographs and Afterword by Inge Morath, Introduction by Arthur Miller. New York: Aperture, 1986. 80 p.
 Includes a short critical essay on Morath's portraits and her own discussion of the circumstances surrounding some of the photographs.

Anaïs Nin, 1959, p. 9; *Elizabeth Hardwick*, 1978, p. 10; *Rebecca Miller*, 1977, p. 11, 21; *Marietta Tree*, 1981, p. 12; *Jean Cocteau*, 1958, p. 13; *Han Suyin* 1976, p. 14; *Alfred Kazin*, 1965, p.15; *Jayne Mansfield*, 1959, p. 16; *Farmer*, 1970, p. 17; *William Styron*, 1967, p. 18; *Philip Roth*, 1965, p. 19; *Barbara Rosman and Sharon Goldberg*, 1965, p. 22; *Maya Plisetskaya*, 1967, p. 23; *Marilyn Monroe*, 1960, p. 24; *Dominique Aubier with Bruno*, 1955, p. 26; *Elzbieta Chezevska*, 1978, p. 27; *Jason Robards*, 1963, p. 29; *Dustin Hoffman in "Death of a Salesman,"* 1985, p. 30; *George C. Scott in "Death of a Salesman,"* 1975, p. 30; *Arthur Miller*, 1963, p. 31; *Mary McCarthy*, 1956, p. 33; *Arnold Keyserling*, 1978, p. 34; *Honor Moore*, 1985, p. 35; *Jane and Rebecca Miller*, 1966, p. 36; *John Huston*, 1960, p. 37; *Erica Jong*, 1983, p. 38; *Luis Herrera de la Fuente*, 1960, p. 39; *Bernard Buffet*, 1957, p. 40; *Vladimir Horowitz and Isaac Stern*, 1977, p. 41; *Paul Tortellier*, 1954, p. 42; *Saul Steinberg*, 1959, p. 45; From the Mask Series with Saul Steinberg, p. 46-53; *Juan Jose Arreola*, 1960, p. 54; *Hans Hartung*, 1958, p. 55; *Octavio Paz*, 1959, p. 56; *Carlos Pellicer*, 1960, p. 57; *Marcus Prachensky*, 1979, p. 58; *Alexander Calder*, 1976, p. 59; *Hans Richter*, 1969, p. 60; *André Malraux*, 1956, p. 62; *Heinrich Böll*, 1972, p. 62; *Janet Flanner*, 1973, p. 63; *Tom Keogh*, 1958, p. 64; *Bride, Tunisia*, 1960, p. 65; *Mr. Otani*, 1970, p. 66; *Louise Bourgeois*, 1982, p. 66; *Juan Soriano*, 1960, p. 67; *Mr. and Mrs. Louis Untermeyer*, 1967, p. 68; *Jean Arp*, 1956, p. 69; *Victoria Sackville-West*, 1961, p. 70; *Alberto Giacometti*, 1958, p. 71; *Lilia Carillo*, 1960, p. 73; *Alice Roosevelt Longworth*, 1965, p. 74; *Olga Andreyev Carlisle*, 1972, p. 75; *Mrs. Eveleigh Nash*, 1953, p. 76-77, 80; *Lola Ruiz Vilato*, 1954, p. 78; *Jaime Vilato*, 1954, p. 79; *Eleanor Roosevelt and Adlai Stevenson*, 1961, p. 81; *Professor Mikhail Gerasimov*, 1965, p. 82; *Igor Stravinsky*, 1959, p. 83; *Henri Cartier-Bresson*, 1961, p. 84; *Gloria Vanderbilt*, 1956, p. 85; *Ingeborg Ten Haeff*, 1980, p. 86; *Henry Moore*, 1954, p. 87; *The Duchess of Argyll*, 1958, p. 89.

Morehouse, Marion

776. Morehouse, Marion. *Adventures in Value.* Fifty photographs by Marion Morehouse and Text by e. e. cummings. New York: Harcourt, Brace & World, 1962.

Renaissance, p. I. 1; *Ahmed*, p. I, 2; *Progression*, p. I, 3; *The Mountain,*, p. I, 4; *Monument*, p. I, 5; *Monster*, p. I, 6; *Anthesis*, p. II, 1; *Inanimation*, p. II, 2; *Form*, p. II, 3; *Composition*, p. II, 4; *Rhythm*, p. II, 5; *Whiteness*, p. II, 6-8; *Sunlight As Joy*, p. III, 1; *Aspiration*, p. III, 2; *Innumerability*, p. III, 3; *ΕΛΕΦΑΣ*, p. III, 4; *Tendril*, p. III, 5-6; *Seedling and Raindrops*, p. III, 7; *Zucchini*, p. III, 8; *Fascicles*, p. III, 9; *Lichen & Granite*, p. III, 10; *Calligraphy*, p. III, 11; *Atombomb*, p. III, 12; *Explosion*, p. III, 13; *&*, p. III, 14; *Patchin Place*, p. III, 15; *Don Q*, p. III, 16; *Ferns*, p. III, 17-20; *Awakening*, p. III, 21; *Miracle*, p. III, p. 22; *Moipa*, p. III, p. 23; *Rus*, p. III, p. 24; *Inverno*, p. III, p. 25; *The Awkward Age*, p. IV, 1; *Thérèse*, p. IV, 2; *Marianne Moore*, p. IV, 3; *Am*, p. IV, 4; *Doveglion*, p. IV, 5; *Old Mr. Lyman*, p. IV, 6; *Minnie*, p. IV, 7-8; *John Finley*, p. IV, 9; *Cougar*, p. IV, 10; *Jess*, p. IV, 11.

Morgan, Barbara Brooks, 1900-1992
See also #1000, 1008, 1054, 1058, 1061, 1069, 1070, 1072

777. Allen, Casey. "Barbara Morgan," *Camera 35* 21, 4 (May 1977): 56-60.

778. *Barbara Morgan.* Cincinnati, OH: Lightborne Communications, 1983. Video recording, 30 minutes. Interviewer, Paul Schranz.
"Sensitive to the underlying essence and rhythm of living things, Barbara Morgan discusses the details of her photographs of Martha Graham, her early work as a painter, and her relationship with her husband Willard D. Morgan." oclc

779. *Barbara Morgan, Visual Poet.* Chicago: Loyola University Media Services, ?1980, 1986. Videorecording, 30 minutes. Interview.

780. Cameron, Franklin. "Barbara Morgan: Quintessence," *Petersen's Photographic* 13, 11 (March 1985): 34-44.

781. Carter, Curtis L. and William C. Agee. *Barbara Morgan: Prints, Drawings, Watercolors & Photographs.* Milwaukee, WI: Patrick & Beatrice Haggerty Museum of Art, Marquette University, 1988. 128 p. Includes a chronology and selected bibliographical references.
Catalogue of an exhibition with two essays: "Barbara Morgan: Philosopher/Poet of Visual Motion" by Carter and a biographical and critical essay, "Barbara Morgan: American Painter Turned Photographer" by Agee. The Carter essay incorporates many quotes from Morgan's writings. Agee's essay focuses more on Morgan's paintings and their relationship with her photographs.
Willard Morgan with Model A Leica in Bandelier National Monument, 1928, p. 9; *Martha Graham, "Satyric Festival" (with studio lights)* 1940, p. 19, 95; *Willard Morgan Descending Canyon de Chelly,* 1928, p. 25; *Wind Ripples in Mono Lake,* 1929, p. 26; *Pure Energy and Neurotic Man,* 1941, p. 28, 90; *City Street,* 1937, p. 73; *Hearst Over the People,* 1939, p. 74; *Protest,* 1940, p. 75; *Spring on Madison Square,* 1938, p. 76; *City Shell,* 1938, p. 77; *Crystallized Skyscraper,* 1973, p. 78; *UFO Visits New York,* 1965, p. 79; *Use Litter Basket,* 1943, p. 80; *Hullabaloo,* 1959, p. 81; *Fossil in Formation,* 1965, p. 82; *Nuclear Fossilization,* 1979, p. 83; *Searching,* 1979, p. 84; *Emergence,* 1979, p. 85; *Samahdi,* 1940, p. 87; *Cadenza,* 1940, p. 88; *Emanation I,* 1940, p. 89; *Cosmic Effect,* 1965, p. 91; *Martha Graham, "Ekstasis,"* 1935, p. 93; *Martha Graham, "Lamentation,"* 1935, p. 94; *Louise Kloepper, "Statement of Dissent,"* 1938, p. 96; *Charles Weidman, "Lynchtown" (Bea Seckler solo),* 1938, p. 97; *Martha Graham, "American Document" (trio),* 1938, p. 98; *Doris Humphrey, "Square Dance for Moderns" (waltz),* 1938, p. 99; *Martha Graham, "El Penitente," Merce Cunningham,* 1940, p. 100; *Doris*

Humphrey, "Passacaglia," 1938, p. 101; Martha Graham, "Every Soul Is a Circus," 1940, p. 102; Martha Graham, "El Penitente," Erick Hawkins, 1940, p. 103; Martha Graham, "War Theme," 1941, p. 104; Martha Graham, "Letter to the World," 1940, p. 105; José Limón, "Mexican Suite" (Indian), 1944, p. 106; José Limón, "Chaconne," 1944, p. 107; José Limón, "Mexican Suite," (peon), 1944, p. 108; Merce Cunningham, "Root of the Unfocus," 1944, p. 109; Doris Humphrey-Charles Weidman, "Rehearsal Nightmare," 1944, p. 110; Valerie Bettis, "Desperate Heart," 1944, p. 111; Amaryllis, 1943, p. 113; Corn Leaf Rhythm, 1947, p. 114; Corn Tassel Through Broken Window, 1967, p. 115; Beech Tree IV, 1945, p. 116; Beech Tree I, 1945, p. 117; Delicate Beech, 1945, p. 118; Resurrection in the Junkyard, 1947, p. 119; Pregnant, 1940, p. 120; Macy's Window, 1939, p. 121; Children Dancing by the Lake, 1940, p. 122; Girl Playing Recorder, 1945, p. 123.

782. Maslow, Sophie and Morgan, Barbara. "Dialogue with Photographs," *Massachusetts Review* 24, 1 (1983): 65-80.

783. Morgan, Barbara. *Barbara Morgan*. Introduction by Peter Bunnell. Hastings-on-Hudson, NY: Morgan & Morgan, 1972. 159 p. Chiefly illustrations.

This collection is particularly useful for the inclusion of many of Morgan's dance photographs and her photomontages. The short introduction discusses them both, and the book concludes with a short essay, "Working Thoughts," by Barbara Morgan. Includes chronologies of exhibitions, lectures and articles about Morgan, and important events in her life.

Emanation I, 1940, frontispiece; Martha Graham, Primitive Mysteries, 1935, pl. 13; Martha Graham, Frontier, 1935, pl. 14, 15; Martha Graham, War Theme, 1941, pl. 16; Martha Graham, Extasis (Torso), 1935, pl. 17; Martha Graham, El Pentiente (Erick Hawkins Solo, "El Flagellante"), 1940, pl. 19; Martha Graham, Celebration (Trio), 1937, pl. 22; Martha Graham, American Document ("Puritan Love Duet"), 1938, pl. 23; Martha Graham, Letter to the World (Duet with Cunningham), 1940, pl. 24; Martha Graham, Letter to the World (Swirl), 1940, pl. 25; Martha Graham, American Provincials (Group), 1935, pl. 20; Martha Graham, Lamentation, 1935, pl. 21; Martha Graham, Letter to the World (kick), 1940, pl. 27; Spring on Madison Square, 1938, pl. 28; Doris Humphrey, With My Red Fires ("Matriarch"), 1938, pl. 30; Doris Humphrey, With My Red Fires (Swirl), 1938, pl. 31; Doris Humphrey, Shakers (Humphrey-Weidman Group), 1938, pl. 32; Doris Humphrey, Shakers (Bea Seckler Solo), 1938, pl. 33; Doris Humphrey, To the Dance, 1944, pl. 34; Doris Humphrey, Passacaglia, 1938, pl. 35; Doris Humphrey, Square Dance (Duet with Charles Weidman), 1938, pl. 37; Tree Trunk, 1948, pl. 38; Rehearsal Nightmare, 1944, pl. 39; Charles Weidman, On My Mother's Side, 1944, pl. 40; Charles Weidman, Daddy Was a Fireman (Duet with Hamilton), 1944, pl. 41; Charles Weidman, Lynchtown (Bea Steckler Solo), 1938, pl. 42; Charles Weidman, Lynchtown (Humphrey-Weidman Group), 1938, pl. 43; Dawn Window, 1945, pl. 44; Continuum, 1944, pl. 45; José Limon, Cowboy Song, 1944,

pl. 47; *José Limon, Mexican Suite*, 1944, pl. 48; *Corn Leaf Rhythm*, 1945, pl. 49; *José Limon, Chaconne*, 1944, pl. 51; *Helen Tamiris, When the Saints Come Marching In (Duet with Daniel Nagrim)*, 1944, pl. 52; *Asadata Dafora (from Sierra Leone, Africa)*, 1942, pl. 53; *Pearl Primus, Speak to Me of Rivers*, 1944, pl. 54; *Cadenza*, 1940, pl. 55; *Hanya Holm, Trend*, 1938, pl. 56; *Anna Sokolow, The Exile*, 1940, pl. 57; *Valerie Bettis, Desperate Heart*, 1944, pl. 58, 59, 61; *Merce Cunningham, Totem Ancestor*, 1942, pl. 62; *Merce Cunningham, Root of the Unfocus*, 1944, pl. 63; *Merce Cunningham and Pearl Lang, Leap*, 1942, pl. 64; *Merce Cunningham, Leap*, 1942, pl. 65; *Tossed Cats*, 1942, pl. 66; *Erick Hawkins Jumping with Lloyd*, 1942, pl. 67; *Boy with Frog*, 1948, pl. 69; *Boy with Snake*, 1948, p. 70; *Three Buddies, Camp Treetops*, 1945, p. 71; *Boy with Hamster*, 1948, p. 72; *Girl Playing Recorder, Camp Treetops*, 1945, p. 73; *Children Singing in the Rain*, 1950, p. 75; *Boy with Visor*, 1948, p. 76; *Out to Pasture*, 1946, p. 77; *Diving Off the Dock*, 1946, p. 78; *Girls Dancing by the Lake*, 1945, p. 79; *Children Dancing by the Lake*, 1940, p. 81; *Bee Sting*, 1948, p. 82; *Bear Hugging*, 1946, p. 83; *Bedtime Story, Camp Treetops*, 1946, p. 84; *Doug in Rafters*, 1943, p. 85; *Beech Limb*, 1945, p. 86; *Charles Sheeler and His Favorite Beech Tree*, 1945, p. 88; *Beech Tree II*, 1945, p. 89; *Marie*, 1947, p. 90; *Corn Stalk*, 1945, p. 91; *Beech Tree I*, 1945, p. 93; *Light Waves*, 1945, p. 94; *Le Courbusier in New York*, 1946, p. 95; *Crash*, 1947, p. 96; *City Sound*, 1972, p. 97; *Chassis-Cranium*, 1947, p. 98; *Trajectory*, 1946, p. 99; *Resurrection in the Junkyard*, 1947, p. 101; *Corn Tassel through Broken Windshield*, 1967, p. 102; *Opacities*, 1968, p. 103; *Willard's Foot*, 1945, p. 104; *Willard Morgan Descending into Canyon de Chelly*, 1938, p. 105; *Walnut*, 1943, p. 106; *Gerald Heard*, 1954, p. 107; *Pregnant*, 1940, p. 109; *Brothers*, 1943, p. 110; *Delicate Beech*, 1945, p. 111; *Hearst over the People*, 1939-39, p. 112; *Artificial Life from the Laboratory*, 1967, p. 113; *Forming Currents*, 1970, p. 114; *Nancy Newhall*, 1942, p. 115; *Pure Energy and Neurotic Man*, 1941, p. 117; *Broken Light Bulb*, 1945, p. 118; *Use Litter Basket*, 1943, p. 119; *Funkia Leaf*, 1950, p. 120; *Macy's Window*, c. 1939, p. 121; *Battered Tin Can*, 1942, p. 122; *Saeta, Ice on Window*, 1942, p. 123; *City Street*, 1937, p. 124; *Brainwashed*, 1966-69, p. 125; *Willard Morgan with Model A Leica in Bandelier National Monument, New Mexico*, 1928, p. 126; *Dr. Saisetz Teitaro Suzuki*, 1950, p. 129; *Martha Graham, American Document (Trio)*, 1938, p. 130; *City Shell*, 1938, p. 131; *Changing Grid*, 1970, p. 132; *Briarlock*, 1943, p. 133; *Leaf Floating in City*, 1970, p. 134; *Fossil in Formation*, 1965, p. 135; *Beaumont Newhall, Ansel Adams and Willard Morgan (in Barbara Morgan's Studio)*, 1942, p. 136; *Beaumont Newhall Leaping*, 1942, p. 137; *Ansel Adams Jumping on Stool*, 1942, p. 137; *Begonia*, 1943, p. 138; *Man's Knee*, 1940, p. 139; *Ikons in Time-Stream*, 1963, p. 140; *Inner and Outer Man*, 1972, p. 141; *Samadhi*, 1940, p. 143; *Beech Tree IV*, 1945, p. 144; *Stump*, 1945, p. 145; *Martha Graham, Frontier*, 1935, p. 146; *Willard's Fist*, 1942, p. 147; *Amaryllis Seed Pod*, 1943, p. 148; *Amaryllis Bud*, 1943, p. 149; *Lloyd's Head*, 1944, p. 151.

784. Morgan, Barbara. "Barbara Morgan: Modern Dance," *Popular Photography* 16, 6 (June 1945): 44-47+.

785. Morgan, Barbara. *Barbara Morgan - Photomontage*. Dobbs Ferry, NY: Morgan & Morgan, 1980. 61 p. Chiefly illustrations. Bibliography: p. 60. Biographical notes: p. 61.

Short introduction by Morgan discusses and describes the motivation and techniques used in several of the photographs.

Pure Energy and Neurotic Man, 1945, cover; *Spring on Madison Square,* 1938, p. 12; *City Street,* 1937, p. 13; *Hearst over the People,* 1939, p. 14; *City Shell,* 1938, p. 15; *Transference,* 1956, p. 16; *Third Avenue El,* 1936, p. 17; *Macy's Window,* 1939, p. 18; *Confrontation,* 1970, p. 19; *Emerging,* 1979, p. 20; *Martha Graham: Lamentation,* 1935, p. 21; *Reticulate,* 1960, p. 22; *Frolic in the Lab,* 1965, p. 23; *Martha Graham: Death and Entrances (group),* 1945, p. 24; *Martha Graham: Death and Entrances,* 1945, p. 25; *Humphrey-Weidman: Rehearsal Nightmare,* 1944, p. 26; *José Limón: Cowboy Song,* 1944, p. 27; *Saeta: Ice on Window,* 1942, p. 28; *Solstice,* 1942, p. 29; *Emergence,* 1979, p. 30; *Martha Graham: American Document (trio),* 1938, p. 31; *Merce Cunningham: Root of the Unfocus-II,* 1944, p. 32; *Merce Cunningham: Root of the Unfocus-I,* 1944, p. 33; *Ghost of the Accident,* 1978, p. 34; *Corn Stalks Growing,* 1945, p. 35; *Briarlock,* 1943, p. 36; *Leaf Floating in City,* 1972, p. 37; *Brainwashed,* 1966, p. 38; *Fossil in Formation,* 1965, p. 39; *Third Avenue El with Cars,* 1939, p. 40; *Inner Stratas,* 1970, p. 41; *ESP Breaking Through,* 1969, p. 42; *Incoming,* 1956, p. 43; *Valerie Bettis: Desperate Heart-I,* 1944, p. 44; *Valerie Bettis: Desperate Heart-II,* 1944, p. 45; *Corn Tassel through Broken Windshield,* 1967, p. 46; *Computerized Manhattanites,* 1973, p. 47; *Layout,* 1946, p. 48; *Opacities,* 1944, p. 49; *Cosmic Effort,* 1965, p. 50; *City Sound,* 1972, p. 51; *Searching,* 1979, p. 52; *Yin-Yang in Flight,* 1956, p. 53; *Protest,* 1940, p. 54; *Use Litter Basket,* 1943, p. 55; *Nuclear Fossilization-V,* 1979, p. 56; *Nuclear Fossilization-I,* 1979, p. 57; *Serpent Light-III,* 1948, p. 58; *Artificial Life from the Laboratory,* 1967, p. 59; *UFO Visits New York,* 1965, p. 60; *Hullabaloo,* 1959, p. 61; *Wild-Bee Honey Comb Skyscraper,* 1973, back cover.

786. Morgan, Barbara. "Dance Photography," *U.S. Camera* 1, 8 (February-March 1940): 52-56+.

787. Morgan, Barbara. "Growing Americans: Shooting Stills for a Government Short [Movie]," *U.S. Camera* 7, 1 (February 1944): 44-47+.

788. Morgan, Barbara. "In Focus: Photography, the Youngest Visual Art," *Magazine of Art* (November 1942): 248-255.

789. Morgan, Barbara. *Martha Graham: Sixteen Dances in Photographs*. New York; Duell, Sloan, and Pearce, 1941. Revised edition, Dobbs, Ferry, NY: Morgan & Morgan, 1980. 168 p.

Chiefly Illustrations.

Essays include: "Dancer's Focus," by Martha Graham, an introduction by Barbara Morgan, program notes by "Martha Graham: A Perspective," by George Beiswanger, "Dance Into Photography," by Barbara Morgan,

"Choreographic Record," by Louis Horst and a chronological list of Dances--1941-1980."
From *Frontier*, solo, p. 18-29; From *Lamentation*, solo, p. 31-37; From *Ekstasis*, solo, p. 39-41; From *Celebration*, company, p. 42-43; From *Primitive Mysteries*, company, p. 44-53; From *American Provincials*, company, p. 54-57; From *Harlequinade*, solo, p. 58-59; From *Imperial Gesture*, solo, p. 61-63; From *Sarabande*, solo, p. 65-67; From *Primitive Canticles*, solo, p. 69-73; From *Deep Song*, solo, p. 75-84; From *Satyric Festival Song*, solo, p. 86-87; From *El Penitente*, trio, p. 88-100; From *Every Soul Is a Circus*, company, p. 102-113; From *Letter To the World*, company, p. 115-127; From *American Document*, company, p. 129-141.

790. Morgan, Barbara. *Prestini's Art in Wood*. Text by Edgar Karfmann, Jr. Lake Forest, Il: Pocahontas Press, 1950. 32 p. Chiefly illustrations.
A catalogue of photographs of the wood turning of James Prestini.

791. Morgan, Barbara. *Summer's Children; A Photographic Cycle of Life at Camp*. Scarsdale, NY: Morgan and Morgan, 1951. 156 p. Chiefly illustrations.
Photographic documentation of real children, at a real camp, enjoying themselves as children should. Children are seen grooming the horses, playing, sleeping and camping out.

792. Morgan, Barbara. "Photomontage," in *Miniature Camera Work*, New York: Morgan & Lester, 1938, pp. 145-166.

793. Morgan, Barbara. "Photographing the Dance," in *Graphic Graflex Photography*, Morgan & Lester, 1940, pp. 230-239.

794. Morgan, Barbara. "Dance Into Photography," *U.S. Camera* (December 1941): 102+.

795. Morgan, Barbara and Willard D. "Desert Adventuring on Foot into the Segi and Betatakin Canyons of Northern Arizona," *Camera Craft* 37, 4 (April 1930): 177-181; 37, 5 (May 1930): 223-227; 37, 6 (June 1930): 283-287.

796. Stodelle, E. "Barbara Morgan; Emanations of Energy," *Dancemagzaine* 65, 8 (1991): 44-47.

797. Stodelle, E. "Interlocking Insights - Barbara Morgan," *Ballet Review* 20, 3 (Fall 1992): 36-40.

798. Towers, D. "Barbara Morgan, Everything Is Dancing," *Dancemagazine* 61, 5 (1987): 96.

799. *Visions and Images; American Photographers on Photography [Barbara Morgan.]* 1986. Videorecording.
February 1980-May 1980, Barbara Morgan. Taped at the New School for Social Research in New York City.
Interview by Barbaralee Diamonstein.

Morgan, Ruth
 See also #1071
Morris, Kathy
 See also #1006
Moser, Lida
 See also #1069, 1072
Mosley, Leigh H.
 See also #1072
Moulton, Rosalind
 See also #1006

Moutoussamy-Ashe, Jeanne, 1951-
 See also #1026, 1058

800. Moutoussamy-Ashe, Jeanne. *Daufuskie Island: A Photographic Essay*. Foreword by Alex Haley. Columbia: University of South Carolina Press, 1982.
This essay is a photographic documentation of Daufuskie Island. At one time this small island off of the coast of South Carolina had been an isolated refuge for those who can trace their ancestors to freed slaves. With land being sold to developers, Moutoussamy-Ashe hoped to record this unique area before it was lost.

A little girl escorts her sister, pl. 1; *Mary Fields Elementary School*, pl. 2; *Girl in a screen door*, pl. 3; *Emily's son at nursery school*, pl. 4; *Emily in front of her home*, pl. 5; *Emily's kitchen*, pl. 6; *Blossum*, pl. 7; *Miss Mary in her kitchen*, pl. 8; *Mary in her front yard*, pl. 9; *An old fallen house*, pl. 10; *Woman with her dogs*, pl. 11; *Susie Smith*, pl. 12; *Washing clothes*, pl. 13; *Afternoon with Aunt Tootie*, pl. 14; *Bertha*, pl. 15; *Car with no windows*, pl. 16; *Frances Jones with her mother*, pl. 17; *Susie next to a holy picture*, pl. 18; *Family memorabilia*, pl. 19; *An old woman at a table*, pl. 20; *Hat on a chair*, pl. 21; *A ninety-eight-year-old Edisto islander*, pl. 22; *Jake and sister Susie*, pl. 23; *Stalled car*, pl. 24; *Willie*, pl. 25; *Johnny Hamilton*, pl. 26; *"Fast Man,"* pl. 27; *The old winery*, pl. 28; *The Silver Dew Winery*, pl. 29; *"Stretch,"* pl. 30; *A shrimper and his son*, pl. 31; *Shrimper pulling in the line*, pl. 32; *Haig's Point Lighthouse*, pl. 33; *Ox cart and driver*, pl. 34; *Jake*, pl. 35; *The Waving Girl*, pl. 36; *Willie meets the Waving Girl*, pl. 37; *Inside the Waving Girl*, pl. 38, 40; *A young man*, pl. 39; *Dafuskie dock at the Cooper River*, pl. 41; *Couple greeting each other*, pl. 42; *Old prayer house before Hurricane David*, pl. 43; *Old prayer house after Hurricane David*, pl. 44; *Old church with the old Hamilton schoolhouse*, pl. 45; *Union Baptist Church*, pl. 46; *Gathering before*

church, pl. 47; *Preparing communion*, pl. 48; *Members join hands in prayer*, pl. 49; *Silent prayer*, pl. 50; *Reverend Green*, pl. 51; *Young man playing the piano*, pl. 52; *Mother fixes her little girl's shoe*, pl. 53; *Sunlight pours through the window*, pl. 54; *Deacon Hamilton*, pl. 55; *Man in front of the church*, pl. 56; *Mrs. Jones*, pl. 57; *After church gathering*, pl. 58; *Mrs. Jones leaving church*, pl. 59; *Cleaning up after church service*, pl. 60; *The old white cemetery*, pl. 61; *Tombstone dated 1790*, pl. 62; *Cast iron caskets*, pl. 63; *Willie in the black cemetery*, pl. 64; *Livinia Robinson's funeral*, pl. 65; *Grieving friend*, pl. 66; *Born on Dafuskie; laid to rest of Dafuskie*, pl. 67; *The wedding party*, pl. 68.

Muehlen, Bernis von zur
 See also #1006,1070
Mulcahy, L. P.
 See also #1070
Murray, Carol
 See also #1006
Murray, Frances
 See also #1071
Murray, Joan
 See also #1058
Myers, Barbara Cannon
 See also #1066

Myers, Joan, 1944-
 See also #1053

801. Myers, Joan. *Along the Santa Fe Trail.* Essay by Marc Simmons. Albuquerque: University of New Mexico Press, 1986. 184 p.
 The text, which covers the first half of this volume is a contemporary and historical exploration of the Santa Fe Trail.
Old Franklin, Missouri, p. 91; *Boone's Lick, Missouri*, p. 93; *Arrow Rock, Missouri*, p. 95; *Sappington Cemetery, Missouri*, p. 97; *Fort Osage, Missouri*, p. 99; *Polly Fowler, Independence, Missouri*, p. 100; *Westport Landing, Missouri*, p. 101; *Rice Plantation, Missouri*, p. 103; *110-Mile Creek, Kansas*, p. 105; *Havanna Stage Station, Kansas*, p. 106; *Dragoon's Grave, Kansas*, p. 107; *Kawa Commissary, Council Grove, Kansas*, p. 109; *Roe Groom, Kansas*, p. 110; *Council Grove, Kansas*, p. 111; *Last Chance Store Window, Council Grove, Kansas*, p. 113; *Lost Spring, Kansas*, p. 115; *Sarah at Durham, Kansas*, p. 117; *Cow Creek, Kansas*, p. 119; *Pawnee Rock, Kansas*, p. 121; *Larned, Kansas*, p. 123; *Ash Creek Crossing, Kansas*, p.124; *Earl Mongernear Kinsley, Kansas*, p. 125; *Lower Spring, Kansas*, p. 126; *Lower Spring Marker, Kansas*, p. 127; *Middle Spring, Kansas*, p. 128; *Upper Spring, Oklahoma*, p. 129; *Fort Nichols, Oklahoma*, p. 131; *Inscription Rock, Oklahoma*, p. 133; *McNees Crosing, New Mexico*, p.135; *Turkey Creek, New Mexico*, p. 137; *Rabbit EarsCreek, New Mexico*, p. 139; *Rock Mound, New Mexico*, p. 141; *Krystal at Point of Rocks, New Mexico*, p. 143; *Dorsey Mansion, New*

Mexico, p. 145; *Bent's Fort, Colorado*, p. 147, 149; *William Bent's Grave, near Boggsville,Colorado*, p. 151; *Boggsville, Colorado*, p. 153; *Iron Springs Stage Station,Colorado*, p. 155; *Raton, New Mexico*, p. 157; *Ocaté, New Mexico*, p. 159; *Wagon Mound, New Mexico*, p. 161; *Les Vilda, New Mexico*, p. 160; *Fort Union, New Mexico*, p. 163; *Masonic Temple, Watrous, New Mexico*, p. 165; *Livery Stable,Watrous, New Mexico*, p. 167; *Tecolote, New Mexico*, p. 169; *San Miguel, New Mexico*, p. 170, 171; *San José, New Mexico*, p. 173; *Pecos, New Mexico*, p. 175; *Pigeon's Ranch, New Mexico*, p. 177; *Cañoncito, New Mexico*, p. 179; *San Miguel Church, Santa Fe, New Mexico*, p. 181; *Santa Fe Trail Entering Santa Fe, New Mexico*, p. 183.

Nance, Marilyn, 1953-
 See also #1015, 1055, 1058
Natal, Judy
 See also #1006
Naylor, Genevieve, 1915-1989
 See also #1058
Neikrug, Marjorie
 See also #1070

Neiman, Roberta

802. Neiman, Roberta. *Ever Since Durango*. New York: Passenger Press, 1977.
 Unpaged. Chiefly illustrations.
Los Angeles, 1974 (2); *Sea Wolf Island, Cape Breton, Nova Scotia*, 1975; *New York City*, 1972 (3); *Abandoned House of Lighthouse Keeper, Nova Scotia*, 1975; *Ceremonial Circle, Arizona*, 1973; *Performance by Joan Jonas, New York City*, 1972; *Sculpture by Richard Serra, Bronx, New York*, 1971; *Ace Gallery, Venice, California*, 1975; *Carole, Los Angeles*, 1972; *Bathtub, New York City*, 1971; *Los Angeles*, 1974; *Kristin, New York City*, 1971; *Wedding, Cape Breton, Nova Scotia*, 1970; *Museum of Modern Art, New York City*, 1972; *Joan Performing, Venice, California*, 1972; *Rudy, New York City*, 1970; *Richard Dancing, Venice, California*, 1972; *Tatyana, Los Angeles*, 1973; *David and Bill, Cape Breton, Nova Scotia*, 1975; *Toby, Aspen, Colorado*, 1971; *Rodeo, Snowmass, Colorado*, 1973; *Joan, Mabou Mines, Nova Scotia*, 1975; *Lynda, Joanne, Helen and Richard, Sea Wolf Island, Nova Scotia*, 1975; *June, Sea Wolf Island, Nova Scotia*, 1975; *Shack on Sea Wolf Island, Nova Scotia*, 1975; *Joanne, Zach and Juliette, Dunvegan, Nova Scotia*, 1971; *Beach at Dunvegan, Nova Scotia*, 1972; *Sea Wolf Island, Cape Breton, Nova Scotia*, 1972; *Monte Alban, Mexico*, 1971; *Pauline's Mound, Great Barrington, Massachusetts*, 1976; *Robert and Rudy on Sea Wolf Island, Nova Scotia*, 1975; *Sea Wolf Island, Cape Breton, Nova Scotia*, 1974 (2); *Movie Set near Durango, Mexico*, 1972; *Sea Wolf Island, Cape Breton, Nova Scotia*, 1971; *Sara, Monte Alban, Mexico*, 1973; *Marin County, Malibu, California*, 1971; *Bathtub, Florence, Massachusetts*, 1976; *Windshield, Cape Breton, Nova Scotia*, 1974; *Waterfall, Leeds, Massachusetts*, 1976.

Neimanas, Joyce, 1944-
See also #1058
Nelson, Janet
See also #1070
Nestor, Helen
See also #1007
Netherwood, Joan Clark
See also #1000

Nettles, Bea, 1946-
See also #1006, 1008, 1058

803. Canavor, Natalie. "Rachel's Holidays," *Popular Photography* 92, 1 (January 1985): 24-25+.

804. Krantz, Claire Wolf. "(State of Illinois Art Gallery, Chicago; Exhibit)" *New Art Examiner* 19 (April 1992): 34-35.

805. Nettles, Bea. *Complexities.* Urbana, IL: Inky Press Productions, 1992. 43 p.
Photographs and text by Nettles.

806. Nettles, Bea. *Flamingo in the Dark: Images.* Rochester, NY: Inky Press Productions, 1979. 66 p. Unpaged. Chiefly illustrations.
Short autobiographical essay accompanies the photographs.
Wedding Dream, 1976; *Flying Chair,* 1977; *Florida Family Portrait,* 1977; *Tropical Seas,* 1979; *Tropical Childhood,* 1976; *3 Kids in the Lake,* 1976; *Island Sunset,* 1976; *C Sleeping on the Riverbank,* 1976; *Santa Fe Lake,* 1976; *Island Mirror,* 1976; *Mirror on the Coastline II,* 1977; *Today, Tomorrow, Always, etc.,* 1977; *Cornered Birds,* 1978; *Swan Sunset,* 1976; *Palm Tray,* 1978; *Three Frogs,* 1978; *Bee in a Corner,* 1978; *Leavin Home,* 1976; *2:35,* 1976; *C in the Moonlight,* 1976; *My Connie on Pt. Lobos,* 1977; *Three Deer,* 1977; *Card Game,* 1979; *Silver Palm,* 1977; *Fantastic Skies,* 1978; *Flyin Princess Triptych,* 1978; *Trees and Rings,* 1979; *Seaside,* 1976; *St. Croix Cactus,* 1977; *Rainforest,* 1977; *Florida Moonrise,* 1976; *Spanish Moss,* 1978; *Dawn,* 1977; *Rising Waters,* 1976; *Moon and Dish,* 1977; *Tomato Fantasy,* 1976; *Versailles,* 1976; *Crow in the Pines,* 1977; *Birdsnest,* 1977; *Sea Oats,* 1979; *Gifts,* 1979; *Three Blueberries,* 1978; *Embroidered Skies,* 1978; *Rachel in the Pines,* 1978; *Second Week,* 1978; *R and Delphiniums,* 1978; *R. L. and Duck,* 1978; *Swan in the Tub,* 1978; *Bathroom Corner,* 1978; *Suppertime Triptych,* 1978; *Crib View,* 1978; *Kiss,* 1979; *January Portrait,* 1979; *B. Nettles Fishes,* 1979; *Rachel and the Bananaquit,* 1979; *Heart on the Water,* 1979.

807. Nettles, Bea. *Gifts: A Retrospective of Works by Bea Nettles 1969-1983: [Exhibition] Frank E. And Seba B. Payne Falley, Moravian College,*

Bethlehem, PA, Oct. 20-Nov. 13, 1983. Bethlehem, PA: Payne Gallery of Moravian College, 1983. 20 p. Illustrations. Includes bibliographical references.

808. Nettles, Bea. *Grace's Daughter.* Urbana, IL: Inky Press Productions, 1994. Unpaged.
Nettles states that this book is a "collection of family stories and images inspired by: the passage of the ruby ring, silver spoons, coffee cups...leaving home, memory."

809. Nettles, Bea. *Knights of Assisi: A Journey Through the Tarot.* Urbana, IL: Inky Press Productions, 1990. Unpaged.
A tarot card deck made by a collection of photographic images.

810. Nettles, Bea. *The Skirted Garden: 20 Years of Images.* Urbana, IL: Inky Press, 1990. 44 p. Unpaged. Bibliography: p. 43-44. Chiefly illustrations. Includes autobiographical text by Nettles.
Landscape Pocket, 1969; *Self portrait in studio,* 1970; *The Moon, Queen of Pentacles, and 9 Swords* from *Mountain Dream Tarot,* 1970-1975; *Sister in the Parrot Queen,* 1970; *Sister in the Garden with Birdbaths,* 1972; *Eve...expelled,* 1970; *M's Hidden Lake,* 1969; from *Neptune and Lake Lady,* 1970, From *Ghosts and Stitched Shadows,* 1970-1971: *Lake Lady as a Young Girl; Christmas Doll; Christmas Gun; Leda* from *B and the Birds,* 1970-1971; *Suzanna...Surprised,* 1970; *Fish Tank,* 1971; *Koolaid Hearts,* 1972; *Self portrait behind Trout Stream;* from *Florida Fantasy,* 1972; from *Escape; Fish Fantasy,* 1975; *Moonrise Thru the Pines,* 1976; *Bridnest,* 1977; *Gifts,* 1979; *Rachel in the Pines,* 1978; *Snake Through the Window Dream,* 1982; *Bad Laughing Frog,* 1982; *Pack up Your Troubles,* 1982; *Humpty Dumpty,* 1982; from *Rachel's Holidays,* 1984; *Bug House; Valley of the Shadow; Headband; Rocket; Snowmen; Hansel and Gretel; Missing; Luck; Chicken/Egg; Money; Gavin with the World; Spider Catches Flies; Feminine/Masculine; Rapunzel Triptych; Faces/Phases,* 1989; from *Mountain Dream Tarot.*

811. Nettles, Bea. *Turning Fifty.* Urbana, IL: Inky Press Productions, 1995. Unpaged. Illustrated.

812. Zelevanzky, L. "Bea Nettles," *Artnews* 81, 6 (1982): n.p.

Neumaier, Diane
See also #1055

Niccolini, Dianora
See also #1004, 1069, 1072

813. Steigman, David. "Photograffiti: Dianora Niccolini Uses Felt-tip Markers

to Transform Her Prints Into a New Form of Photographic Art," *Popular Photography* 82, 5 (May 1978): 110-113.

Niro, Shelley
 See also #1055

814. Barkhouse, Mary Anne. "Truth and Dare: Profile on Shelley Niro," *Matriart* 3 (1993): 4-6.

815. Ryan, Allan J. " I Enjoy Being a Mohawk Girl: The Cool and Comic Character of Shelley Niro's Photography," *American Indian Art Magazine* 20 (Winter 1994): 44-53.

Noggle, Anne, 1922-
 See also #1007, 1055, 1058

816. Berland, Dinah. "Signs of Age. (Orange Coast College, Costa Mesa, California, exhibit)," *Artweek* 18 (February 7, 1987): 17.

817. Fishcel, Anne. *The Politics of Inscription in Documentary Film and Photography*. Doctoral Dissertation, University of Massachusetts at Amherst, 1992. 179 p. Includes bibliographical references. Illustrated.

818. Gutsche, Clara. "The Tragedy of Fallen Flesh: The Photographs of Anne Noggle," *Photo Communique* 5, 3 (Fall 1983): 9-17.

819. "The Long, Skinny (Short Fat?) Pictures of Capt. Annie Noggle & Matthew Klein," *Camera 35* 17, 1 (January/February 1973): 60-67+.

820. Noggle, Anne. *Anne Noggle*. London: Photographers' Gallery, 1988. 24 p. Illustrations.
 "Published on the occasion of the exhibition, *The Wheel of Life: Photographs of Anne Noggle and Sue Packer*.

821. Noggle, Anne. *A Dance with Death: Soviet Airwomen in World War II*. Text and contemporary portraits by Anne Noggle. Introduction by Christine A. White. College Station: Texas A&M Univeristy Press, 1994. 318 p.
 Noggle, a former Women Airforce Service Pilot, went to the Soviet Union to interview and photograph women Soviet Army Air Force veterans, the first women to ever fly combat. The lengthy text and interviews are interspersed with photographs of the Soviet women during their years in the service. Noggle's contemporary portraits round out the volume.
Nina Raspopova, p. 248;*Irina Rakobolskaya*, p. 249; *Mariya Smirnova*, p. 250; *Polina Gelman*, p. 251; *Serafima Amosova-Taranenko*, p. 252; *Klavdiya Ilushina*,

p. 253; *Yevgeniya Zhigulenko*, p. 254; *Olga Yerokhina-Averjanova*, p. 255; *Mariya Tepikina-Popova*, p. 256; *Nina Yegorova-Arefjeva*, p. 257; *Larisa Litvinova-Rozanova*, p. 258; *Zoya Parfyonova*, p. 259; *Irina Sebrova*, p. 260; *Matryona Yurodjeva-Samsonova*, p. 261; *Nadezhda Popova*, p. 262; *Nina Karasyova-Buzina*, p. 263; *Raisa Zhitova-Yushina*, p. 264; *Alexandra Akimova*, p. 265; *Mariya Akilina*, p. 266; *Valentina Savitskaya-Kravchenko*, p. 267; *Valentin Markov*, p. 268; *Antonina Bondareva-Spitsina*, p. 269; *Yevgeniy Gurulyeva-Smirnova*, p. 270; *Yevgeniya Zapolnova-Ageyeva*, p. 271; *Antonia Dubkova*, p. 272; *Mariya Dolina*, p. 273; *Anna Kirilina*, p. 274; *Antonina Pugachova-Makarova*, p. 275; *Antonina Leipilina*, p. 276; *Yelena Kulkova-Malutina*, p. 277; *Nataliya Alfyorova*, p. 278; *Galina Brok-Beltsova*, p. 279; *Marta Meriuts*, p. 280; *Galina Chapligina-Nikitina*, p. 281; *Yekaterina Chujkova*, p. 282; *Ludmila Popova*, p. 283; *Yekaterina Musatova-Fedotova*, p. 284; *Mariya Kaloshina*, p. 285; *Galina Tenuyeva-Lomanova*, p. 286; *Nataliya Smirnova*, p. 287; *Tamara Pamyatnykh*, p. 288; *Yekaterina Polunina*, p. 289; *Alexandra Makunina*, p. 290; *Mariya Kuznetsova*, p. 291; *Nina Yermakova*, p. 292; *Valentina Kovaloyova-Sergeicheva*, p. 293; *Valentina Petrochenkova-Neminushaya*, p. 294; *Nina Slovokhotova*, p. 295; *Anna Shibayeva*, p. 296; *Klavdiya Pankratova*, p. 297; *Zinaida Butkaryova-Yermolayeva*, p. 298; *Raisa Surnachevskaya*, p. 299; *Galina Drobovich*, p. 300; *Klavdiya Terekhova-Kasatkina*, p. 301; *Inna Papportnikova*, p. 302; *Valentina Kislitsa*, p. 303; *Valentina Volkova-Tikhonova*, p. 304; *Nina Shebalina*, p. 305; *Galina Burdina*, p. 306; *Irina Lunyova-Favorskaya*, p. 307; *Tamara Voronova*, p. 308; *Marina Muzhikova*, p. 309; *Yelena Karakorskaya*, p. 310; *Kareliya Zarinya*, p. 311; *Zoya Pozhidayeva*, p. 312; *Zoya Malkova*, p. 313; *Anna Timofeyeva-Yegorova*, p. 314; *Anna Popova*, p. 315.

822. Noggle, Anne. *For God, Country, and the Thrill of It: Women Airforce Service Pilots in World War II*; with an introduction by Dora Dougherty Strother. College Station: Texas A & M University Press, 1990. 162 p. Chiefly illustrations.

With a poem, "Sky High," and a short essay, "Remembrance," by Anne Noggle. A former pilot, herself, Noggle chose to record for history the portraits and the story of the Women Airforce Service Pilots, pioneer flyers who were the first licensed women pilots in the United States to fly military planes for a military service. Strother's introduction provides the history of the WASPs, from its inception, to its final and abrupt end. Snapshots taken by other WASPs during the War are included.

Mary Rosso Lewis, p. 65; *Anne Berry Lesnikowski*, p. 67; *Marie Mountain Clark*, p. 69; *WAFS Florence Miller Watson*, p. 71; *Lois Hollingsworth Ziler*, p. 73; *Yvonne C. Pateman*, p. 75; *Harriet Urban White*, p. 77; *Lorraine Zillner Rodgers*, p. 79; *Shirley Condit deGonzales*, p. 81; *Ruth Shafer Fleisher*, p. 83; *Jacqueline Twitchell Morgan*, p. 85; *Frances Thompson Hunt*, p. 87; *Suzanne DeLano Parish*, p. 89

Dorothy Swain Lewis, p. 91; *Lois Brooks Haile*, p. 93; *Francie Meisner Park*, p. 95; *Nona Highfill-Holt Pickering*, p. 97; *Bernice Falk Haydu*, p. 99; *Iris Heillman*

Schupp, p. 101; *Eileen Kealy Worden*, p. 103; *Marguerite Hughes Killen*, p. 105; *Anne Noggle*, p. 107; *Dorathea Rexroad Scatena*, p. 109; *Lillian Glezen Wray*, p. 111; *Mary Regalbuto Jones*, p. 113; *Betty Stagg Turner*, p. 115; *Rosa Charlyne Creger*, p. 117; *Betty Martin Riddle*, p. 119; *Dora Dougherty Strother*, p. 121; *Barbara Hershey Tucker*, p. 123; *Joyce Sherwood Secciani*, p. 125; *Violet Thurn Cowden*, p. 127; *Evelyn L. Tammell*, p. 129; *Mary Estill Fearey*, p. 131; *Elizabeth Briscoe Stone*, p. 133; *Yvonne Ashcraft Wood*, p. 135; *Janet Wayne Tuch*, p. 137; *Alma Newsom Fornal*, p. 139; *Kate Lee Harris Adams*, p. 141; *Helen M. Schaefer*, p. 143; *Hazel Armstrong Turner*, p. 145; *Geraldine Bowen Olinger*, p. 147; *Ida F. Carter*, p. 149; *Joan Smythe McKesson*, p. 151; *Grey Allison Hoyt Dunlap*, p. 153; *Mary Retick Wells*, p. 155; *Pearl Brummett Judd*, p. 157; *Shirley Chase Kruse*, p. 159; *Bonnie Dorsey Shinski*, p. 161.

823. Noggle, Anne. *Silver Lining*. Text by Janice Zita Grover. Foreword by Van Deren Coke. Albuquerque, University of New Mexico Press, 1983. 193 p. Chiefly Illustrations.

Also includes "Seeing Ourselves," from a speech delivered by Anne Noggle to the Class of 1983, Portland School of Art, Maine, and a poem by Noggle. Grover's essay. "Anne Noggle's Saga of the Fallen Flesh," is a critical exploration of the career of Anne Noggle and the faces and bodies, the portraits in this volume.

Myself as a Pilot, 1982, frontispiece; *Self-portrait before Surgery*, 1975, p. 17; *La Posada*, 1970, p. 21; *Agnes*, 1969, p. 35; *Agnes and Shelley*, 1970, p. 37; *Self-portrait with Pepe*, 1970, p. 39; *Agnes, La Jolla*, 1970, p. 41; *Agnes, 84th Birthday*, 1974, p. 43; *La Jolla No. 3*, 1975, p. 45; *Face-lift No. 3*, 1975, p. 47; *Artifact*, 1976, p. 49; *Self-portrait*, 1976, p. 51; *Mary, Afternoon November 1976*, p. 53; *Santa Fe Spring*, 1976, p. 55; *Santa Fe Summer No. 1*, 1976, p. 57; *Santa Fe Summer No. 2*, 1976, p. 59; *Moonlight over Albuquerque*, 1976, p. 61; *Morris*, 1976, p. 63; *Agnes*, 1976, p. 65; *Myself, 7 a.m.*, 1977, p. 67; *Stonehenge Decoded*, 1977, p. 69; *Self-image in Cochiti Lake*, 1978, p. 71; *Self-image No. 2*, 1978, p. 73; *Harry from Australia*, 1978, p. 75; *Shelley*, 1978, p. 77; *Yolanda*, 1978, p. 79; *Silver Lining Nos. 1-5*, 1978-9, p. 81, 83, 85, 87, 89; *Cavalliere*, 1979, p. 91; *The Gay Divorcee*, 1979, p. 93; *Self-image in the Grass*, 1979, p. 95; *Agnes*, 1979, p. 97; *Agnes in a Fur Collar*, 1979, p. 99; *Self-image*, 1979, p. 101; *Ruth Leakey*, 1980, p. 103; *Yolanda in Her Silk Hat*, 1980, p. 105; *Reminiscence: Portrait with My Sister*, 1980, p. 107; *Mary Jenkins*, 1980, p. 109; *A Family Portrait, Bellingham, Washington*, 1981, p. 111; *Louise*, 1981, p. 113; *Yolanda in the Patio*, 1981, p. 115; *Mary*, 1981, p. 117; *Edith "Tiny" Keene*, 1981, p. 119; *Darkroom*, 1981, p. 121; *Untitled*, 1981, p. 123; *Henry Bumkin, Detective*, 1981, p. 125; *Rosa Wiley, Seamstress*, 1982, p. 127; *Margaret Walsh, Writer*, 1982, p. 129; *Pauline Aleaz, El Paso, Doyenne*, 1982, p. 131; *Myself as a Guggenheim Fellow*, 1982, p. 133; *Helen Hobart*, 1982, p. 135; *Profile of Yolanda*, 1982, p. 137; *Southwest Passage*, 1982, p. 139; *Charles Mattox, Sculptor, and His Wife, Dorothy*, 1982, p. 141;

From a series *Seattle Faces*, 1982: *K. S.*, p. 143; *A. O.*, p. 145; *J. T.*, p. 147; *L. H.*, p. 149; *A. R. and D. R.*, p. 151; *K. B.*, p. 153; *R. S.*, p. 155; *V. P.*, p. 157; *N. B.*, p.

159; *A. P.,* p. 161; *B. A., and W. A.,* p. 163; *B. B.,* p. 165; *H. M. W.,* p. 167; *J. E.,*
p. 169;
Winnie Beasley, Flyer, 1983, p. 171; *Donna Humble, Copywriter,* 1983, p. 173;
Yolanda, 1983, p. 175; *Shelley,* 1983, p. 177; *Myself in Amarillo,* 1983, p. 179;
JoAnn Cockelreas and Her Daughter Jean, Commerce, Texas, 1983, p. 181;
Richard Parrish, Commerce, Texas, 1983, p. 183; *B. J. And Mary Jo Garner,*
Commerce, Texas, 1983, p. 185; *Chester and Kittie Gibbs, Commerce, Texas,* 1983,
p. 187; *J. B. Jackson, Author,* 1983, p. 189; *Daria Masterson, "Miss Amarillo*
College, 1956," 1983, p. 191; *The Late Great Me,* 1983, p. 193.

824. Tucker, Anne Wilkes. "Anne Noggle. (Interview)," *Art Journal* 53 (Spring
 1994): 58-60.

Norfleet, Barbara, 1926-
 See also #1006, 1058, 1063

825. Bogre, Michelle. "Among the Hidden Class: Barbara Norfleet Talks
 About the Triumphs and Tribulations of Shooting America's Most Elusive
 Social Group--the Upper Class," *American Photographer* 23, 5
 (November 1989): 54-60.

826. Matthews, Sandra. "Looking Up at the Upper Class: The Photographs of
 Barbara Norfleet," *Exposure* 26 (Fall 1988): 26-30.

827. Norfleet, Barbara P. *All the Right People.* Foreword by Stephen
 Birmingham. Boston: Little, Brown and Company, 1986. 129 p. Chiefly
 Illustrations.
 Short essay by the author on her glimpse into the world of the "hidden rich
 in their private lives." Anonymous essays, by some of the people
 photographed, on being brought up by nannies, their justification for
 having more money than others, their education and the sense that they are
 of a different class.
Chilton Club, Boston, Massachusetts, 1983, frontispiece; *Private House, Dublin,*
New Hampshire, 1985, p. 3; *Private House, Manchester,* Manchester, 1983, p. 5;
Private Club, New Providence Island, The Bahamas, 1982, p. 6; *Birthday Party,*
Private House, Brookline, Massachusetts, 1985, p. 7; *Birthday Party, Manchester,*
Massachusetts, 1983, p. 9; *Private House,* Brookline, Massachusetts, 1985, p. 11;
Under-Five Class, Devon Horse Show, Devon, Pennsylvania, 1980, p. 15; *Horse*
Show, p. 18; *Dance Class, Cosmopolitan Club,* New York City, 1985, p. 22, 23;
Family Plantation, Mississippi Delta, 1984, p. 25, 49; *Flying Horse Farm,*
Hamilton, Massachusetts, 1981, p. 27; *Private Girls' School,* Wellesley,
Massachusetts, 1981, p. 29; *Winsor Senior Prom, Ritz-Carlton Hotel,* Boston,
Massachusetts, 1983, p. 31; *Summer Place,* p. 33; *Edgartown Yacht Club,*
Edgartown, Massachusetts, 1981, p. 37; *Flying Horse Farm,* Hamilton,
Massachusetts, 1983, p. 39; *Longwood Cricket Club,* Brookline, Massachusetts,

1982, p. 41; *Edgartown Yacht Club, Edgartown, Massachusetts*, 1983, p. 42; *Three Brothers, Cambridge Boat Club, Cambridge, Massachusetts*, 1983, p. 43; *Final Club Garden Party, Harvard University, Cambridge, Massachusetts*, 1984, p. 45; *Wedding, Lincoln, Massachusetts*, 1982, p. 47; *Hunt*, p. 52; *Private House, New Providence Island, The Bahamas*, 1982, p. 55; *Essex County Club, Essex, Massachusetts*, 1984, p. 57; *Vintage Car Club Races, Private Estate, Camden, Maine*, 1984, p. 59; *International Jumping Derby, Portsmouth, Rhode Island*, 1981, p. 61; *Belle Meade Country Club, Belle Meade, Tennessee*, 1981, p. 63; *Farm*, p. 66; *Hunt Club's Winter Beach Ride, Ipswich, Massachusetts*, 1982, p. 69; *Private House, Sumner, Mississippi*, 1984, p. 71; *Tennis & Racquet Club, Boston, Massachusetts*, 1982, p. 73; *Chilton Club, Boston, Massachusetts*, 1983, p. 75; *Newport Casino, Newport, Rhode Island*, 1981, p. 76; *Party, American Academy of Arts and Sciences, Cambridge, Massachusetts*, 1984, p. 77; *Private Estate*, p. 79; *Picnic, Hunt Club, The North Shore, Massachusetts*, 1983, p. 83; *Box Lunch Party, Iroquois Steeplechase, Nashville, Tennessee*, 1981, p. 85; *Horse Auction, Portsmouth, Rhode Island*, 1981, p. 86; *Pavilion Party, Myopia Hunt Club Event, Hamilton, Massachusetts*, 1981, p. 87; *Flying Horse Farm, Hamilton, Massachusetts*, 1981, p. 89; *Myopia Hunt Club Driving Event, Hamilton, Massachusetts*, 1981, p. 91; *Master of the Fox Hounds Training the Hounds, Myopia Hunt Club, Hamilton, Massachusetts*, 1982, p. 93; *Hunters's Pace, Ipswich, Massachusetts*, 1984, p. 95; *Race*, p. 100; *Downtown Office, Boston, Massachusetts*, 1984, p. 103; *Yacht Club, Northeast Harbor, Maine*, 1982, p. 105; *Eating Club, Princeton University Reunion, Princeton, New Jersey*, 1982, p. 106; *Point-to-Point Race, Butler, Maryland*, 1983, p. 107; *Palm Beach Polo and Country Club, Florida*, 1983, p. 109; *Private Club, New Providence Island, The Bahamas*, 1982, p. 111; *Edgartown Yacht Club, Edgartown, Massachusetts*, 1983, p. 112; *Newport Casino, Newport, Rhode Island*, 1981, p. 113; *Country House*, p. 116; *Chilton Club, Boston, Massachusetts*, 1983, p. 119; *Boston Athenaeum Wednesday Afternoon Tea, Boston, Massachusetts*, 1985, p. 121; *Tailgating, Foxfield Steeplechase, Charlottesville, Virginia*, 1984, p. 123; *Country Wedding, Private Farm, Sherborn, Massachusetts*, 1984, p. 125; *Benefit for the Mount Vernon Ladies' Association of the Union, Copley Plaza Hotel, Boston, Massachusetts*, 1983, p. 127; *Private House, Cambridge, Massachusetts*, 1982, p. 129.

828. Norfleet, Barbara. "Studio Photographers and Two Generations of Baby Raising," *Photo Communique* 10, 1 (Spring 1988): 14-23.

829. Wiese, Epi. "Flowers of Evil: The Photographs of Barbara Norfleet," *Photo Communique* 4, 1 (Spring 1982): 14-17.

Norman, Dorothy
 See also #1015, 1026
North, Kenda, 1951-
 See also #1058

Noskowiak, Sonya, 1900-1975
 See also #1008, 1058
Novak, Lorie
 See also #1058
Nye, Carol Anne
 See also #1071

Ockenga, Starr, 1938-
 See also #1000, 1004, 1007, 1058, 1072

830. Jussim, Estelle. "Starr Ockenga's Nudes: Some Notes on the Genre," *The Massachusetts Review* (Spring 1983): 96-106.

O'Hara, Sheila
 See also #1070
Olsen, Alis
 See also #1071
O'Neill, Elaine
 See also #1072
Opie, Catherine
 See also #1055
Oppenheimer, C. K.
 See also #1006
Opton, Suzanne
 See also #1069, 1070, 1072

Orkin, Ruth, 1921-1985
 See also #1008, 1058, 1069

831. Benedek, Yvette E. "Contact: Ruth Orkin," *American Photographer* 6, 5 (May 1981): 56-57.

832. Bultman, Janis. "Candor and Candids: An Interview With Ruth Orkin," *Darkroom Photography* 4, 6 (September/October 1982): 18-25+.

833. Busch, Richard. "Ruth Orkin: Inspiration From a 15th-Floor Window," *Popular Photography* 74, 4 (April 1974): 96-99.

834. Orkin, Ruth. "How to Make a Sequence," *Modern Photography* 13, 1 (September 1949): 80-81+.

835. Orkin, Ruth. *More Pictures from My Window*. New York: Rizzoli, 1983. 144 p.
 Short introductory essay by the New York City Commissioner of the Department of Parks and Recreation, "Are they really all from one

window? by Ruth Orkin, and a short essay on "Central Park--Its Beginnings," also by Ruth Orkin.

Panorama from My Window, 1983, p. 8; *American Girl in Italy*, 1951, p. 11; *View from my window o West Eighty-eighth Street*, 1952, p. 13; *My mother, Mary Orkin with her grandson Andy aged four, painting in Central Park*, 1963, p. 4; *Central Park South in the 1950s*, p. 16; *Central Park and Fifth Avenue in the 1950s*, p. 16; *Mary and Andy*, 1983, p. 17; *Richie Andrusco as "The Little Fugitive,"* 1953, p. 17; *For a change I'm standing in Sheep Meadow and shooting toward my window*, c. 1970, p. 21; *Pink sunset*, 1981, p. 22; *Sunlit streets in the east sixties*, 1977, p. 24; *Strange green mist*, 1982, p. 26; *Sunrise*, 1980, p. 28; *Sunset*, 1980, p. 29; *Evening lights*, 1980, p. 30; *Evening windows*, 1962, p. 31; *These five buildings look as if they're all on 5th Avenue*, 1982, p. 32; *Green-cooper [sic] roof*, 1981, p. 33; *Your usual chic New York crowd leaving the James Taylor concert--67th Street and Central Park West*, 1979, p. 34; *Same four corners four months later*, 1979, p. 35; *Rally protesting the Democratic Convention being held at Madison Square Garden*, 1980, p. 36; *Antique-car luncheon*, 1979, p. 37; *"Caution,"* 1962, p. 38; *Taxis mating*, 1979, p. 38; *Three buses filled with the ex-hostages and their families had just gone by*, 1981, p. 39; *Workmen repairing bricks on our building*, 1982, p. 40; *Movie Crew shooting "I'll Cry Tomorrow" starring Susan Hayward*, c. 1956, p. 41; *Old Playground*, 1963, p. 42; *New Playground*, 1967, p. 43; *Maypole dancing on the Meadow*, 1963, p. 43; *Muted autumn*, 1979, p. 44; *Summer green*, 1981, p. 45; *Spring on East Drive*, 1979, p. 46; *Autumn on 67th Street*, 1978, p. 46; *Winter on the corner of 66th Street and Central Park West*, 1981, p. 47; *Autumn in Manhattan*, 1980, p. 48; *White feathery trees*, 1981, p. 50; *a scene from the movie "Kramer vs Kramer" is being filmed in the Meadow*, 1978, p. 52; *The brand-new Meadow covered with sunbathers*, 1982, p. 53; *Fireworks*, 1978, p. 54; *Movie lights*, 1979, p. 55; *Moon over concert*, 1978, p. 56; *Blue Snow*, 1981, p. 57; *Lighting behind 5th Avenue*, 1958, p. 58; *A flower of fireworks*, 1978, p. 59; *Sheep Meadow lit up for the the landing of Nixon's helicopter in the late fifties*, p. 60; *Central Park in preparation for Fidel Castro's speech in the bandshell*, 1959, p. 61; *Yellow blurred lines, the result of long exposure, represent people leaving a concert in the Meadow*, 1975, p. 62; *This was taken when we could still look through the Tavern windows and read a menu*, c. 1950, p. 63; *Runner on 67th Street. These were all the participants in the first New York City Marathon in 1970, and with one execption, they were all men*, 1970, p. 64; *Bill Rogers winning the 1979 marathon*, p. 65; *Women stretching before the start of the Women's 10km L'eggs Mini Marathon*, 1981, p. 66; *The women's mini marathon began in 1972 and today attracts over 6,000 runners*, 1981, p. 66; *Women disappearing into Central Park at 72nd Street during the mini marathon*, 1982, p. 68; *Winter birds*, 1978, p. 69; *260,000 holiday lights in front of the Tavern-on-theGreen*, 1976, p. 70; *Waiting for the bus*, 1978, p. 72; *Buried cars*, c. 1960, p. 73; *Snowing on 67th Street and Central Park West*, 1977, p. 74; *During the 1969 blizzard, 6,000 people were stranded for three days at Kennedy Airport*, 1969, p. 75; *6 p.m. winter*, 1977, p. 76; *These buildings are barely visible to me anymore since the trees have grown to block the view*, 1963, p. 77; *People still ride the bridle paths*, 1978, p. 78; *Taxi*

heading for the tunnel on the 66th Street transverse, 1967, p. 79; *Central Park South*, 1977, p. 80; *The Plaza*, 1979, p. 81; *Several days out of the year, the sun's angle makes the Plaza's green-copper roof look like gold*, 1976, p. 82; *The Roman window of Temple Emanu-El at 5th Avenue and 65th Street*, 1975, p. 83; *Temple Emanu-El surrounded by apartment windows*, 1982, p. 84; *The Temple in gray haze*, 1980, p. 85; *Black clouds over 5th Avenue*, 1981, p. 86; *Double rainbow at sunset*, 1981, p. 88; *"All's right with the world..."* n.d., p. 90; *A cult of red-clad people*, 1981, p. 92; *Herding sheep on Sheep Meadow was done once as a publicity stunt*, 1979, p. 93; *A "Snow Games" day was held in the Meadow by a local sporting goods store*, 1979, p. 93; *Sunlovers in March*, 1982, p. 94; *Sunbathers in June*, 1982, p. 95; *Resodding fences on an "Irish" meadow*, 1980, p. 96; *One large and one small homemade skating rink on the Meadow*, 1977, p. 97; *Baseball during a blizzard!* 1979, p. 98; *Cricket players on an English lawn...at first glance...turn into frisbee players on the Meadow*, 1980, p. 99; *Five orange balloons...suddenly materialized out of nowhere*, 1981, p. 100; *Ten orange buses...waiting for their riders*, 1961, p. 101; *Golden glow--5th Avenue and Central Park South*, 1980, p. 102; *After the rain*, 1981, p. 104; *July 4th*, 1976, p. 105; *Rosy city*, 1981, p. 106; *Purple city*, 1981, p. 107; *The huge Anti-Nuclear Rally filled the Great Lawn with an estimated seven hundred thousand to one million demonstrators*, 1982, p. 108; *Japanese marchers*, 1982, p. 108; *Crowds of mourners for John Lennon gathers at the intersection at Central Park West and 72nd Street outside the Dakota*, 1980, p. 110; *Later 100,000 mourners filled the Mall area* , 1980, p. 111; *[Rainbow]* 1980, p. 112; *"Aurora Borealis,"* 1982, p. 114; *Gray and peach clouds*, 1982, p. 115; *Sheepskin clouds*, 1979, p. 116; *Clouds over upper 5th Avenue*, 1978, p. 117; *After the storm*, 1978, p. 118; *Orange sunrise*, 1979, p. 119; *Sheep Meadow as it looked before the lawn was worn out by heavy use*, 1959, p. 120; *This crowd had gathered for one of the last New York Philharmonic concerts presented in the Meadow in 1979*, p. 120; *By 1978 there were only a few patches of green lawn left on the Meadow*, 1979, p. 122; *Then in April came all the yellow tractors--as fifteen acres of new green sod was unrolled*, 1979, p. 123; *"An Italian hilltown." The fences were windbreaks to protect the newly planted sod*, 1980, p. 124; *It was worth the wait*, 1981, p. 125; *On a sunny day*, 1982, p. 126; *At sunset*, 1982, p. 127; *Red buildings on 5th Avenue*, 1980, p. 128; *Early arrivals, a father and his two children*, 1959, p. 130; *Late arrivals*, 1977, p. 131; *Olive Oyl, the first female float*, 1982, p. 132; *The movie cast of "Annie" ... riding atop a float*, 1981, p. 132; *Mickey Mouse walking down Central Park West*, 1981, p. 133; *The Tift County Marching Band from Tifton, Georgia*, 1981, p. 134; *Spring*, 1967, p. 135; *Here is a fifty-foot geodesic dome that stood in the parking lot for five days*, 1969, p. 136; *Warner Leroy reopened the Tavern on October 6, 1976, after it had been closed for two years*, p. 137; *Dog obedience class*, 1975, p.138;*Before the Tavern's reopening the parking lot was frequently used for publicity purposes*, 1975, p. 138; *Treasure hunt in a taxi*, 1963, p. 139; *White police vans*, 1975, p. 139; *"Star Wars" in mid-Manhattan*, 1983, p. 140; *Three new towers--IBM, AT&T and Trump Tower*, 1983, p. 141; *"Save the Whale" rally*, 1979, p.142;*Buried balloon*, 1976,p. 143; *Balloons signal the start of the Women's 10km L'eggs Mini Marathon*, 1982, p. 144.

144.

836. Orkin, Ruth. "No Sun For Me," *Modern Photography* 16, 8 (August 1952): 62-65.

837. Orkin, Ruth. *A Photo Journal*. New York: Viking Press, 152 p.

838. Orkin, Ruth. *Ruth Orkin*. New York: M. Engel, 1995. 40 p. Includes bibliographical references. Illustrated.
Exhibition catalogue.

839. Orkin, Ruth. "Story in Pictures," *U.S. Camera* 15, 9 (September 1952): 34-35.

840. Orkin, Ruth. *A World through My Window*. Text assembled by Arno Karlen. New York: Harper and Row, 1978. 119 p.
Short introduction by Orkin on how she came to take her photographs and explanatory notes on her cameras, and her recollections about the shooting of the photographs.
Park Lights, p. 11; *Lavender Haze*, p. 13; *North Woods*, p. 15; *Rain Cloud*, p. 17; *My Tree*, p. 19; *Temple Emanu-el after a Rainstorm*, p. 21; *Central Park South*, p. 22; *Jogger in the Snow*, p. 22; *Plaza in the Snow*, p. 23; *Central Park West Snow*, p. 25; *Central Park South Windows*, p. 27; *Car on the Sidewalk*, p. 28; *Shriner Parade*, p. 29; *Balloon*, p. 31; *English Landscape*, p. 33; *Low-Hanging Fog*, p. 35; *The Turkey*, p. 36; *Orange Autumn*, p. 37; *Christmas Tree*, p. 39; *Winter Sunrise*, p. 41; *White Trees, Central Park South*, p. 43; *5:00 p.m. Winter*, p. 45; *Pruning Trees*, p. 46; *Kite Day*, p. 47; *Circus Press Conference*, p. 49; *Rolls-Royce Luncheon*, p. 51; *Philharmonic Concert*, p. 53; *Mickey Mouse*, p. 54; *Marching Band*, p. 55; *Answer Lie-In*, p. 57; *Last Big Peace March*, 1972, p. 59; *Fireworks*, p. 60, 61; *3:00 p.m. The Brown Storm*, p. 63; *Blackout,* November 9, 1965, p. 65; *Con Ed Stacks*, p. 67; *After the Red Rainbow*, p. 68; *Black Clouds over the Carlyle Hotel*, p. 69; *Mist over the Sheep Meadow*, p. 71; *Lightning Over the Sheep Meadow*, p. 73; *Sidewalk Footprints*, p. 75; *GM Building at Sunrise*, p. 77; *The Sherry-Netherland Tower*, p. 78; *Clear Morning, Central Park South*, p. 79; *Rainbow over Fifth Avenue*, p. 81; *Citicorp Pink*, p. 83; *Moonlight #2*, p. 85; *Andy and Morris Sledding*, p. 86; *Morris Buttering Bread*, p. 86; *Mary Watching the Balloon*, p. 86; *Family Portrait in the Parking Lot*, p. 87; *Little Pink Clouds*, p. 88.

841. Reynolds, Charles. "Window Shopping: Photographs by Ruth Orkin," *Popular Photography* 90, 9 (September 1983): 58-65.

842. Stevens, Nancy. "Ruth Orkin: A Retrospective Look at the Life and Work of a Humanist Magazine Photojournalist," *Popular Photography* 80, 5 (June 1977): 100-109+.

Oskini, Christine
 See also #1006
Ottinger, Debi
 See also #1039
Page, Christine
 See also #1006
Pagliuso, Jean
 See also #1058

Palfi, Marion, 1907-1978
 See also #1008, 1058, 1061

843. *Invisible in America: An Exhibition of Photographs by Marion Palfi.*
 Introduction by Lee Witkin. Lawrence, KS: University of Kansas Museum
 of Art, 1973. 176 p. Chiefly illustrations.
 This is an exhibition catalog of one of the first comprehensive exhibitions
 of the photographs of Palfi. It is a collection of the various studies she
 undertook.

From *Suffer Little Children*: *Florida*, 1946-1949, pl. 1; *New York City*, 1946-1949,
pl. 2; *New York City, Abandoned and Neglected Children, "They fall asleep
exhausted ..shortly after breakfast,"*1948, pl. 3, 4, 5, 6, 7; *New York City, "The
loveless life leads him to mental illness,"* 1948, pl. 8; *New York City, "The gates
are closed...."* 1948, pl. 9; *Detroit, Wayne County Juvenile Detention Home*, 1946-
49, pl. 10; *New York State, Hudson School for Girls*, 1946-49, pl. 11; *New York
City, "Gang,"* 1946-49, pl. 12; *Florida*, 1946-49, pl. 13; *California, Children of
a Migratory Family*, 1946-49, pl. 14; *Los Angeles*, 1946-49, pl. 15; *Knoxville*,
1946-49, pl. 16; *Detroit, Rent Collection*, 1946-49, pl. 17; *Georgia, Son of a Tenant
Farmer*, 1946-49, pl. 18; *Washington, D.C., In the Shadow of the Capitol*, 1946-49,
pl. 19; *Georgia (?), Under to [sic] Brooklyn Bridge*, 1946-49, pl. 20; *The South*:
Atlanta, Peach Street, 1949, pl. 21; *Atlanta, 1949*, pl. 22, 23, 24; *Louisville*, 1949,
pl. 25; *Georgia*, 1949, pl. 26; *Georgia, Bean Pickers*, 1949, pl. 27; *Georgia, Bean
Picker*, 1949, pl. 28; *Georgia, Overseer*, 1949, pl. 29; *Sledge, Mississippi,
Sharecropper's Children*, 1949, pl. 30; *Louisville, Laundress*, 1949, pl. 31;
Georgia, Mid-wife, 1949, pl. 32; *Knoxville, Tennessee*, 1949, pl. 33; From *There
Is No More Time*: *Irwinton, Miss Rosa*, 1949, pl. 34; *Irwinton, Saturday in
Irwinton*, 1949, pl. 35; *Irwinton, The Mayor*, 1949, pl. 36; *Irwinton*, 1949, pl. 37;
Irwinton, County Representative and Publisher of the Wilkinson County News,
1949, pl. 38; *Irwinton, The Postman*, 1949, pl. 39; *Irwinton, Wife of the Victim*,
1949, pl. 40; From *You Have Never Been Old*: *New York City, Old Age Home*,
1956-58, pl. 41, 42; *New York City*, 1956-58, pl. 43, 44, 45; *Civil Rights*: *Portland,
Oregon*, 1946, pl. 46, 47; *Miami, Florida, Bus Station*, 1946-49, pl. 48; *Florida*,
1946-49, pl. 49; *Somewhere in the South, City Bus*, 1946-49, pl. 50; *Atlanta,
Columbian--the sign of loyalty*, 1946-49, pl. 51; *Atlanta, Columbian Flag*, 1946-49,
pl. 52; *Atlanta, Columbians*, 1946-49, pl. 53; *Los Angeles, An Anti-Klan Meeting*,
1946-49, pl. 54; *Tennessee, Highlander Folk School*, 1946-49, pl. 55; *Washington,*

D.C. , 1964, pl. 56; *Greenwood, Mississippi,* 1963, pl. 57; *Chicago, School Boycott,* 1964, pl. 58; *Washington, D.C., March on Washington,* 1963, pl. 59; From: *...First I Liked the Whites, I Gave Them Fruits...* *Hotevilla, Hopi Reservation, Arizona, View from Hotevilla, a traditional village,* 1967-69, pl. 60; *Hotevilla, Hopi Reservation, Arizona, The way to the Hopi women's gardens,* 1967-69, pl. 61; *Hotevilla, Hopi Reservation, Arizona, David Monogje, traditional high leader with his grandchild,* 1967-69, pl. 62; *Hotevilla, Hopi Reservation, Arizona, Dan Katchongva, eldest leader of the Hopi,* 1967-69, pl. 63; *Navajo, The Blue Lake Family,* 1967-69, pl. 64; *Hotevilla, Hopi Reservation, Arizona, Hopi Clan Meeting,* 1967-69, pl. 65; *Moencopi, Arizona, BIA School,* 1967-69, pl. 66; *San Miguel, a church near the Mexican Border, services,* 1967-69, pl. 67; *Navajo, Relocation, Leaving Home,* 1967-69, pl. 68; *Navajo, Relocation, Waiting for the Papers to be Signed,* 1967-69, pl. 69; *Navajo, Relocation, The Official Signing of the Papers,* 1967-69, pl. 70; *Madera, California, A New Arrival for "Acculturation" and "Relocation",* 1967-69, pl. 71; *Navajo, Living "Modern" in low cost housing which has neither water or electricity,* 1967-69, pl. 72; *Los Angeles,* 1967-69, pl. 73, 74.

844. Center for Creative Photographer, University of Arizona. "Marion Palfi," *The Archive,* Research Series, 19 (September 1983). 39 p.
 Portfolio of photographs are accompanied by an introductory essay by Elizabeth Lindquist-Cock which explores the various photographic studies that Palfi undertook.

From the *Georgia Study Series,* 1949: *Saturday, Louisville, Georgia,,* cover; *Untitled,* p. 4, 5, 6; *Langston Hughes Broadcasting,* p. 7; From *Suffer Little Children* series, 1946-49: *Washington, D. C., In the Shadow of the Capitol,* p. 7; *Hudson School for Girls, the Only New York State Training School for Delinquent Girls, Solitary,* pl. 10; From the *That May Affect Their Hearts and Minds* series, 1963-64: *Chicago School Boycott,* p. 8; From the *You Have Never Been Old* series, 1956-58: *Old Age Home, Welfare Island, New York,* p. 9; *Case History,* pl. 11, 12; *Men's Shelter, New York--Your Fortune Must Be Less Than $2 To Be Acceptable,* pl. 13; From the *In These Ten Cities* series, 1951: *Charlottesville, Virginia,* pl. 1; *Chicago,* pl. 2, 3; *Waterbury, Connecticut,* pl. 4; *Phoenix,* pl. 5; *Detroit,* pl. 8; From the *There Is No More Time* series, 1949: *Wife of the Victim,* pl. 9; From the *First I Liked the Whites, I Gave Them Fruits* series, 1967-69: *Untitled,* pl. 14, 16; *Navajo Family Life, the Blue Lake Family on the Black Mesa,* pl. 15; *Laura Kerman, the Papago Folk Artist, Lives in Topawa,* pl. 17; From the *Ask Me If I Got Justice* Series, 1975: *Untitled,* pl. 18, 19.

845. University of Arizona. Center for Creative Photography. *Marion Palfi Archive.* Tucson, AZ: The Center, 1985. 78 p. Bibliography: p. 13-16.
 A catalog of the archive.

Parada, Esther, 1938-
 See also #1007, 1055, 1058

Pararo, Cynthia
> See also #1006

Park, Patricia
> See also#1071

Parker, Olivia, 1941-
> See also #1000, 1007, 1008, 1012, 1034, 1058

846. Christensen, Judith. "Images of the Interior," *Artweek* 19 (October 15, 1988): 17-18.

847. Edwards, Owen. "Olivia Parker: Still Lifes That Seduce the Eye As They Engage the Spirit," *American Photographer* 4, 2 (February 1980): 64-71.

848. Featherstone, David. "Olivia Parker: Shaping Color to Sensibility," *Modern Photography* 44, 3 (March 1980): 94-99+.

849. Fulton, Marianne. "Olivia Parker," *Image* 24, 1 (September 1981): 20-23.

850. Horenstein, Henry. "Visions: Olivia Parker's Still Lifes Cast Ordinary Objects in a New Light," *Popular Photography* 93, 12 (December 1986): 60-67.

851. Jordan, Jim. "Confined Images. (Robert Koch Gallery, San Francisco, Exhibit)," *Artweek* 17 (November 8, 1986): 11.

852. Parker, Olivia. *[Olivia Parker, Photographer.]* Duluth, MN: Audiovisual Division, Library and learning Resources Services, University of Minnesota, Duluth, 1987. Videorecording, 70 minutes.
"Parker describes her life, training, techniques and works....The lecture was presented March 30, 1987." oclc

853. Parker, Olivia. *Signs of Life: Photographs*. Boston: L. David R. Godine, 1978., 66 p. All Illustrations.
The introduction by Olivia Parker offers a brief explanation of the photographs and types of objects they include.
Drop Coin; Mixed Nuts; Pea Pod; Posts; Mask; Pods of Chance; James; Eliza; Victorian Lace; Bosc in a Box; Orchids; Gull; Runes; Lemon Pie; Oriental Rain; Dance; Valentine; Memento Mori; Parasol; Indian Pipes; An Orderly Mind; Vicksburg Feather; Cinquefoil; Amaryllis; Pear; Forever Young; Michael; Gaea; Victoria P.; Some Cherries; Hazelnuts; Pheasant; On the Wing; Silver Heat; Miss Appleton's Shoes II; Vegetable; V. G. ; The Asparagi; Tiger; Bosc; Wigged Soul; Can Dance; His Book; Eggshells; Stone Soul; Rose; Tympanum; Moment; For Blake; Empress; Crab; Box; Evidence.

854. Parker, Olivia. *Under the Looking Glass*. Introduction by Mark Strand. Boston: Little, Brown, 1983. 83 p. Unpaged. Chiefly Illustrations.

Child, 1980; *Three Strawberries,* 1978; *Pheasant,* 1979; *Maples,* 1980; *Chambers,* 1981; *Thistle,* 1982; *Lady Slipper,* 1979; *Jack in the Pulpit,* 1981; *Circles of Memory,* 1980; *Isabella's, Bit of the Florida Coast,* 1982; *Marine II,* 1981; *Columbine,* 1980; *Hybrids,* 1978; *Pomegranates,* 1979; *Night Bird,* 1980; *Gravity,* 1982; *A Reasonable Argument,* 1980; *Kinglet,* 1979; *Red Cages,* 1980; *Mangoes,* 1978; *The Black Package,* 1980; *Starlight Game,* 1981; *Ending,* 1980; *Garlic,* 1981; *La Felicita,* 1980; *Possibility,* 1979; *Golden Pears,* 1979; *The Eastern Garden,* 1980; *Three Feathers - Three Crystals,* 1981; *Residue,* 1981; *Contact,* 1978; *Song,* 1980; *Swan's Ladies,* 1982; *Between Time and Eternity,* 1980; *Hearts,* 1980; *For Marianne Moore,* 1982; *Street Flowers,* 1981; *Three of Hearts,* 1980; *The Devil's Tea Party,* 1981; *Turkey Shoot,* 1981; *Peaches,* 1980; *Children with Acorns,* 1981; *Four Pears,* 1979.

855. Parker, Olivia. *Weighing the Planets*. Boston: Little, Brown, 1987. 80 p. Chiefly Illustrations.

Short essay by Parker explaining her exploration for and chooses of objects to combine and photograph.

Weighing the Planets, front cover; *Interrupted Information,* back cover; *At the Edge of the Garden,* frontispiece; *The Edge of Time; The Cartographers; Ocean; The Burning Glass; Structural Options; Displacement; Broken Nautiluses; Site II, Deer; Interior with Pears; Hiatus; Circumnavigation; Mechanisms; Feral Tape; The Quarrellers; Edges; Carousel; Pears; Adam and Eve A.D.; A Summer Afternoon; Training; Doorway; Never; Trap; Site I; Blackbird; World of Wonder; Suspension; on the Wall; Freesia; Help Is Here; Inner Workings; Dovecote; What If . . .; Statue Seen by a Man and Observed by a Pigeon; The Artificial Sphere; End Game; Cinemechanics; Last Resort; Partition; Rhode Island Red Hits the Sack; Seven; An Unpleasant Surprise; Dislocation; An Unknown Idea; Iconoclasm; Second Nature; in the Works; Leaving the Scene.*

856. Porter, Allan. "Parker," *Camera* (Switzerland) 60, 10 (October 1981): 22-29.

857. Rollow, David. "Shadow Boxes: Photographs by Olivia Parker," *Camera Arts* 1, 3 (May/June 1981): 72-77.

858. Roth, Evelyn. "Winter Dreams," *American Photographer* 18, 1 (January 1987): 46-51.

859. Stapen, Nancy. (Robert Klein Gallery, Boston, Exhibit) *Art News* 92 (December 1993): 138.

Patterson, Marion
See also #1053

Paul, Kathryn
 See also #1053
Pavia, Joanne
 See also #1039

Pearson Cameron, Victoria , 1955-

860. Roth, Evelyn. "Victoria Pearson Cameron (Stylish images that are very
 fashion-forward)," *American Photographer* 23 (July 1989): 52-55.

Peck, Mary
 See also #1053
Peterich, Gerda
 See also #1000
Peugh, Karen A.
 See also #1006
Pfeffer, Barbara
 See also #1072
Pickens, Marjorie
 See also #1072
Pietromartire, Judith - Love
 See also #1071
Pincus, Hildy
 See also #1006
Piper, Adrian
 See also #1055
Pitchford, Emily H., 1878-1956
 See also #1058
Pitt, Pam
 See also #1071
Pitts, Mary
 See also #1006
Plachy, Sylvia
 See also # 1058, 1072
Plesur, Karen
 See also #1006
Poitier, Jacqueline
 See also #1072
Polin, Nancy
 See also #1072
Portner, Dinah Berland
 See also #1006
Posner, Skyler
 See also #1006
Prager, Marcia

See also #1070

Prall, Virginia
See also #1022

Purcell, Rosamond W., 1942-
See also #1008, 1058

Rachel, Vaughan
See also #1071

Ragan, Vicki
See also #1006

Ragland-Njau, Phillda

861. Ragland, Phillda. "Have Camera Will Travel; Phillda Ragland Photographing Social and Economic Projects," *Ebony* 24, 5 (March 1969): 112-120.

Rakoff, Penny
See also #1072

Ramsess, Aliki-Casundra
See also #1040

Rankaitis, Susan
See also #1008

Ravid, Joyce
See also #1070, 1072

Ray, Ruby
See also #1071

Raymond, Lilo
See also #1008, 1069

862. "Lilo Raymond: Portfolio," *Infinity* 13, 11 (November 1964): 14-19.

863. Raymond, Lilo. *Revealing Light: Photographs*. Introduction by Mark Strand. Boston: Bulfinch Press, 1989. 87 p. Chiefly illustrations.
Short introductory essay describing some of Raymond's photographs.
Gardenias, Florida, 1984, after title page; *Glass, Wellfleet*, 1971, opposite title page; *Pitcher, New York*, 1980, p. 3; *Grasses*, 1976, p. 4; *Cup on Mantel*, 1974, p. 5; *Bowl*, 1982, p. 7; *Ice Window*, 1986, p. 8; *Rain, Fourteenth Street*, 1966, p. 9; *Bed, Stratford*, 1972, p. 11; *Lily of the Valley*, 1982, p. 12; *Apples*, 1983, p. 13; *Paper Bags*, 1982, p. 15; *Peony*, 1984, p. 16; *Door and Flats*, 1988, p. 17; *Unmade Bed, Roxbury*, 1972, p. 19; *Paper Cup*, 1986, p. 20; *Pitcher and Soap Dish*, 1972, p. 21; *Shades, Maine*, 1978, p. 22; *Pitcher and Bowl*, 1982, p. 23; *Broken Panes*, 1964, p. 25; *Window, Fontvielle*, 1986, p. 26; *Coat*, 1981, p. 27; *Garlic on Table*, 1983, p. 29; *Onion Flower*, 1974, p. 31; *Bed, Amagansett*, 1977, p. 33; *Window, Sun, Roslyn*, 1963, p. 34; *Window, Roslyn*, 1963, p. 35; *Julie's Curtain*, 1976, p. 37; *Window and Road*, 1972, p. 38; *Window, Pine*, 1972, p. 39; *Three Bottles*,

1965, p. 40; *Window, Ice, Fourteenth Street,* 1963, p. 41; *Hydrangeas,* 1965, p. 43; *Windows, Wellfleet,* 1971, p. 44; *Door, Noank,* 1972, p. 45; *Shaker, Sock Frame,* 1980, p. 46; *Shaker Hat,* 1980, p. 47; *Laundry, Florida,* 1964, p. 48, 49; *Spoon,* 1987, p. 50; *Enamel Pitcher,* 1988, p. 51; *Tulip,* 1982, p. 53; *Curtain and Vase,* 1977, p. 54; *Dress,* 1978, p. 55; *Pears, Amagansett,* 1977, p. 57; *Door, Crete,* 1973, p. 58; *Lemons,* 1976, p. 59; *Nightgown,* 1987, p. 60; *Dotted Shirt,* 1987, p. 61; *Pears In Bowl,* 1964, p. 63; *Chairs, Long Island,* 1963, p. 64; *Rome,* 1970, p. 65; *Fountain, Rome,* 1970, p. 66; *Tree, France,* 1970, p. 67; *Ilo Ilo Market,* 1975, p. 68; *Vegetables, Paper Bags,* 1976, p. 69; *Oyster Shells,* 1971, p. 71; *Cucumbers,* 1980, p. 72; *Fish, Bangkok,* 1975, p. 73; *Window, Daisies,* 1982, p. 75; *Queen Anne's Lace,* 1972, p. 77; *Eggs, Roxbury,* 1976, p. 79; *Clock, Broadway,* 1964, p. 81; *Daisies, Maine,* 1980, p. 82; *Table, Wellfleet,* 1969, p. 83; *Fence,* 1976, p. 84; *Salt Marsh,* 1972, p. 85; *Flowers and Curtain,* 1988, p. 87.

Reece, Jane, c. 1869-1961
 See also #1058, 1061

864. Brannick, John A. "Jane Reece and Her Autochromes," *History of Photography* 13, 1 (January/March 1989): 1-4.

865. Chambers, Karen S. "Jane Reece's Portraits of Artists," *Exposure* 17, 3 (Fall 1979): 13-21.

866. Vasseur, Dominique H. *The Soul Unbound: The Photographs of Jane Reece.* Dayton, OH: Dayton Art Institute, 1997. 185 p.

Reeves, Caroline
 See also #1072
Reichek, Elaine
 See also #1015
Reilley, Shawna
 See also #1006

Resnick, Marcia.
 See also #1008, 1061

867. "Marcia Resnick: Pop-up People," In: *Photography Year/1974 Edition.* New York: Time-Life Books, 1974: 134-140.

868. Resnick, Marcia. "The Layered Eye: Painted Photographs by Marcia Resnick," *Camera 35* 18, 5 (July 1974): 46-51.

869. Resnick, Marcia. *Re-Visions.* Toronto: The Coach House Press, 1978. Unpaged.
She learned about morality at an early age...; She always drew the same picture...;

She played with her slinky toys...; She would chew gum...; In class, one day, she was bitten by a mosquito...; She was forced to spend long hours watching walls...; She was horrified to learn...; When she played the beautiful flower...; Inspired by a visit to the United Nations...; She derived great pleasure from dressing her boy dolls...; She was repeatedly told to stop looking at her feet...; She was mortally afraid of clowns...; She would sneak licks of icing...; She had a poor sense of direction...; She couldn't grasp the logic...; "Fingers are like forks"...; She became an expert shoplifter...; She enjoyed making loud noises...; She painted racing stripes...; While playing with her toys...; She was often gripped with the desire...; On hot summer nights...; She would also gaze out the front window...; She couldn't sleep...; By placing false teen under her pillow...; At late hours...; She would rendezvous in her bed...; She would often pass the shopping bag woman...; She first learned the facts of life...; Thereafter, she would break out in peculiar rashes...; She secretly lusted...; In her drama club...; She would accompany her father...; Not wanting to be publicly kissed...; When her mother first noted...; She developed slowly...; She scotch-taped her nose up...; In order to be fashionably thin...; She was told that her eyes...; For fear of being a wallflower...; She inevitably ran her nylons...; Loves me, love me not...; She would demurely sip...; She imagined herself a starlet...; They were continually telling her...; Looking at her books upside down...; She always read the endings....

870. Sweetman, Alex. "Marcia Resnick: An Interview," *Exposure* 16, 2 (Summer 1978): 7-16.

Rexroth, Nancy
 See also #1008
Richards, Wynn, 1888-1960
 See also #1058

Rickard, Jolene
 See also #1029, 1055

870.1 Hufnagel, Amy. *Jolene Rickard, Cracked Shell*. Syracuse, NY: R. B. Menschel Photography Gallery, 1994.

Roberson, Pam
 See also #1039

Roberts, Ines E.

871. Fredericks, Victoria. "Urban Landscapes," *Popular Photography* 86, 5 (May 1980): 104-107+.

Roberts, Martha McMillan
 See also #1013

Roberts, Selina
 See also #1072
Roberts, Wilhelmina
 See also #1040

Robeson, Eslanda Cardoza Goode, 1896-1965.
 See also #1040

872. Childress, Alice. "Remembrances of Eslanda," *Freedomways* 6, 4 (Fall
 1966): 329-330.

Robinson, Abby
 See also #1070
Rosen, Trudy
 See also #1070
Rosenblatt, Carol Simon
 See also #1055
Rosenblum, Nancy
 See also #1071
Rosener, Ann
 See also #1013
Rosett, Jane
 See also #1062
Rosler, Martha
 See also #1055

Ross, Judith Joy, 1946-
 See also #1008, 1063

873. Ross, Judith Joy. *Judith Joy Ross.* Essay by Susan Kismaric. New York:
 The Museum of Modern Art, 1995. 80 p. Bibliography: p. 77-79. List of
 Exhibitions: p. 76-77.
 Introductory essay offers a critique and an understanding of the work and
 subjects Ross has chosen, in context to her own history.
Untitled, from *Eurana park, Weatherly, Pennsylvania, 1982,* p. 17-24; *Untitled,*
from *Portraits at the Vietnam Veterans Memorial, Washington, D.C., 1983-84,* p.
27-36; *Senator Strom Thurmond, Republican, South Carolina, 1987,* p. 39;
Congressman William L. Dickinson, Republican, Alabama, 1987, p. 40; *Susan
Stoudt Elving, Administrative Assistant to Congressman Norman E. Mineta,
Democrat, California, 1986,* p. 41; *Congressman John P. Hiler, Republican,
Indiana, 1987,* p. 42; *Scott Fillipse, Aide to Congressman James F. Sensenbrenner,
Jr., Republican, Pennsylvania, 1987,* p. 43; *Congresswoman Pat Schroeder,
Democrat, Colorado, 1987,* p. 44; *Senator Robert C. Byrd, Democrat, West
Virginia (Majority Leader), 1987,* p. 45; *Untitled,* from *Easton Portraits, 1988,* p.
48-51; *Blond Woman at Asbury Park, 1990,* p. 52; *Mike* from *Jobs, 1990,* p. 53;

Staff Sergeant Richard T. Koch, U.S. Army Reserve, on Red Alert, Gulf War, 1990, p. 54; *P.F.C. Maria I. Leon, U.S. Army Reserve, on Red Alert, Gulf War,* 1990, p. 55; *Michael Bodner, A. D. Thomas Elementary School, Hazleton, Pennsylvania,* 1993, p. 57; *Jackie Cieniawa, A. D. Thomas Elementary School, Hazleton, Pennsylvania,* 1993, p. 58; *Randy Sartori, A. D. Thomas Elementary School, Hazleton, Pennsylvania,* 1993, p. 59; *The Stewart Sisters, H.F. Grebey Junior High School, Hazleton, Pennsylvania, 1992, p.* 60; *Brian Ellis Presenting a Lecture on the Mafia to Seventh Grade Class, H.F. Grebey Junior High School, Hazleton, Pennsylvania,* 1992, p. 61; *Robert Gaudio, English Teacher, Hazleton High School, Hazleton, Pennsylvania,* 1992, p. 62; *Casey Leto, Hazleton Area High School, Hazleton, Pennsylvania,* 1994, p. 63; *Brandon Brown, First Grade, Almira Elementary School, Cleveland, Ohio,* 1993, p. 65; *Cynthia Redding and James Gloeckner, Second Grade, Almira Elementary School, Cleveland, Ohio,* 1993, p. 66; *Carmen Williams, Second Grade, Almira Elementary School, Cleveland, Ohio,* 1993, p. 67; *Kelly Griffin, Kimberly Proffitt, Tyra Lardell, Second Grade, Mrs. Gray's Class, Almira Elementary School, Cleveland, Ohio,* 1993, p. 68; *Cornelius McLean, Samuel Miranda, Matthew Jung, Second Grade, Mrs. Gray's Class, Almira Elementary School, Cleveland, Ohio,* 1993, p. 69; *Toiya Phillips, Almira Elementary School, Cleveland, Ohio,* 1993, p. 70; *Le Shaun Franklin, Gallagher Junior High School, Cleveland, Ohio,* 1993, p. 71; *Nina Miller, Gallagher Junior High School, Cleveland, Ohio,* 1993, p. 72; *Dionte D. Dennis, Gallagher Junior High School, Cleveland, Ohio,* 1993, p. 73; *Robert Williams, Gallagher Junior High School, Cleveland, Ohio,* 1993, p. 74.

Rosskam, Louise
　　　See also #1013
Roth, Sura
　　　See also #1071

Roundtree, Deborah M., 1953-

874.　　"Upcoming Photographer," *Art Direction* 42 (October 1990): 76+.

Ruben, Ernestine
　　　See also #1008

Rubenstein, Meridel, 1948-
　　　See also #1008, 1053, 1055, 1058

875.　　Bloom, John. "Interview With Meridel Rubenstein," *Photo Metro* 6, 62 (September 1988): 4-11.

876.　　Laurent, Amy. "Surveying Land and Culture. (Museum of New Mexico, Santa Fe, New Mexico; Exhibit)," *Artweek* 16 (August 10, 1985): 13-14.

877. "Photographs by Meridel Rubenstein," *Untitled* 14 (1978): 38-42.

878. Rubenstein, Meribel. *La Gente de la Luz.* Santa Fe: New Mexico Museum of Fine Arts, 1977.

879. Solnit, Rebecca. "Dying and Reviving Myths," *Artweek* 18 (November 14, 1987): 15-16.

880. Solnit, Rebecca. "Images of Power and Grace. (Fuller Gross Gallery, San Francisco; Exhibit)," *Artweek* 19 (October 1, 1988): 11.

881. Solnit, Rebecca. "Unsettling the West: Contemporary American Landscape Photography," *Creative Camera* 319 (December/January 1992-1993): 12-23.

882. Tamblyn, Christine. (Fuller Gross Gallery, San Francisco; Exhibit) *Arts News* 87 (December 1988): 170+.

Rubini, Gail
See also #1072

Rubinstein, Eva, 1933-
See also #1008, 1069, 1070

883. "Eva Rubinstein," *Camera* (Switzerland) 52, 1(January 1973): 24-32.

884. Hughes, Jim. "Eva Rubinstein: A Woman Who Makes Timeless Images Finds Herself in the Throes of Success," *Popular Photography* 77, 3 (September 1975): 76-85+.

885. Rubinstein, Eva. "Notes From Two Irelands," *Camera 35* 16, 9 (November 1972): 36-46.

886. Wieder, Laurence. "Transparent States: Photographs by Eva Rubinstein," *Camera Arts* 2, 2 (March/April 1982): 42-49.

Rueb, Debra
See also #1071
Russell, Gail
See also #1072
Ruth, Sura
See also #1072

Rynne, M. K., 1955-

887. Horwitz, Simi. "Exotic Nights: A Young Woman Photographs the Modern World of Strippers," *American Photo* 3 (May/June 1992): 38-39+.

Sage, Linn
 See also #1072
Samaras, Connie
 See also #1062
Sargent, Nickola M.
 See also #1070
Sartor, Margaret
 See also #1052

Savage, Naomi, 1927-
 See also #1008, 1058, 1061, 1072

888. "Naomi Savage," *Album* 10 (October 1970): 2-10.

889. Scully, Julia. "The Ever-Changing Faces of Naomi Savage," *Modern Photography* 34, 1 (January 1970): 80-85.

890. "Visual Answers to Verbal Questions," *Untitled* 7/8 (1974): 68-74+.

Sax, Stephanie
 See also #1071
Schmidt, Esther
 See also #1039
Schoenfeld, Diana
 See also #1007
Schreibman, Jane
 See also #1006
Schultz, Mary Ellen
 See also #1039

Schumacher, Ann

891. Alvic, Philis. "Ann Schumacher: Reflections of Our Time. (Doris Ulmann Gallery, Berea College, Berea, Kentucky; Exhibit)," *Art Papers* 19 (September/October 1995): 60-61.

Schuman, Hilda
 See also #1055
Schwartz, Linda
 See also #1006, 1071
Schwartz, Robin
 See also #1070

Sears, Sarah C.
 See also #1058
Seed, Suzanne
 See also #1070, 1072
Seid, Eva
 See also #1070
Sewall, Emma D.
 See also #1058
Sewall, Mary Wright
 See also #1009
Sharpe, Geraldine
 See also #1053
Shattil, Wendy
 See also #1039
Shaw, Susan
 See also #1011
Shepherd, Beth
 See also #1070
Sheridan, Sonia Landy, 1925-
 See also #1061

Sherman, Cindy, 1954-
 See also #1000, 1008, 1026, 1028, 1036, 1055, 1058, 1063

892. Bonney, Claire. "The Nude Photograph: Some Female Perspectives," *Woman's Art Journal* 6 (Fall/Winter 1985-1986): 9-14.

893. Brittain, David. "True Confessions," *Creative Camera* 308 (February/March 1991): 34-38.

894. Frascella, Larry. "Cindy Sherman's Tales of Terror," *Aperture* 103 (Summer 1986): 48-54+.

895. Heartney, Eleanor. "Two or Three Things I Know About Her," *Afterimage* 15, 3 (October 1987): 18.

896. Livingston, Kathryn. "The Girl of Our Dreams: Tracing Cindy Sherman's March Toward Depravity," *American Photographer* 19, 5 (November 1987): 34-36.

897. Melville, Stephen W. "The Time of Exposure: Allegorical Self-Portraiture in Cindy Sherman," *Arts Magazine* 60 (January 1986): 17-21.

898. Nilson, Lisbet. "Q. & A.: Cindy Sherman," *American Photographer* 11, 3 (September 1983): 70-77.

899. Russo, Antonella. "Picture This. (Pleasure and terror in the work of Cindy Sherman)," *Art Monthly* 181 (November 1994): 8-11.

900. Smith, Caroline. "Why Is Cindy Sherman a Key Figure for Women Photographers? (*Women's Art Magazine* takes a straw poll from fourteen photographers)," *Women's Art Magazine* 59 (1994): 40.

Sherwood, Maggie
See also #1069

Shoats, Soledad Carrillo
See also #1006

Shook, Melissa, 1939-

901. Shook, Melissa. "Krissy's Xmas Present," *Camera Arts* 1, 1 (January/February 1981): 22-25+.

Shostak, Marjorie
See also #1072
Sieff, Jeanloup
See also #1005
Simmons, Laurie
See also #1063
Simon, Stella
See also #1058

Simpson, Coreen, 1942-
See also #1032, 1040, 1055, 1058

902. Birt, R. "Coreen Simpson - An Interpretation," *Black Literature Forum* 21, 3 (1987): 289-304.

Simpson, Lorna 1961-
See also #1031, 1032, 1055

903. Wilkes, Andrew. "Lorna Simpson," *Aperture* 133 (Fall 1993): 14-23.

904. Willis-Thomas, Deborah. *Lorna Simpson.* San Francisco: Friends of Photography, 1992. 72 p. Bibliography: p. 68-70.
Text includes a conversation between Willis-Thomas and Simpson, and a critical essay on Simpson's work.
Sounds Like, 1988, cover; *Back,* 1991, back cover; *1978-1988,* pl. 1; *Gestures/Reenactments,* pl. 2; *Screen 1,* pl. 3; *Waterbearer,* pl. 4; *Twenty Questions (A Sampler),* pl. 5; *Plaques,* pl. 6; *You're Fine,* pl. 7; *Stereo Styles,* pl. 8; *Five Day*

Forecast, pl. 9; *Three Seated Figures*, pl. 10; *Guarded Conditions*, pl. 11; *Easy For Who to Say*, pl. 12; *Dividing Lines*, pl. 13; *Necklines*, pl. 14; *Untitled(Prefer, Refuse, Decide)*, pl. 15; *Outline*, pl. 16; *ID*, pl. 17; *Time Piece*, pl. 18; *Double Negative*, pl. 19; *Square Deal*, pl. 20; *Flipside*, pl. 21; *The Service*, pl. 22; *Counting*, pl. 23; *Queensize*, pl. 24; *Figure*, pl. 25; *Same*, pl. 26; *Back*, pl. 27; *She*, pl. 28; *Suit*, pl. 29; *Practical Joke*, pl. 30; *Magdalena*, pl. 31; *Bio*, pl. 32; *Shoe Lover*, pl. 33.

Simqu, M. K.
 See also #1070

Sipprell, Clara Estelle, 1885-1975
 See also #1053, 1058

905. Gaston, Diana. "Picturing Domestic Space: Clara E. Sipprell and the American Arts and Crafts Movement," *Image* (Rochester, NY) 38 (Fall/Winter 1995): 16-29.

906. Khrabroff, Irina. "The Art of Clara Sipprell: Her Scenic Photographs Are Silent Poems," *The Mentor* (August 1926): 23-29.

907. Sipprell, Clara E. *Moment of Light: Photographs of Clara E. Sipprell*. Introduction by Elizabeth Gray Vining. New York: The John Day Company, 1966. Unpaged.
 Accompanying the photographs is a short biographical essay which relates the events in Sipprell's life to her photographic career.
Charles W. Eliot, President of Harvard University, 1910-1920s; *Arthur M. Dow*, 1910-1920s; *The Lesson*, 1910-1920s; *Count Ilya Tolstoy*, Son of Leo, 1910-1920s; *Charles Coburn*, Actor in <u>*The Better'ole*</u>, 1910-1920s; *Max Weber and friends*, 1910-1920s; *Felix Adler*, Founder of the Ethical Culture Movement, 1910-1920s; *The Abyssinian Jew*, 1910-1920s; *Mrs. Thurston*, 1910-1920s; *Late in the Afternoon*, Vermont Neighbors, 1910-1920s; *Mr. Speed of Union Village*, 1910-1920s, *John Cotton Dana*, Librarian, 1910-1920s; *Maxfield Parrish*, Artist, 1910-1920s; *The Blacksmith*, 1910-1920s; *Michel Fokine*, Choreographer, 1910-1920s; *Madame Brezhkovsky*, 1910-1920s; *The Last of the Guslars*, Yugoslavia, 1910s-1920s; *Mestrovic*, Yugoslavia's great sculptor, 1910s-1920s; *V. V. Luzhsky*, Actor--Moscow Art Theater, 1910s-1920s; *The Property Man in Yellow Jacket*, 1910s-1920s; *Vassily Kachalov*, Actor--Moscow Art Theater, 1910s-1920s; *Constantin Stanislavsky*, Moscow Art Theater--Founder, 1910s-1920s; *Madame Knipper-Chekova*, Wife of Chekhov, 1910s-1920s; *Bulgakov*, Actor, 1910s-1920s; *Chaliapin*, Russian opera singer, 1910s-1920s; *Ivan Moskvin* as Luka in "The Lower Depths," 1910s-1920s; *Alfred Stieglitz*, Photographer, 1910s-1920s; *Young Man in Serbian National Costume*, 1910s-1920s; *Sergei Koussevitzky*, Russian American conductor, 1910s-1920s; *Sergei Rachmaninoff*, Pianist, 1910s-1920s; *Quaker Ladies*, 1910s-1920s; *Mrs. Truscott*, Thetford, Vermont, 1910s-1920s;

Lorado Taft, Sculptor, 1910s-1920s; *Tania*, 1910s-1920s; *Malvina Hoffman*, Sculptor, 1910s-1920s; *Plevitskaya*, Russian Folk Singer, 1910s-1920s; *William Lathrop*, Painter, 1930's -1940s; *Child with Doll*, 1930's -1940s; *Snooks*, Georgia, 1930's -1940s; *Paul Ouzounoff*, 1930's -1940s; *Sadja Stokowski*, 1930's -1940s; *Edwin Markham*, Poet, 1930's -1940s; *Albert Einstein*, 1930's -1940s; *Father Bulgakov*, Head of the Russian Orthodox Church in Paris, 1930's -1940s; *Sergei Konenkov*, Russian sculptor, 1930's -1940s; *John Finley*, Editor of the New York Times, 1930's -1940s; *Oliver Wendell Holmes*, 1930's -1940s; *General Nicholas Khrabroff*, 1930's -1940s; *Emil Ludwig*, Writer, 1930's -1940s; *Hilda Yen*, Chinese lecturer, 1930's -1940s; *Carl Eldh*, Swedish sculptor, 1930's -1940s; *Sally Cleghorn*, Poet, 1930's -1940s; *Ragnar Ostberg*, Swedish architect, 1930's -1940s; *H.R..H. Prince Eugene of Sweden*, 1930's -1940s; *H.R..H. Crown Princess Louise*, later Queen of Sweden, 1930's -1940s; *H.R..H. Prince Carl of Sweden*, Head of International Red Cross, 1930's -1940s; *H.R..H. King Gustavus V*, on his 80th birthday, 1930's -1940s; *Carl Milles*, Swedish sculptor, 1930's -1940s; *Governor Professor Hjalmar Hammarskjöld*, 1930's -1940s; *Dorothy Canfield Fisher*, Writer, 1930's -1940s; *Miss Kendall*, Wellesley College Professor, 1930's -1940s; *Royal Cortissoz*, Noted art critic, 1930's -1940s; *Roland Palmedo, age 14*, 1930's -1940s; *Liverpool Hazard*, Slave from Butler Plantation, 1930's -1940s; *Nat Canfield*, Vermonter, 1930's -1940s; *Count Folke Bernadotte*, 1930's -1940s; *Little Georgia Girl*, 1930's -1940s; *Amy Loveman*, editor of *The Saturday Review*, 1930's -1940s; *Roy Harris*, composer, 1930's -1940s; *Prayer for Rain*, 1930's -1940s; *Ruth St. Denis*, Dancer, 1930's -1940s; *Santha Rama Rau*, Writer, 1930's -1940s; *Elisabeth Achelis*, 1930's -1940s; *Robinson Jeffers*, Poet, 1930's -1940s; *Isabella de Palencia*, Spanish patriot, 1930's -1940s; *Sergei Konenkov in his studio in New York*, 1930's -1940s; *Korean Dancer*, 1930's -1940s; *Emma Mills*, 1930's -1940s; *Charles Edward Ives*, Composer, 1930's -1940s; *Albert Schweitzer*, 1930's -1940s; *Eleanor Roosevelt*, 1930's -1940s; *John Sloan*, 1930's -1940s; *Ella Young*, Irish folklorist, 1930's -1940s; *Toni, Hopi Indian*, Taos, N.M., 1930's -1940s; *Swami Nikhilananda*, 1950s -1960s; *Robert Frost*, 1950s -1960s; *Langston Hughes*, Poet, 1950s -1960s; *Elizabeth Coatsworth*, Writer, 1950s -1960s; *Irwin Edman*, 1950s -1960s; *Jane as a Bride*, 1950s -1960s; *Walter Hard*, Vermont poet, 1950s -1960s; *Frances Perkins*, Secretary of Labor, 1950s -1960s; *Elizabeth Gray Vining*, Author, 1950s -1960s; *Grandma Moses*, 1950s -1960s; *Phyllis Fenner*, Writer, anthologist, librarian, 1950s -1960s; *Maxfield Parrish at 85*, 1950s -1960s; *Dr. Daisetz Suzuki*, 1950s -1960s; *Mother and Children*, 1950s -1960s; *Jeanne Andonian*, French novelist, 1950s -1960s; *Ralph Bunche*, United Nations, 1950s -1960s; *Dag Hammarskjöld*, 1950s -1960s; *Kabuki Koto Player*, 1950s -1960s; *Carroll Glenn*, Violinist, 1950s -1960s; *Dr. Boris Bogoslovsky*, translator at Nuremberg Trails, 1950s -1960s; *Mrs. Rudolf Bultmann*, German singer, 1950s -1960s; *Sir Savepali Radhakrishnan*, President of India, 1950s -1960s; *Alida's Hand*, 1950s -1960s; *Clarence Pickett*, Quaker leader, 1950s -1960s; *Rudolph Bultmann*, German theologian, 1950s -1960s; *Granville Hicks*, literary critic, 1950s -1960s; *Rudolf Serkin*, Pianist, 1950s -1960s; *Pearl Buck*, Writer, 1950s -1960s; *Armstrong Sperry*, artist and author, 1950s -1960s; *Welthy Honsinger Fisher*, 1950s -1960s; *Howard*

Thurman, then Dean of Marsh Chapel, Boston University, 1950s -1960s; *Mrs. Wyman*, Our Vermont neighbor, 1950s -1960s; *Edward E. Miller*, Inventor, 1950s -1960s; *Jay Connaway*, Painter, 1950s -1960s; *Roland Hayes*, Singer, 1950s - 1960s; Janet, 1950s -1960s; *Nina at 12 hours old and father*, 1927; *Nina at seven months and mother*, 1928; *Nina at one year and mother*, 1928; *Nina at two*, 1929; *Nina and her grandfather*, 1929; *Nina and her shadow*, 1930; *Three years old*, 1930; *Nina reading on porch*, 1934; *Nina at ten years old*, 1937; *Nina at twelve years old*, 1939; *Nina and her first baby*, 1952; *Nina and Peter*, 1952; *Peter*, 1953; *One of my earliest still life arrangements*; *Thetford Hill, Vermont*; *Along the Apache Trail, Arizona*; *House in winter*, Thetford, Vermont; *Where the Sava and the Danube meet, Belgrade*; *Ancient bridge at Salona, Yugoslavia*; *Pineas, Dalmatian Coast, Yugoslavia*; *The White Birch*; *New York Harbor*; *Rufus Jones' Bibles*.

908. Sipprell, Clara E. "With a Camera in French Canada," *Country Life* (July 1929): 39-42.

Skoff, Gail, 1949-
 See also #1007, 1008, 1053

909. Murray, Joan, "Beauty In the Badlands. (Robert Koch Gallery, San Francisco; Exhibit)," *Artweek* 18 (March 21, 1987): 10.

Skoglund, Sandy, 1946-
 See also #1008, 1012, 1058, 1063

Sligh, Clarissa
 See also #1031, 1055, 1058

910. Willis, Deborah. "Clarissa Sligh," *Aperture* 138 (Winter 1995): 4-11.

Slobodin, Linda
 See also #1071
Smith, Ethel M., 1886-1964
 See also #1058
Smith, Mrs. R. A.
 See also #1000
Smith, Shelly J.
 See also #1000
Snyder, Suellen
 See also #1072

Solomon, Rosalind, 1930-
 See also #1024, 1050, 1058, 1063

911. Atkins, Robert. "In Grief and Anger: Photographing People with AIDS," *Aperture* 114 (Spring 1989): 70-72.

912. Hagen, Charles. (Museum of Modern Art, New York; Exhibit) *Artforum* 25 (October 1986): 133.

913. Kolodny, Rochelle. "Photographs As Artifacts: The Work of Rosalind Solomon," *Photo Communique* 7, 4 (Winter 1985/86): 10-17.

914. Sturman, John. (Lieberman & Saul Gallery, New York; Exhibit) *Art News* 86 (March 1987): 159.

Sonnenman, Eve, 1950-
 See also #1008, 1058
Spence, Jo
 See also #1062
Spencer, Ema
 See also #1000
Spurgeon, Lucia A.
 See also #1072
Stanton, Lorna
 See also #1039
Starr, Nina Howell
 See also #1006, 1070, 1072
Steber, Maggie, 1949-
 See also #1058
Stenmark, Ruthann
 See also #1071
Stevens, Jane
 See also #1071

Stevens, Myrta Wright, c. 1860-1944
 See also #1038

915. "The Artistic Vision of Myrta Wright Stevens," prepared by the editors. *Montana, the Magazine of Western History.* 25, 3 (Summer 1975): 36-47.

Stewart, Sharon
 See also #1055
Stirek, Catherine A.
 See also #1071
Stone, Erika
 See also #1069
Stratton, Margaret
 See also #1055

Streetman, Evon
 See also #1053
Sturmer, Caren
 See also #1000
Sullivan, Connie
 See also #1019
Summers, Rita
 See also #1039
Sunday, Elisabeth, 1958-
 See also #1058
Suris, Sherry
 See also #1070
Sutton, Eva
 See also #1000
Swoope, Martha
 See also #1070
Szabo, Marilyn
 See also #1006

Szasz, Suzanne, -1997
 See also #1009, 1070

916. Appell, Clara and Morey. *We Are Six; the Story of a Family.* Photographs by Suzanne Szasz. New York: Golden Press, 1959. Unpaged
Children's book on the growth of a family, with the arrival of a new baby.

917. Schwalberg, Bob. "Portfolio: Suzanne Szasz," *Popular Photography* 91, 1 (January 1984): 14-20.

918. Shorr, Ray. "Suzanne Szasz,' *The Picture Universe. U.S. Camera 1961.* New York: U. S. Publishing Co., 1960.

919. "Suzanne Szasz Shows How to Take Natural Pictures of Children," *Popular Photography* 42, 4 (April 1958): 59-63+.

920. Szasz, Suzanne. "Children's Pictures for a Cause" *Popular Photography* 52, 3 (March 1963): 72-75+.

921. Szasz, Suzanne. "The Invisible Photographer," *U.S. Camera* 15, 1 (January 1952): 38-40.

922. Szasz, Suzanne. *Guide to Photographing Children.* New York: Chilton Co. 1959. 128 p.
A how-to manual on photographing children with numerous examples by Szasz.

923. Szasz, Suzanne. "Shoot a Sequence," *Popular Photography* 28, 6 (June 1951): 76-79.

924. Szasz, Suzanne. "Take Your Camera to Camp," *Modern Photography* 15, 7 (July 1951):58-61+.

925. Szasz, Suzanne. "Two Are Better Than One," *Popular Photography* 24, 2 (February 1949): 44-45+.

926. Szasz, Suzanne. "Want to Be a Freelance?" *Popular Photography* 30, 5 (May 1952): 46-51+.

927. Weber, Mrs. Helen. "Youngsters in Action: Two Days with Suzanne Szasz," *The Professional Photographer* 82 (November 1955): 30-35+.

928. Wolf, Anna W. M. and Suzanne Szasz. *Helping Your Child's Emotional Growth*. New York: Doubleday & Co., 1955. 305 p.
This work is a guide for parents to help child rearing by combing text and photographs which illustrate various stages of emotional and physical development of children. The photographs are candid portraits of childhood.

Tani, Diane
 See also #1055
Tarsches, Abigayle
 See also #1071

Taylor, Mary Lyon, 1872-1956.

929. "Photographic Studies of Home Life: How One Woman Has Developed a Pastime into Work That Possesses Great Individuality and Charm," *The Craftsman* 13, 2 (November 1907): 150-157.

Teal, Elnora
 See also #1040
Tenneson, Joyce Cohen
 See also #1006,1008, 1058
Tharp, Brenda
 See also #1039
Thomas, Morgan
 See also #1071
Thorne, Harriet V.S., 1843-1926
 See also #1058
Thorne-Thomsen, Ruth, 1943-
 See also #1058, 1063

930. Edwards, Owen. "Tripping the Light Fantastic," *American Photographer* 12, 3 (March 1984): 22-23.

931. Stevens, Nancy. "Gallery: Ruth Thorne-Thomsen," *American Photographer* 2, 6 (June 1979): 64.

Tiberio, Annie
 See also #1039

Tiernan, Audrey C., c. 1955-

932. Rosen, Fred. "Operation, Rescue / Concerned Photography Shows a New Dimension," *American Photographer* 22, 2 (February 1989): 76-78.

Tinkelman, Susan
 See also #1072
Toops, Connie
 See also #1039

Tracy, Edith Hastings, 1874-
 See also #1058

933. Tracy, Edith Hastings. *The Panama Canal During Construction from the Photographs of Edith H. Tracy, 1913...*. New York: Redfield Brother, c. 1914. 64 p. Chiefly illustrations.

Traux, Karen
 See also #1061

Tress, Dawn Mitchell
 See also #1070

Tsinhnahjinnie, Hulleah J., 1954-
 See also #1029, 1055

934. Fitzsimmons, Casey. "Cultural Confrontation. (Art and society face to face: Wiegand Gallery. College of Notre Dame, Belmont, California, Exhibit)," *Artweek* 22 (November 21, 1991): 12.

935. Jenkins, Stevens. "A Conversation with Hulleah J. Tsinhnahjinnie," *Artweek* 24 (May 6, 1993): 4-5.

936. *Mixing It Up 5*. Boulder, CO: University of Colorado, Academic Media Services, 1992. Videorecording. (Part of a series of interviews)

937. Rapko, John. "Sovereignties. (San Francisco Art Institute; Installation),"
 Artweek 24 (May 6, 1993): 4.

938. *Stand.* Produced by the Office of Television and Media Services,
 Edinboro University. Edinboro, PA: The Office, 1993. Videorecording,
 20 minutes.

Tucker, Carlyn
 See also #1071

Tucker, Jane
 See also #1006

Tucker, Toba Pato

939. Engel, Nancy Timmes. "Native American Faces: Toba Tucker's
 Expressive Portraits of Zuñi and Navajo Indians Reflect the Essence of an
 Ancient Vanishing Culture," *Popular Photography* 89, 6 (June 1982): 88-
 95+.

940. Grundberg, Andy. "New Talent Series: Toba Tucker," *Modern
 Photography* 44, 4 (April 1980): 124-125.

941. Lyons, Oren R. "Hodinonshonni: Portraits of the Firekeepers," *Native
 Peoples* 8 (Fall 1994): 60-64.

942. "Survivors: Photographs by Toba Tucker," *Camera Arts* 1, 3 (May/June
 1981): 48-53.

Tuell, Julia E.

943. Aadland, Dan. *Women and Warriors of the Plains: The Pioneer
 Photography of Julia E. Tuell.* New York: Macmillan, 1996. 182 p.
 Bibliography: p. 177-182.

Tuite, Kathy
 See also #1072
Turbeville, Deborah, 1937-
 See also #1008, 1058
Turk, Elizabeth
 See also #1072

Turner, Judith
 See also #1058, 1070

Turyn, Anne

944. Turyn, Anne. *Missives: Photographs.* Essay by Andy Grundberg. New York: Alfred van der Marck Editions, 1986. Unpaged. Chiefly illustrations.

Critical essay by Grundberg discusses Turyn as a storyteller, and each photograph bears text and captions, along with the image.

From *Dear Pen Pal*, 1979-1980: *We don't just grow food. We manufacture it*, pl. 1; *Here in America, we are a nation of consumers*, pl. 2; *Here in America some friends are silvers and some are gold*, pl. 3; *We Americans are rude to people we know intimately*, pl. 4; *One can always have a friend*, pl. 5; *We love to talk*, pl. 6; *Here in America we say 'our brains are like computer,'* pl. 7; *Here in American we love machines*, pl. 8; *We Americans go to the moon*, pl. 9; *There are 2 kinds of people in America*, pl. 10; *We Americans love variety*, pl. 11; *We in America are dying to know everything*, pl. 12; *After the revolution everyone will have four cylinder cars*, pl. 13; *We Americans are a very religious people*, pl. 14; *I've been thinking*, pl. 15; *Life is a spectator sport, here in America*, pl. 16; *We in America know that time passes*, p. 17; From *Dear John*, 1981: *Dear John*, pl. 18; *I hope you'll understand and forgive me, Johnny*, pl. 19; *Here's to the pounding of hearts*, pl. 20; *You're like a record I listened to over and over*, pl. 21; *The only thing left between us is scar tissue*, pl. 22; *Our love is like white bread*, pl. 23; *Thank God and Greyhound you're gone*, pl. 24; *Your favorite emotion makes me sick*, pl. 25; *I can see now*, pl. 26; *I'll be putting the oil in another pan from now on*, pl. 27; *I'm cutting sweets out of my life*, pl. 28; *Living (Loving) is skipping rope*, pl. 29; *Our volleys are tiresome*, pl. 30; *Next time you deal*, pl. 31; *You are one big creep*, pl. 32; *I really feel that we both made some wrong moves*, pl. 33; *Either figure out a new color scheme*, pl. 34; *Mind you*, pl. 35; *Of late, living my life is like trekking through the jungle*, pl. 36; *This is where I came in*, pl. 37; *John*, pl. 38; From *Lessons & Notes*, 1982: *And when you think to whom are you talking?* pl. 39; *This is not what I expected*, pl. 40; *How do you mark the years passing?* pl. 41; *Where does history happen?* pl. 42; *Babies--place of origin*, pl. 43; *No one ever told me the sky was blue*, pl. 44; *Who are you?* pl. 45; *Everyone is has a mother*, pl. 46; *Stability insures change*, pl. 47; *What's stronger than a lion*, pl. 48; *Black humor*, pl. 49; *Fun*, pl. 50; *With no future tense, who would be happier?* pl. 51; *What if I cry*, pl. 52; *After the war which language will we speak*, pl. 53; *What do you whisper when*, pl. 54; *If thoughts are yo-yos*, pl. 55; *The world is not my oyster*, pl. 56; *Misunderstand?* pl. 57; *Will you live your life regretting having done*, pl. 58; *The hard part is not knowing the end of the story*, pl. 59; From *Flashbulb Memories*, 1986: *Giant Army Dirigible Wrecked*, pl. 60; *Japanese Death Toll May Reach 300,000*, pl. 61; *Byrd Flies to North Poll and Back*, pl. 62; *Gertrude Ederle Swims the Channel*, pl. 63; *Amelia Earhart Flies Atlantic*, pl. 64; *Legal Liquor Due Tonight*, pl. 65; *Hindenburg Burns in Lakehurst Crash*, pl. 67; *The War in Europe is Ended!* pl. 69; *Bomber Hits Empire State Building*, pl. 70; *Secrets of Radar Given to World*, pl. 71; *Japan Surrenders to Allies*, pl. 72; *Dodgers Win First World Series Title*, pl. 75; *Soviet Fires Earth Satellite into Space*, pl. 76; *Hawaii*

Is Voted into Union, pl. 77; *Two Soviet Dogs in Orbit,* pl. 78; *127 Die As Two Airliners Collide,* pl. 79; *Power Failure Snarls Northeast,* pl. 80; *Egypt and Syria Agree to U.N. Cease-fire,* pl. 81; *Men Walk on Moon,* pl. 82; *Minh Surrenders,* pl. 83; *The Shuttle Explodes,* pl. 84.

Tweedy-Holmes, Karen, 1942-
See also #1058, 1070, 1072
Twiddy, Susan
See also #1071

Ulmann, Doris, 1882 or 4- 1934
See also #1000, 1008, 1026, 1037, 1058, 1061, 1063

945. Banes, Ruth A. "Doris Ulmann and Her Mountain Folk," *Journal of American Culture* 8, 1 (1985): 29-42.

946. Eaton, Allen H. *Handicrafts of the Southern Highlands: With an Account of the Rural Handicraft Movement in the United States and Suggestions for the Wider Use of Handicrafts in Adult Education and Recreation.* Containing Fifty-eight Illustrations from Photographs Taken for the Work by Doris Ulmann. New York: Russell Sage Foundation, 1937. 370 p.
During 1933 and 1934 Ulmann spent much of her time in the mountains of the Southern Highlands, photographing the mountain people and their handicraft traditions. The prints, which were made from exposed plates after Ulmann's death, are an important part of this classic study of the people and the culture of the handicrafts and the Handicraft Movement.
Typical Mountain Cabin, p. 48; *A Home of Handicrafts,* p. 49; *The Old Spring House,* p. 52; *An Old-Time Highland Corn Mill,* p. 53; *Sleds Take the Place of Wagons,* p. 56; *Mill Run by Water Power,* pl. 57; *A Good Board Maker,* p. 60; *Mountain People Love Flowers,* p. 61; *Log House Roadside Shelter,* p. 62; *Carding Wool by Hand in Kentucky,* p. 63; *The High Spinning Wheel,* p. 68; *Spinning Wool on the High Wheel,* p. 69; *An Old-Time Spinner and Weaver,* p. 72; *Old Home-Made Mountain Loom,* p. 73; *Kentucky Spinner and Weaver,* p. 78; *Link between the Old and New,* p. 79; *Primitive Cotton Gin,* p. 80; *Old-Time Weavers Have High Standards,* p. 81; *Pioneer Weaver of Tennessee,* p. 84; *A Weaver and a Ballad Singer,* p. 85; *A Spinner in Her Hundredth Year,* p. 88; *Making a Patchwork Quilt,* p. 89; *Shaving or Drawing Horse,* p. 92; *A Mountain Chairmaker,* p. 93; *Hand-Power Wood-Turning Lathe,* p. 95; *Isaac Davis, Broom Maker of Blue Lick, Kentucky,* p. 98; *Corn-Husk Chair Seats,* p. 99; *Loom Maker at Work,* p. 106; *The "Lastingest" Chair Bottom,* p. 107; *Fine Furniture by Mountain Boys,* p. 110; *A Basket Maker of Kentucky,* p. 111; *A Tennessee Mountain Woodworker,* p. 114; *Honeysuckle Basket Makers,* p. 115; *A North Carolina Mountain Whittler,* p. 122, 126; *Tennesse Mountain Whittler,* p. 123; *Kentucky Mountain Poppet Maker,* p. 127; *A Mountain Whittler,* p. 130; *A Music Maker of the Highlands,* p. 131; *Four Dulcimer Makers of the Highlands,* p. 138; *Stirring Clay for Mountain Pottery,* p.

139; *A Young Potter in the Georgia Highlands*, p. 142; *Family of Mountain Potters*, p. 143; *The Daughter of a North Carolina Potter*, p. 146; *A Potter of Distinction*, p. 147; *One-Man Tanning Works*, p. 154; *A Craftswoman of Great Versatility*, p. 155; *Making a Hooked Rug*, p. 158; *Boring Out Mountain Rifle Barrels*, p. 159; *A Rural Community Museum*, p. 162; *Mountain Man and His Jennies*, p. 163; *Pioneer Cabin of William and Aunt Sal Creech*, p. 170; *A Mountain Blacksmith Turned Craftsman*, p. 171; *Berea College Chapel at Night*, p. 174.

947. Featherstone, David. *Doris Ulmann, American Portraits.* Albuquerque: University of New Mexico Press, 1985. 228 p. Bibliography: p. 227-228. The photographs are accompanied by a critical and biographical essay by Featherstone.

Unknown subject, ca. 1934, fig. 1; *Charles Jaeger, Doris Ulmann's husband photographing at Gloucester Bay, Massachusetts*, early 1920s, fig. 2; *Girl with ball*, n.d., fig. 3; *Ansel Adams*, Spring 1933, fig. 4; *Unknown subject*, ca. 1927, fig. 5; *George Webler, Doris Ulmann's chauffeur*, ca. 1933, fig. 6; *John Jacob Niles carrying Ulmann's photographic equipment*, ca. 1933, fig. 7; *John Jacob Niles carrying Doris Ulmann across Cutshine Creek, near Higdon, Kentucky*, 1933, fig 8; *John Jacob Niles playing the Dulcimer in Ulmann's New York apartment*, ca. 1932, fig. 9; *John Jacob Niles opening bottle of wine, from a series depicting his hands in a variety of activities*, ca. 1932, fig. 10; *Doris Ulmann and Julia Peterkin*, early 1930s, fig. 11; *Shadows on a wall, done during on of Ulmann's summer trips*, ca. 1933, fig. 12; *Schoolchildren around a school bell*, ca. 1933, fig. 13; *Doris Ulmann with her tripod*, ca. 1933, fig.14; *Girl in cooking class, Berea College*, 1934, fig. 15; *Students with teacher, Berea College*, 1934, fig. 16; *Gloucester, Massachusetts*, early 1920s, pl. 1, 2; *Unknown Sitter*, pl. 3, 4, 56-58, 72; *Calvin Coolidge*, pl. 5; *Anna Pavlova*, pl. 6; *Lewis Mumford*, pl. 7; *Ruth St. Denis*, pl. 8; *Albert Einstein*, pl. 9; *Untitled*, ca. 1927, pl. 10; *Sister Adelaide, Mt. Lebanon, New York*, pl. 12; *Unknown Sitters*, pl. 13, 61, 62; *Mennonite Woman, Virginia*, ca. 1927, pl. 14; *South Carolina, [portraits of African-Americans]* 1929-30, pl. 15-36; *Sacred-image Carver, New Orleans*, 1931, pl. 37; *New Orleans*, 1931, pl. 38; *Doll Dresser, New Orleans*, 1931, pl. 39; *Art Shop Owner, New Orleans*, 1931, pl. 40; *Street Vendor, New Orleans*, 1931, pl. 41; *Vegetable Seller, Bleecker Street, New York City*, 1932, pl. 42; *Artist' Street Exhibition, Greenwich Village, New York*, 1932, pl. 43; *Bee Stands, Gatlinberg, Tennessee*, 1934, pl. 44; *Jason Reed, Chairmaker*, ca. 1933, pl. 45; *Mrs. Combs, Puncheon Camp Creek, Kentucky*, 1934, pl. 46; *Mrs. Hyden Hensley and Child, Brasstown, North Carolina*, ca. 1933, pl. 47; *Unknown Sitter*, ca. 1934, pl. 48, 63, 65, 70; *Martha Nichols, Culbertson, North Carolina*, 1934, pl. 49; *Wilma Creech, Pine Mountain, Kentucky*, 1934, pl. 50; *Ainer Owensby, Gatlinberg, Tennessee*, ca. 1934, pl. 51; *Elsie Stewart, Brasstown, North Carolina*, 1934, pl. 52; *Cheevers Meadows and His Daughters, Cleveland, Georgia*, ca. 1933, pl. 53; *Unknown Sitter*, ca. 1927, pl. 54, 64; *Cora Coker, Brasstown, North Carolina*, ca. 1934, pl. 55; *J. E. Welsh Bybee, Kentucky*, 1934, pl. 59; *Mrs. Green, Brasstown, Kentucky*, ca. 1933, pl. 60; *Peter Ingram,*

Chairmaker, Berea, Kentucky, 1934, pl. 66, 67; *Performer at Bunyan's Pilgrim's Progress Day, Ashland, Kentucky,* ca. 1933, pl. 68; *Virginia Howard, Brasstown, North Carolina,* ca. 1933, pl. 69; *Christopher Lewis, Preacher, Wooton, Kentucky,* ca. 1933, pl. 71; *Oscar Lewis Bachelder, Potter, Omar Kayyam Pottery, Candler, North Carolina,* 1934, pl. 73; *Arthur Hipps and Wife, Top of Turkey Mountain, near Asheville, North Carolina,* 1934, pl. 74.

948. Lamuniere, M. C. "'Roll, Jordan, Roll' and the Gullah Photographs of Doris Ulmann," *History of Photography* 21, 4 (Winter 1997): 294-302.

949. McEuen, M. A. "Doris Ulmann and Marion Post Wolcott: The Appalachian South," *History of Photography* 19, 1 (Spring 1995): 4-12.

950. Peterkin, Julia. *Roll, Jordan, Roll.* Photographic Studies by Doris Ulmann.New York: Robert O. Ballou, 1933. 251 p.
[Seated man with cane] frontispiece; *[Women ironing]* p. 13; *[Women in maids' dress, peeling potatoes]* p. 14; *[Digging potatoes]* p. 17; *[Woman with large tin buckets on head]* p. 21; *[Driving an ox cart]* p. 25; *[White-haired man in suit]* p. 29; *[Woman quilting]* p. 33; *[Woman in print dress]* p. 37;*[Cemetery]* p. 45, 217; *[Two mules]* p. 46; *[Woman with braids]* p. 51; *[Smiling man with bottle]* p. 55; *[Young man holding shoes]* p. 61; *[Young man and young and woman with basket and tray]* p. 65; *[Shinning boots]* p. 66; *[Man by large bell]* p. 69; *[Woman pulling bell rope]* p. 70; *[Going to church]* p. 73; *[Man reading from the Bible]* p. 74; *[Preaching]* p. 77; *[Kneeling at altar]* p. 78; *[Baptism in the river]* p. 81, 82; *[Couple talking]* p. 85; *[Portrait of a woman]* p. 86, 147; *[Men washing feet]* p. 89; *[Women washing feet]* p. 90; *[Couple by bundle of hay]* p. 93; *[Woman plowing behind ox]* p. 94, 97; *[Seated woman]* p. 101; *[Woman in white robe]* p. 111, 112; *[Church choir singing]* p. 117; *[Man in rowboat]* p. 118, 128; *[Prison gang]* p. 123, 124 127; *[Seated old man]* p. 135, 143, 156, 166, 191; *[Trees in water]* p. 151; *[Log cabin]* p. 155; *[Woman smoking pipe]* p. 161, 170; *[Man in overalls]* p. 165; *[Woman scrubbing window sill]* p. 169; *[Young girl walking]* p. 173; *[Row of wood shacks]* p. 174; *[Young girl with large bow in hair]* p. 177; *[Young boy sitting on bale of cotton]* p. 178; *[Line of young boys]* p. 181; *[Young boys leaning on fence]* p. 182, 240; *[Small boy]* p. 185; *[Group of children outside house]* p. 192; *[Bundling asparagus]* p. 195, 201; *[Woman by doorway]* p. 196; *[Two children on a mule]* p. 207; *[In church]* p. 211; *[Man with bale of cotton]* p. 235, 236; *[Driving a wagon full of cotton]* p. 239; *[Chair by fireplace]* p. 247.

951. Ulmann, Doris. *The Appalachian Photographs of Doris Ulmann*; remembrance by John Jacob Niles. Highlands, NC: Jargon Society, 1971. The introduction "They All Want to Go and Dress Up " provides brief biographical information and a discussion of the process involved in having this work published. The second essay, "Doris Ulmann: As I Remember Her," is by Niles, traveling companion and discoverer of the mountain folk-ballad.

An unkown preacher, pl. 3; *W. J. Martin, Brasstown, North Carolina, woodcarver,* pl. 5; *An unnamed member of the Holiness sect,* pl. 7; *John Alexander Meadows, operated a gristmill,* pl. 8; *A coal-miner,* pl. 9; *J.O. Penland, farmer,* pl. 11; *Christopher Lewis, preacher,* pl. 12; *Mr. Ritchie, Viper, Kentucky,* pl. 115; *A Pennsylvania fireman,* pl. 17; *Mrs. Lowery, Brasstown, North Carolina,* pl. 19; *Ella Webster, Texana, singer,* pl. 20; *Aunt Sophie Campbell, clay-pipe maker,* p. 21; *Mrs. Teams, Pine Log, North Carolina,* pl. 22; *Mrs. Stewart, Housewife and singer, Brasstown, North Carolina,* pl. 23; *Mrs. Bird Patten, Brasstown, North Carolina,* pl. 27; *Mrs. Johnson. Farmer's wife and singer, Brasstown, North Carolina,* pl. 29; *Mrs. Ford, Wooten, Kentucky,* pl. 30; *Three outlanders--shrimp fisherman from around Mobile, Alabama,* pl. 33; *Elsie Stewart, Brasstown, North Carolina,* pl. 34; *Chever Meaders and two of his children. He was a potter near Cleveland, Georgia,* pl. 35; *Uncle Geroge Leaman and John Jacob Niles, Gatlinburg, Tennessee,* pl. 35; *Mr. and Mrs. Anderson. Makers of hooked rugs, Saluda, North Carolina,* pl. 37; *Mr. Eversole, Hazard, Kentucky,* pl. 38; *Two Meulungeon boys,* pl. 40; *Mr. Mac McCarter. Basketmaker, Gatlinburg, Tennessee,* pl. 41; *Mrs. Ritchie, Viper, Kentucky,* pl. 42; *Mrs. Green Williams. Maker of dolls (poppets), Knott County, Kentucky,* pl. 43; *Covey Odom. Tanner, Luther, Tennessee,* pl. 44; *John Andrew Coffman, Fiddler and composer, Russellville,Tennessee,* pl. 45; *Mr. Stewart, Crosstie-maker, Brasstown, North Carolina,* pl. 46; *Jason Reed. He made chairs and lived in North Carolina,* pl. 47; *Aunt Cord Ritchie. Basket-maker, Hindman, Kentucky,* pl. 48; *Haden Hensley. Wood-carver, Brasstown,North Carolina,* pl. 49; *Aunt Lizzie Regan. Weaver, Gatlinburg, Tennessee,* pl. 51; *Miss Lula Hale, Director of an experimental farm and community center at Homeplace, Kentucky,* pl. 52; *James Duff (and JJN) Fiddler, Hazard, Kentucky,* pl. 53; *Mrs. Zachariah Field. Weaver, Russellville, Tennessee,* pl. 54; *Arlenne Ritchie. Doll-maker, Knott County, Kentucky,* pl. 55; *Mary Wilmott. Quilter and student, Berea College, Kentucky,* pl. 56; *Arline McCarter. Basket-maker, Gatlinburg, Tennessee,* pl. 58; *Wilma Creech. Student at Pine Mountain School, Pine Mountain, Kentucky,* pl. 59; *Virginia Howard, Brasstown, North Carolina,* pl. 61; *Miss Howard, Berea, Kentucky,* pl. 62; *Aunt Lou Kitchen. Spinner and weaver, Shootin' Creek, North Carolina,* pl. 63; Unlisted plates are portraits of unidentifed men and women.

952. Ulmann, Doris. *The Darkness and the Light: Photographs by Doris Ulmann.* With *A New Heaven and a New Earth* by Robert Coles. Millerton, NY: Aperture, 1974. 111 p. Chiefly illustrations.
 This work contains a series of photographs of African-Americans, an essay by Coles, and a preface by William Clift explaining the sensitivity and inspiration Ulmann found in the vanishing cultures of the subjects of her photographs.

[Young girl walking] frontispiece; *[Woman in loose white robe]* p. 15; *[Man in tattered hat]* p. 16; *[Woman with braids]* p. 17; *[Woman framed by curtains]* p. 18; *[Old man with hand on chin]* p. 19; *[Man holding rope]* p. 20; *[Person with basket on head]* p. 21; *[Young woman near doorway]* p. 22; *[Young man shining his boots]* p. 23; *[Old woman in plaid dress]* p. 24; *[At outdoor market]* p. 25; *[Riding a mule]* p. 26; *[Group of children]* p. 27; *[Plowing with a mule]* p. 28; *[Two*

mules] p. 29; *[Seated person with pipe in mouth]* p. 30; *[Ox and cart]* p. 31; *[Woman plowing with ox]* p. 32, 33; *[Closing up bale of cotton]* p. 34, 35; *[Prison gang working]* p. 36, 37; *[Man with net, in rowboat]* p. 38; *[Man with fish and basket]* p. 39; *[Man standing in mud, with bucket]* p. 40; *[Man with bucket on boat]* p. 41; *[Old woman with tin pans on head]* p. 42; *[Uniformed women in kitchen]* p. 43; *[Woman ironing]* p. 44; *[Young couple with basket of flowers and tea pot]* p. 45; *[Woman with laundry basket on head]* p. 46; *[Woman leaning out of window, with scrub brush]* p. 47; *[Boy sitting on bale of cotton]* p. 48; *[Women and children]* p. 49; *[Boys in caps]* p. 50; *[Girl with large hair bow]* p. 51; *[Straw-hatted boys on mule]* p. 52; *[Boy and old man with cane]* p. 53; *[Man with white hair]* p. 54; *[Woman in print dress]* p. 55; *[Bearded man with cane]* p. 56; *[Old woman quilting]* p. 57; *[Man in overalls]* p. 58; *[Woman with pipe in mouth]* p. 59; *[Household items near grave headstone]* p. 60; *[Wooden cabin]* p. 61; *[Trees growing in water]* p. 62; *[Woman in beads and large hat]* p. 63; *[Man reading large book]* p. 64; *[Woman pulling rope]* p. 65; *[Group going to Church]* p. 66; *[Man by large bell]* p. 67; *[Giving a sermon]* p. 68; *[Standing and clapping in church]* p. 69; *[Children kneeling in church]* p. 70; *[Women listening]* p. 71; *[Man and woman]* p. 72, 73; *[Woman washing feet of other women]* p. 74; *[Man washing feet of other men]* p. 75; *[Men and women in white robes]* p. 76; *[Standing in the river in white robes]* p. 77, 78; *[Cemetery and trees]* p. 79.

953. Ulmann, Doris and Naef, W. *Doris Ulmann: Photographs from the J. Paul Getty Museum.* Malibu, CA: The J. Paul Getty Museum, 1996. 143 p.

Text includes a Foreword by John Walsh, Introduction and commentary on the photographs provided by Judith Keller, and an edited transcript of a colloquium on Ulmann's work. A chronology of significant events in Ulmann's life is also included.

Harbor Scene, Probably Gloucester, Massachusetts, ca. 1916-25, pl. 1; *Still Life with Vines and Shadows, Possibly Georgetown Island, Maine,* ca. 1920, pl. 2; *Barn Interior, Probably, New England,* before 1931, pl. 3; *Two Men at Work,* ca. 1916-25, pl. 4; *Cobbler, West Ninety-Second Street, New York City,* ca. 1917-22, pl. 5; *Construction Worker on a Cigarette Break,* 1917, pl. 6; *Portrait of Max Broedel, Professor of Art as Applied to Medicine, Johns Hopkins University,* 1920, pl. 7; *Ruth Page Performing with Masks,* ca. 1920-30, pl. 8; *Irvin S. Cobb and Robert H. Davis, Editors of* Munsey's Magazine, 1924-25, pl. 9; *José Clemente Orozco,* ca. 1929, pl. 10; *Brother William of the Shaker Settlement, Mount Lebanon, New York,* ca. 1925-27, pl. 11; *Sister Sarah of the Shaker Settlement, Mount Lebanon, New York,* ca. 1925-27, pl. 12; *The Minister's Wife, Ephrata, Pennsylvania,* ca. 1925-27, pl. 13; *The Minister, Ephrata, Pennsylvania,* ca. 1925-27, pl. 14; *John Jacob Niles Playing the Dulcimer, New York City,* ca. 1930, pl. 15; *John Jacob Niles in Hat and Overcoat,* ca. 1927-34, pl. 16; *A Study of Hands (John Jacob Niles Unlocking the Door),* ca. 1932-34, pl. 17; *Sidewalk Grocer, Bleecker Street, New York,* ca. 1925-30, pl. 18; *Bill Williams's Boy, Whitesburg, Kentucky,* ca. 1928-34, pl. 19; *Young Wife, Possibly North Carolina,* ca. 1928, pl. 20; *Monday (Melungeon Woman,*

Probably North Carolina), before 1929, pl. 21; *Portrait Study, Probably, South Carolina or Louisiana*, ca. 1929-31, pl. 23; *Maum Duck, South Carolina*, ca. 1929-31, pl. 24; *The Grave of Hackless Jenkin, Probably, South Carolina*, ca. 1929-31, pl. 25; *Portrait of Miss Katy, South Carolina*, ca. 1929-31, pl. 26; *The Herbalist, Probably Louisiana or South Carolina*, ca. 1929-31, pl. 27; *Member of the Order of the Sisters of the Holy Family, New Orleans*, December 1931, pl. 28; *Fisherman with Wooden Leg, Near Brookgreen Plantation, Murrells Inlet, South Carolina*, ca. 1929-31, pl. 29; *Father and Son with Harvested Berries, Possibly Kentucky*, before 1931, pl. 30; *Farm Couple with Picked Cotton, Southeastern U.S.*, before 1931, pl. 31; *Aunt Cord Ritchie and Family, Hindman, Kentucky*, ca. 1932-34, pl. 32; *Grace Combs, Hindman, Kentucky*, ca. 1928-34, pl. 33; *Interior of Olive Dame Campbell's House, Brasstown, North Carolina*, ca. 1933-34, pl. 34; *Christopher Lewis, Preacher, Wooton, Kentucky*, ca. 1928-34, pl. 35; *Jason Reed, North Carolina Chairmaker*, ca. 1933-34, pl. 36; *Hayden Hensley, Woodcarver, Brasstown, North Carolina*, ca. 1933-34, pl. 37; *Landscape with Pump and Barn*, ca. 1920-34, pl. 38; *John Jacob Niles with Lysette Engel at the Piano, New York City*, ca. 1926-30, pl. 39; *John Jacob Niles with Carol Deschamps and a Dulcimer, Brasstown, North Carolina*, ca. 1933-34, pl. 40; *Anne May Hensley, Brasstown, North Carolina*, ca. 1933-34, pl. 41; *John Jacob Niles with Blanche Scroggs, Brasstown, North Carolina*, ca. 1933-34, pl. 42, 43; *Jean Thomas and John Jacob Niles, Near Ashland, Kentucky*, ca. 1932, pl. 44; *Rosie Day, Wife of The Fiddler James William Day, Ashland, Kentucky*, ca. 1928-34, pl. 45; *Weaver and Pianist, Ashland, Kentucky*, ca. 1928-34, pl. 46; *Fiddler, Probably, Ashland, Kentucky*, ca. 1928-34, pl. 47; *Teenager with Sleeping Child, Linefork, Kentucky*, ca. 1930-34, pl. 48; *May Apple*, May 6, 1934, pl. 49; *Self-portrait with Julia Peterkin*, ca. 1930, p. 100 .

Underhill, Linn
 See also #1055
Unterberg, Susan
 See also #1071
Ursillo, Catherine
 See also #1072
Van Buren, Amelia C.
 See also #1058

Van Cleve, Barbara 1935-

954. "Barbara Van Cleve: Contemporary Ranch Women," *Southwest Art* 25 (November 1995): 54-59, cover.

Vandamm, Florence, 1883-1966
 See also #1058
Vaughan, Caroline
 See also #1052

Vaughan, Caroline
 See also #1052
Vaughan, Martha
 See also #1071
Vereen, Dixie D., 1957-
 See also #1058
Vida
 See also #1041, 1053
Vignes, Michelle
 See also #1058
Virga, Ethel
 See also #1072
Vogt, Jeannette
 See also #1058
Wachstein, Alison
 See also #1070
Wagner, Catherine
 See also #1063
Waidhofer, Linde
 See also #1039, 1062
Wald, Carol
 See also #1072

Ward, Catharine Weed Barnes, 1851-1913
 See also #1009, 1026, 1058

955. Palmquist, Peter E. *Catharine Weed Barnes Ward: Pioneer Advocate for Women in Photography*. Aracata, CA: P.E. Palmquist, 1992. 96 p. Illustrations. Bibliography: 85-96.
 Short biographical essay by Palmquist is followed by a chronology and eight essays written by Ward. These essays include: "Why Ladies Should Be Admitted to Membership in Photographic Societies"; "Photography from a Woman's Standpoint"; "Women As Professional Photographers"; "Dark Rooms"; "The Object of Photography"; "Amatuer Photography"; "Hints to Sitters"; "Press Photography."
Enoch Arden, 1980, pl. 1; *Echo Lake, Catskill Mountains,* 1890, pl. 2; *The Song of Love and Death,* 1891, pl. 3; *Cinderella,* 1891, pl. 4; *By Still Waters,* 1892, pl. 5; *A Family Gathering,* 1899, pl. 6; *Leather Lane, London,* 1900, pl. 7; *Untitled,* 1900, pl. 28; *In Haddon Hall,* 1904, pl. 9; *Parsonage Farm, Oare,* 1907, pl. 10; *Canterbury: Doorway to St. John's Hospital,* 1909, pl. 11; *Canterbury: Bell Harry Tower and Gateway from Prior's Green,* 1909, pl. 12.

Washington, Leah Ann
 See also #1040
Watkins, Kathy

See also #1039
Watriss, Wendy, 1943-
 See also #1058

Watson, Edith S., 1861-1943
 See also #1058

956. Carlevaris, A. M. "Edith S. Watson and 'Romantic Canada,'" *History of Photography* 20, 2 (Summer 1996): 163-165.

957. Rooney, Frances. *Working Light: The Wandering Life of Photographer Edith S. Watson.* Ottawa: Carleton University Press, 1996. 123 p. Chiefly illustrations. Includes bibliographical references: p. 121-123.
 Preface by Rooney explains the investigative process she went through to obtain biographical information and, eventually, the photographs of Watson. There is also a biographical essay to accompany the photographs. Incorporated into the essay are excerpts from the diary of Edith's companion, Queenie. Notes about the images that had been written by Edith or Queenie and were found on the back of the photographs are also included.

Sarah Watson, p. 8; *Reed Watson,* p. 9; *Queenie crossing a river,* p. 12; *Queenie and one of Jobin's statutes,* p. 15; *Queenie on the beach in Nassau,* p.'16; *On the Richelieu,* p. 18; *A happy day,* p. 19; *Queenie writing on the pier,* p. 20; *Queening fishing at Percé,* p. 23; *The homemade quilt,* p. 25; *Melting lead,* p. 26; *The water carrier,* p. 27; *Harvesting hay,* p. 28; *Spruce boughs for firewood,* p. 29; *Spreading fish,* p. 30; *At the well,* p. 31; *Carrying water,* p. 32; *Hoeing potatoes,* p. 33; *Uncle Tom and Lovey,* p. 34; *Capt(ain) Borland,* p. 35; *Drying the seines,* p. 36; *A typical outport,* p. 37; *At the Spring,* p. 38; *Fish stages,* p. 39; *Dismantling the whale,* p. 40; *Feeding the flock,* p. 41; *In Hopedale,* p. 42; *Milking the cow,* p. 43; *Mending nets,* p. 44; *Extracting bones,* p. 45; *Beheading codfish,* p. 46; *Fisherman's luck,* p. 47; *A veteran cooper,* p. 48; *In from the Banks,* p. 49; *Packing mackerel,* p. 50; *Codfish drying,* p. 51; *"The British Lion,"* p. 52; *The Lallah Rookh,* p. 53; *Digging clams,* p. 54; *House Harbor,* p. 55; *On the boy's side,* p. 56; *Mama makes the baby's cap,* p. 57; *Homeward bound,* p. 58; *Little "Marie,"* p. 59; *The first strawberries,* p. 60; *A sister of Ste. Rosaire,* p. 61; *Louis Jobin,* p. 62; *M. Jobin's nephew,* p. 63; *Convent school,* p. 64; *Dog carts and dinner pails,* p. 65; *Harvesting sweetgrass, Pierreville,* p. 66; *Harvesting sweetgrass, Odonak,* p. 67; *The ferry landing at Pierreville,* p. 68; *The ferry landing at Yamaska,* p. 69; *Treading out oats,* p. 70; *In Au Chat,* p. 71; *Ann Grogan,* p. 72; *What's for dinner,* p. 73; *The Hotel Frontenac,* p. 74; *The mail carrier,* p. 75; *Drinking off his paddle,* p. 76; *At French River Camp,* p. 77; *At the Reservation,* p. 78; *In the cucumber patch,* p. 79; *Bunching up rhubarb,* p. 80; *Harvesting onions,* p. 81; *On a Galician farm,* p. 82; *From the old country,* p. 83; *A Galician woman,* p. 84; *Mushrooms,* p. 85; *Cree babies,* p. 86; *Drying fox skins,* p. 87; *In the Mennonite village,* p. 88; *The village herd,* p. 89; *A "stooker,"* p. 90; *Our hospitable hostess,* p. 91; *Social service*

workers, p. 92; *Lake Louise,* p. 93; *Mount Edith,* p. 94; *After the rain,* p. 95; *Mountain goats,* p. 96; *Banff Springs Hotel,* p. 97; *Photo album,* p. 98; *Peter Verigin,* p. 99; *Peacefully sleeping,* p. 100; *Harvest time,* p. 101; *Her load of beans,* p. 102; *Harvesting flax,* p. 103; *Jam,* p. 104; *Religious ceremony,* p. 105; *Plastering a ceiling,* p. 106; *Dried fruit,* p. 107; *Knitting needles,* p. 108; *Doukhobor village,* p. 109; *Apple paring bee,* p. 110; *"Madonna of the Kootenays,"* p. 111; *Celebration for the dead,* p. 112; *Fisherman's house,* p. 113; *The totem,* p. 114; *A community house,* p. 115; *Totem pole family tree,* p. 116; *Of the Whale tribe,* p. 117; *Native canoeing,* p. 118; *Haida Indian woman,* p. 119; *Horses grazing,* p. 120.

Watson-Schütze, Eva, 1867-1935
 See also #1000, 1022, 1058

958. Block, Jean F. *Eva Watson Schütze: Photo-Secessionist.* Chicago: University of Chicago Library, 1985. 40 p.
 This collection of photographs and the catalog from an exhibition held in the Joseph Regenstein Library, "Eva Watson Schütze and the Philosophers' Circle, draw on letters, diaries, and memoirs to help recreate the relationships between some of the University of Chicago's most notable faculty and their families." Catalog includes a lengthy biographical essay and a "Note on the Signatures" she used throughout her work.
Martin Schütze, 1902, pl. 1; *John Dewey,* c. 1902, pl. 2; *Alice Dewey, Jane, and Gordon,* c. 1902, pl. 3; *Fred Dewey,* 1905, pl. 4; *Lucy Dewey,* c. 1905, pl. 5; *Cynthia Tufts,* c. 1902, pl. 6; *James Hayden Tufts,* c. 1916, pl. 7; *George Herbert Mead,* c. 1903, pl. 8; *Helen Castle Mead,* 1929, pl. 9; *Henry Mead,* c. 1908, pl. 10; *Frau Amalie Steckner,* c. 1909, pl. 11; *Liese Steckner Webel,* c. 1909, pl. 12; *Helga and Hanni Jahrmarkt,* c. 1909, pl. 13; *Elinor Castle,* c. 1910, pl. 14; *Mabel Wing Castle,* c. 1906, pl. 15; *Jane Addams,* 1910, pl. 16; *John U. Nef, Jr.,* 1917, pl. 17; *Ermine Cross and Hattie Castle Coleman,* 1916, pl. 18; *Elinor Castle Nef,* 1921, pl. 19.

959. Keiley, Joseph T. "Exhibition of Prints by Eva L. Watson," *Camera Notes IV,* 2 (October 1900): 122-123.

960. Keiley, Joseph T. "Eva Watson-Schütze," *Camera Work* 9 (January, 1905): 23-26.

961. Watson-Schütze, Eva. "Salon Juries," *Camera Work* 2 (April 1903): 46-47.

962. Watson-Schütze, Eva. "Some Fragmentary Notes on the Chicago Salon," *Camera Notes* V, 3 (January 1902): 200-202.

Webb, Nancy
 See also #1039

Weems, Carrie Mae, 1953-
 See also #1008, 1015, 1031, 1055, 1058

963. Benner, Susan. "A Conversation with Carrie Mae Weems," *Art Week* 23 (May 7, 1992): 4-5.

964. Doniger, Sidney, Sandra Matthews and Gillian Brown, eds. "Personal Perspectives on the Evolution of American Black Photography: A Talk with Carrie Weems," *Obscura*: 2, no. 4 (Spring 1982): 8-17.

965. Heartney, Eleanor. "Carrie Mae Weems," *Artnews* 90, 1 (January 1991): 154-55.

966. Kirsh, Andrea. *Carrie Mae Weems*. Andrea Kirsh and Susan Fisher Sterling. Washington, D.C.: The National Museum of Women in the Arts, 1993. 116 p. Biography. Selected Bibliography: p. 112-113.
Catalogue to accompany a traveling exhibit, which includes two essays, "Carrie Mae Weems: Issues in Black and White," an analyzation of Weems' focus on how images shape our perception of color gender and class, and "Signifying: Photographs and Texts in the Work of Carrie Mae Weems," which are part of her artistic process to address the issues "encircling African American culture," p. 19.
Blue Black Boy, front cover; *Untitled, (Boone Plantation),* frontispiece; *Denise, NYC,* 1978, fig. 1; *Girls on Bus, NYC,* 1977, fig. 2; *S.E. San Diego Kermit,* 1983(detail), fig. 3; *Family Pictures and Stories, Mom and Dad with Grandkids,* 1982-84(detail), fig. 4; *Ain't Jokin: What's a Cross Between an Ape and a Nigger?* 1987-88, Fig. 5; *Family Pictures and Stories: Mom and Willy,* 1981-82, fig. 7; *Ode to Affirmative Action,* 1989, fig. 8; *Jim, if you choose...,* 1990, fig. 9; *Untitled (Sea Island Series), Untitled (Steven's Pies),* 1992, fig. 12; *Family Pictures and Stories* Series, 1978-84:
Welcome Home, pl. 1; *Mom at Work,* pl. 2; *Alice on the Bed,* pl. 3; *Dad and Son-Son,* pl. 4; *Van and Vera,* pl. 5; *Family on the Beach,* pl. 6; *Van and Vera with Kids in the Kitchen,* pl. 7; *Dad with Suzie-Qs,* pl. 8; *Ain't Jokin* Series, 1987-88: *Black Woman with Chicken,* pl. 9; *White Patty,* pl. 10; *Mirror, Mirror,* pl. 11; *What Are the Three Things You Can't Give a Black Person?* pl. 12; *A Child's Verse (In 1944 My Father Went to War),* pl. 13; *American Icons,* 1988-89: *Untitled (letter opener),* pl. 14; *Untitled (salt and pepper shakers),* pl. 15; *Untitled (ashtray),* pl. 16; *Colored People,* 1989-90: *Magenta Colored Girl,* pl. 17; *Burnt Orange Girl,* pl. 18; *Blue Black Boy,* pl. 19; *Golden Yella Girl,* pl. 20; *Violet Colored Girl,* pl. 21; *Chocolate Colored Man,* pl. 22; *Honey Colored Boy,* pl. 23; *Untitled (Kitchen Table Series),* 1990: *Untitled (Man and Mirror),* pl. 24; *Untitled (Man Smoking),* pl. 25; *Untitled (Eating Lobster),* pl. 26; *Untitled (Man Reading Newspaper),* pl. 27; *Untitled (Woman and Phone),* pl. 28; *Untitled (Woman with Friends),* pl. 29; *Untitled (Woman Brushing Hair),* pl. 30; *Untitled (Woman and Daughter with Makeup),* pl. 31; *Untitled (Woman with Daughter),* pl. 32; *Untitiled (Woman and Daughter with*

children), pl. 33; *Untitiled (Woman Standing Alone)*, pl. 34; *Untitled (Woman Feeding Bird)*, pl. 35; *Untitled (Nude)*, pl. 36; *Untitled (Woman Playing Solitaire)*, pl. 37; *And 22 Million Very Tired and Very Angry People*, 1991: *A Hot Spot in a Corrupt World*, pl. 38; *A Little Black Magic*, pl. 39; *Some Theory*, pl. 40; *By Any Means Necessary*, pl. 41; *An Armed Man*, pl. 42; *A Veiled Woman*, pl. 43; *Untitled (Sea Island* Series) 1991-1992: *Untitled (Healing Oil and Mirrors)*, pl. 44; *Untitled (Palm Trees)*, pl. 45; *Untitled (Graveyard with Tombstone Cross)*, pl. 46; *Untitled (Hubcaps in yard)*, pl. 47; *Untitled (Trees with Mattress Springs)*, pl. 48; *Untitiled (Slave quarters, Open Windows)*, pl. 49.

967. Princethal, Nancy. "Carrie Mae Weems at P.P.O.W.," *Art in America* 79, 1 (January 1991): 129.

968. Reid, Calvin. "Carrie Mae Weems," *Arts Magazine* 65 (January 1991): 79.

969. Tarlow, Lois. "Carrie Mae Weems," *Art New England* 12 (August/September 1991): Cover + 10-12.

Weil, Mathilde, active late 1890s-c.1910
 See also #1058
Weinberg, Carol
 See also #1072
Weiner, Sandra, 1921-
 See also #1058
Weiss, Eva
 See also #1072
Weissman, Jane
 See also #1006

Wells, Alice, 1927-1987 (name varies)
 See also #1058, 1061

970. "Alice Andrews: Multiple images of singular strength," *Creative Camera* 62 (August 1969): 282-285.

971. Wells, Alice. "Time After Time: The Photographs of Alice Wells: A Visual Studies Workshop Traveling Exhibition," Rochester, NY: Visual Studies Workshop, 1990. Unpaged. Bibliography and Exhibitions list. The catalogue essay includes biographical information, dicussion of her practice of Zen and the development of her photographic development and experimentation.
Untitled, 1961-1970, 24 plates.

Welty, Eudora, 1909-
 See also #1028, 1063

972. Center for Southern Folklore. *Images of the South: Visits with Eudora Welty and Walker Evans.* Southern Folklore Reports, Number 1. Memphis: Center for Southern Folklore, 1977. 43 p. Bibliography: p. 41-42.

Welty and Evans independently travelled throughout the Deep South in the 1930s and photographed the people, the landscape and the culture. This work consists of a lengthy interview with each of them, illustrated by their photographs and quotes from their writings.

Cafe window in Fayette, Mississippi, c. 1930, cover, p. 18; *Black woman near Jackson, Mississippi*, c. 1930, cover, p. 25; *United Daughters of the Confederacy delegate at Governor's Mansion, Jackson, Mississippi*, c. 1930, cover, p. 19; *Wagon in Yalobusha County, Mississippi*, c. 1930, p. 12; *Eudora Welty, a worker in the W.P.A. publicity office in Jackson, and a storekeeper and his family, near Florence, Mississippi*, c. 1930, p. 13; *Helen Lotterhos in front of sign, City of Crystal Springs, Mississippi*, c. 1930, p. 14; *Grenada on Saturday afternoon, Grenada, Mississippi*, c. 1930, p. 15; *Fiddler at fair gate, Jackson, Mississippi*, c. 1930, p. 16; *School children in Jackson*, c. 1930, p. 17; *Youths at a side show at the State Fair, Jackson, Mississippi*, c. 1930, p. 17; *Child on front porch, near Jackson, Mississippi*, c. 1930, p. 20; *Woman on front porch, Jackson, Mississippi*, c. 1930, p. 20; *Riverboat in Vicksburg, Vicksburg, Mississippi*, c. 1930, p. 21; *Tomato-pickers' recess, Copiah County, Mississippi*, c. 1930, p. 22; *Century Theatre, Jackson, Mississippi*, c. 1930, p. 23; *Street scene, Canton, Mississippi*, c. 1930, p. 24; *Watermelon on courthouse grounds, Pontotoc, Mississippi*, c. 1930, p. 25; *Window shopping, Grenada, Mississippi*, c. 1930, p. 41.

973. Pitavysouques, D. "Eudora Welty Photographs of Fallow Land - A Meditation On the American Landscape of the South," *Revue Francaise d'Etudes Americaines* 48, 4 (1991): 281-290.
In French.

974. Mann, Charles. "Eudora Welty Photographer," *History of Photography* 6, 2 (April 1982): 145-149.

975. Welty, Eudora. *One Time, One Place: Mississippi in the Depression: A Snapshot Album.* New York: Random House, 1971. 113 p. Chiefly illustrations.

In the introductory essay, Welty explains her rationale for taking these photographs, her consideration of these pictures more as a family album not a social document, and the trust among people as a white woman, taking pictures of black people.

Chopping in the field, p. 11; *Cotton Gin*, p. 12; *Hog-killing time*, p. 13; *Boiling pot*, p. 14; *Making cane syrup*, p. 15, 16; *Tomato-packers' recess*, p. 17; *WPA farm-to-market road worker*, p. 18; *Washwoman*, p. 19; *Washwoman carrying clothes*, p.

19; *Schoolchildren*, p. 20; *Schoolchildren meeting a visitor*, p. 21; *Nurse at home*, p. 22; *Blind weaver on the WPA*, p. 22; *Scchoolteacher on Friday Afternoon*, p. 23; *Saturday off*, p. 27; *Staying home*, p. 28; *Boy with his kite*, p. 29; *Coke*, p. 30; *Hairdressing queue*, p. 31; *Front yard*, p. 32; *With a dog*, p. 33; *With the baby*, p. 34; *With a chum*, p. 35; *Home*, p. 36, 37, 38, 39; *Fisherman and his boys*, p. 40; *Home with bottle-trees*, p. 41; *Home, ghost river town*, p. 42; *Home after high water*, p. 43; *Home to the public*, p. 44; *Home abandoned*, p. 45; *To play dolls*, p. 46; *To find plums*, p. 47; *To all go to town*, p. 48; *Saturday arrivals*, p. 49; *Saturday in town*, p. 50; *Village*, p. 50; *Hamlet*, p. 51; *Town in a store window*, p. 52; *The store*, p. 53; *Window shopping*, p. 54; *Crossing the pavement*, p. 55; *Strollers*, p. 56; *Farmers in town*, p. 57; *Tall story*, p. 57; *Store front*, p. 58; *In the bag*, p. 59; *If it rains*, p. 60; *Confederate veterans meeting in the park*, p. 61; *Making a date for Saturday night*, p. 62; *Making a date*, p. 63; *The fortune-teller's house*, p. 64; *The bootlegger's house*, p. 65; *Political speaking*, p. 66; *Political Speech*, p. 67; *Watermelon the courthouse grounds*, p. 68; *County float, State Fair parade*, p. 69; *Church float*, p. 70; *Club float, Negro State Fair parade*, p. 71; *Free Gate, State Fair*, p. 72; *Beggar at the Fair Gate, with jigging dolls*, p. 73; *Side show, State Fair*, p. 74; *Hypnotist, State Fair*, p. 75; *Sideshow wonders, State Fair*, p. 76; *The Rides, State Fair*, p. 77; *Too far to walk it*, p. 78; *Sunday School child*, p. 81; *Sunday School. Holiness Church*, p. 83; *Preacher and leaders of Holiness Church*, p. 83; *Make a joyful noise unto the Lord*, p. 84; *Speaking in the Unknown Tongue*, p. 85; *Baby Holiness member*, p. 86; *Baptist deacon*, p. 87; *Members of a Pageant of Birds*, p. 88; *Bird Pageant costumes*, p. 89; *Baby Bluebird, Bird Pageant*, p. 90; *Author and director of the Bird Pageant*, p. 91; *Country church*, p. 92, 93, 94; *Church in Port Gibson*, p. 95; *A slave's apron*, p. 96; *Carrying the ice for Sunday dinner*, p. 97; *Wild flowers*, p. 101; *Ida M'Toy, retired midwife*, p. 102; *Ida M'Toy*, p. 103; *Storekeeper*, p. 104; *Delegate*, p. 105; *Hat, fan, and quilts*, p. 106; *Mother and child*, p. 107, 110; *A village pet*, p. 108; *Yard man*, p. 109; *Four sisters*, p. 111; *Home by dark*, p. 113.

976. Welty, Eudora. "Another Time," *American Photographer* 13, 1 (July 1984): 64-69.

977. Welty, Eudora. *Photographs*. Foreword by Reynolds Price. Jackson: University Press of Mississippi, 1993. 227 p. Chiefly illustrations.
 Price offers a short analysis and comparison of Welty's fiction and her photographs. It is followed by a lengthy interview with Welty.
A Woman of the 'thirties,' Hinds County, 1935, pl. 1; *Delegate, Jackson*, pl. 2; *Picking Cotton, Hinds County*, pl. 3; *Schoolteacher on Friday Afternoon, Jackson*, pl. 4; *Ida M'Toy, Midwife, "Mama's Brooch", Jackson*, pl. 5; *"Born in This Hand," Jackson*, pl. 6; *Nurse at Home, Jackson*, pl. 7; *[Stylish young woman] Jackson*, 1930s, pl. 8; *Day's End, Jackson*, 1930s, pl. 9; [Woman with grocery bag, laughing] *Jackson*, 1930s, p. 10; *Home, Claiborne County*, 1930s, pl. 11; *Woman with Ice Pick, Hinds County*, 1930s, p. 12; *Blind Weaver, Oktibbeha County*, 1930s, pl. 13; *Hat, Fan, and Quilts, Jackson*, 1930s, pl. 14; *Saturday Off*,

Jackson, 1930s, pl. 15; *Window Shopping, Grenada,* 1930s, pl. 16; *If It Rains, Jackson,* pl. 17; *The Guinea Pig, Jackson,* 1930s, pl. 18; *A Drink of Water, Jackson, 1930s,* pl. 19; *Chopping Cotton in the Field, Warren County,* 1935, pl. 20; *Boiling Pot, Hinds County,* 1930s, pl. 21; *[Old man on porch with watermelons]* Grenada County, 1930s, pl. 22; *Storekeeper, Rankin County,* 1930s, pl. 23; *Tall Story, Utica,* 1930s, pl. 24; *The Store, Madison County,* 1930s, pl. 25; *Farmers in Town, Crystal Springs,* 1930s, pl. 26; *Village pet "Mr. John Paul's Boy," Rodney,* 1930s, pl. 27; *Storefront, Canton,* 1930s, pl. 28; *Baptist Deacon, Jackson,* 1930s, pl. 29; *Confederate Veterans Meeting in the Park, Jackson,* 1930s, pl. 30; *Tomato-packers Recess, Copiah County,* 1936, pl. 31; *Hog-killing Time, Hinds County,* 1930s, pl. 32; *Making Cane Sugar, Madison County,* 1930s, pl. 33; *[Three men leaning on mail box]* Grenada, 1930s, pl. 34; *[Men looking in loan shop window]* Jackson, 1936, p. 35; *Political Rally on the Courthouse Grounds, Pontotoc,* 1930s, pl. 36; *Mother and Child, Hinds County,* 1935, pl. 37; *[Mother and children on porch]* Jackson, 1930s, pl. 38, 39; *Hairdressing, Jackson,* 1930s, pl. 40; *Too Far to Walk It, Star,* 1930s, pl. 41; *Plum Pickers, Copiah County,* 1930s, pl. 42; *[Mother and child]* Hinds County, 1930s, pl. 43; *Child on Porch, Hinds County,* 1939, pl. 44; *[Barefoot boy leaning against wooden porch]* Hinds County, 1930s, pl. 45; *Boy with His Kite, Jackson,* 1930s, pl. 46; *Pet Pig, Jackson,* 1930s, pl. 47; *Dancing for Pennies,* 1930s, pl. 48; *Brothers, Jackson,* 1930s, pl. 49; *Sister and Brother, Jackson,* 1930s, pl. 50; *Dolls, Jackson,* 1930s, pl. 51; *Wildflowers, Jackson,* 1930s, pl. 52; *Sister, Jackson,* 1930s, pl. 53; *New Orleans,* 1930s, pl. 54; *Wildflowers, Jackson,* 1930s, pl. 55; *At Livingston Park, Jackson,* 1930s, pl. 56; *School Children, Jackson,* 1930s, pl. 57; *Sunday School Child, Jackson,* 1930s, pl. 58; *Front Yard, Yazoo County,* 1930s, pl. 59; *Coke, Jackson,* 1930s, pl. 60; *Home, Jackson,* 1930s, pl. 61; *Political Speech, Tupelo,* 1930s, pl. 62; *[Women walking on railroad tracks]* Jackson, 1930s, pl. 63; *Courthouse Steps, Fayette,* 1930s, pl. 64; *Town Square, Canton,* c. 1935, pl. 65; *Mule-drawn Wagon, canton,* c. 1935, pl. 66; *Lanterns, Canton,* c. 1936, pl. 67; *Conversation, Grenada,* 1935, pl. 68; *Courthouse Town, Grenada,* 1935, pl. 69; *Saturday Strollers, Grenada,* 1935, pl. 70; *Making a Date, Grenada,* 1935, pl. 71; *Town of Tin, Hermanville,* 1930s, pl. 72; *[Oversize tomato as advertisement]* Crystal Springs, 1930s, pl. 73; *[Looking through a cafe window]* Fayette, 1930s, pl. 74; *[Conversation near a car]* Utica, 1930s, pl. 75; *Maypoles, Jackson,* 1930s, pl. 76; *Club Float, Black State Fair Parade, Jackson,* 1930s, pl. 77, 80; *Church Float, State Fair Parade,* 1930s, pl. 78; *County Float, State Fair Parade,* 1930s, pl. 79; *Parade Float, Jackson,* 1930s, pl. 81; *[Colored Entrance]* Jackson, 1930s, pl. 82; *Crossing the Pavement, Utica,* 1930s, pl. 83; *Hello and Good-bye, Jackson,* 1930s, pl. 84; *[Conversation by front porch]* Jackson, 1930s, pl. 85; *Washwoman, Jackson,* 1930s, pl. 86; *The Mattress Factory, Jackson,* 1930s, pl. 87; *Saturday Trip to Town, Hinds County,* 1939, pl. 88; *[Mule-drawn wagon]* Grenada, c. 1935, pl. 89; *[Old Miss. Slaughter Pen]* Mississippi, 1930s, p. 90; *[Store signs]* Jackson, 1930s, pl. 91, 92, 93; *[Men passing by wooden church]* Jackson, 1930s, pl. 94; *Back Street, New Orleans,* 1930s, pl. 95; *Mule Team, Utica,* 1930s, pl. 96; *Church, Port Gibson,* 1930s, pl. 97; *Twin Tombstones, Mississippi,* 1930s, pl. 98; *Cemetery Monument, Mississippi,*

1930s, pl. 99; *Members of a Pageant of Birds, Farish Street Baptist Church, Jackson,* 1930s, pl. 100; *Bird Pageant Costumes, Jackson,* 1930s, pl. 101; *Bird Pageant, Jackson,* 1930s, pl. 102; *Baby Bluebird, Bird Pageant, Jackson,* 1930s, pl. 103; *Sunday School Holiness Church, Jackson,* 1939, pl. 104; *Speaking in the Unknown Tongue, Holiness Church, Jackson,* 1939, pl. 105; *Baby Holiness Member, Holiness Church, Jackson,* 1939, pl. 106; *Preacher and Leader of Holiness Church, Jackson,* 1939, pl. 107; *On the Pearl River, Jackson,* 1930s, pl. 108; *Houseboat Family, Pearl River,* 1939, pl. 109; *Shantyboat Life, Pearl River,* 1939, pl. 110; *Home, Ghost River-town, Rodney,* 1930s, pl. 111; *Backyard, Rankin County,* 1930s, pl. 112; *Pasture Gate, Hinds County,* 1930s, pl. 113; *Washwomen Carrying the Clothes, Yalobusha County,* 1930s, pl. 114; *Home by Dark, Yalobusha County,* 1936, pl. 115; *Lillies on Grave, Rodney Cemetery,* 1940s, pl. 116; *Home Abandoned, Old Natchez Trace, near Clinton,* 1930s, pl. 117; *Catholic Church, Rodney,* 1940s, pl. 118; *Ruins of Windsor, Port Gibson,* 1942, pl. 119; *Country Church, Rodney,* 1940s, pl. 120; *House with Bottle-trees, Simpson County,* 1941, pl. 121; *Suspension Bridge, Strong River,* 1940s, pl. 122; *Country Church, near Old Washington,* 1940s, pl. 123; *Ghost River-town, Rodney,* 1942, pl. 124; *Road Between High Banks, Hinds County,* 1940s, pl. 125; *Free Gate, State Fair, Jackson,* 1939, pl. 126; *Fiddler at Fair Gate with Jigging Dolls, Jackson,* 1939, pl. 127; *Carnival Work Crew, Jackson,* 1939, pl. 128; *Here It Comes!, Jackson,* 1930s, pl. 129; *Ticket Office, State Fair, Jackson,* 1939, pl. 130; *Sideshow, State Fair, Jackson,* 1939, pl. 131, 132, 133, 134, 135, 136, 139; *Hypnotized, State Fair, Jackson,* 1939, pl. 137; *Hypnotist, State Fair, Jackson,* 1939, pl. 138; *Sideshow Wonders, State Fair, Jackson,* 1939, pl. 140; *Death Defying, State Fair, Jackson,* 1939, pl. 141, 142 *Mardi Gras, New Orleans,* 1930s, pl. 143, 145, 146, 147; *Royal Street, New Orleans,* 1930s, pl. 144; *Charleston, South Carolina,* 1930s, pl. 148, 149; *Under the El, New York City,* 1930s, pl. 150; *East Side, New York City,* 1930s, pl. 151; *Union Square, New York City,* 1930s, pl. 152, 153, 154; *Hattie Carnegie Show Window, New York City,* 1940s, pl. 155; *Saratoga Springs, New York,* 1940, pl. 156, 157, 158, 159, 160; *Mexico,* 1936, pl. 161, 162, 163, 164, 165; *England,* 1954, pl. 166, 169; *Monk's House, Rodmell, England,* 1954, pl. 167; *The River Cam, Cambridge,* 1954, pl. 168; *Peterhouse, Cambridge,* 1954, pl. 170; *Harlech Castle, Wales,* 1956, pl. 171; *Wales,* 1956, pl. 172, 173; *Mitchelstown, Ireland,* 1950s, pl. 174, 175, 176, 177; *Ireland,* 1950s, pl. 178, 180, 182, 183; *Power's Court, Ireland,* 1950s, pl. 179; *Kilcolmen Castle, Ireland,* 1950s, pl. 181; *Bowen's Court, County Cork, Ireland,* 1950s, pl. 184, 186, 187; *"Lamb's Drawing Room," Bowen's Court, County Cork, Ireland,* 1950s, pl. 185; *San Lorenzo, Italy,* 1949, pl. 188, 189; *Notre Dame, Paris,* 1949, pl. 190; *Paris,* 1949, pl. 191, 193; *The Seine, Paris,* 1949, pl. 192, 194; *Mardi Gras, Nice,* 1949, pl. 195, 196, 197, 198; *Diarmuid Russell, Katonah, New York,* 1940s, pl. 199; *John Woodburn, Yaddo,* 1940, pl. 200; *Diarmuid and Ruth Russell, Katonah, New York,* 1940s, pl. 201; *John Woodburn and Pamela Russell, Katonah, New York,* 1940s, pl. 202; *Katherine Anne Porter, South Hill Farm, near Saratoga Springs,* 1940, pl. 203, 204, 206; *Katherine Anne Porter, Yaddo,* 1940, pl. 205; *Karnig Nalbandian, Yaddo,* 1940, pl. 207; *José de Creeft Yaddo,* 1940, pl. 208; *Eddy Sackville-West,*

Ireland, 1950s, pl. 209; *Elizabeth Bowen, Ireland,* 1950s, pl. 210; *May Lavin with Daughters Elizabeth and Valentine, County Meath, Ireland,* 1950s, pl. 211; *Mary Louise Aswell, Paris,* 1949, pl. 212; *Barbara Howes, William Jay Smith, John Robinson, Sienna,* 1949, pl. 213; *Cleanth Brooks and Tinkum Brooks, Natchez Trace,* 1985, pl. 214; *Sir V. S. and Lady Pritchett, Savannah Georgia,* 1985, pl. 215; *Lehman Engel, Jackson,* 1930s, pl. 216; *George Cooper, Jackson,* 1930s, pl. 217; *Hubert Creekmore, New Orleans,* 1942, pl. 218; *Frank Lyell, Hubert Creekmore, Rosa Wells, Hildegarde Dolson, Westchester County, NY,* 1940s, pl. 219; *Eudora Welty, Hubert Creekmore, Margaret Harmon, and Nash K. Burger, Brown's Wells, Miss.,* 1930s, pl. 220; *Willie Spann, Jackson,* 1930s, pl. 221; *Helen Lotterhos, Jackson,* 1930s, pl. 222; *Edward Welty and Elinor Welty, Jackson,* 1940s, pl. 223; *Mittle Creekmore Welty and Walter Welty, Jackson,* 1940s, pl. 224; *Chestina Andrews Welty, Jackson,* 1950, pl. 225; *Chestina Andrews Welty and Christian Webb Welty, Jackson,* 1927, pl. 226.

978. Wolff, S. "Welty Snapshots - Motions in Place," *Mississippi Quarterly* 43, 2 (1990): 237-239.

Wenzel, Ann F.
 See also #1006

White, Lily E., 1868-1931
 See also #1001

979. Watkins, Carleton, E. et al., "Collections: Magnificent Photographic Images of the Columbia River Gorge," *Oregon Historical Quarterly* 93, 3 (1992): 305-313.

White, Linda Szabo
 See also #1070

Wiggins, Myra Albert, 1869-1956
 See also #1001, 1058

980. Albert, Myra. "Amateur Photography through Women's Eyes." *Photo-American* (March 1894): 134.

981. Glauber, Carole. *Witch of Kodakery: the Photography of Myra Albert Wiggins, 1869-1956.* Pullman: Washington State University Press, 1997. 134 p. Bibliography: p. 132-133.
 This volume includes several portraits of Wiggins, and illustrations of her paintings, as well as her photographs. It is the first comprehensive biography of Wiggins who exemplified the growing number of women entering the professional fields at the turn of the century.
The Old Albert Barn, c. 1889, p. xviii; *Camping Out,* 1889, p. 2; *On the Way to*

Nestucca, c. 1892, p. 3; *Drift Creek, Memorial Day Weekend*, 1890 or 1891, p. 5; *Pink Greenaway Party*, c. 1890, p. 6; *Mock Wedding*, c.1890, p. 6; *Mt. Jefferson, Oregon*, c. 1890, p. 9; *Salem Flood*, 1890, p. 10; *Untitled*, Winter 1890-91, p. 13; *William Merritt Chase's Art Class, Art Students League*, c. 1892, p. 14; *An Art Student's Flat, Lena's Corner*, 1891-1892, p. 16; *When Company Comes*, 1891-1892, p. 17; *Lena Knight in Corner of Our Flat*, c. 1892, p. 17; *Swimming Pool, Mehania*, c. 1891, p. 18; *Untitled*, c. 1892, p. 19; *Augustus Saint-Gauden's Sculpture Class, Art Students League*, c. 1892, p. 20; *Babes in the Park*, c. 1892, p. 21; *Mirror Tarn, Oregon*, c. 1891, p. 22; *Mt. Jefferson from Grizzly, Tarn, Oregon*, c. 1891, p. 23; *Wedding Party of Myra Albert and Fred Wiggins*, 1894, p. 23; *The Forge*, 1897, p. 24; *Silver Creek Falls*, 1894, p. 26; *Indian Basket Maker*, 1898, p. 28; *Unloading the Catch*, 1898, p. 29; *Sheep*, c. 1898, p. 30; *A Promise of Rain*, 1898, p. 30, *The Gathering Mist*, 1899, p. 31; *Great Expectations (Hunger is the Best Sauce)*, 1898, p. 32; *Variation on Hunger ist de Beste Koch*, 1898, p. 32; *The Lacemaker*, 1899, p. 33; *The First Snow*, 1899, p. 34; *The "City of Seattle" in Glacier Bay with the Muir Glacier in the Distance*, 1899, p. 35; *Sitka, Alaska*, 1899, p. 35; *White Pass (Lynn Canal in Distance)*, 1899, p. 35; *Looking Seaward*, c. 1898; p. 36; *Wiggins Family Portrait*, 1899, p. 37; *Advertising Photograph for Eastman Kodak Company*, c. 1900, p. 38, 40; *Head of the Grand Court*, 1900, p. 42; *Paris Exposition at Night*, 1900, p. 42; *Interior of Dutch House*, 1900, p. 44; *The Spinner*, 1898, p. 46; *Nursery Rhyme*, 1900, p. 47; *Returning Thanks*, 1900, p. 47; *The Mother*, 1901, p. 49; *The Babe*, 1901, p. 51; *Laverne*, 1902, p. 52; *Heimweih*, 1901, p. 53; *Wiggins' Barn Studio, Exterior*, 1901?-1905, p. 55; *Barn Studio, Interior*, c. 1901-1904, p. 56; *Family Cares*, 1902, p. 61; *The Edge of the Cliff*, 1903, p. 63; *Tiberias*, 1904, p. 64; *The Parthenon*, 1904, p. 67; *Sea of Galilee*, 1904, p. 68; *Arab Clasroom*, 1904, p. 69; *In Venice Waters*, 1904, p. 71; *Venice*, 1904, p. 71; *Still Life*, 1905, p. 74; *Song of the Sea*, 1903, p. 77; *Shadows*, 1905, p. 78; *Portrait of Fred Wiggins*, n.d., p. 81; *Wentz, the Artist*, c. 1905, p. 81; *Margaret*, 1903, p. 82; *My Pupil*, c. 1900, p. 82; *Friends (Mildred Wiggins and Margaret Ferr)*, c. 1912, p. 84; *Portrait of Mildred*, 1900-1901, p. 85; *Edge of the Wood*, 1906, p. 86; *Early Morning*, 1906, p. 86; *Irene*, 1906, p. 88; *Nymphaea*, c. 1908, p. 89; *Hollyhocks (June Idyl)*, c. 1910, p. 90; *Hallowe'en*, 1905, p. 91; *Family Portrait, Toppenish*, c. 1909, p. 93; *My Improvised Photo Studio in Our Alley in Toppenish*, 1929, p. 96; *The Wiggins Home, Toppenish, Washington*, p. 97; *Dethroned*, 1924, p. 98; *Broken Thread (The Tangle)*, 1929, p. 99; *Waiting for the Sand Man*, 1929, p. 100; *Sleepytime*, 1929, p. 100; *Hunger is the Best Cook*, 1898, p. 110; *Three Girls Flat*, c. 1892-1893, p. 112; *Myra and Lena's Studio Exhibition*, c. 1899, p. 113; *Polishing Brass*, 1903, p. 113; *Two Pilgrims*, 1904, p. 113; *Boy Twins of New York*, c. 1892, p. 115; *Difficult Phrasing*, c. 1900, p. 121; *The Knot*, c. 1899, p. 122; *Madonna*, 1908, p. 123.

982. Hull, R. "Myra Wiggins and Helen Gatch--Conflicts in American Pictorialism," *History of Photography* 16, 2 (Summer 1992): 152-169.

983. Wiggins, Myra Albert. "Alone in Holland," *American Annual of*

Photography and Photographic Times Almanac. New York, 1903. p. 227-231.

Williams, Adine
 See also #1040
Williams, Carla
 See also #1055
Williams, Elizabeth 'Tex'
 See also #1040

Williams, Pat Ward
 See also #1031, 1055

984. *Pat Ward Williams: Interview.* Chicago: Video Data Bank, The School of the Art Institute of Chicago, 1990. Video recording, 37 minutes. Interview by Angela Kelly.

985. Roth, Moira and Portia Cobb. "An Interview With Pat Ward Williams," *Afterimage* 16, 6 (January 1989): 5-7.

Wilson, Helena Chapellin
 See also #1070
Wilson, Joyce R.
 See also #1040
Winston, Judith
 See also #1071
Winterberger, Suzanne
 See also #1006
Withington, Eliza, 1825-1877
 See also #1058

Wolcott, Marion Post, 1910-1990
 See also #1008, 1013, 1037, 1053, 1058, 1063

986. Boddy, Julie M. *The Farm Security Administration Photographs of Marion Post Wolcott: A Cultural History.* Dissertation. State University of New York at Buffalo, 1982. 171 p.

987. Brumfield, John. "America's Depression Years. (Santa Barbara Museum of Art, Exhibit)," *Artweek* 19 (June 4, 1988): 11.

988. Clement, James. "Colour From the FSA. (Images of the 1930s Depression, Stills Gallery, Edinburgh, Scotland)," *British Journal of Photography* 131 (July 13, 1984): 727-729.

989. Hendrickson, Paul. *Looking for the Light: The Hidden Life and Art of Marion Post Wolcott*. New York: Alfred A. Knopf, 1992. 309 p.

A biography of Wolcott that is interspersed with many fragments of her letters and notes. The author has traveled to many of the places Wolcott photographed, and offers his own analysis of the photographs he included. *Up the south fork of the Kentucky River, Breathitt County, Kentucky,* 1940, p. xv; *Snowy Night, Woodstock, Vermont,* 1940, p. xxi; *Man reading* Life *magazine behind his car in trailer park, Sarasota, Florida,* 1941, p. xxii; *Migrant family from Missouri, Belle Glade, Florida,* 1939, p. xxiv; *A Negro going in the Entrance for Negroes at a movie theater, Belzoni, Mississippi,* 1939, p. 2; *Daughter of mulatto family returning home after fishing in Cane River; near Melrose, Louisiana,* 1940, p. 62; *Coal miner's child taking home kerosene for lamps, Scotts Run, West Virginia,* 1938, p. 64; *Unemployed miner's wife on company-owned house, Marine, West Virginia,* 1938, p. 68; *Children on bed (cornflakes boxes and dolls), coal miner's children, Charleston, West Virginia,* 1938, p. 69; *Coal miner's child coming through the "cathole." Bertha Hills, Scotts Run, West Virginia,* 1938, p. 70; *Coal miner who is known as "lady's man" and "smart guy," Bertha Hills, West Virginia,* 1938, p. 71; *Two couples in a booth in a juke joint, near Moore Haven, Florida,* 1939, p. 79; *Negroes jitterbugging in Juke Joint, Clarksdale, Mississippi,* 1939, p. 81; *An advertisement on the side of a drugstore, Wendell, North Carolina,* 1939, p. 83; *R. B. Whitley, who was one of the first citizens of the town, Wendell, North Carolina,* 1939, p. 85; *Baptism in Triplett Creek, Primitive Baptist Church, Rowan County, Morehead, Kentucky,* 1940, p. 87; *Parishioners peeling tomatoes for benefit picnic supper at St. Thomas church hall, Bardstown, Kentucky,* 1940, p. 89; *Cashiers paying off cotton pickers in plantation store, Marcella, Plantation, Mileston, Mississippi,* 1939, p. 91; *Negro men and women working in a field, Bayou Bourbeaux Plantation, Natchitoches, Louisiana,* 1940, p. 93; *Tenant farmer's children, younger one with rickets from malnutrition, Wadesboro, North Carolina,* 1938, p. 96; *A Negro woman and her children taking a rest from hoeing in the field, Natchitoches, Louisiana,* 1940, p. 107; *Member of the Wilkins family making biscuits for dinner on Corn Shucking Day, North Carolina,* 1939, p. 112; *Wilkins Clan assembled in the dining room, Stern, North Carolina,* 1939, p. 118; *Tenant farmer brings cotton samples to buyer and discusses price, Clarksdale, Mississippi,* 1939, p. 120; *Mosquito Crossing, near Greensboro, Georgia,* 1939, p. 131; *Bennie's grocery store, Sylvania, Georgia,* 1939, p. 132; *Signs in Bible Belt, Greene County, Georgia,* 1939, p. 133; *Torso of old Negro man, ex-slave, seated, Camden, Alabama,* 1939, p. 134; *Child in doorway of shack of migrant pickers and packing house workers, near Belle Glade, Florida,* 1939, p. 137; *Baby's sore eyes. The children of a migrant laborer, Belle Glade, Florida,* 1939, p. 139; *Entrance to Roney Plaza Hotel, Miami, Florida,* 1939, p. 141; *Spectators at horse races, Hialeah Park, Florida,* 1939, p. 142; *Brunch being served to member of private club, Miami, Florida,* 1939, p. 143; *A typical scene on a private beach club boardwalk, Miami, Florida,* 1939, p. 144; *The two sons of Mr. and Mrs. Ellis Adkins, a rural rehabilitation family, Coffee County, Alabama,* 1939, p. 147; *Playing checkers outside a service station on a Saturday afternoon, Greensboro,*

Georgia, 1939, p. 149; *Colored maids with white child in stroller visiting together on street corner, Port Gibson, Mississippi*, 1940, p. 156; *Uncle Joe Rogue, a Cajun, Natchitoches, Louisiana*, 1940, p. 157; *Barnyard in snow outside, Woodstock, Vermont*, 1940, p. 158; *Main Street during blizzard, Brattleboro, Vermont*, 1940, p. 159; *Proprietor of pool hall playing cards on pool table, Woodstock, Vermont*, 1940, p. 162; *One of the mulattos who works on the John Henry Plantation, Louisiana*, 1940, p. 165; *Child in doorway of old mountain cabin made of hand-hewn logs, Jackson, Kentucky*, 1940, p. 167; *Marion Post Wolcott helping change tire, with fence post as jack, in borrowed car, Breathitt County, Kentucky*, 1940, p. 168; *Children at desks, one-room schoolhouse, Breathitt County, Kentucky*, 1940, p. 169; *Russell Spears's tobacco barn, near Lexington, Kentucky*, 1940, p. 171; *Pie and box supper, Jackson, Kentucky*, 1940, p. 172; *Up Squabble Creek, near Buckhorn, Kentucky*, 1940, p. 173; *Tourist cabins imitating Indian teepees, Horse Cave, Kentucky*, 1940, p. 175; *Sunday afternoon in the front yard, near Lawrenceburg. Kentucky*, July 28, 1940, p. 177; *Planting corn before storm, Shenandoah Valley, near Luray, Virginia*, 1941, p. 184; *Post office in blizzard, Aspen, Colorado*, 1941, p. 188; *County judge on Main Street in front of mortuary, Leadville, Colorado*, 1941, p. 196; *Freight train, grain elevators, wheat, Great Plains, Carater, Montana*, 1941, p. 197; *Workhorses on an FSA project, Scottsbluff, Nebraska*, 1941, p. 200; *Linda Wolcott, Loudoun County, Virginia*, c. 1946, p. 212; *Michael and Lee Wolcott, Loudoun County, Virginia*, c. 1949, p. 213; *Lee Wolcott, Iran*, 1963, p. 228; *Washing children and laundry, cooking utensil, etc., in "jube." Iran*, 1961, p. 230; *Clinic, Lahore, Pakistan*, 1962, p. 231; *Minister, relatives, and friends of the deceased at a grave, Breathitt County, Kentucky*, 1940, p. 247; *Young cotton pickers waiting to be paid, Marcella plantation store, Mileston, Mississippi*, 1939, p. 260; *Sulky races, Mercer County, Kentucky*, 1940, p. 263; *Country peddler who goes from Door to door selling hardware and groceries, Woodstock, Vermont*, 1940, p. 264; *Transportation for hepcats, Louisville, Kentucky*, 1940, p. 265; *Winter visitors on running board of car on beach, Sarasota, Florida*, 1941, p. 267; *Cutting crested wheat grass with an old binder pulled by a four-horse team, Judith Basin, Montana*, 1941, p. 269; *Wife of muskrat trapper, bayou country*, 1941, p. 271; *Satterfield tobacco warehouse, Liberty Cafe, Durham, North Carolina*, 1939, p. 301; *Cars parked along the highway near the Duke University stadium, Durham, North Carolina*, 1939, p. 302; *Waiting for strikebreakers (scabs) to come out of the copper mines, Ducktown, Tennessee*, 1939, p. 303; *Coal miners waiting for a ride, Caples, West Virginia*, 1938, p. 304; *Mexican miner and child, Berth Hill, Scotts Run, West Virginia*, 1938, p. 305; *Swimming in the fountain across from Union Station, Washington, D.C.*, 1938, p. 306; *Lineup of migrant vegetable pickers getting paid off in field, near Belle Glade, Florida*, 1939, p. 307; *A Spanish muskrat trapper in the doorway of his marsh home, Delacroix Island, St. Bernard Parish, Louisiana*, 1941, p. 308; *A Spanish muskrat trapper telling about the trappers' war, St. Bernard Parish, Louisiana*, 1941, p. 309; *Sunset Village, FSA project for defense workers, Radford, Virginia*, 1941, p. 310.

990. Hurley, F. Jack. *Marion Post Wolcott: A Photographic Journey.* Albuquerque: University of New Mexico Press, 1989. 228 p. Bibliography: p. 226-228.

A major biography and portfolio of Marion Post Wolcott's photographic images, through the Depression years, into the resorts and the wealthy and into rural America. Hurley incorporates her correspondence into the text to help to provide a glimpse into difficulty photographers of the period faced.

Morris Carnovsky, 1935, p. 16; *Elia Kazan*, 1935, p. 17; *Ralph Steiner filming "People of the Cumberlands," Near Highlander School, Tennessee*, 1937, p. 19; *Tenant Farmer's Children, the Younger One with Rickets. Near Wadesboro, North Carolina*, 1938, p. 25; *Mrs. Lloyd, Ninety-One Years Old, and Daughter with Pellagra, in Doorway of Old Log House. Near Carboro, North Carolina*, 1939, p. 26; *Ida Valley Farms, Shenandoah Homesteads. Luray, Virginia*, 1941, p. 28; *Hot Lunches for children of agricultural workers in day nursery of Okeechobee Migratory Labor Camp. Belle Glade, Florida*, 1941, p. 29; *Coal miner's daughter carrying home can of kerosene to be used in oil lamps. Pursglove, Scott's Run, West Virginia*, 1938, p. 32; *Miner's wife on porch of their home, and abandoned company store. Pursglove, West Virginia*, 1938, p. 33; *Project Borrower. Greene County, Georgia*, 1939, p. 34; *A Negro shack with a mud chimney. Beaufort, South Carolina*, 1938, p. 35; *A woman from new jersey picking beans. Homestead, Florida*, 1939, p. 37; *Migrant laborer's children living in overcrowded camps with very bad sanitary conditions. Belle Glade, /Florida*, 1939, p. 39; *Oldest child of migrant packing-house workers preparing supper. Near Homestead, Florida*, 1939, p. 41; *Roadside signs. "Bible Belt," Greene County, Georgia*, 1939, p. 43; *Jorena Pettway sorting peas inside her smokehouse. Gee's Bend, Alabama*, 1939, p. 45; *The May Day--Health Day queen and her attendants. Near Irwinville, Georgia*, 1939, p. 47; *Gladys Crimer drying her hands on a paper towel and Bernice Mathis and Edna Law washing theirs in the cleanup corner in the second- and third-grade schoolroom. Near Montezuma, Georgia*, 1939, p. 48; *Part of the old house and the new home of Little Pettways' family, Gee's Bend, Alabama*, 1939, p. 49; *Members of the Negro county land-use planning committee working on the county map. Yanceyville, North Carolina*, 1940, p. 59; *A Negro tenant family on the porch of their home. Caswell County, North Carolina*, 1940, p. 60; *Members of the Wilkins clan at dinner. Stem, North Carolina*, 1939, p. 62; *Corn-shucking at the Fred Wilkins Farm. Stem, North Carolina*, 1939, p. 63; *Haircutting in front of general store, Marcella Plantation. Mileston, Mississippi*, 1939, p. 66; *Cashiers paying off cotton pickers in plantation store. Mileston, Mississippi*, 1939, p. 67; *Barnyard blizzard. Near Woodstock, Vermont*, 1940, p. 69; *Workers in paper mill returning home. Berlin, New Hampshire*, 1940, p. 70; *Maple sugaring--gathering sap from trees. North Bridgewater, Vermont*, 1940, p. 71; *Town Hall. Center Sandwich, New Hampshire*, 1940, p. 73; *Townspeople at town meeting. Woodstock, Vermont*, 1940, p. 74; *Counting ballots to see whether the town will go wet or dry. Woodstock, Vermont*, 1940, p. 74; *Main Street during blizzard Brattleboro, Vermont*, 1940, p. 75; *During the Cotton Carnival. Memphis, Tennessee*, 1940, p. 77; *Working in the*

field, Ida Valley farms. Near Luray, Virginia, 1940, p. 78; *A sign advertising tourist cottages. Pensacola, Florida,* 1941, p. 80; *New housing for migrant agricultural workers. Belle Glade, Florida,* 1940, p. 84; *A guest at a trailer camp washing his car. Sarasota, Florida,* 1941, p. 86; *Loading Hay on Edgar Back's Farm. Noctor, Kentucky,* 1940, p. 87; *Farmer in buggy taking home sack of feed. Lexington, Kentucky,* 1940, p. 88; *Baptism in Triplett Creek. Morehead, Kentucky,* 1940, p. 89; *Marion Post Wolcott helping change tire. Breathitt County, Kentucky,* 1940, p. 90; *The Hazards of traveling by car. Jackson, Kentucky,* 1940, p. 91; *Minister, relatives, and friends of the deceased at a memorial meeting. Breathitt County, Kentucky,* 1940 p. 93; *Couple carrying home groceries, kerosene on horseback. Kentucky Mountains,* 1940, p. 93; *Children at desks, one-room schoolhouse. Breathitt County, Kentucky,* 1940, p. 94; *Wagons deliver tobacco o a barn on the farm of Russell Spears. Near Lexington, Kentucky,* 1940, p. 96; *Mountaineers cutting tobacco. Jackson, Kentucky,* 1940, p. 97; *The Titus Oaskley family stripping, tying, and grading tobacco in their bedroom, Granville County, Kentucky,* 1939, p. 97; *Hanging hands of tobacco to dry in barm. Near Lexington, Kentucky,* 1940, p. 98; *Mr. and Mrs. Compton, Negro sharecroppers, stripping and grading tobacco. Carr, North Carolina,* 1939, p. 99; *Farmers getting their checks at the warehouse offices after their tobacco has been sold. Durham, North Carolina,* 1939, p. 99; *Wife of Spanish-American muskrat trapper. In the Bayou area of Louisiana,* 1941, p. 101; *Marion Post Wolcott with Rolleiflex and Speed Graphic in hand, on assignment. Vermont,* 1939-40, p. 104; *Affluent couple leaving the horse races. Warrenton, Virginia,* 1941, p. 106; *A judge at the horse races. Warrenton, Virginia,* 1941, p. 107; *Cutting crested wheat grass, old binder-four horse team. Judith Basin, Montana,* 1941, p. 111; *Freight train, grain elevators, wheat, Great Plains, Carter, Montana,* 1941, p. 112; *The Rocky Mountains, west of the Continental Divide, as seen from the top of Logan Pass on Goping-to-the-Sun Highway,* p. 114; *Post Office in blizzard. Aspen, Colorado,* 1941, p. 117; *Michael and Lee Wolcott,* 1949, p. 120; *Wolcott child, Virginia,* 1942, p. 122; *John and Lee Wolcott. Waterford, Virginia,* 1944, p. 123; *John Wolcott with rubber doll and Linda Wolcott. Lovettsville, Virginia,* c. 1946, p. 124; *Linda and John Wolcott in Creek on Farm, Lovettsville, Virginia,* c. 1944, p. 125; *Plowing. Near Waterford, Virginia,* c. 1951, p. 127; *Gail with neighbor's goat. Oakton, Virginia,* 1942, p. 129; *Indian children, recuperating from tuberculosis in Presbyterian Hospital. Albuquerque, New Mexico,* c. 1957, p. 132; *Washing children and laundry, cooking utensil, etc., in "jube." Hamadan, Iran,* 1961, p. 133; *Tribal settlement enroute from Teheran to the Caspian Sea. Iran,* 1960, p. 134; *Clinic, Lahore, Pakistan,* 1963, p. 135; *Nurse discussing the "loop" with villager, family-planning clinic. India,* 1968, p. 136; *Sick people in front of clinic. Lahore, Pakistan,* 1962, p. 136; *Police waiting for the arrival of the shah. Teheran, Iran,* 1961, p. 138; *Esso kerosene cart. Aswan, Egypt,* 1967, p. 139; *Protest meeting, Grey Panthers and other groups. San Francisco, California,* c. 1984, p. 143; *Winter visitors picnic on running board of car on beach. Sarasota, Florida,* 1941, p. 151; *Spectators at horse races. Hialeah Park, Florida,* 1939, p. 153; *Sulky races. Shelbyville County Fair, Kentucky,* 1940, p. 154; *Men at horse races, Hialeah Park, Florida,* 1939, p.

155; *Mr. Whitley in his general store. Wendell, North Carolina*, 1940, p. 156; *Tenant farmer brings his cotton sample to buyer/broker to discuss price. Clarksdale, Mississippi*, 1939, p. 157; *Young Negroes waiting to be paid for picking cotton, inside plantation store. Mileston, Mississippi*, 1939, p. 158; *Taking a drink and resting from hoeing cotton. Natchitochoes, Louisiana*, 1941, p. 159; *Colored maids with white child in stroller visiting together on street corner. Gibson, Mississippi*, 1940, p. 160; *Entrance to Roney Plaza Hotel. Miami, Florida*, 1939, p. 161; *"The Whittler," an old Negro man (ex-slave). Camden, Alabama*, 1939, p. 162; *Typical Scene, private beach club boardwalk. Miami, Florida*, 1939, p. 163; *Migrants playing checks, on juke joint porch. Near Okeechobee, Florida*, 1939, p. 164; *Gambling with their "cotton money" in back of juke joint. Clarksdale, Mississippi*, 1939, p. 165; *Negro men and women working in a field. Natchitoches, Louisiana*, 1940, p. 166; *Two Negro women carry packages. Natchez, Mississippi*, 1940, p. 167; *Mosquito Crossing. Near Greensboro, Georgia*, 1939, p. 169; *Bennie's grocery store. Sylvania, Georgia*, 1939, p. 170; *Migrant agricultural workers waiting in line. Belle Glade, Florida*, 1939, p. 171; *Winter visitor being served brunch in a private beach club. Miami, Florida*, 1939, p. 172; *Winter visitors relaxing on the beach beside their car near a trailer park. Sarasota, Florida*, 1939, p. 173; *A child of migratory packing-house workers washing her doll. Belle Glade, Florida*, 1939, p. 174; *A day laborer chopping cotton. Perthshire, Mississippi*, 1940, p. 175; *A member of the Wilkins family making biscuits for dinner. Stem, North Carolina*, 1939, p. 176; *Parishioners peeling tomatoes for a church benefit supper. Bardstown, Kentucky*, 1940, p. 177; *Migrant family from Missouri camping out in cane brush. Canal Point, Florida*, 1939, p. 178; *Man reading Life magazine in trailer park. Sarasota, Florida*, 1941, p. 179; *Coal miners waiting for a ride. Caples, West Virginia*, 1938, p. 180; *Coal miner's children. Charleston, West Virginia*, 1938, p. 181; *"Pahokee Hotel," migrant vegetable pickers' quarters. Near Homestead, Florida*, 1941, p. 182; *Coal miner's child using the "cathole." Scott's Run, West Virginia*, 1938, p. 183; *Coal miner's wife carrying water from the hill. Scott's Run, West Virginia*, 1938, p. 184; *A street in Charleston, West Virginia*, 1938, p. 185; *Mexican miner carrying water up a hill to his home. Scott's Run, West Virginia*, 1938, p. 186; *Movie advertisement on the side of a building, "Birth of a Baby." Welch, West Virginia*, 1938, p. 187; *Coal miners' card game on the porch. Chaplin, West Virginia*, 1938, p. 188; *Picketing copper miners on strike waiting for the "scabs." Ducktown, Tennessee*, 1939, p. 189; *Mexican miner and child. Scott's Run, West Virginia*, 1938, p. 190; *Migrant vegetable picker's children. Near Belle Glade, Florida*, 1939, p. 191; *Farmers sleeping in a "white" camp room in a warehouse. Durham, North Carolina*, 1939, p. 194; *Pie and box supper. Near Jackson, Kentucky*, 1940, p. 195; *Two couples in a booth in a juke joint. Near Moorehaven, Florida*, 1939, p. 196; *On assignment in a borrowed car and stuck in a creek bed road. Breathitt County, Kentucky*, 1940, p. 197; *Planting corn before the storm in the fertile Shenandoah Valley. Near Luray, Virginia*, 1941, p. 198; *Work horses on a Farm Security Administration project. Scott's Bluff, Nebraska*, 1941, p. 199; *Wigwam Motel. Bardstown, Kentucky*, 1940, p. 200; *Carnival signs, Strawberry Festival. Plant City, Florida*,

1939, p. 201; *County judge on the main street. Leadville, Colorado,* 1941, p. 202; *Steel worker. Pittsburgh, Pennsylvania,* 1935, p. 203; *Dudes watching rodeo, Crow Agency Fair. Montana,* 1941, p. 204; *Mulatto worker on John Henry cotton plantation, Natchitoches, Louisiana,* 1939, p. 205; *Man playing guitar with his two children on porch. Natchitoches, Louisiana,* 1940, p. 206; *Daughter of a Cajun family. Melrose, Louisiana,* 1940, p. 207; *A Negro family on the porch of their home. Natchitoches, Louisiana,* 1940, p. 208; *A fireplace in an old mud hut. Melrose, Louisiana,* 1940, p. 209; *Proprietor of a pool hall playing cards. Woodstock, Vermont,* 1939, p. 210; *After a blizzard, center of town. Woodstock, Vermont,* 1940, p. 211; *Peddler who goes door to door, selling hardware and groceries. Woodstock, Vermont,* 1940, p. 212; *Farmhouse and attached shed in snow. Putney, Vermont,* 1939, p. 213; *Sunset village, A Farm Security Administration project for defense worker. Radford, Virginia,* 1941, p. 214; *Boy Scouts inspecting and learning about army equipment. Washington, D.C.,* 1941, p. 215; *Soldiers on a street corner. Starke, Florida,* 1940, p. 216; *Swimming in the fountain across from Union Station. Washington, D.C.,* 1938, p. 217; *Negro using outside stairway for "colored" to enter movie theatre. Belzoni, Mississippi,* 1939, p. 219; *Satterfield tobacco warehouse, Liberty Cafe. Durham, North Carolina* 1939, p. 220.

991. Murray, Joan. "Marion Post Wolcott: A Forgotten Photographer from the FSA Picks Up Her Camera Again," *American Photographer* 4, 3 (March 1980): 86-93.

992. Raedeke, Paul. "Interview with Marion Post Wolcott." *Photo Metro* (February 1986): 3-17.

993. Raedeke, Paul. "Marion Post Wolcott: Photographs for the Farm Security Administration Documenting Rural American Life in the 1930s and 1940s." *Arrival* (Berkeley, CA) (Summer 1987): 16-27.

994. Tweton, D. Jerome. "'Taking Pictures of the History of Today': The Federal Government Photographs of North Dakota, 1936-1942," *North Dakota History* 57, 3 (1990): 2-13.

995. Wolcott, Marion Post. *FSA Photographs.* Introduction by Sally Stein. Carmel, CA: Friends of Photography, 1983. 48 p. Chiefly illustrations. Bibliography: p. 50. Chronology and Correspondence: p. 44-48.
 Stein's introduction, "Marion Post Wolcott: Thoughts on Some Lesser Known FSA Photographs," considers the relationship between the New Deal documentary photography projects and Stryker and Wolcott.
Coal miner's child carrying home a can of kerosene, Scotts Run, West Virginia, 1938, pl. 1; *Unemployed miner's wife, on porch of company house, Marine, West Virginia,* 1938, pl. 2; *Log cabin by creek in Appalachian Mountains, Tennessee,* 1940, pl. 3; *Coal miner's children in their shack; no water, sanitary facilities or*

electricity, Charleston, West Virginia, 1938, pl. 4; *Mosquito Crossing, Greene County, near Greensboro, Georgia,* 1939, pl. 5; *Bennie's grocery, in Negro area of town, Sylvania, Georgia,* 1939, pl. 6; *Advertisement on the side of a drug store, Wendell, North Carolina,* 1939, pl. 7; *Business managers paying off cotton picker, Marcella Plantation, Mileston, Mississippi,* 1939, pl. 8; *Sharecropper negotiating price of his cotton with cotton broker, Clarksdale, Mississippi,* 1939, pl. 9; *Waiting for strike-breakers to come out of the copper mines, Ducktown, Tennessee,* 1939, pl. 10; *Men playing checkers on porch, Florida,* 1939, pl. 11; *Gambling (skin game) in juke joint on Saturday night, near Moore Haven, Florida,* 1941, pl. 12; *Haircutting in front of general store on Saturday afternoon, Marcella Plantation, Mileston, Mississippi,* 1939, pl. 13; *Fields of shucked corn near Marion, West Virginia,* 1940, pl. 14; *A member of Wilkins family making biscuits on corn-husking day, Tallyho, North Carolina,* 1939, pl. 15; *Children going to school, Breathitt County, Kentucky,* 1940, pl. 16; *Baptism of members of Primitive Baptist church in Triplett Creek, Rowan County, near Morehead, Kentucky,* 1940, pl. 17; *Street Scene with a church sign, Charleston, South Carolina,* 1938, pl. 18; *Negro entering movie theater by outside entrance to upstairs colored section, Belzoni, Mississippi,* 1939, pl. 19; *Negro boys waiting inside plantation store to be paid for picking cotton, Marcella Plantation, Mileston, Mississippi,* 1939, pl. 20; *Jitterbugging on a Saturday night in juke joint near Clarksdale, Mississippi,* 1939, pl. 21; *Two men from a cotton plantation in a juke joint near Clarksdale, Mississippi,* 1939, pl. 22; *Two young couples in a juke joint, near Moore Haven, Florida,* 1939, pl. 23; *Winter visitor being served brunch in a private club, Miami, Florida,* 1939, pl. 24; *Woman lying in the sun, Miami beach, Florida,* 1939, pl. 25; *Winter tourists picnicking on running board of car near trailer park, Sarasota, Florida,* 1941, pl. 26; *Man reading <u>Life Magazine</u> behind his car in trailer park, Sarasota, Florida,* 1941, pl. 27; *Meeting of the Colored County Land Use Planning Committee to work on county maps, in school house, Yanceyville, North Carolina,* 1940, pl. 28; *82-year-old woman reading in literacy class, FSA project, Gee's bend, Alabama,* 1939, pl. 29; *Hot lunch in day-care center in new FSA project community building, Okeechobee migrant labor camp, Belle Glade, Florida,* 1941, pl. 30; *Defense worker's home in FSA housing project, Sunset Village, Radford, Virginia,* 1941, pl. 31; *Tenant farmer's children, younger one with rickets from malnutrition,* 1939, pl. 32; *Two colored maids on a street corner with white child in stroller, Port Gibson, Mississippi,* 1940, pl. 33; *Main Street during blizzard, Brattleboro, Vermont,* 1940, p. 46; *Board of Directors of FSA Two Rivers non-stock cooperative inspecting Farmall tractor, Waterloo, Nebraska,* 1941, p. 47; *Spectators at horse races, Hialeah Park, Miami, Florida,* 1939, pl. 47.

Woodbridge, Louise Deshong, 1848-1925
 See also #1058,1063

Woodman, Francesca

996. Hirsch, Faye. "Odd Geometry: The Photographs of Francesca Woodman,"

The Print Collector's Newsletter 25 (May/June 1994): 45-48.

Woodworth, Grace
 See also #1009
Wooten, Bayard, 1875-1959
 See also #1058
Worthington, Ethel
 See also #1040
Wrausmann, Gale
 See also #1071
Wright, Holly
 See also #1063
Wuebker, Mary Ann
 See also #1071
Wynroth, Via
 See also #1069

Yeager, Bunny

997. Cohen, Barney. "Innocent Fascination: Bunny Yeager Reigned As Queen
 of Cheesecake in the 1950s, but Then Sex Got Graphic and the Big Blond
 Photographer From Miami Was Out," *American Photographer* 19, 1 (July
 1987): 44-55.

998. Yeager, Bunny. *How I Photograph Myself.* New York: A. S. Barnes,
 1964. 157 p.

999. Yeager, Bunny. *How I Photograph Nudes.* New York: A.S. Barnes, 1963.
 144 p.

Ylla (Camilla Koffler)

999.1 Ylla. *The Little Elephant.* New York: Harper Row, 1956.

999.2 Ylla. *Polar Bear Brothers.* New York: Harper Row, 1960.

Zadorozny, Kathy
 See also #1071

BIBLIOGRAPHY OF COLLECTED WORKS OF AMERICAN WOMEN PHOTOGRAPHERS

1000. Albin O. Kuhn Library & Gallery. Specials Collections Department.
 *Fields of Vision: Women in Photography: From the Photography
 Collections, Specials Collections Department, Albin O. Kuhn Library &
 Gallery, University of Maryland, Baltimore County.* Baltimore: The
 Library, 1995. 68 p.
 Catalogue of an exhibition, photographs are arranged in chronological
 order in an attempt to place these women photographers in the larger
 context of the history of photography. Each section is prefaced by a short
 essay, and each photographer's images which are represented in the
 catalogue are augmented by critical text.

Abbott, Berenice: *Saints for Sale, 382 Water Street,* c. 1932, pl. 33; **Arbus,**
Diane: *Identical Twins, Cathleen (l.) and Colleen, Members of a Twin Club in New
Jersey,* 1967, pl. 60; **Boughton,** Alice; **Bourke-White,** Margaret: *Steel Worker:
Magnitogorsk,* 1951, pl. 25; **Brigman,** Anne W.:*Finis,* c. 1910, pl. 22; **Cahn,**
Elinor B.; **Cowin,** Eileen: *Untitled,* 1985, pl. 96; **Crane,** Barbara: *Albanian Soccer
Players,* 1975, pl. 79;**Cryor,** Cary Beth; **Dalzell,** Pat; **Dater,** Judy: *Vickie Singer,*
1988, pl. 83; **Davenport,** Alma; **Fellman,** Sandi; **Flaherty,** Frances Hubbard:
Untitled, c. 1932-34, pl. 31; **Grossman,** Mildred: *Untitled,* 1957, pl. 53; **Hughs,**
Mariah; **Jacobi,** Lotte: *Photogenic,* pl. 41; **Käsebier,** Gertrude; **Kasten,** Barbara;
Klochko, Deborah; **Larrabee,** Constance Stuart; **Lewis,** Mrs. J.B., n.d.: *Untitled,*
pl. 1; **Lopez,** Martina; **Mark,** Mary Ellen: *India,* 1989, pl. 97; **Mathis,** Jill; **Model,**
Lisette: *Broadway Singer, Café Metropole,* c. 1946, pl. 38; **Morgan,** Barbara:
Funkia Leaf Solarized, 1950, cover; **Netherwood,** Joan Clark; **Ockenga,** Starr:
Jacob and My Father's Portrait, 1970s, pl. 61; **Parker,** Olivia: *Shell Beans,* 1980,
pl. 85; **Peterich,** Gerda; **Rebhan,** Gail S.; **Rich,** Linda; **Sherman,** Cindy; **Simqu,**
M.K.; **Smith,** Mrs. R.A. (Rebecca Ann Reynolds Smith): *[Men's portraits]* pl. 13;
Smith, Shelly J.; **Spencer,** Ema; **Sturmer,** Caren; **Sutton,** Eva; **Ulmann,** Doris:
H.L. Mencken, before 1925, pl. 23; **Watson-Schütze,** Eva; **Young,** Barbara.

1001. Allen, Lois. "Women in Photography," *Artweek* 28 (December 1997): 24-
 26.

Ladd, Sarah Hall; **White,** Lily; **Wiggins,** Myra Albert.

1002. Baker, Tracey. "Nineteenth Century Minnesota Women Photographers,"
 Journal of the American West, 28, 1 (1989): 15-23.

1003. Bond, Constance. "A Traveling Exhibition on Women Photographers
 Doesn't Skirt the Issue," *Smithsonian,* 27 (March 1997): 112-119.

1004. Bonney, Claire. "The Nude Photograph: Some Female Perspectives,"
 Woman's Art Journal 6 (Fall/Winter 1985/86): 9-14.

Dater, Judy; **Sherman,** Cindy; **MacAdams,** Cynthia; **Ockenga,** Starr; **Niccolini,**
Dianora.

1005. Calhoun, Catherine. "The Secrets of Their Success," *American Photo* 6

(July/August 1995): 34-36+.
Siefff, Jeanloup; **Leibovitz**, Annie; **Mark**, Mary Ellen.

1006. Cohen, Joyce Tenneson. *In/Sights: Self-portraits by Women*. With an
essay by Patricia Meyer Spacks. Boston: David R. Godine, 1978. 134 p.
Includes brief notes by the photographers and very brief biographies. A
personal selection of photographs, compiled from solicited submissions.
Allport, Catherine Gardner: p. 45; **Aschenbach**, June: p. 34; **Benedict-Jones**,
Linda: p. 42;**Berger**, Eileen: p. 47; **Bondy**, Friedl, p. 52, 53; **Bransfield**, Susan, p.
5; **Brown**, Gillian: p. 28; **Carrey**, Bobbi: *Legacies,* p. 74*; Terra Firma,* p. 75*; Site
Unseen,* p. 76; *Weight Watcher,* p. 77; *Solitary Confinement,* p. 78; *Photosynthesis,*
p. 79; **Clemens**, Karen: *Portrait to Myself,* p. 64; **Cohen**, Joyce Tenneson, p. 104-
109; **Conklin,** Honor: *Anna's Susan,* p. 70; **Crosby**, Susan Camp: *Woman at
Clothesline,* p. 10; **Culver**, Joyce: *Self-Portrait With Judy,* p. 67; **Daniels,** Tessie:
p. 18, 19; **Diamond**, Ethel: *Self-portrait as the Mother of Two Small Children,* p.
12; **Dorfman**, Elsa: *A Note on 'My Thirty-ninth Birthday,'* April 16, 1976, p. 30;
Edelson, Mary Beth: p. 46, 72; **Emond**, Suzanne: p. 13; **Enos**, Chris, p. 7; **Fallan,**
Anne-Catherine, p. 51; **Fellman**, Sandi, p. 8, 9; **Fisher,** Elaine: p. 31; **Galembo**,
Phyllis, p. 65; **Golden**, Judith: from the *Chameleon Series: Faye Dunaway, cool...,*
p. 86*; Star Struck,* p. 87*; Redhead Fantasy,* p. 88; *World War II Ace,* p. 89*;
Frankly, My Dear, I Don't Give a Damn,* p. 90*; Sweet Sue,* p. 91; **Heyman**,
Abigail, p. 1; **Hiser**, Cherie: *Untitled,* p. 22; *Husband's Mistress,* p. 23; **Hurley**,
Patricia, p. 4; **Jennings**, De Ann, p. 92-97; **Johnston**, Joyce: p. 49; **Kessler**, Eve:
Untitled, p. 2, *I Always Wanted to Look Like My Father,* p. 14; **Lasko**, Katrina: *Joy,*
p. 55; **Leonard,** Joanne: *Variations on a Sleeping Theme,* p. 16; *Journal Entry
(Woman and Frog),* p. 17; **Lindroth**, Linda: *Nude Descending a Staircase,* p. 44;
Livingston, Jacqueline: *Better Phone Home--Gut Shit,* p. 62; **Lynne**, Jill: *The
Queen of Hearts, #III,* p. 33; **Mandelbaum**, Ann: *Untitled,* p. 6, 38; **Morris**, Kathy:
Fruit of the Loom, p. 43; **Moulton**, Rosalind: p. 36, 40; **Murray**, Carol: p. 32;
Natal, Judy, p. 60; **Nettles**, Bea: *Christmas Doll* from *Ghosts and Stitched
Shadows,* p. 98, 99*; Swan(song) dream* from *Bea and the Birds,* p. 100; *Lady Lake
as a Young Girl* from *Ghosts and Stitched Shadows,* p. 101*; Summer of '70,* p. 102;
Lake Lady Legs from the *Neptune Series,* p. 103; **Norfleet**, Barbara, p. 57;
Oppenheimer, C. K.: *Inheritance,* p. 59; **Osinki**, Christine: from *The Bedroom
Suite,* p. 26; **Page**, Christine: *The Way I Saw Myself Before Becoming a
Photographer,* p. 11; **Pararo**, Cynthia, p. 68; **Peugh**, Karen A.: *Me and Baby Dear,*
p. 15; **Pincus**, Hildy:*Self-Portrait,* 1975, p. 29; **Pitts**, Mary, p. 58; **Plesur**, Karen,
p. 63; **Portner**, Dinah Berland: *The Shell,* 1976, p. 69; **Posner**, Skyler Rubin: *Self-
Portrait According to Gertrude Stein ('That's the Answer'),* p. 25; **Ragan**, Vicki:
p. 41, 54; **Reilley**, Shawna: p. 39; **Schreibman, Jane**: *The Ladies,* p. 66, *Inside the
Irving,* p. 66; **Schwartz**, Linda J.: p. 37; **Starr, Nina Howell**: *Considering Myself,*
p. 71; **Shoats**, Soledad Carrillo: *La Camisole,* p. 20; *Untitled,* p. 21; **Szabo**,
Marilyn, p. 61; **Tucker**, Jane: *Nudes in the Attic,* p. 35; **Valois**, Pamela: p. 27; **Von
Zur Muehlen**, Bernis, p. 3; **Weissman**, Naomi: *The Photographer as Muhammad
Ali,* p. 24; *New Shoes,* p. 50; **Wenzel**, Ann F.: *Self-Portrait with Bruce,* p. 48;

Winterberger, Suzanne: *Untitled,* p. 80-84; *Imitating Saguaro Cacti,* p. 85; **Younger**, Cheryl, p. 56;

1007. "Connections: An Invitational Portfolio of Images and Statements by Twenty-Eight Women," *Exposure* 19, 3 (1981): 19-44.
Brooks, Eileen: *Untitled,* 1981; **Burns,** Marsha: from *Anima/Animus,* 1976; **Cowin**, Eileen: *Untitled;* **Dater**, Judy: *Untitled,* 1980; **Edelson**, Mary Beth: *Private Ritual, Port Clyde, Maine,* 1978; **Enos**, Chris: *Untitled (Plant Series)* 1979; **Faller**, Marion: from a series of street portraits, 1972-5; **Golden,** Judith: *Jacki,* 1981; *Joy,* 1981; *Naomi,* 1980; *Marsha,* 1981; **Gordon**, Bonnie: *Antler Envy,* 1971; *Words About Deer,* 1981; **Hahn**, Betty: *Chicago Family: Grandmother,* 1979; **Heyman**, Abigail; **Kasten**, Barbara: *Construct,* 1980; **Lehman**, Minnette: from *Unadorned,* 1976-81; **Leonard**, Joanne: *Julia and Bird Water-Whistle,* 1980; **Lyons**, Joan: *"A Composite of Some Current Concerns";* **MacNeil**, Wendy: *Mariet Baratte,* 1978/81; **Mendieta**, Ana: *Silveta Series,* Oaxaca, Mexico, 1980; **Mitchell**, Margaretta K.: *Granny Hood in the Early Morning,* 1975; **Nestor,** Helen: *Three Divorced Women Share a Home with Their Three Daughters,* 1978; **Noggle**, Anne: *Yolanda in the Patio,* 1981; **Ockenga**, Starr: *Mother with Daughters,* 1981; **Parada**, Esther: *"Memory Warp;"* **Parker**, Olivia: *Cyclamen,* 1980; **Schoenfeld**, Diana: *Leaf with Stamen;* **Skoff**, Gail: *Lizard Mound,* 1980.

1008. *Contemporary Photographers.* St James Press.
 First edition, 1982; Second edition, 1988; Third edition, 1995. Includes biographical information, list of individual exhibitions, selected group exhibitions, a representative photograph, collections, publications, autobiographical statement of their work or on contemporary photography and a signed critical essay.
Abbott, Berenice; **Arnold,** Eve; **Astman**, Barbara; **Auerbach**, Ellen; **Barney**, Tina;**Bassman**, Lillian; **Bernhard**, Ruth; **Bing**, Ilse; **Bullock**, Edna; **Burson**, Nancy; **Caffery**, Debbie Fleming; **Callis**, Jo Ann; **Charlesworth**, Sarah E.; **Connor**, Linda; **Corpron**, Carlotta M.; **Cosindas**, Marie; **Cowin**, Eileen; **Crane**, Barbara; **Cunningham**, Imogen; **Dahl-Wolfe**, Louise; **Dater**, Judy; **Decock**, Liliane; **Ess**, Barbara; **Freedman**, Jill; **Frissell**, Toni; **Gilpin**, Laura; **Golden**, Judith; **Groover**, Jan; **Hahn**, Betty; **Heyman**, Abigail; **Hoban**, Tana; **Honey**, Nancy; **Jacobi**, Lotte; **Knorr**, Karne; **Kolko**, Berenice; **Lake**, Suzy; **Lemieux**, Annette; **Lennard**, Erica; **Leonard**, Joanne; **Levitt**, Helen; **Lipper**, Susan; **Lyons**, Joan; **Mann,** Sally; **Mark**, Mary Ellen; **Mayes**, Elaine; **Meiselas**, Susan; **Miller**, Lee; **Model**, Lisette; **Morath**, Inge; **Morgan**, Barbara; **Nettles**, Bea; **Noskowiak**, Soyna; **Orkin**, Ruth; **Palfi**, Marion; **Parker**, Olivia; **Post Wolcott**, Marion; **Purcell**, Rosamond Wolff; **Rankaitis**, Susan; **Raymond**, Lilo; **Resnick**, Marcia; **Rexroth**, Nancy; **Ross**, Judith Joy; **Ruben**, Ernestine; **Rubenstein**, Meridel; **Rubinstein**, Eva; **Savage**, Naomi; **Sherman**, Cindy; **Skoff**, Gail; **Skoglund**, Sandy; **Sonnenman**, Eve; **Tenneson**, Joyce; **Turbeville**, Deborah; **Weems**, Carrie Mae.

1009. Doherty, Amy S. "Photography's Forgotten Women," *AB Bookman's*

Weekly (November 4, 1985): 3272-3312.

1010. Douglas, Anna. "Childhood: A Molotov Cocktail For Our Time,"
Women's Art Magazine 59 (1994): 14-18.
Baylis, Diane; **Honey,** Nancy; **Mann**, Sally.

1011. "The Dreamer Dreamed," *Aperture* 114 (Spring 1989): 56-69.
Augeri, Lynne; **Burson**, Nancy; **Dater**, Judy; **Golden**, Judith; **Shaw**, Susan.

1012. *8 Visions: Works By Eight Contemporary American Women.* Tokyo:
Parco, 1988.
Japanese and English Text. 92 p. Chiefly Illustrations.
Includes brief statements by the artists.
Burns, Marsha: *#45007 (Nude with Bathing Cap).* 1979; *Invitation #4, #2, #5,*
1977; *Pony, Seattle,* 1984; *#2024044,* 1983; *Michelle, New York,* 1986; *N'Bushe,
New York,* 1986; **Coleman**, Judy: *All Fall Down,* 1986; *Smokey Leg,* 1983; *Head
Thrown Back,* 1983; *Hug, 1984; Two Hands on Back,* 1984; *Untitled,* 1987; *Fire
Fly,* 1986; ; **Filter,** Karen: *Man with Umbrella,* 1984; *Untitled,* 1987; *Lips,* 1987;
Untitled, 1985; *Untitled,1986 Bedroom,* 1985; *Mirror,* 1986; **Groover**, Jan:
Untitled, 1987, 1978, 1984, 1982, 1983, 1985; **Haber**, Sandra L.: *Pink Flowers,*
1985; *Haitian Fish,* 1983; *Haitian Morning,* 1983; *Untitled,* 1987 (4); **Kasten**,
Barbara: *Construct XXIX,* 1985; *Construct NYC-9,* 1983; *Construct XV,* 1982;
Construct NYC-11, 1985; *Construct NYC-17,* 1984; *Metaphase 3,* 1986; *Metaphase
3,* 1986; *Metaphase 4,* 1986; *Architectural Site 5,* 1986; *Architectural Site 8,* 1986;
Architectural Site 7, 1986; *Architectural Site 13,* 1987; **Parker,** Olivia:
Earthenware, 1987; *The West Wall,* 1985; *Looking Up and Looking Down,* 1987;
Transformation, 1987; *Systems,* 1981; *Distant Connections,* 1985; *Love, Money
and Death,* 1987; *Taking Turns,* 1987; *The Artificial Sphere,* 1987; *End Game,*
1987; **Skoglund**, Sandy: *Revenge of the Goldfish,* 1981; *Maybe Babies,* 1983;
Hangers, 1980; *Radioactive Cats,* 1980; *Germs are Everywhere,* 1983; *Green
Glove,* 1986; *Parallel Thinking,* 1986; *Pink and Blue Car,* 1986; *Purple Blender,*
1986; *The Invention of the Wheel,* 1986; *The Value of Wasted Time,* 1986; *The Lost
and Found,* 1987; *A Breeze at Work,* 1987.

1013. Fisher, Andrea. *Let Us Now Praise Famous Women: Women
Photographers for the US Government 1935 to 1944.* London: Pandora,
1987. 160 p.
Researched to accompany a major exhibition, this works studies and
catalogs the relatively unknown photographic images of eight women
artists who recorded life in the United States between 1935 and 1944.
Fisher states that the essay is less concerned with biographical information
than with "the terms in which each was made visible within her respective
moment." (p.4) The documentary photographs, originally made for the
Farm Security Administration, were transferred to the Office of War
Information in 1941. With the transfer and with the war, the women

profiled here entered a different era of social consciousness and economic institutions.

Bubley, Esther: *Brother Edwin Foote preaching a sermon at the First Wesleyan Methodist Church,* Washington, D.C., p. 42; *The waiting room at the Greyhound bus terminal,* Pittsburgh, Pennsylvania 1943, p. 55; *Children playing in a fountain in Dupont Circle,* Washington, D.C., 1943, p. 56; *Soldiers looking at the statue in front of the Federal Trade Commission building,* Washington, D.C., 1943, p. 57; *[Soldier in photo booth]* Washington, D.C., p. 58; *Soldier in front of Capitol Theatre,* Washington, D.C., 1943, p. 59; *Boarders often speculate on the identity of the owner of the house across the street,* Washington, D.C., 1943, p. 60; *[Two women near a metal headboard]* 1943, p. 61; *Sally Dessez, a student at Woodrow Wilson High School, in her room,* Washington, D.C., 1943, p. 63; *The telephone in a boarding house is always busy,* Washington, D.C., p. 64; *Women gossiping in a drugstore over Cokes,* Washington, D.C., 1943, p. 65; *In the lounge at the United Nations service center,* Washington, D.C., 1943, p. 69; *In the hall of a boarding house,* Washington, D.C., 1943, p. 71; *Miss Genie Lee Neal reading a perforated tape at the Western Union telegraph* office, Washington, D.C., 1943, p. 87; *Little boy riding on a streetcar,* Washington, D. C. , 1943, p. 89; *[Men and women playing cards near sleeping woman]* 1943, p. 90; *Students at Woodrow Wilson High School,* Washington, D.C. 1943, p. 91; *[A conversation in the hallway]* Washington, D. C., 1943, p. 92; *Girls in cafeteria flock around a sailor who graduated in June,* Washington, D. C. , 1943, p. 94; *Girl sitting alone in the Sea Grill, a bar and restaurant waiting for a pickup,* Washington, D. C. , 1943, p. 95; *[Girl lying on bed, near radio]* 1943, p. 104; *Listening to a murder mystery on the radio in a boarding house room,* Washington, D. C. , 1943, p. 117; *[Things on a dresser]* Washington, D.C., p. 118; *[Washing diapers in the kitchen]* Washington, D. C., 1943, p. 138; *[Drying laundry in a boarding house room]* 1943, p. 154; **Collins,** Marjory: *Shopping district just before closing time at 9pm on Thursday night,* Baltimore, Maryland, 1943, p. 54; *Mrs. Frank Romano putting her baby to bed,* New York, p. 62; *Armistice day parade,* Lancaster, Pennsylvania, 1942, p. 67; *Windows of a Jewish religious shop on Broom Street,* New York, p. 68; *Photographer's display on Bleecker Street,* New York, 1942, p. 70; *Third Avenue and 42nd Street from the steps leading to the elevated train,* New York, 1942, p. 74; *St. Mark's Place and the Bowery at midnight,* New York, 1942, p. 75; *Turkish night club on Allen Street,* New York, 1942, p. 76; *Sunday School picnic on the edge of the Patuxent river,* St. Mary's County, Maryland, 1942, p. 77; *Recently employed women being sworn into the Rubber Workers Union at a Sunday meeting,* Buffalo, New York, 1945, p. 78; *Sleeping in a car on Sunday in Rock Creek park,* Washington, D. C., 1942, p. 93; *R. H. Macy & Co., department store during the week before Christmas,* New York, p. 122; **Ehrlich,** Pauline: *Detail of a hay baler showing rotating knives which cut hay into proper lengths,* Dresher, Pennsylvania, 1944, p. 83; *Detail of baling machine showing hay being picked up at the Spring Run farm,* Dresher, Pennsylvania, 1944, p. 85; **Lange,** Dorothea: *Migratory family traveling across the desert, U.S. Highway 70, in search of work in the cotton,* Roswell, New Mexico, p. 13; *A mother in California who, with her husband and*

two children will be returned to Oklahoma by the relief administration, p. 14; *Desert Highway 70; the route on which many refugees cross*, New Mexico, 1938, p. 15; *Billboard on U.S. Highway 70 in California "World's Highest Wages,"* 1937, p. 16; *Mexican truck driver's family*, Imperial Valley, California, 1935, p. 17; *Farm Security in Adminstration mobile camp for migratory farm labor. Baby from Mississippi left in a truck in camp*, Merrill Klamath County, Oregon, 1939, p. 18; *Entrance to Amalgamated Sugar Company factory at the opening of the second best season*, Nyssa, Oregon, 1939, p. 19; *Mexican migrant woman harvesting tomatoes*, Santa Clara Valley, California, 1938, p. 20; *Native of Indiana in a migratory labor contractor's camp*, California, 1937, p. 21; *Tenant farmers displaced by power farming*, Farmer, Texas, 1937, p. 22, 23; *Mexican field laboroers, on strike in the cotton picking season, applying to FSA for relief*, Bakersfield, California, 1938, p. 24; *Mexican woman at the US immigration station*, El Paso, Texas, 1938, p. 25; *Destitute pea pickers in California, a 32 year old mother of seven children "Migrant Mother,"* 1936; *Dustbowl farm, Coldwater district*, Texas, 1938, p. 27; *Corner of the Dazey kitchen in the Homedale district*, Vale-Owyhee irrigation project, Malheur County, Oregon, 1939, p. 35; *Men pause a moment to watch the Salvation Army and then pass on*, San Francisco, California, 1939, p. 38; *Campaign posters in a garage window, just before the primaries*, Waco, Texas, 1938, p. 39; *San Francisco, California, seen from the first Street ramp of the San Francisco-Oakland Bay bridge*, p. 53; *Tenant farmers who have been displaced from their land by tractor farming*, Texas, p. 136; *"We ain't no paupers,"* p. 142; *"We got troubles enough without going communist,"* p. 143; *Daughter of a migrant Tennessee coal miner living in American River Camp*, Sacramento, California, 1936, p. 150; **Roberts**, Martha McMillan: *A torpedo plant worker and her family from Ohio, living in a trailer*, Alexandria, 1941, p. 84; *Three sisters at the cherry blossom festival*, p. 88; **Rosener**, Ann: *National Exhibition at the Library of Congress of paintings, photographs and posters dealing with aspects of war*, Washington, D.C., 1943, p. 66; *Blood donors enjoying light refreshments before leaving the American Red Cross Center*, Washington, D.C., 1943, p. 72; *Blood donor at the American Red Cross Blood Bank*, Washington, D.C., 1943, p. 73; *Victory gardening in the northwest section*, Washington, D.C., 1943, p. 79; *OWI research workers*, Washington, D.C., 1943, p. 80; *Italian-Americans at work on a bomber in the Douglas aircraft plant*, Santa Monica, California, 1943, p. 81; *Periodic complete vehicle inspection is required of all US army drivers*, Baltimore, Maryland, 1943, p. 82; *Permanente Metals Corporation, Shipbuilding division, Yard no. 2,* Richmond, California, 1943, p. 86; *All nursing and no play might make Frances Bullock a dull girl!*, p. 127; *Saving waste fats and greases from which war materials will be made*, Washington, D. C., 1943, p. 128; **Rosskam**, Louise: *Proprietor of general store*, Lincoln, Vermont, p. 37; *Old Edison victrola in a farm house*, Bristol, Vermont, 1940, p. 46; *Air view of a cemetery and twon*, Lincoln, Vermont, 1940, p. 51; **Wolcott**, Marion Post: *Buildings on main street of a ghost town*, Judith Basin, Montana, 1941, p. 28, 29; *A farm*, Bucks County, Pennsylvania, 1939, p. 30; *Coal mining community*, Welch, West Virginia, p. 31; *Control room at the water works on Conduit Road,*

Washington, D.C., 1940, p. 32; *Corn shocks in a field*, Maryland, 1940, p. 33; *A barn on rich farmland*, Bucks County, Pennsylvania, 1939, p. 34; *Drug store window display in a mining town*, Osage, West Virginia, 1938, p. 36; *Negro man entering movie theater "colored" entrance*, Belzoni, Mississippi, 1939, p. 40; *A juke joint and bar in the vegetable section of the Glades are of south central Florida*, 1941, p. 41; *Movie advertisement o the side of a building*, Welch, West Virginia, 1938, p. 43; *Center of town*, Woodstock, Vermont, p. 44; *Young people in a "juke joint" and bar in the vegetable section of the Glades area of south central Florida*, p. 45; *Miner who has worked in the mine since he was 14 years old*, Scott's Run, West Virginia, 1938, p. 47; *A more prosperous miner listing to the radio*, Westover, Scott's Run, West Virginia, p. 48; *Children in the bedroom of their home*, Charleston, West Virginia, 1938, p. 49; *Coal mine tipple in foreground*, Caples, West Virginia, 1938, p. 50; *Road, wheat and corn fields*, Harve, Montana, 1941, p. 52; from *Fair Is Our Land*, p. 148; *Advertisement on the side of a drugstore window*, Wendell, North Carolina, 1939, p. 152.

1014. *For Women Only: An Exhibition of Local Black Women Photographers: in the Founders Library, November 21, 1983-January 13, 1984, Moorland-Springarn Research Center, Howard University, Washington, D.C.* Washington, D.C.: Moorland-Springarn Research Center, Howard University, 1983.

1015. (40 Years of *Aperture*: A Photographic History) *Aperture* 129 (Fall 1992): 1-79.
Bridges, Marilyn; **Caffrey**, Debbie Fleming; **Chadwick**, Helen; **Goldin**, Nan; **Groover**, Jan; **Heyman**, Abigail; **Kruger**, Barbara; **Levitt**, Helen; **Mark**, Mary Ellen; **Nance**, Marilyn; **Norman**, Dorothy; **Reichek**, Elaine; **Weems**, Carrie Mae.

1016. Fryer, Judith. "Women's Camera Work: Seven Propositions in Search of a Theory," *Prospects* 16 (1991): 57-117.

1017. Gardener, Paul. "The French Guy in Goggles & Other Favorite Photographs," *Art News* 91 (March 1992): 102-107.
Barney, Tina; **Callis**, Jo Ann; **Davis**, Lynn; **Ess**, Barbara; **Groover**, Jan; **Kasten**, Barbara; **Mark**, Mary Ellen; **Metzner**, Sheila.

1018. Garner, Gretchen. "Gertrude **Käsebier** and Helen **Levitt**. (Museum of Modern Art; Metropolitan Museum of Art, New York; Traveling Exhibit)," *Art Journal* 51 (Winter 1992): 83-85+.

1019. Golden, Judith. *Extending Straight Photography: A Trisolini Gallery exhibition, February 8 to March 15, 1989: Judith Golden, Frederick Schreiber, Connie Sullivan*. Athens, OH: Ohio University, 1989. 28 p. Illustrations.
An exhibit catalogue, with an introduction by Arnold Gassan.

Golden, Judith: From: *Memories, Myth & Magic* series, 1988: *Rabbit Women*, p. 8; *Lizard Woman*, p. 9; *Swan Woman*, p. 10; *Pheasant Man*, p. 11; **Sullivan,** Connie: p. 22-26.

1020. Golden, Judith. *Photo/trans/forms: [exhibition] August 21-October 11, 1981, San Francisco Museum of Modern Art.* San Francisco, CA: The Museum. 1981. 13 p.

A catalogue with short critical essays, chronology and list of exhibitions.
Golden, Judith; from the *Chameleon Series*, from the *Portrait of Women Series*; **Leonard**, Joanne: from the *Night Sky Series;*

1021. Gover, C. Jane. *The Positive Image: Women and Photography in Turn of the Century America.* Dissertation, State University of New York at Stony Brook, 1984. 354 p. Bibliography: p. 334-354.

1022. Gover, C. Jane. *The Positive Image: Women Photograpers in Turn of the Century America.* Albany: State University of New York, 1988. 191 p. Bibliography: p. 167-183.

Allen, Mary and Frances: *[Two Women Gossiping]*, c. 1900, pl. 5; **Austen**, Alice: *E. Alice Austen, Full Length with Fan*, 1892, pl. 13; *Clear Comfort*, c. 1890, pl. 14; *Staten Island Ladies Club Tournament, Miss Cahill and Miss McKinley*, pl. 15; *Bicycles and Riders-Staten Island Bicycle Club Tea*, 1895, pl. 16; *Violet Ward and Daisy Elliott*, c. 1896, pl. 17; *Bathing Party on South Beach*, 1886, pl. 18; *The Darned Club*, 1891, pl. 19; *Trude and I, Masked, Short Skirts*, 1891, pl. 20; *Mrs. Snively, Julie and I in Bed*, 1890, pl. 21; *Julia Martin, Julia Bredt, and Self Dressed Up as Men*, 1891, pl. 22; *Trude Eccleston's Bedroom*, 1889, pl. 23; *Ground Floor Bedroom*, 1889, pl. 24; **Bartlett**, Mary A.: *[Young Woman Seated in Front of Curtained Window]*, c. 1900, pl. 4; **Boughton**, Alice: *[Two Women Under a Tree]*, c. 1910, pl. 7; **Brigman**, Anne: *My Self*, 1920, pl. 35; *Incantation*, c. 1905, pl. 36; *Soul of the Blasted Pine*, 1908, pl. 37; *The West Wind*, 1915, pl. 38; **Farnsworth**, Emma: *Diana*, c. 1897, pl. 1; **Johnston**, Frances Benjamin: *Self-Portrait*, c. 1896, pl. 25; *Self-Portrait*, c. 1905, pl. 26; *Exterior, Frances Benjamin Johnston's Studio, Washington, D.C.*, c. 1895, pl. 27; *Woman Worker, Lynn Massachusetts*, c. 1895, pl. 28; *Working Girls of Lynn, Massachusetts*, c. 1895, pl. 29; *Student Orchestra*, c. 1899-1900, pl. 30; *Carpentry Class*, c. 1899-1900, pl. 31; *Alice Roosevelt in White House Conservatory*, 1902, pl. 32; *Inauguration of President McKinley*, 1900, pl. 33; **Käsebier**, Gertrude: *Gertrude Käsebier*, c. 1912, pl. 8; *[Family Group]*, c. 1912, pl. 9; *Blessed Art Thou Among Women*, 1899, pl. 10; *The Manger*, 1899, pl. 11; *The Picture Book*, c. 1899, pl. 12; **Prall**, Virginia: *[Two Girls Reading]*, c. 1900, pl. 6; **Watson-Schütze**, Eva: *[Child with Oak Fringe]*, c. 1900, pl. 2; *[Woman with Lily]*, c. 1903, pl.3.

1023. Grover, Jan Zita. "Books and Audio/Visual Sources By and About Women Photographers: A Bibliography," *Exposure* 19, 3 (1981): 45-53.

1024. Hallmark Photographic Collection. *Wanderlust: Work by Eight Contemporary Photographers from the Hallmark Photographic Collection.* Kansas City, MO: Hallmark Cards, Inc., 1987. 91 p.

Catalogue to accompany a traveling exhibition. List of photographer's exhibitions and collections are noted and photographs are prefaced by a short critical note.

Conner, Lois: *Yangshou, China,* 1985, p. 73, 74, 75; *Hangzhou, China,* 1984, p. 76; *Beihai Park, Beijing, China,* 1984, p. 77, 79; *Die Cai Shan, Guilin, China.* 1985, p. 78; *Huang Shan,China,* 1984, p. 80. **Connor,** Linda: *Indus River, Ladakh, India,*1985, p. 13; *Pony Man, Sanskar, India,* 1985, p. 14; *Chorten, Ladakh, India,* 1985, p. 15; *Vajra, Ringdum Gompa, Sanskar, India,* 1985, p. 16; *Death Figure, Tiktse Monastery, Ladakh, India,*195, p. 17; *Monks, Phiyang Monastery, Ladakh, India,* 1985, p. 18; *The Oracle of Sabu, Ladakh, India,* 1985, p.19; *Monk's Residence, Stonde Monastery, Zanskar, India,* 1985, p. 20. **Solomon**, Rosalind: *India,* 1982, p. 63, 65; *India,* 1981, p. 64; *Kangra, India,* 1981, p. 66, 69; *Kulu Valley, India,* 1981, p. 67; *Calcutta, India,* 1982, p. 68, 70.

1025. *High Heels and Ground Glass: Pioneering Women Photographers.* Videorecording. Written and produced by Deborah Irmas and Barbara Kasten. New York: Film makers Library, 1990. 29 min.

"Portrays the life and work of five women photographers (Gisele **Freund**, Louise **Dahl-Wolfe**, Maurine **Loomis**, Lisette **Model**, Eiko **Yamazawa**).... Using examples of their work, their interviews are woven together to tell a story about professional women...[in] the mid-twentieth century." oclc

1026. Horwitz, Margot F. *A Female Focus: Great Women Photographers.* New York: Franklin Watts, 1996. 127 p. Bibliography: p. 121-123.

This book for young adults is an historical survey of American women photographers from the late 1800s to the 1990s. It also includes many portraits of the photographers.

Abbott, Berenice: *Manhattan Bridge Walkway, New York,* 1934; **Arbus**, Diane: *Boy with a Straw Hat Waiting to March in a Pro-War Parade,* 1967; **Arnold**, Eve: *Elijah Muhammad's Daughter at a Nation of Islam Meeting,* 1961; **Bourke-White,** Margaret: *Bombing of Moscow,* 1944; **Brigman, Anne**: *The Incantation,* 1905; *Spirit of Photography,* 1908; **Cunningham**, Imogen: *False Hellebore,* 1926; *Self-Portrait on Geary Street,* 1955; **Dahl-Wolfe**, Louise: *The Couvert Look,* 1949; **Dater**, Judy: *Joyce Goldstein in Her Kitchen,* 1969; **Gilpin**, Laura: *Sunrise, San Luis Valley,* 1921; **Harleston**, Elise Forrest: *Grand Army of the Republic Veteran,* c. 1924; **Johnston**, Frances Benjamin: *Self-Portrait,* c. 1896; **Käsebier,** Gertrude: *The Manger,* 1899; **Lange**, Dorothea: *Migrant Mother,* 1936; **Leibovitz**, Annie: *Self-Portrait,* 1991; **Mark**, Mary Ellen: *Ethiopia,* 1985; **Moutoussamy-Ashe**, Jeanne: *Josette's Wedding,* 1981; **Norman**, Dorothy: *Alfred Stieglitz,* 1933; **Sherman**, Cindy: *Untitled #193,* 1989; **Ulmann**, Doris: *Portrait Study, Lang Syne Plantation,* 1929; **Ward**, Catharine Barnes: *Five O'Clock Tea,* 1888.

1027. Hust, Karen. "The Landscape (Chosen by Desire): Laura Gilpin Renegotiates Mother Nature," *Genders* 6 (1989): 20-48.
Brigman, Anne; **Gilpin**, Laura.

1028. *Illuminations: Women Writing on Photography from the 1850s to the Present.* Edited by Liz Heron and Val Williams. Durham, NC: Duke University Press, 1996. 521 p.
A compilation of critical writings by and of women in photography and personal accounts of their own photographic work. Essays relevant to this bibliography include:
Abbott, Berenice: "Photography at the Crossroads," p. 203; **Arbus**, Diane: "What Becomes a Legend Most: The Short, Sad Carer of Diane Arbus," by Catherine Lord; **Bourke-White**, Margaret: "Life Begins, 133; **Dahl-Wolfe,** Louise: "Early Years," p. 127; **Goldin**, Nan: "The Other Side," p. 291; **Hughes**, Alice: "A Lady Never Photographs Men," p. 3; **Lange**, Dorothera: "The Assignment I'll Never Forget," p. 151; **Miller**, Lee: "I Worked with Man Ray," p. 74; "The Siege of St. Malo," p. 178; **Sherman**, Cindy: "Cindy Sherman: Burning Down the House," by Jan Avgikos, p. 300; **Welty,** Eudora: "One Time, One Place," p. 161.

1029. *Image and Self In Contemporary Native American Photoart: Carm Little Turtle, Shelley Niro, Jolene Rickard, Hulleah Tsinhnahjinnie, Richard Ray Whitman.* Hanover, NH: Hood Museum of Art, Dartmouth College, 1995. 24 p.
This is a catalog of a "self-representative" exhibition which dealt with the perception of identity and the "still-dominant image of Native Americans by a culture other than their own."(p. 3) The photographs are accompanied by personal statements of the artists.
Little Turtle, Carm: *El Diablo y Sandia with Woman done Wrong*, 1992, p. 9; Niro, Shelley: *Mohawks in Beehives, I,* 1991, p. 12; **Rickard**, Jolene: *Sky Woman's Reality*, 1995, p. 10; **Tsinhnahjinnie**, Hulleah: *Would I Have Been a Member of the Nighthawk, Snake Society or Would I Have Been a Half Breed, Leading the Whites to the Full Bloods? (Detail)*, 1990, p. 15.

1030. "India: Ritual and the River," *Aperture* 105(Winter 1986):2-73.
Connor, Linda; **Solomon**, Rosalind.

1031. Jones, Kellie. "In Their Own Image," *Artforum* 29 (November 1990): 132-138. Bibliography.
Bhimji, Zarina; **Kempadoo**, Roshini; **Pollard,** Ingrid; **Simpson**, Lorna; **Sligh,** Clarissa; **Tabrizian**, Mitra; **Weems**, Carrie Mae; **Williams**, Pat Ward.

1032. Jones, Kellie. "Trading Places: Transatlantic Traditions," *Creative Camera* 10 (1988): 35-36.
Simpson, Coreen; **Simpson**, Lorna.

1033. Jones, Peter C. "Hot Photographers," *Connoisseur* 220 (November 1990): 150-155+.
Conner, Lois; **Gall**, Sally; **Mann**, Sally.

1034. Katz, Vincent. "Wild Irises: A Nash Editions Portfolio," *Aperture* 136 (Summer 1994): 38-45.
Butler, Lynn; **Cowin**, Eileen; **Parker**, Olivia.

1035. Kennedy, Martha H. "Nebraska's Women Photographers," *Nebraska History* 72, 2 (1991): 62-77.

1036. Liu, Catherine. "In the Realm of the Senses: Through the Violence of the Image, the Field of Vision is Usurped," *Flash Art (International Edition)* 142 (October 1988):100-101, 123.
Mann, Sally; **Sherman**, Cindy.

1037. McEuen, Melissa A. *Changing Eyes: American Culture and the Photographic Image, 1918-1941.* Dissertation. Louisiana State University, 1991. 383 p.
Abbott, Berenice; **Bourke-White**, Margaret; **Lange**, Dorothea; **Ulmann**, Doris; **Wolcott**, Marion Post.

1038. Morrow, Delores J. "Female Photographers on the Frontier: Montana's Lady Photographer Artists, 1866-1900," *Montana* 32, 3 (1982): 76-84.

1039. *Mother Earth: Through the Eyes of Women Photographers and Writers.* Edited by Judith Boice. San Francisco, CA: Sierra Club, 1992. 142 p.
A personal compilation of photographs and writings to "inspire people with the beauty of the Earth." (vii). Brief statements by the photographers are included.
Angel, Heather: *Snowfall on Painted Desert, Arizona*, p. 2; *Earth Star Dispersing Spores*, p. 50; *Macaque Mother and Child, Shiga Heights, Japan*, p. 64; *Dawn on Li River. Near Guilin, China*, p. 108; **Bauer**, Peggy: *Bobcat. Northern Montana, near Canadian Border*, p. 82; **Blum**, Arlene: *Early Morning in the Khumbu Icefall. Mount Everest, Nepal*, p. 103; **Boice**, Judith: *Sand Worm Casting. Cape Hillsboro National Park, Australia*, p. 19; *Goddess Sheela-Na-Gi, Nunnery Ruins, Isle of Iona, Scotland*, p. 27; *Shakti Carving, Shore Temple. Mammallapuram, Tamil Nadu, India*, p. 129; **Brundege**, Barbara: *Weaving Loom, Canyon de Chelly National Monument, Arizona*, p. 21; *Skunk Cabbage and Berry Vine. Walton, New York*, p. 36; *Raven Tracks at Pine Creek. Zion National Park, Utah*, p. 49; *Fall Color. Zion National Park, Utah*, p. 55; *Sunset and Cypress. Big Cypress National Preserve/Everglades National Park, Florida*, p. 127; **Bullaty**, Sonja: *Vermont Pond in Autumn*, p. 120; *Cloud Bank over Mountain. Isle of Skye, Scotland*, p. 124; *Lavender Field, Provence, France*, p. 131; **Bumgarner**, Gay: *Stormy Ocean. North of Jenner, California, on Sonoma County Coast*, p. 11; *Toad and Worm. Boone*

Northwest Territories, Canada, p. 81; **Webb**, Nancy: *Pink Phlox and Chair in Garden. Zachary, Louisiana*, p. 110;

1040. Moutoussamy-Ashe, Jeanne. *Viewfinders: Black Women Photographers.* New York: Dodd, Mead and Co., 1986. 195 p. Bibliography: p. 192-195. Geographical Index and Bio-Bibliography.

Photographers are arranged in chronological order, with each era introduced by and historical overview. Portrait of the photographer is usually included, with examples of her work and biographical sketch.

Agins, Michelle: *Mayor Harold Washington at a Community Forum*, fig. 154; *Mayor Harold Washington at a Graduation*, fig. 155; *'Twas the Night Before Christmas*, fig. 156; *McWashington (Mayor Harold Washington Leads the St. Patrick's Day Parade,)* fig. 157; **Ali**, Salimah: *Audre Lorde*, fig. 158; **Allen**, Winifred Hall: *Brown Bomber Bread*, fig. 57; *A Musical and Dance Group*, fig. 58; *Man at Piano in Spats*, fig. 59; *A Harlem Music School*, fig. 60; *A Harlem Social Club*, fig. 61; *Untitled Portrait of Boy*, fig. 62; *Portrait, in a Satin Dress*, fig. 63; *Untitled Portrait*, fig. 64, 66, 68; *Miss Webster*, fig. 65; *Willie Lipsett*, fig. 67; *Mr. Baker*, fig. 69; *Lilac Beauty Shop*, fig. 70; *Beauticians of the Ritz Beauty Shoppe*, fig. 71; *Mrs. Scott, Owner of Ritz Shoppe, Seated in Front*, fig. 72; *A Hairstyle*, fig. 73; *A Harlem Church Choir*, fig. 74; *Sister Gertrude*, fig. 75; *First Holy Communion*, fig. 76; *A Soldier*, fig. 77; *William E. Woodard, Photographer*, 1936, fig. 78; *A Garveyite*, fig. 79; *Two Men Looking Over Papers*, fig. 80; *A.C. Harris, Cleaning the Lido Pool on 146th Street*, fig. 81.**Bomar**, Johnnie Mae; **Brown**, Alberta H. ; **Cryor**, Cary Beth: *Rites of Passage #1- #5*, fig. 159-163; **Davis**, Billie Louise Barbour: *Experimental Photograph*, fig. 85; *Untitled, from Dance, Series*, fig. 86; *J. Saunders Redding, the Writer*, fig. 87; **Davis**, Lenore: *End of the Northeast War*, fig. 164-169; **Downs**, Emma Alice; **DuMetz**, Barbara: *An Advertisement for Coke*, fig. 170; **Ferrill**, Mikii: *Graffiti, Chicago Street Gangs*, fig. 123; *Dr. King*, fig. 124; *Dr. King at the Freedom Festival*, fig. 125;**Hardison**, Inge: *Bongo Player*, fig. 127; *Young Man with a Cowbell*, fig. 128; *Street Music*, fig. 129; **Harleston**, Elise Forrest: *The Harleston's Building Which Housed the Harleston Studio*, 1922, fig. 22; *Edwin Harleston, the Painter*, fig. 23; *The Harleston Studio Greeting Card*, fig. 24; *Unidentified Portrait*, fig. 25; *Elise's Sister*, fig. 26; *Old Man "Scout,"* fig. 28; *Unidentified Woman in Portrait*, fig. 29; *Market Woman*, fig. 30; *Chimney Sweep*, fig. 31; *Landscape*, fig. 32; **Howard**, Master Sergeant Grendel A; **Jackson**, Ann Elizabeth; **Jackson**, Vera: *Mrs. Bass Switching on the First Stop Light on Central Avenue in Los Angeles*, fig. 95; *Dorothy Dandridge*, fig. 96, 97; *Phillipa Schuyler and Hattie McDaniel*, fig. 98; *Birthday Celebration for Mary McLeod Bethune; Lena Horne Standing at Far Left*, fig. 99; *Mrs. Charlotta Bass, Adam Clayton Powell, Jr., Hazel Scott*, fig. 100; *Max the Printer*, fig. 101; **Jefferson**, Louise: *Louis Armstrong*, fig. 131; *Autumn Fog*, fig. 132; *Alabama Boy*, fig. 133; **Jones**, Julia: *Jesse Jackson in Syria*, fig. 171; **Logan**, Fern: *Millerton Station*, fig. 172; *Clouds*, fig. 173; **Martin**, Louise: *Street Scene in Tulsa*, fig.136; *Dr. Martin L. King, Jr.*, fig. 137; *Dr. King Speaking at a College Commencement Being Congratulated by the College President*, fig. 138;

The King Family Being Escorted to the Funeral, fig. 139; *A Young Jesse Jackson at Dr. King's Funeral,* fig. 140; *The King Family at Martin Luther King, Jr.'s Funeral,* fig. 141; *A Portrait,* fig. 142, 143; **Miller,** Dora; **Ramsess,** Akili-Casundra: *Guitar Player,* fig. 174; *Peanut Man,* fig. 175; **Roberts,** Wilhelmina Pearl Selena: *Wilhelmina Roberts' Daughter,* fig. 34; *Little Girl and Roses,* fig. 35; *Grandmother With Three Children,* fig. 36; *Unidentified Woman,* fig. 37; **Robeson,** Eslanda Cardoza Goode: *Jawaharal Nehru and Indira Ghandi, London, 1938,* fig. 105; *China Trip, Mme. Chou En Lai, 1950,* fig. 106; *Fisherman's Village, 1946,* fig. 107; *Portrait of Eslanda, 1950s,* fig. 108; *Eslanda Cardoza Goode, the Photographer's Mother,* fig. 109; *Paul, Sr., and Jr.,* fig. 110; **Simpson,** Coreen: *Untitled,* fig. 176-179; **Teal,** Elnora: *Arthur C. Teal, Husband of Elnora,* fig. 39; *Jewel D. Chaney,* fig. 40; *Famed Tenor, Roland Hayes,* fig. 41; *Ethel Mosley,* fig. 42; *Unidentified Portrait,* fig. 43, 44; *Mrs. Irene Frazier,* fig. 45; *Lucille B. Moore,* fig. 46; **Washington,** Leah Ann: *Portrait,* fig. 180; *Point Lobos--at Carmel, California,* fig. 181; **Williams,** Adine: *Camera Masters Studio, 1946-1956,* fig. 151; **Williams,** Elizabeth "Tex": *Listening to the Radio at the Bamboo Fence,* fig. 112; *The Photographer,* fig. 113; *WAC Nurse, "Enemy Ears Are Listening,"* fig. 116; *A WAC-M.P.,* fig. 117; *WAC Nursing Staff,* fig. 118; *"Tex" Among Her Other Photo Division Colleagues,* fig. 119; *Landscape,* fig. 120; **Wilson,** Joyce R.; **Worthington,** Ethel: *Unidentified Portrait,* fig. 122.

1041. Nicholson, Chuck. "An Awareness of the Earth," *Artweek* (7 November 1987): 11.
Albuquerque, Lita; **Braunstein,** H. Terry; **Bridges,** Marilyn; **Brown,** Laurie; **Dater,** Judy; **Vida.**

1042. Palmquist, Peter E. *A Bibliography of Writings By and About Women in Photography.* 2d ed. Arcata, CA: Peter E. Palmquist, 1994. 332 p.

1043. Palmquist, Peter E. *Camera Fiends and Kodak Girls: 50 Selections by and about Women in Photography, 1840-1930.* New York: Midmarch Arts Press, 1989. 272 p.

1044. Palmquist, Peter E., ed. *Camera Fiends and Kodak Girls II: 60 Selections By and About Women in Photography, 1855-1965.* New York: Midmarch Arts Press, 1995. 352 p.
 An anthology of selected articles written by or about women in the history of photography "When taken together, these sixty writings form a fascinating rear-view mirror into the numerous accomplishments of women photographers over time. However, these essays also capture the ongoing struggles of women for recognition, as well as to document their successes." p. x. The book also includes some examples of photographs by some of these early women photographers.
Abbott, Berenice; **Adams,** Laura M.; **Barnes,** Catharine Weed.; **Bell,** Beatrice B.; **Bonney,** Therese; **Boughton,** Alice: *The Fuller Sisters,* 1915, p. 166; **Bourke-**

White, Margaret; **Brigman**, Anne W.:*Via Dolorosa*, 1918, p. 178; **Brownell**, Rowena; **Browning**, Mary Eleanor; **Custis**, Eleanor Parke: *Penguins Three*, 1941, p. 234; **Davis**, Sally J.; **Dew**, Gwen; **Fleischman**, Elizabeth; **Freeman**, Emma B.: *Emma B. Freeman...Dressed As a Yurok Indian*, c. 1915, p. 170; **Hovey,** Clarissa: *Mother and Daughter*, 1914, p. 158; **Käsebier**, Gertrude; **Ladies of the Chicago Camera Club**; **Larimar**, Mrs. ; **Lauffer,** Sophie L.: Marion, 1932, p. 192; **Lindley**, Marguerite; **Loehr,** Sidonia E.; **Model**, Lisette; **Orrill**, Doris; **Platnick**, Harriet; **Randolph**, Mary; **Snelling**, Alice Lee; **Sperry**, Miss M. E.; **Weisman**, Clara; **Wright**, Mrs. James Osborne; **Ylla**.

1045. Palmquist, Peter E. "Photographers in Petticoat," *Journal of the West* 21, 2 (1982): 58-64.

1046. Palmquist, Peter E. "Pioneer Women Photographers in Nineteenth Century California," *California History* 71, 1 (1992): 110-127.

1047. Palmquist, Peter E. *Shadowcatchers I: A Directory of Women in California Photography Before 1901*. Arcata, CA: Peter E. Palmquist, 1990. 166 p.
 The compiler states that is the first in an ongoing series of directories listing women active in photography in California from 1850 to date.

1048. Palmquist, Peter E. *Shadowcatchers II: A Directory of Women in California Photography, 1900-1920*. Arcata, CA: Peter E. Palmquist, 1991. 352 p.
 See previous entry.

1049. Palmquist, Peter E. *Women Photographers: A Selection of Images from the Women in Photography International Archive, 1852-1997*. Kneeland, CA: Iaqua Press, 1997. 84 p. of plates.

1050. Palmquist, Peter E. "Women Photographers and the American West," *Rendezvous* 28, 1-2 (1992-1993): 121-129.

1051. Perrone, Jeff. "Women of Photography: History and Taste," *Artforum* 14 (March 1976): 31-35.

1052. Price, Reynolds. "Neighbors and Kin," *Aperture* 115 (Summer 1989): 32-39.
Mann, Sally; **Sartor,** Margaret; **Vaughan**, Caroline.

1053. *Reclaiming Paradise: American Women Photograph the Land*. Gretchen Garner, guest curator. Tweed Museum of Art. Duluth: University of Minnesota, 1987. 64 p.
 Catalog of an exhibition, short biographical and critical sketches are

accompanied by a selected bibliography and an illustrative photograph by each photographer. The catalog also includes several essays on the history of women photographers of the American landscape.

Abbott, Berenice: *Pine and Henry Streets*, 1935, p. 19; **Brigman**, Anne: *Dawn*, 1912, p. 13; **Connor**, Linda: *Petroglyphs, Pualoa, HI*, 1986, p. 57; **Crane**, Barbara: *Tar Findings, Whole Roll Series*, 1975, p. 33; **Cunningham**, Imogen: p. 25; **Dater**, Judy: **DeCock**, Lilianne: *Abandoned House, PA*, 1967, p. 29; **Edelson**, Mary Beth: *The Nature of Balancing*, 1978, p. 59; **Faller**, Marion: *Route 20, Bouckville, November 30, 1981...*, p. 41; **Gammell**, Linda: *Apples and Tomatoes, Polly's Garden*, 1986, p. 43; **Geesaman**, Lynn: *Love Temple, Longwood Gardens*, 1984, p. 45; **Gilpin**, Laura: *The "He" Rain*, 1946, p. 17; **Hahn**, Betty: *Road and Rainbow*, 1971, p. 35; **Lange**, Dorothea: *Tractored Out, Childress County, TX*, 1938, p. 21; **Myers**, Joan: *Topaz, UT (victory garden)*, 1984, p. 55; **Patterson**, Marion: *Untitled*, 1985, p. 31; **Paul**, Kathryn: *Man at Lusk Creek*, 1982, p. 47; **Peck**, Mary: *Junction 741/742 near Loving, NM*, 1983, p. 51; **Rubenstein**, Meridel: *Native Son*, 1982, p. 39; **Sharpe**, Geraldine: *Untitled*, n.d, p. 27; **Sipprell**, Clara E.: *Vermont Farm*, n.d., p. 15; **Skoff**, Gail: *Utah Blues*, 1983, p. 49; **Streetman**, Evon: *Florida/Public*, 1985, p. 37; **Vida**: *Billie Mine*, from, *Death Valley Portfolio*, 1979, p. 53; **Wolcott**, Marion Post: *Baptism by Immersion, Morehead, KY*, 1940, p. 23.

1054. *Recollections; Ten Women of Photography* by Margaretta K. Mitchell. New York Viking Press, 1979. 208 p. Includes biographical notes and selected bibliographies on each of the photographers: p. 199-204.

The photographs in this collection were chosen by the photographers and the editor. The images, with the text of interviews, illuminate the lives of these "pioneers" both as women and as photographers. Each section includes portraits of each photographer and lengthy interviews on how their backgrounds and beliefs influenced their art.

Abbott, Berenice: *Cocteau's Hands*, 1927, p. 15; *Sylvia Beach*, 1927, p. 16; *Sophie Victor*, 1927, p. 16; *Princesse Marthe Bibesco*, 1927, p. 17; *Jane Heap*, 1927, p. 17; *Edward Hopper*, 1949, p. 18; *Eugène Atget*, 1927, p. 19; *James Joyce*, 1928, p. 20; *Princess Eugène Murat*, 1929, p. 21; *West Street, New York*, 1932-33, p. 22; *Fifth Avenue and 8th Street, New York*, 1937, p. 23; *Pennsylvania Station, New York*, 1937, p. 24; *Jersey Railroad Yard*, 1932, p. 25; *Canyon, Broadway and Exchange Place, New York*, 1933, p. 26; *New York at Night*, c. 1932, p. 27; *Magnetic Field*, 1959, p. 28; *Pendulum Swing*, 1960, p. 29; **Bernhard**, Ruth: *Doll's Head*, 1936, p. 33; *Lifesavers*, 1930, p. 34; *Frederick Kiesler, 8th Street Theater, New York*, c. 1945, p. 35; *Bone and Passion Flower*, n.d., p. 36; *Broken Shell*, c. 1934, p. 37; *Teapot*, 1976, p. 38; *Enigma*, c. 1975, p. 39; *Two Leaves*, 1952, p. 40; *Two Forms*, c. 1963, p. 41; *Candy II*, 1942, p. 42; *Classic Torso*, 1952, p. 43; *"Embryo,"* 1934, p. 44; *"Seed,"* 1970, p. 45; *Doorknob*, 1970, p. 46; *Garden Hose*, c. 1969, p. 47; **Corpron**, Carlotta M.: *Interior of a Church in Havana*, 1942, p. 51; *Solarized Calla Lilies*, 1948, p. 52; *Rae Ann with Amaryllis*, 1949, p. 53; *Light Follows Form of Greek Head*, 1947, p. 54; *Light Follows Form*, 1948, p. 55;

Nature Dancer, 1946, p. 56; *Strange Creature of Light*, 1948, p. 57; *Light, White Paper, and Glass*, 1945, p. 58; *Space Composition and Chambered Nautilus*, 1948, p. 59; *A Walk in Fair Park, Dallas*, c. 1948, p. 60; *Winds Between the Worlds*, c. 1948, p. 61; *Fluid Light Design*, 1946, p. 62; *Captured Light*, 1946 or 1948, p. 63; *Woven Light*, 1948, p. 64; *Eggs Reflected and Multiplied*, 1948, p. 65; **Dahl-Wolfe**, Louise: *Paestum, Italy*, 1927, p. 69; *William Edmondson, Sculptor, Nashville*, 1939, p. 70; *Tennessee Mountain Woman*, 1932, p. 71; *Colette, Paris*, 1951, p. 72; *Dior Dress, Paris*, 1950, p. 73; *The Swan*, 1949, p. 74; *Nude*, 1941, p. 76; *ight Bathing*, 1939, p. 77; *Dior Ball Gown, Paris*, 1950, p. 78; *Calla Lilies*, 1931, p. 79; *Cecil Beaton, New York*, 1950, p. 80; *Mr. and Mrs. Edward Hopper, New York*, 1933, p. 81; *Sogne Fjord, Norway*, 1951, p. 82; *Sigrid Undset, New York*, 1940, p. 83; **Dorr**, Nell: *Lillian Gish*, 1908, p. 87; *Rosa--Alone with the Sea*, 1929, p. 88; From *In a Blue Moon*, 1939, p. 91; *"Secrets," Win and Chris*, 1942, p. 92; *Mother and Child*, 1940, p. 93; *Mother and Child (Nursing Mother)*, 1945, p. 94; *Baby in Big Bed*, 1943, p. 95; *Flower and Chalk Figure*, 1940, p. 96; *Kitten as a Small Child in Wales*, 1950, p. 97; *RAF Pilot*, 1939, p. 98; *Carl Sandburg*, 1939, p. 99; *Win*, c.1929, p. 100; *Abstract--used in* Night and Day, 1968, p. 101; **Frissell**, Toni: *Five Girls Running, New York*, c. 1930s, p. 105; *"Spring of the Mermaid, Weeki Wachee Spring, Florida for* Harper's Bazaar, December 1947, p. 106; *Floating Boat, Montego Bay, Jamaica, for* Harper's Bazaar, 1946, p. 107; *The First Bikini, Jamaica, for* Vogue, c. 1946, p. 107; *Alida Chanler Emmett at Ninety-Four Years, Long Island, for* Life, September 1966, p. 108; *Winston Churchill in His Knight of the Garter Robes at 10 Downing Street on Queen Elizabeth's Coronation Day*, June 2, 1953, p. 109; *American Soldier in Bombed Church in World War II, Italy*, January 1945, p. 110; *Shock--V2 London--Parents Buried in Rubble*, January 1945, p. 111; *Switzerland*, c. 1950, p. 112, 113; *Hounds on the Scent, Meath Hunt, Ireland*, November, 1956, p. 114; *Annie and Tobin Armstrong, King Ranch, Texas, for* Vogue, December 1967, p. 115; *Hilary Paley, for* Vogue, September 1944, p. 116; *People, Too--Kensington Garden Nannies, England*, April 1963, p. 117; *My Daughter Sidney and Her Grandmother, Long Island*, June 1944, p. 118; *Hugh, Lord David and Jonathan Cecil, England*, June 1950, p. 118; *[Fantasy,] Stanford White Granddaughters, Long Island*, June 1963, p. 119; **Gilpin**, Laura: *The Prelude (platinum print)*, 1917, p. 123; *Fortuny Gown (platinum print)*, c. 1920, p. 124; *Iris (platinum print)*, 1925, p. 125; *Georgia O'Keeffe in Her Studio*, 1953, p. 126; *Boardman Robinson in His Studio*, 1939, p. 126; *Eliot Porter*, c. 1950, p. 127; *Hogan Interior with Miss Elizabeth Forster, R.N., Administering Medicine (from* The Enduring Navaho*)* p. 128; *Little Medicine Man*, 1932, p.129; *Mr. Francis Nakai*, 1932 (from *The Enduring Navaho*) p. 129; *Irene Yazzie at Pine Springs, Arizona*, 1952 (from *The Enduring Navaho*) p. 130; *Tying the Chongo*, n.d. (from *The Enduring Navaho*) p. 131; *Canyon de Chelly, Spider Rock*, n.d., p. 132; *Stairway, Chichén Itzá, Yucatán*, 1932, p. 133; *The Picuris Church, Picuris Pueblo, New Mexico*, 1961, p. 134; *Detail of the White Sands, New Mexico*, 1946, p. 135; *The Storm*, 1946, p. 136; *The Rio Grande Yields Its Surplus to the Sea, Texas and Mexico*, 1946 (from *Rio Grande, River of Destiny*) p. 138; *B29 Bomber Coming Out of the Factory, Boeing, Wichita, Kansas*, 1944,

p. 139; **Jacobi**, Lotte: *Self-portrait, Berlin, Germany,* 1931, p. 142; *Lil Dagover, Berlin,* 1930, p. 143; *Louis Douglas, American Dancer, Berlin (palladium print)* 1932, p. 144; *Anna May Wong, Actress, Berlin,* 1931, p. 145; *Head of a Dancer, Berlin,* c. 1929, p. 146; *Lil Dagover, Actress, Berlin,* c. 1930, p. 147; *Käthe Kollwitz, Artist, Berlin,* 1931, p. 148; *Beate Sauerlander, Amityville, Long Island,* 1940, p. 149; *Mrs. Limbosch, Brussels,* 1963, p. 150; *Albert Einstein, Physicist, Nobel Prize Winner, Princeton, New Jersey,* 1938, p. 151; *Chagall and Daughter Ida, New York,* 1945, p. 152; *Alfred Stieglitz, Photographer, at An American Place, New York,* 1938, p. 153; *Anton Walbrook, Actor, Berlin,* 1933, p. 154; *Leo Katz, Artist, New York,* 1938, p. 155; *Pauline Koner, Dancer, New York,* c. 1937, p. 156; *Photogenic "Silverlining,"* c. 1950, p. 157; **Kanaga**, Consuelo: *Downtown, New York,* 1924, p. 161; *Widow Watson,* 1925, p. 162; *Fire,* 1925, p. 162; *One of the Hundred Neediest,* 1928, p. 163; *Poor Boy II,* 1928, p. 164; *Poor Boy,* 1928, p. 165; *The Question,* 1950, p. 166; *Annie Mae Meriweather II,* 1936, p. 167; *"She Is a Tree of Life to Them,"* 1950, p. 168; *After Years of Hard Work,* 1950, p. 169; *San Francisco Kitchen,* 1930, p. 170; *Glasses and Reflections,* 1948, p. 171; *The Camelia,* 1927, p. 172; *Colt II,* 1940, p. 173; *Amy Murray,* 1936, p. 174; *Alfred Stieglitz,* 1936, p. 175; *Wharton Esherick,* 1940, p. 176; *Milton Avery,* 1950, p. 177; **Morgan,** Barbara: *Willard Morgan with Model A Leica in Bandelier National Monument,* 1928, p. 181; *Tossed Cats,* 1942, p. 182; *Children Dancing by Lake,* 1940, p. 183; *Pregnant,* 1940, p. 184; *Samadhi (light drawing),* 1940, p. 185; *Funkia Leaf (solarized),* 1950, p. 186; *Lloyd's Head,* 1944, p. 187; *Corn Leaf Rhythm (macro)* 1945, p. 188; *Martha Graham--"Ekstasis,"* 1935, p. 189; *Martha Graham--"Letter to the World,"* 1940, p. 190; *Valerie Bettis--"Desperate Heart,"* 1944, p. 191; *Martha Graham--"Lamentation,"* 1935, p. 192; *Pearl Primus-- "Speak to Me of Rivers,"* 1944, p. 193; *Protest--New York City,* 1940s-1970, p. 194; *Martha Graham--"El Penitente," (solo Hawkins el Flagellante),* 1940, p. 195; *Spring on Madison Square,* 1938, p. 196; *Fossil in Formation,* 1965, p. 197; *Feather Icon,* 1942, p. 198.

1055. *Reframings: New American Feminist Photographies.* Edited by Diane Neumaier. Philadelphia: Temple University Press, 1995. 319 p.
 An anthology of photographs and critical essays which express diverse feminist priorities and issues. Neumaier's introduction discusses process by which the fomation of the book was a call for the critical examination of the work these feminist artists to other feminists, and the pro-activism of the writers and the photographers, themselves. Very brief statements about the photographers are also included.
Aguilar, Laura: from *Latina Lesbians,* p. 242-245; **Bachman**, S.A.: from *It's All There In Black and White: Patrilocality,* p. 80; *'Come and Get It',* p. 80; *Finding an Outlet,* p. 82; *Are You Telling Yourself a Little White Lie?* p. 83; **Barton**, Nancy: from *Live and Let Die,* p. 68-71; **Bright**, Deborah: *How the West Was Won,* 1985, p. 50-51; *The Management of Desire: Assisted by Mary Ann Nilsson,* p. 280-283; **Brooke**, Kaucyila: from *Making the Most of Your Backyard: The Story Behind an Ideal Beauty,* p. 26-29; **Brooks**, Linda: from *Between the Birthdays,* p. 60-63;

Carroll, Pamela: *When She Stopped Gasping for Breath,* 1993, p. 194; **Casanave**, Martha: Untitled Pinhole Photographs, p. 162-165; **Creates**, Marlene: from *where my grandmother was born,* from the series *Places of Presence,* 1989-1991, p. 43; **Cypis**, Dorit: from *X-Rayed (Altered)* p. 182-185; **Deadman**, Patricia: *Beyond Saddleback III,* 1991, p. 41; **Duarte**, Carlota: text by Odella, portraits of Odella, p. 150-153; **Fairbrother**, Fay: detail from *The Quilt Shroud Series,* 1991-92, p. 92; **Fessler**, Ann: *Ancient History/Recent History,* p. 272-275; **Gallagher**, Carole: *Animal Cages, Frenchman's Flat, Site of 27 Detonations, Nevada Test Site,* 1993, p. 56; **Goldin**, Nan: from *The Ballad of Sexual Dependency,* 1978-: *Mark and Mark,* Boston, 1978, p. 222; *Philippe M. And Risé on Their Wedding Day,* New York City, 1978, p. 223; *Greer and Robert on the Bed, New York City,* 1982, p. 223; *Philippe H. and Suzanne Kissing at Euthanasia, New York City,* 1981, p. 224; *Joey and Andres in Bed, Berlin,* 1992, p. 224; *The Hug, New York City,* 1980, p. 225; **Green,** Renee: *Sa Main Charmante,* 1989, p. 306; **Hart,** Sarah: from *Valley Girls: The Construction of Feminine Identity in Consumer Culture,* p. 94-97; **Hatch**, Connie: from *The DeSublimation of Romance,* p. 202-205; **Hayashi**, Masumi: *Gila River Relocation Camp,* 1990, p. 46; **Hinkley**, Caroline: *Death of the Master Narrative,* 1991, p. 47; *Open Season in the Weimar Colorado,* 1993, p. 198; **Jahoda**, Susan: from *Theatres of Madness,* p. 288-291; **Kaida,** Tamarra: from *Tremors from the Faultline: The Vegetarian,* p. 210; *Ex-Wife,* p. 211; *Malice,* p. 212; *Hawks,* p. 213; **Kane**, *Leigh: from A Legacy of Restraint,* p. 98-101; **Kelly**, Mary: from *Corpus,* p. 292-295; **Kruger**, Barbara: *Public Art Fund, New York City, Bus Shelter,* 1991, p. 14; *Campaign for Legal Abortion & Women's Reproductive Rights, New York City, poster,* 1990, p. 15; *Public Art Fund, New York City, billboard,* 1989, p. 15; *London, billboard,* 1986, p. 16; *Against the AntiGay Referendum, Portland, Oregon, bus placard,* 1992, p. 16; *New York City, poster campaign,* 1991, p. 17; *Campaign Against Domestic Violence, San Francisco, billboard,* 1992, p. 17; **Lacy**, Suzanne: *Falling Apart,* 1976, p. 188; **Lee**, Betty: *Miss America,* 1989, p. 163; from *Contemplation of the Journey Home: The Temple of Amah,* p. 276; *The Centurion,* p. 277; *Contemplation of the Journey Home,* p. 278; *The Wall,* p. 279; **Lee**, Jin: from *Untitled Heads,* p. 174-177; **Little Turtle**, Carm: from *Earthman Series: Earthman Won't Dance Except with Other Women,* 1992, p. 116; *Earthman Playing Chihuahua Love Songs He Thought He Heard in Taos,* p. 250; *Navajo Cowboy at Del Mar,* p. 251; *She Was Used to Abiding by Her Own Decisions,* p. 252; *Earthman Thinking about Dancing with Woman from Another Tribe,* p. 253; **Lohrke**, Deborah: *Untitled (Diet Scale),* 1993, p. 192; **Meiselas**, Susan: from *Archiving Abuse,* p. 76-79; **Millner**, Sherry: *Voyeurism and Its Discontents,* p. 30-33; **Min**, Yong Soon: *Decolonization,* p. 134-137; *Demilitarized Desire,* 1991, p. 190; from *Defining Moments, #4: Kwang Ju Massacre,* 1992, p. 268; **Nance,** Marilyn: *Deaconess Rosa Williams, Women's Day, Progressive Baptist Church, Brooklyn, NY,* p. 18; *Progressive Baptist Church,* p. 19; *First Annual Community Baptism for the Afrikan Family, Midnight Healing Session, Brooklyn, NY,* p. 19; *Women's Initiation Ceremony, New York City,* p. 20; *Akan Priestesses, New York City,* p. 21; **Neumaier**, Diane: from *Metropolitan Tits,* p. 284-287; **Niro**, Shelly: *500 Year Itch,* 1992, p. 121; **Noggle**, Anne: *Geraldine*

Bowen Olinger, Woman Air Force Service Pilot, USA, WWII, 1986, p. 22; *Nadezhda Popova, Pilot, Hero of the Soviet Union, Soviet Air Force Army, WWII*, 1991, p. 23; *Mariya Akilina, Bomber Pilot, Soviet Air Force Army, WWII*, 1991, p. 24; *Violet Thrun Cowden, Woman Air Force Service Pilot, USA, WWII*, 1986, p. 25; **Opie**, Catherine: from *Being and Having: Chief*, p. 254; *Whitey*, p. 254; *Chicken*, p. 255; *Oso Bad*, p. 255; *Dyke*, p. 256; *Self-Portrait*, p. 257; **Parada**, Esther: *Esther Parada, (not the typical) Portrait of a Revolutionary*, p. 130-133; **Piper**, Adrian: *Decide Who You Are #21: Phantom Limbs*, p. 102-103; *Decide Who You Are #6: You'r History*, p. 104-105; **Rebhan**, Gail S.: from *The Family Tapes*, p. 64-67; **Rickard**, Jolene: *Self-portrait--Three Sisters*, 1988, p. 117; **Rosenblatt**, Carol Simon: *Is This How I Look?* p. 34-37; **Rosler**, Martha: from *Bringing the War Home: House Beautiful: Boys' Room*, p. 126; *Balloons*, p. 127; *Red Stripe Kitchen*, p. 128; *Vacation Getaway*, p. 129; *Tract-House Soldier*, p. 129; **Rubenstein**, Meridel: *Broken Landscape*, 1990, p. 53; **Schuman**, Hilda: from *Dear Shirley*, p. 218-221; **Sherman,** Cindy: *Untitled*, p. 214-217; **Simpson**, Lorna: *Three Seated Figures*, 1989, p. 308; **Simpson**, Lorna: *Same*, p. 106; *Figure*, p. 107; *Guarded Conditions*, p. 108; **Simpson**, Coreen: from *Aboutface*, p. 258-261; **Sligh**, Clarissa: from *Reframing the Past: She Sucked Her Thumb*, p. 72; *Kill Or Be Killed #2*, p. 73; *Slept With Her Brother*, p. 74; *Waiting For Daddy*, p. 75; *What's Happening with Momma?*, 1988, p. 90; **Stewart**, Sharon: *Chevron's 160 Acre Uranium Mill Tailings Pond*, 1992, p. 55; **Stratton**, Margaret: *Justice on TV*, from *A Guide to the Wasteland*, p. 246-249; **Stratton**, Margaret: *Item #2, Item #127, Item #17, Item #211, Inventory of My Mother's House*, 1992, p. 88; **Tani**, Diane: *Diversification*, p. 110; *Hard Glance*, p. 111; *Self Identity*, p. 112; *Boiled*, p. 113; *Ancestors*, p. 113; *But in the Land of Promise*, p. 114; *Duel*, 1989, p. 265; **Tsinhnahjinnie**, Hulleah: *Talking About Aunt Lucy*, from the series *My Heroes Have Always Been Native*, 1993, p. 119; from *Native Programming: Mattie Looks for Stephen Biko*, p. 138; *Return of the Native*, p. 139; *Vanna Brown, Azteca Style*, p. 140; *"Oklahoma," the Unedited Version*, p. 141; *Census Makes a Native Artist*, 1992, p. 196; **Underhill**, Linn: from *Claiming the Gaze*, p. 166-169; from *The Global Face of AIDS: Photographs of Women .Sharon-Confidential*, 1987, p. 170; *Eleana and Rosa*, 1988, p. 171; *Natalie with Her Daughter, Carolyn and Her Son, Doug*, 1991, p. 171; *Leonor and Jose*, 1990, p. 172; *Rose*, 1993, p. 172; *Cheryl and Missy*, 1988, p. 173; **Weems**, Carrie Mae: from *Sea Island Series*, 1992, p. 45; Untitled from *Kitchen Table Series*, p. 206-209; **Williams**, Carla: installation views, *How to Read Character*, 1990-91, p. 85; from *How to Read Character*, p. 178-181; **Williams**, Pat Ward: Two installations: *I Remember It Well*, p. 142; *What You Lookn At*, 1993, p. 144.

1056. Rice, S. "Essential Differences: A Comparison of the Portraits of Lisette **Model** and Diane **Arbus**," *Artforum* 18, 9 (1980): 66-70.

1057. *Rising: Photographs and poetry by Women.* Syracuse, NY: Women's Photography Workshop & Women's Writers Workshop of the Women's Center at Syracuse University, 1974. 39 p. Illustrations.

Publication of the collective effort of these workshops resulted in this catalog of photographs and poetry.

Es, Winifred. **Troeller**, Linda . **Roth**, Marion. **Dugger**, Donna. **Bai**, Debbie. **Zucchino**, Nancy. **Jaffe**, Ellen. **Bostrom**, Paula Kimbro Inanna.

1058. Rosenblum, Naomi. *A History of Women Photographers*. New York: Abbeville, 1995. Bibliography by Peter Palmquist: p. 328-347. "Biographies" by Jain Kelly: p. 290-327. Bibliographical notes: p. 282-289.

This work is one of the first major chronological examinations of the history of women photographers from 1839 to the feminist vision of the 90s. Text accompanies the images throughout the volume.

Abbee, Kathryn: *Lisa Fonssagrives-Penn and Her Son*, 1955, pl. 222; **Abbott**, Berenice: *Cheese-Store, Bleecker Street*, c. 1937, pl. 168; *Marie Laurencin, Paris*, 1926, pl. 122; *Soap Bubble*, c. 1940, pl. 208; **Allen**, Frances S. and Mary E. **Allen**: *Pocumtuck Basket Makers*, c. 1900, pl. 53; **Appleton**, Jeannette M.: *Eagle Head Rock*, 1890, pl. 88; **Arbus**, Diane: *Seated Man in Bra and Stockings*, 1967, pl. 256; **Arnold**, Eve: *Owner of the 711 Bar*, 1952, pl. 178; **Auerbach**, Ellen: *Threads*, 1930, pl. 132; **Austen**, Alice: *Hester Street, Egg Stand Group*, 1895, pl. 104; **Austin**, Alice: *Reading*, c. 1900, pl. 77; **Bartlett**, Mary (Mrs. N. Gray): *Three Young Women in Woods*, c. 1900, pl. 97; **Ben-Yusuf**, Zaida: *The Odor of Pomegranates*, c. 1899, pl. 67; **Bernhard**, Ruth: *Two Forms*, 1963, pl. 254; *Creation*, 1936, pl. 233; **Bing**, Ilse: *It Was a Windy Day on the Eiffel Tower*, 1931, pl. 135; **Blondeau**: Barbara: *Untitled*, c. 1966-67, pl. 255; **Bonney**, Thérèse: *Refugee*, 1940, pl. 174; **Boughton**, Alice: *Nature's Protection*, c. 1905, pl. 262; **Bourke-White**, Margaret: *Woman with Plough, Hamilton, Alabama*, 1936, pl. 164; *Wounded G.I., Cassino Valley, Italy*, 1943-44, pl. 176; *Wind Tunnel Construction, Ft. Peck Dam*, 1936, frontispiece; **Bridges**, Marilyns: *Arrows Over Rise, Nazca, Peru*, 1979, pl. 243; **Brigman**, Anne W.: *Incantation*, 1905, pl. 102; **Brooks**, Charlotte: *Farm Cellar, New York*, 1945, pl. 207; **Brown**, Beatrice A.: *Students at Work, Clarence H. White School of Photography*, 1924-25, pl. 103; **Brush**, Gloria Defilipps:1947-*Untitled*, 1982, pl. 17; **Bubley**, Esther: *Duluth, Mesabi, and Iron Ore Range*, 1947, pl. 206; **Buehrmann**, Elizabeth: *Portrait of Julie Hudak*, pl. 79; **Burns**, Marsha: *No. 45006*, 1979, pl. 258; **Burson**, Nancy: *Untitled (Computer-generated portrait)*, 1988, pl. 237; **Butler**, Linda: *Magic Garden, Aichi-Ken, Japan*, 1987, pl. 240; **Caffery**, Debbie Fleming: *Sunset--Tractor, Harvesting*, 1986, pl. 210; **Callis**, Jo Ann: *Man Standing on Bed*, 1978, pl. 28; **Cameron**, Evelyn: *Mabel Williams Brings Water to the Threshing Crew*, 1909, pl. 55; **Cohen**, Lynne: *Corporate Office*, pl. 214; **Collins**, Marjory: *Photographer's Display on Bleeker[sic] Street*, 1942, pl. 167;**Cones**, Nancy Ford: *Threading the Needle*, c. 1907, pl. 57; **Connor**, Linda: *Dots and Hands, Fourteen Window Ruin, Bluff, Utah*, 1987, pl. 242; **Content**, Marjorie: *Untitled (Skies at Mill House)*, 1941, pl. 147; **Corpron**, Carlotta M.: *Light Pours Through Space*, 1946, pl. 229; **Cory**, Kate: *A Young Hopi Girl*, 1905-1912, pl. 80; **Cosindas**, Marie: *Richard Merkin*, 1967, pl. 25; **Cowin**, Eileen: *Untitled*, 1987, pl. 27; **Crane**, Barbara: *Wrightsville Beach,*

North Carolina, 1971, pl. 238; **Cunningham**, Imogen: *False Hellebore*, 1926, pl. 141; *Two Sisters*, 1928, pl. 155; **Dahl-Wolfe**, Louise: *The Covert Look*, 1949, pl. 6; **Dater**, Judy: *Consuelo Cloos*, 1980, pl. 247; **De Cock**, Liliane: *At the Base of Acoma, New Mexico*, 1970, pl. 241; **Dorr**, Nell: *Happiness*, 1940, pl. 166; **Eddy**, Sarah J: *The Bride*, c. 1900, pl. 66; **Emmons**, Chansonetta: *Untitled*, 1900, pl. 96; *Spinning Wool, West Portland, Maine*, 1910, pl. 54; **Farnsworth**, Emma J.: *A Muse*, pl. 98; **Fellman**, Sandi: *Horiyoshi III and His Son*, 1984, pl. 33; **Ferrato**, Donna: *Jackie--in the Hospital, Colorado*, 1984, pl. 202; **Flaherty**, Frances Hubbard: *Untitled*, pl. 215; **Fleischmann**, Trude: *Portrait of Alban Berg*, 1934, pl. 115; **Fletcher**, Christine B.: *Muscats*, c. 1938, pl. 150; **Freeman**, Emma B.: *Allegiance Vivian Chase, Hupa*, 1914-1915, pl. 81; **Frissell**, Toni: *Models Against Sky*, pl. 154; **Garner**, Gretchen: *Echo Pond Woods*, 1990, pl. 24; **Gilpin**, Laura: *Mariposa Lily*, 1922, pl. 156; *Bryce Canyon*, 1930, pl. 157; **Gledhill**, Caroline Even: *Portrait of Keith*, 1917, pl. 4; **Golden**, Judith: *Plays It Hot*, 1977, pl. 12; **Goldin**, Nan: *Nan and Brian in Bed, New York City*, 1983, pl. 29; **Greenfield**, Lois: *Untitled (Daniel Ezralow and David Parsons)*, 1982, pl. 231; **Groover**, Jan: *Untitled*, 1977, pl. 14; **Gunterman**, Mattie: *Two Prospectors*, early 1900s, pl. 108; **Hahn**, Betty: *Ultra Red and Infra Violet*, 1967, pl. 36; **Hanscom**, Adelaide: *Plate from "The Rubáiyat of Omer Khayyám*, 192, pl. 58; **Harleston**, Elise Forrest: *Portrait*, pl. 142; **Harold-Steinhauser**, Judith: *Dancing Tulips*, 1982-84, pl. 35; **Heyman**, Abigail: *Passover Seder*, 1979, pl. 263; **Hofer**, Evelyn: *Haughwout Building, New York*, 1975, pl. 226; **Irvine**, Edith: *The Burned Tree* (San Francisco Earthquake), April 1906, pl. 59; **Jacobi**, Lotte: *Photogenics*, 1946-1955, pl. 232; *Head of a Dancer*, c. 1929, pl. 121; **Jaques**, Bertha Evelyn: *American Senna, Cassia Marylandica, South Haven River Bank*, August 9, 1909, pl. 39; **Johnson**, Belle: *Three Women*, 1898, pl. 78; **Johnston,** Frances Benjamin: *Alice Lee Roosevelt*, 1902, pl. 75; *Self-Portrait* (as "new woman"), c. 1896, pl. 49, back cover; *Measuring and Pacing*, 1899-1900, pl. 61; **Kanaga**, Consuelo: *Mother with Children*, 1922-1924, pl. 170; **Käsebier**, Gertrude: *Portriat of Robert Henri*, c. 1900, pl. 64; *Flora* (Alternatively titled *Portrait Study, the Velvet Mantle* and *Florentine Boy*), c. 1897, pl. 70; *The Manger*, 1899, pl. 76; *Zitkala-Sa*, 1898, pl. 82; **Kasten**, Barbara: *Architectural Site 7, July 14, 1986*, 1986, pl. 16; **Kelly**, Angela: *Monica in Her Bedroom*, 1986, pl. 209; **Kemmler**, Florence B.: *The Trapeze Act*, 1928, pl. 159; **Kendal**, Marie Hartig: *Haycocks with Haystack Mountain*, c. 1890, pl. 56; **Krementz**, Jill: *E. B. White*, 1976, pl. 198; **Kruger**, Barbara: *Untitled (Use Only As Directed)*, 1988, pl. 26; **Lange**, Dorothea: *Pledge of Allegiance, San Francisco*, 1942, pl. 204; *Migratory Cotton Picker, Eloy, Arizona*, 1940, pl. 165; **Larsen,** Kristine: *Untitled (Homeless Woman, NYC)*, 1988, pl. 197; **Lavenson**, Alma: *Calaveras Dam II*, 1932, pl. 158; **Leibovitz**, Annie: *Isabella Rosellini and David Lynch*, 1986, pl. 225; **Lepkoff**, Rebecca: *Broadway Near Times Square*, 1948, pl. 217; **Levitt**, Helen: *New York*, 1942, pl. 218; **Louise**, Ruth Harriet: *A Self-portrait (?) With Joan Crawford*, 1928, pl. 160; **MacNeil**, Wendy Snyder: *Marie Baratte*, 1972-73, pl. 244; **Mandel**, Rose: *Untitled* from the series *On Walls and Behind Glass*, 1947-48, pl. 235; **Mann**, Sally: *Jessie at 5*, 1987, pl. 261; **Mark**, Mary Ellen: *Untitled (Home for the Dying)*,

1980, pl. 201; **Mather,** Margrethe: *Billly Justema in Man's Summer Kimono,* c. 1923, pl. 161; **McLaughlin-Gill,** Frances: *At the Galerie des Glaces, Versailles,* 1952, pl. 221; **Meiselas,** Susan: *Demonstrating against U.S. presence in the Philippines,* December 1985, pl. 10; **Mieth,** Hansel: *Boys on the Road,* 1936, pl. 177; **Miller,** Lee: *Buchenwald,* 1945, pl. 175; **Mitchell,** Margaretta K.: *Old Rose,* 1991, pl. 34; **Model,** Lisette: *Singer, Sammy's Bar, New York,* 1940-44, pl. 220; **Morath,** Inge: *Tarassa, Catalona,* 1961, pl. 200; **Morgan,** Barbara: *Valerie Bettis: Desperate Heart, I,* 1944-1972, pl. 230; **Moutoussamy-Ashe,** Jeanne: *Beverly Hodge, Bedford Hills Women's Correctional Center,* pl. 195; **Murray,** Joan: *Untitled* No.1 from the series *Man,* 1971, pl. 259; **Nance,** Marilyn: *First Annual Community Baptism for the Afrikan Family, New York City,* 1986, pl. 249; **Naylor,** Genevieve: *Eleanor Roosevelt,* 1956, pl. 223; **Neimanas,** Joyce: *Untitled No. 12,* 1982, pl. 18; **Nettles,** Bea: *Birdsnest,* 1977, pl. 15; **Noggle,** Anne: *Agnes in a Fur Collar,* 1979, pl. 246; **Norfleet,** Barbara: *Catbird and Bedspring Debris,* 1984, pl. 23; **North,** Kenda: *Untitled,* 1975, pl. 32; **Noskowiak,** Sonya: *White Radish,* 1932, pl. 162; **Novak,** Lorie: Detail of *Traces,* 1981, pl. 248; **Ockenga,** Starr: *Mother and Daughter,* 1974, pl. 245; **Orkin,** Ruth: *American Girl in Italy,* 1951, pl. 219; **Pagliuso,** Jean: *Untitled,* 1986, pl. 7; **Palfi,** Marion: *Saturday, Louisville, Georgia,* 1949, pl. 205; **Parada,** Esther:*At the Margin,* 1992, pl. 9; **Parker,** Olivia: *In the Works,* 1984, pl. 239; **Pitchford,** Emily H.: *Portrait of Adelaide Hanscom,* c. 1905, pl. 73; **Plachy,** Sylvia: *Transvestite,* 1988, pl. 257; **Purcell,** Rosamond W.: *Exeuction,* 1980, pl. 20; **Reece,** Jane: *The Poinsettia Girl,* 1907, pl. 74; **Richards,** Wynn: *Cigarettes,* c. 1925, pl. 152; **Rubenstein,** Meridel: *The Swallow's House, Progresso, New Mexico,* 1982-83, pl. 21; **Savage,** Naomi: *Catacombs,* 1972, pl. 234; **Sears,** Sarah C. *Lily,* pl. 92; **Sewall,** Emma D.: *The Clam Diggers,* c. 1895, pl. 107; **Sherman,** Cindy: *Untitled,* 1981, pl. 30; **Simon,** Stella: *Untitled,* c. 1927, pl. 146; **Simpson,** Coreen: *Doo Rag,* 1985, pl. 253; **Sipprell,** Clara: *Ivy and Old Glass,* 1922, pl. 153; **Skoglund,** Sandy: *The Green House,* 1990, pl. 31; **Sligh,** Clarissa: *He Was Her Husband When They Played "House,"* 1984, pl. 250; **Smith,** Ethel M.: *March,* c. 1945, pl. 149; **Solomon,** Rosalind: *Demon Attendants of the Goddess Kali,* 1981, pl. 212; **Sonneman,** Eve: *Beatrice Wyatt's Rock Garden: Rocks and Magnolia,* 1988, pl. 22; **Steber,** Maggie: *When Hunger Overcomes Fear (Photographed in Haiti),* 1986, pl. 11; **Sunday,** Elisabeth: *Basket of Millet,* 1987, pl. 252; **Tenneson,** Joyce: *Suzanne in Contortion,* 1990, pl. 13; **Thorne,** Harriet V. S.: *Man in Shower,* c. 1900, pl. 85; **Thorne-Thomsen,** Ruth: *September 4th, Wisconsin* from the series *Songs of the Sea,* 1991, pl. 236; **Tracy,** Edith Hastings: *Pananma Canal Construction,* c. 1913, pl. 60; **Turbeville,** Deborah: *Italian Vogue, Paris, 1981,* 1981, pl. 8; **Turner,** Judith: *Peter Eisenman, House VI, Cornwall,Connecticut,* 1976, pl. 227; **Tweedy-Holmes,** Karen: *Paul and Matthias,* 1967, pl. 260; **Ulmann,** Doris: *Mrs. Hyden Hensley and Child, North Carolina,* c. 1933, pl. 144; **Van Buren,** Amelia C.: *Madonna,* 1900, pl. 99; **Vandamm,** Florence: *Portrait of Unidentified Actor,* pl. 143; **Vereen,** Dixie D.: *Man and Child,* 1990, pl. 196; **Vignes, Michelle:** *Eli Mile High Club, Oakland,* 1982, pl. 211; **Vogt,** Jeannette (Jean Bernard): *Untitled* (Woman photographing through

doorway), 1890s, pl. 52; **Ward,** Catharien Barnes (Catharine Weed Barnes): *Five-O'Clock Tea,* 1888, pl. 51; **Watriss,** Wendy: *Untitled (Only One Son),* 1987, pl. 203; **Watson,** Edith S.: *Quebec Rural Scene,* c. 1920, pl. 110; **Watson-Schütze,** Eva: *Portrait of Hanni Steckner Jahrmarkt and Liese Steckner Webel,* c. 1909, pl. 72; *Untitled,* c. 1900, pl. 86; **Weems,** Carrie Mae: *"Jim, If You Choose to Accept, the Mission Is To Land on Your Own Two Feet,"* 1987, pl. 251; **Weil,** Mathilde: *The Embroidery Frame,* 1899, pl. 71; **Weiner,** Sandra: *Easter Morning, Ninth Avenue,* 1973, pl. 199; **Wells,** Alice: *Untitled (Child and Dog),* 1969-71, pl. 228; **Wiggins,** Myra Albert: *Hunger is the Best Sauce,* c. 1900, pl. 94; *The Forge,* 1897, pl. 95; **Withington,** Eliza: *Miners' Headquarters by the River,* c. 1874, pl. 43; **Wolcott,** Marion Post: *Pahokee "Hotel" (Migrant Vegetable Pickers' Quarters, near Homestead, Florida),* 1941, pl. 169; **Woodbridge,** Louise Deshong: *The Outlet of the Lake,* c. 1890, pl. 87; **Wooten,** Bayard: *Hands of Nell Cole Graves, Steeds, North Carolina,* 1930s, pl. 145.

1059. Rosenblum, Naomi. "Women in Photography: An Historical Overview," *Exposure* 24 (Winter 1986): 6-26.

1060. Rule, A. "Archives of American Women Photographers," *History of Photography* 18, 3 (Fall 1994): 244-247.

1061. San Francisco Museum of Art. *Women of Photography: an Historical Survey: exhibition. organized by San Francisco Museum of Art, April 18-June 15, 1975...*San Francisco: The Museum, 1975. Unpaged. Bibliography.
Each photograph is accompanied by a short biographical sketch of the photographer. The catalogue is introduced by an historical survey of women in photography.

Abbott, Berenice: *Fulton Street, Brooklyn, N.Y.,* 1936; **Arbus,** Diane: *The King and Queen of a Senior Citizen Dance, N.Y.C.,* 1972; **Austen,** Alice: *The Darned Club,* 1891; **Beals,** Jessie Tarbox: *[Girl in Kitchen];* **Bernhard,** Ruth: *[Pregnant Woman],* 1972; **Bourke-White,** Margaret: *The Conversation Club;* **Brigman,** Anne: *The Hamadryads;* **Carrey,** Bobbi: *Cyanotype #3,* 1974; **Corpron,** Carlotta M.: *Fluid Light Design,* 1946; **Cunningham,** Imogen: *Imogen with Camera,* 1910, cover; *Magnolia,* 1925; **Dahl-Wolfe,** Louise: *Wanda Landowska,* 1945; **Dater,** Judy: *Laura Mae,* 1973; **Dorfman,** Elsa: *Winnie Laurence at Home,* 1970; **Dorr,** Nell: *[Mother Kissing Infant]* from *"Mother and Child,"* 1954; **Emmons,** Chansonetta Stanley: *[Old Man and Two Old Woman at Table];* **Frank,** JoAnn: *Gibbs' Staircase, New York,* 1971; **Gilpin,** Laura: *Indian Ovens, Taos, New Mexico,* 1923; **Hahn,** Betty: *Road and Rainbow,* 1971; **Hanscom,** Adelaide: *[Figure on Sphere],* 1905; **Henri,** Florence: *Selbsportrait,* 1928; **Heyman,** Abigail: *Beauty Pageant,* from "Growing Up Female," 1971; **Jacobi,** Lotte: *Photogenic #303;* **Johnston,** Frances Benjamin: *Local History at the School, from the "Hampton Album";* **Käsebier,** Gertrude: *Happy Days,* c. 1900; **Klute,** Jeannette: *Indian Pipe,* 1950; **Koga,** Mary: *Hutterite Bride,* 1972; **Land-Weber,** Ellen:

Untitled, 1974; **Lange,** Dorothea: *Bad Trouble Over the Weekend,* 1964; **Leonard,** Joanne: *Romanticism Is Ultimately Fatal,* from "Dreams and Nightmares," 1972; **Mark,** Mary Ellen: *Central Park, N.Y.,* 1974; **Matthews,** Kate: *The Little Colonel,* c. 1898; **Model,** Lisette: *Old French Lady, Paris,* 1937; **Morgan,** Barbara: *Lloyd's Head,* 1944; **Palfi,** Marion: *Wife of the Lynch Victim,* from *"There Is No More Time,"* 1949; **Reece,** Jane: *Takka Taka-Yoga Taro,* 1922; **Resnick,** Marcia: *The Strawberry Bandito at the Glenwood Springs Strawberry Festival and Rodeo,* n.d.; **Savage,** Naomi: *Mask,* 1960; **Sheridan,** Sonia Landy: *Untitled,* 1971; **Truax,** Karen: *A Star Studded Day,* 1973; **Ulmann,** Doris: *[Singing in Church],* c. 1926; **Wells,** Alisa (Alice Andrews): from "Found Moments Transformed," 1969.

1062. *Stolen Glances: Lesbians Take Photographs.* Boffin, Tessa and Jean Fraser, eds. London: Pandora, 1991. 252 p. Bibliography: p. 244-245.
 Short essays by the photographers and other writers make up the major portion of this work; short biographical notes are included.

Abbott, Berenice: *Janet Flanner,* 1926-29, p. 36; **Austen,** Alice: *Julia Martin, Julia Bredt and Self Dressed Up as Men,* 1891, p. 25; *Self-portrait, full length with Fan,* 1892, p. 25; *Trude and I masked,* 1891; *Coasting--Wheeling from the Pegs,* p. 54; **Boffin,** Tessa: *The Knight's Move,* p. 44-48; **Bright,** Deborah: *Untitled* from the series *Dream Girls,* 1989-90, p. 145-150; *Angelic Rebels: Lesbians and Safer Sex,* 1989, p. 181; **Brooke,** Kaucyila: *Unknown Deviances (What a Dish!),* p. 163-172; **Cade,** Cathy: from *"A Lesbian Photo Album,"* p. 115-117; from *"Lesbian Mothering"* p. 118;Corinne, Tee: *Yantra #7,* 1982, p. 223; *Yantra #22,* 1982, p. 224; *A Woman's Touch #7,* p. 225; *The Three Graces,* p. 226; *Isis in the Woods,* p. 227; **Duckworth,** Jacqui: Stills from the film *Coming Out Twice,* p. 161; **Ferrill,** Mikki: *Gay Ball,Chicago,* p. 192; *'Dykes on Bikes,' Gay Pride Parade, San Francisco,* p. 193, 194; *Hallowe'en, Castro Street, San Francisco,* p. 195; *Castro Street, San Francisco,* p. 196; **Fraser,** Jean: *Celestial Bodies,* p. 77-85;**Grace,** Della: *The Ceremony,* p. 141-143; **Gwenwald,** Morgan: *Butch/Fem Picnic,* p. 230-232; **Meredith,** Ann: *Sharon--Confidential* from the series *Until that Last Breath: Women with AIDS,* 1987, p. 179; **Molnar,** Lynette: *Familiar Names and Not-so-familiar-faces,* p. 121-126; **Rosett,** Jane: *Carol LaFavor and Allyson Hunter,* 1987, p. 174; *PWA Vera Ajanaku participating in her first 'Die-In,'* 1988, p. 175; **Samaras,** Connie: *Paranoid Delusions: Acquired Immune Deficiency Syndrome,* 1985, p. 178; **Schuman,** Hinda: *Dear Shirley,* p. 87-93; **Spence,** Jo: *Transforming the Suit--What do Lesbians Look Like?* p. 27;

1063. Sullivan, Constance, ed. *Women Photographers.* Essay by Eugenia Parry Janis. New York: Harry N. Abrams, 1990. 263 p. Chiefly illustrations.
 Janis' critical essay on many of the photographers that are included offers insight into the paths some of these photographers took, their place in the history of photography and the continuing development, from one decade to the next.

Abbott, Berenice: *Jean Cocteau, Paris,* 1926, pl. 82; *Gwen Le Gallienne, Paris,* 1927, pl. 83; *Deputy M. Scappini, Paris,* 1927, pl. 84; *Walkway, Manhattan Bridge,*

New York, 1936, pl. 102; *Photomontage - New York,* c. 1930, pl. 103; *53 Gannesvoort Street, Brooklyn, New York,* 1936 or later, pl. 104; *Court of the First Model Tenements, New York,* 1936, pl. 105; **Arbus,** Diane: *Albino Sword Swallower at a Carnival, MD,* 1970, pl. 130; *Girl with Patterned Stockings,* c. 1965-69, pl. 131; *Girl with a Watch Cap, New York City,* 1965, pl. 132; *Untitled (7),* 1970-71, pl. 133; **Barney,** Tina: *The Landscape,* 1988, pl. 158; *The Graham Cracker Box,* 1983, pl. 159; **Beals,** Jesse Tarbox: *Man and Children in Tenement Back Yard, New York,* n.d., pl. 24; *Children with Burlap Sacks and Wheelbarrow,* n.d., pl. 25; **Bing,** Ilse: *Paris,* 1932, pl. 59; *Can-Can Dancers at the Moulin Rouge, Paris,* 1931, pl. 60; *Street Organ, Amsterdam,* 1933, pl. 61; **Bourke-White,** Margaret: *George Washington Bridge,* c. 1930s, pl. 56; *Untitled,* late 1920s, pl. 57; *Hydro Generators, Niagara Falls Power Co.,* 1928, pl. 58; *Fazenda Rio des Preda,* 1930s, pl. 121; **Brigman,** Anne: *A Study in Radiation,* 1924, pl. 15; *Saga--The Golden Fleece,* 1924, pl. 16; *Untitled, 1922, pl. 17;* **Caffery,** Debbie Fleming: *Untitled,* 1984, pl. 144; *Enterprise Sugar Mill,* 1987, pl. 145; **Callis,** Jo Ann: *Man Doing Pushups,* 1984-85, pl. 196; *Woman Twirling,* 1984, pl. 197; **Carroll,** Patty: 1946- *Xmas Tree in Window, Pompano Beach, Florida,* 1976, pl. 179; *Motel in Hell, Michigan,* 1975, pl. 180; **Clay,** Maude Schuyler, b. 1953: *Langdon and Anna Clay, near Rome,* 1988, pl. 162; *William Eggleston, Memphis,* 1988, pl. 163; **Cohen,** Lynne, 1944-:*Lecture Hall,* n.d., pl. 175; *Observation Room,* n.d., pl. 176; **Conner,** Lois: 1951-*Beijing, China,* 1988, pl. 184; *Buddha, Le Shan, Szechuan, China,* 1986, pl. 185; **Connor,** Linda: *Prayer Flag with Chörtens, Ladakh, India,* 1988, pl. 187; *Chörten, Ladakh, India,* 1985, pl. 186; *Monks, Phiyang Monastery, Ladhakh, India,* 1985, pl. 188; *The Oracle of Sabu in Trance, Ladhakh, India,* 1988, pl. 189; **Content,** Marjorie: *From 29 Washington Square,* c. 1928, pl. 62; *Untitled,* c. 1928, pl. 63; **Cunningham,** Imogen: *Triangles,* 1928, pl. 36; *Snake in Bucket,* 1929, pl. 37; *Nude,* 1932, pl. 38; *Breast,* c. 1927, pl. 39; *Aloe Bud,* c. 1926, pl. 40; *Untitled (Portia Hume),* c. 1930, pl. 41; *Calla,* c. 1929, pl. 42; **Ess,** Barbara: Untitled, from the *Food for the Moon* series, 1986, pl. 192; *Untitled,* 1988, pl. 193; **Gilpin,** Laura: *Sunrise, San Luis Desert,* 1921, pl. 30; *Cottonwoods, Taos Pueblo,* 1923, pl. 31; *The Tall Man at the Circus,* c. 1920s, pl. 32; **Goldin,** Nan: *Patrick Fox and Teri Toye on Their Wedding Night, New York City,* 1987, pl. 154; *Brian on the Phone, New York City,* 1981, pl. 155; *Cookie at Tin Pan Alley, New York City,* 1983, pl. 156; **Groover,** Jan: *Untitled,* 1983, pl. 171, 172; Untitled, 1984, pl. 173; Untitled, 1988, pl. 174; **Halverson,** Karen: 1941-*Lake Powell, near Wahweap Marina, Utah,* 1987, pl. 182; *Hite Crossing, Lake Powell, Utah,* 1988, pl. 183; **Hellebrand,** Nancy: *Mary Lee,* 1983, pl. 168; **Jacobi,** Lotte: *Franz Lederer, Berliner,* c. 1929, pl. 75; *Head of a Dancer (Niura Norskaya),* c. 1929, pl. 76; **Johnston,** Frances Benjamin: *Stairway of Treasurer's Residence. Students at Work,* 1899-1900, pl. 22; *Agriculture Mixing Fertilizer,* 1899-1900, pl. 23; **Kanaga,** Consuelo: *Girl in Straw Hat,* c. 1940, pl. 51; *The Girl with a Flower (Francis),* 1928, pl. 52; **Käsebier,** Gertrude: *Miss Dix,* n.d, pl. 18; *Indian Portrait,* c. 1905, pl. 19; *Gertrude and Charles O'Malley, Newport, Rhode Island,* 1902, pl. 20; *Gertrude Käsebier O'Malley at Billiards,* c. 1909, pl. 21; **Kasten,** Barbara: *Puye Cliff Dwelling,* 1990, pl. 181; **Lange,** Dorothea: *Torso, San Francisco,* 1923, pl.

43; *White Angel Kitchen, San Francisco,* 1933, pl. 117; *San Francisco Waterfront,* 1933, pl. 118; *Damaged Child, Shacktown, Elm Grove, Oklahoma,* 1936, pl. 119; *Homeless Wandering Boy,* 1933, pl. 120; **Lavenson,** Alma: *Child with Doll,* 1932, pl. 53; *Egg Box,* 1931, pl. 54; *Calaveras Dam II,* 1932, pl. 55; **Leibovitz,** Annie: *Randy Travis, Nashville,* 1987, pl. 160; *David Byrne, Los Angeles,* 1989, pl. 161; **Levitt,** Helen: *Children and Fire Hydrant,* c. 1945, pl. 122; *New York City,* 1945, pl. 123; *New York,* c. 1942, pl. 124; *Mexico City,* 1941, pl. 125; **MacNeil,** W. Snyder: *Jazimina,* 1985-87, pl. 164; *Jazimina and Ronald,* 1987-89, pl. 165; *Ezra Sesto,* 1977-88, pl. 166; *Adrian Sesto,* 1977-88, pl. 167; **Mann,** Sally: *Tobacco Spit,* 1987, pl.. 146; *Blowing Bubbles,* 1987, pl. 147; *Drying Morels,* 1988, pl. 148; *Jessie at Six,* n.d., pl. 149; **Mark,** Mary Ellen: *Blind Orphan at Shishu Bhawan, Calcutta, India,* 1980, pl. 140; *Home for the Dying, Calcutta, India,* 1981, pl. 141; **Mather,** Margrethe: *Moon Kwan with Yib Kirn,* n.d., pl. 79; *Semi-nude,* c. 1923, pl. 80; *Billy Justema, L.A.,* c. 1922, pl. 81; **Meiselas,** Susan: *Cuesta del Plomo. Hillside outside Managua, a well-known site of many assassinations carried out by the National Guard. People searched here daily for missing persons,* 1978-79, pl. 138; *Children rescued from a house destroyed by a 1000-pound bomb dropped in Managua They died shortly thereafter,* 1978-79, pl. 139; **Miller,** Lee: *Nude (Self-portrait), Paris,* c. 1931, pl. 69; *Eiffel Tower,* c. 1931, pl. 70; *Man Standing near Asphalt, Paris,* c. 1930, pl. 71; *Dead Prisoners, Dachau Concentration Camp, Germany,* April 30, 1945, pl. 72; *Beaten Guards Begging for Mercy, Dachau Concentration Camp, Germany,* April 30, 1945, pl. 73; **Model,** Lisette: *Woman at Opera with Face Covered,* c. 1945, p.126; *Sailor and Girl, Sammy's Bar, New York,* c. 1944 (before 1950), pl. 127; *Lower East Side,* 1940, pl. 128; *Black Dwarf, Lower East Side,* 1950, pl. 129; **Modica,** Andrea: *Treadwell, New York,* 1986, pl. 150; *Treadwell, New York,* 1987, pl. 151; **Norfleet,** Barbara: *Muskrat and Dick Francis: Black Point Pond, MA,* 1985, pl. 199; **Ross,** Judith Joy: Untitled from *Eurana Park, Weatherly, PA,* 1982, pl. 152; Untitled from *Portraits at the Vietnam Veterans Memorial, Washington, D.C.,* 1983-84, pl. 153; **Sherman,** Cindy: *Untitled,* 1989, pl. 200; *Untitled #96,* 1981, pl. 157; **Simmons,** Laurie: *Whiteman Coming,* 1981, pl. 194; *Vertical Water Ballet,* 1981, pl. 195; **Skoglund,** Sandy: *Radioactive Cats,* 1980, pl. 198; **Solomon,** Rosalind: *Bathers, Guatemala,* 1979, pl. 134; *Man at Swayamanboth Temple, Kathmandu, Nepal,* 1985, pl. 135; **Thorne-Thomsen,** Ruth: *Cones* from the *Expedition* series, c. 1982, pl. 190; *Head with* Plane from the *Expedition* series, c. 1979, pl. 191; **Ulmann,** Doris: *Woman Seated on Steps,* c. 1930, pl. 26; *Laundress, Peterken Farm, South Carolina,* 1929, pl. 27; *Baptism, South Carolina,* c. 1930, pl. 28; *Bell Ringer, South Carolina,* c. 1930, pl. 29; **Wagner,** Catherine: *Vista from Monorail, Wonderwall, Louisiana World Exposition, New Orleans, Louisiana,* 1984, pl.177; *Northwestern Corner with Sawhorse and Cement Mixer, George Moscone Site, San Francisco, California,* 1981, pl. 178; **Welty,** Eudora: *Bird Pageant Costumes,* before 1935, pl. 106; *Preacher and Leaders of the Holiness Church,* c. 1935-36, pl. 107; *Saturday Off,* before 1935, pl. 108; *Staying Home,* before 1935, pl. 109; *Untitled,* c. 1935, pl. 110, 111, 113; *Making a Date,* before 1935, pl. 112; **Wolcott,** Marion Post: *The Whittler, Camden, Alabama,* 1939, pl. 114; *[Guest being served lunch at private*

beach club, Palm Beach, Florida], 1939, pl. 115; *[Day laborers waiting to be paid, Marcella Plantation, Mileston, Mississippi],* 1939, pl. 116; **Woodbridge**, Louise Deshong: *Ladies Pool,* c. 1890, pl. 6; **Wright**, Holly: Untitled from the *Vanity* series, 1988, pl. 169, 170.

1064. Tucker, Anne, ed. *The Woman's Eye.* New York: Alfred A. Knopf, 1973. 169 p. Bibliography: p. 170.

Introductory essay by Tucker explores the place of women in the arts, expresses the struggles women photographers have had in gaining acceptance, and puts forth her thesis that there is, indeed, a relationship between [an artist's] sex and her art. Biographical and critical essays, with text from the artist's own writings, accompany each of the photographer's collection of images.

Abbott, Berenice: *André Gide*, p. 82; *Princess Eugéne Murat*, p. 83; *Sylvia Beach*, p. 84; *Hands of Jean Cocteau*, p. 85; *Daily News Building, New York City*, p. 86; *West Street, New York City*, p. 87; *Department of Docks, New York City*, p. 88; *Courtyard of model early tenement, East 70s, New York City*, p. 89; *Multiple exposure of a swinging ball in an elliptical orbit*, p. 90; *Parabolic mirror, made of many small sections, reflecting one eye*, p. 91; **Arbus**, Diane: *Man at a parade on Fifth Avenue, New York City*, 1969, p. 117; *A flower girl at a wedding, Connecticut*, 1964, p. 118; *A young Brooklyn family going for a Sunday outing, New York City*, 1966, p. 119; *Albino sword swallower at a carnival, Maryland*, 1970, p. 120; *The King and Queen of a Senior Citizens Dance, New York City*, 1970, p. 121; *Triplets in their bedroom, New Jersey*, 1963, p. 122; *Masked man at a ball, New York City*, 1967, p. 123; **Bourke-White**, Margaret: *Hydro generators, Niagara Falls Power Company*, 1928, p. 50; *Col. Hugh Cooper, Dnieper Dam, Soviet Union*, 1930, p. 51; *Village school, Kolomna, Volga Region, Soviet Union*, 1932, p. 54; *Locket, Georgia*, 1936, p. 55; *The Living Dead of Buchenwald*, April 1945, p. 56; *Death's tentative mark, India*, 1947, p. 57; *The Great Migration, Pakistan*, 1947, p. 58; *Gold miners, Nos. 1139 & 5122, Johannesburg, South Africa*, 1950, p. 59; **Dater**, Judy: *Laura Mae*, 1973, p. 144; *Joyce Goldstein in her kitchen*, 1969, p. 145; *Maureen*, 1972, p. 146; *Cheri*, 1972, p. 147; *Aarmoor Starr*, 1972, p. 148; *Gwen*, 1972, p. 149; *Maggie*, 1970, p. 150; *Woman, Beverly Hills*, 1972, p. 151; *Lucia*, 1972, p. 152; *Twinka*, 1970, p. 153; **Johnston,** Frances Benjamin: *Self-portrait*, p. 31; *Mrs. Logan's Boy*, p. 34; *Jane Cowl*, June 1908, p. 35; *Helmsman, U.S.S. Olympia*, 1899, p. 36; *Building in which Tuskegee began*, 1902, p. 37; *Stairway of Treasurer's Residence, Hampton Institute. Students at work*, 1900, p. 38; *Adele Quinney, Stockbridge tribe*, 1900, p. 39; *Woman factory worker in shoe factory, Lynn, Massachusetts*, 1895, p. 40; *Men breaking lumps in Kohinoor mine, Shenandoah City, Pennsylvania*, 1891, p. 41; *Stairway of Green-Meldrim House, Savannah, Georgia*, p. 42; *Warehouse, Fredericksburg, Virginia*, c. 1928, p. 43; **Käsebier**, Gertrude: *Portrait of Clarence White and his mother*, c. 1910, p. 28; *The Manger*, 1899, p. 19; *The Sketch*, c. 1902, p. 20; *Blessed Art Thou Among Women*, 1899, p. 21; *The War Widow (Beatrice Baxter Ruyl)*, p. 22; *The Heritage of Motherhood*, c. 1900, p. 23; *The Picture Book*, 1902, p. 24; *Happy*

Days, 1902, p. 25; *American Indian portrait*, c. 1899, p. 26; *Portrait of Sadakichi Hartmann*, c. 1910, p. 27; **Lange**, Dorothea: *Damaged child, Shacktown, Elm Grove, Oklahoma*, 1936, p. 66; *Street demonstration, San Francisco*, 1933, p. 67; *Tractored out, Childress County, Texas*, 1938, p. 68; *Sharecropper and family, Georgia*, 18, p. 69; *Lettuce cutters, Salinas Valley, California*, 1935, p. 70; *Ex-slave with a long memory, Alabama*, 1937, p. 71; *Gunlock, Utah*, 1953, p. 72; *Berryessa Valley, California*, 1956, p. 73; *Irish child, County Clare, Ireland*, 1954, p. 74; *Woman in purdah, Upper Egypt*, 1963, p. 75; **Morgan**, Barbara: *Martha Graham, Extasis (Torsol)*, 1935, p. 98; *Martha Graham, Letter to the World (Kick)*, 1940, p. 99; *José Limón, Mexican Suite (Peon)*, 1944, p. 100; *Samadhi (light drawing)*, 1940, p. 101; *Hearst over the people*, 1938-39, p. 102; *City shell*, 1938, p. 103; *Beech tree IV*, 1945, p. 104; *Brothers*, 1943, p. 105; *Beaumont Newhall*, 1942, p. 106; *Nancy Newhall*, 1942, p. 107; **Nettles**, Bea: *Self-portrait*, p. 156, 162; *"Escape,"* 1972, p. 159; *[Apartment building]*, p. 160; *[Lace across window]*, p. 161; *[Swimmer]*, p. 163; *[Reflection in mirror]*, p. 164; *[Airplane wing]*, p. 165; *[Pigeons]*, p. 166; *[Bride]*, p. 167; *[Child running]*, p. 168; *[Windows of house]*, p. 169; **Wells**, Alisa: *Self-portrait from the Blue Haze series*, p. 126; *"End of the Beginning/Beginning of the End." Berby Hollow, New York,*, 1963, p. 130; *Smoky Mountains, North Carolina*, 1967, p. 131; *"Hospital/DA and RWF,"* July 1967, p. 132; *Sue and Sam, Vick Park B.* (From *The Glass Menagerie)*, 1968, p. 133; *"Either/Or." Tallahassee, Florida*, 1969, p. 134; *"RZC picnic," Mendon, New York*, 1968, p. 135; from *Found Moments Transformed*, 1969-72, p. 136, 137, 138; from the *Blue Haze* series, Penland, North Carolina, 1970, p. 139.

1065. Whelan, Richard. "Are Women *Better* Photographers Than Men?" *ARTnews* (October 1980): 80-88.

1066. *Woman By Three*. Prose and poetry selected by Evan S. Connell, Jr. Menlo Park, CA: Pacific Coast Publishers, 1969. Unpaged.
 A collection of untitled photographs of women by Joanne **Leonard**, Michael E. **Bry** and Barbara Cannon **Myers.**

Leonard, Joanne: *[Young women with babies, sitting on wall] [Pregnant woman hanging laundry on clothesline] [Naked pregant woman lying on rug][Pregnant woman on rocking chair][Naked woman holding infant][Woman kissing child by run-down house][Blond woman on print chair][Pregnant woman and man at sides of large window][Woman removing dress, near bed][Woman near man in water][Young woman and young boy playing][Three women laughing on couch][Woman in formal, with long gloves][Graduates kissing][Women with children, laughing on street][Man and woman on couch][Woman in print bathing suit][Older couple hugging][Older woman, dressed as if for church][Woman searching through burned-out building][Seated young girl in polka dot dress][Seated young woman in striped dress][Seated young young woman with hand on chest][Seated older woman on large chair][Family with children on wooden bench][Standing young couple with infant]*; **Myers**, Barbara Cannon: All images are faces of various women.

1067. *Women Come to the Front: Journalists, Photographers, and Broadcasters.* Washington, D.C.: Library of Congress, 1997.
"War, Women and Opportunity--Eight women who came to the front: Therese Bonney; Toni Frissell; Marvin Breckinridge Patterson; Clare Booth Luce; Janet Flanner; Esther Bubley; Dorothea Lange; May Craig-- Accredited women correspondents during World War II. An exhibit spotlighting the work of women journalists.
Internet address: http:// lcweb.loc.gov.exhibits/wcf/wc0001.html

Bonney, Therese: *Took Refuge in Barns*, c. 1940; *So few have understood the Quakers, Red Crosses---nuns*, c. 1940; *Timidly ---they climb the walls to would-be homes in gutted houses*, c. 1940; *Meals cooked in the fields*, c. 1940; **Bubley**, Esther: *A busy shoe store on the last day....* 1943; *The schedule for use of the boarding house bathroom*, 1943; *Western Union telegram messengers*, 1943; *An instructor of the Capital transit company*, 1943; *Passengers, who have struck up a friendship*; *Boarding a special bus for service men*, 1943; *Jitterbug at an Elks' Club dance*, 1943; *Decorating a soldier's grave*, 1943; *Waiting for a bus at the Memphis terminal*, 1943; **Lange**, Dorothea: *Residents of Japanese ancestry awaiting the bus*, 1942; *An early comer*, 1942; *Children of the Weill public school*, 1942; *Civilian Executive Order No. 5*, 1942; **Patterson,** Marvin Breckinridge: *Savoy Hotel guests in shelter*, 1939; *Volunteer air-raid wardens*, 1939; *Funeral of Altmark seamen*, 1940.

1068. *Women Look at Women: a Library of Congress Exhibit.* Washington, D.C.: Library of Congress, 1979. 12 p.
Includes essay: "American Women in Photography: A Historical Overview 1850-1945" by Anne E. Peterson, and an checklist of the traveling exhibition.

1069. *Women of Vision: Photographic Statements/by twenty women photographers.* Edited by Dianora Niccolini. Introduction by Arlene Alda. Verona, NJ: Unicorn Pub. House, 1982. "A visual statement by twenty contemporary New York women photographers reflecting the positive and creative aspects of life." Each photographer submitted her own work that exemplified the theme, and accompanied them with a brief statement about her work. Each statement is also enhanced by a brief bibliographical statement about the photographer, and a portrait.

Abbe, Kathryn: *Leslaw and Waclaw Janicki, Twin Actors*, 1979, p. 41; *Laughing Horse*, 1978, p. 42; *Bubble Gum Machine*, 1980, p. 43; *Vivian and Marion Brown, San Francisco Twins*, 1979, p. 44; *Dancing at the Wedding*, 1981, p. 45; **Alda**, Arlene: *Japanese Schoolchildren*, 1981, p. 71; *Chinese Woman*, 1981, p. 72; *Chestnut Vendor, Japan*, 1981, p. 73; *Lotus Leaf, California*, p. 74; *Swan, California*, p. 75; **Brown**, Nancy: *Pennsylvania Dutch Man and Child*, 1977, p. 77; *Shepherd, Germany*, 1970, p. 78; *Man with Oxen, Holland*, 1970, p. 79; *Laundry, Italy*, 1970, p. 80; *Woman in Doorway, Italy*, 1970, p. 81; **Bullaty,** Sonia: *Sunrise, Kaibab Forest*, 1980, p. 65; *Firepinks, Great Smoky Moutnians*, 1974, p. 66; *Forest*

Leaves, Vermont, 1976, p. 67; *Deep Snow, High Sierra,* 1971, p. 68; *March Sunset, New York,* 1976, p. 69; **Buttfield,** Helen: *Kapiti Island,* 1967, p. 123; *Cherryplain, Winter,* 1976, p. 124; *Cherryplain, Summer,* 1975, p. 125; *Lake Benmore,* 1966, p. 126; *Farewell Spit,* 1967, p. 127;**Cunningham,** Imogen: **Freedman,** Jill: *Roseland Matinee,* 1976, p. 47; *The Total Woman,* 1975, p. 48; *Toga Dance,* 1978, p. 49; *Hector,* 1972, p. 50; *Mabel,* 1977, p. 51; **Hoban,** Tana: *Lemons in Wire Basket,* 1981, p. 89; *Eggshells,* 1981, p. 90; *Pebbles in Water,* 1981, p. 90; *Peaches on a Paper Bag,* 1980, p. 91; *Eggs in Wire Basket,* 1979, p. 91; **Keegan,** Marcia: *Taxco Street Scene in Mexico,* 1971, p. 83; *Himalayan Goatherd,* 1980, p. 84; *Classical Lawnmowing at the Taj Mahal,* 1980, p. 85; *Floating Garden of Dal Lake, Kashmir,* 1980, p. 86; *Kashmiri Lotus Unfolding,* 1980, p. 87; **Krementz,** Jill: **McLaughlin-Gill,** Frances: *Riverboat Gamblers,* 1979, p. 23; *Betha and Harriet Troxell, Gymnasts,* 1979, p. 24; *Marilyn and Rosalyn Borden,* 1979, p. 25; *The Dancing Class,* 1947, p. 26; *The Tent Makers,* 1961, p. 27; **Morgan,** Barbara: *El Flagellante,* 1940, p. 29; *Girls Dancing by the Lake,* 1945, p. 30; *Children Singing in the Rain,* 1950, p. 31; *Piglets nursing,* 1960, p. 32; *Bear Hugging,* 1946, p. 33; **Moser,** Lida: *Aaron Siskind,* 1949, p. 53; *Danny Clark,* 1976, p. 54; *The Dotzlers,* 1954, p. 55; *Pawel Checinski,* 1976, p. 56; *Leonard John Crofoot Studying a Painting by John Koch,* 1975, p. 57; **Niccolini,** Dianora: *Sun through Web of Hair,* 1974, p. 105; *Calla Lily,* 1982, p. 106; *Fold and Form,* 1982, p. 107; *Freesia,* 1982, p. 108; *Gladioli,* 1982, p. 109; **Opton,** Suzanne: *Untitled, 1980,* 1978, 1979, p. 93-96; *Children Ever Born to Women Ever Married,* 1981, p. 97; **Orkin,** Ruth: *American Gil in Florence, Italy,* 1951, p. 11; *Kids Reading Comics,* late 1940s, p. 12; *Jimmy the Storyteller, New York City,* 1947, p. 13; *Opening Night Party of Member of the Wedding, Ethel Waters, Carson McCullers and Julie Harris,* 1950, p. 14; *Hollywood Bowl Easter Sunrise Services,* 1948, p. 15; **Raymond,** Lilo: *Amagansett,* 1977, p. 111; *Still Life,* 1976, p. 112; *Pear,* 1980, p. 113; *Franny, Roxbury,* 1976, p. 114; *Franny, Warwick,* 1973, p. 115; **Rubinstein,** Eva: *Minneapolis,* 1979, p. 117; *Sister Virginia,* 1979, p. 118; *Church, Italy,* 1979, p. 119; *Monterey,* 1977, p. 120; *Versailles,* 1976, p. 121; **Sherwood,** Maggie: *Central Park Lake,* 1969, p. 99; *Snowstorm, Garment Center, New York,* 1965, p. 100; *Boardwalk, Atlantic City,* 1963, p. 101; *Coney Island Ferris Wheel,* 1961, p. 102; *Central Park Trees,* 1962, p. 103; **Stone,** Erika: *Mirage,* p. 35; *Danny Kaye at Tanglewood,* p. 36; *Rita Gam and Marlene Dietrich at the Circus,* p. 37; *Bowery Beauties,* 1942, p. 38; *Test of Strength,* 1942, p. 39; **Szasz,** Suzanne: *Chrissy: Four Days Old, A Year and a Half Old, Three and a Half Years Old, Nine Years Old, Sixteen Years Old,* p. 17-21; **Wynroth,** Via: *Chicago,* 1979, p. 59; *Loch Ness, Scotland,* 1980, p. 60; *Saugerties, New York,* 1981, p. 61; *Diana-on-the-Run Series,* 1978, p. 62, 63.

1070. *Women Photograph Men.* edited by Dannielle B. Hayes; introduction by Molly Haskell. New York: Morrow, 1977.Unpaged. Chiefly illustrations. Includes brief comments on the photographers.

Abbe, Kathryn: *Billy Graham,* pl. 52; *It is Snowing!* pl. 77; *Eli and Randy,* pl. 44; *Street Scene, San Francisco,* after pl. 44; **Alda,** Arlene: *Untitled,* pl. 16; **Andrews,**

Mary Ellen: *Moses Gunn #1-#3*, pl. 54-56; **Antmann**, Fran: *Circus Worker*, pl. 14; *Circus Clown*, pl. 15; **Astman**, Barbara: *Michael B.*, pl. 118; **Baubion-Mackler**, Jeannie: *Matador with Uncle*, pl. 19; **Berger**, Eileen K.: *Untitled*, pl. 117; **Blue**, Patt: *Bill, April*, 1973, pl. 48; *Walt*, November 1972, pl. 68; **Breil**, Ruth: *Giora in Brasilia*, Summer 1972, pl. 113; *Cowboy, Campo de Gato, Bah*ia, Summer 1972, pl. 21; *Cowboy with Star Hat, Bahia*, Summer 1972, pl. 22; **Campbell**, Carolee: *Untitled*, pl. 33, 37, 38, 73; **Carrey**, Bobbi: *Miss World/U.S.A. Beauty Pageant*, 1976, pl. 36; **Carroll**, Patricia: *An Evening with Jerry and Ted*, pl. 101; **Caulfield**, Patricia: *Jimmy Carter*, pl. 51; **Cook**, Susan: *Curtain Call--Rudolf Nureyev*, pl. 13; **Fox**, Flo: *Soldiers in France*, 1973, pl. 30; **Frisse**, Jane Courtney: *Charlie, Syracuse*, 1976, pl. 5; **Gluck**, Barbara: *Bamiyan Afghanistan*, after pl. 44; *Shoeshine Boy, Saigon, Vietnam*, 1973, pl. 45; *Coconut Monk Discipline, Phoenix Island, Vietnam*, 1973, pl. 99; *Soldier, Marble Mountain, Vietnam*, 1973, pl. 29; **Gold**, L. Fornasieri: *Politician, New York City*, pl. 24; *Wedding in Brooklyn*, pl. 92; **Goldberg**, Beryl: *Weaver, Bonwire, Ghana*, pl. 20; **Grunbaum**, Dorien: *Paternity*, pl. 66; *Chris and Toby and Fred*, pl. 67; *Holland*, pl. 102; **Hamilton**, Jeanne: *Moondog*, pl. 2; **Hamilton**, Virginia: *Mr. Bobby Brooks*, pl. 96; **Harrington**, Diane: *Untitled*, pl. 46; **Hayes**, Dannielle B.: *Avant Garde Festival*, 1975, after pl. 44; *After the Argument, Mexico*, pl. 89; *Before Burial, Mexico*, pl. 90; **Henry**, Diana Mara: *For Chief Judge*, 1973, pl. 23; *Student Faculty Advisory Committee*, pl. 25; *Vietnam Veterans Against the War*, pl. 27; **Holland**: *Untitled*, pl. 116; **Klein**, Sardi: *Mark Sunn*, pl. 3; **Larisch**, Kathleen: *Untitled*, pl. 110; **Lehmann**, Minnette: *Valet*, pl. 107; **Liftin**, Joan: *Untitled*, pl. 111; **Lynne**, Jill: *Man with Pinball Machine*; **Mandelbaum**, Ann: *The Float*, pl. 39; *Jim*, pl. 114; **Mark**, Mary Ellen: *Untitled*, pl. 63; **Maxson**, Holly: *Untitled*, pl. 112; **McLaughlin-Gill**, Frances: *Oskar Werner*, pl. 10; *Harold Pinter*, pl. 53; **Menschenfreund**, Joan: *Father and Daughter, Oregon*, pl. 70; **Miller**, Linda Joan: *Jeep*, 1974, pl. 50; **Moberley**, Connie: *Untitled*, after pl. 44; **Mogul**, Rhoda: *Taverna, Greece*, pl. 84; **Morgan**, Barbara: *Willard's Fist*, 1942, pl. 64; *Frog with Toad Prince*, pl. 76; **Muehlen**, Bernis von zur: *Portrait of Peter*, pl. 4; **Mulcahy**, L. P.: *Joe and Zoe*; **Neikrug**, Marjorie: *Peking*, 1975, after pl. 44; **Nelson**, Janet: *Untitled*, pl. 42, 98; **Niccolini**, Dianora: *Untitled*, pl. 65; **O'Hara**, Sheila: *Operation Sail in Operation*, pl. 93; **Opton**, Suzanne: *Untitled*, pl. 85; *Hink and Jim*, pl. 88; *Kenneth*, pl. 17; *Untitled*, pl. 31, 115; **Prager**, Marcia: *Untitled*, pl. 97; **Ravid**, Joyce: *Peter in the Pool*, pl. 40; **Robinson**, Abby: *Untitled*, pl. 41; **Rosen**, Trudy: *New York Knicks 1975, Dave De Busschere*, pl. 32; **Rubinstein**, Eva: *Israeli Soldier, Golan Heights*, October 1973, pl. 26; *Vietnam Veteran, California*, 1974, pl. 28; **Sargent**, Nickola M.: *Man on Horseback*, after pl. 44; *Brooklyn Bridge*, pl. 83; **Schwartz**, Robin: *Untitled*, after pl. 44; **Seed**, Suzanne: *Oil Truck Fire*, pl. 82; **Seid**, Eva: *Untitled*, pl. 47; **Shepherd**, Beth: *Safed, Israel*, 1972, pl. 86; **Simqu**, M. K.: *Untitled*, pl. 87, 94; **Starr**, Nina Howell: *Nathan, Memorial Day*, 1976, pl. 95; *Passport Picture*, pl. 108; **Stone**, Erika: *Test of Strength, Bowery, New York City*, pl. 34; **Stone**, Erika: *Look-Alikes, Central Park, New York City*, pl. 43; **Suris**, Sherry: *Mark and His Adopted Son Ari*, pl. 69; *Raphael Soyer Washing Brushes, Studio, New York City*,

pl. 18; *Orthodox Jewish Wedding Ceremony in the Rain*, pl. 91; **Swope,** Martha: *Mikhail Baryshnikov*, pl. 11; **Szasz,** Suzanne: *Jealousy*, pl. 75; **Tress,** Dawn Mitchell: *Jesus Christ*, pl. 109; **Tress,** Dawn Mitchell: *Richard Burton*, 1960, pl. 12; **Turner,** Judith: *Shimon*, pl. 49; **Tweedy-Holmes,** Karen: *Untitled*, pl. 7; **Wachstein**, Alison: *Rugby, Aspen, Colorado*, pl. 35; **White**, Linda Szabo: *Mannequin:Bachrach*, pl.103; *Two Heads*, pl. 104; *Chest*, pl. 105; *Feet*, pl. 106; **Wilson**, Helena Chapellin: *Unititled*, pl. 1.

1071. *Women Photographers in America, 1985: A national juried competition of women fine art photographers.* Los Angeles, CA: Woman's Building: Women in Photography, 1985. Catalog of the exhibition. 44 p.

Allen, Judy: *Beth-Truckee, CA*; **Armstrong**, Carol: *Composition*; **Baade**, Lee: *Cathedral Light*; **Beckman,** Judith A.: *Untitled*; **Berg**, Niki: *Eleanor & Meredith;* **Bergstedt**, Marie: *Chicken Screen Laundry*; **Bernard**, Cindy: *History Lesson*; **Bloomfield**, Lisa: **Bulin**, Marion: *Situation #4*; **Burnham**, Joan: *She Wanted a Pony, But Got a Dragon*; **Burns**, Millie: **Chung**, P.K.: *Terminal Illusions #1*; **Cleveland,** Jane Marie: *Letters from London #4*; **Collier**, Carlie: *Pink Shoes in the Morning, Madrid*; **Cook**, Diane: *Middleton Place, South Carolina, 1983*; **Crigler**, Cynthia: *Raw Hide*; **Dawson**, Julia Marsalek: *Chairs in the Garden;* **Diamond**, Aviva: **Dibert**, Rita: *Studio Setup #56*; **Drucker**, Barbara: **Evans**, Ina: *Sandra Meyer, Poet*; **Farley**, Kathleen A.: *Untitled #1*; **Fastman**, Raisa: *Raisa Fastman with Her Mother*; **Fliers**, Amani: *Simply Zen*; **Flynn**, Kathe: *Veronica*; **Fong**, Pamela: *Untitled*; **Gamper**, Gisela: *Betsey & George, 1982*; **Grundstein**, Margaret: *Untitled #2*; **Gurdjian**, Annette: *Self Portrait with Buick, Armenian American Princess*; **Hackett**, Linda: *My Parents Slept in Separate Bedrooms*; **Hammid**, Hella: *Interior Spaces #1*; **Herzhaft**, Beth: *Receptionist - Trash & Lingerie*; Judy Fox: **Kaida**, Tamarra: *Marvels of the New West*; **Kajn**, Deborah: *Martha & Jerry*; **Kaplan**, Corey: *Old Lady That Lived in a Shoe*; **Karafin**, Barbara: *Rubber Tree*; **Kenneday**, Elizabeth: *Floats, Goose Lake*; **Kleefeld**, Claudia: *Desecrated Eulogy*; **Kogan**, Deborah: *Untitled #8*; **Krasner**, Carin: *Flowers for Hal*; **Kreisher,** Katharine: *Tree*; **Krensky**, Jane: *Swimsuit Competition*; **Lally**, Diane: *Hot Time in the Old Pueblo*; **Landgraf**, Susan: *Beven*; **Landworth**, Tracey: *Untitled*; **Lauren**, Jilly: *Ellen Van Volkengury Browne - Vital Spirits/Images on Ageing*; **Lewis,** Rita Kurtz: *Glory*; **Lewison**, Brenda L.: *Most Dangerous Revolutionary*; **Meredith**, Ann: *I'm Scotch You Know*; **Morgan**, Ruth: *San Quentin - Maximum Security;* **Murray**, Frances: *Female Still Life: Balance, Self Portrait*; **Nye**, Carol Anne: *Untitled I*; **Olsen**, Alis: *Memories - Cousins*; **Park**, Patricia: *Mexican Postcard Series*; **Pietromartire**, Judith-Love: *Italian Market* ; **Pitt**, Pam: *Cadillac*; **Rachel**, Vaughan: *Kansas City, MO, Landscape, 1984*; **Ray**, Ruby: *Ancient One (Horned Torso)*; **Rosenblum**, Nancy: *Eloise Klein Healy 40, Poet, 1984*; **Roth**, Mary K.: *Magic Stairs*; **Rueb**, Debra: *Earth Mother*; **Sax**, Stephanie: *Constructions #4*; **Schwartz**, Linda: *Untitled*; **Slobodin**, Linda: *Untitled #1*; **Stenmark**, Ruthann: *Untitled*; **Stevens**, Jane: *Storm at the Beach*; **Stirek**, Catherine A.: *Untitled*; **Tarsches**, Abigayle: *Black Windows*; **Thomas**, Morgan: *Guns & Trees*; **Tucker**,

Carlyn: *Ginkgo Petrified State Park WA 2*; **Twiddy**, Susan: *Thanksgiving Visions*; **Unterberg**, Susan: *Self Portrait #1*; **Vaughn**, Martha: *Graffiti, Paris;* **Winston**, Judith: *Golden Arch*; **Wrausmann**, Gale: *Waiting 'Til the Cow's Come Home*; **Wuebker**, Mary Ann: *C.J.*; **Zadorozny**, Kathy: *Flame Tulips*.

1072. *Women See Men*. Yvonne Kalmus, et al . eds. New York: McGraw Hill, 1977.

Photographs are accompanied by very short biographical sketches.

Allen, Mariette Pathy: *Untitled*; **Allen**, Mary North: *Judge of County Court Works His Own Farm*; **Aturk**, Elizabeth: *Tom Fowler*, 1976; **Berg**, Gretchen: *The Late German Director, Fritz Lang, New York*, 1967; **Berger**, Eileen K.: *Two Boys Fighting in Landscape*; **Bernstein**, Andrea J.: *Steve*; **Bernstein**, Nita: *Untitled*; **Bushman**, Naomi: *Untitled*; **Collette**, Rebecca: *Juke Box; Twins (Donnie and Ronnie Wright)*; **Crampton**, Nancy: *Romare Bearden*; **Dena**: *Norman Mailer, Provincetown*, 1965; *Esteban Vicente (Painter)*, 1970; **Ewald**, Wendy: *Slaughter*; **Fox**, Flo: *Coffee Shop, New York City*; **Foy,** Marjorie: *Alexis Blassini, New York*, 1976; **Friedenreich**, Eileen: *the Party - or - For Sir Benjamin Stone*; **Galembo**, Phyllis: *The Millers*; *Jim*; **Gerstein**, Roz: *California*; **Grunbaum**, Dorien: *Fred With Chris and Toby*; **Hornung**, Christine: *Untitled 75 (Portrait of My Father)*; **Hougtaling**, Susan: *Untitled*; **Jacobi,** Lotte: *Peter Lorre, Berlin*, 1930's; **Johnson**, Ellen Foscue: *Man and Chair*; **Katchian**, Sonia: *Saturday Night, Madison Square Garden*; *Munson's diner, New York City*, 1973; *Times Square*; **Klein**, Sardi: *Molly and Hank's Wedding*; *Tailor, New York City*; **Leen**, Sarah E.: *Males in Motion, I*; **Leonard**, Joanne: *Benjamin Rubin, Nine Years Old*; *Man Sleeping*; *Man in Mirror (Bruce Beasley)*; *Benjamin Rubin, Two Years Old*; **Lloyd**, Susan G.: *Untitled;* **Mandelbaum**, Ann: *Untitled*; **Maricevic**, Vivienne: *Untitled*; **Matheson**, Elizabeth: *Untitled*; **Morath**, Inge: *Saul Steinberg, Manhattan*; **Morgan**, Barbara: *Willard's fist*, 1942; *Merce Cunningham--"Root of the Unfocus" (detail)*, 1944; **Moser**, Lida: *Bill Brandt*; *Joey Alan Phipps, 18 Years Old*, May, 1976; **Mosley,** Leigh H.: *Kevin and Tanzania Lassiter*; **Muehlen**, Bernis von zur: *Striped Nude (infra-red)*, 1976; *Infra-red Portrait of Peter*, 1975; **Niccolini**, Dianora: *Untitled*; **Ockenga**, Starr: *Untitled*; **Opton**, Suzanne: *Untitled*; **O'Neill**, Elaine: *Self Portrait With D. Snyder, Dayton, Ohio*; **Pfeffer**, Barbara: *Isaac Bashevis Singer*; **Pickens,** Marjorie: *Teenager in Water Fountain Spray*; **Plachy,** Sylvia: *Kite Flying, Long Island*; **Poitier**, Jacqueline: *Dancer and Baby*; **Polin**, Nancy: *Untitled*; **Rakoff**, Penny: *Untitled*; **Ravid**, Joyce: *Untitled*; **Reeves,** Caroline: *Untitled*; **Roberts**, Selina M.: *Untitled*; **Robinson**, Abbey: *Untitled*; **Rubini**, Gail: *Untitled*; **Russell**, Gail: *Wayne*, 1973; **Ruth**, Sura: *Untitled*; **Sage**, Linn: *Veteran's Day, New York*, 1968; *WBBG*, 1976; *Frank's Barbershop, Vermont*, 1976; *Coney Island*; **Savage**, Naomi: *Marcel Duchamp and Man Ray*; **Seed**, Suzanne: *Bartender, Indiana*; **Shostak**, Marjorie: *Male Dancer with Partner, Boston, Mass.*; **Snyder**, Suellen: *Larry in Hammock; Men at Dog Show*; **Spurgeon**, Lucia A.: *Untitled*; **Starr**, Nina Howell: *To Hire*, 1974; **Tinkelman**, Susan: *Marshall's Hand With Pear*; **Tuite,** Kathy: *Paul Tuite; Ken Gordon*; **Turk**, Elizabeth: *Kim Harrison, Summer*, 1976;

Tweedy-Holmes, Karen: *Frank;* **Ursillo**, Catherine: *Naples, Italy;* **Virga**, Ethel: *C at the 79th Street Rotunda--Night;* **Wald**, Carol: *Black Man; Tower of Babel;* **Weinberg**, Carol: *Untitled;* **Weiss**, Eva: *Daniel Allen.*

1073. *Women's Creativity: Five Arizona Photographers.* Video recording, 58 minutes. Arizona: Cactus Rose Productions, 1992.
"Interviews with five women photographers: Frances **Murray**, Patricia **Katchur**, Linda **Ingraham**, Judith **Golden** and Tamarra **Kaida**. A collaboration between behavior scientists and artists to discover what motivates the photographers, what happens during their creative process and how they are influenced by internal and external forces."oclc

INDEX TO AUTHORS

NOTE: All numbers are entry numbers

INDEX TO MONOGRAPHIC, DOCTORAL DISSERTATION AND VIDEORECORDING TITLES

NOTE: All numbers are entry numbers